THE GEOMETRY OF CREATION

The Geometry of Creation

Architectural Drawing and the Dynamics of Gothic Design

ROBERT BORK

Routledge
Taylor & Francis Group

LONDON AND NEW YORK

First published 2011 by Ashgate Publishing

Published 2016 by Routledge
2 Park Square, Milton Park, Abingdon, Oxfordshire OX14 4RN
711 Third Avenue, New York, NY 10017, USA

First issued in paperback 2016

Routledge is an imprint of the Taylor & Francis Group, an informa business

British Library Cataloguing in Publication Data
Bork, Robert Odell, 1967–
 The Geometry of Creation: Architectural Drawing and the Dynamics of Gothic Design.
 1. Architectural drawing, Medieval. 2. Architecture, Gothic – Designs and plans. I. Title.
 720.2'84'09022–dc22

Library of Congress Cataloging-in-Publication Data

Library of Congress Control Number: 2011921241

ISBN 13: 978-1-138-24767-3 (pbk)
ISBN 13: 978-0-7546-6062-0 (hbk)

The Geometry of Creation

Architectural Drawing and the Dynamics of Gothic Design

ROBERT BORK

Routledge
Taylor & Francis Group

LONDON AND NEW YORK

First published 2011 by Ashgate Publishing

Published 2016 by Routledge
2 Park Square, Milton Park, Abingdon, Oxfordshire OX14 4RN
711 Third Avenue, New York, NY 10017, USA

First issued in paperback 2016

Routledge is an imprint of the Taylor & Francis Group, an informa business

British Library Cataloguing in Publication Data
Bork, Robert Odell, 1967–
 The Geometry of Creation: Architectural Drawing and the Dynamics of Gothic Design.
 1. Architectural drawing, Medieval. 2. Architecture, Gothic – Designs and plans. I. Title.
 720.2'84'09022–dc22

Library of Congress Cataloging-in-Publication Data

Library of Congress Control Number: 2011921241

ISBN 13: 978-1-138-24767-3 (pbk)
ISBN 13: 978-0-7546-6062-0 (hbk)

Contents

List of Figures

Unless otherwise noted, all geometrical graphics are by the author. For figures listed without photo source, photo credit belongs to the institution holding the object.

Acknowledgements

I find it both humbling and gratifying to realize how much support and encouragement I have received over the years as I have pursued my often solipsistic passion for Gothic architectural geometry. In one sense, the long genesis of this project reaches back to my early teenage years, when I began to obsessively draw cathedrals after a visit to Reims with my parents. I went on to develop this interest in college and graduate school under the tutelage of Stephen Gardner, Sergio Sanabria, Virginia Jansen, Robert Mark, and Stephen Murray, all of whom I thank for launching me into my career in architectural history. And in 1998, my first year teaching in the wonderfully supportive art history department at the University of Iowa, I began to explore Gothic geometry more systematically while investigating the choir of Metz Cathedral.

The real beginning of this project dates to the summer of 2001, when I was able to examine and measure Strasbourg Plan B, a drawing that figured prominently in my ongoing study of Gothic spire design. The summer of 2001 proved pivotal also because Norbert Nussbaum kindly invited me to participate in a conference in Schwäbisch-Gmünd, where I connected with many of the other scholars whose work has informed and inspired this project, including Hans Böker, Paul Crossley, Peter Kurmann, Pablo de la Riestra, Marc Schurr, and Achim Timmermann. That fall term, under the shadow of the September 11 attacks, I was fortunate to continue working alongside Norbert in Cologne, thanks to a Career Development Award and an International Programs travel grant from the University of Iowa. My primary objective at that point was to complete the manuscript for my first book, *Great Spires: Skyscrapers of the New Jerusalem*, but it was already becoming apparent that my next major project would involve the geometry of drawings. Already in 2003, therefore, I visited Vienna, where Hans Böker and Monika Knofler thoughtfully facilitated my examination of many drawings from the unrivaled collection of the Kupferstichkabinett at the Akademie der bildenden Künste.

Late in 2004 I was thrilled to receive substantial grant support for my project: a Faculty Scholar Award from the University of Iowa, a Sabbatical Fellowship from the American Philosophical Society, and a Frederick Burkhardt Fellowship from the American Council of Learned Societies. I am profoundly grateful for this institutional largesse, which allowed me to concentrate intensively on my geometrical research in ways that would have been impossible otherwise. I spent the summer of 2005 on a delightful research trip with Achim Timmermann and Jackie Jung, examining Gothic drawings and tracking down specimens of microarchitecture throughout the German-speaking world; during this period I also began to enter into serious discussions about this book project with Ashgate editor John

Smedley. I am tremendously grateful to John for being so encouraging and supportive throughout this book's long gestation period.

Bolstered by this generous backing, I spent the spring semester of 2006 in Europe, living roughly a month at a time in Cologne, Strasbourg, and Munich, before traveling through Italy and Switzerland. My family and I passed the 2006–2007 academic year at CASBS, the Center for Advanced Study in the Behavioral Sciences in Stanford, California, an idyllic setting in which I was able to draft roughly half of this book manuscript. For their hospitality in California, I am particularly grateful to Bob Scott and the members of the Sarum Seminar, and to Jennifer Summit and the members of the Stanford University program in Medieval Studies. Before returning to Iowa, I received two more grants that I am happy to acknowledge: a publication subvention from the Samuel H. Kress Foundation, and a fellowship from the Alexander von Humboldt Stiftung that allowed me to spend the summers of 2008, 2009, and 2010 in Cologne, working again alongside Norbert Nussbaum and his students. In the summer of 2010, finally, I welcomed the perceptive feedback on my manuscript from Paul Crossley, whose excellent suggestions I've done my best to incorporate.

The preceding chronology already hints at the extent to which the production of this book has been made possible by support from a diverse array of individuals and institutions, but many important contributors remain to be acknowledged. Given the nature of this project, I am particularly indebted to the staff members of the many museums that have granted me access to or publication rights for the Gothic drawings in their collections: the Historisches Museum in Bern; the Archives départmentales du Puy-de-Dôme in Clermont-Ferrand; the Domarchiv and Stadtmuseum in Cologne; the Historisches Museum in Frankfurt; the Münsterbauverein in Freiburg; the Archives de l'État in Fribourg; the Collection M in Leuven; the Victoria and Albert Museum in London; the Cloisters in New York; the Opera del Duomo in Orvieto; the Bibliothèque de l'Institut de France and the Bibliothèque nationale de France in Paris; the Diözesanmuseum and Dombauhütte in Regensburg; the Opera della Metropolitana in Siena; the Musée de l'Oeuvre Notre-Dame and Fondation de l'Oeuvre Notre-Dame in Strasbourg; the Stadtarchiv, Stadtmuseum, and Dombauhütte in Ulm; and the Dombauhütte, the Wien Museum and the Kupferstichkabinett of the Akademie der bildenden Künste in Vienna.

I am also grateful to many other individuals not yet named above who have made my work on this project more pleasant, more rewarding, and altogether better. If I were to detail their contributions, my list of acknowledgments would grow to rival the length of the book itself. With apologies for the concise format, then, I am pleased to thank the following friends and colleagues: James Ackerman, Valerio Ascani, Carl Barnes, Klara Benešovská, Christoph Brachmann, Shirley Prager Branner, Bill Clark, Greg Clark, Matthew Cohen, Meredith Cohen, the Colby-Westphal family, Thomas Coomans, Danya Crites, Michael Davis, Cecile Dupeux, Natasha Eaton, Thomas Flum, Christian Freigang, Alexandra Gajewski, Gudrun Gersmann, the Graf-Bicher family, Max Grossman, Klaus Hardering, Ulrike Heckner, Stefan Holzer, Stephan Hoppe, Ann Huppert, Linda Jack, Dick and Ann Jones, Andrea Kann, Thomas DaCosta Kaufmann, Matt Kavaler, Steve Kerrigan, Holger Klein, Hubertus Kohle, Alex Kobe, Astrid Lang, Sabine Lepsky, Kris Luce, Gerhard Lutz, Therese Martin, Abby McGehee, Nico Menéndez González, Jeff Miller, Maureen Miller, Scott Montgomery, Linda Neagley, Lucie and Rosa Nussbaum,

Zoë Opačíć, Jean-Pierre Reeb, Hermann Reidel, Cornelia Reiter, Lucio Riccetti, Stefan Roller, Mary Sarotte, Emily Schaum, Barbara Schock-Werner, Helmut Selzer, John Senseney, Ellen Shortell, Gisbert and Vera Siegert, Charlotte Stanford, Marc Steinmann, Richard Sundt, Arnaud Timbert, Marvin Trachtenberg, Steve Walton, Christopher Wilson, Nancy Wu, and Wolfgang Zehetner. Many of these individuals have contributed valuable ideas and suggestions to this book project, and I freely acknowledge that any errors that may have crept into my text are entirely my responsibility.

Of the many colleagues who have contributed to this project, two in particular deserve my very special thanks. Norbert Nussbaum and Achim Timmermann have shared large portions of my professional journey over the past decade, and they have become dear friends along the way. I feel very fortunate indeed to have developed this project in close consultation with such warm, witty, and expert scholars.

My family has shared my journey even more closely, having traveled with me back and forth between Iowa, Europe, and California over the past decade. My son Stephen, now fourteen years old, can scarcely remember a time when I was not working obsessively on Gothic geometry. My wife Sally has been an amazing partner throughout, providing a mix of love, support, and insightful critique without which I would never have been able to complete this book. Since this project has enriched and complicated our family life in so many ways over the years, I am delighted to dedicate the final product to Sally and Stephen.

Cologne, August 2010

INTRODUCTION
Geometry and the Gothic Design Process

EXPLAINING THE ROOTS OF THE GOTHIC AESTHETIC

Gothic church architecture powerfully conveys impressions of movement and restless growth. In many Gothic interiors, slender columns seem to soar heavenward, as if unconstrained by gravity, before sprouting ribs that knit together into complex vaults. Exterior elements such as spires and pinnacles further emphasize the sense of upward thrust, while leafy crockets and other foliate carvings literalize the organic growth metaphor. Gothic churches also have a crystalline quality that adds a dynamism of its own to the architecture. Both the buildings themselves and their small components generally have polygonal plans, with faceted surfaces meeting at sharp edges. The alignments between these surfaces define planes of reflection and axes of rotation about which the architecture seems to organize itself. The formal kinship between large and small-scale elements, meanwhile, recalls that seen in mineral crystals.[1] These features of Gothic architecture together suggest that the church building is a living microcosm of a divinely created cosmos.

The organicity and complexity of Gothic churches, which contribute so strongly to their aesthetic effect, have, ironically, obscured the working methods of the designers who conceived them. Because Gothic buildings tend to dazzle their beholders, their visual pyrotechnics can appear to defy rational analysis. The striking fact remains, however, that Gothic churches were created not by miraculous cosmic forces, but by preindustrial workers armed only with simple tools. The church designers, in particular, developed their plans using mainly the compass and the straightedge rule. These men would have received their early training in the stoneyard, but by 1200 or so, the greatest masters had begun to function principally as draftsmen, working out their designs in elaborate drawings before the start of each building campaign.[2] Fortunately, several hundred of these drawings survive to document the designers' creative practice in remarkably intimate detail. These drawings include compass prick holes, uninked construction lines, and other telltale traces of the draftsman's labor. Their proportions, moreover, directly reflect the designer's original vision, uncorrupted by the small errors and misalignments that can creep into full-scale buildings during construction. Careful analysis of these drawings, therefore, can reveal a great deal about the logic of the Gothic design process.

[1] Self-similarity of this sort is also seen in the mathematical objects known as fractals, which began to be studied only after computers made it possible to examine the forms that result from the repeated application of simple rules to make complex structures. For an early study of these forms, see Benoit Mandelbrot, *Fractals: Form, Chance and Dimension* (San Francisco, 1977).

[2] A pioneering study of this pivotal phase is Robert Branner, "Villard de Honnecourt, Reims and the Origin of Gothic Architectural Drawing," *Gazette des Beaux-Arts*, 6th ser., 61 (March 1963): 129–46.

This book is called *The Geometry of Creation* because it seeks to explain the geometrical design methods by which Gothic draftsmen conceived their audacious building plans. By presenting a series of case studies of major Gothic drawings, it will demonstrate, in detailed step-by-step fashion, how simple geometrical operations could be combined to produce designs of daunting quasi-organic complexity. Ultimately, it will show that Gothic architecture was governed by procedural conventions, rather than by fixed canons of proportion. The Gothic tradition, in other words, treated the finished building as the physical trace of a dynamic design process whose internal logic mattered more than the shape of the final product. The seeming organicity of Gothic architecture, therefore, is more than skin deep. It reflects the basic character of Gothic architectural order, which differs fundamentally from the more static modular order seen in most subsequent western architecture.

To understand why a book like the present one can provide a valuable new perspective on Gothic creativity, it helps to briefly review the history of previous attempts to explain Gothic design practice. Gothic designers themselves, unfortunately, left behind no very satisfying treatises on the subject. This is hardly surprising, since their training emphasized visual rather than textual communication. Until the fourteenth century, at least, most Gothic designers would have been functionally illiterate, and ill-prepared to record their methods in writing.[3] The so-called portfolio of Villard de Honnecourt from the early thirteenth century admittedly includes many architectural drawings, geometrical figures, and associated commentaries, some of which will be considered in detail below, but a variety of factors suggest that it should be treated as something less than a fully reliable guide to then-current architectural practice.

The drawings in Villard's portfolio, which rank among the oldest extant Gothic drawings, differ in several respects from the genuine workshop drawings that survive from roughly 1250 and later. To begin with, some of them provide dramatic quasi-perspectival spatial cues that suggest a subjective point of view. In his large exterior view of the Laon Cathedral tower, for example, the tops of the tabernacles are pitched diagonally to suggest a view from below (Figure 0.1 top). These tabernacles, moreover, appear much larger than they do in the actual tower. Even in Villard's drawings that present information more accurately and objectively, like his plan for the Laon tower, his rough draftsmanship sets his work apart from later and more geometrically precise building plans drawn with a compass and rule (Figure 0.1 bottom). In yet other cases, Villard's drawings differ quite markedly from the buildings they purport to represent, sometimes in ways that suggest genuine misunderstandings rather than simply alternative design proposals; his drawings of the Reims Cathedral choir, for example, differ from the real building in terms of both proportion and detailing.[4] For these reasons, among others, modern scholars tend to believe that Villard de Honnecourt was not actually an architect, but rather an

[3] This is not to say, of course, that they lacked recognized expertise and high social standing, which was respected even by Scholastic writers. See Paul Binski, "'Working by Words alone': The Architect, Scholasticism and Rhetoric in Thirteenth-century France," in Mary Carruthers (ed.), *Rhetoric beyond Words: Delight and Persuasion in the Arts of the Middle Ages* (Cambridge, 2010), pp. 14–51.

[4] Quasi-perspectival cues are especially evident in Villard's views of the Reims chapels, folios 30v and 31r. The Reims choir buttressing is shown rather inaccurately on folio 32v. See William W. Clark, "Reims Cathedral in the Portfolio of Villard de Honnecourt," in Marie-Thérèse Zenner (ed.), *Villard's Legacy: Studies in Medieval Technology, Science and Art in Memory of Jean Gimpel* (Aldershot, 2004).

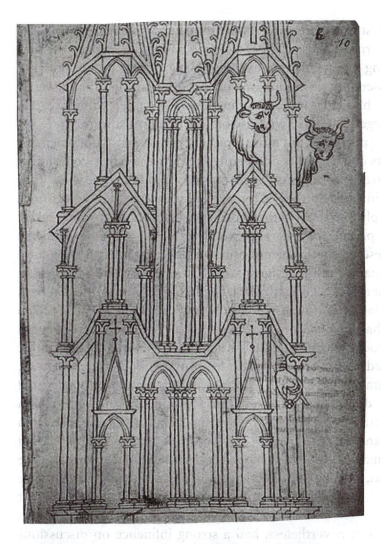

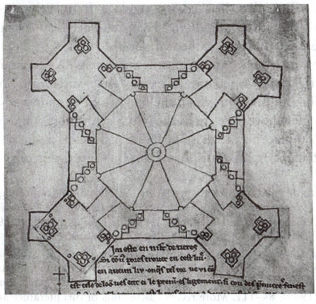

Figure 0.1
Villard de Honnecourt, plan
(below) and impressionistic
elevation (above) of a tower
from Laon Cathedral, from the
Portfolio, folios 9v and 10r,
respectively. The two drawings
have here been set to a common
scale, so that their architectural
elements align, although the
elevation was drawn to a larger
scale.

itinerant artist with a lively interest in architecture.[5] His commentaries, which he probably dictated to a scribe rather than writing himself, are interesting and wide ranging, but they certainly do not provide anything like a coherent explanation of Gothic design practice. Since Villard's portfolio was essentially a unique one-off production, one that came to prominence only following its publication in the mid-nineteenth century, it cannot readily be seen as representative of a larger discourse within Gothic workshop culture.

Less charismatic than Villard's portfolio, but more typical of the medieval documentary tradition, are the expense reports and accounts of meetings held by the fabric committees overseeing major Gothic architectural projects. Such unillustrated records, when they survive, can provide a wealth of information useful for analyzing construction procedures, dating building campaigns, and placing them in their social context, but they rarely reveal much about the Gothic design process *per se*. The extensive fabric accounts from the cathedral of Milan, however, deserve special mention in this context, because they have often been invoked to help explain Gothic design practice in general. The situation in Milan, though, was anything but typical. The cathedral, begun in 1386, was unusual both in its grandiose scale and in the fact that its construction brought together designers from both sides of the Alps, who by that time had begun to work in very different architectural traditions.[6] The northerners argued that the building should conform fully to the Gothic cathedral type that had emerged in France, with slender proportions, large windows, deep buttresses, and small capitals. The Italians, by contrast, had never fully accepted the premises of northern Gothic design. The Milanese thus continued to take inspiration from their local Romanesque tradition, even as they sought rhetorical support from sources as diverse as Aristotle and the re-emergent classical idea that a column should have the proportions of the human body. The debates between the northerners and the Milanese were often acrimonious, and the building that resulted from their work must be understood as an unusual hybrid, rather than a normative specimen of a single coherent design tradition.

The Milan fabric accounts have, nevertheless, had a strong influence on discussions of the Gothic approach to geometry, especially since they provide a frequently cited source for the phrases "*ad quadratum*" and "*ad triangulum*." Heinrich Parler, a German consultant active at Milan, recommended that the cathedral should be designed "*ad quadratum*" or "to the square," meaning in this context that the total height of its main vessel should equal the combined width of the vessel and its aisles. "*Ad triangulum*," by analogy, has often been used to describe buildings in which the height of the main vessel equals the height of an equilateral triangle whose base spans the width of the vessel and its aisles. Some Gothic buildings actually do incorporate these proportions, as the discussion of Strasbourg Cathedral in Chapter 2 will demonstrate. At Milan, however, this purely

[5] This argument has been made most forcefully and consistently by Carl Barnes. For his most thorough treatment, see *The Portfolio of Villard de Honnecourt: A New Critical Edition and Color Facsimile* (Farnham, 2009). Barnes's study effectively supersedes Hans R. Hahnloser's *Villard de Honnecourt: Kritische Gesamtausgabe des Bauhüttenbuches ms. fr. 19093 der Pariser Nationalbibliothek* (Graz, 1972).

[6] This debate is the subject of a series of classic articles by Paul Frankl, "The Secret of the Medieval Masons," *Art Bulletin*, 27 (1945): 46–60; Erwin Panofsky, "An Explanation of Stornaloco's Formula," *Art Bulletin*, 27 (1945): 61–4; and James S. Ackerman, "'Ars Sine Scientia Nihil Est': Gothic Theory of Architecture at the Cathedral of Milan," *Art Bulletin*, 31 (1949): 84–111. More recent discussions of this literature are usefully summarized in Valerio Ascani, *Il Trecento Disegnato: Le basi progettuali dell'architettura gotica in Italia* (Rome, 1997), esp. pp. 36–43. See also Chapter 6, below.

geometrical format was quickly abandoned. Already in 1390 the Italian mathematician Gabriel Stornaloco was called in to provide a revised building section, one in which a simple grid of modules would provide a close approximation to the proportions of the equilateral triangle as determined by geometry. By 1400, moreover, this scheme was rejected in favor of one with a lower overall height, in which the proportioning system changed midway up the elevation from Stornaloco's modular system to one governed by horizontally oriented 3-4-5 right triangles. To the extent that its construction involved repeated changes of plan, the case of Milan actually was typical, since such changes were frequent in Gothic workshops. Even in drawings and in unified building campaigns, however, simple schemes based solely on the square or equilateral triangle were rare. By themselves, therefore, the terms *"ad quadratum"* and *"ad triangulum"* provide only an impoverished binary palette of terminology, one that cannot capture the subtlety and detail characteristic of Gothic design in all its shadings.

In the fifteenth century, at last, a few northern Gothic designers began to record their methods in written texts. Increasing literacy rates facilitated this development, but a more important factor was probably the authors' desire to demonstrate the legitimacy of Gothic architectural practice, which was beginning to be challenged by the new fashion for classical design spreading from Renaissance Italy.[7] By the final decades of the century, the invention of the printing press had permitted many educated patrons and builders north of the Alps to gain some familiarity with treatises crucial to classical architectural theory, including most notably *De Architectura*, by the ancient Roman architect Vitruvius, and *De Re Aedificatoria*, by his Renaissance successor Alberti. From a strictly Vitruvian or Albertian perspective, the Gothic tendency to stretch columns heavenward could only be condemned as a deviation from "correct" canonical models based on the proportions of the human body. The creative freedom Gothic designers enjoyed, more generally, could only be deplored as license, while the complexity and virtuosity of Gothic design could be criticized for departing from the clear formal order of classicism.

Gothic designers never managed to mount an effective textual challenge to the emergent Renaissance critique of Gothic architecture, and their few published attempts to explain their methods can most charitably be described as underwhelming. Two small booklets, Matthäus Roriczer's *Büchlein von der Fialen Gerechtigkeit*, of 1486, and Hans Schmuttermayr's roughly contemporary *Fialenbüchlein*, deal only with the design of pinnacles and gablets.[8] Roriczer later published a short booklet called *Geometria Deutsch* demonstrating several basic geometrical constructions, and he may have intended to expand his explicitly architectural discussion, but he certainly left many important design issues unaddressed in his writings.[9] Roriczer's silence on so many topics is particularly frustrating because his position as master of the prestigious Regensburg

[7] The northern Gothic writings are well discussed in Ulrich Coenen, *Die spätgotischen Werkmeisterbücher in Deutschland* (Munich, 1990). For the possible impact of Italian theory, see Paul Crossley, "The Return to the Forest," *Kunstlerlicher Austausch* (Berlin, 1992): 71–90; and Ethan Matt Kavaler, "Architectural Wit," in Matthew Reeve (ed.), *Reading Gothic Architecture* (Turnhout, 2007), pp. 130–50.

[8] See Coenen, *Die spätgotischen Werkmeisterbücher*; and Lon Shelby, *Gothic Design Techniques* (Carbondale, 1977).

[9] A recent attempt to infer larger lessons from Roriczer's writings is Wolfgang Strohmayer, *Das Lehrwerk des Matthäus Roriczer* (Hürtgenwald, 2004); this attempt is critiqued in Stefan Holzer's review of Strohmayer's book in *Kunstform*, 7 (2006), Nr.03, www.arthistoricum.net/index.php?id=276&ausgabe=2006_03&review_id=10507.

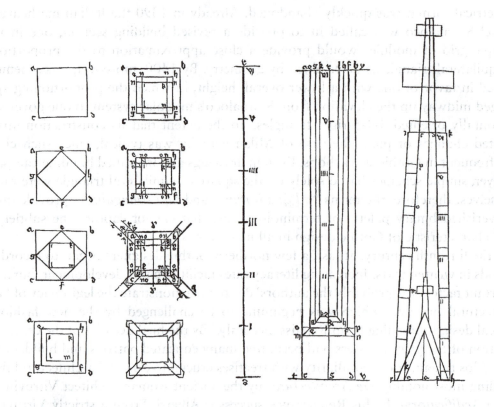

Figure 0.2 Successive stages in pinnacle design, from Roriczer, *Das Büchlein von der Fialen Gerechtigkeit*, 1486, arranged by author

Cathedral workshop qualified him well to discuss all the major issues of Gothic design. It is interesting and significant, however, that both he and Schmuttermayr chose to focus on pinnacles as paradigmatic products of the Gothic design method. Both authors agree that the first step in designing a pinnacle should be to establish a square as its basic groundplan. Next, a series of progressively smaller rotated squares should be inscribed within the original square, in a sequence often called "quadrature" (Figure 0.2). Further permutations of these figures, easily accomplished with the compass and straightedge, sufficed to determine the complete groundplan of the pinnacle. The elevation of the pinnacle was then determined by stacking up a series of modules based on the groundplan. This process of extrusion from the groundplan into the third dimension, which German authors call *Auszug*, or "pulling out," was fundamental to the Gothic design method as a whole. Roriczer himself hints that something more general than pinnacle construction is at stake in his booklet. On its first page, he explains to his learned patron, Wilhelm von Reichenau, the Bishop of Eichstätt, that his writings will "explain something of the art of geometry, beginning with first steps in extruding stonework . . . using proper measures determined with a compass."[10] As the case studies in the subsequent chapters of this book will demonstrate, geometries like those described by Roriczer and Schmuttermayr occur in a wide variety of Gothic drawings, not just those depicting tabernacles, church spires,

10 Shelby, *Gothic Design Techniques*, p. 83.

and other pinnacle-like structures, but also those depicting complete churches and their buttressing systems. These authors may well have chosen to focus on pinnacles for basically pedagogical reasons, thinking that this simple example could clarify design principles of wide applicability, but the seeming narrowness of their topic surely diminished the impact of their writings.

Roriczer, Schmuttermayr, and the few late medieval authors who attempted to provide more comprehensive pictures of Gothic design practice encountered a fundamental problem, one that has bedeviled all similar projects up to the present day—namely, the fact that the geometrical logic of Gothic architecture is hard to explain in words. Because Gothic design conventions govern the rules of the process more than the shape of the final product, the spatial relationships between building components varied far more widely in Gothic than in classical architecture. This, in turn, means that precision can be achieved only with explicit description, rather than with allusions to venerated prototypes. Roriczer, who sought to explain only a simple pinnacle, labeled every single point in his illustrations, describing the successive steps of the design process in numbing detail. Having established the basic square abcd in step one, for example, he explains the next step as follows: "Divide the distance from a to b into two equal parts, and mark an e at the midpoint. Do the same from b to d and mark an h; from d to c and mark an f; from c to a and mark a g. Then draw lines from e to h, h to f, f to g, and g to e, as in the example of the figure drawn hereafter . . ."[11] Despite its tediously explicit detail, Roriczer's text is all but unintelligible without reference to his illustrations.

Three decades after the publication of Roriczer's booklet, the noted Heidelberg court architect Lorenz Lechler tried to explain Gothic design more quickly and economically in his *Unterweisungen*, a more comprehensive compendium of architectural advice for his son Moritz.[12] Although Lechler's known architectural works, such as the sacrament house of S. Dionys in Esslingen, are formidable in their geometrical complexity, his writings present mostly short rules of thumb based on simple arithmetical ratios. He recommends, for example, that side aisle spans should be one half as great as the free span of the main central vessel, which he takes as his fundamental module. The thicknesses of the walls and piers, he suggests, should equal one tenth of this module. The capitals of the main vessel should fall either one module, or alternatively one and a half modules, above the floor. Lechler's short modular recipes are less painful to read than Roriczer's detailed geometrical instructions, but they ultimately prove frustrating, since they fail utterly to explain the origins of the complex dynamic forms that make German late Gothic design so interesting. These examples, moreover, are unillustrated, at least in the three surviving manuscripts of the *Unterweisungen*. These manuscripts do, however, include several illustrations showing how combinations of geometrical and arithmetical subdivision could be used to generate the cross-sections of window mullions, taking the wall thickness in this case as the given module (Figures 0.3 and 0.4). Here, one begins to catch a glimpse of how Gothic designers derived the details of their buildings from the dimensions of the larger structure, but it is hard to extrapolate from these examples to get a satisfying picture of the overall design process.

[11] Quoted from Shelby, *Gothic Design Techniques*, p. 85.
[12] Coenen, *Die spätgotischen Werkmeisterbücher*, pp. 15–25 and 146–52.

Figure 0.3 Cross-sections of large and small mullions, from Lechler's *Unterweisungen*.

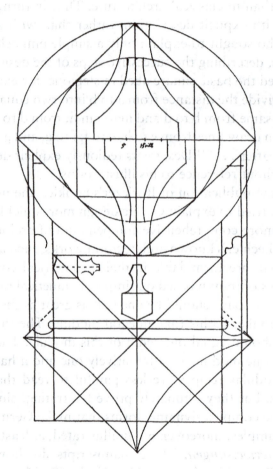

Figure 0.4 Cross-sections of mullions and moldings in relation to wall thickness, from Lechler's
Unterweisungen.

Before going on to consider the reception of the late Gothic design handbooks, it is worth pausing briefly to ponder the ways in which geometrical and arithmetical thinking could intersect in the Middle Ages, since this topic will arise repeatedly in subsequent chapters. Medieval masons and church designers, of course, approached geometry with a view to its practical application in architecture. Unlike modern mathematicians, and

unlike the ancient Greeks, they cared little for analytical logic and the construction of rigorous proofs. The distinction between rational and irrational numbers, which mattered greatly to Greek theorists, was not terribly important to Gothic builders, who frequently used arithmetical ratios to approximate the irrational quantities that result from geometrical operations.[13] This can be seen not only in Stornaloco's intervention at Milan, but also in the illustrations from Lechler's *Unterweisungen*, here reproduced as Figures 0.3 and 0.4.[14] The two nested forms in Figure 0.3 represent the cross-sections of the large and small window mullions in a given church choir. As the numbered hash marks along the side of the figure show, the smaller should be five sevenths as tall as the larger. The recurrence of these profiles in the upper half of Figure 0.4, however, makes clear that this 5:7 ratio is actually just an approximation to the $1:\sqrt{2}$ ratio arising from square rotation and quadrature. This example thus differs in an important sense from Lechler's previously cited recommendation that wall thicknesses equal a tenth of the main vessel width, a rule in which the design method was truly and exclusively modular. Lechler and his Gothic colleagues, however, never systematically distinguished between the geometrical and arithmetical design modes. Indeed, their few surviving writings are strikingly unsystematic altogether. Like many other medieval technical texts, in fact, they are essentially just compilations of recipes, rather than polished treatises with clear organization and argument structure.

Since the Gothic design process was inherently difficult to describe, and since the few late medieval authors who tried to do so lacked rhetorical sophistication, it is perhaps unsurprising that their work was largely swept aside by the wave of theoretical writings on architecture coming from Renaissance Italy. The publication of Serlio's lavishly illustrated seven-volume *Libri d'Architettura*, in particular, helped to establish a taste for classical design even in northern courts where Gothic architecture had formerly predominated. By the middle of the sixteenth century, in fact, classical art and architecture had largely taken over in Europe's leading centers of fashion. Many different factors seem to have contributed to the rapid collapse of the Gothic tradition, as the final chapter of this book will explain, but the great rhetorical appeal of Renaissance writings was surely one of the most important. It is possible to argue, in fact, that Renaissance architecture, like so many new commodities, achieved popularity more because of effective marketing than because of the product's inherent quality. The classical critique of Gothic art, which had only begun to emerge in the fifteenth century, achieved canonical status in Vasari's *Lives*, one of the earliest and most influential histories of art ever written. Vasari's condemnation of Gothic

[13] For the general principles of this conversion process, see Peter Kidson, "A Metrological Investigation," *Journal of the Warburg and Courtauld Institutes*, 53 (1990): 71–97. For an excellent example of how this transition between geometrical schemes and arithmetical approximations could be applied in medieval building, see idem, "The historical circumstance and the principles of the design," in Thomas Cocke and Peter Kidson (eds), *Salisbury Cathedral: Perspectives on the Architectural History* (London 1993), pp. 31–97, esp. 62–75. Kidson explicitly points out (p. 62) that the use of rational approximations was widespread prior to the advent of architectural drawing. Once drawing became commonplace, however, it surely would have been simpler for draftsmen to construct quantities like $\sqrt{2}$ and $\sqrt{3}$ by using their compasses to make squares and triangles, rather than by using arithmetical approximations. So, while the approximations discussed by Kidson were likely used on building sites throughout the Gothic era, emphasis in the present study will remain on the geometrical relationships that the draftsmen developed on their parchments.

[14] These illustrations are carefully discussed in Werner Müller, *Grundlagen gotischer Bautechnik: ars sine scientia nihil* (Munich, 1990), pp. 90–94.

architecture as a barbaric and lawless deviation from classical correctness continues to color popular perceptions of art history still today, even though his association of this architecture with the Goths who sacked Rome has long been recognized as a polemical myth.[15] The triumph of classical art in the Renaissance, of course, was not absolute, and the line between Gothic and Renaissance visual culture could be surprisingly blurred at times. In 1521, for example, the Milanese Cesare Cesariano published a pioneering Italian-language edition of Vitruvius's *De Architectura* featuring illustrations not only of classical buildings and their components, but also of Milan Cathedral with an idealized "*ad triangulum*" overlay. In Germany and England, moreover, remnants of Gothic architectural culture survived as a craft tradition even into the seventeenth and eighteenth centuries.[16] By the time interest in Gothic architecture revived in the years around 1800, however, a great deal about genuine medieval design practice had been forgotten.

Over the past two centuries, many attempts have been made to rediscover the lost "secrets" of the Gothic design method. Progress in this direction, however, has not been steady. Some of the earliest writings of the Gothic revival already contain valuable insights, while some recent publications, unfortunately, still present fantastic ideas unsupported by strong evidence. The young Goethe, in his path-breaking 1773 essay "*Von Deutscher Baukunst*," helped to set the stage for later authors by praising the west façade of Strasbourg Cathedral as a highly ordered work of genius. He recognized, in other words, that classical dismissals of Gothic architecture as chaotic were unfair. Subsequent attempts to characterize Gothic architectural order have run the gamut from impressionistic to analytical. The Romantic writers Georg Forster and Friedrich Schlegel compared Gothic buildings, respectively, to ancient forests and to mineral crystals. These admittedly vague comparisons actually have some merit, because, as the following chapters will demonstrate, Gothic design really does involve sequences of geometrical operations that have more in common with organic and crystalline growth than they do with the more narrowly circumscribed modularity of most post-medieval architecture. In the early nineteenth century, meanwhile, scholars and antiquarians began to republish authentic Gothic documents, including the portfolio of Villard de Honnecourt, in France, and the later design booklets written by Roriczer, Lechler, and their colleagues, in Germany. Such publications, together with the careful study of original Gothic buildings in the course of restoration, helped to make the nineteenth-century Neo-Gothic era a highly productive time for research into Gothic design practice. By the middle of the century, therefore, a sizable literature on Gothic geometry and proportioning had begun to emerge, but the results of this research remain controversial.[17]

[15] Particularly influential contributions to this literature are usefully summarized in Paul Frankl, *The Gothic: Sources and Literary Interpretations through Eight Centuries* (Princeton, 1960). See also Annemarie Sankovitch, "The Myth of the Myth of the Medieval," *RES: Anthropology and Aesthetics*, 40 (2001): 29–50.

[16] For a good discussion of sixteenth- and seventeenth-century German technical drawings of residually Gothic style, see Müller, *Grundlagen gotischer Bautechnik*, pp. 31–44. Müller also cites the *Vitruvius Deutsch*, by Rivius, a near-copy of Cesariano's Italian Vitruvius, on pp. 41–53.

[17] See, for example, Friedrich Hoffstadt, *Gotisches ABC-Buch, das ist: Grundregeln des gothischen Styls für Künstler und Werkleute* (Frankfurt, 1840), or Carl Alexander Heideloff, *Die Bauhütte des Mittelalters* (Nuremberg, 1844).

METHODOLOGICAL PROBLEMS IN THE STUDY OF GOTHIC GEOMETRY

Three closely linked methodological problems have undercut the authority of most publications on Gothic geometry: imprecision, ambiguity, and wishful thinking. Geometrical imprecision of one important sort arises when the object studied by the modern scholar differs in its proportions from the original designer's intentions. Most studies of Gothic geometry have been based on modern survey drawings of the buildings in question, which can be imprecise in two ways: the modern drawing may not faithfully reflect the shape of the building; and the building, in turn, may not faithfully reflect the designer's vision if errors or changes were introduced in the construction process. Another sort of imprecision can arise in the testing of geometrical hypotheses if, for example, the testing method involves drawing candidate lines manually across the underlying survey drawing. Even very careful draftsmen using rulers and protractors can drift slightly off the intended angle, and this can create large dimensional differences if the line grows long. When the underdrawings are small and the tip of the drafting instrument is large, even line thickness can become a source of imprecision.

Ambiguity in proportional studies often stems from uncertainty about which points in the building were geometrically meaningful to the original designer. Should the width of an aisle, for example, be measured to the inner wall surface, the outer wall surface, or the centerline in between? Should the height of a nave be measured to the top of the vault keystones, or to the top of the gutteral walls? Such questions can be multiplied almost *ad infinitum*, unless some external constraint is brought to bear. With so many degrees of freedom in the geometrical system, it becomes possible to generate armies of trial lines, adjusting their position and orientation until they appear to hit something interesting.

Because imprecision and ambiguity have been so prevalent in studies of Gothic proportions, especially those undertaken before 1950 or so, wishful thinking has played an important role in shaping claims about the geometrical character of Gothic design. Many scholars, having found apparent evidence for one kind of proportioning system in a given Gothic building, sought to demonstrate its more widespread application by adding trial lines to drawings of other buildings. The turn-of-the-century architectural historian Georg Dehio, for example, published a series of graphics purporting to show that medieval church sections of all sorts depended on *"ad triangulum"* schemes like those briefly entertained at Milan.[18] Other authors argued for the widespread application of different figures, such as the 45-degree isosceles triangle, the pentagon, or its famous cousin, the so-called Golden Section, which is the ratio \emptyset satisfying the harmonic equation $\emptyset = 1/(\emptyset-1)$.[19] These figures were sought out in Gothic architecture not so much

[18] Georg Dehio, *Untersuchungen über das gleichseitige Dreieck als Norm gotischer Bauproportionen* (Stuttgart, 1894); idem, "Zur Frage der Triangulation in der mittelalterlichen Kunst," *Repertorium für Kunstwissenschaft*, 18 (1895); and Dehio and G. von Bezold, *Die kirchliche Baukunst des Abendlandes* (Stuttgart, 1901). E.-E. Viollet-le-Duc also thought triangular proportions contributed to stability. See his article "Proportion," in *Dictionnaire Raisonné de l'architecture francaise* (Paris, 1858–68), vol. 7, esp. pp. 532–42.

[19] The 45-degree triangle was championed by Karl Alhard von Drach in *Das Hüttengeheimnis von gerechten Steinmetzgrund* (Marburg, 1897). Pentagons figure prominently in Karl Witzel, *Untersuchungen über gotische Proportiongesetze* (Berlin, 1914). Julius Haase, meanwhile, claimed that the Golden Section established the location of the crossing spire of Cologne Cathedral, in "Der Dom zu Köln am Rhein in seinen Haupt-Maßverhältnisse auf Grund der Siebenzahl und der Proportion des goldenen Schnitts," in

because the medieval evidence suggested their presence, but because they were associated, in the researchers' minds, at least, with prestigious theories of beauty and meaning.[20] The Golden Section has a distinguished ancient pedigree, having been known to both the Egyptians and the Greeks. Regular polygons, meanwhile, evoke the surfaces of the Platonic solids, and the number of sides on each figure can readily be associated with numerological theories, both ancient and medieval. Written sources from the Gothic era demonstrate that clergymen often did use numerological references to link architecture with meaning, as when Abbot Suger of Saint-Denis compared the twelve inner columns of his church with the twelve apostles, but such *post-facto* associations provide indirect evidence, at best, for the working methods of the church designers themselves.

In seeking to connect Gothic architecture with prominent aesthetic and symbolic systems, therefore, many twentieth-century researchers drew dense networks of lines based on their pet systems all over drawings of Gothic buildings; Figure 0.5 shows a typical example, taken from Fredrik Macody Lund's 1921 *Ad Quadratum*, in which a system based on the pentagram is imposed on the cross-section of Notre-Dame in Paris.[21] Most of the key points in the diagram lie below ground or in the air, rather than on crucial elements of the building, which is represented in accord with a conjectural reconstruction by the nineteenth-century architect Viollet-le-Duc that has been rejected by subsequent scholarship. Some work in this genre may include valuable observations, but the imprecision and ambiguity inherent in the testing process make it all but impossible to distinguish the justified conclusions from the flights of interpretive fancy. Much of the early work in this field, therefore, was dismissed in a rigorous critical study published by Walter Thomae in 1933.[22] Three decades later, in his magisterial review of writings on the Gothic period, Paul Frankl wrote in apparent frustration that "The question of what is actually gained by such research becomes urgent. There can be no doubt that Gothic architects made use of triangulation and the like, but the excogitated networks made up of hundreds of lines to determine all points has not been proved and is probably undemonstrable and unlikely."[23] Perhaps the most devastating critique of this geometrical research tradition came in the early 1970s from Konrad Hecht, whose writings will be considered in detail below. Despite such skepticism in the academy, a wide range of authors continue to publish more or less plausible theoretically driven geometrical overlays even

Zeitschrift für Geschichte der Architektur, 5 (1911/1912); and Otto Kletzl claimed that the Golden Section established the relative heights of the tower and spire in Freiburg, in "Zwei Plan-Bearbeitungen des Freiburger Münsterturms," *Oberrheinische Kunst*, 7 (1936): 15. This claim was repeated by Adolf Wangart in *Das Münster in Freiburg im Breisgau im rechten Maß* (Freiburg, 1972).

[20] This is not to say, of course, that such figures were never used in Gothic design. Stephen Murray and James Addiss have effectively demonstrated the use of the Golden Section in "Plan and Space at Amiens Cathedral: With a New Plan Drawn by James Addiss," *Journal of the Society of Architectural Historians*, 49 (1990): 44–66. Peter Kidson, meanwhile, has documented the use of the Golden Section at Salisbury, and he has gone on to show that good rational approximations for $\sqrt{2}$, $\sqrt{3}$, $\sqrt{5}$, and Ø were known throughout the Middle Ages. See "The Historical Circumstance and the Principles of the Design." These rigorous modern studies are supported by a degree of archaeological and documentary evidence unseen in the more speculative publications of the early twentieth century.

[21] Fredrik Macody Lund, *Ad Quadratum* (London, 1921).

[22] Walter Thomae, *Das Proportionswesen in der Geschichte der gotischen Baukunst und die Frage der Triangulation* (Heidelberg, 1933).

[23] Paul Frankl, *The Gothic*, p. 721.

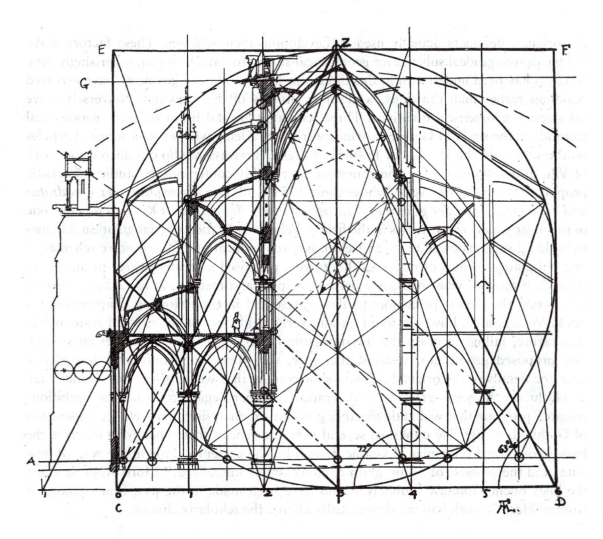

Figure 0.5 Hypothetical geometrical overlay drawn by Fredrik Macody Lund on an equally hypothetical cross-section of Notre-Dame in Paris, which was originally proposed by Viollet-le-Duc. Source: Lund, *Ad Quadratum*, Figure 52, p. 36.

today.[24] By themselves, however, such publications are unlikely to dispel the lingering distrust that many scholars feel for geometrical studies of Gothic design.

The study of original Gothic architectural drawings offers at least a partial way out of this impasse, because this approach avoids many of the imprecision and ambiguity problems outlined above. Drawings, unlike buildings, can be measured easily and directly, and their proportions are uncompromised by errors introduced in the construction process. The presence of compass prick points and construction lines in the drawings, moreover, helps to solve the ambiguity problem by suggesting which points and lines

[24] On the more methodologically rigorous side, Nigel Hiscock's *The Wise Master Builder* (Aldershot, 2000), deserves mention. Not everyone will be convinced by Hiscock's argument for the relevance of Platonic geometry for medieval architecture, but he does carefully describe his research method and the precision of his claimed results. More troubling is Thierry de Champris, *Cathédrales, le verbe géométrique* (Paris and Brussels, 1994), which purports to connect the geometry of French cathedral façades with the "paths of wisdom" leading through the Old and New Testaments to Pythagorean Greece and ancient Egypt.

the original designers actually used in developing their schemes. These factors make Gothic drawings ideal subjects for geometrical study. To date, however, surprisingly little progress has been undertaken in this direction. Most studies of geometry have involved buildings rather than drawings, while most studies of the drawings, conversely, have sidestepped geometrical questions. Three scholars who did begin to apply geometrical methods to the study of Gothic drawings were Otto Kletzl, who wrote a series of articles on the subject in the 1930s and 1940s[25]; Walter Ueberwasser, who considered the work of Villard de Honnecourt in the course of his roughly contemporary studies of artistic proportion[26]; and Maria Velte, whose short 1951 book *Die Anwendung der Quadratur und Triangulatur bei der grund- und aufrißgestaltung der gotischen Kirchen* remains one of the most widely cited studies in the field.[27] Velte's application of triangulation schemes to building sections owed much to Dehio, but her application of quadrature schemes to original plan drawings of major Gothic towers promised a greater degree of analytical rigor than most of what had come before. In spirit and method, in fact, these analyses are among the closest precursors to those presented in the following chapters of this book. Velte tended, however, to adopt an overly rigid view of geometrical systems like quadrature, failing to grasp the quasi-organic flexibility of the Gothic design system. Her proposed geometrical systems, therefore, sometimes align only very imperfectly with the details of the original plans, a shortcoming that was not lost on skeptics such as Hecht. In the years around 1970, François Bucher began to outline an ambitious research program that would tie together geometrical analysis with careful consideration of Gothic drawings. He published several valuable articles that evocatively describe the basic geometrical principles of Gothic design, but he presented little in the way of new data, and the promise of his program remains largely unrealized.[28] More progress along the lines Bucher foresaw probably would have been made in the past four decades, if Konrad Hecht's work had not dramatically altered the scholarly climate.

[25] Otto Kletzl, "Werkrißtypen deutscher Bauhüttenkunst," *Kunstgeschichtliche Gesellschaft Berlin, Sitzungberichte,* (1937–38): 20; "Ein Werkriss des Frauenhauses in Strassburg," *Marburger Jahrbuch für Kunstwissenschaft,* 11–12 (1938–39): 103–58; *Plan-Fragmente aus der deutschen Dombauhütte von Prag in Stuttgart und Ulm* (Stuttgart, 1939); "Die Kressberger Fragmente: Zwei Werkrisse deutscher Hüttengotik," *Marburger Jahrbuch für Kunstwissenschaft,* 13 (1944): 129–70. Also relevant are his analyses of the Freiburg tower in "Zwei Plan-Bearbeitungen des Freiburger Münsterturms," *Oberrheinische Kunst,* 7 (1936): 14–35; and his critical review of Thomae's *Das Proportionenwesen in der Geschichte der gotischen Baukunst,* in *Zeitschrift für Kunstgeschichte,* 4 (1935): 56–63.

[26] Walter Ueberwasser, "Nach rechtem Maß: Aussagen über den Begriff des Maßes in der Kunst des XIII.–XVI. Jahrhunderts," in *Jahrbuch des preußischen Kunstsammlungen* 6 (1935): 250–61 and Abb. 7 esp.; idem, "Der Freiburger Münsterturm im 'rechten Maß'," *Oberrheinische Kunst* 8 (1939): 25–32.

[27] Maria Velte, *Die Anwendung der Quadratur und Triangulatur bei der grund- und aufrißgestaltung der gotischen Kirchen* (Basel, 1951). Velte's work was very positively reviewed by James Ackerman in *Art Bulletin,* 35 (1953): 155–7.

[28] François Bucher, "Design in Gothic Architecture: A Preliminary Assessment," *Journal of the Society of Architectural Historians,* 27, (1968): 49–71; idem, "Medieval Architectural Design Methods, 800–1560," *Gesta,* 11 (1972): 37–51; idem, "Micro-Architecture as the 'Idea' of Gothic Theory and Style," *Gesta,* 15/1–2 (1976): 71–91; idem, *Architector, The Lodge Books and Sketch Books of Medieval Architects* (New York, 1979). This last, which considered only the work of Villard de Honnecourt, Hans Böblinger, and the so-called Master WG, was intended to be the first of a multi-volume set discussing many of the major drawings of the Gothic period, but the anticipated sequels were never published.

KONRAD HECHT'S PROBLEMATIC CRITIQUE OF GEOMETRICAL RESEARCH

Hecht's work occupies a singular place in the historiography of Gothic design, because his critique of geometrical research was so aggressive, comprehensive, and densely argued that it nearly stopped the field in its tracks, with particularly demoralizing impact on the drawing-related investigations that Kletzl, Velte, and Bucher had begun to explore. Hecht began, it seems, with the best of intentions, seeking to restore historical realism to a field in which fantastic hypotheses had grown unchecked.[29] He opened his major publication in the field, *Maß und Zahl in der gotischen Baukunst*, with a rigorous critical review of previous literature, amply demonstrating the arbitrariness, implausibility, and mutual incompatibility of much that had come before.[30] Next, he set out to demolish all the successive attempts to illustrate geometrical proportioning systems in the tower of Freiburg Minster, which had become something of a hobbyhorse for writers in the field. Through careful numerical analysis, Hecht showed that imprecision, ambiguity, and wishful thinking do indeed flaw most of these studies.

Reacting against the excesses of purely geometrical design theory, Hecht proposed an even more implausible alternative, suggesting that Gothic designers worked almost exclusively in arithmetical modular fashion. To make this argument, Hecht had to look south of the Alps for evidence, while simultaneously working to diminish the evidence for geometrical design practices in the northern Gothic world. He used documents related to the construction of Milan Cathedral and San Petronio in Bologna to show that module-based thinking was, indeed, crucial for Italian architectural practice in the later Middle Ages. This, however, proves very little about the northern Gothic situation, since Italy had never fully accepted the premises of northern Gothic design. Hecht then attempted to show that module use could provide a better explanation than geometry for certain famous specimens of northern Gothic design, including the portfolio of Villard de Honnecourt, the tower of Freiburg Minster, and the drawings related to the planning of Ulm Minster.[31] In discussing Villard's plan for the tower of Laon Cathedral, for example,

[29] Other more complex ideological forces may well have informed Hecht's distrust of geometrical explanations for Gothic design. Since the geometrical sophistication of German Gothic design was a source of nationalist pride for authors such as Kletzl who enjoyed favored positions in the Third Reich, this intellectual legacy likely appeared tainted after the Second World War. This would have been particularly the case for Hecht, since he worked at the University of Braunschweig, where a strict and reductive modernism dominated the architecture school in the decades after the war, providing a strong critique of the Reich and its bombastic historicism. On Kletzl's career in the war years, see Adam Labuda, "Das Kunstgeschichtliche Institut an der Reichsuniversität Posen und die „nationalsozialistische Aufbauarbeit" im Gau Wartheland 1939–1945," in Jutta Held and Martin Papenbrock (eds), *Kunstgeschichte an den Universitäten im Nationalsozialismus* (Göttingen 2003), pp. 143–60. On the architecture school in Braunschweig, see *Die Architekturlehrer der TU Braunschweig*, eds Roland Böttcher, Kristiana Hartmann and Monika Lemke-Kokkelink (Braunschweig, 1995).

[30] Hecht's *Maß und Zahl in der gotischen Baukunst* first appeared as three successive issues of *Abhandlungen der Braunschweigischen Wissenschaftlichen Gesellschaft*: 21 (1969), 22 (1970), and 23 (1970). The complete study has been republished as a single volume by Georg Olms Verlag (Hildesheim, 1979). The page numbers cited in the present study are from the more widely available 1979 version.

[31] Hecht's *Maß und Zahl* includes the following passages cited here: the general critique of earlier literature, mostly on pp. 2–60; the critique of geometrical literature on the Freiburg tower in particular, pp. 60–92; the appeal to Italian sources, pp. 130–71; Villard de Honnecourt, pp. 201–17; a modular approach to the Freiburg tower, pp. 334–61; Gothic drawings in general, 381–7; the Ulm elevation drawings in particular, pp. 387–468.

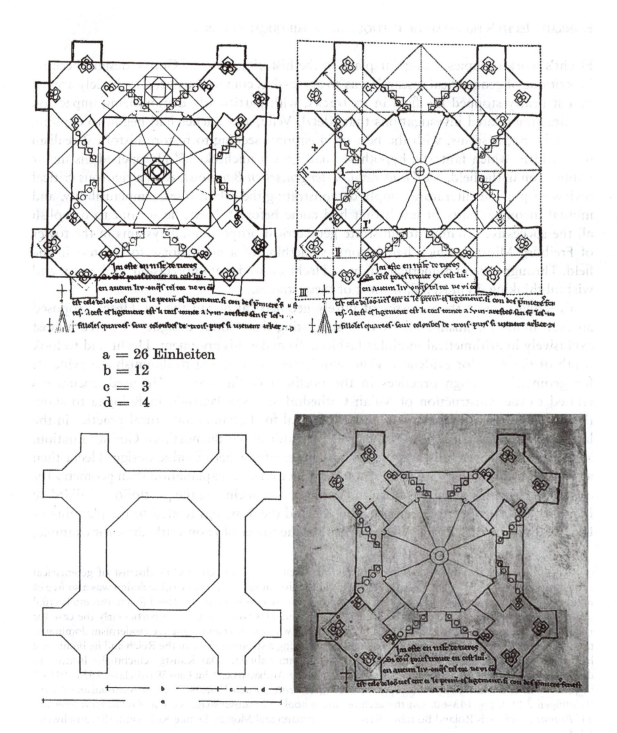

$$a = 26 \text{ Einheiten}$$
$$b = 12$$
$$c = 3$$
$$d = 4$$

Figure 0.6 Comparison between four different approaches to Villard de Honnecourt's Laon towerplan. The original drawing (as in Fig. 0-1) appears at bottom right; Ueberwasser's geometrical scheme at upper right; Velte's alternative geometrical scheme at upper left, and Hecht's modular description at lower left.

Hecht noted with apparent satisfaction that Ueberwasser and Velte suggested very different geometrical schemae to explain Villard's drawing. He then proposed a purely numerical proportional system which, he claimed, explains the drawing better than either of the geometrical systems (Figure 0.6).[32] In doing so, he failed to admit two key facts: first, that Ueberwasser's scheme actually explains the basic proportions of Villard's drawing quite well; and, second, that his own modular scheme explains very little, since he gave no reason why the tower proportions should involve the modules he proposed. He was, in essence, just presenting a numerical approximation to a set of proportions that could easily have been determined by geometrical means. This, indeed, is the fundamental problem with his overall argument.

Seeking to provide a more convincing demonstration of his theories than analysis of Villard's imprecise sketches can provide, Hecht proposed a modular explanation for the proportions of the Freiburg tower and spire. His discussion appears rigorous at first sight, since it invokes hundreds of careful measurements of the structure, and since it includes meticulous centimeter-by-centimeter error analyses that compare these data with his hypotheses. Upon closer investigation, however, this appearance of rigor dissolves, as it becomes clear that Hecht shrank from obvious conclusions when they challenged his *a priori* assumptions. For example, he refused to admit that the inner layer of the Freiburg tower wall was likely meant to be half the total width of the wall, even though he clearly showed that their two thicknesses were, respectively, 98 and 196 centimeters. Instead of simply observing that $196 = 2 \times 98$, Hecht worked laboriously backwards from his assumption that the tower was laid out in feet and inches, where he claimed that the foot unit in the Freiburg workshop was 31.095 centimeters. On this dubious basis, he concluded, first, that the 196-centimeter wall thickness was actually meant to be 194 centimeters, which would be 6 feet 3 inches according to his system, and second, that the 98-centimeter layer thickness was meant to be 101 centimeters, which would be 3 feet 3 inches in his system.[33] He basically conjured constructional errors out of thin air, in other words, self-consciously shrinking and expanding the building's dimensions to fit them into the Procrustean bed of his modularity thesis. Even after torturing the evidence to fit his preconceptions, though, Hecht could not explain why the Freiburg designer would have chosen these particular lengths. Indeed, he does not even try. And, Hecht effectively limited himself to describing an imagined rectilinear space box around each tower component, rather than considering what the shape and articulation of the component may suggest about its formal logic. Small wonder, since the shapes of the elements in the Freiburg tower clearly reveal the importance of a geometrically based design process, as the analysis in Chapter 2 of this book will show. There is no way to describe these forms, or even the simple octagonal form of the tower core itself, in purely modular terms, a fact that Hecht admitted only very grudgingly. He implicitly acknowledged the importance of geometrical constructions, for example, when he used the proportions of a perfect octagon to compute the ideal side lengths for the Freiburg tower octagon, even though the diagonals in the octagon introduce irrational numbers that can have no place in a purely modular design system. Despite such occasional slips from his own arithmetical orthodoxy, however, Hecht generally remained critical of geometrical explanations for

[32] Hecht, *Maß und Zahl*, pp. 207–10.
[33] Hecht, *Maß und Zahl*, pp. 353, 358, Abb. 81.

Gothic proportion, concentrating his creative energies on the elaboration of complex modular systems.

The final section of Hecht's study, and the one of greatest relevance for this book, discusses Gothic architectural drawings. Here, as usual, he made many important and valid points, while simultaneously managing to ignore the copious evidence for the importance of geometrical design methods in the Gothic era. Hecht correctly observed, for example, that Gothic drawings typically include only a few geometrical construction lines—certainly far fewer than one would expect from the modern authors who support their arguments with dense networks of lines. He went astray, however, in arguing that geometrical proportioning figures were not used by Gothic designers to establish the main outlines of their compositions.[34] As the following chapters will demonstrate, such figures certainly were used, especially in the development of groundplans, but also in the construction of elevations. Compass holes and construction lines bear witness to this in many cases. Their relative paucity in any given drawing seems to reflect both the draftsmen's economy of means, and their desire to keep especially their presentation drawings free of distracting lines that would have no place in the finished building.[35] In some cases, moreover, dimensions may well have been worked out geometrically on a groundplan, before being transferred to the corresponding elevation, obviating the need for many construction lines in the latter.

Hecht took care to consider not just the appearance of Gothic drawings, but also their size. He strongly objected to the popular idea that Gothic designers developed their drawings geometrically starting from baselines of essentially arbitrary scale. He argued, on the contrary, that Gothic drawings originally had simple scale relationships to the buildings they depicted. He claimed, in particular, that these relationships were often based on decimal or duodecimal subdivision. The drawings, in other words, might be smaller than the full-scale buildings by factors such as 10, 20, 30, or 40; or 12, 24, 36, or 48. Such scalings were actually mentioned in medieval documents, including Lechler's *Unterweisungen*, and many surviving drawings at least roughly accord with these proportions, so Hecht's basic claim is probably correct.[36] It seems certain, at any rate, that Gothic builders established the scales of their drawings carefully and systematically.

There are several respects, however, in which Hecht's larger argument about scaling breaks down. First, it is by no means clear that all Gothic drawings were scaled in the simple way he describes. Many of the drawings discussed in this book, and even many of the examples he cites himself, now have scales that differ measurably from those he sees as normative. To explain these discrepancies Hecht invoked the dimensional instability of parchment, which shrinks and expands in response to changes in humidity. Using a complex and rather unconvincing argument based on the statistical analysis of trial dimensions, Hecht concluded that the total shrinkage factors over the centuries might be

[34] Hecht, *Maß und Zahl*, pp. 370–72.

[35] In the literature on Gothic drawings, a distinction has often been observed between lavishly detailed presentation drawings designed to appeal to patrons, and humbler technical drawings intended only for the use of workshop insiders. This distinction should not be seen as absolute, however, since even the large and impressive Gothic drawings discussed in this book were clearly created using geometrical means precisely like those seen in the smaller workshop drawings.

[36] Hecht, *Maß und Zahl*, pp. 381–2; idem, "Zur Maßstablichkeit der mittelalterlichen Bauzeichnung," *Bonner Jahrbuch*, 166 (1966): 253.

as great as 7 percent. With tolerances this large, it is fairly easy to connect the drawings to one hypothetical scale or another. So, the evidence for consistent decimal and duodecimal scalings is not as precise and powerful as it might be.

Even if it could be demonstrated that the scale of every single Gothic drawing related to that of the real building by a simple integer multiple, just as Hecht proposes, this would not imply that the design method in question was based exclusively on modular rather than geometrical thinking. There is no reason, in principle, why a Gothic draftsman could not work geometrically within the framework of a well-chosen module, or even within a modular array. Such combinations of geometrical and modular proportioning schemes, in fact, appear to have been typical of Gothic design practice, as the following chapters will demonstrate. In this book, with its emphasis on geometry rather than modularity, discussions of scale will figure less prominently than in Hecht's study. This approach is warranted because only differential changes of scale affect geometrical relationships. In most instances discussed in this book, such differential changes are negligible, as one can tell from the fact that compass-drawn circles remain truly circular, for example. Even overall changes of scale, which leave geometry unaffected, appear in directly testable cases to be far smaller than those claimed by Hecht.[37]

Hecht's study culminates with proportional analyses of the elevation drawings from Ulm Minster, analyses that must be criticized as unsatisfying despite their seeming rigor.[38] Hecht approached the drawings in a purely quantitative fashion, transforming these masterpieces of draftsmanship into dense and almost unreadable tables of numbers. This approach can be helpful for the testing of hypotheses, but it has major drawbacks, since it obscures relationships that would be obvious from a more visual perspective. Hecht's decision to consider only the elevation drawings is also problematic, since the proportions of the elevations reflect those that had already been established in the corresponding groundplan drawings, where compass pricks and construction lines clearly attest to the use of geometrical rather than strictly arithmetical planning methods. As Chapter 4 of this book will reveal, in fact, geometrical constructions initially established in the Ulm groundplans go on to govern the elevations as well, even determining the location of details such as crockets and pinnacles. Hecht's purely arithmetical analyses reveal none of these important relationships. His stubborn rejection of geometrical hypotheses thus deprived his careful quantitative analyses of much of their value. In the end, therefore, his discussion of the Ulm drawings manages to be exhausting without being truly exhaustive.

Because Hecht's work appears to be so rigorous and comprehensive, at least on the surface, the publication of *Maß und Zahl in der gotischen Baukunst* has had a chilling effect on geometrical research in Gothic architecture, with particularly damaging consequences for the study of drawings. None of the major studies of Gothic drawings published over the last three decades has any substantial geometrical component.[39] Three

[37] The groundplans of the parish church in Steyr that were drawn on both paper and parchment still have almost exactly the same scale, differing only by about .3 percent. See Johann Josef Böker, *Architektur der Gotik/Gothic Architecture* (Salzburg, 2005), p. 25.

[38] Hecht, *Maß und Zahl*, pp. 387–464.

[39] Geometrical and proportional issues are almost totally neglected in Peter Pause, *Gotische Architekturzeichnungen in Deutschland* (Bonn, 1973), and in Hans Koepf, *Die Gotischen Planrisse der Wiener Sammlungen* (Vienna, 1969). Bucher's *Architector* (1979) presents little in the way of specific geometrical analyses, although its introduction alludes to the importance of geometry. The comprehensive

important developments, however, have significantly advanced the state of geometrical research in Gothic architecture since the middle of the twentieth century. First, there has been a growing appreciation that Gothic design involved dynamic processes of geometrical unfolding, rather than just the rigid application of "*ad triangulum*" or "*ad quadratum*" design schemes.[40] Second, building surveys have grown more precise, allowing geometrical hypotheses to be tested far more rigorously than they could be in the decades around 1900.[41] Third, and perhaps most importantly, the emergence of affordable computers and computer-aided-design (CAD) software has begun to allow medievalists to process geometrical information with unprecedented flexibility and rigor. While these techniques have been profitably applied to the study of Gothic buildings, however, their potential for the examination of Gothic drawings has never been effectively exploited.[42] In this context, it makes good sense to revisit the geometry of Gothic architectural drawings, using the computer as an analytical tool.

A NEW APPROACH TO THE GEOMETRY OF GOTHIC DRAWINGS

This book sets out to complement previous studies by providing this particular new perspective on Gothic architectural creativity. Its scope will be fairly broad, in chronological terms, since original design drawings survive from the thirteenth century to the end of Gothic era. In geographical terms, too, its total scope will be broad, since Gothic drawings survive from France, Spain, Italy, and the Holy Roman Empire. The

catalog edited by Roland Recht, *Les Bâtisseurs des cathédrales gothiques* (Strasbourg, 1989) does include geometric discussion, but not in the drawings section, and not related to the catalog of objects. Recht's *Le Dessin d'architecture* (Paris, 1995) says little of geometry. Böker's *Architektur der Gotik*, far and away the most ambitious publication ever undertaken on Gothic drawing, includes only a few short geometrical asides, although it does reinforce Hecht's valuable point about Gothic drawings being scaled.

[40] In the 1950s, already, there was Willy Weyres, "Das System des Kölner Chorgrundrisses," *Kölner Domblatt*, 16–17 (1959): 97–104. In the 1960s, Luc Mojon proposed a plausible design sequence for the choir of Bern Minster, in *Der Münsterbaumeister Matthäus Ensinger* (Bern, 1967), pp. 40–46. More recently, Stephen Murray and his students have proposed geometrical unfolding schemes for a variety of great churches in northern France. See, for example, Stephen Murray, *Notre-Dame, Cathedral of Amiens* (Cambridge, 1996). See also Paul von Naredi-Rainer, *Architektur und Harmonie: Zahl, Maß und Proportion in der abendländischen Baukunst* (Cologne, 1995).

[41] The emergence of laser-based surveying systems has been especially important in this connection. See *New Approaches to Medieval Architecture*, eds Robert Bork, William W. Clark, and Abby McGehee (Farnham, 2011). For application of these techniques to the study of vault design geometry, see David Wendland, "Cell Vaults: Research on Construction and Design Principles of a Unique Late-Mediaeval Vault Typology," in Karl Eugen Kurrer, Werner Lorenz, and Volker Wetzk (eds), *Proceedings of the Third International Congress on Construction History*, Brandenburg University of Technology, Cottbus, 20–24 May 2009 (3 vols, Berlin, 2009), pp. 1501–8.

[42] Many of the workshops charged with maintaining Gothic buildings now have sophisticated 3-D computer systems at their disposal. Meanwhile, in the academy, pioneering computer-based studies of buildings include Linda E. Neagley, "Elegant Simplicity: The Late Gothic Plan Design of St-Maclou in Rouen," *Art Bulletin*, 74 (1992): 423–40, and Michael T. Davis and Linda Elaine Neagley, "Mechanics and Meaning: Plan Design at Saint-Urbain, Troyes and Saint-Ouen, Rouen," *Gesta*, 39 (2000): 159–80. Neagley has established an impressive track record of computer use for geometrical research on Gothic buildings, but her one computer-based analysis of a Gothic drawing proves less fully satisfying, for reasons explained in Chapter 5. See "A Late Gothic Architectural Drawing at the Cloisters," in Elizabeth Sears and Thelma K. Thomas (eds), *Reading Medieval Images: The Art Historian and the Object* (Ann Arbor, 2002), pp. 90–99.

emphasis of this book, however, will necessarily be on the Germanic world, home to the vast majority of the surviving Gothic drawings. Of the roughly 600 such drawings known in the world today, well over 480 are in territories of the former Empire. Indeed, 442 of them are in a single city, Vienna.[43] Even in Vienna, many important drawings appear to have been lost, since there are no surviving drawings to document major projects such as the completion of the local workshop's masterpiece, the south spire of the Stephansdom, which was the tallest masonry structure in Europe upon its completion in 1433. One must imagine, therefore, that the Stephansdom workshop must once have possessed at least 500 drawings, and there is no reason to doubt that other major Gothic workshops once had comparably many. The surviving sample of Gothic design drawings, therefore, represents only a tiny fraction of the total originally produced. Significantly, too, most of these surviving drawings depict churches designed in what might be called the grand manner, with complex carved stone components that follow in the tradition pioneered by the great cathedral lodges of France. Brick architecture, despite its importance in so many regions of Europe, left behind few documentary traces of this kind. Secular architecture, and the simplified church architecture of the mendicant orders, are also under-represented in the drawings. Even within the elite tradition of church architecture that predominates in the drawings, certain building components received particular emphasis: façades, towers, tabernacles, and vaults. This is no coincidence, for these were not only among the most prestigious and visible elements of ecclesiastical architecture, but also some of the most complex and challenging to design. Thus, while surviving drawings cannot by themselves provide a full overview of Gothic architectural culture, they can reveal a tremendous amount about the design problems that Gothic draftsmen themselves saw as most interesting and exciting. This book, similarly, offers something less than a comprehensive analysis of all Gothic drawings, but it will demonstrate the geometrical methods of Gothic design in a new way, using several dozen of the most impressive Gothic drawings as examples.

The principal purpose of this book is to show, in detailed step-by-step fashion, how Gothic draftsmen could create architectural schemes of great subtlety using only simple tools and basic geometrical operations. Because this topic deserves careful attention in itself, this study will not deal at length with some other issues that have previously loomed large in discussions of Gothic geometry and design practice. Discussions of symbolism and numerology, for example, will have no place here; such associations may well have been important to patrons and builders, but they likely had little bearing on the precise mechanics of the design process. In this book, moreover, the emphasis will be on the original conception of each drawing, rather than on the complex process by which the ideas in the drawings were translated into full-scale architectural form. Foot units and systems of measure, therefore, will not figure prominently in this study, even though this topic has generated a fairly substantial specialized literature of its own.[44] As noted above, many Gothic drawings have simple and direct scale relationships with the finished

[43] The vast majority of these, 428 drawings, are in the Kupferstichkabinett in the Akademie der bildende Künste, which will henceforth be called simply the Vienna Academy collection. Another 14 important drawings are in the collection of the Wien Museum Karlsplatz, formerly known as the Historisches Museum der Stadt Wien. See Böker, *Architektur der Gotik*, esp. pp. 16, 415.

[44] For introductions to these issues, see, for example, Kidson, "A Metrological Investigation," and Eric Fernie, "A Beginner's Guide to the Study of Architectural Proportions and Systems of Length," in Eric

buildings, but others do not, which suggests that several different modes of translation from drafting table to stoneyard may have been used with rough simultaneity. Intermediate stages in this translation process are traceable in the full-scale drawings scratched into the masonry fabric of several completed buildings. In such instances the detail forms initially scratched into the building often differ subtly from those finally executed in three dimensions. This fact clearly demonstrates that the design process continued to move forward even after most of the composition had been worked out at small scale in the draftsman's studio.[45] Full-scale drawings, therefore, are certainly important records of the planning process, but the focus here will remain on the small parchment and paper drawings that most directly record the early phases of this process.

Gothic draftsmen certainly used geometrical operations to help generate their designs, but these geometrical steps did not take place in a vacuum. Tradition, functional requirements, and educated guesses about structural stability all would have informed the design process, establishing the basic outlines of the architectural scheme in ways that geometry by itself never could. Most Gothic designers, therefore, probably had at least a rough idea in mind even before sitting down at the drafting table. Geometrical play with the compass and rule then served to sharpen the focus, by generating specific trial lines that could be accepted or rejected depending on their usefulness in the overall scheme. In a sense, therefore, a Gothic design can be seen as an architectural topiary, in which geometry provides the quasi-random growth factor, while artistic judgment guides the pruning process. This dialog between growth and pruning helps to explain the organic quality characteristic of Gothic design.

The investigative method employed in this book closely resembles the Gothic design process itself. Here, once again, basic geometrical operations have been used to generate trial lines. In this project, however, the importance of a line can be judged by how well it matches lines already drawn on the medieval parchment, rather than by how well it matches a vague phantom in the mind's eye. This distinction, of course, makes the investigative process less open-ended than the original design process, but the resonance between the two has great methodological importance. In order to generate plausible hypotheses for testing, the researcher has to empathize with the original designer, imagining how a given design can be brought forth step by step on an initially blank sheet. It may be effectively impossible for citizens of the modern world to put themselves into the overall mindset of medieval draftsmen, but, in the narrowly circumscribed sphere of architectural geometry, it is possible to make educated guesses about the thought processes behind a given design. It makes sense to imagine, for example, that Gothic draftsmen usually approached their projects in a straightforward manner, establishing basic lines such as buttress axes and pier centerlines before going on to elaborate the smaller elements of the composition. As the following chapters will demonstrate, geometrical operations undertaken in this

Fernie and Paul Crossley (eds), *Medieval Architecture and its Intellectual Context: Studies in Honour of Peter Kidson* (London, 1990), pp. 229–38.

[45] As at the cathedrals of Clermont-Ferrand and Aachen, for example. See Michael T. Davis, "On the Drawing Board: Plans of the Clermont Terrace," in Nancy Wu (ed.), *Ad Quadratum: The Practical Application of Geometry in Medieval Architecture* (Aldershot, 2002), pp. 183–204; Wolfgang Schöller, "Le Dessin d'architecture à l'époque gothique," in Recht, *Bâtisseurs*, pp. 226–35; and Ulrike Heckner and Hans-Dieter Heckes, "Die gotischen Ritzzeichnungen in der Chorhalle des Aachener Doms," in Ulrike Heckner and Gisbert Knopp (eds), *Die gotische Chorhalle des Aachener Doms* (Petersberg, 2002), pp. 339–61.

order can indeed generate even the details of many complex drawings from the Gothic era. And, while there was certainly no single formula governing all Gothic design, the close relationships between many of these drawings make it possible to apply lessons learned in analysis of one drawing to other similar cases. Like medieval apprentices, therefore, modern researchers can learn through practice to appreciate and even recreate the subtleties of the Gothic design tradition.

Creative empathy may be one of the keys to understanding Gothic design, but scholarship in this field also depends on the rigorous testing of geometrical hypotheses that use of the computer facilitates. For every drawing considered in this book, photographs or digital scans of the original document were imported into the Vectorworks CAD environment. These scanned images almost perfectly replicate the proportions of the original drawings, as on-site measurement of the original drawings confirms.[46] On-site investigation also helps to locate compass prick holes, uninked construction lines, and other subtle traces of the draftsman's labor that may not be readily visible in scanned reproductions. These traces help to identify the points and lines that were important to the original draftsman. Once these clues are taken into account, the computer can be used to draw trial lines and polygons on top of the scanned drawing. In all the graphics in this book, the geometries of these added lines are perfect, in the sense that the squares are square, the circles circular, the verticals vertical, and so forth. These figures, in other words, have never been adjusted or "fudged" to match the scanned drawing. The computer, moreover, treats these figures as assemblages of perfectly thin lines, so that the user never has to worry about the issue of line width.[47] The combination of computer use and careful on-site examination of drawings, therefore, minimizes the problems of imprecision and ambiguity that had troubled earlier generations of geometrically inclined medievalists. This method, in fact, allows modern researchers to test geometrical hypotheses with unprecedented rigor.

Because the analytical method described here is so powerful, the greatest challenges in this area of research may now involve presentation rather than substance. The best way to present the results of this geometrical research would be to redraw each of the drawings in question, step by step, using the same tools as the original draftsmen did. That approach, unfolding over time, would fully capture the dynamics of the design process. It is difficult to replicate this procedural quality in a book without using a prohibitive number of illustrations for each case study. In a book of reasonably wide scope like this one, therefore, the results of the creative process must be compressed into a small number of images, typically two or three per drawing. Each of these illustrations explicitly shows geometrical figures to make visible geometrical operations that the original draftsmen likely used in creating their drawings. The draftsmen themselves, however, would not have had to draw complete geometrical figures like these in order to establish the layout of their compositions. A designer wishing to establish points outside an already constructed square, for example, might use his compasses to unfold the diagonals of the square to its baseline, but he would have had no need to actually draw in the arcs describing the path of the compass. Indeed, he would have had good reason not to, since such visible arcs

[46] In a number of cases where the parchment pieces of the drawing were obviously misaligned with each other at some point after its creation, the CAD system was used to rotate the pieces into their correct vertical alignments. In no case, however, were the proportions of the pieces altered from the original scans.

[47] This quality of the computer models, unfortunately, does not translate onto the printed page, where all the lines in both the original drawing and the overlaid figures must appear as ink bands of finite width.

would have appeared intrusive and distracting in the final drawing. Gothic draftsmen took care to leave few extraneous lines and marks on their drawings, especially on the large and impressive elevation drawings that were likely used for public presentation.[48] This logic helps to explain the relative dearth of construction lines that Hecht used to argue against the geometrical quality of Gothic design. In their groundplans and detail studies, however, Gothic draftsmen left many such lines, and even the great elevation drawings often include subtle geometrical traces that Hecht overlooked. In the illustrations for this book, the geometrical figures are conspicuous presences instead of mere traces, because the point of these illustrations is to make visible the logic of the creative process, rather than to create a purely architectural final image. Because of the complexity of the drawings in question, many of these geometrical overlays become quite dense. To clarify the logic behind their creation, a detailed explanatory text becomes necessary.

The joy of geometrical discovery, unfortunately, translates only very imperfectly into prose. In this sense, too, the modern researcher confronts a problem similar to that faced by the original Gothic designers, whose handbooks and recipes proved so much less satisfying than the new treatises emerging from Renaissance Italy. Because Gothic architectural practice emphasized procedural rules rather than the shape of the finished product, the only way to fully appreciate a Gothic drawing or building is to trace the likely sequence of steps in its creation.[49] Descriptions of this process can be wearying, as the previously cited passage from Roriczer's booklet on pinnacle design demonstrates. It is difficult to imagine any other way, however, to convey the true nature of the process to an audience of readers. Even Roriczer's decision to label all the major points in his pinnacle design cannot be dismissed as unreasonably pedantic, since there is no other technical or formal vocabulary available to precisely describe all the points the designer actually needed to consider. In the following chapters, therefore, similar labeling systems will also be used, even though this risks making the book read more like a mathematics textbook than a typical work of art-historical scholarship. Paul Frankl once wrote that "Anyone for whom geometric descriptions are tedious or irksome is unsuited for the history of architecture," but that Olympian comment is surely unrealistic.[50] Because uninterrupted descriptions of Gothic geometry can become numbing even for the heartiest enthusiasts, more general interpretive discussions frame each of the case studies in the following chapters, calling attention to the main aspects of each analysis. These discussions should help to make the key themes of each chapter accessible to the general reader. This, at least, is the hope, since geometrical research has implications that may be of interest to medieval scholars and Gothic enthusiasts of all stripes.

[48] In some instances, in fact, the draftsmen appear to have used protective screens to keep their drawings from being punctured at key points where a compass had to be used repeatedly. In the drawing known as Rahn Plan A, for example (Figure 2.51), a series of concentric arcs were carefully drawn, quite obviously with a compass, to describe the inner arch profiles of a flying buttress. There is, however, no hole or prick point at their geometrical center. This effect could have been achieved by temporarily attaching a small parchment patch atop the main drawing to shield the centerpoint during the arc construction process.

[49] It is effectively impossible to provide an adequate simple overview of this process, showing only the "major" steps, because the location of seemingly major elements often depends on the establishment of seemingly minor elements earlier in the process. This is especially the case in drawings of towers, where details in the lower stories often help to determine the proportions of the upper stories.

[50] Paul Frankl, *Principles of Architectural History* (Cambridge, Mass., 1968), p. xv.

The chapters in this book build in essentially chronological order, so as to provide a reasonably comprehensive overview of Gothic architectural drawing production. Chapter 1 traces the origins of Gothic drawing, with an emphasis on developments in thirteenth-century France. The central documents in this section will be the portfolio of Villard de Honnecourt and the two façade drawings preserved in the so-called Reims Palimpsest. Chapter 2 considers the refinement of architectural drawing practices in the Rhineland in the decades bracketing 1300, paying particular attention to innovations made in the Strasbourg, Cologne, and Freiburg workshops. Chapter 3 provides a brief interlude south of the Alps, exploring the intrusion of geometric design practices into Italy. Modular approaches to design have usually been seen as typical of Italy, but evidence from the cathedral workshops of Orvieto and Siena will show that dynamic geometry was also used, at least in these elite ecclesiastical projects, in the early fourteenth century. Chapter 4 discusses the heroic late Gothic tower projects of central Europe, which are better documented in drawings than are any other architectural projects of the era. Crucial examples here include the towers of Prague Cathedral, Vienna's Stephansdom, Ulm Minster, Frankfurt's Bartholomäuskirche, and the cathedrals of Regensburg and Strasbourg. To provide a somewhat broader perspective, Chapter 5 explores a variety of other late Gothic drawings, from all across the European continent, which depict building plans, vaults, tabernacles, and façades. Chapter 6, finally, explores the emergence of classical design in Renaissance Italy, and the collision between this newly fashionable mode and the established traditions of the Gothic world.

Together, these chapters will argue for seven principal theses. First, and most importantly, this book will demonstrate that Gothic draftsmen developed their designs using a dynamic approach to geometry, in which sequences of simple geometrical operations could be combined to produce final forms of great complexity. This view of Gothic design practice differs significantly from the three basic options that have previously been proposed: the networks of symbolic lines first postulated in the nineteenth century; the rather static imposition of rigid geometrical figures suggested by Velte; and the purely modular system proposed by Hecht. Second, and in a related vein, this book will reveal that Gothic architectural ornament and articulation often calls attention to the very points that played especially important roles in the design process—a finding that deserves particular emphasis because it shows that Gothic articulation patterns are actually more logical and less capricious than most scholars have assumed. Third, this study will document remarkable continuity in northern Gothic design practice over the course of three centuries. The same geometrical relationships that govern the thirteenth-century drawings in Villard's portfolio can still be traced in the tower and vault designs from early sixteenth-century Germany and Austria, for example. Fourth, these case studies will show that Gothic designers employed only a small "tool-box" of basic geometrical operations, a fact which helps to make their work analytically tractable. Even relationships that have not received sustained scholarly attention can often be understood as permutations on simple principles. So, for example, the principle of polygon nesting seen in the rotated squares of Roriczer's "quadrature" (see Figure 0.2) can easily be generalized to the inscribing of other figures such as hexagons, octagons, and dodecagons within their generating circles. The relationship between octagons and their circumscribing circles, in particular, appears so frequently in Gothic drawings that "octature" deserves to be seen

alongside "quadrature" as one of the foremost proportioning strategies of the era (Figure 0.7). Fifth, the following chapters will demonstrate that Gothic draftsmen created their designs in a straightforward and practical manner, typically developing a single major geometrical composition on a single manageably sized parchment, even when designing tall towers and façades where many such sheets had to be assembled together to create the final image. This approach makes a great deal more sense, from the draftsman's point of view, than trying to establish global geometrical relationships over the whole composition, since tower drawings could reach heights of four meters and more. The parchments in these drawings, in fact, were often trimmed in ways that subtly express the geometrical armature underlying the architectural scheme. Sixth, this book will suggest that the progressive divergence of Italian from northern European design practice over the course of the Gothic era, and the divergence between Italian modular planning and northern geometrical planning in particular, helped to set the stage for the more obvious battle between Gothic and classical styles in the Renaissance. Finally, and in a related vein, the concluding chapter will argue that the triumph of the classical mode in the sixteenth century reflected not the inherent superiority of classical architecture, but rather the greater marketability of the classical mode, with its prestigious ancient associations and its easily legible formal order.

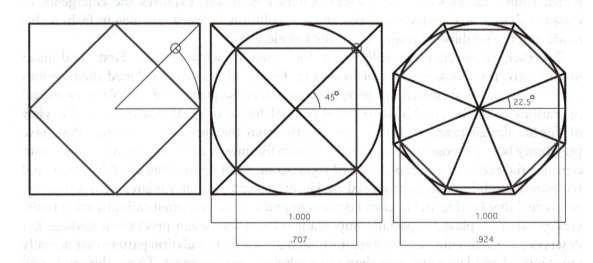

Figure 0.7 Basic proportioning figures of quadrature (at left and center) and octature (at right). In quadrature a rotated square can be inscribed directly within an original framing square, as at left. As the arc in this diagram indicates, the smaller square can be rotated back into alignment with the framing square, so that the center diagram results. This makes clear that the smaller square inscribes a circle that, in its turn, inscribes the framing square. The inscribed square is smaller than the framing square by a factor of √2. Its sides are thus .707 times as long as those of the framing square. In octature, at right, one considers a circle nested between two octagons instead of between two squares. The inner octagon is .924 times as large as the framing octagon. In trigonometric terms, .707=cos(45°) and .924=cos(22.5°).

Above and beyond arguing those specific points, this book aims to foster greater interest in the geometrical logic of the Gothic design process, a rich topic about which

much remains to be said. The drawings discussed here can certainly be studied further, and there are hundreds of other Gothic drawings that have never been analyzed from a geometrical perspective. The lessons of drawing-based research, moreover, have never been fully integrated with the results of recent geometrical and metrological research on full-scale Gothic buildings, and the field still suffers from the effects of Hecht's well-motivated but overly polemical critique. The scholarly enterprise, like the process of Gothic design, evolves through both growth and pruning, and geometrical research is an area now ripe for healthy future growth. If this book can help to re-establish geometrical study as a flourishing branch of Gothic architectural scholarship, it will have served its purpose.

CHAPTER ONE
The Origins of Gothic Architectural Drawing

The flowering of Gothic architecture in the decades around 1200 coincided with a dramatic increase in the importance of architectural drawings. Gothic builders certainly were not the first to use drawings in the planning process; a statue of the ancient Mesopotamian ruler Gudea of Lagash, made in the late third millennium before Christ, has an architectural plan inscribed on its lap. There is good reason to believe that drawings of one kind or another were also used by the Egyptians, the Greeks, the Romans, and some builders in the early Middle Ages.[1] None of these societies left behind a large number of original design drawings as the Gothic draftsmen would, however. Such Gothic drawings thus deserve recognition as the world's oldest extant "blueprints." It was only in the Gothic period, moreover, that the linearity of drawing began to directly influence the character of the architecture itself, as builders strove to reproduce in stone the virtuoso detailing conceived by the master designers at their drafting tables. The intimate relationship between geometry, drawing, and architectural practice achieved in the Gothic era went far beyond anything that had come before, and it has rarely been rivaled since. The spectacular effusion of architectural drawing in the Gothic era emerges with particular clarity when seen against the striking paucity of earlier documentation in this field.

One of the only surviving early medieval architectural drawings is the so-called Plan of Saint Gall, an idealized Carolingian monastery plan sent by Abbot Haito of Reichenau to his colleague Abbot Gozbert of Saint Gall shortly before the year 820. In a series of publications culminating in a massive and celebrated 1979 study of the drawing, Walter Horn argued that the dimensions in the drawing were based on a grid system representing 40-foot squares.[2] Konrad Hecht independently arrived at similar conclusions, insisting once again on the centrality of modularity in medieval design.[3] More recently, Eric Fernie has argued that the proportions of the Saint Gall Plan were based on a series of geometrical unfoldings similar to, but simpler than, those later seen in Gothic design. Fernie proposes, in particular, that the length of the church was created by unfolding the diagonal of the square cloister, creating a $\sqrt{2}$ ratio. This suggestion is plausible, since it situates Carolingian design in an intermediate position between the Roman and Gothic traditions. The Roman architect Vitruvius had already mentioned rooms with proportions of 1 to $\sqrt{2}$ as one harmonious format, although his other recommendations were all for rooms of rational modular proportions. Fernie himself, moreover, claims to have found

[1] For a general discussion, see Recht, *Le Dessin d'architecture.*

[2] Walter Horn, "The Dimensional Inconsistencies of the Plan of St. Gall," *Art Bulletin*, 38 (1966): 285–308; Walter Horn and Ernest Born, *The Plan of Saint Gall* (Berkeley, 1979).

[3] Konrad Hecht, "Der St. Galler Klosterplan: Schema oder Bauplan?" *Abhandlung der Braunschweigischen Wissenschaftlichen Gesellschaft*, 17 (1965): 165–206; idem, "Zur Geometries des St. Galler Klosterplanes," *Abhandlung der Braunschweigischen Wissenschaftlichen Gesellschaft*, 29 (1978): 57–96; idem, *Der St. Galler Klosterplan* (Sigmaringen, 1983). Hecht, like Horn and Born, argued that the plan was drawn to a 1:192 scale.

1 to √2 relations not only in the Saint Gall plan, but also in the groundplans of several major Romanesque churches in England.[4] This may well be correct, but precision in these matters is harder to achieve than in the study of Gothic workshop drawings.[5] And, it is difficult to connect the Saint Gall plan directly to the later Gothic design tradition, for two basic reasons: first, because it has often been seen as an ideal theoretical exercise rather than a practical proposal for a real building project; and second, because the few surviving Romanesque drawings of specific buildings are even further removed from the workshop culture of the Gothic world. The so-called Waterworks drawing of Canterbury Cathedral, for example, is essentially an elaborate sketch with subtly inconsistent points of view, rather than a geometrically precise plan, elevation, or detail study like those common in the Gothic era.[6]

Drawings may have been used in the design process in the early Middle Ages, at least for the most ambitious building projects, but solid documentary evidence for this practice begins to emerge only at the dawn of the thirteenth century. There are, therefore, no surviving drawings related to construction of Saint-Denis Abbey, Sens Cathedral, or the other earliest specimens of Gothic architecture. The oldest surviving Gothic drawings, or at least the oldest closely related to design practice, are detail studies scratched into the stone surfaces of several French and English buildings in the 1190s. Rosette patterns, for example, appear at Soissons Cathedral, Byland Abbey, and the church of Notre-Dame-en-Vaux at Chalons-sur-Marne, while pier profiles can be found at Jervaulx Abbey in Yorkshire.[7] Because most of these are drawn at full scale, they appear to be close cousins of the templates that would have been used to cut stones for construction. For this reason, Robert Branner argued in a fundamental 1963 article that Gothic drawing practice originally arose in the context of stone working, as detail forms grew too complicated to cut without templates being carefully drawn up ahead of time. Branner suggests that drawing then migrated, in the decades around 1200, from the worksite into the drafting studio, from stone onto parchment, and from full to reduced scale.[8] This development,

[4] Eric Fernie, "The Proportions of the Saint Gall Plan," *Art Bulletin*, 60 (1978): 583–9; Vitruvius, *The Ten Books on Architecture*, trans. Morris Hicky Morgan (New York, 1960), pp. 177–9.

[5] For more recent critical perspectives on the St. Gall plan, see Werner Jacobsen, *Der Klosterplan von St. Gallen und die karolingische Architektur: Entwicklung und Wandel von Form und Bedeutung im fränkischen Kirchenbau zwischen 751 und 840* (Berlin, 1992); and the continuously updated website www.stgallplan.org.

[6] Peter Fergusson, "Prior Wibert's Fountain Houses," in Evelyn Staudiger Lane, Elizabeth Carson Pastan, and Ellen M. Shortell (eds), *The Four Modes of Seeing: Approaches to Medieval Imagery in Honor of Madeleine Harrison Caviness* (Farnham, 2009), pp. 83–98.

[7] On Jervaulx, see Peter Fergusson, "Notes on Two Cistercian Engraved Designs," *Speculum* 54 (1979): 1–17. On Byland, see Stuart Harrison and Paul Barker, "Byland Abbey, North Yorkshire: The West Front and Rose Window Reconstructed." *Journal of the British Archaeological Association*, 3rd ser., 140 (1987): 134–51. See also Schöller, "Le Dessin d'architecture à l'époque gothique," 226–35.

[8] Branner, "Villard, Reims and the Origin of Gothic Architectural Drawing." The overall sequence sketched by Branner is highly plausible, but the details of the chronology remain debatable. Branner felt that the oddness of Villard de Honnecourt's portfolio argued against there being a well-established tradition of design drawing in his day, but Villard is no longer understood as a practicing architect, so this argument carries less weight than it did in 1963. James Ackerman observes, therefore, that there must indeed have been a fairly robust tradition of drawing for Villard to copy, since Villard himself was unlikely to have come up with the variety of sophisticated representation strategies seen in his portfolio. See "Villard de Honnecourt's Drawings of Reims Cathedral: A Study in Architectural Representation," *Artibus et Historiae*, 35 (1997): 47; and more broadly "The Origins of Architectural Drawing in the Middle Ages and Renaissance," in idem, *Origins, Imitation, Conventions: Representation in the Visual Arts* (Cambridge, 2002), pp. 28–65. Given the

in turn, made it practical to draw whole buildings in plan and elevation, rather than just their small component pieces. Drawing thus became a powerful new tool of architectural planning. The rise of drawing, in fact, would turn out to be one of the most significant methodological innovations in the history of medieval architecture.

Villard de Honnecourt

Valuable early evidence for the emergence of drawing-based design practices comes from the portfolio of sketches produced by Villard de Honnecourt in the years around 1230. As noted previously, however, Villard probably was not a designer himself.[9] Even the purely architectural drawings in his portfolio do not belong to a single coherent tradition of representation. Instead, they seem to depend on a mixture of influences. Some, like his drawings of the window moldings and pier templates for Reims Cathedral, suggest close familiarity with full-scale stoneyard drawings like those just discussed (folios 15v and 32r). Others attest to his awareness of more comprehensive drawings. One interesting example gives a highly schematized plan of a Cistercian church, rendered essentially as a grid of line segments, with small circles at their intersections and small rectangles at their ends describing piers and buttresses, respectively (folio 14v, Figure 1.1). This emphasis on linear armatures, and on the conceptual priority of pier axes in particular, would characterize the Gothic drawing tradition well into the sixteenth century. Villard's more detailed plan of Cambrai Cathedral's east end, drawn on the same sheet, likely copies a drawing he had seen in the Cambrai workshop, and his decision to produce elevations and buttress sections of Reims Cathedral may reflect his exposure to analogous prototypes (folio 31v and 32v).[10] In other cases, Villard introduced perspectival cues that owe more to traditions of manuscript illumination than they do to the strictly orthogonal plan and elevation formats typical of genuine workshop drawings throughout the Gothic period. A few, such as a sketch of a clock tower, attempt to capture the full three-dimensional presence of the structure in question, although with far less sophistication than pictorial representations made in the later Middle Ages and Renaissance (folio 6v). By comparison with the later design drawings discussed in this book, moreover, Villard's sketches were quite small. The pages of his portfolio measure only about 24 by 15 centimeters. The earliest thirteenth-century drawings from the Strasbourg workshop, by contrast, measure nearly a meter square, and some late Gothic tower drawings could reach heights in excess of 4 meters.

Even the drawings in Villard's portfolio that appear most closely modeled on genuine workshop drawings are less than precise in their execution. The plan of the Cambrai

very poor survival rate of medieval drawings, and the sophistication of Gothic architecture already in the mid-twelfth century, it is entirely possible that scaled design drawings were already in use well before 1200.

 9 See Barnes, *The Portfolio of Villard de Honnecourt.*

 10 On the precocious development of orthogonal representations in Gothic workshops and in Villard's Reims drawings, see James Ackerman, "The Origins of Architectural Drawing in the Middle Ages and Renaissance," in idem, *Origins, Imitation, Conventions: Representation in the Visual Arts* (Cambridge, 2002), pp. 28–65. See also Clark, "Reims Cathedral in the Portfolio of Villard de Honnecourt," and M. F. Hearn, "Villard de Honnecourt's Perception of Gothic Architecture," both in Fernie and Crossley, *Medieval Architecture and its Intellectual Context,* pp. 127–36.

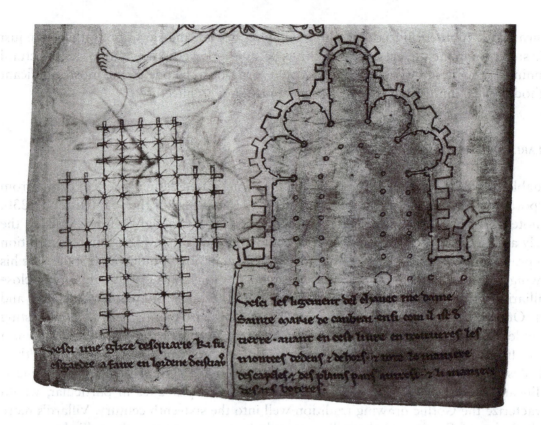

Figure 1.1 Villard de Honnecourt, detail view showing the schematic groundplan of a Cistercian church, and a more detailed groundplan of the Cambrai Cathedral choir, from the Portfolio. Parchment, ca. 24 x 15 cm. Paris, Bibliothèque nationale de France, MS Fr 19093, folio 14v.

choir, for example, was constructed with the aid of a compass, but two basic problems compromise its geometrical rigor (Figure 1.2). First, Villard's freehand drawing of the building outlines is wobbly and imprecise, with a looser overall feel than the ruler-drawn lines seen in later workshop drawings. Second, and more interestingly, Villard's attempted subdivision of the hemicycle into five equal slices succeeds only approximately. The construction starts fairly accurately at right, but the chapels are slightly bigger than they should be, pushing the left margin of the hemicycle below its center. A precisely analogous error occurs in the hemicycle plan that Villard developed with Pierre Corbie, which was supposed to be subdivided into seven equal slices (folio 15r).

Such inaccuracies are hardly surprising, since medieval builders knew no simple geometrical construction to produce perfect pentagons and heptagons. Even Roriczer's *Geometria Deutsch*, from 1486, includes only approximate constructions for these polygons. Medieval builders could, of course, achieve highly precise subdivisions of arcs when it truly mattered to them, as it would when laying out the hemicycle of a great church at full scale.[11] The east ends of Reims Cathedral and the collegiate church of Saint-Quentin, for example, incorporate highly accurate pentagonal symmetries. By the late

11 As Kidson notes, good arithmetical approximations known throughout the Middle Ages would have permitted the construction of nearly perfect pentagons. See "A Metrological Investigation," pp. 91–3. For

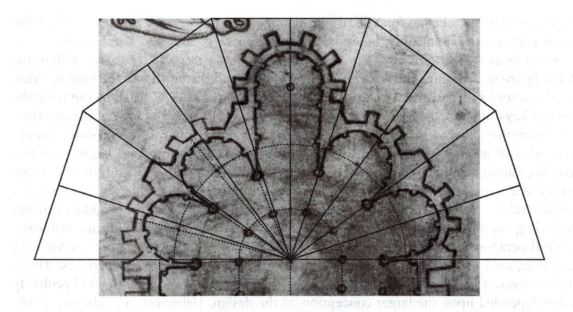

Figure 1.2 Villard de Honnecourt, Cambrai Cathedral apse plan with geometrical overlay.

thirteenth century, moreover, pentagonal tracery motifs had become relatively common. There is a world of difference, though, between being able to achieve pentagonal symmetry when necessary, which medieval designers could do, and being able to achieve it easily and quickly, which they could not. For this reason, pentagonal and heptagonal figures seem to occur in Gothic drawings only in those fairly rare cases where the depicted structure itself was meant to have that symmetry for some particular programmatic or symbolic reason.[12] By contrast, easily drawn figures based on the equilateral triangle, the square, and their immediate derivatives such as the octagon governed the proportions of many Gothic drawings, as the following chapters will demonstrate, even when the structure in question has no obvious triangular, square, or octagonal form.

Because Villard's drawings are fairly imprecise in their execution, interpretation of their geometrical structure must involve some subjective judgment about what is logical or natural in a given design situation, above and beyond objective quantitative analysis. In the case of Villard's Laon tower plan, for example, it makes sense to imagine that octagons might play a role in governing the drawing's proportional structure, since the tower core itself should have octagonal symmetry. Taking this argument a step further, it is reasonable to look for rotated square geometries in this plan, since these relate so closely to the explicitly drawn octagon of the tower core. Rotated squares deserve investigation in this context, also, because they figure so prominently in the late Gothic treatises on the design of towerlike pinnacles.[13] Such thinking led both Ueberwasser and Velte to propose

draftsmen, however, figures that could be constructed with purely geometrical means were surely simpler to handle.

[12] The seven-sided formats used in baptismal fonts, for example, call to mind the seven sacraments.

[13] Such proportions were already seen in the mid-twelfth century, as in the plan of the Tour Saint-Jean at Auxerre. See Robert Bork, *Great Spires: Skyscrapers of the New Jerusalem* (Cologne, 2003), pp. 47–8.

quadrature-based schemes for Villard's drawing (see Figure 0.6).[14] Their proposals differ from each other significantly, however. Ueberwasser took the span between the tower buttress faces as his point of departure, using a single set of rotated squares within this basic figure to determine the width of the tower core and the buttresses framing it. Velte, on the other hand, constructed a longer sequence of rotated squares reaching out from the central keystone to a square framing the colonnette clusters near the edge of the drawing. The incompatibility of these two published schemes admittedly casts some doubt on the reliability of geometrical research on Villard, but Hecht was wrong to suggest that this conflict automatically discredits both. Such disagreement requires, instead, that only one of the alternatives be incorrect. Of the two, Velte's appears more vulnerable to criticism, for several reasons. First, it involves many lines that are not visible in the original drawing, including the outer framing square, and the square one-half its size that fits just inside the central octagonal space of the tower. Second, it fails to explain key features of Villard's drawing, such as the width, span, and salience of the principal tower buttresses. Third, and conversely, it deals mainly with details, such as the keystone size, that would probably have depended upon the larger conception of the design. Ueberwasser's scheme, on the other hand, cannot be easily dismissed.[15] It plausibly connects the major lines actually present in Villard's drawing, most notably the buttress faces, the outer walls of the tower substructure, and the inner walls of the spire octagon, using only a simple quadrature relationship. This general scheme appears credible not only because of its own internal logic, but also because it has much in common with geometrical schemes evident in many later and more carefully drawn tower plans, where compass pricks and construction lines make it clear that thinking of this general sort guided the design process. Villard's plan lacks these telltale signs, and its crookedness and irregularity complicate geometrical analysis of its proportions.

Despite these limitations, the likely steps in the generation of the Laon tower plan prove fairly easy to discern (Figure 1.3). The original designer of the tower, whose drawing Villard may have copied, probably would have begun by establishing a large square with side lengths corresponding to the total width of the tower, measured to its outer buttress faces. This dimension would have been a crucial constraint on his design process, since it would have been determined by the size of the buttresses that had already been constructed in the lower stories of the tower. Within that outer square, he could then have inscribed a rotated square, an octagon, another rotated square, and another octagon, each smaller than the first by a factor of $\sqrt{2}$. The space between these two nested octagons corresponds to the thickness of the upper tower wall, as the black-shaded portion of the upper left diagram in Figure 1.3 shows. Projecting this thickness out to the borders of the framing square, as in the middle diagram, one finds the outlines of the salient tower buttresses. Finally, one locates the diagonal flanges between the buttresses by constructing

14 Ueberwasser, "Nach rechtem Maß," esp. pp. 250–61 and Abb. 7; Velte, *Die Anwendung der Quadratur und Triangulatur*, pp. 53–5. Both are critiqued by Hecht in *Maß und Zahl*, pp. 207–10.

15 Fernie notes that Branner had been skeptical of Ueberwasser's reconstruction, and he also points out that Ueberwasser "fudged his diagram," so as to disguise "those parts which did not coincide" with Villard's rather crooked original. After careful analysis of the lengths in question, though, Fernie concludes that "Ueberwasser applied the right diagram to Villard's drawing." See "A Beginner's Guide to the Study of Architectural Proportions and Systems of Length," 230–32.

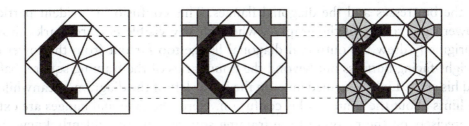

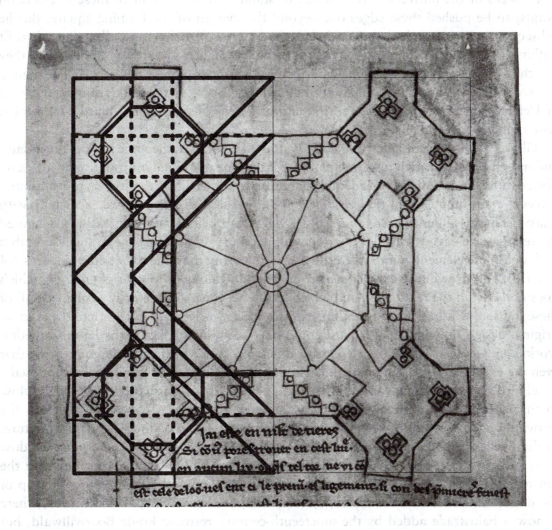

Figure 1.3 Villard de Honnecourt's Laon tower plan with geometrical overlay (below), and three
successive stages in proposed development of the plan (above).

a small octagon with face length equal to the buttress width at each of the four corner
points where the buttress axes cross.

As the lower half of Figure 1.3 shows, this simple geometrical scheme matches Villard's
drawing beautifully—or at least as beautifully as one could dare to hope, given the
roughness of his draftsmanship, and his apparent confusion about the precise relationship

between the buttresses and the diagonal flanges. This confusion is evident particularly at the lower-right corner of the graphic, where clearly visible erasure marks show that Villard originally drew the outboard diagonal flange too far out from the tower center, and the right-facing buttress out beyond the boundaries of the framing square, before he corrected his error. Lightly scribed lines on the lower left of the diagram, meanwhile, offer valuable hints about the source of his confusion. Here, the diagonal flanges are extended to meet precisely on the margin of the framing square. Villard evidently knew that the front edges of the buttresses were meant to stand slightly in front of these intersection points, so he pushed these edges out beyond the margin of the framing square. But he subsequently seems to have realized that the buttresses really were all supposed to fit within the square. The flanges then had to be pulled slightly inwards as well, so that they matched closely with the octagons described in the upper part of Figure 1.3. This match can see seen in the upper-left quadrant of the figure.[16] So, despite Hecht's doubts, the logic of Ueberwasser's basic scheme and its natural extensions explains Villard's Laon plan remarkably well.

Villard's Laon tower plan, while sloppily drawn, belongs to the same basic genre as later and more precisely drawn tower plans, since it presents its visual information in a strictly objective fashion, but his considerably larger exterior view of the tower appears more subjective and impressionistic (see Figure 0.1).[17] Villard drew the tower aediculae with quasi-perspectival depth cues to indicate a view from below, and he greatly exaggerated the relative size of the aediculae and the sculpted oxen that occupy them, suggesting that he found these elements more interesting or noteworthy than the tower core (Figures 1.4 and 1.5). This drawing also includes a prominent hand along its lower-right margin, which does not exist in the real tower, and which has never been satisfactorily explained. All of these unusual features suggest that the exterior view was less dependent than the plan on original design drawings that Villard could have seen while visiting the Laon Cathedral workshop. Geometrical analysis confirms this impression, while also demonstrating that even the exterior view has more geometrical coherence than has usually been supposed.

Villard's exterior view turns out to have a geometrical structure surprisingly close to that of the real Laon tower, as Figure 1.5 demonstrates. To begin with, both the drawing and the actual tower elevation fit precisely within a double-square armature. In the drawing, the baseline of this double-square is the bottom of the double-window story near the base of the page, while the top of the double square coincides with the top margin of the page. In the actual tower, the baseline is the same, while the top of the double-square marks the top edge of the octagonal aediculae; above this level there is now a balustrade added by the nineteenth-century restorer Emile Boeswillwald, but originally this was the level where the spire and pinnacles of the tower began to taper inwards, as Villard's view of the tower exterior shows. The width of the double-square equals the span of the salient buttresses in the actual lower tower story, just as in Villard's plan drawing. Calling this dimension one unit, it quickly becomes apparent that some of the internal proportions of the present tower design also match those shown in Villard's

[16] The octagons actually model the upper aediculae of the tower, while the flanges occur a story lower, at the level where the oxen stand. The slight displacement between the octagons and the flanges in Fig. 1.4 might charitably be interpreted as Villard's attempt to record a subtle distinction between these levels that he might have seen in a real design drawing in the Laon workshop.

[17] Villard's portfolio, folio 10r. See Barnes, *The Portfolio of Villard de Honnecourt*, pp. 73–4.

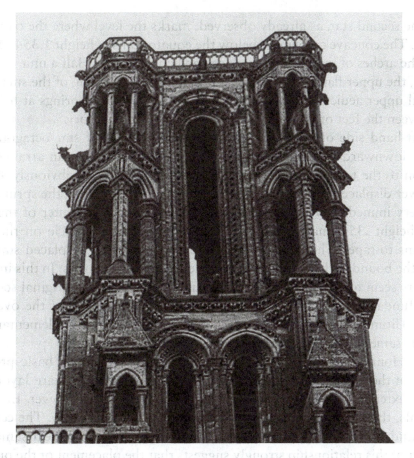

Figure 1.4 Laon Cathedral, south tower of west façade.

exterior view. Thus, for example, the oxen in the real tower stand on platforms three-quarters of the way up the composition, at height 1.500. This same level marks the eye of the right-hand ox in the drawing. In view of these similarities, Villard's exterior view cannot be dismissed as merely impressionistic. Instead, his drawing process must have been informed by some direct knowledge of the basic proportioning scheme really used in the Laon workshop. But, in view of the many other gross differences of proportion between his drawing and the actual structure, he hardly seems to have been making a copy of a real workshop drawing in this instance. It is tempting to imagine that the basic idea of the double-square was communicated to him verbally by someone "in the know," but that he used his imagination when attempting to locate the details of his drawing within that simple frame.

To understand the extent to which Villard grasped the design of the Laon tower, one must investigate the proportions of the tower and his drawing in more detail. As the left portion of Figure 1.5 indicates, the geometry of the actual tower was based on an elegant arrangement of stacked star octagons. The right-hand half of the tower elevation shows what might be called the main series of star octagons, reaching up from height 0 to height 2.000. The bottom flat edge of the first star falls at height .146, defining the top edge of the arcaded gallery over the rose window. The corresponding upper edge of the first star falls at height .854, locating the junction between the two main tower stories. The

equator of the second star, as already observed, marks the level where the oxen stand, at height 1.500. The concave corner just below the equator falls at height 1.354, defining the level where the arches of the diagonally placed aediculae spring. Half a unit further up, at height 1.854, the upper flat surface of the star defines the springing of the small arches in the octagonal upper aediculae. The main arch in the tower core springs at height 1.750, halfway between the feet of the oxen and the top of the tower story.

As the left-hand side of the elevation shows, this system of star octagons can also be displaced downward by the height of one small diagonal facet, an arrangement that calls attention to the tower proportions in a different way. Most obviously, the bottom tip of the lower displaced star comes down to height -.146, defining the springline of the arcaded gallery immediately beneath the main tower story. The center of the displaced octagon, at height .354, marks the level where the small tabernacle on the outboard buttress begins to taper. The point where the upper and lower displaced stars touch is height .854, the boundary between the upper and lower tower stories. In this instance, the displaced stars seem to have a kind of conceptual priority, but the original set otherwise seems more fundamental, since it aligns with the top and bottom of the overall tower composition. Ultimately, though, the two systems are just two complementary ways of describing the same star-based geometrical relationships.

Villard de Honnecourt appears to have understood some of the basic proportional relationships in the Laon tower, starting with the overall double-square layout, but the details of his exterior view differ markedly from those of the real tower. Even some of the odd details, though, appear to have some geometrical significance. The center of the mysterious hand, for example, falls at height .500, exactly halfway up the first main square. The precision of this relationship strongly suggests that the placement of the outboard ox face at height 1.500 was intentional rather than coincidental. The hand may thus have been added to the drawing as an explicit geometrical marker. This might at first appear surprising, but later Gothic draftsmen definitely did use figural ornament to call attention to crucial geometrical points in their drawings, as subsequent chapters will demonstrate. The hand in Villard's Laon drawing may thus provide one of the earliest instances of such geometrical sign-posting. The level indicated by the hand was particularly important because Villard relied more heavily on the subdivision of squares into halves and quarters than the actual Laon tower builders did. Thus, while the hand falls at height .500, the colonnettes on the lowest tabernacles end at height .250. And, while the outer ox eyes fall at height 1.500, the main tower story and its tabernacles terminate at height 1.750, except for the pseudo-perspectival extensions of the latter.

Villard's exterior view of the Laon tower does not seem to incorporate a star-based geometry like the one governing the actual tower, but his understanding of the tower's groundplan was sufficient for him to introduce at least a few familiar quantities into his elevation. The buttress widths in both of his drawings agree with those in the actual tower, which includes quadrature-derived dimensions like $(\sqrt{2})/4 = .354$, which is the span from the centerline to the outer faces of the front faces of the buttresses.[18] If a semicircle of this radius is placed at the bottom center of Villard's exterior view, a smaller circle sitting atop it and centered at height .500 will rise to height .500 + (.500 - .354) = .500 + .146 = .646.

[18] It is worth noting here that Villard's exterior view of the Laon tower was drawn at considerably larger scale than the plan, so that these are correspondences of proportion, not absolute dimension.

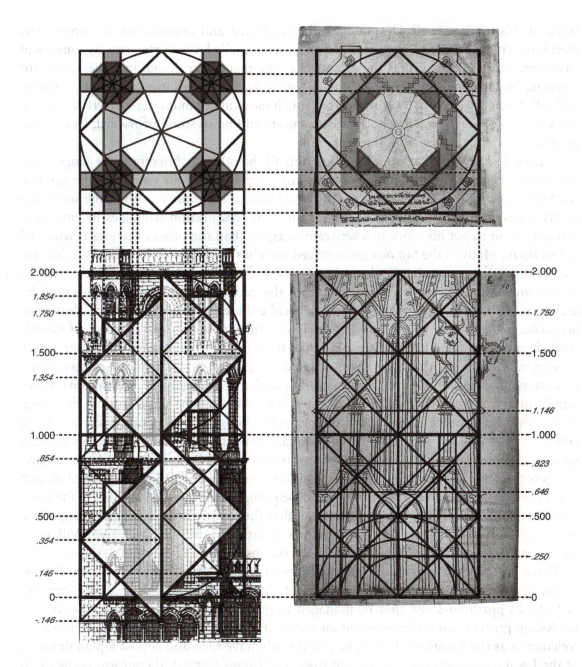

Figure 1.5 Comparison between proportions of the actual Laon tower (at left), and Villard de Honnecourt's corresponding plan and elevation drawings (at right)..

This height, as it turns out, marks the top of the main tower story and the base of the rotated tabernacles, when measured on their outboard surfaces. The pseudo-perspectively raised front surfaces terminate at height .823, which can be found by striking verticals up one quadrature step inward from the buttress interiors until they hit height .646, and then striking diagonals out to the outer buttress faces. Diagonals struck up from the top of the small circle, finally, rise from level .646 to level 1.146, locating the upper outboard corners of the rotated tabernacles. The capitals on the colonnettes in the foreground

begin at this level, as well. Despite its rather distorted and impressionistic appearance, therefore, Villard's exterior view of the Laon tower actually has a fairly precise geometrical structure, and it even captures the essentials of the real tower design in some important respects, but it could hardly be mistaken for an accurate elevation of the real tower. Villard's Laon tower plan, by contrast, has much more in common with surviving Gothic workshop drawings, since it is both more accurate and more straightforward, lacking the perspectival depth cues seen in the elevation.

In considering Villard's Laon drawings, and all the other architectural drawings in his portfolio, a central question must be the relationship between his work and the genuine workshop tradition of Gothic design. The roughness of his draftsmanship, the small size of his pages, and the unconventional blending of representation strategies he employed certainly seem to put his work in a separate category than the other drawings considered in this book. Many of the famous geometrized sketches in his portfolio, moreover, involve faces, human figures, and animals, rather than buildings. Such drawings, by themselves, do not argue strongly for his familiarity with the geometrical design strategies used by architects of his day. The surprising geometrical coherence of Villard's Laon drawings, however, suggests that he was paying fairly careful attention to this aspect of Gothic workshop culture. The Laon tower plan, like the Cambrai choir plan, should probably be seen as a fairly faithful copy of an original design drawing, despite its rather rough execution. The elevation drawing is more problematic, since its proportions differ significantly from those of the present tower. It is hard to imagine this elevation, therefore, as a copy of a genuine workshop drawing, even though it incorporates certain basic geometrical structures, such as the double-square governing framework, that also would have been present in such a drawing. In contrasting Villard's two Laon drawings, in fact, one gets the sense that he was copying a visual document when drawing up his plan, and that he was following a verbal recipe when developing his elevation. Someone in the Laon workshop could have told him, for example, that the tower elevation could be inscribed in a double-square, and that the oxen fall three quarters of the way up, leaving Villard to work out the rest of the details himself, based on observation of the actual tower.

Three independent glosses on the reliability of Villard's drawings come from Reims, in one way or another. First, the drawings of the Reims Cathedral window templates in Villard's portfolio show that he managed to gain an insider's perspective on Gothic workshop practice, even if he was not an architect himself. If the Laon workshop was as welcoming as the Reims workshop, he could easily have seen and copied a plan drawing of the Laon tower. Second, the western towers of Reims Cathedral conform perfectly to the ideal geometrical scheme derived above from Villard's Laon tower plan (Figure 1.6). This striking result underscores the enduring importance of the Laon workshop as a role model for the builders of Reims Cathedral. Scholars have long recognized Laon as a crucial precursor for Reims in terms of tower number, since both cathedrals were meant to have seven-towered profiles, with fully towered transept façades. In formal terms, too, the airy aediculae of the Laon towers clearly inspired those later built both at Reims Cathedral and at the Remois abbey church of Saint-Nicaise. The absolute congruence between the plan of the Reims towers and the Laon plan roughly depicted by Villard shows that this influence had a significant geometrical component as well. Interestingly, too, this channel of influence appears to have operated over a long period, because the

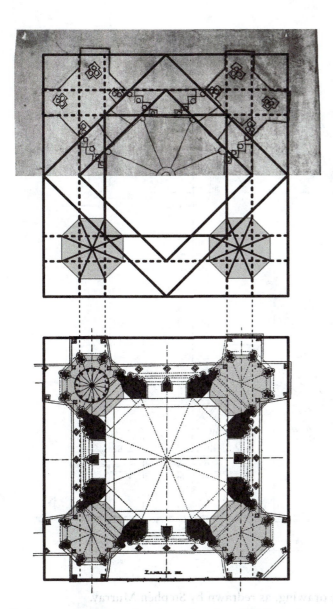

Figure 1.6
Comparison between Villard de
Honnecourt's Laon tower plan (above),
and the plan of a west façade tower
from Reims Cathedral (below).

Reims towers were begun only after 1300, and completed only in the fifteenth century. So, a tower geometry developed in Laon around 1200, early enough to permit the completion of the Laon towers before Villard's visit in the years around 1230, was still known and respected at least a century later.[19] The durability of this geometrical idea strongly suggests that it was recorded in at least one careful workshop drawing, one that could have been seen both by Villard and by the designers of the Reims Cathedral towers. Altogether,

[19] The Reims workshop was marked by a high degree of continuity, but the current tower plan cannot have been determined in the early years of the Reims Cathedral project. As Peter Kurmann has demonstrated, the façade design was repeatedly revised in the second half of the thirteenth century; see *La Façade de la cathédrale de Reims* (Paris, 1987). Careful examination of Figure 1.5 will show, moreover, that there is a subtle shift between the centerlines of the façade buttresses and the axes of the aediculae above. This shows that the aediculae were located by inscribing a figure like Villard's on the square platform of the buttress structure, rather than simply continuing their vertical lines. This geometric shift appears to have been introduced only after the completion of the buttresses up to the rose window, which was completed by around 1300.

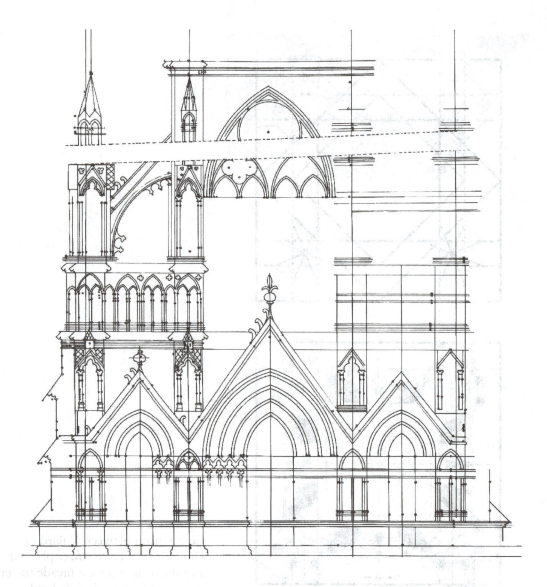

Figure 1.7 Reims Palimpsest, first façade drawing, as redrawn by Stephen Murray.

therefore, this evidence from the Reims towers suggests that Villard really did have access
to a genuine Laon tower plan, even if he did not copy it very well. A third category of
evidence related to Reims, though, points up the strangeness of his Laon tower elevation.
Villard's elevation differs greatly in conception and execution from those found in the
Reims Palimpsest, which are in many respects more typical of the mature Gothic drawing
tradition.

THE REIMS PALIMPSEST

The drawings in the Reims Palimpsest rank with those in Villard's portfolio as some of
the oldest Gothic drawings to survive on parchment. They survive, however, only as
faint traces, because they were erased already by 1270, when the sheets they were drawn

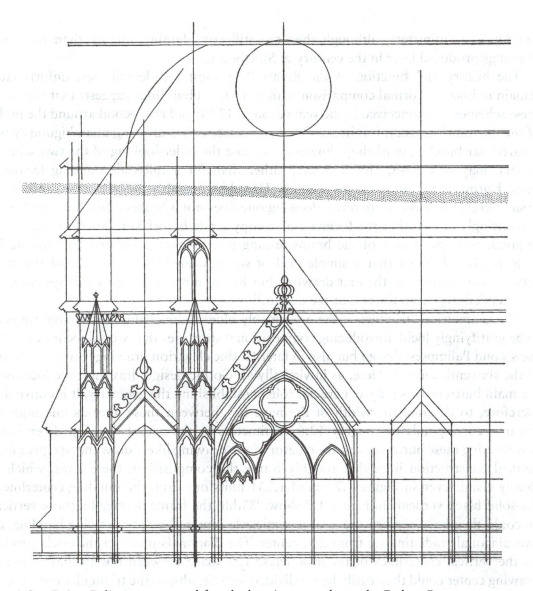

Figure 1.8 Reims Palimpsest, second façade drawing, as redrawn by Robert Branner.

on were reused to record an obituary for the Reims Cathedral Chapter. Some of these traces were noticed in the nineteenth century, but it was the ubiquitous Robert Branner who first produced reliable modern reproductions of the Palimpsest drawings in a major 1958 article.[20] Branner identified elements such as choirstall components, finials, and façade schemes among the Palimpsest drawings. Perhaps the most interesting of these are the two partial façade drawings (Figures 1.7 and 1.8). Unlike Villard's Laon elevation, with its dramatic quasi-perspective depth cues, these drawings present straightforward orthogonal projections, as most subsequent Gothic drawings also would. Unlike nearly all of Villard's drawings, moreover, these façade schemes are carefully ruler-drawn, just as most later Gothic workshop drawings would be. They are also somewhat larger than Villard's drawings, with the more complete scheme in Figure 1.7 reaching a height of

20 Robert Branner, "Drawings from a Thirteenth-Century Architect's Shop: The Reims Palimpsest," *Journal of the Society of Architectural Historians*, 17 (1958): 9–21.

roughly 38 centimeters, although they are still considerably smaller than the design drawings produced later in the century at Strasbourg.

The history and function of the Reims Palimpsest façade schemes, unfortunately, remain unknown. Formal comparison with well-dated buildings suggests that the first of these schemes was conceived in the years around 1220, and the second around the middle of the thirteenth century. It is impossible to associate either drawing unambiguously with a particular building workshop, however. At least the older-looking of the two schemes, in fact, may be a design for a shrine, rather than for a full-scale building façade, as Peter Kurmann has recently proposed.[21] This drawing also includes many prominent prick marks, while the more recent-looking one does not. On this basis, Stephen Murray convincingly argued that the former was a copy made by pricking holes through a lost original, perhaps as part of the brainstorming process that generated the later design. Murray also observed that a simple grid of squares lined up with some of the major articulation elements in the first drawing, but he did not explain how this system might be extended to govern the rest of the design.[22]

The geometrical structure of the presumably older Reims Palimpsest design turns out to be gratifyingly lucid, introducing compositional strategies that would recur not only in the second Palimpsest design but also in later Gothic elevation drawings down to the turn of the sixteenth century. Here, as in virtually all Gothic design drawings, the location of the main buttress axes played a crucial role in establishing the geometry. It is convenient, therefore, to describe the width of the nave bay between these axes as one unit; this distance corresponds to roughly 12.6 centimeters in the actual drawing. Even before constructing these buttress axes, the creator of the drawing likely drew the two prominent vertical construction lines that roughly frame the composition; these lines, which are clearly visible even in Figure 1.7, stand 1.131 units out from the building centerline, as the solid black verticals in Figure 1.9 show. Within the frame defined by those verticals, he could then have constructed a large semicircle centered on the drawing baseline, and two diagonals radiating up from that center. The diagonals intersect the circle precisely on the vertical centerlines of the aisle bays. The space between the aisle axes and the drawing center could then easily be subdivided into eighths, as the triangular construction along the bottom margin of Figure 1.9 indicates. The axes of the nave-flanking buttresses could then be chosen five-eighths of the way to the aisle axis. Since the aisle portals are symmetrical, the outer buttress axis falls $.800 + (.800 - .500) = 1.100$ units out from the building centerline, as the small dotted semicircle on the lower right of the figure shows. These buttress axes are shown as dotted lines, slightly but measurably offset from the solid verticals of the framing construction lines.

[21] Peter Kurmann has argued that the first Reims Palimpsest drawing should be understood as a goldsmith's drawing for a shrine, rather than as a design for a full-scale façade. See "Architecture, vitrail, et orfèvrerie: à propos des premiers dessins d'édifices gothiques," in *Représentations architecturales dans les vitraux* (Liège, 2002), pp. 33–41. Kurmann may well be correct, but it still makes sense to speak of the drawing as a façade scheme, since reliquaries in this period had begun to take on the forms of churches, at least in an approximate sense. As the analysis presented here demonstrates, moreover, the author of the Reims Palimpsest drawing was using the same design strategies as the draftsmen responsible for projects that really were intended for full-scale use.

[22] Stephen Murray, "The Gothic Façade Drawings in the 'Reims Palimpsest'," *Gesta*, 17/2 (1978): 51-6.

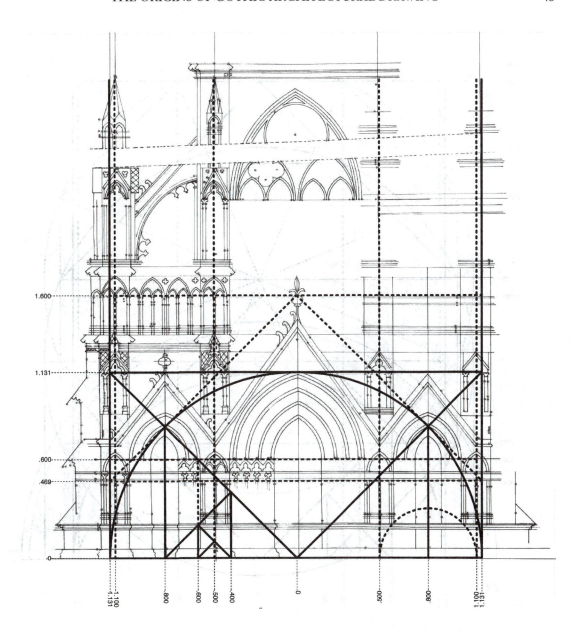

Figure 1.9 Reims Palimpsest, first façade drawing with geometrical overlay, stage 1.

The simple .500, .800, 1.100 sequence of the buttress and aisle axes involves arithmetical relationships, but the overall logic of the first Reims Palimpsest design is manifestly geometrical rather than purely modular. This may be seen, for example, in the √2 relationship between the aisle axes and the distance to the construction lines (.800 × √2 = 1.131), a dimension that also equals the height from the drawing baseline to the tops of the aisle portal gables and the capitals on the small aediculae on the buttress faces. The height up to the springlines of the small arches in the triforium, meanwhile, is 1.600, which is equal to the span between the aisle axes, as the rotated square with the dotted upper half shows. Continuing these dotted diagonals downwards until they hit the outer construction lines, one finds intersection points at height .469, the level of the

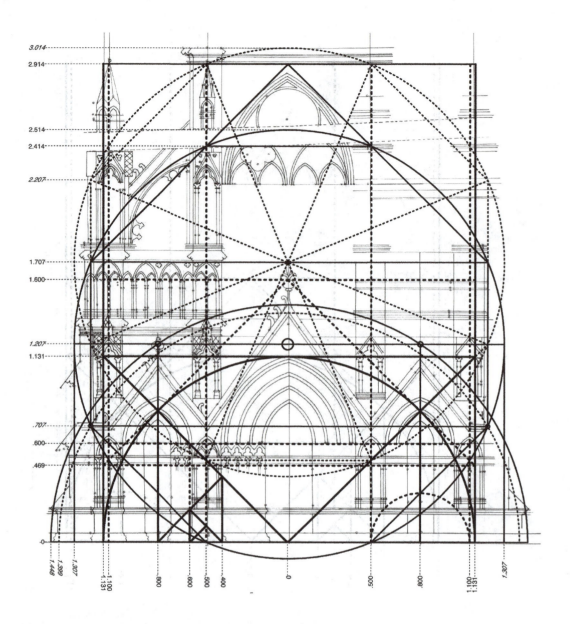

Figure 1.10 Reims Palimpsest, first façade drawing with geometrical overlay, stage 2.

capital bases in the portals and on the buttresses. This diagonal construction hints at the importance of geometries based on the rotated square.

Many of the most important dimensions in the first Palimpsest design, as it turns out, are based on the construction of octagons and their circumscribing circles, as Figure 1.10 shows. A great octagon whose lowermost facet coincides with the baseline of the nave bay reaches up to height 2.414, where the tracery of the main window is interrupted by trimming, and where, more tellingly, horizontal lines subdivide the buttresses at right. The upper and lower lateral corners of this great octagon fall, respectively, at height 1.707, aligned with the tips of the arches in the triforium, and at height .707, aligned with the baseline of the portal gables. Its equator falls at height 1.207, which is precisely

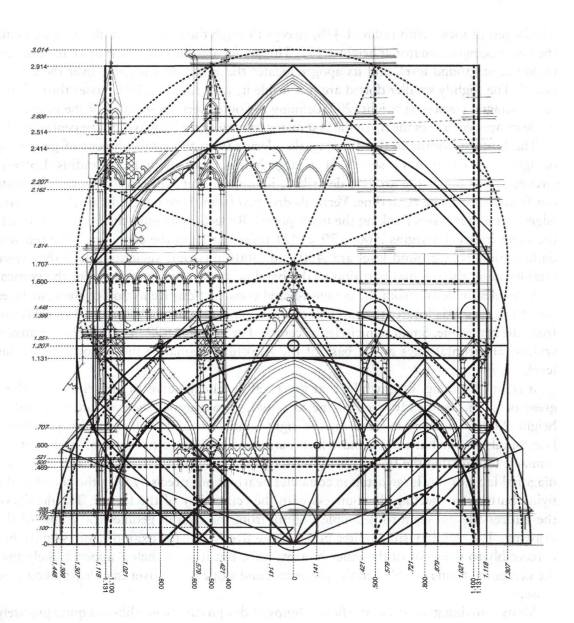

Figure 1.11 Reims Palimpsest, first façade drawing with geometrical overlay, stage 3.

the level at which a short horizontal line segment bisects the small oval at the tip of the aisle gable. If the upper diagonal sides of this octagon are extended, they will converge at height 2.914, which marks the top edge of the main nave wall, just below the final cornice moldings. And if an identical great octagon is constructed with this level as its top facet, the circle circumscribed around it will rise to height 3.014, precisely defining the top edge of the cornice. The center of this octagon falls at height 1.707, as the dotted lines in the figure show. The circles circumscribed about these two large octagons have radii of 1.301 units, so that verticals framing the circles coincide with the lateral buttress margins above level .707. The further outboard edges of the buttresses, meanwhile, can be found by constructing large semicircular arcs centered on the bottom center of the drawing.

The largest of these, with radius 1.448, sweeps through the point where the aisle axis cuts the lower octagon equator at height 1.207. This arc locates the outermost lip of the buttress moldings at ground level, and its apogee locates the vertex of the gable over the central portal. The slightly smaller dotted arc just inside it, with radius 1.399, passes through the outer octagon corners at height .707, defining the outer vertical surfaces of the buttresses, while its apogee locates the tip of the first major triangular molding within the central gable.

The buttress widths in the drawing also derive from the establishment of governing octagons, as Figure 1.11 shows. If a large half-octagon with facial radius 1.399 is circumscribed about the arc just described, its upper facet will have corners .579 units out from the drawing centerline. Verticals dropped from these points define the outboard edges of the buttresses flanking the main portal. Reflection around the buttress axis sets the inner buttress margins .500 - .79 = .421 units out from the centerline. The buttress dado moldings at ground level are .400 and .600 units out, suggesting that they were established in the original partition of the baseline shown in Figure 1.9, but the vertical surfaces clearly derive from the octagon-based construction. Reflection of these surfaces about the aisle axis locates the surfaces of the outer buttresses 1.021 and 1.118 units out from the centerline. Small semicircles at centered at height 1.399 highlight these buttress widths. Horizontal lines at the base of the triforium dramatize the importance of this level.

It is worth noting, meanwhile, that the 1.399 level can serve as the center of a third great octagon, identically sized to the first two, whose upper facet would then fall at height 2.606, which is marked on the right-hand side of the drawing by prominent horizontals on the buttresses, and which marks the springline of the small arches in the pinnacle terminating the free-standing buttress on the left of the drawing. The upper-left diagonal facet of this large octagon coincides nearly if not precisely with the chord of the flying buttress connecting this buttress with the center bay of the façade. The details of the buttress design seem to decouple slightly from the overall geometrical frame of the drawing. The clearly visible center point of the flyer's arc, for example, sits slightly but perceptibly to the right of the inner buttress axis. But it nevertheless appears likely that the octagonal frame established the placement and slope of the flyer in at least a heuristic sense.

Many remaining details of the first Palimpsest design can be established quite precisely within the geometrical framework just described. The triangular construction along the baseline, for example, sets not only the height of one set of horizontal lines at height .200, but also the width of the central doorway, whose margins lie .141 units out from the building centerline, a perfect $\sqrt{2}$ relationship to the basic .100 module in that zone. The inner margins of the aisle doors, meanwhile, fall .721 units out from the building centerline, i.e. halfway between the previously established faces of the inner and outer buttresses; .721 is halfway between .421 and 1.021, as the arc in the right-hand side of Figure 1.11 shows. The centers of curvature for all the portal arches lie on the same verticals as the door margins.

In several instances, the intersections of major verticals with raking lines in the geometrical armature establish important horizontal levels. The diagonal facets of the first great octagon, for example, cross the inner faces of the outer buttresses at height .521, establishing the top level of the capitals in the portals. Further up, at height 1.251,

the dotted rays of the second great octagon cut the outer buttress axes, establishing the baseline of the moldings under the triforium. The analogous construction above the octagon's equator locates a horizontal at height 2.162 that serves as the baseline for the capitals in the buttresses; it was perhaps intended to serve as the baseline for the mullion capitals in the main window, as well, although these are not shown in the palimpsest. Finally, the upper diagonal facets of the first great octagon cut the outer buttress axes at height 1.814, establishing the top edge of the triforium zone.

The high precision with which the first Reims Palimpsest design was executed provides strong evidence for the importance of octagon-based geometries in its composition, and further independent confirmation for this hypothesis comes from analysis of the second façade drawing in the Palimpsest, whose geometrical structure turns out to be very similar indeed. As Figure 1.12 shows, the overall governing frame of this second design is again a great octagon whose lower facet coincides with the base of the nave bay. And again, the top edge of the main composition falls at a height of 2.914 nave spans, which is found by extending the diagonal sides of the governing octagon upwards until they converge. These similarities are particularly striking because the scales of the two drawings differ significantly: the interaxial nave width in the second drawing is roughly 15.5 centimeters, instead of the 12.6 centimeters seen in the first one. This means that the creator of the second drawing had to understand and recreate the geometrical structure of the first one, rather than just mechanically copying or transferring dimensions.

The relative horizontal proportions of the second Reims Palimpsest design differ slightly from those of the first drawing, even though both are framed by the same basic octagonal armature. The aisles in the second design, for example, are slightly narrower, with centerlines that fall .765 instead of .800 units out from the centerline. This is because the aisle axes result from a simple geometrical construction that grows out of the nave space, instead of helping to define the nave space, as it had in the older design. The .765 dimension can be found by constructing an octagon framed by the nave axes, circumscribing a circle about that octagon, and then striking diagonals tangent to the circle until they meet on the level of its equator, as the solid lines in Figure 1.12 show. The outer buttress axes can then be found by reflection, at distances .765 + (.765 - .500) = 1.031 from the drawing centerline, as the dotted arc on the right of the figure shows. The vertical facets of the governing octagon, which fall 1.207 units from the centerline, coincide closely with the outer margin of the complete lateral buttress at left, especially in its upper reaches.

This simple octagon-determined geometrical structure controls the heights in the drawing as well as the widths. The three main arches in the central portal, for example, spring at height .500, and the gablets on the main buttresses spring at height 1.000. The gables depart from height .765, which is also the level where the first salient glacis molding steps out from the lateral buttress. The equator of the great octagon, at height 1.207, marks the springline of the tiny arches in the pinnacled buttress tabernacles, and the corner of the octagon at height 1.707 establishes the springline for the blind tracery on the inner buttress face. Just as in the first design, the intersections between vertical axes and raking lines help to determine important horizontals. The outer buttress axes, for example, cut the upper diagonals of the great octagon at height 1.883, which marks the top edge of another drip molding on the buttresses.

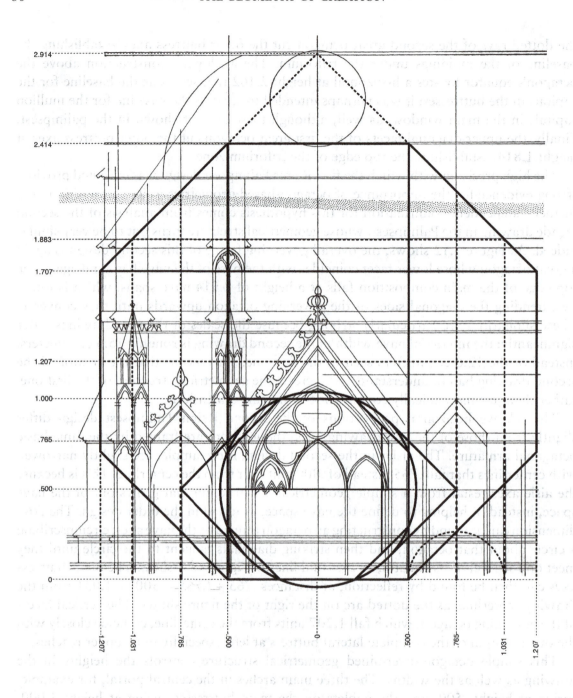

Figure 1.12 Reims Palimpsest, second façade drawing with geometrical overlay, stage 1.

In the second Reims Palimpsest scheme, as in the first, arcs as well as octagons help to set the proportions of the composition. Figure 1.13 shows a whole series of arcs concentric with the middle of the main portal, which together help to define much of the fine structure in the drawing. The innermost of these is framed by the aisle axes. It sweeps past height 1.000 at a point .579 units out from the centerline, thereby establishing the outer face of the interior buttress. The other buttress faces can then be found by reflection

about the buttress and aisle axes, so that they wind up .421, .951, and 1.110 units from the drawing centerline, respectively.

Before going on to consider the next major arcs, it is necessary to briefly explore the geometry of the portals and the moldings that flank them, since these help to set the diameters of the arcs. The boldly gabled main portal frames three subsidiary arches. Their relative widths can be found by inscribing a rotated square within the main buttress axes, and an octagon within that rotated square. The verticals separating the principal arches fall .146 units out from the building centerline, so that they frame the octagon's central facets. The outer margins of the outer arches, meanwhile, are .353 units from the centerline, aligned with the octagon's outboard facets. A cluster of vertical lines, probably meant to describe slender moldings, fills the space between this arch and the buttress face at .421. The corresponding bundle of lines on the buttress face beside the aisle portal is considerably narrower. More specifically, its width can be found by constructing a small circle centered on the buttress axis and reaching in to the central portal, so that its radius is .500 – .353. Reducing this dimension by a factor of $\sqrt{2}$, as one can do by striking a diagonal within the circle, one finds a new vertical .500 + (.500 – .353)/$\sqrt{2}$ = .604 to the right of the drawing centerline. This new vertical forms the left margin of the right-hand aisle portal. The corresponding right-hand margin of the portal is .927 units to the right of the centerline. Above level 1.000, the moldings flanking the portals terminate, and the margins of the buttresses in the upper façade rise from the middle of the molding clusters; this may be seen in the left half of Figure 1.13.

With these results in hand, the geometry of the larger arcs becomes comprehensible. The dotted arc struck through the .927 portal margin rises to height 1.427, establishing the top edge of a decorative belt across the façade. The next arc, struck through the outer buttress axes, rises up to the middle of the large finial where the main gable's sloping sides converge; halfway between this level and the top of the composition, a prominent horizontal crosses the façade at height 2.222. A slightly larger arc, shown on the right-hand side of the figure, is struck through the outer buttress margin up to height 1.634, locating the tip of the finial. As the small dot at this level on the left side of the figure indicates, this is also the height where a ray of the great governing octagon crosses the vertical axis of the outer buttress.[23] In the same vicinity, a second dot marks the point where the left margin of the inboard buttress cuts the horizontal at height 1.707, even with the octagon's corner. An arc struck through this point rises to height 1.844, the bottom edge of the molding whose upper edge was already established at height 1.883. The same arc also sweeps down to the left, locating the leftmost element of the lateral buttress 1.344 units to the left of the centerline.

This sequence of operations locates virtually all of the elements in the drawing, confirming its close geometrical kinship with the other, stylistically more conservative, façade design in the Reims Palimpsest. Geometrical analysis of these drawings thus offers valuable new evidence for the sophistication of Gothic design practice in the first half of the thirteenth century. Many of the compositional strategies seen in the Palimpsest schemes would recur in façade designs and building cross-sections throughout the Gothic era, as the following chapters will show. The geometries based on octagons and their

[23] This construction thus gives an alternative way to derive the thickness of the moldings around the doors.

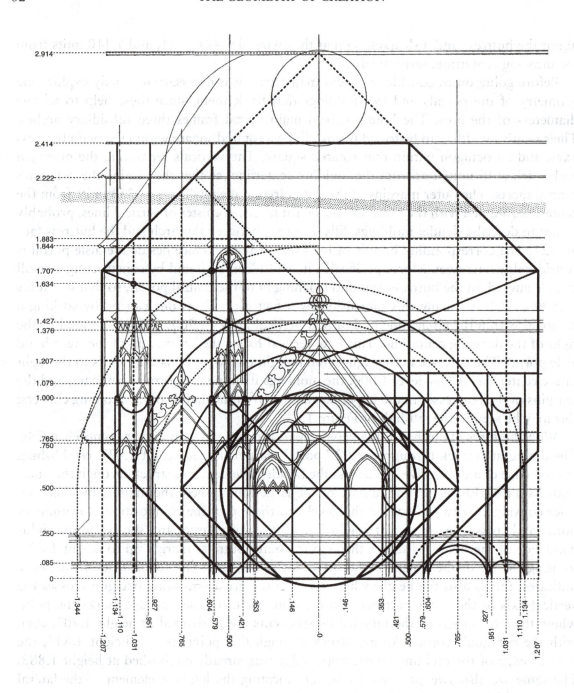

Figure 1.13 Reims Palimpsest, second façade drawing with geometrical overlay, stage 2.

circumscribing circles, here called octature, would enjoy particular prominence in mature Gothic design practice. And, as observed previously, the close geometrical relationship between the two differently scaled Palimpsest drawings clearly shows that the creator of the second design understood the logic of the first one well enough to reproduce it with modifications, even as he introduced a more up-to-date formal vocabulary. This mix of methodological continuity and formal innovation would continue to characterize Gothic workshop culture throughout its history.

The first century of the Gothic style, between roughly 1140 and 1240, left behind a magnificent architectural legacy, but only a few drawings that can shed light on the design process behind the architecture. The full-scale detail studies scratched into building surfaces starting in the 1190s are valuable records of building practice, but they reveal little about the larger-scale planning of the buildings in question. Villard de Honnecourt's portfolio provides this broad perspective more effectively, but his sketches generally lack the precision of true Gothic workshop drawings. Despite its limitations, the portfolio is an invaluable source for information about the geometrical roots of Gothic design. Villard's plan of the Laon cathedral tower, for example, appears to be a fairly faithful copy of a simple quadrature-based workshop drawing that would have guided the construction of the tower. This geometrical scheme also helped to determine the tower elevation, which demonstrates that the basic compositional strategies described by late Gothic builders such as Roriczer were already in use in the early thirteenth century. The façade drawings in the Reims Palimpsest are more geometrically precise than most of Villard's sketches, and they display the strictly orthogonal projection typical of later Gothic elevation drawings, but they cannot be related directly to specific buildings as Villard's drawings can. None of these drawings, therefore, can provide the same kind of richly detailed information about Gothic design practice that later workshop drawings can.

It is clear, despite the scarcity of surviving design drawings from the period, that a thriving tradition of Gothic architectural draftsmanship had arisen by the middle of the thirteenth century. Drawing may have seemed, at first, like little more than a helpful supplementary tool for builders grappling with the increasing complexity of church design. The rise of drawing-based design practices, though, fundamentally transformed the whole history of Gothic architecture. By the middle of the thirteenth century, the leading designers had become professional draftsmen rather than humble masons, a change noted with interest—and sometimes consternation—by contemporary observers. The Mendicant preacher Nicolas de Biard, for example, complained that the new designers received greater wages than the stoneworkers even though they did no physical work.[24] In formal terms, meanwhile, the rise of drawing encouraged designers to think about buildings as networks of lines rather than as sculptural masses. The plasticity of the High Gothic style thus increasingly gave way to the linearity of the mid-century Rayonnant style, in which the intricate geometry of compass-drawn window tracery often played a dominant role. The use of drawings also fostered the rapid transmission of architectural ideas. By the middle of the thirteenth century, therefore, advanced architectural ideas developed in the Rayonnant workshops of northern France had already begun to penetrate into the Rhineland, where visionary draftsmen soon developed building schemes of unsurpassed ambition and refinement.

[24] This frequently cited passage is reproduced, for example, in Teresa Frisch, *Gothic Art 1140–c. 1450: Sources and Documents* (Toronto, 1987), p. 55. For a detailed gloss on this passage and its social implications, see Binski, "'Working by Words alone,'" esp. 22–4.

CHAPTER TWO
The Flowering of Rayonnant Drawing in the Rhineland

In the second half of the thirteenth century, the Rhineland emerged as one of the most dynamic centers of Gothic architectural culture, thanks largely to the flowering of architectural drawing and related design practices. The cathedral workshops of Strasbourg and Cologne, in particular, became laboratories for the development of new and complicated design solutions that would have been literally unthinkable without the use of drawing. It is hardly a coincidence, therefore, that many of the oldest surviving design drawings of the Gothic era are associated with these two workshops, and with the Freiburg workshop that depended so closely upon them. The radical transformative power of drawing was even more striking in the Rhineland than in the environs of Paris, because the break with earlier traditions was much sharper.

Because the use of drawing facilitated such rapid communication between neighboring workshops, the designers in Strasbourg, Cologne, and Freiburg were able to react to each other's innovations with impressive speed. The histories of these three workshops, however, developed along strongly contrasting lines. In Strasbourg, architectural innovation tended to proceed in dramatic lurches. The east end of the cathedral, built in the twelfth century, was purely Romanesque. The transept, designed around 1200, remained substantially Romanesque in character, despite the intrusion of certain French-inspired Gothic elements, such as subtly pointed arches and traceried rosettes. The nave, begun by the mid-thirteenth-century, embodies a perfect assimilation of up-to-date French Rayonnant precedents, in a faithful transmission of architectural ideas that surely must have depended on the use of drawing. In the cathedral's west façade project, finally, the use of drawing permitted the development of fantastic schemes that left all French prototypes behind, as in the pioneering Strasbourg Plan B, which proposes to wrap the whole façade block in a skin of delicate openwork tracery (Figure 2.1). In Cologne, by contrast, the overall outlines of the complete cathedral design appear to have been established at the beginning of the project, in 1248. Cologne and Strasbourg also served as conduits for different sets of French architectural ideas, since the Strasbourg lodge drew principally on the flat, brittle Rayonnant style seen in Paris and at Saint-Nicaise in Reims, while the Cologne workshop drew on a wider range of French Rayonnant and High Gothic precedents. Competition and dialog with Strasbourg surely fostered innovation within the Cologne workshop, though, especially in the development of complex tracery-based articulation patterns. One fruit of this competitive dialog was the invention of the openwork spire type, a spectacular form in which the verticality and skeletalization stereotypically associated with Gothic design achieve their simultaneous climax. The first such spire was completed in Freiburg sometime around 1330, but the idea can be traced in the enormous Cologne Plan F and in several drawings related to the early history of the

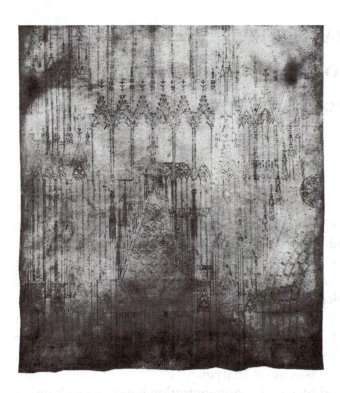

Figure 2.1
Strasbourg Plan B, lower portion.

Freiburg project (Figures 2.2 and 2.3). The designers of the Freiburg spire incorporated influences from both Strasbourg and Cologne; the overall shape of the spire emerges from the tradition of the Cologne workshop, but its articulation and detailing recall Strasbourg far more strongly. It is clear, therefore, that the rapid exchange of drawing-based design ideas contributed significantly to the progress of Rhenish architecture in the century between 1250 and 1350.

The dynamism of Rhenish architectural culture in these years fostered innovation in design practice as well as in the formal sphere. As time went by, designers increasingly came to exploit the potential of drawings to establish the appearance of complete structures, rather than just subsidiary components. It is instructive, in this connection, to compare three of the most famous early Rhenish architectural drawings: Strasbourg Plan A, Strasbourg Plan B, and Cologne Plan F (Figures 2.4a, b, c). Strasbourg Plan A, produced most probably in the 1250s as an early design study for the Strasbourg Cathedral façade, shows only the lower right-hand section of the façade, with the rose window tracery left blank (Figure 2.5).[1] This drawing, which fills a single parchment sheet measuring 86 by 62 centimeters, is roughly twice as large as the drawings in the Reims Palimpsest. It appears small and humble, however, next to Strasbourg Plan B, which stretches across four parchment pieces to reach a height of 274 centimeters even in its present truncated state. Unlike Plan A, Plan B shows the full vertical extent of the façade—or nearly so, since the façade base and spire tip were trimmed off at some point in the drawing's long history. Interestingly, however, there is a dramatic change of drawing style between the lower and upper portions of Plan B. The meticulously detailed lower section, drawn in reddish-brown ink, differs strikingly from the more cursorily

1 Plan A is preserved in Strasbourg's Musée de l'oeuvre Notre-Dame, where it holds inventory number 1. For a convenient bibliography on the drawing, see Recht, *Bâtisseurs*, 381–2.

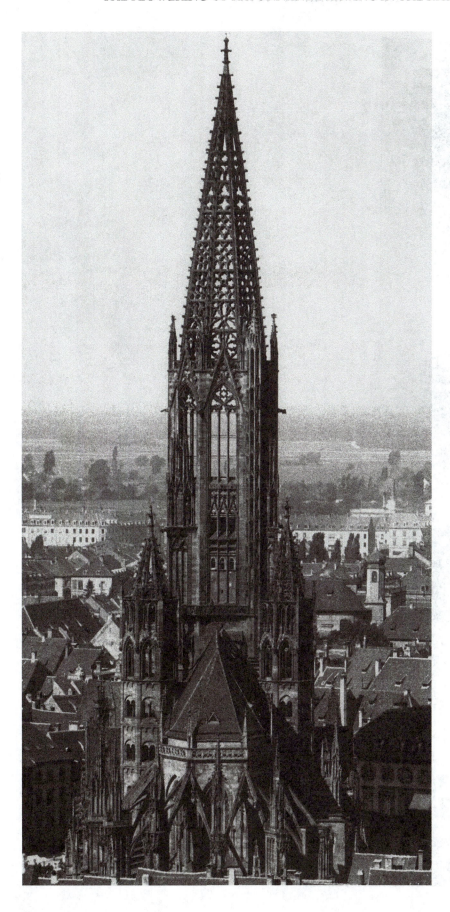

Figure 2.2
Freiburg im Breisgau,
openwork spire of
the minster.

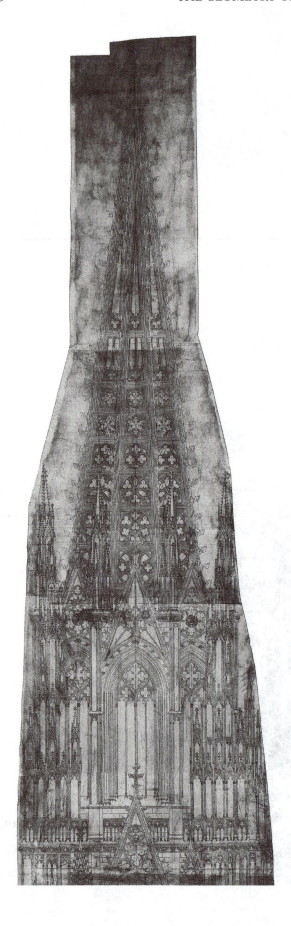

Figure 2.3
Cologne Plan F, upper portion.

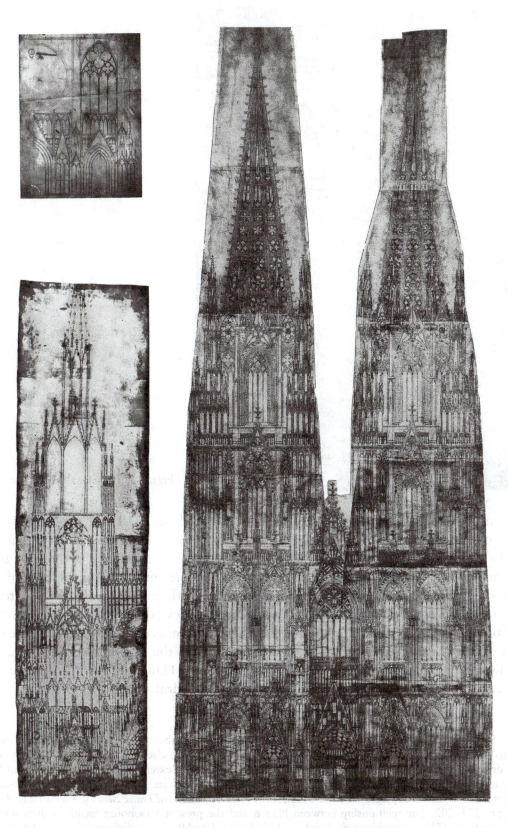

Figure 2.4 Comparison of Strasbourg Plan A, Strasbourg Plan B, and Cologne Plan F.

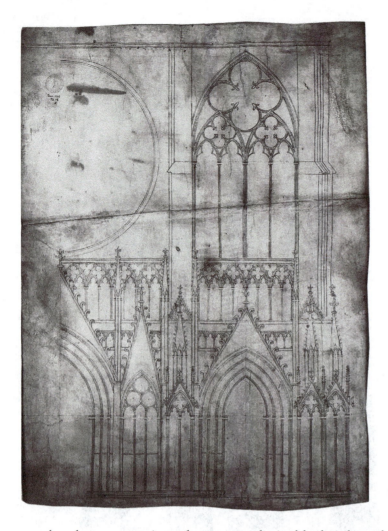

Figure 2.5 Strasbourg Plan A.

rendered upper section, drawn mostly in black ink and pencil. Thus, while the lower section of Plan B has been unanimously dated to the 1270s, based on its close kinship with the actual Strasbourg façade, which was begun in 1277, the dating of the spire zone has remained controversial.[2] Figure 2.6 contrasts the presumably original part of the drawing, at left, with the full façade scheme, at right. As the geometrical analysis later in this chapter will demonstrate, there is good reason to believe that even the spire was part of the original designer's master plan, but the clear differences of facture between the two halves of the drawing certainly attest to discontinuity in the drawing's production. No such discontinuities are evident in the masterful Cologne Plan F, an even larger drawing produced around 1300 that shows the Cologne Cathedral façade complete not only

2 Strasbourg, Musée de l'oeuvre Notre-Dame, inventory number 3. Plan B has, over the years, generated an extensive bibliography. Many of the relevant articles are cited by Recht in his catalog entry on the drawing, which appears in idem, *Bâtisseurs*, 386–8. The most extensive recent article on Plan B in particular is Reinhard Liess, "Der Riß B der Straßburger Münsterfassade: eine baugeschictliche Revision," in *Orient und Okzident in Spiegel der Kunst: Festschrift Heinrich Gerhard Franz zum 70. Geburtstag* (Graz, 1986), pp. 171–202. The relationship between Plan B and the present Strasbourg façade is discussed by Roland Recht in *L'Alsace gothique de 1300 à 1365: Etude d'architecture religieuse* (Colmar, 1974), pp. 36–54, and by Reinhard Wortmann in a series of articles culminating in "Noch einmal Straßburg-West," *Architectura*, 27 (1997): 129–72.

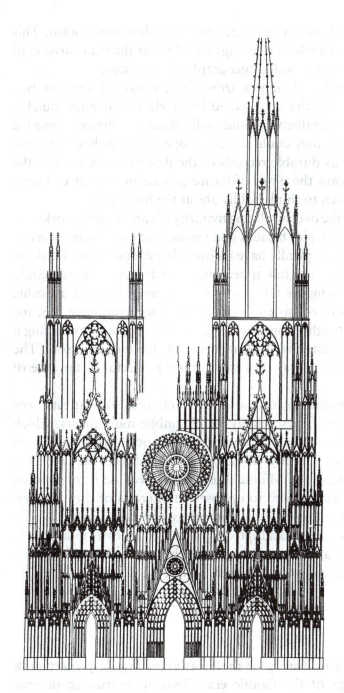

Figure 2.6 Strasbourg Plan B, redrawing to show the presumably original portions at left and the completed façade scheme at right.

from top to bottom, but also from left to right.[3] Unlike the earlier Strasbourg drawings, Cologne Plan F could convey the precise appearance of the contemplated façade even to a lay audience, which was probably one of its principal purposes. Indeed, the power of this drawing was such that it continued to excite the popular imagination even in the nineteenth century. Its rediscovery after the Napoleonic Wars permitted the completion of Cologne Cathedral, which had been left as an incomplete fragment at the end of the Middle Ages. The cathedral's twin openwork spires were the tallest structures in the

[3] The most in-depth recent study of Plan F is Marc Steinmann, *Die Westfassade des Kölner Domes: Der mittelalterliche Fassadenplan F* (Cologne, 2003).

world upon their completion in 1880, nearly six centuries after their conception. This dramatic story underscores the extent to which drawings could foster the transmission of architectural ideas across great temporal as well as geographical distances.

The use of drawings, then, liberated designers from the passage of time in two complementary ways. On the one hand, drawings could be produced far more quickly than actual buildings. This meant that draftsmen could easily develop cohesive plans for enormous structures whose completion they could scarcely hope to see in their lifetimes. On the other hand, drawings served as durable records of the designer's ideas, with the potential to constrain or at least inform the work of future generations, as at Cologne. Both factors thus encouraged draftsmen to think boldly about the long term.

Such thinking helps to explain why the overwhelming majority of early Gothic workshop drawings, and many of the later ones, depict façades and spires. Each successive story in one of these towering structures would typically have its own shape, and its own distinct pattern of articulation. This meant that the full appearance of a tower or façade could be established only by a drawing showing its full elevation. The main body of a Gothic church, by contrast, had a much more consistent modularity, since each nave bay, for example, would usually resemble its neighbor quite closely. By drawing or constructing a single bay, therefore, a designer could establish a clear precedent for his successors. The impact of drawing on long-term planning was thus much more powerful in the case of towering structures.

The relative prevalence of façade and towers in Gothic drawings also attests very clearly to the prestige and importance of these highly visible public monuments, which announced the presence of the church to the urban audience. The social meaning of such monuments could vary greatly from city to city. In Cologne, for instance, the cathedral façade remained incomplete at the end of the Middle Ages largely because it represented the power of the local archbishops, who tended to oppose the interests of the citizenry. In Strasbourg and Freiburg, though, great openwork spires were completed in the Gothic era, thanks to the support of the citizenry, who adopted the local churches as monuments of civic pride. Urban politics thus had a strong bearing on the history of Rhenish Gothic architecture, and, by extension, on the history of Rhenish architectural drawing.[4]

STRASBOURG

The drawings associated with the early history of the Strasbourg façade project rank among the most important drawings of the Gothic era.[5] Two, in particular, deserve detailed consideration. Strasbourg Plan A, the oldest of the set, already belongs to a

[4] The interaction between these three workshops in their contrasting social contexts is briefly traced in Bork, *Great Spires*, pp. 110–58; and Robert Bork, "Into Thin Air: France, Germany, and the Invention of the Openwork Spire," *Art Bulletin*, 85 (March 2003): 25–53.

[5] Much of the material in this section was previously published as Robert Bork, "Plan B and the Geometry of Façade Design at Strasbourg Cathedral, 1250–1350," *Journal of the Society of Architectural Historians*, 64 (December 2005): 442–73. The version in this chapter differs from the article principally in the fact that the graphics now incorporate numerical rather than alphabetical labels, for consistency with the rest of the book. This version also leaves out many of the speculative and bibliographical footnotes from the article, to which the interested reader should refer.

different world than Villard de Honnecourt's portfolio, or even the drawings in the Reims Palimpsest. Plan A is more carefully drawn than Villard's sketches, better preserved than the rather enigmatic Palimpsest drawings, and more closely associated with a known workshop than either. Plan A, in fact, should probably be recognized as the oldest surviving representative of what might be called the mature tradition of Gothic design drawings. In its scale, medium, and manner of presentation, it has more in common with late Gothic drawings from the fifteenth century than it does with Villard's portfolio, the Reims Palimpsest, or other earlier medieval drawings.

Strasbourg Plan B, the great successor of Plan A, has been recognized ever since its creation in the 1270s as a work of genius. The creation of this drawing, more than any other single event, marked the emergence of the Rhineland as superpower in Gothic design. By synthesizing and extending many of the most advanced design ideas developed in thirteenth-century France, the anonymous visionary who conceived Plan B established a vocabulary of forms that would go on to inspire Gothic designers for centuries to come. Most immediately, Plan B established the direction of the Strasbourg Cathedral façade project, although telling differences of proportion between the drawing and the actual façade block show that significant changes of plan were being introduced even before the start of construction. The fame of the Strasbourg façade, in turn, led many later Gothic builders to further explore design themes introduced in Plan B. In the eighteenth century, moreover, the glory of the Strasbourg façade led the young Goethe to pen "*Von Deutscher Baukunst*," the short but passionate 1773 essay that effectively launched the German Neo-Gothic movement.

Goethe attributed both Plan B and the bulk of the present façade to the thirteenth-century builder Erwin von Steinbach, whom he praised as an embodiment of German national genius.[6] Goethe recognized that changes had been introduced between the conception of Plan B and the construction of the façade, but he nevertheless managed to establish a legend of Erwin von Steinbach's promethean creativity that has proven remarkably durable, even in the face of growing challenges. In the nineteenth century, Nationalism and Romanticism fostered a quasi-cultic admiration of Erwin and his supposed handiwork, despite increasingly clear evidence that the current Strasbourg façade was a collage of distinct parts, conceived by different masters over the course of nearly two centuries. Even Plan B could not be simply and unproblematically presented as the handiwork of a single superb draftsman, but the differences of facture between its upper and lower sections could be explained away by suggesting that the later draftsman or draftsmen had simply sketched in a design already foreseen by the original "master of the red ink," who could then be identified with the visionary Master Erwin. Rationalization of this sort, together with a characteristically nineteenth-century interest in "fixing" the "mistakes" of past ages, led Gustave Klotz, Strasbourg Cathedral's supervising architect between 1838 and 1880, to produce a perfected redrawing of Plan B featuring plausible tracery infill in the areas that the medieval draftsmen had left blank (Figure 2.7). Klotz's idealized and easily legible version of Plan B immediately achieved a conspicuous place in publications on the Strasbourg façade, and it continues to be the most frequently reproduced version of Plan B even today, more than a century after its creation. Many recent introductory texts

[6] See Frankl, *The Gothic*, esp. pp. 418–26. See also *Goethe on Art*, ed. John Gage (Berkeley, 1980), pp. 103–23.

on Gothic architecture include Klotz's drawing, implicitly presenting Plan B as a unified conception. As the present geometrical analysis will show, this implication is actually justified, even if the attribution of Plan B to Master Erwin is not. The real Erwin von Steinbach appears to have taken his position at the head of the Strasbourg workshop only in 1284, too late to have launched the façade project, and he may have been a fabric administrator rather than a designer; the surviving documents are ambiguous on this point.[7] The brilliant master who conceived Plan B, however, really did have much of the visionary foresight that the heroic Master Erwin was supposed to have had.

The Strasbourg workshop emerged into a position of path-breaking architectural leadership only with the launching of the façade project, but the façade project and the related drawings make sense only when seen against the background defined by the rest of the cathedral, and by its thirteenth-century nave in particular. The construction of the Strasbourg Cathedral nave marked one of the first penetrations of the French Rayonnant style into the Rhineland (Figure 2.8). The interior elevation of the Strasbourg nave closely resembles that of Saint-Denis Abbey, which was substantially rebuilt beginning in 1231. While most scholars have assumed that work on the Strasbourg nave began only a few years later, a strong argument has recently been made for a later date, around 1250.[8] Chronological details aside, it is clear that the nave was under construction in the third quarter of the thirteenth century, setting important formal and geometrical precedents for the subsequent façade campaigns.

Although no original drawings survive to document the design process behind the Strasbourg nave, it is fairly easy to reconstruct some of the basic steps that guided the establishment of the nave proportions. The fundamental module for the designers was surely the half-span of the nave, which was dictated by the presence of the Ottonian foundations, and which can be called one unit for convenience. As Figure 2.9 shows, the height of the arcades from floor to capitals equals 1.000 of these units; the middle of the elevation falls at 2.000; the flying buttresses intersect the nave wall at 3.000; and the total height of the nave wall equals 4.000, setting the height of the nave vessel equal to twice its width.

These, interestingly, are precisely the same proportions that Michael Davis has recently identified at the slightly later church of Saint-Urbain in Troyes, begun in 1262.[9] As at Saint-Urbain, also, these simple modular relationships combine with the use of an equilateral triangle to set the overall proportions of the nave and aisles, effectively knitting together the "*ad quadratum*" and "*ad triangulum*" geometrical schemes. As Figure 2.9 shows, a line falling from the top center of the Strasbourg nave vessel with a slope of 60 degrees hits the ground at a point 2.310 out from the building centerline, establishing the location of the aisle wall. The point halfway along this sloping line, at

7 See, for example, Wortmann, "Noch einmal Straßburg-West." The scholarly debate about the authorship of the Strasbourg façade in general is usefully sketched by Paul Crossley in Paul Frankl, *Gothic Architecture*, rev. edn by Paul Crossley (New Haven, 2000), pp. 337–8, especially n. 111.

8 Yves Gallet, "La nef de la cathédrale de Strasbourg, sa date et sa place dans l'architecture gothique rayonnante," *Bulletin de la cathédrale de Strasbourg*, 25 (2002): 49–82.

9 For a discussion of the Saint-Urbain elevation and its geometry, see Davis and Neagley, "Mechanics and Meaning." The proportional and geometrical relationships between Saint-Urbain and the Strasbourg nave are particularly striking, since Saint-Urbain includes unusual formal features, such as the single set of flying buttresses with inscribed rosettes at their heads, which had been introduced earlier at Strasbourg.

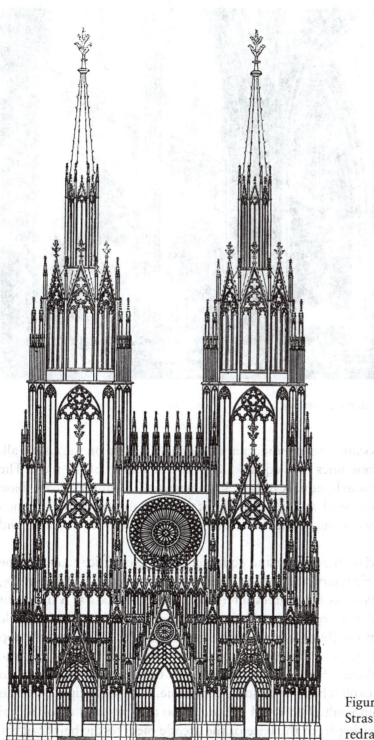

Figure 2.7
Strasbourg Plan B, elaborated
redrawing by Gustave Klotz.

height 2.000, serves as the center from which the designer struck the circular arc of the flying buttress intrados with radius 1.000. The line rising from this center, 1.155 out from the building centerline, precisely locates the shaft rising from the triforium to the flyer head, and its lower extension also coincides closely with the outer margin of the arcade pier. The line descending from the springing of the flying buttress, 2.155 out from the

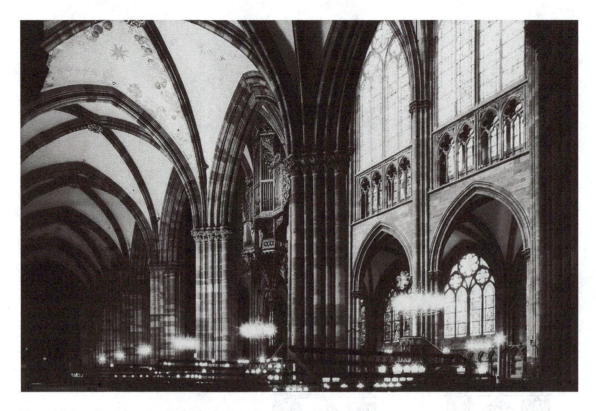

Figure 2.8 Strasbourg Cathedral, nave interior.

building centerline, similarly locates the inner margin of the shaft bundle on the aisle wall. The free aisle span between these lines thus equals 1.000, the half-span of the nave. The interaxial span of the aisles, though, equals fully 1.310, measured from the arcade base to the inner surface of the outer wall at 2.310. By the standards of most earlier French Gothic design, therefore, the Strasbourg aisles were unusually wide in both absolute and proportional terms.

Further constructions based on the square and equilateral triangle suffice to determine most of the remaining geometrical structure of the Strasbourg nave section. A line rising from the middle of the nave floor at 60 degrees intersects the arcade axis at a height of 1.732, establishing the top of the arcade zone and the base of the triforium. A circle struck down to this level from the flying buttress center at height 2.000 rises to the top of the triforium at 2.268, so that the triforium occupies a belt in the exact middle of the elevation. An analogous but slightly larger circle struck down to height 1.414, where an arc swung up from the arcade capital hits the building centerline, rises to a height of 2.586 to locate the spring of the main vault. The 1.414 measure also appears in the horizontal dimension, where a diagonal rising from the base of the arcade piers to the height of the capitals can be swung down to define the outermost surface of the aisle wall at a distance 2.414 out from the building centerline. A similar but less steeply sloped line rising from the arcade base to the point at height 1.000 on that outer wall, finally, can be swept down to locate the outboard face of the main buttress 2.732 out from the building centerline.

The design of the Strasbourg nave impacted on planning for the cathedral's façade project in two principal ways. First, of course, the physical presence of the nave structure

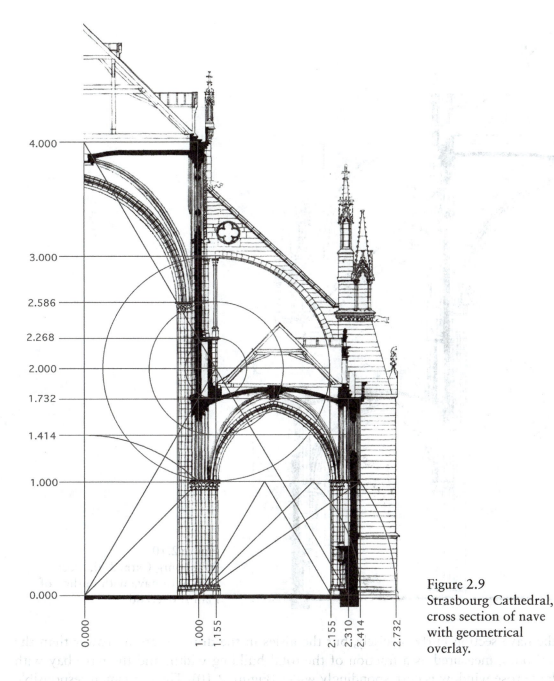

Figure 2.9
Strasbourg Cathedral,
cross section of nave
with geometrical
overlay.

provided a set of situational givens with which the façade builders had to contend. Second, the formal and geometrical ideas governing the nave went on to influence the designers of the façade. This connection appears to have been particularly strong during the first years of the façade project, between roughly 1250 and 1260, when Plan A was being produced. Even in this early phase, though, the relationship between the geometries of the nave section and the façade scheme was less than straightforward.

The relationship between the Plan A façade scheme and the Strasbourg nave design appears harmonious at first sight, but the geometries of the drawing accord imperfectly with those of the nave section. The outlines of the foreseen façade block match those

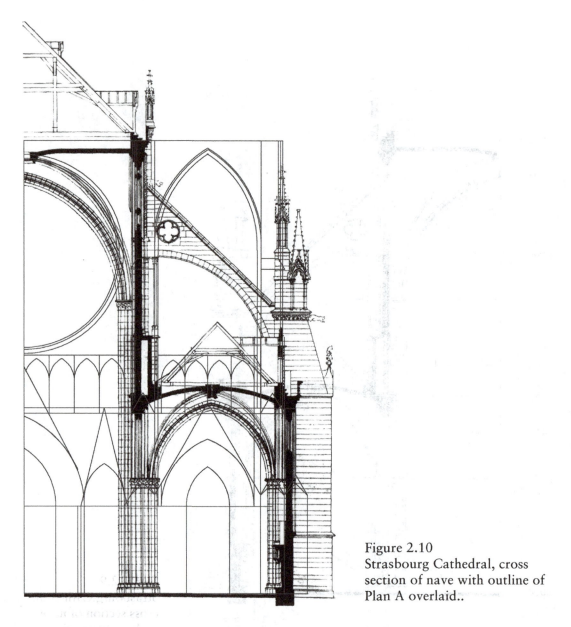

Figure 2.10
Strasbourg Cathedral, cross
section of nave with outline of
Plan A overlaid..

of the nave section fairly precisely, but the aisles in the drawing are narrower than the
actual ones, measured as a fraction of the total building width, and the nave bay with
its large rose window is correspondingly wider (Figure 2.10). The draftsman responsible
for Plan A may well have planned this proportional adjustment on purpose, so that his
design would feature an impressive rose window flanked by soaring clerestory windows,
rather than a small rose flanked by squat windows. By itself, however, this hypothesis
explains neither how he determined the precise proportions in his drawing, nor how he
felt about the resulting geometrical disjunctions between his planned façade block and the
nave: when the heights of the two are equated, as they were surely meant to be, the outer
wall of the façade stands slightly inboard of the nave buttress, the façade triforium dips
below the nave triforium, and the rose window swells slightly above the curve of the nave
vault. Geometrical analysis of the drawing reveals that the creator of Plan A developed

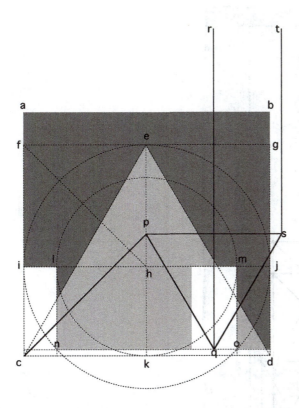

Figure 2.11
Strasbourg Plan A, basic geometrical
scheme of lower portion.

his design using the same basic forms seen in the nave section—squares and equilateral triangles. Because he began with a simple geometrical figure rather than with the actual proportions of the nave, however, he could match the articulation of the façade to the structure of the nave only approximately, as the following discussion explains.

Plan A's geometrical seed, so to speak, is an equilateral triangle sharing its baseline with a square.[10] This square, shown in isolation in Figure 2.11, corresponds to the area of Plan A between the groundline and the top of the triforium, as comparison with Figure 2.12 indicates. The square's vertical centerline divides the nave space, at left, from the aisle space, at right. This even partition of the spaces shows that the designer intended the width of the aisle to equal the half-span of the nave, at least in a certain sense. A subtle inconsistency of buttress treatment, however, disrupts this geometrical balance. Plan A shows two principal façade buttresses: an inboard one separating the nave space from the aisle; and an outboard one abutting the façade's right-hand edge like a bookend. The centerline of the inboard buttress corresponds to the centerline of the main generating square, but the centerline of the outboard buttress does not correspond to the square's right-hand margin. Instead, it sits slightly to the right, outside the square, just as a bookend's centerline must sit beyond the bounds of the book collection proper.

The sequence of letters in Figures 2.11 and 2.12 shows the likely sequence of operations in the construction of the drawing, including the establishment of the outer buttress

10 The geometrical analysis presented here substantially confirms the preliminary version published in Robert Bork, "The Geometrical Structure of Strasbourg Plan A: A Hypothetical Step-by-step Reconstruction," *AVISTA Forum*, 16/1 (Fall 2006): 14–22. In that version, though, a distortion in the source image led to a confusion between the actual façade baseline and the dado level very slightly above. That problem has been rectified here.

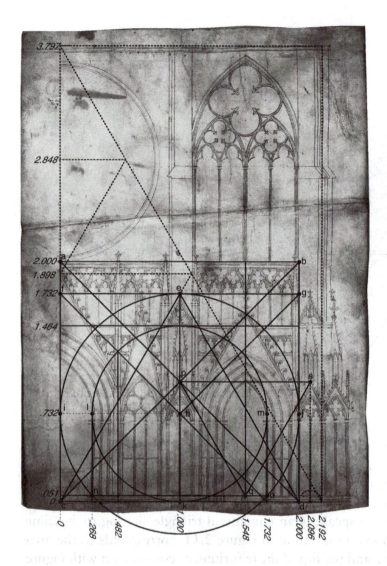

Figure 2.12
Strasbourg Plan A, with
geometrical overlay, stage 1.

centerline. Once the original square **abcd** is drawn, an equilateral triangle with the same baseline **cd** can be constructed with upper vertex **e**, which falls right at the tip of the small triangular gablet on the intermediate buttress. Horizontals through this vertex reach out to points **f** and **g** on the sides of the square, locating the level from which the small arches in the triforium spring. Diagonals struck down from these points intersect the square's vertical centerline at point **h**. If one calls the side length of the square *2 italicized units*, then e, f, and g fall at height *1.732*, and point **h** falls at height *.732*. A circle centered at point **h** and struck through the groundline thus rises to height *1.464*, locating the baseline of the triforium. This circle crosses the diagonal through point **h** at a distance *.482* units to the right of the building centerline, locating the pinnacle between the main portal and the blind tracery gablet that flanks it. This same circle is framed by verticals passing through points **l** and **m**, corresponding to the right margins of the central portal and the aisle portal, respectively. A larger circle centered at point **h** and framed by the margins of the original square passes through these verticals at points **n** and **o**. These points establish the top of the façade dado at height *.051*. In the original drawing, there is a prominent compass prick where this horizontal intersects the vertical centerline of the aisle portal.

This point, here called **q**, can be found by dropping a line with 60-degree slope down from point **p**, the center of the original square. Reflection of point **p** about the vertical through **q** then locates point **s**, establishing the vertical centerline of the outboard buttress.

The placement of this outer buttress centerline has particularly important consequences for the overall proportioning of the façade in Plan A, not only because it sets the relative width of the nave and aisle bays, but also because this, in turn, allows the construction of the overall façade height. In Plan A, the distance from the building centerline to the outer buttress axis is *2.096* times the distance to the inner buttress axis. In the nave structure, by contrast, the open air space in the aisle extends to fully *2.155* times the half-span of the nave, as measured to the arcade pier centerline, with the wall and buttress structure extending even further out. So, while the aisle bay in Plan A is slightly wider than the half-span of the nave, it is not nearly wide enough to bring the relative widths in the drawing into conformity with those in the actual church, with its unusually wide aisles.

Given this significant mismatch between the relative vessel widths in Plan A and the actual nave structure, it might at first appear surprising that the two can be made to overlap as well as they do in Figure 2.10. This approximate correspondence, though, reflects the fact that the *"ad triangulum"* geometrical scheme governed the height–width relationships in both cases. As Figure 2.9 showed, a long line of 60-degree slope rises from the base of the outer aisle wall to the point just above the nave keystones. A very similar relationship obtains in Plan A, as the dotted lines in Figure 2.12 show. Since the left margin and centerline of the outer buttress have already been established at distances *2.000* and *2.096* from the building centerline, the right margin of the buttress can easily be found at distance 2 + 2 (.096) = *2.192* from the building centerline. A line of 60-degree slope rising from the bottom of this buttress margin intersects the building centerline right at the top of the depicted façade, at a height of *3.797*. The tip of the main portal gable and the center of the rose window fall halfway and three-quarters of the way up the façade, respectively, at the heights here called *1.898* and *2.848*. These relationships closely recall those seen in the nave section, where the center of curvature and wall abutment point for the flying buttress fell halfway and three-quarters of the way up to the top of the gutteral wall. This correspondence strongly suggests that the intended scale relationship between the façade and the nave was set by the matching heights of the *"ad triangulum"* construction, rather than by the incompatible relative widths of the nave and aisle bays.

In light of this scaling relationship, it makes sense to describe Plan A with a second set of units equivalent to those already used to describe the nave section in Figure 2.9, so that the geometrical correspondences between the two parts of the building come through explicitly. In Figure 2.13, therefore, these new unit labels appear on the far left and bottom margins of the figure, while the units based on the dimensions of the generating square continue to be shown in italics. In these new units, for example, the base of the great triangle falls 2.310 out from the building centerline, just as in the nave, and the gable tip and rose center fall at heights 2.000 and 3.000. The width of the outer buttress is 2.310 - 2.107 = .203, and the width of the central buttress is the same; its right margin falls halfway up the sloping side of the great triangle, 1.155 to the right of the building centerline, and its left margin falls .952 from the centerline.

The fine lines in Figure 2.13 show how the details of Plan A can be generated naturally within the basic framework already described. The fine verticals .891 and 1.216 to the right

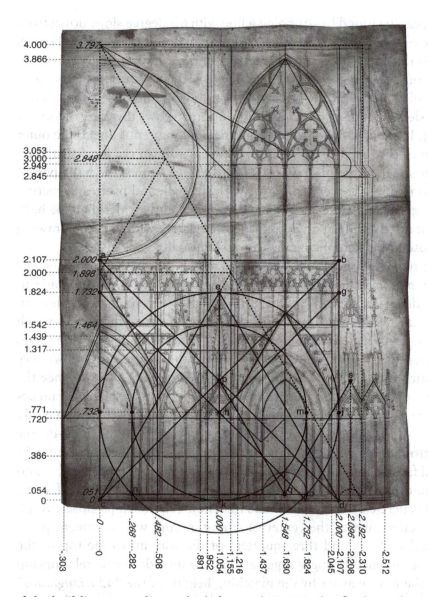

Figure 2.13
Strasbourg Plan A, with
geometrical overlay,
stage 2.

of the building centerline, which frame the pinnacles flanking the central buttress, descend from the points where the baseline of the triforium intersects the sides of the original triangle **cde**. Since a pinnacle of the same width sits just inboard of the outer buttress, the aisle portal fills the space between 1.216 and 2.045 to the right of the building centerline. The centers of curvature of the portal archivolts are found one-quarter of the way across this interval, as the triangular construction in the left half of the aisle bay shows. These points of curvature thus sit just slightly offset from the margins of the door, which are 1.437 and 1.824 from the building centerline. The springline for the archivolts falls at height .720, which is halfway up to the height 1.439 where the diagonal **ap** of the original generating square cuts the circle rising to the triforium base. The center of curvature of the main portal archivolts, which lies .303 to the left of the centerline, appears to have been established by dropping a diagonal down to level .720 from the point where the triforium baseline is cut by the pinnacle flanking the doorway. The outermost archivolt frame was struck with an arc rising up to the triforium baseline, and the inner and outer regular

archivolts appear to have been struck through the previously established left and right margins of the portal embrasures, .282 and .508 to the right of the building centerline.[11] The gable of the aisle portal framing these archivolts has sides with 60-degree slope, expressing the *"ad triangulum"* geometry of the façade, and they converge at the point where the aisle axis crosses the original generating circle with diameter ij.[12]

The geometrical structure of the upper façade zone is even simpler. A diagonal descending from the upper-left corner of the façade hits the right margin of the central buttress at height 2.845, establishing the baseline of a prominent drip molding on the buttresses. A line of 30-degree slope descending from the same point intersects the aisle centerline at height 3.053, locating the baseline of the equilateral triangle defining the traceried head of the upper window in the aisle bay. The top of the molding is halfway between these levels, at height 2.949. Since the rose window is tangent to the 30-degree line descending from the upper-left corner, its radius is .866, which is the long leg of a 30-60-90 right triangle with hypotenuse length 1.000. Like the lower portion of the drawing, therefore, the upper portion has geometrical structure built up of squares and equilateral triangles.

The arrangement of the Plan A façade thus has a complex and contradictory relationship with the nave section. As noted previously, both designs can be subdivided into four equal horizontal strips: the tip of the main portal gable in Plan A falls exactly halfway up the façade, just as the middle of the triforium does in the nave, and the center of the rose window in Plan A falls three-quarters of the way up the façade, just as lower margin of the flyer head sits three-quarters of the way up the nave wall. And, both designs incorporate the same basic *"ad triangulum"* geometry relating the height of the structure to its overall width, so that the two can be overlapped in the superficially satisfactory way shown in Figure 2.10. This alignment of the large-scale outlines in the two designs does not guarantee that all their details will line up, however, because their geometrical substructures relate differently to the wholes. Thus, while the creator of Plan A used the same basic geometrical ingredients seen in the nave design, he could not escape the fundamental mismatch between his symmetrical generating figure and the wide-aisled proportions of the nave.

The awkward fit between the elements of Plan A and the nave structure raises obvious questions about the draftsman's design method. Why, for example, did he choose to make the span of his aisles so close to the half-span of his nave, even though the proportional width of the aisles in the actual cathedral was much wider? Was it simply convenient, from his perspective, to subdivide his generating square into equal halves? If so, why did he make the outboard buttress stand completely outside this generating square, compromising the clarity of his geometry? And why, if he was so willing to deviate from the givens of the nave structure in the horizontal dimension, did he insist on using the

[11] The right jamb of the central portal leans slightly to the right as it rises, perhaps because there appears to have been some confusion about whether the vertical .508 units out from the centerline was supposed to locate the axis of the pinnacle (as it does at the top), or the right margin of the pinnacle (as it does at the bottom).

[12] The left margin of the gable is actually just under 60 degrees in slope, because the centerline of the gable has been pulled slightly to the right by stretching of the parchment, but the intent seems clear. Alternative constructions of the gable height may have been used, rather than the circle intersection method described here, since there are multiple lines in the gable margins.

"*ad triangulum*" recipe to match the overall proportions of his drawing to those of the nave? Was Plan A really intended as a serious proposal for the Strasbourg façade, or was it simply an ideal design study, as Reinhard Wortmann has proposed?[13]

Definitive answers to these questions are effectively unattainable centuries after the fact, at least in the absence of more extensive documentation, but the absolutely precise equivalence between some of the larger geometrical structures in Plan A and the nave structure strongly implies that the drawing was indeed meant for the Strasbourg façade. In this context, the divergences of proportion between Plan A and the nave reveal three interesting facts about the Gothic design method: first, that the internal geometrical harmony of a drawing might matter more than its precise conformity with existing structures; second, that such disjunctions tended to arise when designers used different geometrical "seeds" to develop their schemes; and third, that the choice of geometrical seeds could be influenced by aesthetic judgments. In the case of Plan A specifically, the draftsman's decision to begin with a symmetrical figure equating the width of the aisles to the half-span of the nave may well reflect his desire to create a façade with a large rose window flanked by slender clerestory windows, rather than a small rose flanked by squat windows, as proposed above.

Plan A, whatever the precise circumstances of its creation, certainly deserves to be understood as the direct precursor of the later drawings that actually did guide the conception and construction of the Strasbourg façade block. The retention of many elements of Plan A in later Strasbourg façade schemes demonstrates that Plan A was recognized from a very early date as part of a coherent series of drawings dealing with the same basic architectural problem. The small portal-flanking gables that Plan A had inherited from the transept frontals of Notre-Dame in Paris, for example, recur both in Plan B and in the cathedral's present façade. Some of the triangle-based geometrical structure of Plan A, moreover, was retained in the current façade structure, as explained in detail below, despite the introduction of many other formal and geometrical innovations in the meantime. The existence of an elaborated copy of Plan A, now known as Plan A1, further demonstrates the enduring relevance of Plan A for the Strasbourg façade workshop.[14]

Since Plan A played such an important role in the history of the Strasbourg façade project, it is striking that it embodies a purely planar approach to façade design that was decisively rejected in the subsequent Plan B. Nothing about Plan A involves the third dimension in any significant respect. Plan A admittedly implies a certain layering structure, in which the portal gables stand in front of the triforium, for example, but the thickness of these layers could diminish to zero without compromising the logic of the design. This kind of radical flattening, in fact, is precisely what one sees in the Notre-Dame transept frontals. Plan A makes no reference to the groundplan of the foreseen façade block, or to the depth of the towers that might be built above the aisle bays. It is unclear, therefore, whether the Plan A master meant his façade to be one bay deep, as most tower-carrying west blocks are, or whether he meant to propose a flattened screen front, like that of Amiens Cathedral.

13 Wortmann, "Noch einmal Straßburg-West," 138.

14 Strasbourg, Musée de l'oeuvre Notre-Dame, inventory number 2. See Recht, *Bâtisseurs*, pp. 384–5.

The articulation of Plan A reflects its planar geometry in an interesting way. Virtually every element of the design emerges naturally from a simple process of geometrical development based on the unfolding of forms from the square and triangular "seeds" described previously. The key point here is not simply that the articulation of the façade results from the geometrical structure, but that it actually expresses it. The small triangular medallion on the front of the façade's inboard buttress, for example, sits just within the tip of the main generating triangle, whose 60-degree slope it shares. The small gablets lower down on the buttresses, similarly, subtly outline the form of the inverted triangle used to define the eccentricity of the outboard buttress. On a larger scale, the 60-degree slope of the aisle gable provides another reminder of the façade's "*ad triangulum*" geometrical structure. Whether deliberately or not, the draftsman responsible for Plan A left many formal clues to the geometrical structure of his design, clues that his fellow designers could surely interpret more readily than modern scholars can. Even a fairly cursory examination of the drawing, therefore, would probably reveal to a Gothic designer that Plan A arose from a simple geometrical process based on the interaction of squares and triangles in a single plane.

Strasbourg Plan B, the drawing that established the Strasbourg lodge as one of the most progressive in Europe, has attracted far more scholarly attention than Plan A (Figure 2.14). Its creation clearly set the stage for the construction of the Strasbourg Cathedral façade starting in 1277, and its unprecedented complexity surely reflects the favorable local patronage circumstances of the late thirteenth century, an era that saw the adoption of the cathedral façade as a *de facto* civic monument. Despite Plan B's reputation as one of the most spectacular and influential drawings of the Middle Ages, however, its precise place in the history of Gothic design has remained controversial, for two principal reasons: first, because the dramatic differences of facture between its upper and lower halves call the unity of its conception into question; and second, because its proportions differ subtly but significantly from those of the present façade block, even in its lowest stories.

The question of Plan B's unity, of course, has implications for the dating of its controversial spire zone. Many scholars from the Romantic era onwards have embraced the appealing idea that a single brilliant master conceived the entire Plan B façade scheme. Jean Bony, for example, dated the whole drawing to the 1270s, noting the close formal kinship between the Plan B spire and the Montjoies, pinnacle-shaped roadside markers that were then being erected along the path of Louis IX's funeral cortege.[15] Other scholars, however, reject this dating. Roland Recht, for example, argued that the Plan B spire section could have been added only in the fourteenth century, after the introduction of proto-perspectival optical projection techniques.[16] As Recht notes, the geometry of the spire zone is quite precise, despite its cursory detailing. The central facets of the spire stories are exactly 1.414 times as big as the flanking facets, just as they should

[15] Jean Bony, *The English Decorated Style: Gothic Style Transformed, 1250–1350* (Ithaca, 1979), pp. 20–21. Liess, in "Der Riß B der Strassburger Münsterfassade," argues for a unitary conception of the drawing, which he attributes to Erwin von Steinbach. This attribution has been widely challenged; see, for example, Wortmann, "Noch einmal Straßburg West."

[16] For the fourteenth-century date, see Recht, *Le dessin d'architecture*, pp. 62–3. Recht explicitly criticizes Liess's interpretation of the spire design as a product of the original designer in Recht, *Bâtisseurs*, 388.

Figure 2.14
Strasbourg
Plan B.

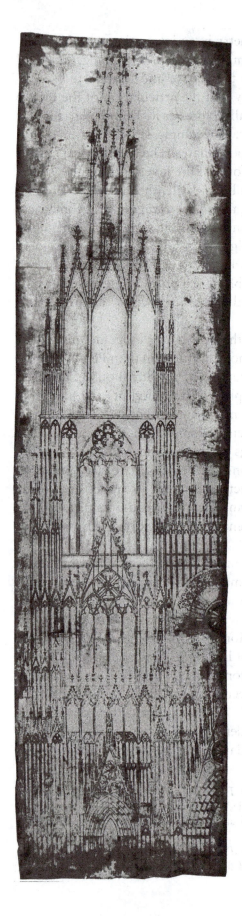

be in a front view of an octagonally symmetrical structure. The window heads in these flanking faces also appear convincingly foreshortened, providing further evidence, in Recht's view, for a late dating. As the following paragraphs will show, however, these seemingly precocious features actually result automatically from the geometrical structure of the whole drawing, which was based on the octagonal plan of the tower bases. Unlike the strictly planar Plan A, therefore, Plan B incorporates relationships between groundplan and elevation similar to those seen already in the Laon towers, and in the later pinnacle designs described by Roriczer.

Geometrical analysis helps to explain not only the relationship between the upper and lower portions of Plan B, but also the proportional mismatches between the drawing and the cathedral's actual masonry structure. The proportions of Plan B, unlike those of Plan A, depart dramatically from those of the nave, as Figure 2.15 shows. If the inner buttress axes of Plan B are aligned with the axes of the nave walls, as the axes of the present façade block are, the rose window jumps so far up that even its bottom margin reaches nearly the height of the nave keystones. From the interior, therefore, the rose would have been all but invisible. This, naturally, was one feature of Plan B that was modified in the construction of the actual façade block. Even the lowest levels of the present façade, though, differ subtly in their proportions from Plan B, for reasons that are far less obvious. The relative width between aisle axes in the built structure, for example, is slightly smaller than it is in the drawing. Geometrical analysis of Strasbourg Cathedral and the associated façade drawings reveals that all their proportions, and even the subsequent adjustments to them, arose naturally in the compass-based design process.

The best place to begin such an analysis of Plan B is at the top of the boxy tower story, where the red ink of the original master gives way to the later black ink and pencil. As Figure 2.6 indicated, the square-topped tower story belongs

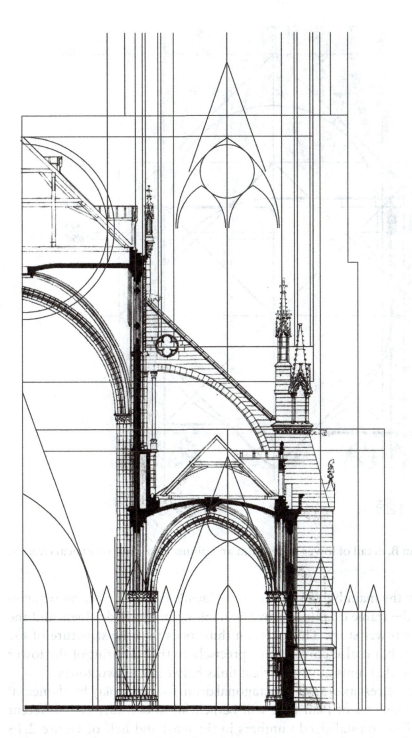

Figure 2.15
Strasbourg Cathedral,
cross section of nave
with outline of Plan B
overlaid.

to the original section of the drawing, as do the slender pinnacle doublets growing from its corners. The slender spire and the two faceted drums beneath it, which are the only elements in the drawing to express an apparent octagonal symmetry in plan, belong to the presumably later black section. Closer inspection reveals, though, that an octagon-based geometry governed the proportions even of the original section drawn by the "master of the red ink." One important clue revealing this geometry is a prominent compass prick point in the middle of the lower drum story. As Figure 2.16 shows, a circle with

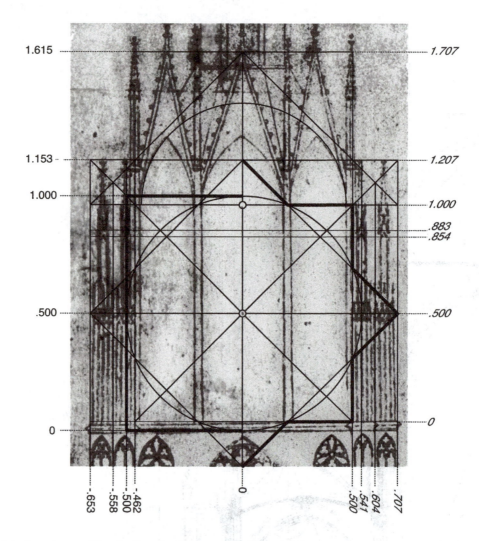

Figure 2.16 Strasbourg Plan B, detail of lower spire drum and pinnacles with geometrical overlay.

this center and framed by the main buttress axes of the façade circumscribes an octagon that fits precisely within the frame established by the flanking pinnacle doublets and the upper surface of the boxy tower story. This octagon thus locks into the structure of the drawing's original portion, but it also corresponds precisely to the footprint of the lower tower drum, a relationship that hints at geometrical links between the two zones.

Here, because both the buttress axes and the octagonal drum footprint play fundamental roles in establishing the geometry of Plan B, it will be helpful to consider two different sets of measuring units. The non-italicized numbers in the left-hand half of Figure 2.16 are measured in a unit equal to the diameter of the circle framed by the buttress axes. The left buttress axis, therefore, is shown .500 of these units to the left of the tower centerline, and the top and bottom edges of the circle are shown at heights 0 and 1.000 respectively. The italicized numbers in the right-hand half of the figure are measured in units equal to the face-to-face diameter of the inscribed octagon, which are therefore smaller than the left-hand units by an octature-defined factor of cos22.5° or .924. In this italicized system, it is the inboard face of the tower buttress rather than its axis that stands *.500 units* offset

from the tower centerline. And, in this system, it is the top edge rather than the bottom edge of the molding terminating the boxy, square-topped story that falls *.500 units* below the compass prick point. The top of the inscribed octagon, at height *1.000* italicized *units*, defines the level where the pinnacles start to taper.

The fundamental importance of the octagon inscribed between the pinnacles becomes even more obvious when its sides are extended to form an 8-pointed star, whose outlines are shown with heavy lines in the right-hand portion of Figure 2.16. The top point of this star, at height *1.207 units*, marks the level at which the pinnacle doublets terminate. And the rightmost point on the star, *.707 units* to the right of the tower centerline, aligns with the right-hand margin of the boxy tower story at the base of the figure. These octagon-based relationships deserve particular note because they involve elements in the original red-inked portion of the drawing. Further evidence for the original draftsman's use of this octature scheme may be found in the subtle but unmistakable inward bias of the tracery patterns in the buttresses. This can be seen in the lower-right corner of the figure, where the "centerline" of the tracery falls just *.541 units* to the right of the tower centerline, which is less than halfway from the left margin at *.500* to the right margin at *.604*. This "centerline" clearly was not located by equal subdivision of the buttress faces; instead, it was located by octature, since it rises to frame the circle circumscribed about the original generating octagon.

Precisely the same octagon-based geometry seen in the pinnacle zone of Plan B recurs in the lower stories of Plan B, as Figure 2.17 shows. In this illustration, the units are set just as in the left-hand side of Figure 2.16, so that one unit equals the span between the buttress axes of the tower bay. Here, though, the heights are shown beginning at the likely location of the original groundline. Because the bottom of the drawing is cut off, however, it makes sense to trace these geometrical relationships by moving downward from the pinnacle zone. The boxy tower story is a perfect square filling the space between heights 3.221 and 4.527. The bottom of the square corresponds with the top rung of the strip-like balustrade running between levels 3.121 and 3.221. A rotated square inscribed within this square, together with verticals descending from the story above, defines an octagon just like the one seen previously. Horizontal lines drawn across from the key points on this octagon locate all the formal punctuation points in the slender pinnacles over the rose window and in the tower buttresses. So, for example, the bottom facet of the octagon locates the springers of the small lancets over the rose, the corner of the octagon at height 3.683 marks the tip of a set of small sub-pinnacles, the octagon center at height 3.874 establishes the top of another set of sub-pinnacles, and the main pinnacles terminate at height 4.201, halfway up the octagon's upper diagonal facets. These pinnacles, significantly, were drawn in black ink, which shows that the later draftsman recognized and actively used the geometrical figures developed by the master of the red ink. This is not surprising, since the grid of uninked horizontal and vertical construction lines still visible on the drawing today was probably created by the original master, establishing an armature on which the later draftsman could hang his forms. The later additions may not reflect the original designer's intentions in every respect, but his geometries clearly informed those who followed in his footsteps.

Moving on down the façade, one finds that the same octagonal module repeats over and over, but with variations in its deployment. The most significant of these variations,

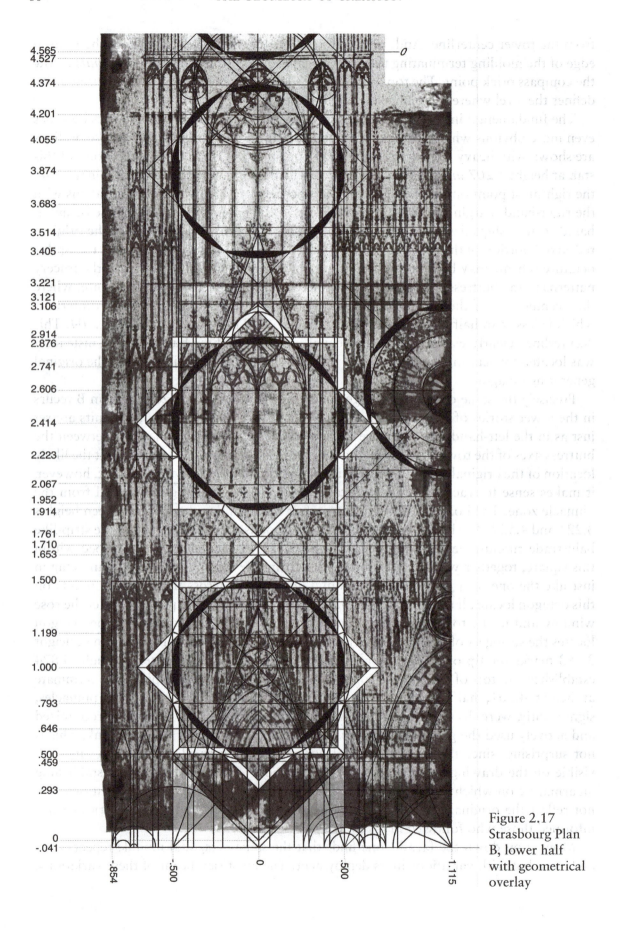

Figure 2.17
Strasbourg Plan
B, lower half
with geometrical
overlay

perhaps, is the displacement of the octagonal module over to the center of the façade, where it defines the geometry of the rose window. The circle of tracery in the rose window proper exactly inscribes an octagon scaled like the ones discussed previously, while the outer frame of the rose window corresponds to the circle circumscribed about the octagon. This is a striking result, because it shows that an octagonal geometry most directly relevant for spire design was deliberately encoded into the rose, the visual focal point of the whole façade.

The echoing of the tower geometry in the rose zone, significantly, established a conceptual and formal equivalence between the nave and the aisles. To see this, it is helpful to refer back to Figure 2.6, which shows the complete two-tower façade proposed in Plan B, but with the left spire eliminated. Reading from left to right, one sees: pinnacle doublet, spire space, pinnacle doublet, nave space, pinnacle doublet, spire, pinnacle doublet. A glance at this graphic makes clear that the width of the "spire space" between the pinnacle doublets at least roughly matches the width of the central "nave space" between the boxy tower stories. This relationship, in fact, is quite precise. The "spire space" equals not only the open "nave space," but also the diameter of the rose window below. In a broad sense, therefore, it makes sense to read the Plan B façade as three equally wide vertical panels, separated by the narrow strips of the buttress doublets and their pinnacles. This conceptual equivalence of the nave and aisle spaces marks a dramatic departure from Plan A, in which the nave space had been roughly twice as wide as the aisles. Even in the Strasbourg nave, where the aisles were unusually wide, the aisle width did not approach the nave width.

Plan B manages to combine the conceptual equivalence of the nave and aisle spaces with its seeming opposite, the greater interaxial width of the nave, because the main buttress axes are asymmetrically positioned within the strips dividing the three main vertical panels. This relationship can be seen most clearly at height 2.414 in Figure 2.17, where the buttress axis is tangent to the black circle circumscribing the octagon in the aisle bay, but slightly displaced to the left of the equivalent octagon in the rose. The star extrapolated from the octagon in the aisle bay, meanwhile, exactly touches the corner of the octagon in the rose zone. These geometrical relationships together mean that the aisle bay is .813 as wide as the nave, when both are measured between the buttress axes. Equivalently, one can observe along the bottom of the figure that the distance between the aisle center and the building centerline is 1.115 units, where one unit equals the width of the aisle bay.

The placement of the rose window signals the way in which the principal buttress axes take on greater importance in the lower reaches of the façade. As Figure 2.17 shows, the center of the rose window falls at height 2.606, at a point 45 degrees down from the point where the buttress axis intersects the bottom of the free tower story at level 3.221. Geometrically, at least, the rose thus occupies the center of a square frame with side length equal to the interaxial width of the nave.[17] The spiky articulation of the triforium beneath the rose tends to obscure this square geometry in Plan B, but the tips of the triforium

[17] Wortmann rightly points out that the idea of a perfectly square rose frame occurs in Plan B and in Plan A's uninked construction lines, as well as in the current Strasbourg façade and in the transept façades of Notre-Dame in Paris. See "Noch einmal Straßburg West," 142.

gablets actually do terminate right at the bottom of this framing square. The notion of the framing square would eventually find clearer expression in the present Strasbourg façade.

In the clerestory zone to the left of the rose window, the familiar octagon-based geometry recurs, but with several twists. In this instance, the center of the composition falls at level 2.414, aligned with the lower-left corner of the octagon around the rose window. As usual, both the octagon itself and its circumscribing circle help to define the horizontal articulation points in the façade. Thus, for example, the center of the clerestory's crowning rosette falls at level 2.914, the top of the circle, while the tips of the small triforium gablets fall at level 1.952, the bottom of the octagon. Interestingly, this is just a bit lower than the height of the gablet tips beneath the rose. Throughout the original portions of Plan B, in fact, the articulation points in the nave zone fall slightly above their analogs in the aisle, as if to signal the more ample proportions of the nave. The slender pinnacles that emerge between the triforium gablets thus terminate just above level 2.067 in the aisle, but at level 2.223 in the nave.

The most important new twist in the treatment of the lower façade geometry is the introduction of a new star octagon figure based on the span between the aisle axes. In Figure 2.17, a narrow star-shaped strip of white marks the space between this new star octagon and its slightly smaller cousin, the generating octagon framed by the pinnacle doublets above. Such a star, of course, could have been drawn around any of the upper façade octagons, as well, but it is only in the lower portions of Plan B that this scheme appears to have guided the façade's articulation.

The importance of the new double-star system becomes especially obvious in the very lowest section of the façade. There, a second large star octagon sits centered on the tracery rosette in the portal gable, at height 1.000. At level 1.710 its upper tip exactly touches the lower tip of the large star just described above, and its upper horizontal margin defines the base of the triforium at level 1.500. Its lower interior corners, at level .793, locate the tips of the gables that articulate the front faces of the principal façade buttresses. Its lower horizontal margin, at level .500, locates the corresponding gable bases. The new large star thus governs the geometry of many of the most prominent components of the lower façade. As in the upper portions of the drawing, though, the circular derivatives of the octagon form also contribute to shaping the façade articulation. Thus, while the archivolts of the main nave portal begin their curving arcs at level .500, the archivolts of the aisle portal start to curve a bit lower, at level .459, which is defined by the lowest point on the circle touching the interior corners of the large octagon. This circle relates to the outer envelope of the white star, just as the black-shaded circle related to its inner envelope. The growing significance of the large octagon and its derivatives in the lower façade thus expresses the fact that the composition of the lower façade involves principally the distance between the main buttress axes. In the upper façade, though, it was the space between the pinnacle doublets that had figured most prominently. This subtle geometrical shift shows that the master of the red ink actively tailored his articulation to reflect the geometrical logic of each façade zone.

The clear logic of the lower façade geometry makes it possible to reconstruct the missing bottom margin of Plan B. In its present truncated form, the drawing lacks the dado zone seen in the actual façade. Since the articulation of the lower façade closely matches that in the drawing, this by itself gives some clue as to the height of the missing section. A more

precise determination of the originally intended dado height emerges from analysis of the portal geometry in the drawing. Two distinct levels deserve mention in this context. The first, here called level 0, falls exactly one unit below the rosette center in the portal gable. As subsequent discussion will show, the equivalent level in the actual façade corresponds to the floor level of the cathedral's interior. The ground level outside, which is slightly lower, corresponds to the level shown at height -.041 in Figure 2.17. This is the level where the sloping sides of the aisle portal and the nave portal converge precisely on the buttress axis. It can be found by dropping diagonals down from the springline of the aisle archivolts, as the white triangles in the lower portion of the figure indicate. Folding out the half-diagonal of one of these triangles, finally, gives the salient length of the northern façade buttress, as the construction in the lower-left corner of the figure shows.

The preceding paragraphs, in clarifying the geometrical methods used by the master of the red ink in his original sections of Plan B, establish a baseline or norm against which to compare the geometrical structure of the drawing's controversial spire zone. The following discussion will demonstrate that the geometry of the spire zone relates closely to that of the lower façade, suggesting that the same workshop traditions informed the conception of the whole drawing. It will also reinforce the obvious point that the octagonal geometries governing all of Plan B arise most naturally in the spire, where the plan geometry of the structure in question was actually supposed to be octagonal. Together, these observations will suggest that the geometry of Plan B as a whole originally grew out of a concept for the spire design, even if this was the part left incomplete by the master of the red ink.

Here, once again, it makes sense to begin the geometrical analysis at the level where the boxy tower story terminates, this time working upwards to the spire tip. As Figures 2.16 and 2.18 show, the same octagon that governed the articulation of the pinnacle doublets drawn by the master of the red ink also governs the layout of the lower spire drum. Because this octagon has the shape and size of the spire drum's groundplan, verticals rising from its inner corners define the corner flanges of the drum. This geometrical construction, which governs the relative proportions of the drum facets when seen from the front, involves nothing more complex than the octagonal form that had already been encoded in the original portions of the drawing. The accuracy of these proportions, therefore, does not automatically push the dating of the spire zone into the fourteenth century, as Recht had argued.[18] Even the seemingly convincing foreshortening of the window heads in the side facets of the drum turns out to be surprisingly simple, since a single semicircular arc defines the extrados of these arches. The compass prick point used to strike this arc is still clearly visible on the drawing at the top of the octagon, as the close-up in Figure 2.16 shows. The draftsmen responsible for inking in the spire zone were using the same geometrical tools as the thirteenth-century master of the red ink, and they may have even been using construction lines that he himself had scribed into the parchment when first establishing the overall layout of Plan B.

Moving upwards, the modules defined by the original generating octagon continue to govern the spire composition. It is therefore convenient in this context to use the italicized units shown on the right-hand margin of Figure 2.18, each one of which equals the face-to-face diameter of this octagon. Diagonals departing from the outermost tower margins

18 Recht, *Le dessin d'architecture*, pp. 62–3.

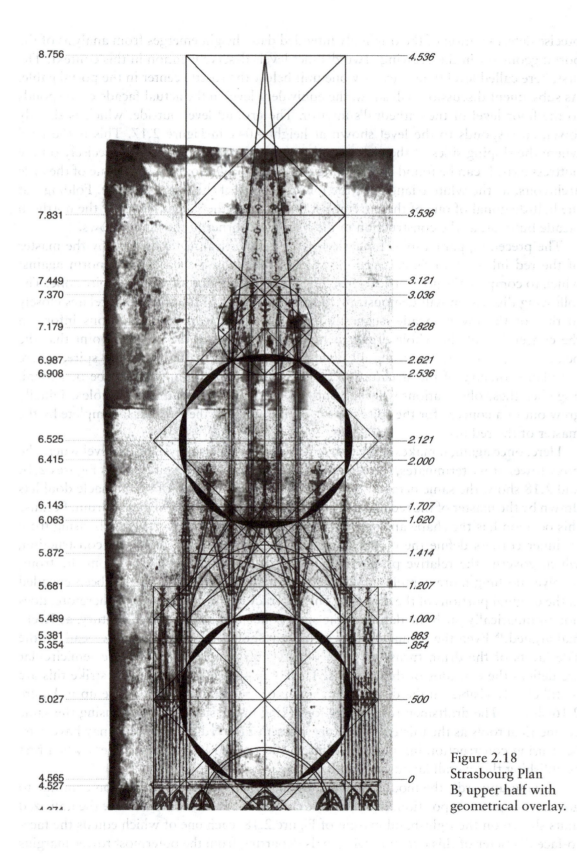

8.756
4.536

7.831
3.536

7.449
3.121
7.370
3.036

7.179
2.828

6.987
2.621
6.908
2.536

6.525
2.121

6.415
2.000

6.143
1.707
6.063
1.620

5.872
1.414

5.681
1.207

5.489
1.000

5.381
.883
5.354
.854

5.027
.500

4.565
0
4.527

Figure 2.18
Strasbourg Plan
B, upper half with
geometrical overlay.

at level *1.000* intersect on the tower axis at level *1.707*, where the tips of the spire drum's gable crown fall. Similar diagonals connect the corners of the square reaching from level *1.000* to level *2.000*, where the tips of the gable-topping finials terminate. An identical square module also defines the height, from *1.621* to *2.621*, of the slender upper spire drum, or shaft. At first, this module may seem to float freely above the geometry of the gable corona, but the connection between them is actually quite straightforward. When the diagonals of the original square module between the pinnacle doublets are unfolded, the resulting arcs reach up from level *1.000* to level *1.414*. There, at level *1.414* on the tower centerline, sits the lower tip of the star octagon circumscribed about the shaft. In Figure 2.18, eight shaded circle segments fall immediately within the tips of this star. The upper and lower circle segments, on the tower axis, play the role of geometrical "lids," sealing the upper and lower ends of the slender shaft. The upper tip of the star, at height *2.828*, establishes the level where the small gablets atop the shaft terminate.

At the base of the tapering spire, just as in the lower façade, a new octagonal module helps to define the geometry. In the lower portions of Plan B, the new octagon was slightly wider than the original, while in the spire zone, not surprisingly, the new module is considerably smaller. Since the total face-to-face width of the shaft equals the width of just one facet of the lower spire drum, its own front faces could only be located by constructing a small octagon with this same face-to-face width. Precisely such a small octagon appears to have been constructed between levels *2.621* and *3.036*, permitting the draftsman to drop the two narrowly separated verticals that define the inner corner flanges of the slender octagonal shaft.

The strongest evidence for the construction of this small octagon comes from the presence of a prominent compass prick on the tower centerline at level *2.536*. This point initially appears meaningless, since it corresponds to no formal punctuation points in the articulation of the shaft, but it falls precisely at the bottom tip of the small star octagon built up around the octagon just described. Geometrical analysis of the tapering spire section, moreover, makes clear why there had to be a compass prick at this point. The spire tip is now missing, because of the truncation of the drawing, but its location can be easily determined: the sloping spire sides converge to a point at height *4.536*, exactly *2.000* units above the compass prick. The construction of the small octagon atop the slender vertical shaft, therefore, paved the way not only for the definition of the shaft faces, but also for the establishment of the main spire's height.

With this fairly complete geometrical analysis of Plan B now in hand, it becomes clear that the same modules and design principles governed the entire drawing. The widespread popularity of quadrature and octature in Gothic design does not suffice to explain the precise and essentially seamless continuity of geometrical conception in Plan B. The striking coherence of the geometrical armature in Plan B argues strongly against a decades-long gap between the conception of the lower façade and the spire zone. Thus, despite the obvious differences of facture between the meticulously detailed lower zone and the much more cursorily rendered spire zone, it makes sense to attribute the whole design to one guiding intelligence, or at least to one coherent workshop tradition. The draftsmen who completed Plan B may have been close followers of the master of the red ink who were familiar with his intentions, for example. It may simply be, though, that the later draftsmen were using construction lines that had been scribed but not inked by

the original designer. This hypothesis would help to explain the curious conflict between the geometrical precision of the spire zone and the frankly sloppy rendering of some of its details, such as the main spire crockets. These options are not mutually exclusive, of course. The draftsman responsible for the intricately detailed pinnacles over the rose may well have been a close follower of the master of the red ink, but the creator of the sloppy crockets probably was not. All of these men, though, appear to have worked within a single unified geometrical framework, one that governed the articulation of Plan B from façade base to spire tip.

The most striking point about the geometry of Plan B is that it derives almost entirely from the octagonal footprint of the foreseen spire. Unlike Plan A, whose geometry involves only the vertical plane, Plan B has a geometrical structure that links the horizontal and vertical planes, since the octagonal module governing the elevation of each story corresponds to the plan of the tower in the horizontal plane, as Figure 2.19 shows. Plan B is thus the oldest surviving workshop drawing to exhibit the characteristic Gothic design system whereby the elevation of a building was determined by an extrapolation of its groundplan.[19] This system, of course, worked particularly well for structures like towers and pinnacles that had quasi-crystalline symmetrical groundplans. It is no coincidence, therefore, that the Plan B geometry was spire centered rather than planar. The creator of Plan B clearly conceived his west block as a pair of spire-carrying towers, rather than as a flat screen in front of the extant nave structure. This made good sense in the abstract, especially given the new level of architectural ambition in the Strasbourg Cathedral workshop of the 1270s. In practice, however, this spire-centered geometry would have to be subtly modified before construction of the Strasbourg façade block could actually begin.

The lower level of the current façade conforms substantially to Plan B, at least in terms of articulation and overall flavor, but slight divergences of proportion show that the process of translation between the drawing and the built structure was not entirely straightforward. These divergences are so small that they might seem meaningless. In fact, though, they demand explanation precisely because they are too subtle to have any effect on the basic character of the façade design, or on its physical relationship to the built nave structure. As Figure 2.15 showed, Plan B fits rather awkwardly onto the nave section, both in the sense that the rose window rises too high for the vault, and in the sense that the outer façade buttresses extend far beyond the outer aisle walls. In the built structure, the aisles are a tiny bit smaller than in the Plan B scheme: their interaxial span is 76.5 percent of the nave span, instead of 81.3 percent in the drawing. This small adjustment, however, does not begin to address the rose window problem, and the outer buttresses of the current structure still stick far out beyond the nave aisle, so nothing of great import seems to have been gained here, at least where the shape of the final structure is concerned.

Questions of process rather than product appear to have motivated these small changes. The geometry of Plan B, as noted above, derived from the footprint of the octagonal spire, with face-to-face diameter of one italicized *unit*. From that geometrical seed, and from the notion that the space between the towers should equal that same dimension,

19 Villard de Honnecourt's Laon tower drawings attest to the existence of this system in the years around 1200, but they are not really workshop drawings like the Strasbourg façade drawings.

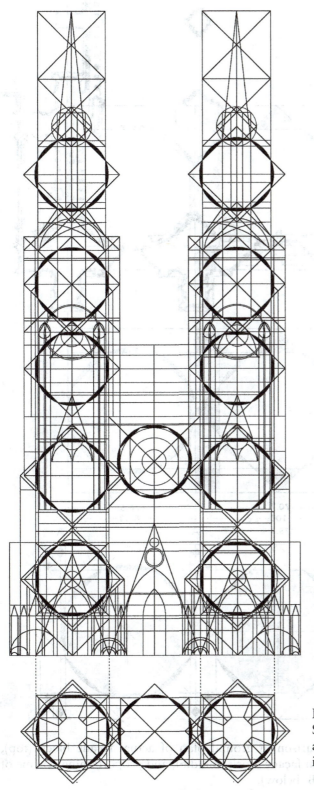

Figure 2.19
Strasbourg Plan B, complete geometrical
armature of façade scheme (above) and its
implied ground plan (below).

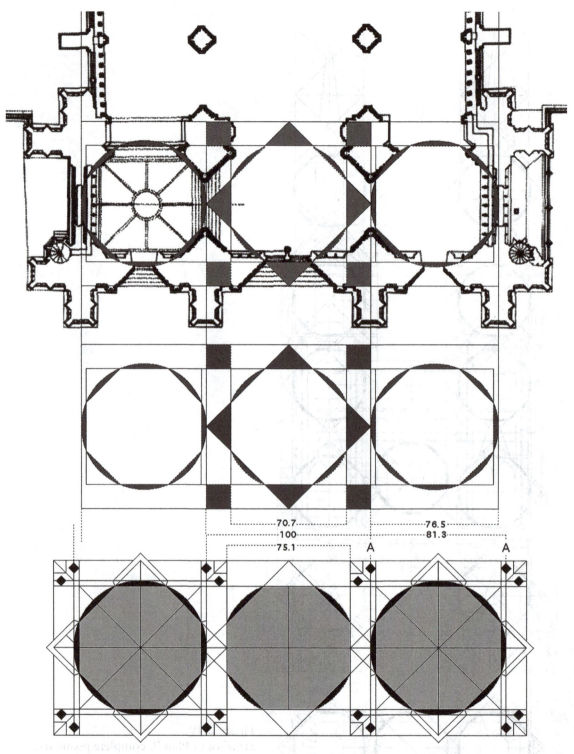

Figure 2.20 Strasbourg Cathedral, comparison of ground plan of actual façade block (top), proportioning scheme of actual façade block (middle), and proportioning scheme of façade block implied by Plan B (below).

all the relative proportions of the west block's groundplan emerged naturally. It was this unfolding from the spire zone that made the interaxial aisle span into 81.3 percent of the nave span. The builders of the actual façade block, though, had good reason to work in the other direction, taking the span of the existing nave as their given, and determining the size of the aisles and towers from that given. This would have saved them from a complex re-scaling of the design.

In practice, therefore, the builders of the Strasbourg façade evidently decided to modify the geometry of Plan B, producing a new plan with the same basic features as the drawing, but based on the span of the extant nave structure. Figure 2.20 shows how this was done, comparing the current plan of the façade block, its basic geometry, and the geometry of the Plan B scheme. The first step in the generation of the revised façade plan was probably the establishment of a large square with side length equal to the nave span, in the area just to the west of the nave. The eastern face of this square lines up with the eastern edge of the wide arches reinforcing the last set of free-standing piers. The western face of the square defines the outer wall plane of the west façade. Construction of a set of rotated squares within this large master square defined a central generating octagon. Although analogous to the generating octagon encountered in the discussion of Plan B, this one would be a tiny bit smaller relative to the nave width, 70.7 percent of the nave width instead of 75.1 percent. Its eastern edge lines up with prominent indentation in the free-standing piers, while its western edge lines up with the plane of the doors in the façade. Both of these articulation points, interestingly, mark the entry into the narthex zone proper. The builders of the Strasbourg façade compensated for the slight reduction in the size of their generating octagon by pushing the equal-sized tower octagons outward a bit from the building centerline. In Plan B, the whole geometrical scheme had been quite compact, so that the tips of the star extrapolated from these generating octagons subtly overlap the circles circumscribed around the neighboring octagon. In the present façade plan, though, the tips of the stars exactly touch the circles rather than overlapping them, thanks to the shrinkage of the octagonal modules. The current proportions of the Strasbourg façade plan, then, reflect not simply arbitrary or pragmatic deviations away from Plan B, but rather the imposition of a new geometrical order in which the principles of Plan B were subtly and elegantly modified to suit a situation in which the nave span rather than the spire width was taken as the main geometrical given.

As work on the Strasbourg façade proceeded, the designers diverged further and further from the Plan B scheme, but they continued to draw inspiration from Plan B—and even from Plan A—surprisingly late in the project (Figure 2.21). In the actual façade, as in Plan B, the width of the aisle bay exactly equals the height from the cathedral's floor level to the rosette over the aisle portal, as Figure 2.22 shows. In the actual building, though, the gable over the central portal visually dissolves into the tracery screen of the façade, because it is treated as an openwork frame, instead of as a flat sheet perforated by a rosette, as it was in Plan B. The most obvious early deviation from Plan B, though, involved streamlining the triforium design. The builders suppressed the autonomy of the triforium by integrating it into the tracery screen of the lower façade, and they eliminated the gablets over the triforium to make way for the rose window, which falls much lower in the present façade than it does in Plan B. This revision, of course, helped to make the rose more fully visible from within the relatively squat nave vessel, something that the

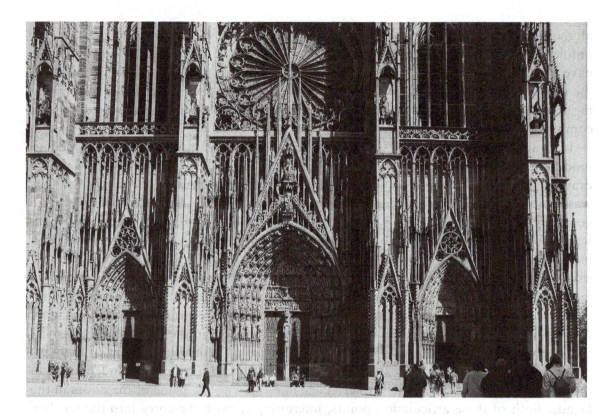

Figure 2.21 Strasbourg Cathedral, lower portion of west façade.

master of the red ink does not appear to have worried about when he was developing Plan B. These changes might make it appear that Plan B had been fully superseded by the time the rose zone was constructed. In fact, however, the tower stories flanking the rose rise almost exactly as high as those foreseen in Plan B; the prominent balustrade that wraps around the tower buttresses at this level thus corresponds quite closely to the balustrade over the rose in the drawing. The gablets of the statue niches over the present rose occupy this same horizontal strip. In several important senses, therefore, the present façade still displays the proportions of Plan B. The only major difference is that the rose and the gablets have exchanged places; the rose has slipped downwards, displacing the gable row upwards from the triforium zone into the strip over the rose window. The lower placement of the rose window and the treatment of the triforium as a solid horizontal base for the rose zone, though, recall Plan A.

The geometry of the lower façade elevation confirms that Plan A continued to inform the designers of the Strasbourg façade even after they had assimilated and modified Plan B. This section of the west front involves combinations of square and triangular geometry like those seen in Plan A, rather than the octagonal geometries seen in Plan B. Calling the nave span 2 N, matching the size of the units used in the earlier discussion of the nave geometry, and defining S = .765 N as the span between aisle axes in the present façade, one can see that a simple set of relations between these modules governs the geometry of the whole lower façade (Figure 2.23). The outermost pinnacle axes of the corner buttresses, for example, are 3 N out from the building centerline, so that the total span of the façade between these framing pinnacles is exactly three times the nave

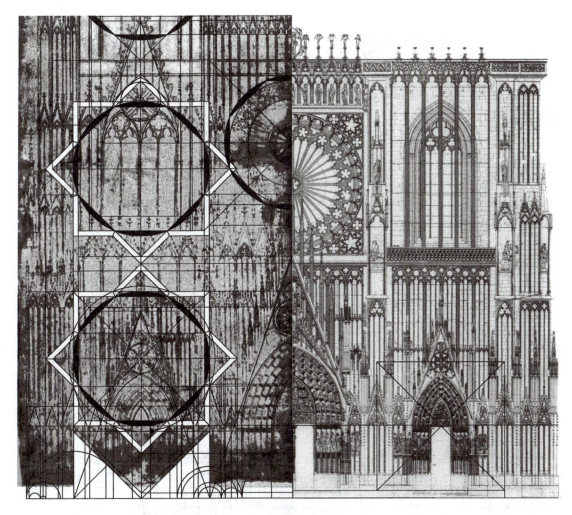

Figure 2.22 Strasbourg Cathedral, comparison of Plan B scheme (at left) with elevation of actual façade (at right).

span.[20] Meanwhile, diagonals across squares of side length S locate the lintels of the aisle portals at .50 S, and the first major horizontal punctuation in the buttresses at 1.50 S. Sixty-degree lines rising across the aisles define the crucial horizontal of the triforium's top margin at a height of 1.73S; this level is effectively the geometrical hinge between the lower façade and the rose/clerestory zone. In the central nave space, a square of height 2 N serves at the base for a tiny row of gablets. Crossing 60-degree lines locate the top of the portal arch at a height of 1.73 N. This triangle-in-square geometry echoes that seen in the earliest geometrical seed of Plan A. In the aisle bays, the tiny gablets rise to this same height 1.73 N. This horizontal corresponds precisely to the height of the main arcade in the nave structure, because both result from the application of the triangular geometry across the nave width. These relationships demonstrate that the elevation of the current lower façade embodies many of the design principles of Plan A and the Strasbourg nave, even though the groundplan of the west block relates more closely to Plan B.

20 This simple relationship does not yet pertain in Plan B, where the equivalent distance is 3.20 nave spans, because of the wide aisles and wide buttresses.

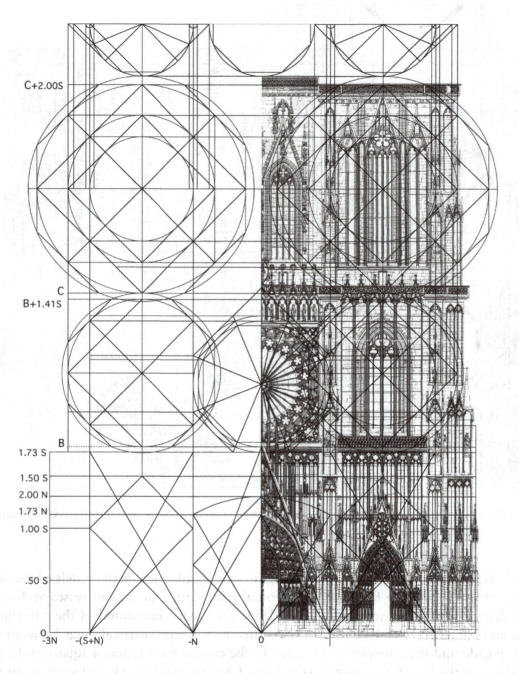

Figure 2.23 Strasbourg Cathedral, elevation of actual façade with geometrical overlay.

The design of the current rose window zone, too, involves a blending of ideas from Plan B, Plan A, and their antecedents. The placement of the rose within a perfectly square frame derives from French Rayonnant structures such as the Notre-Dame transept frontals.[21]

21 The elegant pentafoils inscribed in circles around the Strasbourg rose resemble the one seen below the rose in Plan A1. Because the creator of Plan A1 overlooked the construction lines in Plan A, though, his rose is not framed between four equivalent quadrants like the current Strasbourg rose or the roses of the Notre-Dame transept façades.

The size of the rose is very close to that foreseen in Plan B, but its lower placement and prominent frame give it a dominant role in the façade more analogous to that seen in Plan A. The sixteen-fold symmetry of the rose, meanwhile, hints at the re-emergence of the octagonal geometries that had been seen in Plan B and in the present groundplan, but not in the elevation of the lower façade. As Figure 2.23 shows, a large octagon filling the full width of the nave serves as the outer geometrical frame for the rose window. The width of the visible square frame and the size of the rose window result from the interaction of inscribed circles and octagons within this larger frame. These relationships recall those seen in Plan B, and in the plan of the current west block. The man responsible for this synthesis may well have been Erwin von Steinbach, whose recorded tenure at the head of the Strasbourg workshop—in whatever precise capacity—lasted from 1284 to 1318.[22]

In the second quarter of the fourteenth century, builders led by Erwin's son Johann constructed the towers flanking the rose window, in which octagonal geometries again figure prominently. Just as in Plan B, the height of this tower story results from the construction of an octagon whose face-to-face diameter equals the interaxial aisle span S. In designing this story, Johann evidently took as his point of departure the level B, the baseline of the rose window's visible frame. The tower story then rises from level B to B + 1.414S, so that it perfectly embraces a star octagon circumscribed about the octagon of diameter S. The lower tip of the star falls on the top margin of the triforium, and the upper tip at the level where the buttress uprights begin to step outward to support the salient balustrade. The upper horizontal within this star octagon, meanwhile, lines up with the top of the visible rose window frame, and with the tips of the pinnacles on the main buttresses. The construction of another large octagon and circumscribing circle about this star octagon, finally, gives the base of the balustrade proper, at level C. Thus, while this section of the Strasbourg façade is most famous for its deviations from Plan B, such as the replacement of the large clerestory gable in the drawing by a row of smaller ones, the spirit of Plan B lives on in the geometry of this tower story, much as it does in the tracery "harpstring" articulation that cloaks it.

The octature-based design principles inherent in Plan B continued to guide the Strasbourg builders even in the blocky tower story above the rose window. The south tower, the first to be completed, rises exactly two aisle spans above the balustrade base below, from C to C + 2.00S. A geometrical system of octagons and rotated squares defines the articulation of the tower within this framework. When a large star octagon is inscribed within a circle as tall as the tower, for example, its upper horizontal gives the springers of the small lancets in the buttress flanges, while its lower horizontal gives the platform height for the second set of equestrian statues. Working inwards, the top margin of a smaller octagon defines the tips of the buttress pinnacles, the salient moldings on the flanges between the windows, and the springing of the main tower windows. The persistence of octagonal geometries in the elevation of this tower story makes good sense, because its designer, Master Gerlach, used the octagon to define its vaulting plan, just as he had also in the Saint Catherine chapel, a small episcopal chapel built alongside the cathedral's

22 For a good survey of the literature on the Erwin problem, see Charlotte A. Stanford, "Building Civic Pride: Strasbourg Cathedral from 1300 to 1349" (Ph.D. diss., Pennsylvania State University, 2003), pp. 7–19.

south transept.[23] The octagonal vault was innovative in the context of continental chapel architecture, but it was common in towers, since it helped to prepare the way for the construction of octagonally symmetrical spire stories. There is every reason to believe that Gerlach meant his tower to be the foundation of an octagonal superstructure, just as the analogous structure in Plan B would have been. He even adopted the same format of corner buttress flanges seen in Plan B, with the rotated square construction governing the outer buttress salience, just as in the drawing. Like the equivalent tower story of Plan B, Gerlach's south tower was designed to stand free. By the time of the north tower story's completion in 1365, though, planning for the unusual central belfry between the towers had begun to challenge the traditional two-tower format of the Strasbourg west block.[24] Detailed consideration of this belfry project, and of the tower and spire crowning the Strasbourg façade, belongs in a later chapter. It is worth noting, however, that the spectacular spire completed in 1439 differs radically in kind from the slender, pencil-like spike shown in Plan B. It presents, instead, a sophisticated elaboration of the openwork spire type seen in Cologne Plan F.

In the years from 1300 onwards openwork spires enjoyed great prominence in Germanic architectural culture, but the spire type shown in Plan B did not. The Achilles heel of the Plan B spire scheme, interestingly, may well have been the drawing-based design method that produced it. Because plans and elevations of the sort used by Gothic designers do not convey the full character of the finished building's three-dimensional presence, overly direct reliance on this tool could result in unpleasant aesthetic surprises. In the case of Plan B, the spire scheme looks attractive in the front view seen in the drawing, because the octagonal spire drum appears to fill the full space between the flanking pinnacle doublets. As the plan in Figure 2.20 makes clear, though, these pinnacles actually sit far out from the drum, at the corners of the boxy, square-planned tower story. When seen from a diagonal, therefore, the structure would have presented an awkward silhouette, with prominent air gaps between the drum and the pinnacles, as Figure 2.24 shows. It may well have been the realization of this aesthetic problem that caused the master of the red ink to pause in his work before he could complete the detailing of the spire zone.

The unresolved geometrical awkwardness of the tower-to-spire transition in Plan B provides valuable evidence for the scheme's likely provenance in the realm of microarchitecture rather than in the realm of full-scale spire design. The church spire had arisen as a major monument type in the twelfth century, in the same years when the Gothic style itself was emerging.[25] Early spire designers clearly recognized the structural, geometrical, and aesthetic challenges of placing octagonally symmetrical spires atop square-planned towers. They soon began to add small ancillary structures into the "leftover" spaces of the tower corners. Among the most important of these small structures was the pinnacle, the microarchitectural derivative of the spire. Early pinnacles closely resembled early spires, both in their proportions and in their articulation. Early

[23] See Roland Recht, *L'Alsace gothique de 1300 à 1365: Etude d'architecture religieuse* (Colmar: Editions Alsatia, 1974), pp. 54–71.

[24] The south tower is fully articulated on all four of its faces, including the north face that is now obscured by the belfry. The north tower articulation, by contrast, is crude on its hidden face, showing that the belfry concept had already been introduced before its completion. See Recht, *Bâtisseurs*, pp. 393–7; and Stanford, "Building Civic Pride," pp. 107–13.

[25] See Bork, *Great Spires*, pp. 40–57.

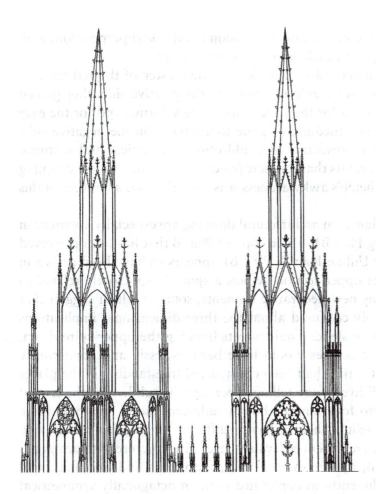

Figure 2.24
Strasbourg Plan B, redrawing
contrasting front view of tower
(at right) with diagonal view of
the same structure
(at left).

pinnacles and spires, moreover, shared an optical solidity with early Gothic façades, most of which retained a residually Romanesque massiveness and murality. In the thirteenth century, though, spire design failed to keep pace with the innovations seen in other facets of Gothic architectural practice. The transparency, linearity, and attenuated proportions of Rayonnant architecture had not yet been translated into the realm of spire design in the 1270s, when work on the Strasbourg west front began. As the members of the Strasbourg workshop must have realized, a simple pyramidal spire of the early Gothic type would have looked ridiculous atop their new façade, with its slender, needle-like pinnacles and delicate screens of openwork tracery. They therefore had good reason to explore new and innovative spire forms related to contemporary developments in microarchitecture. By treating their spires as overgrown pinnacles, they could restore some of the balance between full-scale and microarchitectural forms that had predominated in the early Gothic period. The slender, pencil-like format of the Plan B spire would result naturally from such an approach to design. Bony's perceptive comparison between the Plan B spire scheme and the craggy Montjoies of Saint Louis, similarly, makes good sense in this context. The exploitation of microarchitectural prototypes, however well motivated, had obvious drawbacks, since the designers of pinnacles and free-standing roadside monuments like the Montjoies had no need to unify their soaring creations geometrically or aesthetically with a square tower base, as the Strasbourg spire designers would have to. Thus, while Plan B exhibits a profound unity of geometrical conception, a diagonal view

of the foreseen façade would have conveyed an impression of *ad hoc* superposition, with the octagonal spire drums sitting awkwardly atop the boxy towers.

In adopting drawing as such a central tool of design, the master of the red ink and his followers entered into a Faustian bargain of sorts. On the positive side, they gained a tremendous freedom which allowed for the conception of new forms, and for the easy transposition of influences from one medium or scale to another. On the negative side, the reliance on two-dimensional representations could obscure technical and aesthetic problems with the experimental formats that this new freedom fostered. The late-dawning recognition of the Plan B spire scheme's awkwardness was probably one symptom of this problem.

The problems with a blind reliance on architectural drawing are especially apparent in the drawing known as Strasbourg Plan B1, a free copy of Plan B that has been preserved in Vienna since the Gothic era.[26] Unlike Plan B, Plan B1 appears to have been drawn in a single continuous campaign. Its upper section depicts a spire design closely related to that in Plan B, but including many new decorative elements, some of which suggest that the draftsman involved was deeply confused about the three-dimensional implications of his work (Figure 2.25). He drew slender stair turrets flanking the upper spire drum, for example, even though such structures would have been uselessly and dangerously disconnected from the spire shaft if they had been constructed freestanding in the places that the drawing seems to imply.[27] Even more tellingly, perhaps, he subdivided the central facet of the lower spire drum into four lancets, but the adjacent facets into only three lancets. This suggests that he thought of them as having different lengths, not recognizing that they were actually supposed to represent equivalent faces of a structure with octagonal symmetry. In the original Plan B, by contrast, all the proportions and articulation in the spire zone work together coherently to depict just such an octagonally symmetrical structure. Since there is no reason for the drawings to have these proportions if octagonal symmetry was not intended, it seems clear that even the controversial upper portions of Plan B were completed before the creation of Plan B1.[28] The elaborate but muddled Plan B1 must date to the period around 1300, after the completion of Plan B, but before the emergence of the openwork spire type had rendered the Plan B spire format obsolete.

The history of the Strasbourg lodge in the late thirteenth century, then, reveals both the power and the pitfalls of drawing-based design strategies. It was probably the use of drawings that permitted the rapid transmission of French Rayonnant ideas into the Rhineland in the years around 1250, when the Strasbourg nave was under construction. The roughly contemporary Strasbourg Plan A, the oldest surviving exemplar of what might be called the mature tradition of Gothic architectural drawing, already presents an elegant design solution for the Strasbourg façade. The geometry of Plan A relates closely to that of the nave, in the sense that both involve squares and equilateral triangles in the

26 Plan B1 holds inventory number 105069 in the Wien Museum Karlsplatz. See Recht, *Bâtisseurs*, pp. 88–9; and Böker, *Architektur der Gotik*, p. 448.

27 It is tempting to imagine that knowledge of Plan B1 might have inspired Ulrich von Ensingen to develop his own daring, but slightly more practical, quartets of staircase turrets in his tower schemes for Ulm and Strasbourg, which are discussed in Chapter 4 below.

28 Recht has nevertheless attempted to argue that Plan B1 came first. Although he notes some of the geometrical ambiguities in Plan B1, his lack of appreciation for the geometrical coherence of the spire design in Plan B weakens his analysis. See *Le dessin d'architecture*, pp. 62–3.

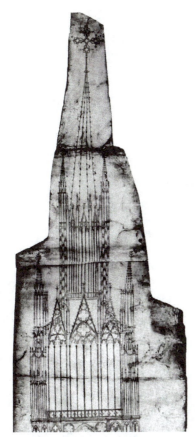

Figure 2.25 Strasbourg Plan B1, detail of spire zone.

vertical plane. The two designs fit together imperfectly, however, because the creator of Plan A grew his drawing from a simple geometrical "seed" whose symmetry did not reflect the full width of the nave aisles. By the 1270s, the anonymous visionary responsible for Plan B had greatly advanced the state of the art, in both formal and conceptual terms. The complex tracery articulation in Plan B certainly deserves its fame, and the overall organization of the drawing deserves comment as well. Even without its controversial spire zone, Plan B embodies a greater degree of vertical integration than any previous workshop drawing known. Geometrical analysis reveals, moreover, that Plan B was conceived as a stack of octagonal modules, each based on the groundplan of the spire base. Despite subtle variations in the treatment of these modules from story to story, this geometrical armature appears substantially unified, which strongly suggests that the original creator of Plan B foresaw the drawing's present spire design in its overall outlines. The striking differences of facture between the upper and lower zones of the drawing, though, suggest that this original draftsman became aware of a problem at the spire base. It is tempting to imagine that this problem involved the awkward spatial relationship between the boxy tower story and the quasi-microarchitectural spire above, a problem that would not have been immediately apparent during the initial layout of a frontally oriented elevation drawing like Plan B. One gets the sense, therefore, that the original creator of Plan B tackled the façade design project with an almost reckless enthusiasm, realizing that he could use drawing to develop visionary formal solutions at every scale, from the minute tracery details to the innovative spire format. The impact of his pioneering work was immense, but the failure of the Plan B spire format reveals the shortcomings of this purely drawing-based approach to design. The invention of the far more successful openwork spire type, which combined the smooth silhouette of conventional spires with lacy skeletal structure, depended on a rather different synthesis of tradition and innovation. This synthetic approach to design flourished less in Strasbourg than in Cologne, the other major center that helped to establish the Rhineland as a major center of Gothic architectural culture.

COLOGNE

The builders of Cologne Cathedral were fully conversant with the greatest achievements of the French Gothic tradition, and determined to surpass them. This would have been obvious from the very start of work on the cathedral in 1248. The first master of the Cologne workshop, Gerhard, designed a spectacular choir based on a wide variety of up-

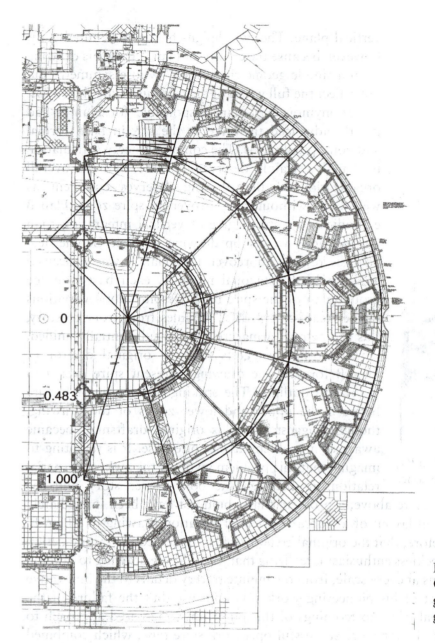

Figure 2.26
Cologne Cathedral,
ground plan of choir with
geometrical overlay.

to-date and impressive French Gothic prototypes.[29] Like the newly remodeled Saint-Denis Abbey, the Cologne choir incorporated compound piers, while the placement of statues on those piers evoked the just-completed Sainte-Chapelle. The plan of the Cologne choir, with its seven small radiating chapels, recalls Amiens and Beauvais, but Gerhard departed from these models by making each of the chapels correspond to a 30-degree wedge of the hemicycle, so that the whole chevet composition fills exactly 7/12 of a circle, instead of the roughly 7/13 seen in those two French cathedrals.[30]

29 For a comprehensive discussion of the first campaigns in the Cologne Cathedral choir and the succession of masters, see Arnold Wolff, "Chronologie der ersten Bauzeit des Kölner Domes 1248–1277," *Kölner Domblatt*, 28–29 (1968): 9–229.

30 For comparison between these three cathedral plans and related buildings, see Norbert Nußbaum, "Der Chorplan der Zisterzienserkirche Altenberg. Überlegungen zur Entwurfs- und Baupraxis im 13.

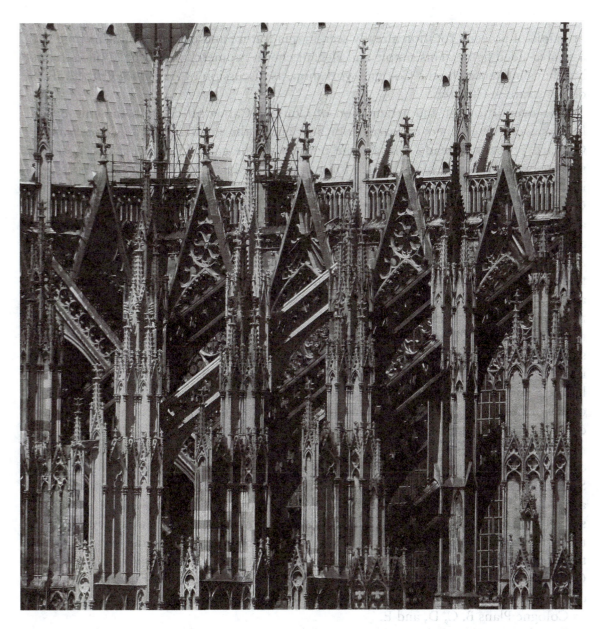

Figure 2.27 Cologne Cathedral, view of upper choir.

Unfortunately, none of Gerhard's drawings for the choir survives, but the very precise construction of the building facilitates geometrical analysis of its design. As Figure 2.26 shows, the subdivision of the chevet plays a crucial role in establishing the relative widths of the main vessel and its side aisles. If the span from the building centerline to the aisle piers is called 1.000, then the span of the main vessel is $2 \times .483 = .966$, which is equal to $\cos 15°$. These proportions, in other words, result from applying the same basic

Jahrhundert," *Wallraf-Richartz-Jahrbuch*, 64 (2003): 7–52. On the Amiens plan, see Stephen Murray and James Addiss, "Plan and Space at Amiens Cathedral: With a New Plan Drawn by James Addiss,"*Journal of the Society of Architectural Historians*, 49 (1990): 44–66, esp. 58–9. On the Beauvais plan, see Stephen Murray, "The Choir of the Church of St.-Pierre, Cathedral of Beauvais: A Study of Gothic Architectural Planning and Constructional Chronology in Its Historical Context," *Art Bulletin*, 62 (1980): 533–51, esp. 538–40.

principle of polygon rotation already seen in quadrature and octature, but this time with a twelve-sided figure. This simple and elegant chevet geometry would be applied in later buildings influenced by the Cologne workshop, as discussion of Augsburg Cathedral will demonstrate in Chapter 5.[31]

The overall format and articulation of Cologne Cathedral confirm that the project leaders were determined to learn from and outdo the greatest buildings of France.[32] Gerhard probably already foresaw the outlines of the cathedral's five-aisled nave and massive western façade block, which follows the same basic plan as that of Notre-Dame in Paris, with giant towers that each correspond to a two-by-two grid of aisle bays. Gerhard's successor, Master Arnold, elaborated further on French precedents, developing a new decorative vocabulary by reinterpreting the Amiens upper choir design in richer and more muscular form. Arnold rejected the openwork flying buttress design seen at Amiens, but he appended rows of openwork rosettes to the back of each of the solid flying buttresses that he built instead (Figure 2.27). Instead of placing just one pinnacle atop each pier buttress, Arnold placed a cluster of five, grouped into a Greek-cross plan reflecting the cruciform shape of the buttress below. Perhaps most tellingly, he repudiated the brittle fragility of the Amiens choir gables, treating the Cologne choir gables as solid sculptural forms rather than as transparent openwork frames. In this respect his inclinations lie diametrically opposed to those of the Strasbourg façade designers, who let their portal gables dissolve into the linear texture field of the screen wall behind. The openwork rosettes, cruciform pinnacle arrays, and opaque gables seen in Arnold's choir design appear also in the design of the cathedral's west façade.

Surviving drawings from the Cologne workshop attest to substantial, albeit incomplete, continuity in the planning of this enormous façade. The radical changes of intent seen at Strasbourg have no parallel at Cologne, where the building seems to have been conceived as a whole all along. Even the drawing usually considered to be the oldest of the set, the so-called Cologne Plan A (Figure 2.28), already describes a façade block very similar to the one eventually built, although it was later decided to enlarge the towers slightly and to reduce the number of portals from the five to three.[33] These refinements appear in Cologne Plan F, the enormous elevation drawing that shows the entire cathedral façade complete with its twin openwork spires, and also in the series of smaller drawings known as Cologne Plans B, C, D, and E.

The dating of the Cologne drawings remains controversial. In very rough terms, all of them belong to the decades around 1300, but more precision than this has proven difficult to achieve. Marc Steinmann, author of the most recent and detailed study of the Cologne drawings, dates Plan A to the 1260s, and Plan F to the 1280s. To support this revisionist chronology, the earliest so far proposed for the drawings, Steinmann invokes many comparisons between tracery elements seen in the Cologne drawings and those seen on dated buildings.[34] His argument, however, depends on the problematic assumption

[31] This theme will also be pursued in the forthcoming sequel to Sabine Lepsky and Norbert Nussbaum, *Gotische Konstruktion und Baupraxis an der Zisterzienserkirche Altenberg* (Altenberg, 2005).

[32] This point was made by Helen Rosenau in *Der Kölner Dom: Seine Baugeschichte und historische Stellung* (Cologne, 1931), pp. 16–18.

[33] Plan A is preserved in the Vienna Academy, with inventory number 16.873. See Recht, *Bâtisseurs*, p. 406; and Böker, *Architektur der Gotik*, pp. 178–81.

[34] Steinmann, *Die Westfassade des Kölner Domes*.

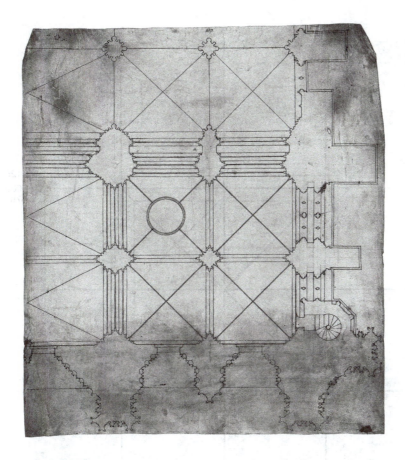

Figure 2.28 Cologne Plan A.

that design influences typically flowed from Cologne to these other centers, rather than conversely. Since the evidence can easily be read the other way around, many experts have expressed doubts about Steinmann's very early datings for the Cologne drawings. Recent archaeological work, moreover, shows that actual construction of the Cologne façade began decades later than had previously been supposed.

The discovery, deep in the south tower foundations, of a coin minted in the 1340s demonstrates that even the oldest part of the façade block dates to the mid-fourteenth century, at earliest.[35] In a recent analysis of Plan A, therefore, Hans Böker has proposed a similarly late date for the Cologne drawings. Böker acknowledges that the drawings could be dated somewhat earlier on strictly formal grounds, but he argues against a decades-long gap between the production of Plan A and the beginning of work on the cathedral foundations.[36] The truth of the matter probably lies somewhere between the extreme positions marked out by Steinmann and Böker.

Since scholarly opinion unanimously accepts the idea that roughly two decades separate Strasbourg Plan A from the beginning of work on the Strasbourg façade in 1277, it seems reasonable to assume that a comparable time elapsed between the initial planning

[35] Ulrich Back, "Die Domgrabung XXXIII: Die Ausgrabungen im Bereich des Südturmes," *Kölner Domblatt*, 59 (1994): 193–224, esp. 200–202.

[36] Böker, *Architektur der Gotik*, 178–81.

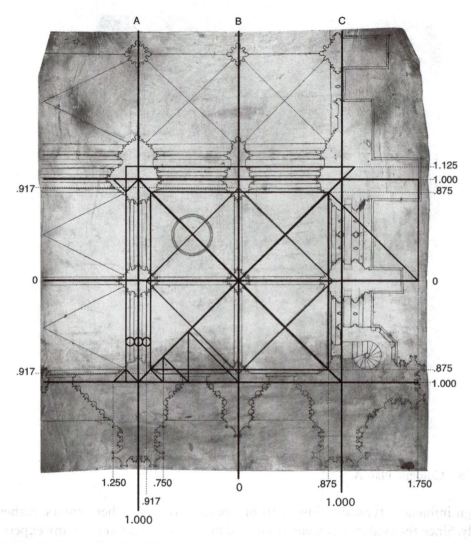

Figure 2.29 Cologne Plan A, with geometrical overlay, stage 1.

of the Cologne façade project and its execution. The relative continuity of intention in the Cologne workshop suggests, in fact, that the gap may have been even greater than at Strasbourg. More specific comparisons with Strasbourg can help to clarify both the chronology and the character of the Cologne drawings. As Steinmann rightly points out, Cologne Plan A has more in common with traditional French façade design than with the various Strasbourg façade schemes.[37] In the Cologne drawing, for example, the statue niches continue all the way around the principal façade buttresses, as at Reims and Amiens, instead of being interrupted by the salient buttresses, as they consistently are at Strasbourg. This suggests that the members of the Cologne workshop produced Plan A before they began to borrow from the work of their colleagues in Strasbourg.

Geometrical analysis of Cologne Plan A underscores its independence from the Strasbourg design tradition. In the Cologne drawing, as in most tower plans, the crucial figure is the square footprint of the tower base. Cologne Plan A thus differs fundamentally from Strasbourg Plan A, an elevation drawing based on triangular geometries operating

37 Steinmann, *Die Westfassade des Kölner Domes*, pp. 186–7.

in the vertical plane. The crucial distinction here is not simply the obvious one between groundplans and elevations, but between façades conceived as flat screens, and those conceived as volumes extruded upwards from tower bases. In this respect the purely planar Strasbourg Plan A actually differs more profoundly from Strasbourg Plan B and Cologne Plan A than the latter two do from each other, since the geometry of Strasbourg Plan B derives from the plan of the spire base, as noted previously. But, there is an important conceptual and geometrical distinction between Strasbourg Plan B and Cologne Plan A, nevertheless. The creator of Strasbourg Plan B appears to have conceived his drawing from the top down, taking the octagonal geometry of the spire superstructure as his point of departure, and stacking related octagonal modules down to ground level. The creator of Cologne Plan A, by contrast, appears to have considered only the lowermost story of the tower, using squares rather than octagons as the main generators of his drawing.

In Cologne Plan A, the geometry of the façade correlates closely with that of the church vessel behind. More specifically, the façade buttress axes labeled A, B, and C in Figure 2.29 align, respectively, with the centerline of the nave arcade, the centerline of the free-standing aisle piers, and the outer surface of the aisle wall. These three lines are equally spaced, and the interval between each can be called one unit. The creator of Plan A probably began his work by constructing the two-by-two square grid of these units to describe the basic footprint of the tower. His next step, it seems, was to subdivide the intervals AB and BC into quarters, and then into eighths. As the lower center of Figure 2.29 shows, the right margin of the principal nave-flanking buttress falls three-quarters of a unit, or .750, to the left of the tower center. The left margin of the buttress thus falls 1.250 units left of the center. The subdivision into eighths, meanwhile, produced a series of lines .875 out from the centerpoint of the tower, producing a box 7/8 as large as the original box defined by buttress axes A and C. This inner box describes the free space of the vaults in the tower hall, measured between the ribs that frame them. The structure of the framing ribs is particularly clear to the left of centerline, where a thick bundle of three ribs separates the tower bays from the nave. This three-fold division of the rib bundle, as indicated by the three small circles in this zone, creates a new vertical .917 units to the left of the tower centerline. The construction of similar lines parallel to all four tower faces creates a new box within which the rotated square of the diagonal vault ribs can be inscribed. The rib bundles at the top of the graphic, separating the tower bay from the aisles, are even thicker and more complex than those on the left, but the subdivision into strips of the same width can again be discerned, especially since a groove starting 1.125 units above the tower centerline separates the tower-flanking triplet from the "extra" ribs on the aisle side. Further to the right, the simple buttress block terminates 1.750 units out from the tower centerline. All of these structures in Plan A can be described by the arithmetical subdivision of simple modules, without any of the octature-based figures that dominate Strasbourg Plan B.

As Figure 2.30 shows, circular arcs and non-arithmetical proportioning schemes do figure in the geometry of Cologne Plan A, but only in a few supporting roles. Arcs struck through the corners of the tower bays, for example, reach points 1.237 above and below the centerpoint of the tower. On the upper side, this point marks the center of the "extra" rib separating the tower from the aisle. The first regular bay division in the nave is exactly one unit higher, 2.237 units above the centerline. The line 1.237 units below the centerline,

meanwhile, marks the middle of the forward-projecting portal segments, between the two jamb statues on those segments. The prominent horizontal describing the front edge of the portals falls 1.374 units below the centerline, where a diagonal descending from the lower left of the tower intersects the vertical halfway across the left tower bay. The salient block of the principal buttresses fills the space between this horizontal and the already established perimeter 1.750 units out from the centerline, so that the center of the block falls 1.562 units below the tower center. The front of the buttress pinnacles falls .250 units further out, 1.812 units below the centerline, thanks to the symmetry of the structure within the frame defined by the verticals .750 and 1.250 to the left of the tower center. The position of the nave centerline 1.932 units to the left of the tower center, finally, was already fixed by the design of the choir, where the relative widths of the main vessel and aisles were established.[38]

As this analysis shows, octature played a far less prominent role in Cologne Plan A than it had in Strasbourg Plan B. The significant geometrical differences between these two drawings, taken together with the formal differences noted by Steinmann, strongly suggest that Cologne Plan A was drawn at a point when the leaders of the Cologne workshop remained substantially immune to influences from Strasbourg. This does not automatically imply, however, that Cologne Plan A predates Strasbourg Plan B. After all, the upper choir of Cologne Cathedral, whose richly sculptural articulation contrasts so dramatically with the brittle linearity of the Strasbourg façade, was still under construction at the close of the thirteenth century. Since the elaborate buttress forms in Plan A closely echo those seen in the choir superstructure, it is tempting to attribute the drawing to Master Arnold, the designer of the upper choir, who led the Cologne workshop between roughly 1270 and 1300.

The groundplan known as Cologne Plan D and the spectacular elevation drawing known as Cologne Plan F belong to a later phase, one in which formal and geometrical ideas from Strasbourg had begun to impact on the Cologne façade project (Figures 2.31 and 2.32). Plans D and F certainly belong together as a set: they were executed at the same scale, and their details match each other quite precisely.[39] Their proportions, moreover, perfectly match those of the actual Cologne tower base, at least in its lowest stories. These drawings depict a façade block similar in its overall outlines to the one shown in Plan A, but equipped with only three portals, instead of five, so that tracery begins to displace sculpture as the dominant element of the design, even at ground level. The gable over the main portal in Plan F, moreover, is an openwork frame like the one seen in the present Strasbourg façade. Since this motif has the brittle vertical tracery characteristic of the Strasbourg workshop, instead of the muscular richness of the Cologne tradition, the artistic current was almost certainly running from Strasbourg to Cologne in this instance. In geometrical terms, too, Plans D and F depend on a new wave of influence from Strasbourg. Proportional analysis reveals that these drawings are based largely on the "octature" principle, which had governed Strasbourg Plan B, but which had played no role in the towers of Cologne Plan A. It is clear, though, that the regular arithmetical

[38] To convert the measurements seen in Figure 2.30, which are expressed in terms of the tower and aisle bays, into those seen in Figure 2.26, which were expressed in units equal to an aisle bay plus the half-span of the main vessel, one need only observe that .932 ÷ 1.932 = .483, the number seen in the choir plan.

[39] On Plan D, see Steinmann, *Die Westfassade des Kölner Domes*, pp. 191–2. There are also two variants known as Plans B and C, which Steinmann discusses on pp. 189–91.

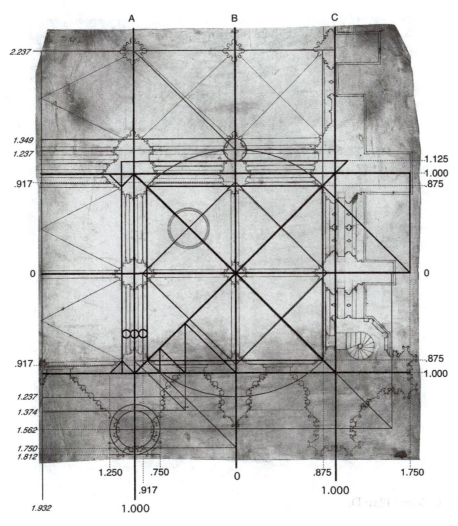

Figure 2.30 Cologne Plan A, with geometrical overlay, stage 2.

subdivision seen in Plan A continued to play a role in these later drawings. In both formal and geometrical terms, therefore, the Cologne workshop remained committed to its traditions even when assimilating new ideas.

The layout of Cologne Plan D departs subtly from that of Plan A. The buttress axes of Plan D, for example, no longer coincide with those of the nave arcade behind. Unlike Plan A, moreover, Plan D shows almost nothing of the aisle bays or nave, a fact that already begins to suggest the geometrical independence of the reconceived façade block from the cathedral behind it. As Christian Freigang has demonstrated, the whole tower block in Plan D fits into a neat 7 × 7 grid of squares.[40] This format, shown in Figure 2.33, represents a natural extension of the system introduced in Plan A, since it is based once again on the subdivision of the tower's interaxial span into fourths and eighths, as the measurements along the base of the figure indicate. In Plan D, though, the system is even

40 Christian Freigang, "Bildlichkeit und Gattungstranszendenz in der Architektur um 1300," in Norbert Nussbaum and Sabine Lepsky (eds), *1259: Altenberg und die Baukultur im 13. Jahrhundert*, Veröffentlichung des Altenberger Dom-Vereins, 10 (Regensburg: Schnell & Steiner, 2010), pp. 377–96.

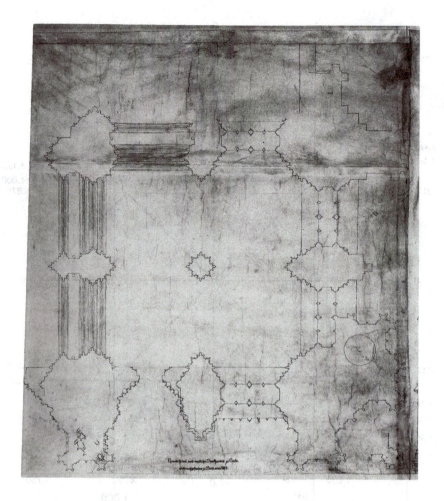

Figure 2.31 Cologne Plan D.

more rigorous, since each of the salient buttress blocks recapitulates the 7 × 7 grid form of the whole tower. This arrangement, first noted by Freigang, provides a beautiful example of the Gothic principles of partiality and subdivision outlined by Paul Frankl.[41] As the upper-left portion of Figure 2.32 shows, it would have been quite easy for the creator of Plan D to achieve this seven-fold subdivision of the buttress block, since all he had to do was draw a diagonal line through the first column of the larger 7 × 7 grid, and note its intersection points with the buttress block.

The geometry of Cologne Plan D involves not only an arithmetically determined grid system, but also a set of octature relations comparable to those seen in Strasbourg Plan B. In Figure 2.34, these are shown as fine lines, and the corresponding dimensions are given in italics along the bottom margin of the figure. Moving from left to right, the first new element that one encounters is the jamb of the nave portal, which sits at the edge of the parchment, 1.531 units to the left of the tower centerline. This dimension is the radius of a large circle circumscribed about an octagon of facial radius 1.414, whose diagonal faces pass through the intersections of the buttress axes 1.000 units out from the tower centerlines. The next smaller circle in the figure has radius 1.414, and the last of the large

[41] Paul Frankl, *Gothic Architecture* (Princeton, 1962), pp. 10–14.

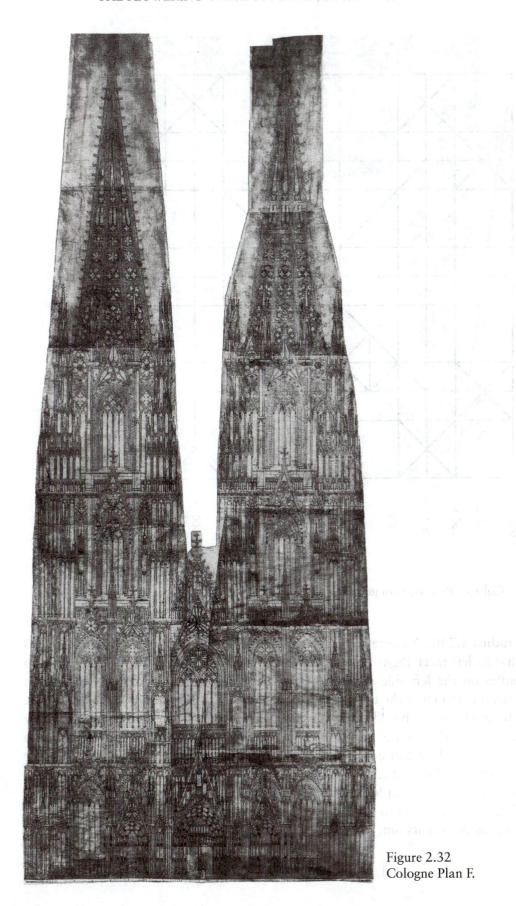

Figure 2.32
Cologne Plan F.

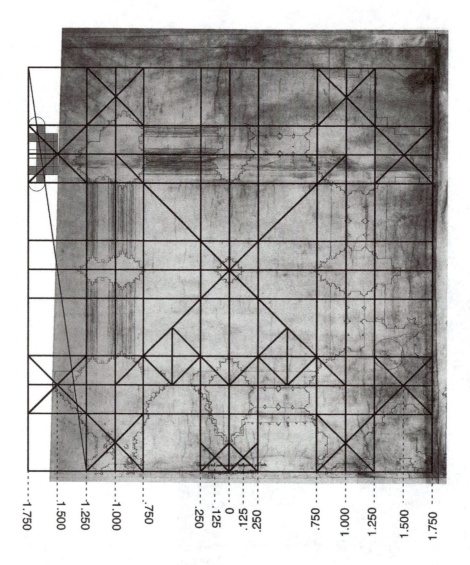

Figure 2.33 Cologne Plan D, with geometrical overlay, stage 1.

circles has radius 1.250. An octagon inscribed within this final circle has facial radius 1.155, so that its left facet aligns precisely with the left edge of the blank space between the rib bundles on the left side of the tower plan. The diagonal face of this octagon crosses the main diagonal of the tower .817 units to the left of its centerline, establishing the border between the rib bundle and the vault web of the tower hall. Moving further to the right, the centerline of the portal into the tower hall is .438 units to the left of the tower centerline, simply because it is halfway between borders of the major and minor buttresses, which are .750 and .125 units to the left of the tower centerline, respectively, in accord with the arithmetical logic of the grid system. The center of the window bay, correspondingly, is .438 units to the right of the tower centerline. The outer wall of the tower hall begins .875 units out, i.e. 7/8 of the way to the buttress axis. The two layers

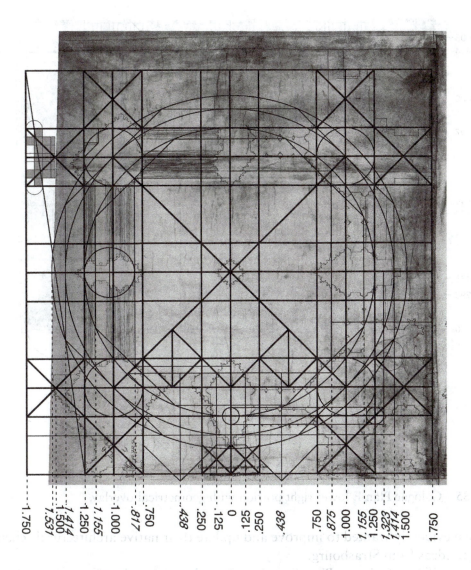

Figure 2.34 Cologne Plan D, with geometrical overlay, stage 2.

of tracery in this outer wall align with the buttress axis and with the side of the 1.155 octagon face, respectively.[42]

The octature-based design method seen in Cologne Plan D corresponds quite precisely to the system seen in Strasbourg Plan B. Geometrical analysis of these drawings thus supports the argument made previously on formal grounds that the members of the Cologne workshop began to accept influences from Strasbourg at some point after the completion of the more strictly arithmetical Cologne Plan A. At the same time, however, they remained stubbornly committed to the basic façade format foreseen in Plan A.

42 The outer plane of the wall, finally, lies 1.323 units out from the tower centerline. This distance can be approximated, at least, by inscribing a circle of radius .250 at the intersection of the main buttress axes, fitting a small square into the space left over between that circle and the grid square that frames it, and using the side length of the small square as the radius for a tiny circle centered 1.250 to the right of the tower centerline. The evidence for this construction, though, is weaker than that for the use of octature in the plan.

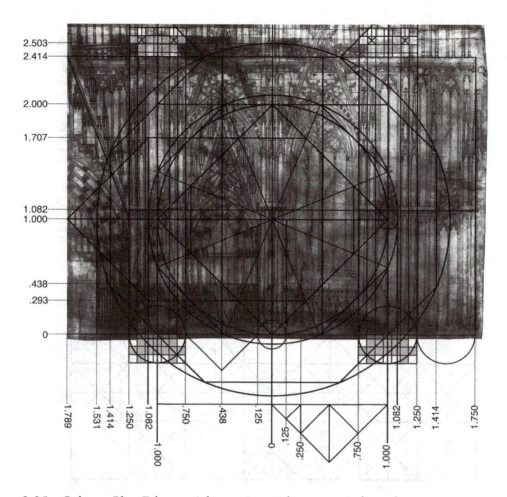

Figure 2.35 Cologne Plan F, lower right portion with geometrical overlay.

These men evidently wanted to improve and update their native architectural schemes by reacting to ideas from Strasbourg.

The magnificent Cologne Plan F presents an elevation scheme corresponding both formally and geometrically to the groundplan shown in Plan D. The two drawings are at the same scale, and they incorporate the same proportioning systems. Figure 2.35 shows how this geometrical structure maps onto the lowest section of the south tower in Plan F, the same part of the building shown in Plan D. This was also almost certainly the first part of the drawing to be completed, as several independent bits of evidence indicate: first, it would make sense to begin at the ground level, where the correlation with Plan D could be made most easily; second, the south tower shown in Plan D was the place where work began on the façade; third, the pattern of parchment trimming suggests that the south tower in Plan F was drawn before the left one, as subsequent discussion will demonstrate; and fourth, the pattern of sutures in the drawing suggests that the lower-right piece was the original one to which the others were attached (see the arrows in left half of Figure 2.37).

The creator of Plan F surely began by establishing his groundline at level 0, and the axes of the principal tower buttresses. Next, he probably constructed a square framed by those axes, effectively flipping the square tower shown in Plan D into the vertical plane. A

rotated square inscribed within this original square has its left and right corners at height 1.000, at the centers of the small quatrefoils on the buttress faces. These quatrefoils, like the small triangular medallions seen on the buttresses of Strasbourg Plan A, call visual attention to crucial points in the host drawing's geometrical armature.[43] Just as in Plan D, the buttresses in Plan F fill spaces between .750 and 1.250 units out from the tower centerline, and these spaces again seem to have been divided into equal sevenths, so that the buttress blocks echo the form of the tower; this is shown in the small schematic plans that descend below the groundline in Figure 2.35. And once again the portal and window centerlines are .438 units out from the tower centerline, since they bisect the spaces between .125 and .750. This same dimension, when flipped into the vertical plane, sets the height where the statues in the portals would have stood. And, just as in Plan D, the right jamb of the central nave portal falls 1.531 units to the left of the tower centerline, aligned with the leftmost point of a great circle circumscribed around a great octagon that is circumscribed in its turn about the square framed by the buttress axes. This great octagon, whose upper facet reaches height 2.414, turns out to be just the first of a stack of six such modules that govern the whole elevation of Plan F from groundline to spire tip.

Before going on to consider the further unfolding of Cologne Plan F in the vertical dimension, it is worth pausing to consider the relative width of the nave and towers in the drawing, both because this is one respect in which Plan F provides more information about the horizontal dimension than Plan D had, and because this analysis underscores the extremely close relationship between Plan F and Strasbourg Plan B. Because Plan D showed only the tower base and right jamb of the central portal, rather than the central trumeau, it did not specify the width of the nave, which the far more complete Plan F necessarily does. Even Plan F, though, must be interpreted with care in this respect, because the drawing is rather crooked, with the centerline of the nave bay wandering to the left as it rises. For this reason, it is important to emphasize once again that the lower-right portion of the drawing was likely the first area to be drawn, and the one likely to provide the most reliable geometrical information.

A fairly simple octature-based construction establishes the overall centerline of Plan F, as Figure 2.35 shows. The first step in this construction is to create an octagon framed by the main tower buttresses. When a circle is circumscribed about this octagon, its outermost points fall 1.082 units out from the tower centerline. Another octagon, smaller by one quadrature step, occupies the space between heights .293 and 1.707. The centerline of the entire façade composition can be found by striking horizontals to the left at those levels until they reach the 1.082 verticals, and then striking diagonals left towards the octagon's equator until they converge 1.789 units to the left of the tower centerline. As the lower half of Figure 2.36 shows, the basic geometrical skeleton of the groundplan implied by Plan F agrees perfectly with the proportions of the Cologne façade as built.

The horizontal proportions of Plan F relate far more closely than one might expect to those of Strasbourg Plan B. At first glance, the drawings appear very different in their proportioning schemes. In the Strasbourg drawing, the towers are narrower than the nave space, but in Cologne Plan F the towers are far larger than the nave. As the middle

[43] It is worth noting that window tracery elements play this geometrical signaling role less often than buttress elements, since the locations of buttresses are more geometrically fundamental; windows tend to be pushed around by the thickness of the buttresses that frame them.

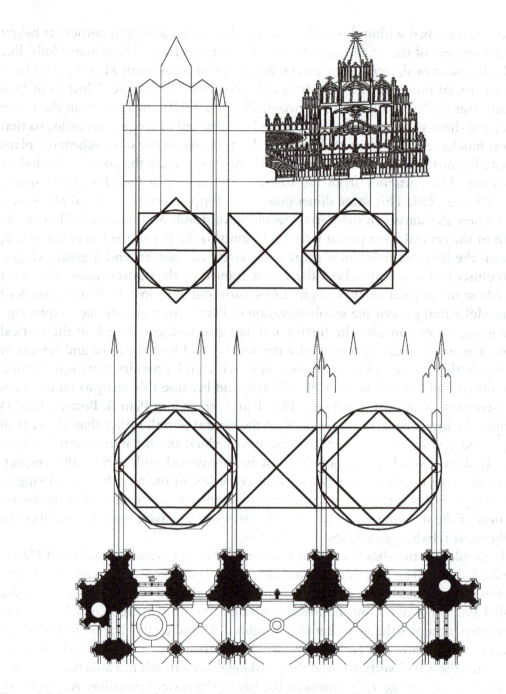

Figure 2.36 Comparison between the proportions of the façade blocks depicted in Strasbourg Plan B and Cologne Plan F. From top to bottom: the elevation of Strasbourg Plan B, shown greatly compressed; the implied ground plan proportioning figure of Strasbourg Plan B; a schematic elevation showing the placement of the pinnacles near the spire base in Cologne Plan F; the implied ground plan proportioning figure of Cologne Plan F; the ground plan of the actual Cologne Cathedral façade.

section of Figure 2.36 shows, though, the groundplans implied by Strasbourg Plan B and Cologne Plan F resemble each other very closely. Both involve octagonal spire footprints, with the nave space corresponding to a closely related square box between the towers. Significantly, too, the span between the buttress axes in Plan F exceeds the equivalent dimension in Plan B by a $\sqrt{2}$ ratio. This relationship appears explicitly in the center-left of the figure, where the groundplans of the two drawings appear to scale. The vertical lines dropping from the aisle axes of Plan B form the sides of a square within the left-hand tower base of Plan F. This square, and a rotated square of the same dimension, can be inscribed within a regular octagon whose outer faces correspond to the main buttress axes of the Cologne façade, as the bottom-left section of the figure indicates. This strongly suggests that the creator of Plan F knew not only the formal vocabulary and geometrical planning methods of the Strasbourg designers, but also their units of measure.

One slight difference between the Plan F and Plan B groundplans suggests that the creator of Plan F knew not only Plan B, but also the geometry of the actual Strasbourg façade. In Strasbourg Plan B, the square in the groundplan corresponding to the central nave space appears to be pinched by the sharp tips of the star octagons flanking it to either side. In Cologne Plan F, though, the small interval between each spire base and its circumscribing circle separates the central nave square from the sharp tips of the star octagons. As noted previously, a precisely analogous arrangement governs the groundplan of the current Strasbourg façade block, begun in 1277 (Figure 2.20). Both Plan F and the Strasbourg façade, in other words, incorporate the same slight permutation on the geometry of Plan B. This should not be seen as surprising, since the openwork central gable in Plan F already attests to formal influences from the Strasbourg façade itself, rather than from Plan B exclusively.

These relationships between Cologne and Strasbourg prove crucial to the dating of Plan F. Since it would have taken at least a decade for work on the Strasbourg façade to reach the level of the central portal gable, the reception of this idea in Cologne Plan F cannot be plausibly dated any earlier than 1290 or so. The very close relationship between Plan F and Strasbourg Plan B, though, suggests that the members of the Cologne workshop still saw the Strasbourg drawing as new and exciting when they produced Plan F. This logic argues against the very late dating of Plan F to the mid-fourteenth century, just before work began on the façade foundation. This evidence, therefore, suggests a date around 1300 for the production of Cologne Plan F and the closely associated Plan D. Such a dating also makes good sense in terms of relating the spire design projects in Cologne, Strasbourg, and Freiburg im Breisgau, as a later chapter section will explain.

The creator of Plan F clearly had intimate familiarity with the work of his colleagues in Strasbourg, but he valued rigorous formal consistency in ways that they did not. In Plan F, for example, opaque gables like those of the Cologne choir crown all the windows in the façade, even the narrow lancet in the upper nave that takes the place of the traditional rose window. In the Cologne drawing, moreover, unbroken horizontal moldings clearly demarcate the divisions between the stories. This almost relentless consistency contrasts with the looser and more improvisational quality of Strasbourg Plan B, in which the mannered misalignments between the façade and buttress articulation convey a sense of restless dynamism. In more general terms, though, Cologne Plan F and Strasbourg Plan B convey similar impressions of virtuosity and verticality, and they achieve this effect

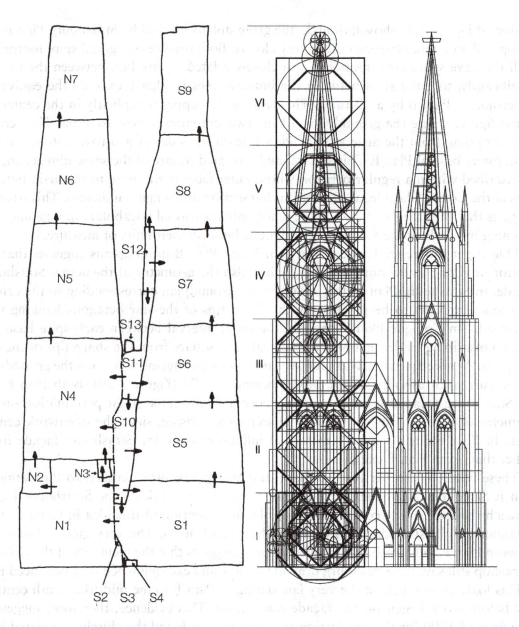

Figure 2.37 Comparison between parchment structure of Cologne Plan F (at left) and the drawing's overall geometrical armature (at right), showing alignment between the six parchments in the right-hand tower and the six octagonal modules in the armature.

through similar formal means: elaborately traceried buttresses, surging pinnacles, steeply pitched openwork gables, and so forth.

In geometrical terms, too, the creator of Plan F modified the precedent of Strasbourg Plan B to achieve an effect of greater rigor and coherence. The basic geometrical frame of Plan F, like that of Plan B, is a stack of octagonal modules corresponding to the footprints of the spire bases. In Plan F, though, these modules stack directly atop each other, with none of the permutations and transitional constructions seen in the Strasbourg drawing

(compare Figures 2.19 and 2.37).[44] In the right-hand tower of Plan F, each of these octagonal modules corresponds to a single piece of parchment, numbered I through VI in Figure 2.37. Each of these parchments, moreover, was trimmed to fit the geometrical armature of the drawing, rather than the depicted architectural forms. These procedures were not followed in the left-hand tower, which was probably produced as a mirror image of the right-hand tower. In Plan F, as in many later drawings, therefore, the trimming of the parchment actually reveals something about the design and production process.

Having established the key horizontal proportions of Plan F, and their close relationship to the equivalent geometries in Strasbourg Plan B, it is now appropriate to consider the vertical dimensions of Plan F. As in Strasbourg Plan B, permutations on the basic quadrature and octature relationships in the drawing's overall geometrical armature suffice to determine even the small details in Plan F. In the following discussion, though, attention will focus on just the most crucial levels of the elevation. Figure 2.38 shows the lower third of Plan F. The first important articulation point above ground level comes at level .438, the level where the statue niches in the portals begin. As noted previously, this height corresponds to the width from the tower centerline to the aisle portal centerline, which was already established in Plan D. The first major horizontal molding across the façade buttresses comes at height 1.082, a height equal to the radius of the circle circumscribed about the octagon framed by the buttress axes. The first story of the façade terminates at height 2.414, aligned with the top of the first great octagonal module. The balustrade in front of the triforium zone terminates at height 2.503, aligned with the top of the circle circumscribed around that great octagon. This level also marks the seam between the first and second parchment pieces in the tower.

The upper portion of Figure 2.38 shows the second great octagon in Plan B, corresponding to the triforium and clerestory levels. The verticals framing the outsides of the main façade buttresses intersect this octagon at height 3.078, defining the top edge of the triforium. The left facet of the octagon rises from height 3.243, the top of the balustrade over the nave triforium, up to height 4.414, which is marked by the capitals in the clerestory windows. The left margin of the great octagon, 1.414 units to the left of the tower centerline, aligns perfectly with the edge of the central nave window. The gablets on the main façade buttresses rise from height 3.828, the equator of the octagon, to height 4.121, which is halfway between this equator and the octagon corner at height 4.414. The top of the octagon, at height 5.243, marks the top edge of the clerestory zone, and the top edge of the second parchment sheet.

The two free tower stories of Cologne Plan F appear in Figure 2.39. The first of these stories corresponds to the third great octagon in the overall stack. The main buttress axes cut the lower diagonal facets of this octagon at height 5.657, establishing the top edge of the balustrade wrapping the base of the story. The center of the octagon, at height

[44] Figures 2.36 and the right half of Figure 2.37 were published in an earlier version of this analysis, Robert Bork "Stacking and 'Octature' in the Geometry of Cologne Plan F," in Alexandra Gajewski and Zoë Opačić (eds), *The Year 1300 and the Creation of a New European Architecture* (Turnhout, 2008), pp. 93–110. The rest of the figures in this section of the present study differ from those earlier graphics in several respects: in their use of numerical rather than alphabetical labels for dimensions; in their greater concision; in some details of the geometry of the finial at the spire tip; and, most significantly, in their consonance with the 7 x 7 grid system identified by Freigang in Plan D. In their essentials, though, the updated graphics presented in this chapter confirm the findings of that 2008 study.

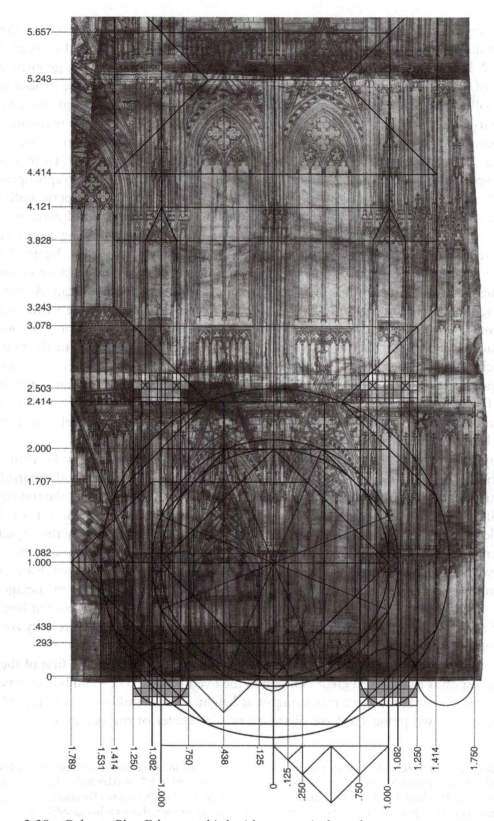

Figure 2.38 Cologne Plan F, bottom third with geometrical overlay.

6.657, falls exactly at the tip of the large pinnacle that terminates the slender intermediate buttress on the tower centerline. This same level also marks the upper vertex of the main gable, at least as far at its traceried main body is concerned. The gable's crockets rise a bit higher, and its finial terminates at height 7.243, even with the upper corner of the octagon's left facet. The finial itself is displaced slightly to the left of the figure's boundary, testifying to the previously mentioned leftward drift of the nave "centerline." This geometrically problematic nave zone, significantly, was drawn on a series of small parchment strips appended to the main stack of pieces constituting the tower (Figure 2.37). It is not surprising, therefore, that its geometrical structure is less precise than that of the tower proper. It is particularly striking, in this context, that the creators of Plan F managed to align the left margin of this strip quite precisely with the left margin of the governing octagon at and around level 7.243. The right-hand margin of the octagon, correspondingly, aligns with a formal division between the south-facing tower buttress and the pinnacle cluster appended to it. The buttress axes cut the upper diagonal facets of the octagon again at height 7.657, a level that marks the top both of the central window in the tower and of the small lancets that flank it. The next seam between parchment pieces falls just above this level. The first free tower story terminates at height 8.071, right at the top of the octagon.

In the second free tower story, which is governed by the fourth great octagon, the circular substructures of the octagon begin to play more prominent roles than they had in the preceding story. Thus, for example, the balustrade wrapping the bottom of the second free story terminates at height 8.403, aligned with the bottom of the circle circumscribed around the octagon framed by the buttress axes. The corners of the great octagon define level 8.899, the bottom margin of the rows of gablets that wrap the large corner pinnacles flanking the tower. The corresponding upper corners, at height 10.071, align closely with the centers of the tracery quatrefoils in the tower windows. Further to the right, the same height locates the tip of the pinnacle terminating the stair turret on the tower's south face. The parchment in this zone has been trimmed to include the octagon corner, before pinching further inwards as it rises. Within this great octagon, a slightly smaller octagon can be inscribed by octature, with its top facet at height 10.792. Verticals descending from the corners of this upper facet frame the large flanges at the corners of this octagonally symmetrical story. The inner edge of these flanges aligns with the corners of the octagon framed by the buttress axes.

In the spire zone of Plan F, shown in Figure 2.40, the respective roles of these subsidiary octagons become clearer, as the buttresses and pinnacles peel away from the core of the structure. The geometrical armature at this level can be interpreted, in fact, as a model of the tower's octagonally symmetrical groundplan.[45] So, for example, the buttress axes cut the sides of the great governing octagon at height 11.314, where small, cardinally oriented squares represent the footprints of the corner pinnacles, which are the last remnants of the

[45] It is interesting in this connection that two horizontal sections of the Cologne tower are drawn onto the back side of Plan F's right-hand tower. One, on the second parchment from the bottom, shows the ground story and the tower hall in very schematic form. The second, on the tapering parchment of Plan F's upper tower story, shows the section of this octagonally symmetrical story. See Steinmann, *Die Westfassade des Kölner Domes*, p. 70. Two variants of the window flange design are shown in this upper section, which strongly suggests that these details were still being worked out as the right-hand half of Plan F was being drawn.

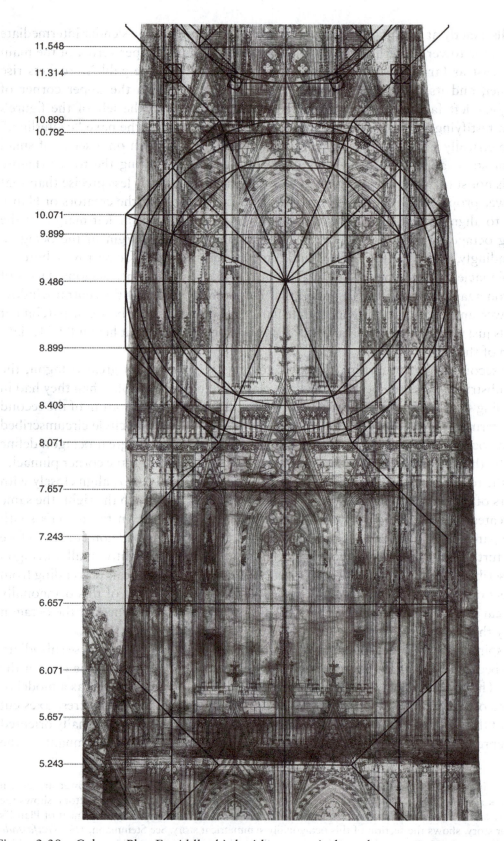

11.548

11.314

10.899
10.792

10.071

9.899

9.486

8.899

8.403

8.071

7.657

7.243

6.657

6.071

5.657

5.243

Figure 2.39 Cologne Plan F, middle third with geometrical overlay.

great masonry masses rising from the main façade buttresses. The slightly smaller tilted squares at the corners of the middle-sized octagon, meanwhile, represent the footprints of the pinnacles clustered around the base of the spire. Since this middle-sized octagon is circumscribed about the buttress axes by octature, the centerlines of the outer pinnacles are 1.082 units out from the tower centerline. These pinnacle axes, in other words, align precisely with the lines used to help define the nave width in the tower base, as explained in the discussion of Figures 2.35 and 2.36.

The sequence of vertical punctuation points in the spire zone, like that below, is governed by these great octagons and their subsidiaries, even though the parchment tapers so as to embrace only the subsidiaries. Level 11.314, where the buttress axes intersect the facets of the large octagon, also locates the tips of the inner fields in the great gables at the spire base. At level 11.548, the midpoints of the diagonal facets in the middle-sized octagon coincide precisely with the outer edges of the tapering spire cone, suggesting that these points may well have been used as its geometrical base. At height 12.762, the parchment has been trimmed on both sides to pass through the corners of this middle-sized octagon, demonstrating once again that the creators of Plan F paid careful attention to this geometrical armature even when cutting their parchment pieces. This finding receives further reinforcement from the layout of the upper spire zone, where the parchments are precisely framed by verticals rising from the midpoints of the mid-size octagon's facets. The parchment that tapers down to this width terminates not at height 13.728, the top of the fifth great octagon, but at height 13.953, where these framing verticals are cut by the circle inscribed within the sixth great octagon. The full circle quite obviously could not be drawn within the confines of the parchment, but the structure of the parchment here attests to the use of these great modules even in the upper spire zone. An octagon concentric with the great circle and framed by the buttress uprights has its lower facet at height 14.377, the level where the final tracery panels in the spire zone begin to taper. These panels terminate at height 15.459, even with the upper corners of its outer facets.

The structure of the spire tip and finial offers further evidence for the use of the great octagonal modules in the topmost portions of Plan F.[46] The right-hand diagonal facet of the sixth and last great octagon can be extended up and to the left, crossing the spire centerline and precisely hitting the corner of the squared notch cut into the parchment at height 17.435. A series of circles centered on the intersection point at height 17.142 determines both the height and the width of the components in the finial. The top of the finial is missing because the parchment has been truncated, but comparison with the more complete left-hand spire of Plan F suggests that it was meant to terminate at height 17.728, coincident with the top of a circle resting on the great octagon's upper facet. The sloping sides of the spire converge to a point on the top edge of a circle inscribed within this one by quadrature. Another quadrature step inward produces a circle whose upper point falls at height 17.435, aligned with the bottom edge of the square notch, and whose lower edge falls at height 16.849, aligned with the collar that separates the spire proper from the finial. This circle also sets the width of the large foliate finial that springs from the centerpoint of the circles. The smaller upper finial is exactly half as large, the result of two more inward quadrature steps.

[46] The analysis of the finial geometry presented here supersedes that presented in Bork, "Stacking and 'Octature'."

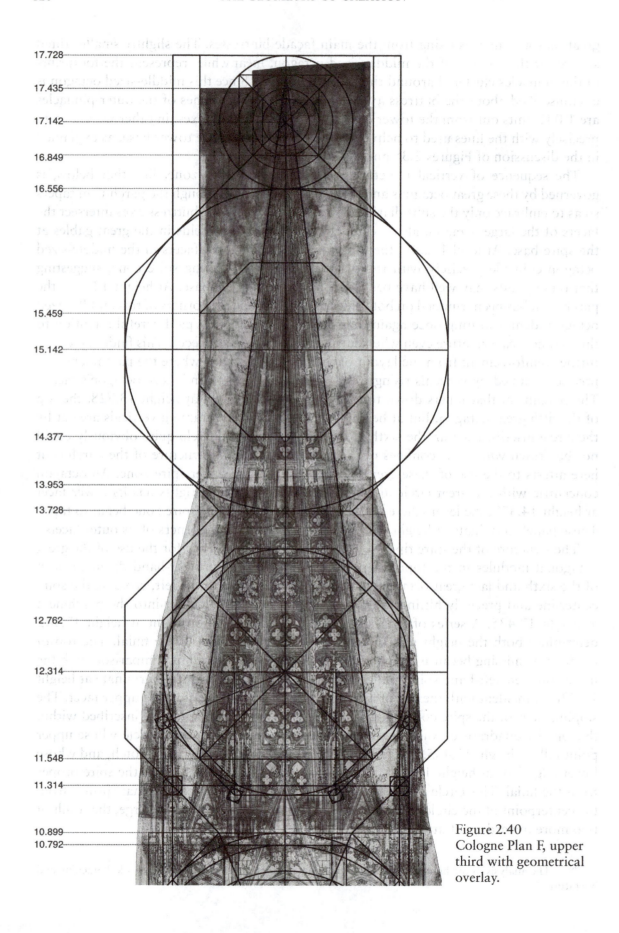

17.728

17.435

17.142

16.849

16.556

15.459

15.142

14.377

13.953

13.728

12.762

12.314

11.548

11.314

10.899
10.792

Figure 2.40
Cologne Plan F, upper
third with geometrical
overlay.

In sum, then, it becomes clear that an amazingly coherent geometrical armature composed of stacked octagonal modules governed the composition of Cologne Plan F from base to spire tip. By treating his enormous drawing as a stack of manageably sized octagonal modules, the creator of Plan F simplified his workshop process. By using identically sized modules at every level of the façade, moreover, he kept the geometrical relationships between the parts of the drawing clear and lucid. This armature closely resembles the one governing Strasbourg Plan B, but it has a more relentlessly consistent quality, just as the formal detailing of the Cologne façade appears similar to, but more consistent than, that of the Strasbourg façade.

In this context, the invention of the openwork spire type begins to look like part of the Cologne workshop's competitive response to the openwork innovations seen in the Strasbourg façade. In 1248, when Master Gerhard began to conceive Cologne Cathedral as an ambitious synthesis of the most impressive French prototypes, he probably planned to crown the building with spires like those of Chartres, Laon, or Senlis. By the 1270s, though, the increasing complexity and linearity of Rayonnant façade articulation would have made such simple spire designs look ridiculous by comparison, as designers in both Strasbourg and Cologne clearly recognized. The openwork spire type was both more traditional and more radical than the quasi-microarchitectural spire seen in Strasbourg Plan B: more traditional, because it retained the basic three-dimensional outlines of the French spire type; and more radical, because it called for the treatment of the entire structure as a linearized skeletal frame.

The use of drawing surely facilitated the leap of imagination that produced the openwork spire concept. Since drawings consist of lines, the act of drawing automatically transforms the depicted object into a linear network. For a draftsman, therefore, there is no real distinction between the lines describing a solid spire and those describing an openwork spire of the same overall shape. The draftsman who first came up with the openwork spire idea did not have to concern himself, initially at least, with the technical challenges of actually building such a skeletal structure. Drawing also invited designers to conceive buildings of unprecedented scale, as Cologne Plan F amply demonstrates by depicting twin openwork spires that would, when completed, reach heights of over 150 meters.[47]

The superbly detailed Plan F obviously represents a fairly mature phase of the façade design process. Earlier and humbler design studies, which no longer survive, must have been made when the openwork spire idea was first introduced into the Cologne workshop. Plan F itself, therefore, cannot be seen as capturing the "Eureka" moment of the openwork spire's invention. Plan F may not even be the oldest surviving drawing to depict an openwork spire, since some drawings associated with the Freiburg project may well be older, as the following chapter section explains. A strong circumstantial case, however, suggests that the openwork spire concept first arose in the Cologne workshop. All the earliest openwork spire designs emerge from towers crowned with opaque gables of the type seen throughout the Cologne upper choir, but never in Strasbourg. The only

[47] More precisely, the height should be given by the interaxial half-width of the Cologne towers times the height of 17.728 given by the ideal geometrical model described here. Since the interaxial width of the towers is 17.09 meters, according to a recent laser-based survey by the Bundesdenkmalamt, the intended height of the towers should be 17.09 m × .5 × 17.728 = 151.49 m.

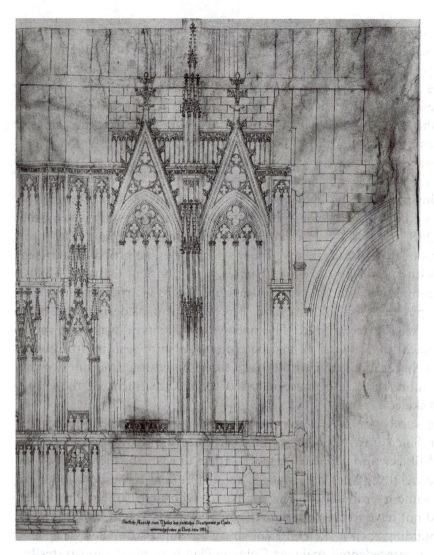

Figure 2.41
Cologne Plan E.

surviving drawings of openwork spires in Strasbourg date from the fifteenth century, long after the type had been well established elsewhere. Strasbourg nevertheless appears to have played an important catalyzing role in the invention of the openwork spire. By demonstrating the revolutionary aesthetic power of openwork articulation, the Strasbourg façade project encouraged designers in Cologne to respond competitively with visionary openwork schemes of their own, as seen in Plan F.

The creation of Plan F marked the artistic high point in the history of the Cologne Cathedral workshop. Work on the cathedral proceeded very slowly in the later Middle Ages, in large part because hostile relations between Cologne's bishops and the local citizenry tended to depress lay donations to the fabric fund. Construction of the cathedral's southwestern tower did not even begin until around 1350, as the previously noted discovery of a coin from the 1340s in the tower foundation demonstrates. Despite this delay, the first campaigns on the Cologne tower follow Plans D and F quite closely, in terms of both proportion and articulation. As construction of the tower went forward, though, small divergences from these drawings began to appear. The buttress format, most obviously, was modified to include tracery triplets in place of the doublets seen in Plan F. An early

experiment with this triplet buttress format can be seen in the drawing known as Cologne Plan E, which shows the eastern face of the cathedral's south tower from the aisle roof into the middle of the first free tower story (Figure 2.41).[48] It would have made sense to produce such a drawing when construction of this zone of the tower was getting underway, a point at which the relationship between the tower and the clerestory zone of the cathedral was having to be established in detail. It hardly seems coincidental, therefore, that Plan E was drawn to the same scale as a study of one of the clerestory windows, instead of sharing a common scale with Plans F and D.

The proportions of Plan E differ subtly from those established in Plan F. As Figure 2.42 shows, the tower windows are slightly narrower than those of Plan F, and their traceried heads ride higher in the elevation. The basic organizational principles of Plan E are straightforward permutations of those already discussed in the context of Plan F. As in Plan F, the whole second tower story is conceived as a square module with sides $\sqrt{2}$ larger than the span between the principal tower buttresses. In Plan E, the baseline of this square falls at the very bottom of the depicted wall, the midpoint lines up with the capitals in the buttress baldachins, and its top edge coincides with the pinnacle tips on the buttresses and the tiny capitals where the heads of the blind tracery on the buttresses start to spring. In the horizontal dimension, the right margin of this square coincides perfectly with the inner molding of the huge arch over the nave. The smaller square with the same center but framed by the buttress axes reaches down to the capitals of the triplet tracery at the triforium level, and up to the capitals in the main tower windows. And, moving in by another $\sqrt{2}$ factor in the same quadrature sequence, a square half as big as the first, whose left and right margins frame the main tower windows, has upper and lower edges coinciding, respectively, with the prominent horizontal moldings on the buttresses and with the top of the triforium.[49] Moving slightly beyond this quadrature sequence, one finds that a circular arc struck through the points where principal buttress axes meet the horizontal of the original generating square will rise up to the level defining the top of the foliate molding terminating the tower story. Above this level the wall articulation becomes far more schematic. This visual abbreviation, and the use of the cut-away technique for rendering the nave wall, suggests that Plan E was meant more for workshop use than for public display, unlike the more accessible and visually appealing Plan F. And, despite the subtle proportional differences between the two, both clearly emerged from the same basic geometrically determined design process.

The second story of the Cologne tower, the last to be completed in the Middle Ages, was built between 1395 and 1411 in full accord with neither Plan F nor Plan E (Figure 2.43). The buttress format, with its tracery triplets, recalls plan E more closely than Plan F, and the blind tracery in the gables has more in common with Plan F, but some of the tower detailing differs from both drawings. Subsequent campaigns at the cathedral, which were slowly pursued into the sixteenth century, involved the construction and furnishing of the north aisles rather than the completion of the façade.[50] At the end of the Middle Ages, therefore,

[48] On Plan E and the present tower torso, see Steinmann, *Die Westfassade des Kölner Domes*, pp. 192–200 and 220–28 respectively.

[49] Or, more precisely, with the top of the uninterrupted uprights in the triforium. There are several horizontal moldings above this level that could be said to belong to the triforium, also.

[50] For the late Gothic campaigns on the nave, see Arnold Wolff, "Der Kölner Dombau in der Spätgotik," in *Beiträge zur rheinischen Kunstgeschichte und Denkmalpflege*, vol. 2 of *Albert Verbeek zum 65. Geburtstag* (Düsseldorf, 1974), pp. 137–50.

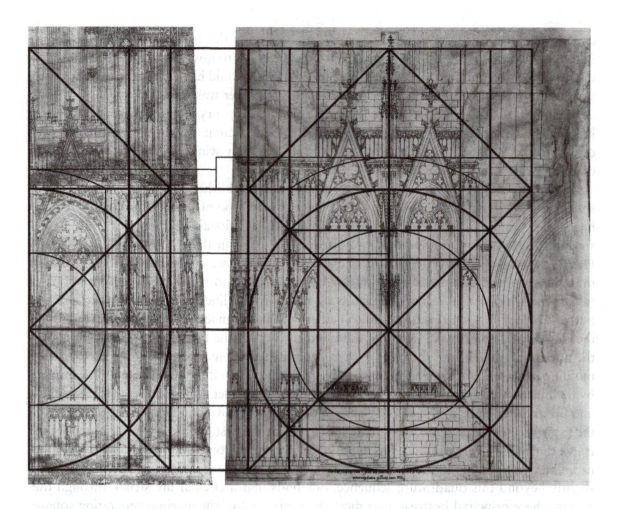

Figure 2.42 Comparison between Cologne Plan F (at left) and Plan E (at right), both with geometrical overlays.

the magnificent dreams of Plan F's creator remained substantially unrealized. For more than four centuries, a medieval construction crane stood atop the cathedral's fragmentary south tower, awaiting a resumption of work that must have seemed increasingly implausible. Following the loss and subsequent recovery of Plan F in the Napoleonic Wars, though, the vision declared in the drawing was embraced afresh by those interested in promoting the completion of the cathedral. In 1880, therefore, the twin openwork spires of Cologne Cathedral were finally completed in substantial accord with Plan F. After more than half a millennium, Plan F had finally fulfilled its mission (Fig. 2.44).

The history of the Cologne workshop differs dramatically from those of Strasbourg and Freiburg, the other two major centers responsible for introducing Rayonnant Gothic architecture into the Rhineland. In Strasbourg, surviving drawings such as Plan A and Plan B attest to radical changes of direction in the early history of the façade project. The actual façade in Strasbourg grew rapidly in the later Middle Ages, propelled by burgher donations and civic pride. In Cologne, by contrast, the surviving drawings attest to substantial continuity in the overall planning for the cathedral, despite the impact of new ideas from Strasbourg. The octature-based planning system seen in Cologne Plans D and F echoes that

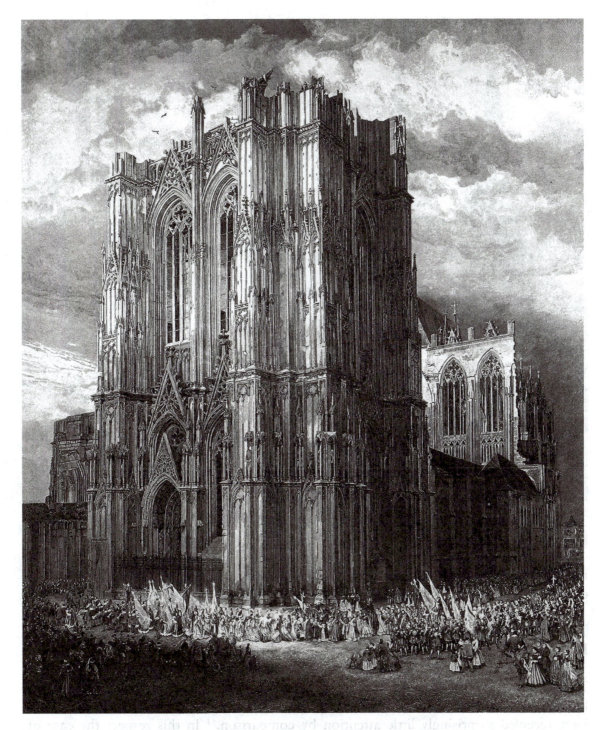

Figure 2.43 Cologne Cathedral in 1842. Engraving by Wilhelm von Abbema, 1846.

seen in the Strasbourg façade, and the invention of the openwork spire may well reflect the competitive response of the Cologne designers to the openwork innovations pioneered by their colleagues in Strasbourg. But, because of the vexed socio-political situation in late

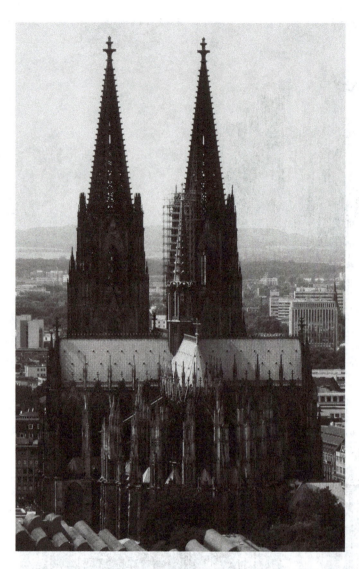

Figure 2.44
Cologne Cathedral, from the east.

medieval Cologne, credit for constructing the first openwork spire must go to the members of the Freiburg workshop, who drew inspiration from Strasbourg as well as from Cologne.

FREIBURG

The spired tower of Freiburg Minster occupies a singularly prominent place in the literature on Gothic architectural geometry, but the drawings associated with the project have received surprisingly little attention by comparison.[51] In this respect the case of Freiburg almost perfectly inverts the case of Cologne, for several obvious reasons. In Cologne, the abandonment of the cathedral façade as an incomplete fragment left Plan F as the most vivid document of the medieval builders' imagination, at least until 1880. In Freiburg, though, the Minster's spire has stood since the early fourteenth century as

[51] For a useful bibliography of what literature there is on the Freiburg drawings, see Reinhard Liess, "Die Rahnsche Riß A des Freiburger Münsterturms und seine Straßburger Herkunft," *Zeitschrift des Deutschen Vereins für Kunstwissenschaft*, 45 (1991): 14.

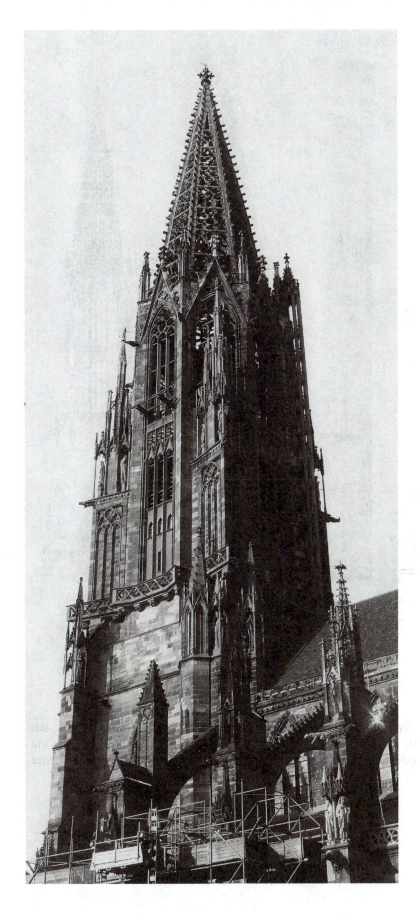

Figure 2.45
Freiburg Minster, overall
view.

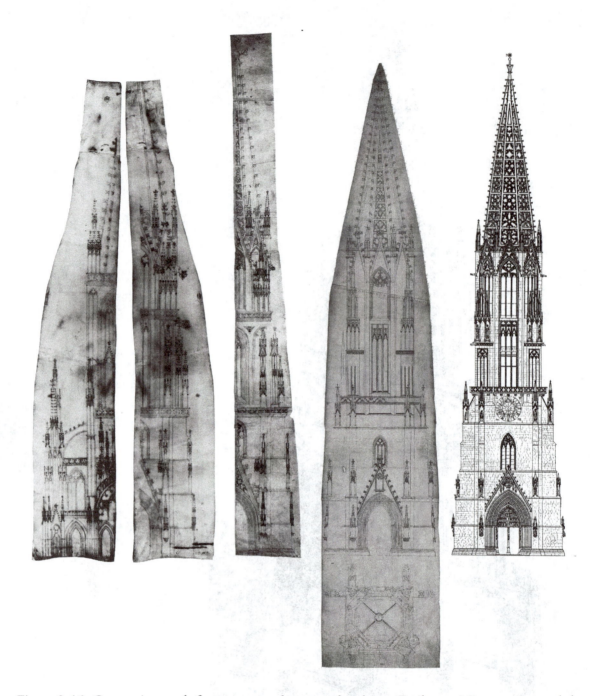

Figure 2.46 Comparison of five tower schemes related to Freiburg Minster. From left
 to right: (a) Rahn Plan A; (b) Rahn Plan B; (c) Drawing 16.869; (d) Drawing
 16.874; (e) Modern elevation drawing of the actual Freiburg Minster
 tower.

a magnificent monument in its own right (Figure 2.45). Many researchers, especially in the late nineteenth and early twentieth centuries, sought to demonstrate their hypotheses about medieval architectural geometry using the Freiburg spire as a central example. Konrad Hecht, reacting to this tradition, demolished most of this work by demonstrating its incompatibility with precise modern surveys of the structure. Hecht suggested that purely modular, rather than geometrical, design methods lay behind the creation of Gothic masterpieces like the Freiburg spire.[52] Hecht's critiques were mostly on target, but his dismissal of geometrical planning methods was profoundly misguided, as the present book has already begun to show. Hecht, like most previous students of architectural proportion, dismissed the drawings most similar to the Freiburg spire as unimportant epiphenomena. These drawings, admittedly, relate less closely to the Freiburg project than the comparable drawings from Strasbourg and Cologne do to their respective churches (Figure 2.46). None of the drawings survives in Freiburg itself, and several of them incorporate features that clearly postdate the completion of the spire. Geometrical analysis of such drawings, and comparison with the present Freiburg tower and spire, can nevertheless reveal a great deal about the early history of the Freiburg spire project.

The drawings associated with the Freiburg spire fall into several distinct types.[53] The simplest to interpret, at least at first glance, are drawings that clearly and unambiguously show the Freiburg tower in something close to its present form. The drawing with inventory number 16.874 in the Vienna Academy, for example, shows the elevation and groundplan of the Freiburg tower, with its characteristically sharp distinction between the blocky lower tower and the lacy upper tower and openwork spire (Figure 2.46d). In its present form, the drawing includes curvilinear tracery of fifteenth-century style. A subtle distinction of ink colors suggests that these details were late additions to the drawing, but it still makes more sense to interpret this drawing as a rough copy after the present structure, rather than as a design study for it.[54] The numerous irregularities in the groundplan, in particular, suggest that the draftsman had observed some of the anomalies in the Freiburg tower geometry without fully understanding them. Since the Freiburg tower served as one of the principal early models for the tower of Vienna's Stephansdom, which was begun in 1359, it seems likely that this drawing was commissioned as a study of Freiburg's tower, after it had already achieved fame in the early fourteenth century. Another drawing, now in Berlin, also shows the Freiburg tower in its basic outlines, although its spire is taller in proportional terms than the one seen today. It, too, appears to be a late copy made after the spire's completion, and it will not be considered further here.[55]

Two other groups of closely related drawings show variants of a design similar to the Freiburg tower, but very clearly distinct from it, featuring two prominent balustrades rather than the single one seen in the present tower. This format blurs the sharp distinction

[52] Hecht, *Maß und Zahl*, pp. 60–95 and 334–61.

[53] For a useful early discussion and categorization of these drawings, see Werner Noack, "Der Freiburger Münsterturm," *Oberrheinische Heimat*, 28 (1941): 226–47, esp. 241–7.

[54] See Böker, *Architektur der Gotik*, pp. 181–4; and Recht, *Bâtisseurs*, pp. 413–14.

[55] Noack in "Der Freiburger Münsterturm," p. 242, notes that this drawing from the Berlin Kupferstichkabinett is signed H.D. and dated 1507. While it is not absolutely clear that these markings are contemporary with the drawing, their presence offers further evidence for a dating long after the spire's conception.

between the blocky tower base and soaring superstructure evident in the present scheme. One "group" consists of a single drawing, with inventory number 16.869 in the Vienna Academy, which shows a comparatively simple boxy belfry story between the two balustrades (Figure 2.46c).[56] Another group of four drawings shows a more complicated belfry design in this zone, with a faceted tower core flanked by pinnacle clusters. The most impressive and best preserved of these drawings, on which attention will focus here, is the so-called Rahn Plan B presently preserved in Fribourg, Switzerland (Figure 2.46b).[57] The other three members of this group are problematic in various ways: one is known only from a nineteenth-century engraving made in Strasbourg by Georg Moller; one in the Stuttgart City Archive is only fragmentary; and the version in the German National Museum in Nuremberg is bizarrely distorted in appearance, with grossly overscaled crockets and finials encrusting a spired tower far more attenuated in its proportions than the actual Freiburg tower.[58] The Moller and Nuremberg drawings, however, do include groundplans, which explicitly show that their belfry stories were meant to be octagonal. Geometrical analysis of Rahn Plan B later in this chapter will confirm that its belfry, too, was meant to have octagonal symmetry. This group of drawings thus records a phase of the design process in which the double-balustrade elevation format seen in 16.869 was combined with an octagonal belfry plan more similar to that seen in the current Freiburg tower.

The relationship between these double-balustrade drawings and the Freiburg tower project has long been controversial. These drawings certainly are not original design drawings for the tower base. They all include complex foliate crockets and tracery forms that clearly postdate the simpler forms seen on the actual tower base, which is shown in Figure 2.46e. Some scholars, therefore, have suggested that these drawings are later reinterpretations of Freiburg design themes, developed for use in other contexts. Hans Koepf, for example, proposed that 16.869 included a second balustraded tower story so that its structure would be compatible with the high roof format of a hall church such as the Viennese Stephansdom.[59] In view of the sharp distinction between the simple tower base and the complex spire superstructure in the current building, though, there is no inherent reason to doubt that these drawings record early schemes for the Freiburg spire superstructure, depicting the already extant tower base with updated details. Geometrical analysis, together with consideration of the Rahn drawings from Fribourg, Switzerland, will support this conclusion.

The drawing on the reverse side of Rahn Plan B, the so-called Rahn Plan A, presents a radically different design for a large axial tower (Figures 2.46a, 2.47a). Instead of the blocky tower bases and visually dynamic tower superstructures seen in all the Freiburg-like drawings, Rahn Plan A features a diaphanous tower base and a blocky tower superstructure. In this respect, Rahn Plan A resembles Strasbourg Plan B. The subdivision

[56] Böker, *Architektur der Gotik*, pp. 165–6.

[57] The "Rahn Plans" are so called because they were introduced to modern audiences by Johann Rudolph Rahn in *Geschichte der bildenden Künste in der Schweiz* (Zürich, 1876). Rahn Plan B occupies one side of the sheet with inventory number 546 in the Affaires Écclésiastiques division of the Archives Cantonales in Fribourg.

[58] See Liess, "Die Rahnsche Riß A," pp. 48-9, 55; and Noack, "Der Freiburger Münsterturm," p. 242.

[59] Koepf, *Die gotischen Planrisse der Wiener Sammlungen*, p. 16. This basic explanation is also accepted in Böker, Architektur der Gotik, pp. 165-6.

of the upper tower story into a four-light window flanked by slender tracery doublets also recalls the Strasbourg drawing. On these bases, among others, Reinhard Liess argued that Rahn Plan A and Strasbourg Plan B were conceived by the same designer.[60] Since the lower parts of Strasbourg Plan B, at least, have been unanimously dated to the 1270s, a similar date seems plausible for Rahn Plan A. By that time, though, work had likely begun on the blocky base of the Freiburg tower. If so, the drawing cannot have been presented as a serious proposal for construction in Freiburg.

Peter Kurmann has recently argued that the two Rahn plans were commissioned by patrons in the Swiss city of Fribourg, where work on the new church of Saint Nicholas began in 1283.[61] Construction of the Fribourg church proceeded very slowly, and its western tower, which differs substantially from those shown in the drawings, dates only from the fifteenth century. At the beginning of work, though, the project patrons would have had good reason to consider the long-term direction of their project, taking account of proposals from the leading workshops in the region. Rahn Plans A and B might thus have been proposed as alternative suggestions for what might eventually be built in Fribourg, based on ideas developed in the Strasbourg and Freiburg workshops, respectively. This scenario effectively explains the presence of both drawings in Fribourg, and it also explains why Rahn Plan B would incorporate updated detailing not seen in the actual Freiburg tower base. The formal vocabulary of both drawings, moreover, makes good sense for the 1280s.

If Kurmann's dating of the Rahn plans is correct, then they would rank with the Strasbourg drawings as among the oldest true workshop drawings of the Gothic era, almost certainly predating Cologne Plan F. Formal and geometrical analysis suggests, moreover, that Rahn Plan B may postdate the Viennese drawing 16.869. These two drawings would thus be the oldest surviving representations of openwork spires. Tellingly, though, they both include ornate gable crowns and compound pinnacles like those previously seen in the Cologne upper choir. This demonstrates that ideas from the Cologne workshop played an important role in the invention of the openwork spire, even if 16.869 and Rahn Plan B both predate the masterful Plan F. The spire of the more Strasbourgish Rahn Plan A, meanwhile, includes no traceried articulation, a fact that underscores the relative independence of the openwork spire concept from the Strasbourg workshop tradition of the thirteenth century.

Before going on to consider the drawings with more direct relevance for the Freiburg tower project, it makes sense to briefly explore the geometry of Rahn Plan A, to help clarify its place in the history of Gothic design. Despite its formal affinities with Strasbourg Plan B, it lacks the geometrical clarity of that masterful drawing. Instead of being organized around a series of modules based on the tower footprint, Rahn Plan A seems to have been conceived in a more *ad hoc* fashion, and in a strictly vertical plane. This planarity is particularly surprising, since the drawing seems to describe a complex three-dimensional array of buttresses arranged around the boxy tower core (Figure 2.50).[62] Curiously, too, its geometrical structure recalls that of the older Reims Palimpsest drawing, since its primary geometrical relationship involves the axes of the side portals, rather than the

 60 Liess, "Die Rahnsche Riß A," esp. p. 44.
 61 Peter Kurmann, *Die Kathedrale St. Nikolaus in Freiburg: Brennspiegel der europäischen Gotik* (Lausanne, 2007), p. 74.
 62 Liess, "Die Rahnsche Riß A," p. 29.

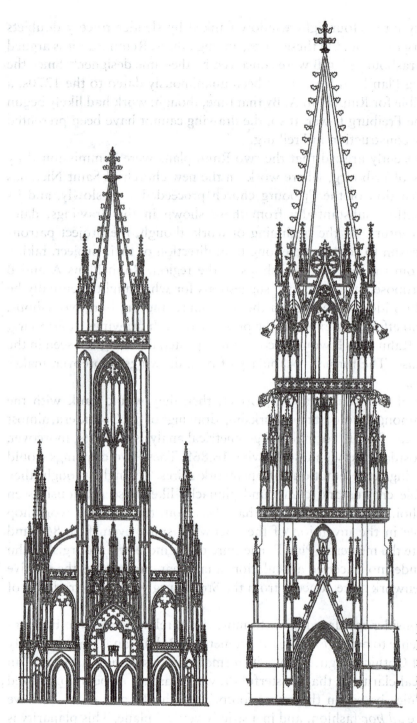

Figure 2.47
Rahn Plans A and B,
modern symmetrized
redrawings by Heribert
Reiners.

axes of the main buttresses. As Figure 2.48 shows, the distance between the building
centerline and the portal axis equals the height from the groundline to the tip of the portal
arch. This may be considered the primary generating square of the drawing; its upper-left
corner can be labeled (-1, 1) in Cartesian (x, y) fashion, and its lower right-hand corner
(0, 0).[63] As the solid lines in the diagram show, if one takes the upper-left tip of the original

63 Inscribing the upper-left quarter of a circle within this box, using the centerpoint (0, 0), and then
inscribing the corresponding part of an octagon within that arc, one finds that the top facet of the octagon

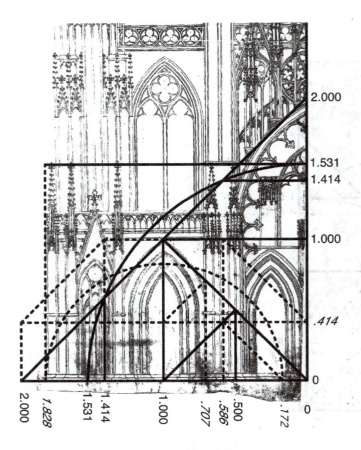

2.000
1.531
1.414
1.000
.414
0

2.000 1.828 1.531 1.414 1.000 .707 .586 .500 .172 0

Figure 2.48
Rahn Plan A, bottom portion with
geometrical overlay, stage 1.

generating square as the centerpoint on the diagonal face of a large octagon centered at point (0, 0), one finds that the circular arc circumscribed about this circle reaches up to level 1.531 (where 1.531 = $\sqrt{2}/\cos 22.5°$), locating both the prominent horizontal molding on the main tower buttress and the tips of pinnacles cladding the buttresses.

After this fairly lucid beginning, the geometry of the Rahn A tower base becomes more convoluted, betraying a curiously anti-structural approach to design that contrasts with the crystalline crispness of Strasbourg Plan B. In Rahn A, for example, the design of the principal buttress flanking the central porch involves an odd mixture of formal and geometrical factors. The front face of this buttress is just a narrow strip squeezed between two diagonally planted pinnacles. The centerline of the right pinnacle falls .500 units out from the building centerline, bisecting the generating box. Further geometrical developments depend on the construction of a large half-octagon, shown in dotted lines, centered on the axis of the side portal and filling the space between the groundline and the tip of the portal. The outer corners of this half-octagon establish a horizontal at height .414. A diagonal struck up from this level on the portal axis intersects the diagonal of the original generating box .707 units left of the building centerline, defining the left margin of the pinnacle doublet flanking the porch. The right corner of the octagon's upper facet falls .586 units left of the building centerline, establishing the middle axis of the doublet, at least at ground level. This centerline, though, is abandoned between heights 1.000 and 1.531, as the buttress shifts slightly to the left. In this zone of geometrical transition,

locates the top of the slightly smaller arch lurking in the main porch space, at height .924 = $\cos 22.5°$.

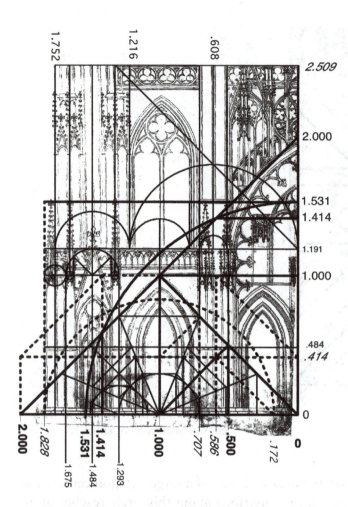

Figure 2.49
Rahn Plan A, bottom portion with
geometrical overlay, stage 2.

moreover, the spatial relationships in the drawing become slightly ambiguous, since
it is hard to tell what plane the buttress face occupies. Such ambiguities never present
themselves in Strasbourg Plan B, or in the even more rigorous Cologne Plan F. It is clear,
though, that the dotted octagon plays an important geometrical role at the ground story.
A diagonal dropped from the intersection of the .586 vertical and the .414 horizontal
intersects the groundline .172 units to the left of the building centerline. A large arc
struck through this point from a center at the base of the portal axis swings upwards and
outwards to intersect the groundline once again 1.828 units to the left of the building
centerline, locating the outboard wall of the ground story.

The outboard buttress in Rahn Plan A, which is considerably wider than the
buttress flanking the porch, appears to have been constructed geometrically in a most
unconventional fashion, as the fine lines in the lower half of Figure 2.49 indicate. The
key generating figure for the design appears to have been a half-octagon, centered at the
base of the side portal and scaled such that its diagonal faces aim towards the portal's
tip. The corners of its upper facet thus fall .707 and 1.293 units to the left of the building
centerline, aligning respectively with the left margin of the buttress flanking the porch,
and with the right margin of the outboard buttress. A considerably smaller half-octagon
can then be drawn centered on the point where the latter vertical hits the baseline, scaled
so that its right-hand diagonal face aims down towards the base of the portal centerline.

A semi-circle inscribed within that half-octagon intersects the ray to the octagon's corner 1.484 units out from the building centerline, establishing the central axis of the outboard buttress.

Several related bits of evidence support the idea that this rather surprising system played a role in the buttress design process. It appears, for example, that other related half-octagons helped to determine the width of the moldings in the side portal, and the height of the first horizontal molding on the buttresses. The smaller octagon, between the verticals .707 and 1.293 units out from the building centerline, has corners that line up with the innermost door jambs of the side portal. The next larger octagon, whose top facet falls at height .414, has corners that align with the outer side of the second bundle of moldings flanking the portal. Yet another concentric octagon has its left facet aligned with the buttress axis 1.484 units out from the building centerline, such that its top facet falls at height .484, the level of the first horizontal molding on the façade, from which the portal arches spring.

The rest of the outboard buttress and lower façade design is far simpler, and more conceptually coherent. The wide outboard buttress presents a traceried front face topped by a gable and framed by two frontally oriented pinnacles; a third such pinnacle stands further to the left like a bookend. Since the right margin and centerline of the buttress have already been established at points 1.293 and 1.484 units to the left of the building centerline, respectively, mirror symmetry locates the left margin of the left pinnacle 1.675 units from the centerline. Another vertical line halfway between 1.675 and 1.828 locates the right margin of the final pinnacle at the edge of the whole composition.[64] This line continues up to form the left margin of the façade in its second story. The centerlines of the twin pinnacles flanking the front face of the buttress, meanwhile, appear to have been determined by quadrature, as the small circle centered at height 1.000 indicates. The centerlines of the pinnacles fall halfway between the equator of the circle and the square inscribed within it. The top of the circle, meanwhile, establishes the top edge of the first balustrade at a height of 1.191. A diagonal rising up and leftwards from this height on the building centerline intersects the vertical of the outboard buttress pinnacle at height 2.509, establishing the top edge of the second balustrade.

The elements between the two lower balustrades do not quite line up with those in the ground story, suggesting once again that the creator of Rahn Plan A was confused, or at the very least that he was thinking more pictorially than architecturally. The definition of widths in this zone also starts reasonably enough. The left-hand margin of the outer buttress in the second story coincides with the right-hand margin of the leftmost pinnacle in the ground story, at $x = -1.752$, as the top edge of Figure 2.49 shows. Reflection about the buttress axis establishes the right-hand margin of the buttress at $x = -1.216$ units. Curiously, though, the right margin of this buttress was apparently used to determine the axis for the main tower buttress at this level, which falls exactly halfway between this margin and the tower centerline. A large circle framed by these verticals and centered on the new buttress axis highlights this relationship in Figure 2.49. Because this construction

[64] The width of the space between these two pinnacles thus equals the pinnacle width, .076 units. This even visual rhythm tends to blur the distinction between the pinnacles and the space between them. An erased gablet in this space shows, in fact, that the draftsman himself became at least briefly confused about the three-dimensional implications of his work in this corner zone. See Liess, "Die Rahnsche Riß A," 22.

has nothing to do with the geometrical logic of the ground story, the buttress axis shifts slightly to the left, moving out from $x = -.586$ to $x = -.608$. This disjunction betrays a curiously non-structural approach on the part of the designer, since virtually every other major Gothic tower design displays greater vertical continuity in the principal tower buttresses.

Another geometrical anomaly in Plan A involves the window of the second story, which is displaced very slightly to the right of the aisle portal immediately below it. In purely formal terms, this reflects the fact that the complex buttress to the left of the window is dramatically wider than the simple tower buttress to the right, so that the window effectively gets shoved to the right by the uneven pressure of its neighbors. In geometrical terms, the distance from the portal centerline to the buttress margin at left precisely equals the distance to the windowpane margin at right, as the small circle in this zone indicates. All of the window articulation is skewed rightwards with respect to this geometrical armature, however. Thus, for example, the centerline of the aisle portal at $x = -1$ corresponds to the left-hand margin of the window mullion above, instead of to its centerline. And, at left, several window moldings step in towards the central mullion, while those at right step out towards the building centerline. Together, these details displace the whole window composition subtly to the right.

The geometry of the next tower stories proves to be more coherent, as Figure 2.51 indicates. The crucial point for the development of the upper zone is $(-.608, 2.509)$, where the tower buttress axis intersects the second balustrade's top margin. An octagon centered on this point and with its right facet on the building centerline has its left facet on the right margin of the outboard buttress, at $x = -1.216$. A circle circumscribed about this octagon then gives the inner arc of the flying buttress in this story. The outer arc in the flyer corresponds to a slightly larger circle, whose leftmost point coincides with the vertical axis of the rightmost sub-pinnacle in the outboard buttress.[65] A diagonal struck over from the top center of the octagon intersects the building centerline at height of 3.725, locating the top margin of the next tower balustrade. Meanwhile, a square constructed adjacent to the octagon in the space of the outboard buttress rises from height 2.509 to 3.044, where moldings punctuate both the forward-facing tower buttress and its transversally oriented sibling at left, which connects to the tower by the visible flying buttress. The sloping top margin of the flyer aims upward from $(-1.406, 3.044)$, where this molding intersects the vertical margin of the pinnacle core, to the point $(0, 3.725)$ where the tower centerline intersects the top of the balustrade.

Even some of the initially confusing-looking details of this zone reflect a straightforward treatment of the geometrical givens established in the more complicated stories below. Thus, for example, the left side of the drawing shows two soaring pinnacles with very slightly offset axes. The more clearly visible one to the far left, which terminates at height 4.432 in a richly crocketed spirelet of apparently octagonal plan, represents a structure in the front plane of the façade. Its vertical axis is therefore that of the buttress face below, 1.484 units to the left of the building centerline. The taller and narrower pinnacle that emerges a hair to the right, with a total height of 4.942, actually represents a structure

[65] There is, curiously, no compass prick at the geometrical center of these manifestly compass-drawn circular arcs, which suggests that the creators of Rahn Plan A used a screen or shield to protect their drawing while striking these arcs.

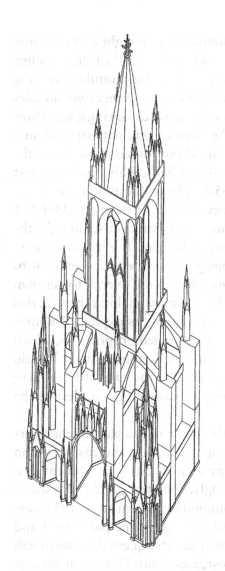

Figure 2.50
Hypothetical reconstruction of tower scheme depicted in Rahn Plan A, after Reinhard Liess.

a full bay to the east of the first, as Reinhard Liess convincingly argued in a 1991 article on the drawing.[66] It seems that the boxy tower of Rahn Plan A was to be surrounded by an array of flying buttress pairs emerging at right angles from each tower corner (Figure 2.50). The forward-facing buttress of this set stands .608 to the left of the building centerline, as explained previously. The pinnacle on the equivalent transversally oriented buttress peeks out behind the lower pinnacle at a distance 1.468 out from the building centerline, where $1.468 = (1 + \sqrt{2})(.608)$. The tips of all these pinnacles, therefore, would touch the corners of a large, horizontally oriented octagon floating at height 4.942, with facets 1.256 long on each side.

As Figure 2.51 indicates, the tower proper has a fairly straightforward geometrical structure, despite the strange shift in buttress axes in the portal zone below. The face-to-face width of the tower is precisely $\sqrt{2}$ smaller than the span between the axes of side aisle portals, so that the left margin of the tower rises directly above the lower buttress margin .707 units to the left of the tower centerline. The width of the forward-facing tower buttress is therefore $2 \times (.707 - .608) = .198$, and the right-hand margin of this buttress falls $.707 - .198 = .509$ to the left of the building centerline. These widths and their derivatives help to govern the heights of the tower core. Thus, for example, a short diagonal dropping from (-.509, 3.725) intersects the one rising from (-.608, 3.117) at height 3.544, the baseline of the third balustrade. The diagonal rising up and left from (0, 3.725) bounces off the buttress axis and back to (0, 4.492), where the sloping edge of the gablet hits the tower centerline; the tall slender satellite pinnacles also terminate at this height. Another diagonal slices rightwards from (-1.484, 3.725) to intersect the tower centerline at height 5.210, locating the level of the gable tip in the tower window. These diagonal lines continue to bounce upwards within the box defined by the tower margin, locating the window arch springer at height 6.115, the rosette center at height, 6.356, and the upper margin of the final balustrade at height 7.063; the lower margin of the balustrade at height 6.822 is found by striking a new diagonal up from the springline point (0, 6.115).[67]

[66] Liess, "Der Rahnsche Riß A," 20–21.

[67] The 6.115 level, in turn marks the intersection of the original diagonal with the buttress margin .509 units left of the building centerline, which coincides closely with the right margin of the mullion in the blind

The geometry of the spire zone turns out to be even simpler. As the right half of Figure 2.51 shows, the diagonal line bouncing upwards from the left edge of balustrade baseline counts out a series of square modules each .707 units on a side. One module above the baseline, at height 7.529, the three small gables in the corner pinnacle spring; two modules up, at height 8.236, the single gablet in the next stage of the pinnacle springs; and three modules up, at height 8.943, the pinnacle terminates. The same zig-zag pattern continues up to define levels 9.650 and 10.357, which defines crucial convergence points in the spire geometry: the outer flanges of the spire converge to (0, 10.357), while the innermost lines describing the front spire facet converge to (0, 9.650). The collar molding between the spire and its terminal finial falls halfway between these points, at height 10.004.[68] A half-module also occurs as the width of the corner pinnacle. Significantly, though, the geometrical structure of Rahn Plan A retains some non-modular aspects even in the spire zone. Thus, for example, the widths of the spire faces appear to have been chosen so as to describe a spire whose octagonal groundplan could be inscribed in the overall tower plan by quadrature. Since the proportions in quadrature involve the irrational number $\sqrt{2}$, this operation cannot be adequately described in modular terms. And, as explained above, the whole structure of the drawing involves geometrically determined proportions, which are evident not only in details, but in large-scale relationships such as the perfect $\sqrt{2}$ ratio between the tower width and the span between the aisle axes. So, the case of Rahn Plan A strongly underscores the centrality of dynamic geometry in Gothic design, despite the strongly modular quality of its spire zone.

In Rahn Plan A, as in many other Gothic drawings, the shape of the parchment offers valuable clues about the history and logic of the drafting process. In the case of Rahn Plan A, the tip of the spire and its terminal finial occupy a small bit of parchment that apparently had to be added for this purpose. Interestingly, too, the parchment sheets occupied by Rahn Plan A were left wide enough to accommodate the entire spatial frame of the tower and its geometrical armature. The relationship between the parchment and the drawing on its reverse, Rahn Plan B, was less optimized, as subsequent discussion will show. These facts strongly suggest that Rahn Plan B postdates Rahn Plan A, at least in terms of when each was actually inked.

Kurmann's suggestion that the two Rahn Plans represent alternative schemes for use in Fribourg, Switzerland, helps to explain the complex relationship between the two drawings. The simple fact that they both depict spired axial towers, combined with their presence on the same parchment sheets, already suggests some purposeful linkage between the two. More intriguingly still, the lower balustrades in the two drawings occupy the same horizontal strip, as though one was traced from the other, even though the two designs use slightly different groundlines. This would make sense if, for example, they

tracery doublet on the tower.

[68] The overall height to the tip of the Rahn A spire is approximately 10.60 units, where these units are defined as the distance from the building centerline to the aisle axis in Plan A. Since there are no dimensions given explicitly in either of the Rahn drawings, it is hard to know precisely how tall this would be in meters. If one assumes, however, that the more Freiburg-like Rahn Plan B has the same interaxial buttress span as the present Freiburg tower, and if one further assumes that the two Rahn Plans were drawn at the same scale, then it is possible to determine a plausible trial height for the Plan A spire. The 10.60 Rahn A units equal 16.65 Rahn B units, where a Rahn B unit equals the span from building centerline to tower buttress axis in Rahn B. Setting this value equal to the equivalent 6.19-meter span in the Freiburg tower, one finds that the total height of the Rahn A spire would have been 16.65 × 6.19 m or 103 meters.

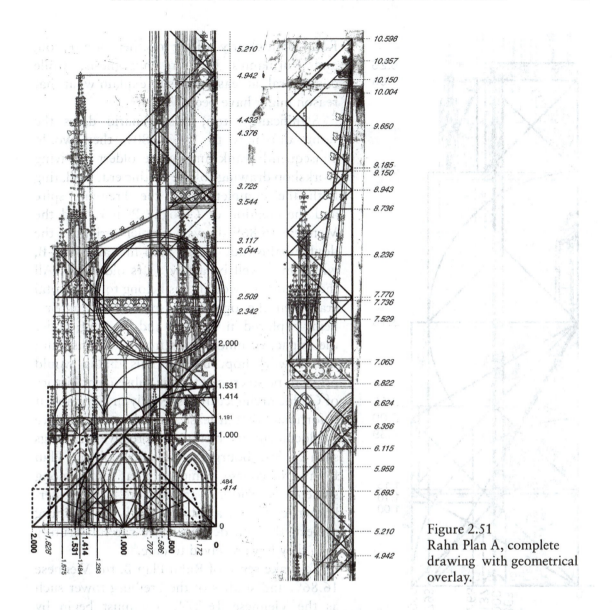

Figure 2.51
Rahn Plan A, complete
drawing with geometrical
overlay.

both record proposed solutions for a single building project, in which the inclusion and
approximate location of such a balustrade was specified by the patron. Since the complex
diaphanous base of Rahn Plan A differs radically from the boxy tower base of Freiburg,
Germany, which was probably under construction by 1270 at the very latest, it must
have been intended for some other center, such as Fribourg, where planning for the tower
project was just beginning. Rahn Plan B, by contrast, clearly relates much more closely
to Freiburg, as its blocky tower base, openwork spire, and prominent gable crown at
the spire base attest. The gable and pinnacle forms seen in Rahn Plan B appear to derive
ultimately from the Cologne upper choir, while the boxy tower and delicate pinnacles
of Rahn Plan A seem to emerge more from the tradition of Strasbourg Plan B. The
stylistic dichotomy between the two schemes is not absolute, however. The prominent
balustrades and Cologne-type corner pinnacles, for example, occur in both drawings,
suggesting that they were produced by draftsmen with many ideas in common—or even
by a single draftsman interested in exploring two contrasting design solutions. The two

Figure 2.52
Freiburg Minster,
elevation of
current tower
base with
geometrical
overlay.

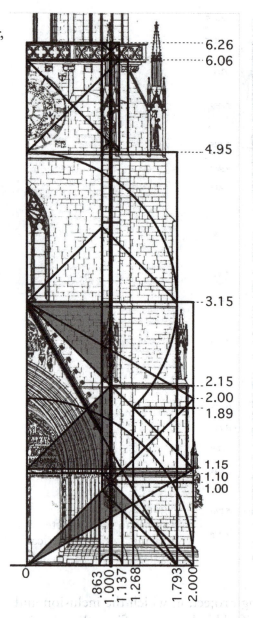

Rahn Plans clearly belong together for a reason, and Kurmann's Fribourg hypothesis, while conjectural, at least begins to explain what that reason might have been.

Significantly, too, this scenario dates the Rahn drawings to the 1280s; they would consequently rank among the oldest surviving workshop drawings of the Gothic era, predating both the completion of the Freiburg spire and the creation of Cologne Plan F. And the Viennese 16.869 shows a simpler variant of the double-balustrade design seen in Rahn Plan B, which may well be a few years older still. All these drawings would thus belong to the pivotal era when the openwork spire idea was first being explored in Cologne and Freiburg, under the impact of innovations from the Strasbourg façade workshop. Because this dialog would prove to be so crucial for the subsequent history of Gothic architecture, especially in Germany, it is fortunate that at least a few drawings survive to document its history. Impressive drawings such as Strasbourg Plan B and Cologne Plan F have, of course, achieved great fame among students of Gothic architecture. The lesser-known drawings associated with the Freiburg project, though, deserve more careful scrutiny than they have received to date.

To make sense of Rahn Plan B, the Viennese 16.869, and studies of the Freiburg tower such as the Viennese 16.874, one must begin by considering the actual Freiburg tower base, which appears to have been a crucial prototype for all these drawings (Figure 2.52). The tower base was built together with the western bays of the nave; no masonry seams separate these two parts of the structure. Since scholars have long recognized similarities between the naves of Freiburg Minster and Strasbourg Cathedral, and since the early part of this chapter demonstrated close links between the geometries of the Strasbourg nave and Strasbourg Plan A, one might well expect to encounter some of the proportioning schemes in the Freiburg tower that occur in those other projects. And, indeed, combinations of square, triangular, and circular geometries govern the proportioning of the tower base. These explain the dimensions in the structure far better than the purely modular schemes proposed by Hecht.

The most important geometrical given in the Freiburg tower base is the span between the buttress axes. Calling this span two units, such that the span from the building centerline to the buttress axis is one unit, one finds that the span from the building centerline to

the outer margins of the lateral buttresses is exactly two units. Hecht recognized this basic relationship, but he could not easily explain the widths of the buttress flanges, which emerge naturally from geometrical constructions, as the lowest shaded triangle in Figure 2.52 shows. The upper-left facet of this triangle is a 45-degree line rising from the trumeau base to height 1.00 on the main buttress axis, while its upper-right facet is given by another diagonal descending from this point towards the outer buttress base. The bottom edge of the triangle is defined by a line of 30-degree slope rising from the trumeau base towards the outer buttress margin, which it intersects at height 1.15. The rightmost point of the shaded triangle thus falls 1.268 units to the right of the tower centerline, precisely aligned with the edge of the buttress flange. The buttress flange location is thus determined by a simple and elegant relationship between the "*ad quadratum*" and "*ad triangulum*" geometries of the square and equilateral triangle. Since this relationship recurs in all the main Freiburg tower drawings, it will henceforth be called, for sake of convenience, the "primary geometrical relationship" in the tower base.[69]

Several other important horizontal dimensions can be established directly from this "primary geometrical relationship." The span of the lateral buttresses between heights 2.15 and 3.15 is 1.793 units, which is precisely $\sqrt{2}$ times the 1.268 unit span of the buttress flanges. This relationship can be seen in the way the large circular arc, centered at height 3.15 and framed by the lateral buttress, sweeps down to meet the buttress flange at height 1.89, along a diagonal falling from the arc's center. The 1.793 width also appears to have been used to help set the width of the forward-facing main buttresses. When a diagonal is struck upwards and to the left from the point on the baseline 1.793 units right of the tower centerline, it hits the bottom face of the lowermost shaded triangle at a point 1.137 units out from the centerline. This point falls on the outer margin of the frontal buttress face. The inner margin of the buttress can be found by reflection, at a distance 1.000 .137 = .863 units from the centerline. In all of these cases the agreement with the survey dimensions cited by Hecht is truly excellent, even better than he achieves with his more *ad hoc* modular assumptions.[70]

The vertical dimensions of the tower base prove somewhat harder to explain in rigorous geometrical terms, in part because the main moldings dividing the tower into stories are not perfectly uniform and horizontal. The second major molding on the tower, for example, is some 40 centimeters higher on the south tower face than it is on the north.[71] While this juggling of levels muddies the geometrical waters somewhat, there is at least a

[69] Interestingly, however, the Nuremberg drawing does not incorporate this relationship in the flange geometry, nor do the distortions in its groundplan match those seen in the actual tower. These disjunctions, along with the drawing's more obviously distorted vertical proportions, suggest that it was a late copy drawn by someone with little understanding of the actual tower design and its nuances.

[70] The measurements provided by Hecht are 15.71 and 12.39 meters for the flange span and buttress axis span, respectively. The ratio of 15.71/12.39 is 1.2679. The triangular construction described here gives 1.2679, also, for accuracy to five decimal places. Hecht, for his part, suggests that the flange span was to have been 50 feet 6 inches, in contrast to the buttress axis span of 40 feet, which gives a ratio of 50.5/40 = 1.2625. The span between the inner buttress faces is 10.69 meters, which divided by the interaxial span of 12.39 meters gives a ratio of .863. The frontal buttress faces are 1.70 meters wide, so that the span between their outer faces is 10.69 + 1.70 + 1.70 = 14.09 m, where 14.09/12.39 = 1.137. See Hecht, *Maß und Zahl*, p. 344.

[71] This anomaly may help to explain why Hecht gives heights of 5.62 and 6.00 meters for the heights of the second and third tower stories, respectively, even though his own graphic clearly shows that the second story is taller than the third on the south side, where he lists his measurements. He appears, in other words, to have transposed numbers from the north side to the south. See Hecht, *Maß und Zahl*, p. 344.

rough equivalence between the stories bounded by the first, second, and third moldings, which are shown at heights 1.15, 2.15, and 3.15 in Figure 2.52. This equivalence is signaled by the presence of two equal-sized shaded triangles filling the space between these levels in the graphic. As subsequent discussion will show, this equivalence also seems to have been noted by the draftsmen who created the drawings of the Freiburg tower variants now in Vienna and Fribourg.

The geometry of the main portal gable interlocks with the overall design of the tower base in several interesting ways. Its sides have perfect 60-degree slope, thereby signaling an "*ad triangulum*" geometry, just as the aisle gables in the closely related Strasbourg Plan A also had (compare Figures 2.52 and 2.13). And, when its apex is taken as the centerpoint of a large circular arc with the previously established radius 1.793, the top of this arc coincides with the top of the fourth tower story, the chapel of Saint Michael.[72] This level, shown as height 4.95 in Figure 2.52, likely marks the last phase of construction according to the original tower design.

The geometrical structure of the present Freiburg tower base recalls that of Strasbourg Plan A not only in its combination of "*ad triangulum*" and "*ad quadratum*" systems, but also in its conceptual planarity. Unlike Strasbourg Plan B and Cologne Plan F, which involve geometrical modules based on the groundplan of the towers, these compositions appear to involve only the vertical plane. For this reason, it was impossible to reliably estimate the depth of the façade portrayed in Strasbourg Plan A. For this reason, too, the Strasbourg nave structure could be extruded along its east–west axis as repeating series of frames based on the buttress section. It may be significant, in this context, that the Freiburg tower base is not a perfect square, but a rectangle slightly longer in its north–south dimension than along its east–west axis. This may suggest that the tower, like the Strasbourg nave, was conceived as the extrusion of an elevation lengthwise, rather than a vertical extrusion of a regular groundplan.

Friedrich Vellguth, one of the few scholars to engage substantively with Hecht's densely argued analysis of the Freiburg tower, proposed that the tower geometry involved not only triangulation and quadrature, but also pentagonal geometries. More specifically, he proposed that the rectangular footprint of the tower plan was chosen to circumscribe a pentagram, with the short side thus relating to the longer one by a factor of cos18°, or .951. This choice, he believes, may have been motivated by the designer's interest in Platonic geometry, or by the patron's desire to incorporate the number 5, which could symbolize the five wounds of Christ.[73] Such appeals to geometry and mysticism distinguish Vellguth's work from Hecht's. Both authors claim that modularity played an important role in the design process, but they cannot agree on the size of the module used in the Freiburg workshop; Hecht argues for a foot of .3109 meters, Vellguth for one of .315 meters.[74] Unlike Hecht, moreover, Vellguth sees the modules as essentially secondary in importance,

[72] The height to the gable apex is given in Figure 2.52 as 3.15, which aligns with the top of the third shaded triangle in the figure. A slightly lower point in the gable frame can also be found by striking a line of 60-degree slope up from the point on the tower baseline 1.793 units out from its center. This construction will give a height of $1.793 \times \sqrt{3} = 1.793 \times 1.732 = 3.11$ units. The interval between 3.11 and 3.15 corresponds closely to the third horizontal molding on the tower. The byplay between these two constructions may relate to the subtle juggling of molding levels in the tower mentioned previously.

[73] Friedrich Vellguth, *Der Turm des Freiburger Münsters* (Tübingen, 1983), pp. 44–7, 225.

[74] Hecht, *Maß und Zahl*, p. 358; Vellguth, *Der Turm des Freiburger Münsters*, p. 12.

providing convenient approximations to forms originally conceived geometrically. Thus, for example, he argues that the footprint of the Freiburg tower base was meant to measure 600 by 630 inches, or 50 by 52.5 feet, which gives a ratio of 20 to 21 units, a known approximation to cos18° based on the proportions of the Pythagorean 20-21-39 right triangle.[75] Vellguth's analysis is valuable, since it begins to explain how geometrical thinking might be converted into workshop practice, and since it has greater explanatory power than Hecht's essentially *ad hoc* modular schemes. His arguments are less than fully convincing, however, for three principal reasons: first, because he credits Gothic builders with a level of mathematical sophistication far beyond that usually imputed to them; second, because his proposed geometries often fail to locate key articulation points in the tower; and third, because he provides many different possible geometrical reconstructions for each element of the tower design.[76] This confusing multiplicity leaves the reader to wonder which alternative scheme, if any, actually had relevance or primacy for the tower's designers. Examination of original medieval drawings such as those discussed in this book suggests the Gothic design process was far simpler and more straightforward than Hecht and Vellguth imply, even in the case of the Freiburg tower.

The Viennese drawing 16.869 depicts a tower base similar in many geometrical respects to the present tower, but not identical (Figures 2.46c and 2.53). Its outboard buttress faces, like those of the present tower, are exactly twice as far out from the building centerline as the axes of the forward-facing buttresses. The same "primary geometrical relationship" between 45-degree and 30-degree lines locates the buttress flanges 1.268 units out from the building centerline in both cases, as the lowest shaded triangles in Figures 2.52 and 2.53 indicate. And the first prominent horizontal molding in both falls at height 1.15. But, the establishment of the buttress widths in 16.869 follows more readily than in the actual tower. In 16.869, a diagonal rising from the trumeau base intersects this horizontal molding at point (1.155, 1.155) so that the buttress margin falls 1.155 units out from the building centerline, instead of the 1.137 seen in the present tower.[77]

The second and third horizontal moldings in 16.869 fall somewhat higher than in the real tower, at heights of 2.42 units instead of 2.15, and 3.68 instead of 3.15. As the upper shaded triangles in Figure 2.53 show, the intervals between the three lowest moldings closely match the span of 1.268 units from the tower centerline to the buttress flange. In the actual tower, the corresponding shaded triangles are smaller, with leg lengths of 1.000 unit instead of 1.268 units, because they were framed by the buttress axes rather than by the buttress flanges. In 16.869, as in the actual tower, a large circular arc of radius 1.793 units determines the height of the tower story that rises above the gable tip. In the drawing this arc is centered at height 3.68, so that it reaches a maximum height of 5.48, locating the top margin of the first tower-wrapping balustrade. The intersection of this arc with the principal buttress axis locates the lower edge of that balustrade at

[75] Vellguth, *Der Turm des Freiburger Münsters*, p. 43.

[76] Vellguth credits the builders with the ability to derive roots by the techniques he calls *Regula falsi* and *Kamelrechnung*. See *Der Turm des Freiburger Münsters*, esp. pp. 9–11, 44, 55.

[77] More precisely, the number here is 1.1547. This has been rounded to 1.15 on the right side of Figure 2.53, but to 1.155 along the bottom margin, since more precision is necessary to effectively describe the smaller lengths seen in the horizontal dimension of the tower. The underlying geometry, though, results from the construction of a perfect square.

height 5.18. Drawing 16.869 thus incorporates a slightly permuted version of the design principles evidently used to set the story heights in the actual tower.

In terms of both form and articulation, the gable in 16.869 departs somewhat from the one in the present structure. Its slope of 67.7 degrees is steeper than the 60 degrees seen in the actual tower base; this slope can be found by connecting the point on the buttress axis at height 1.15 with the point on the tower centerline at height 3.57, where a diagonal struck back from the buttress margin at height 2.42 meets the centerline. This level also marks the base of the molding that terminates at height 3.68. The inner field of the gable in 16.869 is filled with tracery, and there are five ornate vegetal crockets on each gable face, instead of the ten smaller ones seen in the actual tower. The pinnacles on the buttresses flanking the gable are also taller and more elegant than those in the present tower base, and they are placed higher in the overall structure. Their shafts begin to taper at height 1.73, i.e. $\sqrt{3}$, where an arc of radius 2.00 centered on the trumeau base cuts the main buttress axis. This relationship provides further evidence that the creator of 16.869 remained interested in *"ad triangulum"* geometries, even if he eschewed them in the creation of his gable.

Since the detailing of 16.869 appears slightly more advanced than that of the Freiburg tower base, in stylistic terms, it seems likely that the drawing was produced at a time when at least the lowest stories of the tower already stood. The close relationship between the geometrical logic of the drawing and that of the tower, meanwhile, suggests that the draftsman responsible for 16.869 knew the design methods of the Freiburg workshop intimately. The updated detailing and slightly revised proportions in the drawing, though, demonstrate that he was using the tower design as a springboard for his own ideas, rather than representing the structure precisely as it stood. The most likely function for such a drawing would be to develop a design for the tower superstructure and spire, given the structure of the tower base. Alternatively, 16.869 may be a slightly updated copy of an early design for the whole ensemble.

The upper stories of 16.869 may well represent the oldest surviving design for Freiburg's upper tower and spire (Figure 2.54). In this scheme, the tower story between the two balustrades relates clearly and logically to the tower base. The buttresses continue smoothly upward on their established axes—which they do not in the closely related Rahn Plan B and its variants. The tower core appears to be a simple rectilinear box, with the buttresses appended at right angles. The geometry of this zone is very simple as well. The tower and its buttresses fit precisely into a perfect square whose side length is given by twice the 1.793 radius of the large circular arc that defined the width and height of the story just below the lower balustrade. This width, measured across the outside faces of the buttress tabernacles, exceeds the 1.268 unit width of the blocky tower core by a perfect $\sqrt{2}$ factor. In the vertical dimension, this master square reaches from height 5.48 to height 9.07. Its upper corner coincides perfectly with the edge of the parchment at this point, suggesting that the parchment was trimmed deliberately about this element of the geometrical armature. Within that square, a rotated square can be inscribed, and a circle around the resulting octagon. The bottom point on the circle, at height 5.90, locates the capitals of the small tabernacles on the pinnacles. The top point of the circle, at height 8.65, locates the bottom margin of the upper balustrade. The right-hand facet of the octagon, meanwhile, ends at level 7.80, establishing the springline for the main window

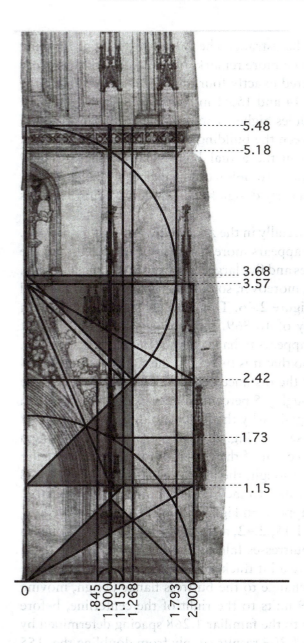

Figure 2.53
Drawing 16.869 (as in Figure 2.46c), lower portion with geometrical overlay.

arches. The upper-right diagonal facet of the octagon crosses the buttress axis at height 8.07, the level where the tiny sub-pinnacles on the buttresses terminate. And the outer flange of the same buttress crosses the lower diagonal face of the octagon at height 6.64, where the outer pinnacles begin to taper.

The presence of an octagonal figure in this part of the tower elevation deserves comment, because it shows that the creator of 16.869 was already beginning to prepare the way for the octagonal geometry of the spire base, even though the tower remains square in plan all the way up to the second balustrade. The grotesque mask in the spandrel below the balustrade tapers to a point just below the corner of the generating octagon, which defines the location of the tower's corner flange in the octagonal story above.[78]

In the next story of 16.869, the octagonal plan geometry reveals itself explicitly, but the basic geometrical givens established lower in the drawing continue to govern the design. The lines framing the entire composition are the verticals 1.268 units out from the building centerline that arose from the basic "primary geometrical relationship" in the lowest story of the tower base. The octagon inscribed within these framing verticals perfectly locates the corner flanges of the octagonal tower core, which terminates in richly crocketed opaque gables like those introduced in the Cologne upper choir. The pinnacles flanking the tower core also recall those of the Cologne upper choir, suggesting once again that influence from this city, rather than from Strasbourg, helped to catalyze the development of the openwork spire in Freiburg. The vertical dimensions of the tower superstructure and spire can be easily counted out in square modules 1.268 units on a side, and the shape of the parchment follows this form, as well. The tips of

78 The rightmost margin of the window frame lies very slightly to the left of this geometrically crucial vertical, either because of imprecision in the drawing process, or because an alternative construction was used. As the dotted lines in Fig. 2-53 show, for example, a diagonal rising to the left of the buttress axis point (1, 5.48) intersects the diagonal rising from (0, 5.48) at (.5, 5.98). The vertical defined by the octagon corner falls .526 units to the right of the tower centerline, instead of .500.

the pinnacles fall two such units above the balustrade. The tips of the finials crowning the gables are another module higher. And even more remarkably, roundels in the tracery articulation of the openwork spire are centered exactly four and five modules above the balustrade, as the small circles at heights 14.14 and 15.41 in Figure 2.54 show, while the tip of the spire finial falls another three modules higher. The total height of the structure would thus be 19.21 times the distance between the building centerline and the principal tower axis. Since the equivalent dimension in the actual Freiburg tower base is 6.19 meters, the total height of the structure shown in 16.869 would have been 118.91 meters, assuming that the drawing actually shows an early design for the Freiburg spire, as seems highly probable.

Rahn Plan B closely resembles 16.869, especially in the zone below the first balustrade. Both drawings include similar detailing that appears more stylistically advanced than the present tower base, featuring slender pinnacles and five large foliate crockets per gable side. Both are drawn at essentially the same scale, moreover, so that their main balustrades fall at the same absolute heights, as shown in Figure 2.46. This strongly suggests that Rahn Plan B was produced as an elaborated copy of 16.869. Interestingly, however, a slight misalignment in the layout of the Rahn Plan appears to have complicated this relationship. The tower axis in Rahn Plan B leans subtly, so that it is further to the right at ground level than it is in the spire zone. This means that the distance between the centerline and the right-hand buttress axis at ground level is roughly 5 percent smaller in Rahn Plan B than it was in 16.869.[79] This, in turn, helps to explain why the lower moldings fall somewhat lower in the Rahn Plan than in the Viennese drawing: the same proportioning system appears to have been applied in the lowest section of the tower, but at a slightly smaller scale. In Figures 2.55 and later illustrations, though, the interaxial span in Rahn Plan B has been set equal to those in the other drawings to facilitate proportional comparison. The same sequence of shaded triangles thus appears in Figures 2.53 and 2.55, establishing the main story-dividing moldings at heights 1.15, 2.42, and 3.68. In Rahn Plan B, just as in 16.869, the faces of the forward-facing buttresses fall .845 and 1.155 units out from the tower centerline, so that the buttresses are a bit thicker than in the actual tower. The creator of Rahn Plan B introduced a small change to the buttress flange design, moving it outward at ground level to a point 1.309 units to the right of the centerline, before allowing it to taper back in its upper reaches to the familiar 1.268 spacing determined by the "primary geometrical relationship." The 1.309 results simply from doubling the .155 interval already used to locate the edges of the main buttresses.

In Rahn Plan B, as in 16.869, the pinnacles on the buttress faces begin to taper at height 1.73, which is $\sqrt{3}$, but this level goes on to play a more important level in the former drawing, as Figures 2.55 and 2.64 show. The top of lip of the third molding falls two units higher, at level 3.73, and the top lip of the first balustrade falls another two units higher, at level 5.73. These new levels introduce several other subtle distinctions between the two drawings. The gable of Rahn B, for example, is a tiny bit steeper than in 16.869, since the apex of the composition falls at height 3.73 instead of 3.57. More consequentially, these height adjustments relate to several width adjustments in the lateral buttress faces, which in turn help to create a geometrical context for the design of the

[79] The span between the centerline and the buttress axis in Rahn Plan B is thus roughly 10.3 centimeters, instead of the roughly 10.8 centimeters seen in 16.869.

Figure 2.54
Drawing 16.869, upper portion with geometrical overlay.

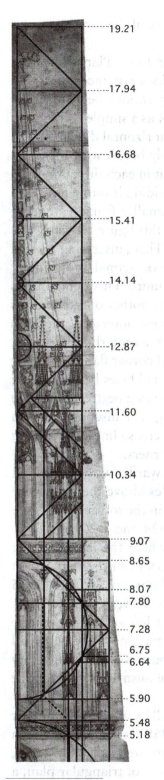

superstructure above the balustrade. A line of 60-degree slope departing from the trumeau base reaches level 3.73, 2.155 units out from the centerline, directly above the point where the buttress sockel meets the ground. The lateral buttress face falls halfway between this point and the vertical 2.000 units out from the centerline. Even at ground level, therefore, the buttresses in Rahn Plan B have slightly greater relative width than they do in 16.869, or in the actual Freiburg tower.[80] This adjustment may signal that Rahn Plan B was intended for Fribourg, Switzerland, or some other center rather than Freiburg, as Kurmann had proposed, although it should be noted that none of the drawings under discussion here fully captures all the nuances of the actual Freiburg tower base design. More immediately, the greater relative width of the Rahn B buttresses translates into a greater radius for the major arc used to establish the height of the chapel story and its articulation. The arc in Rahn Plan B has a diameter of fully 2.000 units, instead of the 1.793 units seen in those other versions of the tower design, so that it sweeps up from height 3.73 to height 5.73, crossing the main buttress axis to locate the bottom margin of the balustrade at height 5.46. So, while the tower bases shown in Rahn Plan B and 16.869 are very similar in their overall dimensions, the one shown in Rahn plan appears slightly taller when each is measured against the span of its respective buttress axes.

One small subtlety of the chapel story in Rahn Plan B hints at the radical rethinking of the belfry geometry that becomes evident above the first balustrade. In the upper portion of Figure 2.55, a dotted line departs the tower centerline at height 3.73, rising to meet the outboard edge of the tower at height 4.56, which is marked by the bottom edge of a drip molding on the lateral buttress. Slightly lower and to the left, this dotted line intersects the large arc of radius 2.000, establishing the location of the buttress face at this level. The slope of this dotted line is 22.5 degrees, the characteristic angle of octagonal symmetry. The proportions of the chapel

[80] The total span from the tower centerline to the outer buttress face approximates 21.6 centimeters in both Rahn Plan B and 16.869, though. This match in absolute dimensions, like the match between the drawings in terms of absolute balustrade heights, reinforces the idea that Rahn Plan B might have been created as a copy of 16.869 or some closely related prototype. Whether the slight contraction of the buttress axes was a deliberately planned refinement or an unintended consequence of the crooked central axis layout, however, remains unclear.

story in Rahn Plan B thus relate directly to the octagonal symmetry of the foreseen tower superstructure and spire.

Above the level of the first balustrade, the plan geometry of Rahn Plan B diverges markedly from that of 16.869. Although the Rahn drawing does not incorporate an explicit groundplan, its proportions prove that its belfry story should be read as an octagonal prism flanked by pinnacles of triangular plan, instead of as a simple rectangular box like the one shown in 16.869.[81] Figure 2.56 shows how the horizontal dimensions in Plan B relate to a plan of this faceted type. The designer probably began with the outer frame of the composition, a simple square extending two units out in each direction from the tower center. By inscribing a circle within that frame, and dividing it into eight slices in the usual octature fashion, he could have defined a slightly smaller frame extending out 1.848 units from the center. As verticals extending up from this figure indicate, this width locates the outer face of the outer pinnacle in the drawing. Then, inscribing rotated squares within this inner frame, he could have established the octagonal footprint of the tower core, whose radius from center to face equals 1.307 units. This octagon has inner corners .541 units out from the centerline, corresponding to another of the verticals shown in the drawing. And, a circle inscribed within this octagon intersects the lines connecting its alternate corners at points .394 and .602 out from the centerline. Together, therefore, these three verticals in the drawing describe the edges of corner flanges framing the octagonal tower core. Equilateral triangles based on the diagonal faces between these flanges have corner tips 1.364 units out from the centerline, coinciding perfectly with the vertical lines in the drawing from which the large gargoyles spring. The discontinuities in the rosette pattern in the balustrade just above the gargoyles are crease lines, confirming that this level is supposed to fold into a star shape with salient corners.

This star-shaped plan is inherently elegant, but it accords awkwardly with the plan of the tower base, as axis shifts in the pinnacles attest. The pinnacles above the balustrade stand slightly outboard of the major tower buttresses established in the tower base. More specifically, the forward-facing pinnacles fall between verticals .924 and 1.207 out from the tower centerline, corresponding to the points in the plan where the large circular arc intersects the rays reaching out at 45 degrees and 22.5 degrees from the centerpoint (Figure 2.56). The buttresses in the lower tower, by contrast, fell between .845 and 1.155 out from the centerline. This shift is evident near the top of Figure 2.55, where the heavy black vertical of the lower buttress axis sits measurably to the left of the tabernacle above. Just above the balustrade in Plan B, meanwhile, the outer margins of the outboard pinnacles are slightly cantilevered outwards with respect to the buttress face in the story immediately below, a highly unusual arrangement that signals the mismatch between the geometrical logic of the tower's base and its superstructure.

These subtle but significant discontinuities show that Rahn Plan B incorporates dramatic new ideas not yet seen in the superficially similar Viennese 16.869. Instead of having a simple boxy second tower story with orthogonally placed buttresses, as 16.869 does, Rahn Plan B features an octagonal tower core flanked by buttresses of triangular plan, a

[81] As noted previously, this basic octagon-plus-triangle format appears explicitly in the groundplans accompanying the Nuremberg drawing and the Moller engraving, both of which show variants of the same double-balustrade elevation format as Rahn Plan B. The plan in the Nuremberg drawing includes dramatic angular distortions unseen in the other drawings, or in the Freiburg tower itself, but the plan in the Moller engraving is quite close to the one implied by Rahn Plan B and shown in Figure 2.56.

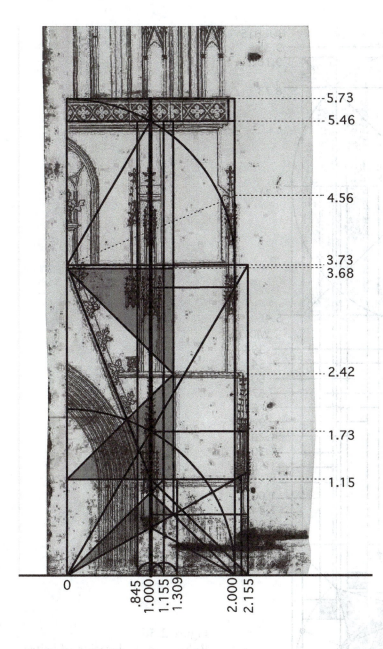

5.73
5.46
4.56
3.73
3.68
2.42
1.73
1.15

0 .845 1.000 1.155 1.309 2.000 2.155

Figure 2.55
Rahn Plan B, lower portion with
geometrical overlay.

format also seen in the present Freiburg spire.[82] In elevation, though, Rahn Plan B closely
resembles 16.869, since both drawings feature two spire-wrapping balustrades, rather
than the single one seen in the present, more concise design. It appears likely, therefore,
that Rahn Plan B represents a "missing link" between the 16.869 scheme and the final
Freiburg scheme. Given the geometrical simplicity of 16.869, the awkward complexity of
Rahn Plan B, and the resolution of these awkwardnesses in the present Freiburg tower,
no other alternative temporal ordering seems plausible. It is possible, as Kurmann has
suggested, that Rahn Plan B was actually commissioned for use in Fribourg, Switzerland,
but the drawing certainly reflects ideas developed in connection with the Freiburg spire

[82] This pinnacle format, seen also at Saint-Denis and at Saint-Etienne in Caen, is to be distinguished
from the cruciform type introduced in the Cologne choir, which would look similar in elevation.

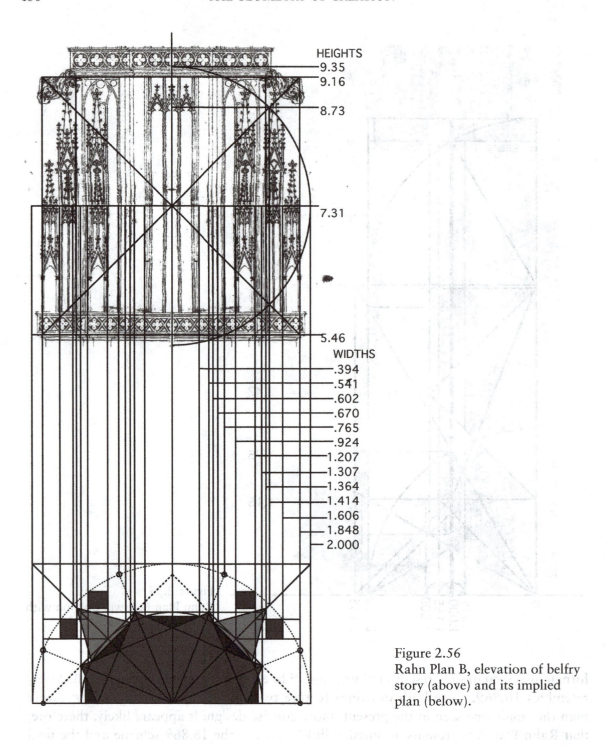

HEIGHTS
9.35
9.16
8.73
7.31
5.46
WIDTHS
.394
.541
.602
.670
.765
.924
1.207
1.307
1.364
1.414
1.606
1.848
2.000

Figure 2.56
Rahn Plan B, elevation of belfry
story (above) and its implied
plan (below).

project. If the drawing's production was indeed associated with the beginning of work on
Fribourg's church of Saint Nicholas in the 1280s, then it probably records ideas current
in the Freiburg workshop at that point.

In the upper stories of Rahn Plan B, as in most Gothic tower designs, the vertical
dimensions in each story relate closely to the horizontal dimensions in the corresponding
groundplan. Figure 2.56 shows that, as in 16.869, the story between the two balustrades
is a perfect square in elevation. The center of this square, at level 7.31 in Plan B, can

be located by striking a diagonal back from the point at (1.848, 5.46), where the outer pinnacle face begins to rise from the baseline of the lower balustrade. This midline of the square also marks the level at which the outer pinnacles flanking the belfry begin to taper. The upper-right corner of the square, at (1.848, 9.16), coincides perfectly with the upper-right corner of the large gargoyle that leans out from the tower just below its upper balustrade. In this instance, and in several later Gothic examples still to be discussed, grotesque figures actually call attention to crucial points in the drawing's geometrical armature. The large circle of radius 2 intersects the upper diagonal of the square $1.414 = \sqrt{2}$ units out from the building centerline at height 8.73, establishing the level where the traceried lancets on the tower faces begin to taper.

The same basic geometrical principles govern the tower story above the second balustrade, as well, as Figure 2.57 shows. Diagonals struck back from the gargoyle corners at height 9.16 intersect the tower centerline at height 11.01, the level from which the second tier of gargoyles springs. An octagon centered at this level and inscribed between the verticals rising from the corners of the buttress flanges below reaches up to height 12.38, locating the base of the spire proper. A rotated square framing this octagon has a lower facet that aligns with the face of the upper salient gargoyle, while its upper tip locates the top of the tower's gable crown at height 12.94. When a cardinally oriented square of the same size is placed on the spire base at level 12.38, its upper corner reaches height 15.10, coinciding quite precisely with a corner of the parchment, demonstrating once again that parchments were often trimmed to fit the geometrical armatures used in the drawing process.

While the overall geometrical organization of Rahn Plan B appears lucid, a number of irregularities complicate geometrical analysis of its uppermost reaches. The most obvious of these problems is that the sloping lines describing the spire continue off the parchment without converging. More than a simple truncation of the parchment seems to be at stake here, since extensions of these lines would converge appreciably to the left of the drawing centerline, which should not happen in any notionally symmetrical design.[83] It is therefore difficult to tell precisely how tall the full structure was meant to be. Since Rahn Plan B generally appears to record an updated and improved version of the design shown in 16.869, its spire was probably meant to be roughly as tall as the one shown in that Viennese drawing. It may well be that the top piece of parchment was added to accommodate the finial of the alternative tower design seen in the opposite side of the sheet, in Rahn Plan A, without providing enough room for the larger spire shown in Plan B, but the sequence of the drawings' production remains unclear.

Rahn Plan B, whatever its precise relationship to Rahn Plan A and to the early tower planning for Fribourg, Switzerland, certainly belongs in the architectural orbit of the

[83] The previously mentioned slope of the centerline of Plan B may have contributed the off-center convergence of the spire-describing lines. Some rotational distortion also appears in the walls of the tower just below level 12.38, as the dotted lines in Figure 2.57 indicate, and this may explain why the small circle on the spire axis is centered just above the square center at level 13.74, rather than precisely on this level, where one might expect to find it. There is also a subtle distinction of scale between the rotated squares centered at level 11.01 and those shown in the groundplan in Figure 2.56. The edges of the former align with the corners of the triangular flanges in the elevation, as one can see just below level 12.38, which means that they fall 1.364 units out from the tower centerline, instead of 1.307 as they should. What role these small distortions may have played in the more dramatic anomalies in the spire layout, however, remains unclear.

Freiburg spire project. The tower base in the drawing derives obviously from the one in Freiburg, despite its updated details. The upper tower design in the drawing, with its octagonal tower core flanked by triangular corner pinnacles, seems to anticipate the format of the current Freiburg spire. The introduction of this new geometry disrupted the vertical continuity seen in the simpler, blockier, and presumably older design shown in 16.869. The creator of Rahn Plan B, though, had not yet chosen to embrace disjunction and contrast as positive formal values. The designer of the present Freiburg spire took this bold step, developing a new scheme in which the streamlined spire superstructure would soar upwards from the blocky tower base like a rocket from a launch pad. He abruptly terminated the large buttresses that his predecessors had constructed, capping them with sloping flanges flanked by small, pinnacled aediculae. Above this short transitional story, he wrapped a single prominent balustrade, whose bladed corners poke out between the dying buttress flanges. The star-shaped plan of this balustrade reflects the footprint of the octagonal tower core and its four triangular corner pinnacles.

The complex plan of the present Freiburg spire has proven stubbornly resistant to scholarly analysis. Here, as in the study of Gothic design more generally, Konrad Hecht's critical writings have played a prominent role. Hecht rightly critiqued naïve geometrical hypotheses that only roughly approximate the tower plan. He found fault, in particular, with Walter Ueberwasser's suggestion that the groundplan of the triangular corner pinnacles could be found by connecting lines from the eight corners of the octagonal tower base to the four corners of the square circumscribed around that base. This construction, Hecht claimed, would produce pinnacles with a corner angle of 57° 21', measurably narrower than the 60° that one would expect from the seemingly equilateral geometry of the pinnacle superstructure, and considerably narrower than the nearly 62° found by carefully measuring the corner flanges under the pinnacles in the actual building. Hecht thus cleverly proposed that the corner angle was determined by striking lines from the corner of a square to points exactly one quarter of the way across the square's opposite faces. This more modular construction gives a corner angle of 61° 56', almost perfectly agreeing with the 62° angle in the measured corner flange.[84] But, there are several fundamental problems with Hecht's analysis. First, he appears not to have realized that the 62° angle occurs only in the transitional story between the tower base and the pinnacles, whose plans are perfect equilateral triangles, just as their articulation suggests. Second, and more importantly, he provides no real explanation for the logic of the tower design as whole, offering instead only rather arbitrary modular approximations to the measured dimensions of the structure. And, finally, these approximations are often quite misleading. As the introduction to this book noted, for example, Hecht refused to acknowledge the perfect 2:1 relationship between the total and partial wall thicknesses of the Freiburg tower core, choosing instead to imagine that the thicknesses measured as 196 and 98 centimeters were actually meant to be 194 and 101 centimeters, which

[84] Hecht, *Maß und Zahl*, pp. 349–51. Part of the problem here is that Walter Ueberwasser wrote only fairly briefly and telegraphically about the tower plan in "Der Freiburger Münsterturm im 'rechten Maß,'" *Oberrheinische Kunst*, 8 (1939): 25–32. Interpreting Ueberwasser's text and sketchy diagram differently than Hecht would, Heinrich Lützeler gave a more detailed description of Ueberwasser's supposed scheme in *Der Turm des Freiburger Münsters* (Freiburg, 1955). This scheme gives a corner angle of 64° 28', which is too wide for the real structure, rather than too narrow.

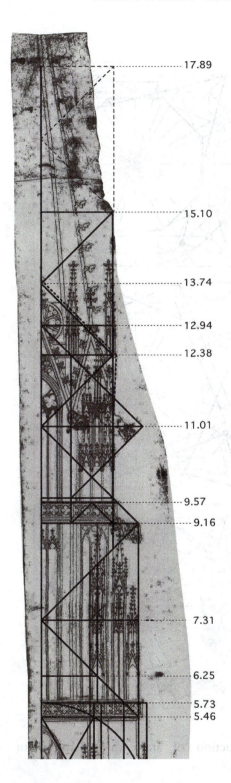

17.89

15.10

13.74

12.94

12.38

11.01

9.57

9.16

7.31

6.25

5.73
5.46

Figure 2.57
Rahn Plan B, upper portion with geometrical overlay.

would be 6 feet 3 inches and 3 feet 3 inches, in his postulated units.[85] Vellguth's analysis of the Freiburg spire plan, meanwhile, has more to recommend it than Hecht's, but its complex combination of modular and geometrical factors remains less than fully convincing.[86] Since Vellguth's approach to geometry remains fundamentally static, moreover, his discussion cannot explain the unfolding logic of the design process.

The details of the Freiburg spire plan become comprehensible when the dynamics of the creative process are taken into account. Figure 2.58 shows how a straightforward sequence of geometrical operations could have produced the Freiburg spire's intricate but elegant plan. The spire designer was certainly a radical formal and geometrical innovator, but he must have paid careful attention to the geometrical givens established in the tower base. The most important of these givens was the span between the axes of the principal buttresses. The spire designer surely began his design process by establishing a base square of this dimension as the generating figure of his groundplan. The corners of this base square, which are highlighted by small circles in Figure 2.58a, locate the tips of the four corner pinnacles flanking the spire. Then, after striking a circle through these corner points, the designer could establish an outer framing square √2 as large as the first. The corners of an octagon inscribed within this square, meanwhile, locate the small corner spurs in the star-shaped balustrade .588 units out from the tower centerline.

Within this octagonally symmetrical framework, the Freiburg spire designer introduced geometries based on the equilateral triangle. As Figure 2.58b shows, he subdivided his tower plan using rays 15 and 30 degrees off each of the tower's cardinal axes. These rays describe narrow petals centered on the 22.5-degree rays of the original generating octagon. The new 30-degree rays intersect the framing circle of the composition at points 1.225 units from the tower

85 Hecht, *Maß und Zahl*, p. 353.
86 Vellguth, *Der Turm des Freiburger Münsters*, pp. 79–89.

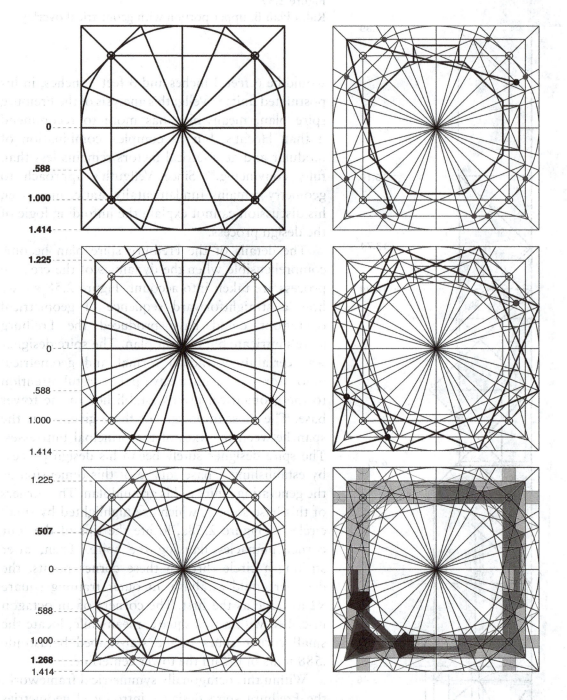

Figure 2.58 Freiburg Minster, hypothetical reconstruction of steps in generation of
tower plan.

centerline, as the black dots in the figure indicate. A square framed by these intersection
points will serve as the armature within which the octagonal tower superstructure was
developed.

In Figure 2.58c, an octagon has been drawn within this square armature, and its alternate corners have been connected to produce two squares rotated 22.5 degrees off the cardinal axes. The corners of these rotated squares represent the footprints of the sharp flanges rising at the corners of the octagonal tower core. These corners each fall .507 units out from the tower centerline. And, as the lower-left quadrant of the figure shows, an equilateral triangle planted with its interior face on the side of the octagon and bounded by the 30-degree rays will have its outboard corner 1.268 units out from the tower centerline. This is the same dimension already defined by the "primary geometrical relationship" in the tower base. So, while the geometrical and formal character of the upper tower and spire differs in many respects from that of the blocky lower stories, the designer of the superstructure managed to retain this crucial dimension from the earlier work by knitting together "*ad quadratum*" and "*ad triangulum*" geometries in a new and clever way. The 1.268 that had described the buttress flanges in the tower base now locates the corners of the triangular platforms on which the pinnacles stand in the tower superstructure.

As Figure 2.58d shows, the corners of the triangular flanges under these pinnacle platforms are slightly set back toward the tower center; the flange is shown in the upper-left corner of the figure, the pinnacle platform at the lower left. The corner of the flange lies 1.225 units out from the tower centerline, on the corner of the square already established in Figure 2.58b. When lines are drawn from this corner point to the rear corners of the pinnacles in the adjacent quadrants, the resultant corner angle is 61° 28', which agrees with the building survey just as well as Hecht's modular scheme. Importantly, too, these lines cut the cardinal axes of the tower at points just inside the perimeter of the original generating square, thus defining a space into which the octagonal inner wall plane of the tower can be inscribed. This octagon, like the rays used to define the corner flanges, is shown with heavy lines in Figure 2.58d. The eight principal uprights of the tower core extend in to meet this octagon. The spaces between these uprights are essentially rectangular boxes in plan; their outboard corners fall at the points where the rotated squares introduced in Figure 2.58c cut the petal lines struck at 15-degree angles to the tower axes. Two of these boxes are outlined in Figure 2.58d.

A few more simple steps suffice to establish the main outlines of the star gallery, as shown in Figure 2.58e. The eight main spurs of the gallery are simply defined by the corners of rotated squares inscribed within the largest octagon in the composition, the one whose sides are 1.414 units from the tower center. As the bottom-left corner of Figure 2.58e indicates, the outermost corner of the star gallery coincides with the corner of the square framing this octagon. The lines describing the angled sides of the gallery run from this corner point to the black dots where the rotated square just described intersects the square with sides 1.225 units out from the centerline. This construction gives a corner angle of 61° 38', closely matching the angle of the triangular spurs at this level of the composition.

Several further steps within this framework establish the thicknesses of the various layers in the wall of the tower core, the very measurements that Hecht had willfully distorted in his discussion of the Freiburg tower plan. As Figure 2.58f shows, a circle inscribed within the octagonal footprint of the tower core cuts the tower's corner flanges just outside the previously described rectangular boxes. The lines between these

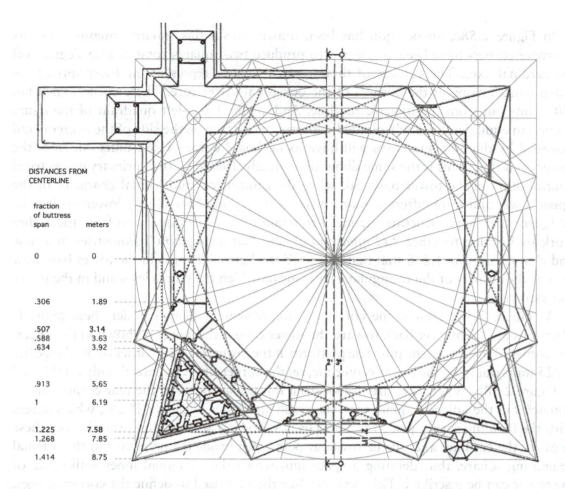

DISTANCES FROM
CENTERLINE

fraction of buttress span	meters
0	0
.306	1.89
.507	3.14
.588	3.63
.634	3.92
.913	5.65
1	6.19
1.225	7.58
1.268	7.85
1.414	8.75

Figure 2.59 Freiburg Minster, plan of current tower with geometrical overlay.

intersection points define the outer wall plane of the tower between the flanges. The outer faces of the rectangular boxes describe the outer faces of the window mullions. And, finally, the inner face of the wall between the eight uprights falls exactly halfway between the inner and outer octagons framing the uprights.

The shading in Figure 2.58f suggests the physical structure of the tower, with the four quadrants of the graphic representing successive stories of the tower. The first quadrant, at upper left, shows the wall of the transitional story, the first part of the tower to be constructed above the tower base. The next quadrant, at upper right, shows how the plan of this story changes, as the wall peels away to reveal the corner flanges of the tower core and the salient blade of the large corner flange under the pinnacle, with its 61° 28' interior angle. The subtle kink in the wall of the transitional story falls where the line defining this interior angle intersects the outline of the star gallery. The tiny slice of wall between this kink and the adjacent corner blade of the tower core falls on the cardinally oriented line connecting these intersection points. The same basic geometry occurs just above the balustrade, as shown in the third quadrant, but windows of the bell chamber start to cut into the center of each of the four main walls. In the upper zone of the tower, such window openings slice into all eight faces of the tower core, leaving just eight bladed uprights as the principal structure; these uprights are shown with dark shading in the

bottom-left quadrant of Figure 2.58f. The corner pinnacle platforms step out slightly to fill the full equilateral triangle footprint of their original generating geometry. The inner structure of the pinnacle involves a slightly smaller triangle with its tip directly above that of the corner flange below, and a hexagon inscribed within that triangle, which are also shown in dark shades.

This geometry agrees beautifully with the measured dimensions of the Freiburg tower core, as Figure 2.59 shows. The quadrants of this graphic are arranged just like those in Figure 2.58f, with cross-sections of the structure taken at four levels. In considering this geometry, of course, one must take account of the fact that the northern and southern facets of the structure were slightly compressed, so that the structure could fit adequately atop the subtly rectangular tower base. As both Hecht and Vellguth noted, the designer of the upper tower removed a narrow strip, 68 centimeters wide, from the middle of his ideal octagonally symmetrical plan, producing a "pseudo-octagon" with six properly sized facets, and two foreshortened ones.[87] Because the subtraction of this strip leaves the other dimensions and angles in the tower unaffected, the notional octagonal geometry of the tower can be easily determined by simply reinserting this missing strip. Figure 2.59 is based on a graphic published by Hecht in which this has been done. The normative dimensions in the tower correspond quite precisely to those predicted by the geometrical design sequence outlined above, which offers greater accuracy and far more explanatory power than the schemes proposed by Hecht and Vellguth.

The elevation of the Freiburg upper tower, like that of so many Gothic towers, involves the extrapolation of geometrical figures defined in the tower's groundplan. When the radical transformation of the tower plan was decided upon, probably sometime around 1300, the tower base stood up to the top margin of the Saint Michael chapel, which terminates at a height of 30.64 meters, or 4.95 units. Above the horizontal molding at this height, the corner flanges of the forward-facing buttresses step in very slightly, to a plane 1.225 units out from the building centerline; this is the span out to the edges of the octagon framing the footprint of the tower core, as determined by the geometrical design process just described. The outboard sides of the statue canopies fall halfway between this edge and the buttress axis, i.e. 1.112 units out from the buttress centerline.[88] This same dimension was chosen as the height of the transitional story. As Figure 2.52 shows, this story thus rises to height $4.95 + 1.11 = 6.06$ units, or 37.5 meters, measured to the base of the star balustrade.

Plays on the plan geometry of the tower core govern the elevation above the balustrade, as Figure 2.60 indicates. The small shaded wedge near the bottom of this figure recapitulates the geometry described in plan with Figure 2.58b, using the interplay between 30- and 45-degree lines within a circle of radius $\sqrt{2}$ to create the fundamental dimension 1.225, which sets the width to the corner flanges of the tower core. When an octagon is inscribed within the frame of verticals so defined, with its base on the balustrade base at height 6.06, many of the basic articulation points in the tower begin to emerge. The octagon's center falls at height 7.29, where the blind tracery below the pinnacles begins to spring,

[87] Hecht, *Maß und Zahl*, p. 353; and Vellguth, *Der Turm des Freiburger Münsters*, p. 72.

[88] At least, this edge is very close to halfway between the buttress axis and the crucial 1.225 spatial envelope. It is hard to tell whether it was supposed to be precisely halfway in between, because there are tiny irregularities in the layout of the story. For purposes of elevation analysis, though, it suffices to observe that the height of the story and the width to the outer face of the canopy both closely approximate 1.11 units.

Figure 2.60
Freiburg Minster,
elevation of
current spire
with geometrical
overlay.

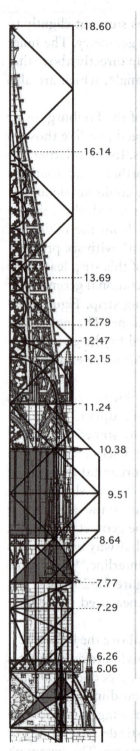

and its upper lateral corner falls at height 7.77, where the leafy horizontal stringcourse marks the base of the pinnacles. Another octagon exactly √2 bigger sits on this level, with its center at level 9.51, and its top facet at height 11.24, marking the top margin of the tower core. A shaded square fills the middle half of this space, reaching from the capitals in the pinnacles at level 8.64 up to the springline of the main tower windows at height 10.38, which is also the level where the gargoyles protrude from the tower. The gargoyles thus play the same geometrical signaling role in the actual tower that they had in Rahn Plan B. The shaded arc between levels 7.77 and 8.64 illustrates the √2 scale relationship between the two octagons that define all the main levels in the upper tower.[89]

Starting at the base of the spire, the geometry of the plan asserts itself in a new and interesting way, as the upper portion of Figure 2.60 demonstrates. The distance from the centerline to the octagon wall, 1.225 units, continues to play a role in defining the elevation. Thus, for example, the eight pinnacles around the tower base terminate at level 12.47, exactly one of these modules above the top margin of the tower core. The first tracery panel of the spire, meanwhile, ends at height 12.15, that is, .913 units above tower core. This distance is none other than the free interior space of the tower, as Figure 2.59 had shown. A circle struck down from 12.47 to 12.15 rises to 12.79, which happens to be the top margin of the second tracery panel. The height of the panel, in other words, equals the difference between the interior and exterior widths of the tower. And it is not just the second panel that has this dimension; all of them do, as the stack of small circles along the left-hand side of the graphic in Figure 2.60 shows. On a larger scale, meanwhile, the bouncing diagonal shows that the total height of the spire cone equals three tower diameters, at least if measured to the small metal sunburst disk atop its terminal finial. By itself, this might seem like a coincidence, since the total height of the spire could be measured to several other slightly different heights, such as the top of the finial proper. Consideration of the drawings most related to the Freiburg tower, however, strongly suggests that this simple 3:1 ratio of height to width was, indeed, intended by the spire designer.[90] As observed previously, this relationship obtained in 16.869, the drawing that may very well record the

 89 Vellguth presents the outlines of this basic geometry in *Der Turm des Freiburger Münsters*, p. 158. This alternative gets lost in the shuffle of possibilities he offers, though, and his horizontal dimensions are not tied to the groundplan of the tower as they are in the scenario sketched here.

 90 Since the current spire is slightly convex, it is shorter than it would have been if the slope of its lower surfaces had been maintained. The 3:1 ratio may well have been the original design goal, before the slope was modified to produce the present profile.

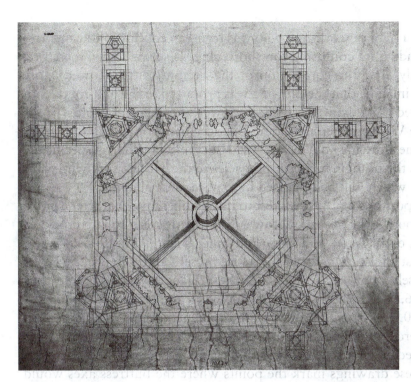

Figure 2.61
Drawing 16.874, detail of
ground plan.

original design for the Freiburg tower. It occurs also in 16.874, which shows a slightly modified version of the present Freiburg tower (Figures 2.46d, 2.61, 2.62 and 2.63).

This precise place of 16.874 in the history of the Freiburg workshop remains unclear, but it probably postdates the construction of the spire. The curvilinear tracery in the main window and balustrade reveals very little about the dating of the drawing's original creation, since these elements were almost certainly added long after the fact, as Hans Böker has demonstrated.[91] The geometry of the tower plan at the bottom of the drawing, though, is more telling, because of its imprecision (Figure 2.61). The draftsman who prepared the drawing certainly meant to capture the format of the Freiburg tower with the greatest possible accuracy. He realized that the real Freiburg tower base was slightly foreshortened in the east–west direction, and he even realized that this had been achieved at the spire level by removing a slice from a regular octagon.[92] However, since he had to develop his spire plan in a rectangular field, rather than in a perfect square, he could not create a regular array of lines by connecting corner points, as the designer of the present spire presumably did before subtracting out the thin middle slice from his generating square. In 16.874, therefore, there was no easy way for the draftsman to control the lengths and angles in his composition, which becomes geometrically muddled as a result. The corner pinnacles, for example, each have different side lengths and different internal angles, ranging from 59.7 to 63.7 degrees. Such errors and inconsistencies would never show up in an original conceptual drawing produced by a designer who perfectly understood the logic of his own work. They would arise very naturally, however, in the

[91] Böker, *Architektur der Gotik*, pp. 181-4.
[92] The creator of the oddly proportioned Nuremberg drawing did not share this insight; instead, he compressed his ground plan by changing the angles and keeping the side lengths equal. This misconception explains some of the geometrical distortions in the Nuremberg ground plan, underscoring the draftsman's unfamiliarity with the nuances of the Freiburg tower design.

work of a later visitor to the Freiburg workshop who was trying to capture all the nuances of its complex design, including its confusing foreshortening. It seems likely, therefore, that 16.874 was begun only after the completion of the Freiburg upper tower. More specifically, it is tempting to imagine that the drawing was produced in the mid-fourteenth century by a visitor interested in studying the Freiburg tower as a relevant prototype for the even larger tower of the Viennese Stephansdom. This scenario would help to explain not only the presence of the drawing in Vienna, but also the inclusion of specifically Freiburgish features such as the triangular corner pinnacles in the earliest surviving plans for the Stephansdom tower, which will be discussed in a subsequent chapter.

The articulation and proportions of 16.874 attest to its documentary character. Unlike 16.869 and Rahn Plan B, both of which show tower bases with large foliate crockets, steeply sloped main gables, extra statue canopies, and other such elaborations, 16.874 depicts a tower base almost indistinguishable from the present one (Figure 2.62). Its horizontal proportions closely approximate those of the present tower base, and they precisely match those of 16.869. In both Viennese drawings, the sequence of buttress measurements is .845, 1.000, 1.155, 1.268, 2.00, as the bottom margins of Figures 2.62 and 2.64 indicate. These proportions arise naturally from the intersection of 30- and 45-degree lines, as explained previously. It is hardly surprising, therefore, that visible prick points on both Viennese drawings mark the points where the buttress axes would intersect 30-degree lines rising from the trumeau base. This evidence clearly demonstrates that the draftsmen conceived their work in geometrical terms, rather than in the modular terms proposed by Hecht. The perfect match between the 1.268 factor seen in the drawings and the proportions of the actual tower, moreover, strongly suggests that the original designer of the tower base determined the width of his buttress flange in precisely the same way. The fact that both Viennese drawings include the same slight deviation from the buttress width—with factors of .845 and 1.155 instead of the .863 and 1.137 seen in the building—shows that their creators understood the built structure imperfectly. And the fact that these men made this same slight mistake suggests that the author of 16.874 may have had a direct familiarity with 16.869. Consideration of the spire articulation in the two drawings will reinforce this impression.

Before going on to explore the upper tower and spire in 16.874, it makes sense to consider the tower base in the drawing more carefully, since this can reveal a great deal about how the Freiburg tower base was understood by later designers. The geometry of the drawing in this lower zone clearly shows combinations of the "*ad quadratum*" and "*ad triangulum*" geometries, just as the real tower does. This resemblance cannot be attributed to the automatic habits of the draftsman, since he abandoned the triangular geometries in the upper part of his drawing, recognizing that the principles of design seen in the actual tower changed above the balustrade to a strictly octagon-based approach.

In geometrical terms, the tower base of 16.874 can be understood as a hybrid of influences from 16.869 and the real Freiburg tower base. As noted previously, the buttress widths precisely match those of 16.869. In the vertical dimension, the springline of the portal archivolts and the top lip of the first molding fall at height 1.15, while the base of the second molding falls at height 2.15. The interval between these main lines is thus exactly one unit, as the shaded triangle in this zone of Figure 2.62 indicates. In proportional terms, this triangle is exactly the same size as the analogous one in the real tower base,

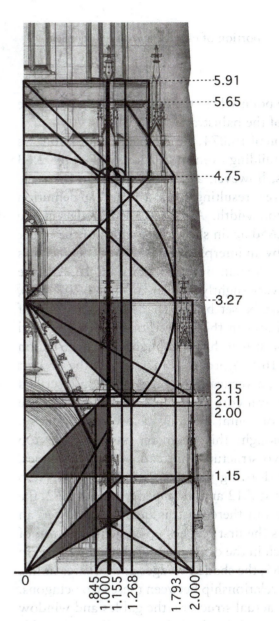

Figure 2.62
Drawing 16.874, lower portion of elevation with geometrical overlay.

as comparison of Figures 2.64c and 2.64d reveals. Drawing 16.874 also includes a prominent horizontal at level 2.00, just below the suture between its two lowermost parchment pieces. The step up between this horizontal and the third horizontal molding is 1.268 units, as the upper shaded triangle in Figure 2.62 reveals. Triangles of this size appear not in the actual Freiburg tower base, but rather in the proportioning of 16.869 and Rahn Plan B. It is unclear whether the creator of 16.874 borrowed from each of these sources in a deliberate act of synthesis, or whether he simply used some of the techniques seen in 16.869 to approximate the form of the Freiburg tower as it stood in his lifetime, but the combination of influences remains striking.

In 16.874, the large arc used to construct the chapel story has its center on level 3.27, and its radius is 1.793 units, i.e. 1.268 times √2, just as in the built structure. But, the chapel in the drawing is shorter, because its upper margin is defined by the point where the circle intersects the main buttress axes, instead of at the uppermost point on the circle. This is the same method used to define the analogous margin in 16.869. The tower base in the drawing, consequently, terminates at height 4.75, instead of 4.95. In both the drawing and the building, the inner face of the buttress falls halfway out from the large circle's radius, .8965 units out from the tower centerline (Figures 2.64c and 2.64d). The outer face of the buttress in 16.874, though, rises smoothly from the ground level with no setback, 1.155 units out from the centerline; the mismatch between these accounts for the slight offset of the tabernacles with respect to the buttresses below. With these widths in hand, the geometry of the transitional story can be determined. The height of the story up to the baseline of the balustrade equals the width from the building centerline to the inner buttress face, while the height including the balustrade equals the width from the building centerline to the outer buttress face. These heights can be found by diagonals struck up to heights 5.65 and 5.91, respectively. In 16.874, even the location of the sloping flange terminating the right-facing tower buttress appears to have been determined by a line in this basic armature; the one struck up from

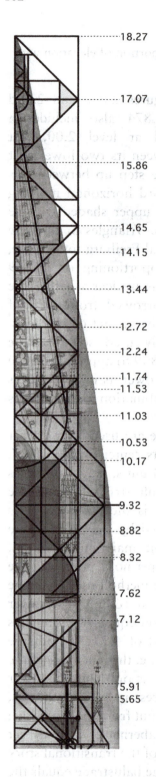

18.27

17.07

15.86

14.65

14.15

13.44

12.72

12.24

11.74
11.53

11.03

10.53
10.17

9.32

8.82

8.32

7.62

7.12

5.91
5.65

Figure 2.63
Drawing 16.874, upper portion of elevation with geometrical overlay

(1.793, 4.75) to the point where the corner of the tower core intersects the base of the balustrade.

In the next portion of 16.874, the geometrical logic follows that of the actual building even more closely (Figures 2.63 and 2.65). There is, however, a tiny difference in the scale of the superstructures, resulting from a different definition of the upper octagon width. As the shaded wedge in the bottom of Figure 2.65d again shows, the width of the upper tower core was set by an interplay of 30- and 45-degree lines and arcs, giving a half-span of 1.225 units. In 16.874, the analogous width is very slightly smaller, around 1.207 units, a dimension that can be set by the shaded combination of 45-degree lines and arcs in the bottom of Figures 2.63 and 2.65c. With these widths in hand, though, the construction of the elevation in 16.874 proceeds much as in the present tower. In both cases, a vertically oriented octagon inscribed in the width of the tower core determines the height from the balustrade to the horizontal molding below the pinnacles. In the drawing, though, this geometry involves the top margins of these two structures, instead of their baselines. The octagon in the drawing thus rises from height 5.91 to 8.32, with its center at 7.12 and its upper corner at 7.62, the pinnacle baseline. From there, just as in the real tower, an octagon √2 as big as the first reaches up to define the top of the tower core, which in the drawing falls at height 11.03. In Figures 2.63 and 2.65, the shaded wedges and squares in this zone show the scale relationship between these two octagons. In 16.874, as in the actual structure, the gables and window head spring at the top of the shaded square, located in this case at height 10.17. The pinnacles of the spire base in the drawing, like those in the real building, are precisely half as tall as the tower core is wide, and the gables protrude above the spire baseline by half the width of the front tower face.

Further powerful evidence for the use of the proportioning armature described here comes from the trimming of the parchment in 16.874, and from the format of its spire. The edges of the parchment pass though the corners of the great octagon, just below level 10.17. The suture between the upper and middle pieces of parchment runs from the upper corner of the octagon's left facet down to its equator on the right facet, at height 9.32. The parchment then tapers to a point at height 18.27, which is precisely three tower widths above the spire baseline at height 11.03. The spire cone of 16.874 drawn within

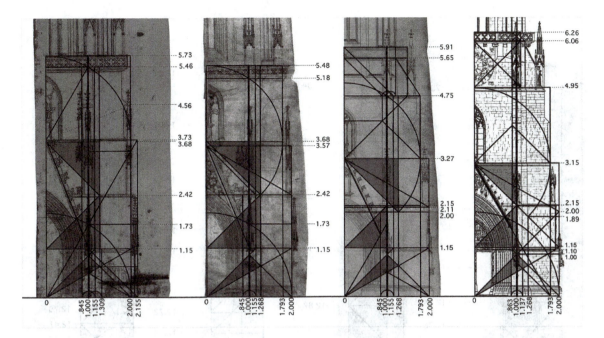

Figure 2.64 Comparison of bases in five tower schemes related to Freiburg Minster, with geometrical overlays. From left to right: a) Rahn Plan A; b) Rahn Plan B; c) Drawing 16.869; d) Drawing 16.874; (e) Modern elevation drawing of the actual Freiburg Minster tower.

this frame differs subtly from the present Freiburg spire, both in its proportions and in its articulation. The spire in the drawing lacks the subtle convexity of the built structure, and its openwork structure consequently frames smaller panels with simpler tracery patterns. In both height and articulation, though, the spire of 16.874 closely resembles that of 16.869. Both are three times as high as their respective tower cores are wide, at least if one measures to the tip of the parchment in 16.874. In both Viennese drawings, moreover, roundels in the tracery call attention to crucial points in the geometrical armature of the spire zone. In 16.874, the roundels at height 13.44 and 14.65 mark points one-third and one-half of the way up the spire cone, respectively. More interestingly, perhaps, a third roundel, at height 14.15, marks a level coincident with the bottom-right corner of an octagon inscribed within the middle third of the spire height. This strongly suggests that such an octagon, equal in size and shape to the footprint of the tower core, was used to count out heights in the spire. Of course, the taper of the parchment in the upper spire would have prevented the whole octagon from being drawn in the top two modules of the three-module stack that comprise the spire. The parchment is large enough, however, to accommodate such an octagon in the lowest level, between heights 11.03 and 13.44. So, while modularity was obviously important for the spire design of 16.874, geometrical figures and their proportions also appear to have played a role in the layout of this zone. And, while the spire articulation of 16.874 resembles that of 16.869 more than that of the current Freiburg spire, the presence of simple 3:1 height:width ratios in both drawn spires strongly suggests that the same relationship was indeed used to guide the design of the real structure before the introduction of the subtle convexity seen today.

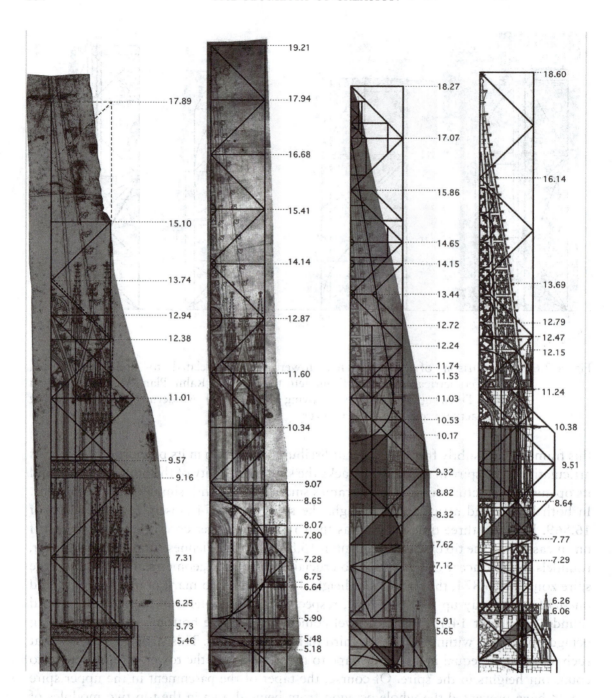

Figure 2.65 Comparison of spire elevations in five tower schemes related to Freiburg
 Minster, with geometrical overlays. From left to right: (a) Rahn Plan A; (b)
 Rahn Plan B; (c) Drawing 16.869; (d) Drawing 16.874; (e) Modern
 elevation drawing of the actual Freiburg Minster tower.

As the preceding analyses demonstrate, consideration of drawings such as 16.869,
16.874, and the Rahn Plans can reveal a great deal about the history of the Freiburg
spire project. Geometrical analysis, in particular, offers a valuable perspective on the
relationship between these drawings (Figures 2.64 and 2.65). Drawing 16.869, whatever

the precise circumstances of its production, almost certainly records an early version of the Freiburg spire design, conceived at a point when the blocky tower base had already been constructed, but before the idea of triangular-planned corner pinnacles had been introduced to the workshop. If the drawing is a thirteenth-century original, it may be the oldest surviving representation of an openwork spire. Rahn Plan B depicts an updated version of the 16.869 scheme, in which the incorporation of the triangular pinnacles introduces unresolved discontinuities between the upper and lower portions of the tower. Since the buttress proportions differ subtly from those in the actual Freiburg tower base, this drawing may well have been commissioned for use in another city, such as Fribourg, Switzerland, as Kurmann proposes. It certainly represents a strongly Freiburgish solution to the problem of axial tower design, though, unlike the more Strasbourgish Rahn Plan A on its reverse. The creator of the present Freiburg spire scheme adopted the triangular pinnacles seen in Rahn Plan B, making a virtue out of the resultant geometrical discontinuity by designing a soaring superstructure whose laciness contrasts dramatically with the blockiness of the tower base. The Freiburg spire, the first openwork spire to be completed, soon achieved well-deserved fame in Germanic architectural culture. The production of 16.874 attests to this interest in the Freiburg project. With its awkwardly distorted groundplan, 16.874 cannot be seen as an original design drawing from the Freiburg workshop, but the generally close match between its geometries and those of the real Freiburg tower shows that its creator was paying careful attention to his prototype. The many detailed resemblances between 16.869 and 16.874, meanwhile, demonstrate that the creator of the latter drawing must have been well familiar with the former. The fact that both drawings have been in Vienna for centuries, probably since the Middle Ages, underlines their relevance for the ambitious tower project begun at the Viennese Stephansdom in 1359. Thus, while the early history of these drawings remains obscure, they clearly attest both to the development of pioneering architectural ideas in the Rhineland, and to the diffusion of these ideas, through the medium of drawing, throughout the Holy Roman Empire.

The refinement of architectural drawing certainly contributed to the emergence of the Rhineland as an architectural superpower in the decades around 1300. The surviving drawings associated with the Strasbourg, Cologne, and Freiburg workshops, in particular, deserve recognition as the first really mature design drawings of the Gothic era, since they far exceed the earlier French drawings from the Portfolio of Villard de Honnecourt and the Reims Palimpsest in scale, complexity, and precision. The geometrically based design practices recorded in great Rhenish drawings like Strasbourg Plan B and Cologne Plan F would remain current in the northern Gothic world well into the sixteenth century. More surprisingly, perhaps, these design practices spread even into Italy, where architectural culture had a very different character than it did in the north.

CHAPTER THREE
Italian Drawings up to 1350

The Gothic style, which had emerged in the environs of Paris, never enjoyed the same status in Italy that it did in northern Europe. Italian builders were hardly unaware of Gothic architectural fashions, however. Pointed arches, ribbed vaults, complex window tracery, and other stereotypically Gothic features had already begun to appear in Italian buildings in the decades bracketing 1200. The growth of the Cistercian order in the twelfth century, and of the Mendicant orders in the thirteenth century, fostered this spread of architectural ideas. Because these orders embraced austerity, though, their designers deliberately avoided the full complexity of the Gothic cathedral type. For this reason, in part, the Gothic tradition tended to serve in Italy as a source for individual motifs, rather than as a comprehensive framework governing architectural creativity, which it became in the north. Another crucial factor in the Italian situation, of course, was the presence of many impressive Roman and early medieval monuments, whose prominence created an unusually strong sense of historical continuity on the peninsula. As Marvin Trachtenberg observed in an incisive 1991 article, Italian builders of the Gothic era often chose to qualify their acceptance of northern Gothic "modernism" by emulating these indigenous models of architectural authority. Italian design thus remained distinctly historicizing, even before the systematic suppression of non-classical forms in the Renaissance.[1]

Since the Gothic style occupied a rather tenuous position in Italian architectural culture, it is by no means obvious, *a priori*, that Italian builders would have used geometrical planning methods comparable to those of their northern contemporaries. In a general sense, it is clear that Italian medieval builders employed both geometrical and modular design strategies. Arithmetical and modular thinking appear to have dominated in the Roman and early medieval architectural traditions, but even Vitruvius had mentioned the geometrically derived $\sqrt{2}$ length-to-width ratio as an acceptable room proportion, and most Italian baptisteries were octagonal in plan. In the Gothic era, many Italian church apses began to display octagonal symmetry, with the east end and crossing dome of Florence Cathedral providing one the most impressive speculations on this geometrical theme in the history of architecture (Figure 3.1). Trachtenberg, in his more recent study of Florentine urbanism, provides a plausible overview of how this east end could have been conceived through a few successive steps of dynamic geometry, but his discussion of this rather singular composition remains atypical of the literature on Italian Gothic design, much of which continues to emphasize the importance of modularity.[2] It is hardly a coincidence, therefore, that Konrad Hecht attempted to buttress his claims about the

[1] Marvin Trachtenberg, "Gothic/Italian Gothic: Toward a Redefinition," *Journal of the Society of Architectural Historians*, 51 (1992): 261–87.

[2] Marvin Trachtenberg, *Dominion of the Eye: Urbanism, Art, and Power in Early Modern Florence* (New York, 1997), pp. 63–71. For a valuable analysis of the interplay between modularity and geometry in the context of Italian architecture and urbanism, see Areli Marina, "Order and Ideal Geometry in Parma's Piazza del Duomo," *Journal of the Society of Architectural Historians*, 65 (2006): 520–49.

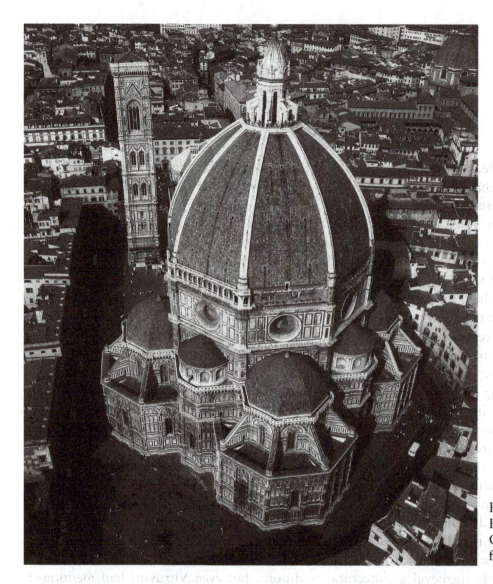

Figure 3.1
Florence
Cathedral, view
from east.

importance of modularity in Gothic design by invoking Italian examples such as Milan
Cathedral and the great church of San Petronio in Bologna, which will be discussed more
fully in a later chapter.[3]

Modular and arithmetical proportioning schemes figure prominently in the work of
Valerio Ascani, who has undertaken the most recent and comprehensive investigation of
Italian Gothic architectural drawings.[4] Ascani, unlike Hecht, accepts the idea that northern
Gothic builders used geometrical design methods, but he concludes that modular design
methods were more important in Italy. He argues, more specifically, that sophisticated
geometrical design practices of the northern type began to penetrate into Italy only in

[3] Hecht, *Maß und Zahl*, pp. 130–71. In Italy, where a comparatively rich trail of documents relates to
medieval construction, it becomes particularly important to remember that references to modules can occur
in textual passages describing monuments that were originally conceived in geometrical terms. There is a
fundamental distinction, in other words, between using modular *language* as a descriptor and using modular
thinking as a design strategy.

[4] Ascani, *Il Trecento Disegnato*. Ascani presented a shorter preliminary version of his arguments as "Le
dessin d'architecture médiéval en Italie," in Recht, *Bâtisseurs*, pp. 255–77.

the closing years of the fourteenth century, at Milan, where they came into conflict with indigenous module-based design strategies pioneered by Nicola Pisano more than a century earlier. Ascani sees Pisano as a crucial figure in part because his 1265 contract for the pulpit in Siena cathedral provides the earliest surviving evidence for the use of measured drawings in Italy.[5] The format of the document, which lists the components of the pulpit in order from bottom to top, and measured in terms of the Pisan *braccia*, strongly suggests that it was based upon a scaled drawing, although the drawing itself does not survive. As Ascani notes, the fact that different Italian towns used different units of measure could easily have become a headache for medieval builders, especially in cases where a designer from one city directed workmen trained in another. For this reason, Ascani argues, designers in the circle of Nicola Pisano began to use the *braccia a terro*, which could be understood all over Tuscany. In the cathedral workshops of Orvieto and Siena, though, Ascani believes that use of the *braccia a terro* was combined with local measurements, so that the designers effectively had to worry about the commensurability of the two modular systems. Close examination of the drawings associated with these two cathedral workshops, though, suggests that northern-style geometrical design strategies may have played a greater role in Italian architectural culture in the decades around 1300 than Ascani had supposed.

Orvieto

The oldest architectural drawings to survive from Italy are two alternative façade designs for the cathedral of Orvieto, one of the most elegant examples of Italian Gothic design (Figure 3.2). The first drawing, which Ascani calls O1, shows a slender façade in which the upper wall of the nave rises freely above the lower wall of the side aisles, which ends in a decorative triforium belt (Figure 3.3). In this design, there are just four large gables: one over each of the three portals in the lower façade, and one surmounting the rose window zone above. This drawing for the Orvieto façade has a more northern flavor than most other Italian Gothic designs. With its large, square-framed rose window zone, steep secondary gables, and smoothly rising buttresses, it impressionistically recalls the transept frontals of Notre-Dame in Paris, despite its clearly Italianate detailing.

The second drawing, Ascani's O2, shows a façade closer in appearance to the one actually built, with a total of six large gables: four analogous to those in O1, joined by two others above the triforia in the aisle bays (Figure 3.4). The façade as a whole appears more squat than that shown in O1: the added gables broaden the upper façade; their moderate slopes create an even visual rhythm across the composition; and a horizontally oriented outer frame surrounds the square frame of the rose window in this design. Because of its close resemblance to the present façade, Ascani and most previous authors have very plausibly ascribed O2 to Lorenzo Maitani, who served as master of the Orvieto workshop from 1310 to 1330, during the decisive phases of work on the lower façade and its famous reliefs. Because the proportions of the outboard buttress towers appear slightly smaller than those in the built structure, though, Ascani sees the drawing as one of Maitani's preliminary schemes, prepared shortly before 1320, when the details of the

5 Ascani, *Il Trecento Disegnato*, p. 20.

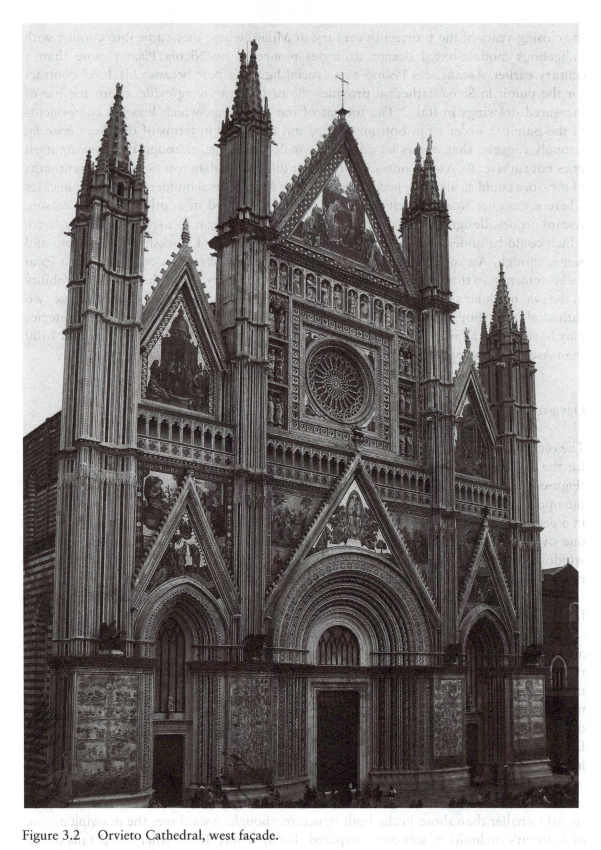

Figure 3.2 Orvieto Cathedral, west façade.

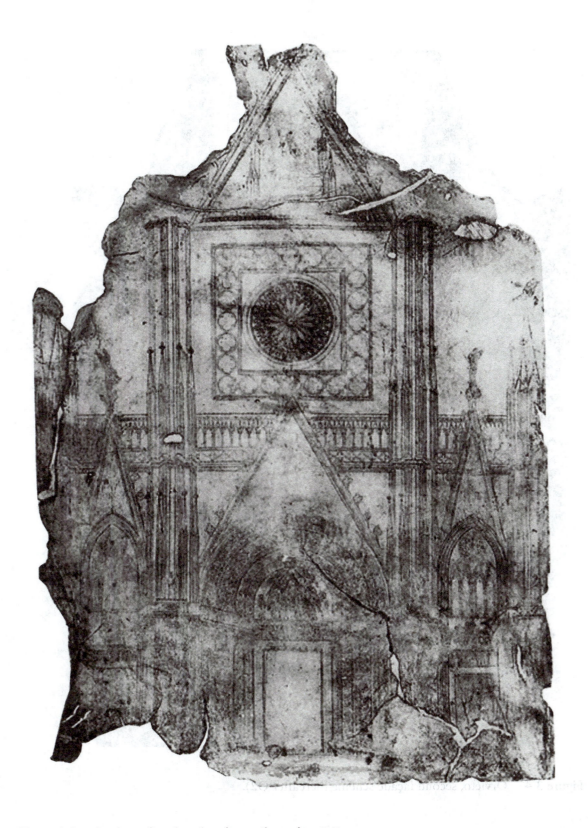

Figure 3.3 Orvieto, first façade scheme (hereafter O1).

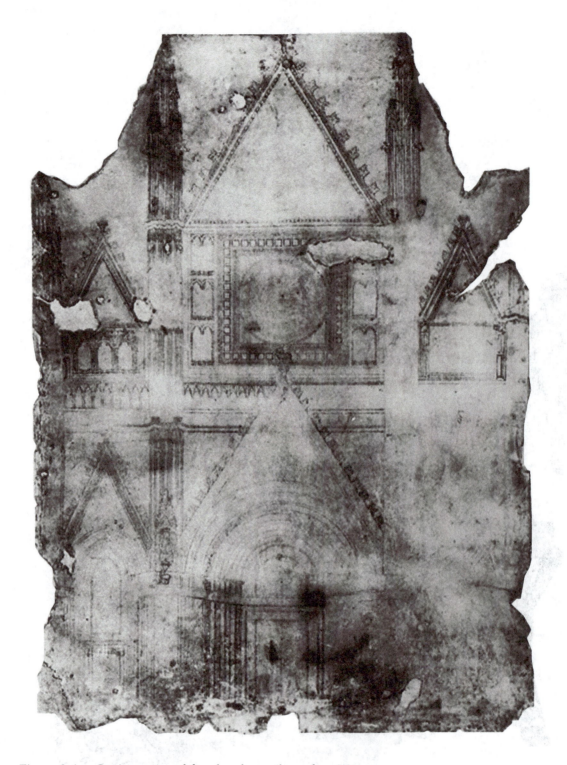

Figure 3.4 Orvieto, second façade scheme (hereafter O2).

design were still in flux. Since O1 differs far more radically from the present façade, Ascani believes that it should be dated to the first decade of the fourteenth century and ascribed to one of Maitani's predecessors, a view shared by many authors who have considered the history of the Orvieto workshop.[6] Other scholars, including most recently Jürgen Wiener, have attributed both drawings to Maitani.[7] The strictly geometrical analysis presented in the following pages cannot definitively settle this question, but the surprisingly close geometrical relationship between the two drawings demonstrates at least that Maitani was fully conversant with the design principles embodied in O1, even if he was not the author of both schemes.

The proportions of the Orvieto drawings had been studied by several of the main contributors to the literature on the façade prior to Ascani's investigation, including Renato Bonelli and John White. Bonelli, author of a major monograph on the cathedral first published in 1952, superimposed squares and equilateral triangles of various sizes on the outlines of the drawings, but the alignments shown appear *ad hoc*, and it is hard to discern any procedural logic or larger governing figure controlling the designs.[8] White, who has also written extensively on the cathedral since the 1950s, proposed superficially rather similar overlays in a paper delivered in 1990 and published in 1995.[9] In this analysis, White pays considerable attention to arithmetical as well as geometrical relationships, arguing that many of the dimensions in the façade drawings were set as simple multiples or fractions of primary lengths such as the rose window diameter.

Ascani, like White, sees the interaction between geometry and modularity as central to the Orvieto façade designs, but he places greater emphasis on the importance of specific standardized measurement units. So, for example, he describes drawing O1 as having "a simple and elegant proportional system *ad quadratum* and *ad triangulum* in Tuscan *braccia a terra*."[10] But the combination of these systems in one drawing would have been rather complex, since it would have been difficult to achieve viable arithmetical relationships in this way, even using rational approximations to the irrational proportional relationships that arise in equilateral triangles and in the diagonals of squares. Ascani believes that Maitani pioneered an even more complex design method in O2, deliberately combining geometrical proportions not only with the Tuscan *braccia a terra*, which measures .551 meters, but also with the local foot of .298 meters. The advantage of this process, Ascani believes, is that it would have allowed collaboration between workers trained in the use of different measurement systems. On the negative side, though, this process was both convoluted and imprecise. It worked only if the building dimensions were chosen such that they could be easily expressed in both unit systems, and even then, the agreement between them was imperfect. Thus, for example, the span of the Orvieto cathedral nave can be approximately described either as 32 *braccia a terra* (32 × .551 m = 17.63 m), or as

6 Ascani, *Il Trecento Disegnato*, pp. 67–82, esp. 79–80.

7 See Jürgen Wiener, *Lorenzo Maitani und der Dom von Orvieto* (Petersberg, 2009), pp. 232–45. For a more general discussion of the building's history, see Lucio Riccetti, *Opera, piazza, cantiere : quattro saggi sul Duomo di Orvieto* (Foligno, 2007).

8 Renato Bonelli, *Il Duomo di Orvieto e l'architettura italiana de duecento trecento*, 2nd edn, rev. (Rome, 1972), pp. 46–7.

9 John White, "I Disegni per la facciata del Duomo di Orvieto," in Guido Barlozzetti (ed.), *Il Duomo di Orvieto e le grandi cattedrali del Duecento* (Turin, 1995), pp. 68–98.

10 Ascani, *Il Trecento Disegnato*, p. 167.

60 local feet (60 × .298 m = 17.88 m).[11] The 25-centimeter difference between these two approximations, though, is far from negligible, especially given the precision with which Maitani and his marble-carving team would have had to work on the actual façade. Even on a drawing like O2, whose scale closely approximates 1:50, the difference would have been perceptible. So, while there is good reason to believe that Italian medieval builders used both geometrical and modular proportioning schemes, depending on the circumstance, it is difficult to see how Maitani and his assistants would have used the complex hybrid process Ascani describes to create O2.

Bonelli, White, and Ascani make many astute observations in their analyses of the Orvieto drawings, and their insights deserve to be taken seriously. None of them, however, provides a very satisfying explanation of how a fourteenth-century draftsman would have established the outlines of the cathedral's façade design. All three authors present their observations in essentially *ad hoc* fashion, instead of tracing a logical sequence of operations necessary to create the drawings. White and Ascani, moreover, imply that the Orvieto designers actively converted back and forth between geometrical and arithmetical paradigms while sitting at their drafting tables. This approach would have forced the designers to confront the inherent complications and imperfections of this conversion process even when seeking to establish the basic outlines of their façade schemes. It would have been far easier for them to work in a more purely geometrical mode, as their northern contemporaries usually appear to have done. The geometrical analyses presented in the following paragraphs suggest that they did exactly this. The builders of Orvieto Cathedral may well have used arithmetical ratios and modular measures at some points in their workshop practice, but the designers of the façade clearly used dynamic geometry to establish the main outlines, and even many details, of their drawings.

The crucial geometrical given with which the façade designers had to contend at Orvieto was the ratio between the width of the cathedral's existing nave and its aisles. Since this ratio very closely approximates 2:1, the creator of O1 chose quite sensibly to incorporate this ratio into his drawing. If one calls the width of the nave bay one unit, therefore, the width of the drawing from the centerline to the outboard margin of each aisle bay is also one unit, and the aisle bay centerlines fall .75 units out from the building centerline, as Figure 3.5 shows. Moving into the vertical dimension, one finds that the tips of the aisle windows are one unit above the groundline, while a great square two units on a side reaches up from the groundline to the horizontal molding just over the rose window. More tellingly, an octagon inscribed within this square defines many crucial dimensions of the drawing. Thus, for example, the top corner of the octagon's vertical sides establishes the top edge of the triforium, 1.414 units above the groundline. The width of this octagon's horizontal facet, meanwhile, establishes the inner face of the main buttresses .414 units out from the building centerline. Reflection about the buttress axis then locates the outer buttress face .586 units from the centerline. As subsequent analysis will reveal, this simple octagon-based construction, which figures nowhere in the work of Bonelli, White, and Ascani, determined the overall proportions not only of O1, but also of O2 and the present Orvieto façade, demonstrating a clear continuity of geometrical communication within the façade workshop.

11 Ascani, *Il Trecento Disegnato*, pp. 74–82.

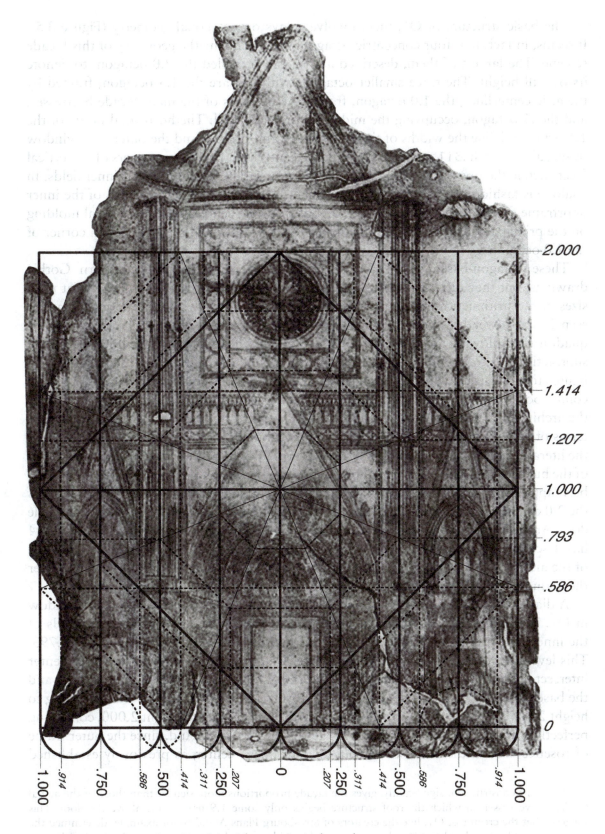

Figure 3.5 Orvieto, drawing O1 with geometrical overlay, stage 1.

The basic structure of O1, then, involves plays on octagonal geometry (Figure 3.5). It seems, in fact, that four concentric octagons help to define the geometry of this façade scheme. The largest of them, described above, can be called the 2.0 octagon, to denote its overall height. The three smaller octagons within it are the 1.5 octagon, framed by the aisle centerlines, the 1.0 octagon, framed by the axes of the main façade buttresses, and the .5 octagon, occupying the middle of the nave wall. The horizontal facets of the 1.5 octagon define the widths of the outer doorframe, below, and the outer rose window frame, above, each .311 out from the building centerline. The upper corners of its vertical facets define the tips of the aisle gables, or, more precisely, the tips of their inner fields. In analogous fashion, the horizontal facets of the 1.0 octagon define the width of the inner doorframe and the inner rose frame, .207 out from the centerline. A horizontal molding on the principal façade buttresses, finally, falls at height 1.207, aligning with a corner of the 1.0 octagon.

These octagon-based geometries obviously recall those seen in northern Gothic drawings, but they differ slightly from their northern counterparts in the way that their sizes relate arithmetically rather than geometrically. Thus, while the nested octagons seen in the tower base of Cologne Plan F relate through a process of subdivision by quadrature, following the sequence 2, $\sqrt{2}$, 1, $\sqrt{.5}$, etc., those seen in O1 follow the strictly subtractive 2, 1.5, 1, .5 sequence. So, while the creator of O1 certainly used geometrical figures to plan his drawing, he engaged more directly with modularity than his northern contemporaries did. The case of O1 thus lends qualified support to Ascani's suggestion that the architectural cultures of Italy and the north had already begun to diverge by 1300, in terms of workshop practice as well as formal vocabulary. In the case of Orvieto, though, the literal intersection between geometrical figures and the arithmetically determined grid of the buttress axes played a more important role in the design process than has previously been appreciated, as Figure 3.6 will demonstrate. Thus, for example, the intersection of the 2.0 octagon with the aisle centerline occurs at height .336, locating the top of the aisle door. And, an equilateral triangle with its apex on the building centerline at height 1.414 has descending sides that cut the main buttress axes at height .548, defining the baseline of the aisle windows. The sides of this triangle define the inner margins of the gable over the main portal.

A dialog between rotated squares and octagons locates the center of the rose window in O1. The large rotated square inscribed within the 2.0 octagon cuts the verticals of the inner rose frame, which rise from the top facet of the 1.0 octagon, at height 1.793. This level then serves as the center of the rose. Diagonals rising up from the rose center intersect the main buttresses at height 2.207, establishing the top edge of the rose zone and the baseline of the main façade gable, which forms a perfect equilateral triangle rising to height 2.925. The rose window proper, meanwhile, reaches up to height 2.000, coinciding perfectly with the top edge of the original generating square.[12] And, since the outer frame of rosettes around the rose extends out .311 from the center, as previously established

[12] This construction, significantly, gives the façade proportions more slender than those of the actual Orvieto nave vessel, in which the roof structure begins only some 1.9 nave spans above the floor. This suggests that the creator of O1, like the creators of Strasbourg Plans A and B, for example, determined the proportions of his façade scheme based on geometrical considerations internal to the drawing, rather than on close examination of the building that the façade would front. In all such cases, detailed harmonization of the design concept with the built structure was apparently deferred until a later phase of the process.

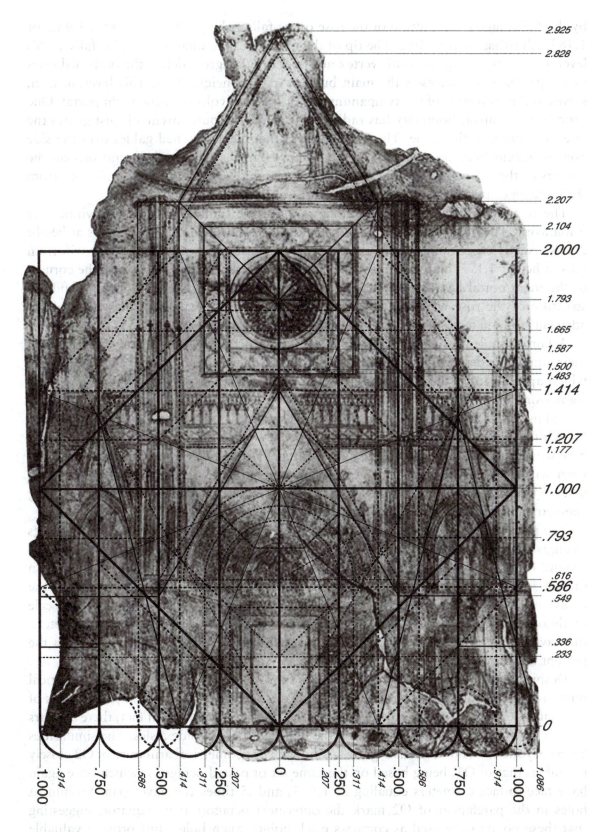

Figure 3.6 Orvieto, drawing O1 with geometrical overlay, stage 2.

by the 1.5 octagon, the bottom of the rose frame falls at height 1.793 - .311 = 1.482, or 1.483, adjusting for rounding. The tip of the gable over the main portal also falls at this level. Lines descending from this vertex at slopes of 60 degrees define the outboard sides of the gable, which intersect the main buttress axes at height .616. This level, in turn, serves as the springline of the tympanum and of the archivolts over the main portal. One prominent archivolt boundary has radius .250, while the outer archivolt just grazes the interior margin of the gable. The inner faces of the steeply pitched gables over the side portals, meanwhile, are found by striking lines from the previously found tips on the corners of the 1.5 octagon down to the corners of the 2.0 octagon, .414 units out from the building centerline at ground level.

The remaining details of façade design O1 can be found quite readily within this framework. The inner field of the upper façade gable, for example, terminates at height 2.828, exactly twice the height to the top of the triforium. The baseline of the triforium falls at height 1.177, halfway up the diagonal facet of the small .5 octagon. The corners of the main portal lie on the diagonals reaching down from the 1.0 octagon. And the structure of the rose window frame emerges by symmetry, based on the width of the adjacent octagon facets.

A fairly simple geometrical framework based on octagons, equilateral triangles, and their immediate derivatives thus suffices to locate all the principal formal elements in O1, which appears to be the oldest surviving Gothic drawing from Italy. This geometrical framework incorporates a number of relationships noted in previous studies, but the preceding paragraphs outline an approach to design rather different than those proposed by White and Ascani. Since the coherent sequence of geometrical operations sketched here would have been easy for a medieval draftsman to conceive, and since the resultant framework locates the elements of the drawing quite precisely, there is no good reason to assume that the creator of O1 used a more complicated approximation scheme mixing geometrical and modular design methods.

The relationships of scale and proportion between the two Orvieto façade drawings strongly suggest that geometry mattered more than modularity in the Orvieto workshop around 1300. The two drawings differ markedly in their scale. O1, with overall dimension of 108.5 by 78 centimeters, has an interaxial nave span of 35 centimeters. Since the equivalent dimension in the actual façade is 1756 centimeters, O1 presently has a scale of almost exactly 1:50. In the slightly larger O2, which measures 122 by 89 centimeters, the nave span is 42 centimeters, giving an overall scale of 1:41.8 measured against the present façade.[13]

Despite this difference in scale, O2 incorporates many of the same geometrical relationships seen in O1. Most obviously, it shares the simple horizontal proportions of O1, with the nave bay twice as wide as the aisles. In both drawings, in fact, there appears to be a simple underlying grid based on the half-width of the side aisles. The similarities go far beyond that, however, as Figure 3.7 shows. The geometrical armature of O2 closely resembles that of O1, being based on the same set of nested octagons, which once again have face-to-face diameters equaling 2, 1.5, 1, and .5 times the nave span. Prominent holes in the parchment of O2 mark the outermost octagon at its equator, suggesting that these points were used as compass prick points. Such holes thus provide valuable

13 For the drawing dimensions, see Ascani, *Il Trecento Disegnato*, pp. 67, 71.

corroboration for use of the geometrical scheme described here. As in O1, the corners of the largest octagon locate the top margin of the triforium at height 1.414, and the inner faces of the main buttresses .414 out from the building centerline. And, as before, the outer faces of the main buttresses thus fall .586 out from the centerline. This time, though, the overall façade is a bit shorter than in O1. The whole façade in O2, with the exception of the crowning gable, fits into a perfect square two units on a side. The top of the inscribed 2.0 octagon thus locates the top of the overall rose window zone in O2, instead of just locating the top of the inner frame, as in O1. The baseline of the large gable over the rose in O2 thus falls at height 2.0, instead of at 2.207, as it had in O1. This reduction, together with the presence of the two new gables flanking the rose zone, makes O2 appear more squat than the earlier drawing. The gable tips fall at height 2.0, .75 units out from the building centerline. The main gable atop the façade is a perfect equilateral triangle with its lower corners at height 2.0 on the main buttress axes. The inner field of the gable, similarly, is an equilateral triangle with its lower corners at the top corners of the 2.0 octagon. These figures thus reach to heights 2.866 and 2.718, respectively.[14]

Intersections between the nested octagons and the drawing's underlying grid help to define the geometry of the lower façade and portal zone, as Figure 3.8 shows. Thus, for example, the circled points where the 1.0 octagon intersects the vertical .5 units out from the building centerline establish the springline of the portal archivolts at height .543. This level also serves as the center of curvature for the main portal tympanum, and it locates the points on the main buttress axes where the sloping sides of the portal gables converge.[15] The base of the tympanum aligns with the bottom facet of the 1.0 octagon. The width of the main portal aperture, .207 units, equals the facet width of the .5 octagon, while the top of the door aperture falls at height .439, aligning with the bottom point of the circle describing the tympanum. The tip of the main gable falls on the top margin of the triforium, at height 1.414, while its sides slope down to the inner buttress faces .414 units out from the building centerline and .750 units above the groundline. The inner field of the main gable, meanwhile, falls at height 1.314, aligned with the corner of the 1.5 octagon, and its sides slope down to meet the buttress axes at height .586. As in O1, the baseline of the triforium falls at height 1.177, halfway up the diagonal facet of the .5 octagon, while the top of the gable over the left portal, the only such gable shown, reaches to height 1.104, aligning with a corner of that octagon.

In O2, the geometry of the rose zone mirrors that of the portal zone in a significant sense. The upper diagonal facets of the 1.0 octagon intersect the verticals .5 units out from the building centerline at height 1.457. These upper intersections define the bottom of the rose window frame, just as the corresponding lower intersections at height .543 define the center of curvature for the tympanum and archivolts. The center of the rose thus falls at height 1.729, halfway between 1.457 and 2.000. A rotated square within this space frames the inner oculus of the rose. The lancet pairs flanking the rose zone fill the space between this frame and the main buttress margins. The left and right gables flanking the rose zone, meanwhile, present subtly different geometries. The baseline of

[14] It may be significant that these heights closely approximate $2\sqrt{2}=2.828$, the dimension that would result from unfolding the diagonal of the large square framing the lower façade This, in essence, is what White argued in "I Disegni," although he paid less attention to the buttress axes than this analysis does.

[15] More precisely, this is the level where the inner field margins of the main gable converge. The outer frame outlines converge slightly higher.

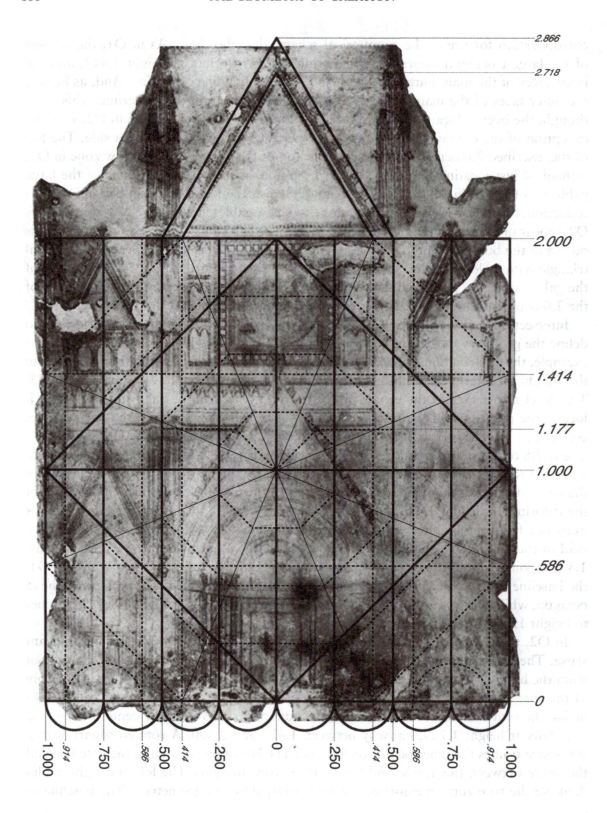

Figure 3.7 Orvieto, drawing O2 with geometrical overlay, stage 1.

the right one falls at height 1.500, while that of the left one falls at 1.561, the level where the 1.5 octagon intersects the main buttress axes. It is obvious, therefore, that the details of the façade design were still being worked out when O2 was produced. Comparison of O2 with the present façade confirms this finding.

The present Orvieto façade deserves its fame as one of the most beautiful products of Italian Gothic architecture (Figure 3.2). It owes its reputation not only to the remarkable relief carvings that decorate its lower buttress faces, but also to its overall formal coherence, which surpasses that of other comparable Italian church façades. It may, in fact, be the most geometrically coherent façade of any major Gothic building. This uniformity is particularly striking since the current design departs from O2 in a number of respects, which could easily lead one to suppose that *ad hoc* modifications were made to the upper façade after Maitani's death in 1330. The following geometrical analysis will show, though, that the present Orvieto façade incorporates not a random series of changes to the geometry of the drawing, but rather a comprehensive refinement of its themes.

Some of the differences between the present Orvieto façade and O2 are obvious, but many are more subtle. The most conspicuous difference is that the present façade includes a row of statues between the rose window zone and the façade-crowning gable. All four of the main façade buttresses extend correspondingly higher than in the drawing, so that the façade recovers some of the verticality lost in the revision from O1 to O2. The lateral buttresses are slightly wider than they appear to be in O2, meanwhile, so that their centerlines stand slightly further than one nave span out from the building centerline. This widening provides a broad field for the famous relief sculptures on the lower buttress stories. And, as the following paragraphs will explain, the façade includes many new details, such as the stringcourse just above the reliefs, that call attention to and visually express crucial points in the geometrical armature governing the design.

In general, the present Orvieto façade may be seen as a rationalized and improved version of the O2 scheme, in which slight geometrical and formal adjustments help to bring the logic of the design into sharper focus.[16] As in O1 and O2, the geometrical framework of the façade involves an underlying grid of squares based on the quarter-span of the nave, and a series of concentric octagons with face-to-face diameters equal to 2, 1.5, 1, and .5 nave spans. As Figure 3.9 shows, though, the current façade also incorporates an overlaid "*ad triangulum*" system connecting the façade base to the center of the rose window. The center of the rose thus falls at height $\sqrt{3} = 1.732$, very slightly but perceptibly above its location in O2. A second identical triangle rises from height 1.207, the level defined by corners of the 1.0 octagon, up to the apex of the main façade gable at height 2.939. This geometry makes room for the statue niches atop the rose window. The interplay of "*ad quadratum*" and "*ad triangulum*" geometries in the Orvieto façade recalls that seen in the Strasbourg nave and in Strasbourg Plan A. The relationship is not so specific as to suggest a direct link between the two workshops, but the basic kinship of form and method certainly attests to some dialog between Maitani's team and their northern European colleagues.

16 Wiener, *Lorenzo Maitani und der Dom von Orvieto*, p. 211, notes that there is no modern photogrammetric elevation of the Orvieto façade. Figures 3.10 and 3.11 are therefore based on the impressively precise 1842 survey drawing reproduced in Bonelli, *Il Duomo di Orvieto*, p. 57.

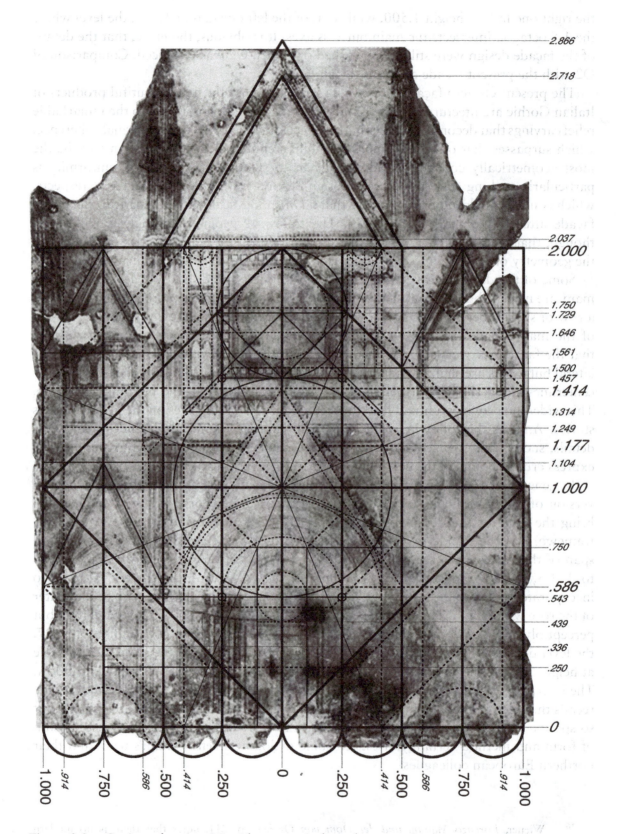

Figure 3.8 Orvieto, drawing O2 with geometrical overlay, stage 2

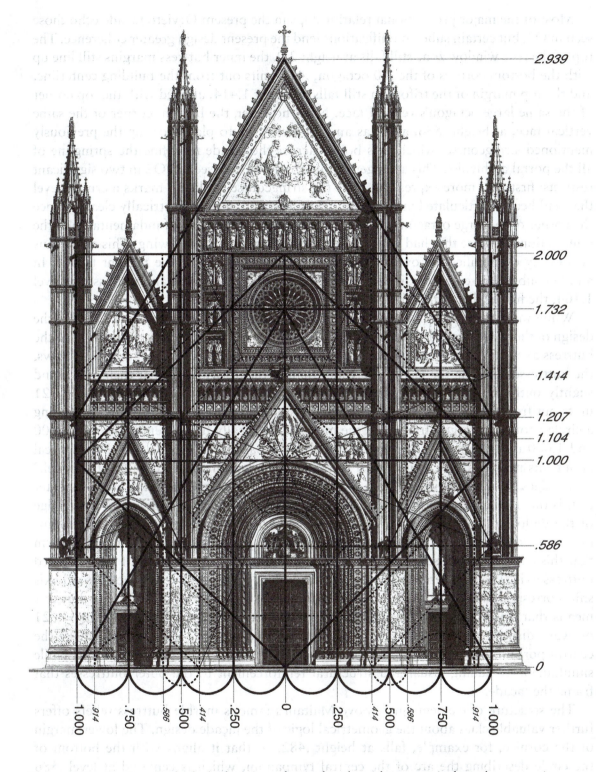

Figure 3.9 Orvieto Cathedral, elevation of west façade with geometrical overlay, stage 1.

Most of the major proportional relationships in the present Orvieto façade echo those seen in O2, but certain subtle modifications lend the present design greater coherence. The top of the rose window zone still falls at height 2.0, the inner buttress margins still line up with the bottom corners of the 2.0 octagon, .414 units out from the building centerline, and the top margin of the triforium still falls at height 1.414, aligned with the top corner of the same large octagon's vertical face. Now, however, the bottom corner of the same vertical face, at height .586, also has an important role to play, locating the previously mentioned stringcourse, which cuts boldly across the façade to define the springline of all the portal archivolts. This arrangement improves on that seen in O2 in two significant respects: first, it is more expressive, since the stringcourse explicitly marks a crucial level that had been unarticulated in the drawing; and second, it is geometrically cleaner, since the corner of the large octagon at height .586 is more conceptually fundamental than the intersection structure that had defined the .543 springline in the drawing. This detail thus beautifully exemplifies the overall relationship between O2 and the present façade. In another subtly expressive detail, rows of tiny gablets decorate the main buttresses at level 1.104, the height that marks the corner of the inner .5 octagon.

While most of the modifications introduced between the production of O2 and the design of the present façade lead to greater geometrical clarity, the slight adjustment of the buttress axes introduces a new level of convolution to the scheme. As Figure 3.10 shows, the buttresses framing the façade are wider than in the drawing, so that their axes stand slightly outboard of the great generating square. More precisely, their axes fall 1.021 units out from the building centerline, a dimension that can be found by circumscribing a circle about an octagon framed by the more geometrically fundamental aisle axes .500 and 1.000 units from the centerline. Since the outboard marble panels are symmetrical about this new axis, reaching inward to the buttress margin .914 units out, the panels' outer edges fall 1.127 units out from the centerline. The distance from the buttress center to this outer margin, .107 units, also equals the height from the ground to the top edge of the dado molding. The height of the side aisle doors, .271 units, equals the radius of the circle used to establish the new buttress axis. These vertical alignments confirm that this octature-based scheme was indeed used to generate the offsets of the outboard buttress axis. The symmetry of the aisle portal and its gable require that the inboard axis shift correspondingly inward, but the comparatively slender format of the inner buttress means that this displacement can be fairly small, just half of the 1.021 - 1.000 = .021 outward displacement of the outer axis. The net effect of these changes is to make the central portion of the façade appear more slender and elegant than it had in O2, while simultaneously adding visual and structural reinforcement to the outer buttresses that frame the façade.

The structure of elements just above Maitani's famous marble buttress reliefs offers further valuable clues about the geometrical logic of the façade design. The lower margin of the cornice, for example, falls at height .482, so that it aligns with the bottom of the circle describing the arc of the central tympanum, which is centered at level .586 with a diameter of .207. The upper margin, meanwhile, falls at level .525, where the lower diagonal facet of the 1.5 octagon crosses the buttress margin .586 units out from the building centerline. Moving upward, one next encounters the prominent molding at height .586, which lines up with the corners of the great 2.0 octagon. This serves as the baseline for the inner field of the portal gable, whose tip falls at height 1.104, even with

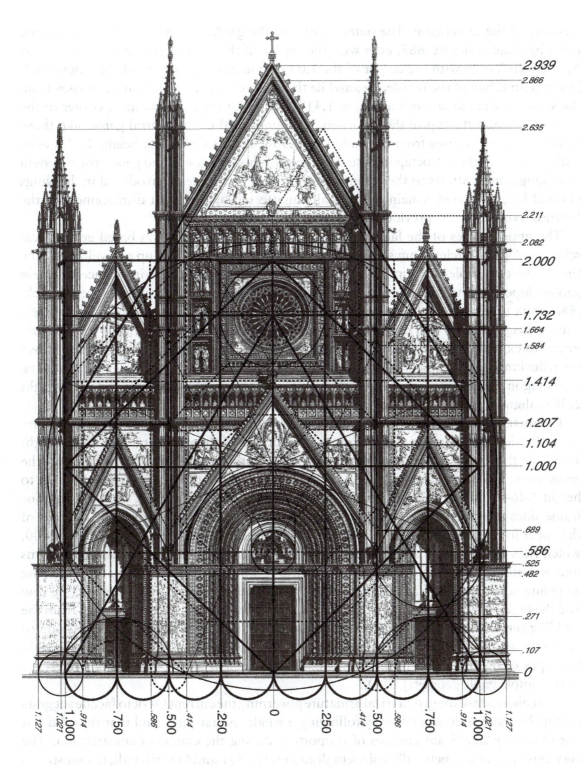

Figure 3.10 Orvieto Cathedral, elevation of west façade with geometrical overlay, stage 2.

a corner of the .5 octagon. The outer margin of the gable, measured along its crockets, has a baseline at height .689, even with the corner of the 1.5 octagon, and its tip falls at height 1.207, even with the corner of the 1.0 octagon and the bottom of the triforium. [17] In the central bay of the façade, meanwhile the outer margin of the main gable rises from the same baseline to an apex at height 1.414, even with the corresponding corner of the 2.0 octagon and the top of the triforium. The inner field of the central gable, like those of the side portals, rises from the molding at .586, and its tip falls at height 1.311, even with a corner of the 1.5 octagon. The coherence of this octagon-based geometrical system is striking, and it attests to the enduring importance of the ideas introduced in drawings O1 and O2, ideas that remained essentially unaffected by the slight displacement of the buttress axes described previously.

The upper stories of the façade incorporate several more octagon-based geometrical schemes. A great circle circumscribed about the 2.0 octagon reaches up to level 2.082; the tips of the two gables flanking the rose zone fall at this height. The inner faces of these gables slope down to the centerpoint from which the main portal archivolts were struck, .586 units up on the building centerline; these sloping lines cross the original buttress axes at height 1.584. The drip moldings punctuating the buttress uprights were clearly meant to express key levels in the façade's geometrical armature. The first of these above the triforium, for example, falls at height 1.664, the level where the diagonal faces of the 2.0 octagon cross the aisle centerlines. The final molding on the outer buttresses, at height 2.082, aligns with the tips of the lateral gables.

Geometries based on the equilateral triangle play important roles in the upper reaches of the Orvieto façade. As previously noted, the center of the rose window falls at height 1.732, at the apex of a large equilateral triangle with base width 2.000 sitting on the groundline. The square frame around the rose thus reaches up to height 2.000, down to height 1.464, and out .268 units to each side of the building centerline, while the interior frame sides stand .207 out, aligned with the corners of the 1.0 octagon. The outlines of the upper nave gable, meanwhile, align with the second great triangle of side length 2.000, which rises from its base at height 1.207 to its apex at height 2.939. These two systems intersect at height 2.211, where lines of 60-degree slope rising from the base of the rose zone intersect the great framing triangle to establish the top edge of the final statue row and the base of the terminal gable. In an analogous construction, lines departing from the building centerline and the inner buttress axis at height 2.211 intersect at height 2.635 to locate the final horizontal molding on the inner pinnacle. It may be significant, as well, that apex of the inner field of the main gable falls at height 2.866, suggesting a reference to the simple gable geometry of O2.

The coherence of the geometrical armature governing the current Orvieto façade suggests that its builders were scrupulously following a single master plan, and that they did not introduce any significant changes of proportion during the course of construction. The very existence of geometrically coherent drawings like O1 and O2, after all, demonstrates that the façade was planned comprehensively rather than piecemeal. It seems, therefore, that there was at least one more such drawing, O3, that guided the construction process. The creator of this drawing, very possibly Maitani, took O2 as his point of departure,

[17] The "architectural baseline" of the triforium is now 1.207, but the decoration on the façade retains the "visual baseline" at height 1.177, just as in the drawings.

but he improved on O2 by refining its details, introducing the "*ad triangulum*" scheme for the rose window location, and restoring some of the verticality originally foreseen in O1. The fact that this definitive drawing has been lost seems unsurprising, in view of the similar patterns of loss seen in the northern Gothic world, where the provisional designs often survive better than the final ones, which may have been worn down by use on the worksite.

The preceding analysis shows that the Orvieto drawings were not only geometrically coherent, but also surprisingly similar to northern drawings in their geometrical logic. This is not to say, of course, that the drawings actually look northern in their details. In architectural terms, the two Orvieto designs have more in common with the façade of Siena Cathedral, for example, than they do with possible northern prototypes such as the transept frontals of Notre-Dame in Paris or the west façade of Strasbourg Cathedral. In terms of drafting technique, too, the quasi-perspectival highlights in O1 and O2 set these drawings apart from northern drawings of the period, as Ascani rightly observed.[18] Even in geometrical terms, these drawings have a somewhat different flavor than their northern brethren, since the arithmetical size progression of nested octagons governing the Orvieto façade schemes contrasts with the more strictly geometrical progressions typical of the Rhenish drawings discussed in the previous chapter. These caveats aside, though, the fundamental similarity of all of these drawings remains striking. All of them employ the same basic geometrical ingredients: equilateral triangles, squares and rotated squares, often combined via quadrature; and octagons, often combined with their circumscribing circles. In the Orvieto drawings, moreover, these figures relate to the architecture much as they did in the northern examples, aligning with crucial elements such as buttress axes and story divisions, and even locating details such as moldings and stringcourses. In O1 and O2, as in many of the northern elevation drawings considered previously, these seemingly decorative details actually articulate elements in the designs' underlying geometrical armature. And, in all of these drawings from both sides of the Alps, the geometrical structures in question can be understood as resulting from a dynamic design process, in which the draftsmen could combine simple forms in step-by-step fashion to create final forms of great complexity and sophistication. In all of these important respects, the Orvieto façade project belongs clearly to the Gothic design tradition, its specifically Italian flavor notwithstanding.

SIENA

Further evidence for the currency of these Gothic design methods in Italy comes from Siena, where the fourteenth century witnessed an ambitious program to vastly enlarge the local cathedral. Four drawings survive to record the project, which had to be abandoned incomplete in the wake of the Black Death. One, called S1 by Ascani, shows the elevation of a svelte campanile, comparable in its lower stories to the campanile of Florence Cathedral, but terminating in a slender octagonal story and crocketed spire of

[18] Ascani, *Il Trecento Disegnato*, p. 54.

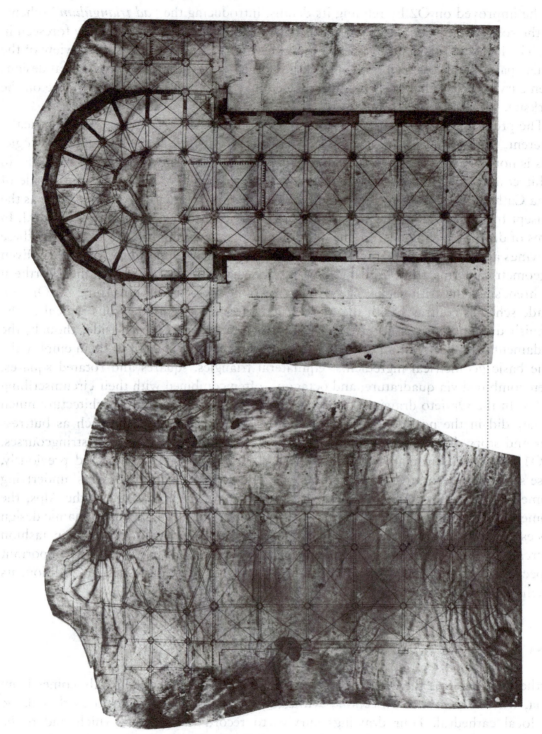

Figure 3.11 Comparison of two alternative schemes for the Duomo Nuovo in Siena: drawing S2
(above); and drawing S3 (below).

vaguely northern flavor.[19] Another, Ascani's S4, shows the façade of the cathedral's east end, which serves as its baptistery. The remaining two, on which attention will focus here, present variants of the cathedral's groundplan, in which a colossal new nave would extend from what had been the old cathedral's south transept façade (Figure 3.11). S2 shows a complex chevet with ambulatory and radiating chapels balancing the new nave, while S3 shows only a simple polygonal apse. Ascani attributes S1 and S3 to Lando di Pietro, a Sienese architect and goldsmith under whose supervision the cathedral expansion project was launched in 1339; he attributes S2 to Lando's follower Giovanni di Agostino, who took over the project after Lando's death in 1340.[20] The geometrical analyses of the two plans that follow will lend further credence to this relative chronology. Moving beyond questions of dating and attribution, though, these analyses will reveal that geometrical methods played a more central role in the Siena Cathedral workshop than Ascani had imagined. Ascani makes a good case for the use of modular planning methods in S1, where the successive stories of the campanile increase in height in seemingly arithmetical fashion, but geometrical methods clearly informed the design of the two groundplans.

The geometries of the Siena plan drawings must be understood in relation to the format of the existing cathedral, which features an unusual hexagonal crossing surmounted by a dome (Figure 3.12). The rest of the old cathedral's plan remains fairly conventional, but the clash between its basically rectilinear bays and the hexagonal crossing already introduces a dialog between four-fold and six-fold symmetry that would emerge as a leitmotif in the two plan drawings for the new church. Significantly, though, both drawings propose radically remodeling the crossing zone. Six columnar piers support the dome in the present crossing, whose geometry is highly distorted and irregular. In S2, by contrast, the crossing has perfectly regular hexagonal symmetry, and the southern column has been eliminated, opening visual access to the new nave, while the northern side of the crossing gains support from the adjacent apse wall. In S3, the crossing rests on just four columns, so that a viewer could look straight from the new nave into the new apse two bays beyond the crossing. Full implementation of either of these schemes would have required the demolition of the present crossing. And, even starting from scratch, the technical difficulties involved in the new construction would have been immense, especially given the scale of the project. Unsurprisingly, therefore, the leaders of the Siena workshop chose to begin construction of the new nave, rather than the crossing zone, leaving the full integration of these components as a task for later generations. The present awkward collision between the fragments of the new nave and the old crossing falls far short of the utopian visions presented in the plan drawings (Figure 3.13). The juxtaposition of the hexagonal crossing and the rectangular nave bays, though, offers valuable clues about the drawings' geometrical logic.

In S2, the drawing with the ambulatory, the four-fold and six-fold symmetries at first appear to have little to do with each other. The hexagonal form of the crossing bay intrudes into the space of the apse, but the rest of the ambulatory scheme involves four-

[19] For a provocative but somewhat outdated consideration of the links between German and Italian Gothic, see Heinz Klotz, "Deutsche und Italienische Baukunst im Trecento," *Mitteilungen des Kunsthistorischen Inhstituts in Florenz*, 12 (1966): 171–206. Klotz associates S1 with the Florence campanile project, and his analyses of the proportional relationships between this drawing, the Freiburg spire, and Strasbourg Plan B are not convincing.

[20] Ascani, *Il Trecento Disegnato*, pp. 86-87, 93-94.

Figure 3.12
Siena
Cathedral,
ground plan
showing
relationship
between old
cathedral and
14th-century
campaigns.

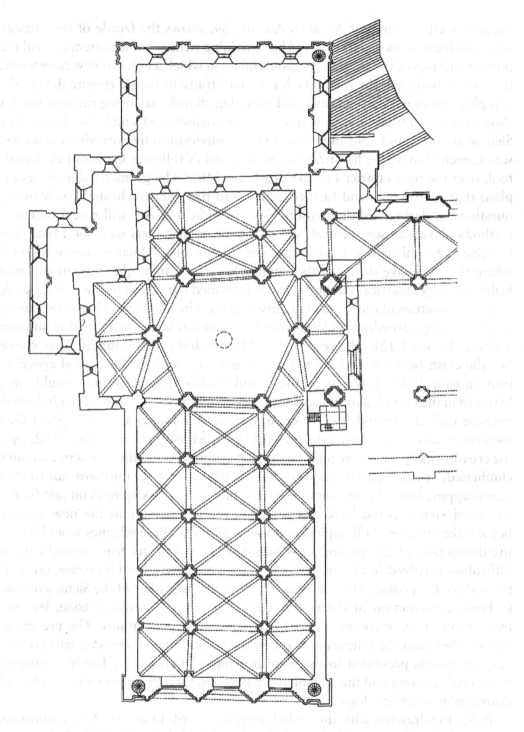

fold symmetries only. Eight identical chapels open off the ambulatory, so that each quarter circle corresponds to four chapels. The proportions of the ambulatory, moreover, appear to have been determined by quadrature (Figure 3.14). The key dimension to consider here is the half-span of the crossing, which is equal to the radius of the apse, measured to the center of the apse wall. As the solid lines in the top half of Figure 3.14 show, the radius from the apse centerpoint to the middle of the outer chapel wall exceeds the radius to the middle of the apse wall by a quadrature-derived factor of $2\sqrt{2}$, or 2.828. Since

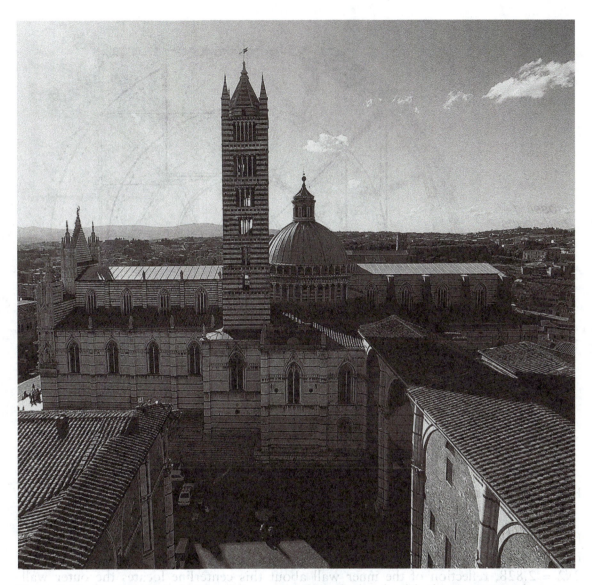

Figure 3.13 Siena Cathedral, view of the crossing from the façade of the fragmentary 14th-century
 nave.

the ambulatory connects smoothly with the rectangular bays flanking the crossing, the
intersection of the chapel wall with the baseline of the ambulatory composition locates
the centers of the piers two bays out from the crossing. Since these two bays are equal in
size, the pier subdividing them falls at the center of the small dotted circle in Figure 3.14,
which fills the space between 1.000 and 2.828 units above the crossing. The distance
from the center of the apse to the center of the pier is thus 1/2 (1+2.828) = 1.914 times
the radius of the apse.

It is the dialog between this constructed dimension and the fundamental 1, √2, 2,
2√2 dimensions of the primary quadrature sequence that give the chevet design its
geometrical interest and subtlety. The dotted arc passing through the just-mentioned pier
center locates the centers of all the engaged columns separating the chapel entrances.
Stepping outwards via quadrature, the outer corners of the chapel spaces fall √2 times

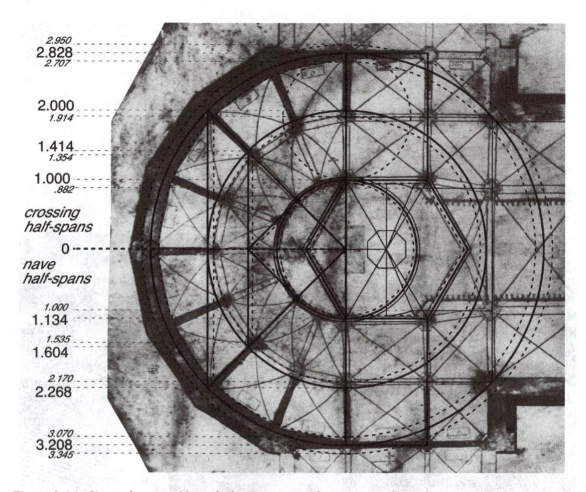

Figure 3.14 Siena, drawing S2, ambulatory zone with geometrical overlay.

further out from the apse center, at an effective radius of $(1.914)\sqrt{2} = 2.707$ apse radii. Since the centerline of the outer wall was already established at effective radius $2\sqrt{2} = 2.828$, reflection of the inner wall about this centerline locates the outer wall surface $(2 + 2 - 1.914)\sqrt{2} = (2.086)\sqrt{2} = 2.950$ apse radii out from the centerpoint. The inner wall of the apse falls at radius $1.914/2 = .957$, halfway out to the centers of the engaged columns. The reflection about the apse wall centerline locates the outer apse wall at radius $1 + 1 - .957 = 1.043$. These dimensions are too close to 1.000 to be labeled in Figure 3.14, but it is clear that a simple scheme based on quadrature and its immediate derivatives thus suffices to determine all the major radii in the chevet composition.

As the quadrature-based geometries of the chevet encounter the hexagonal structure of the crossing bay, the two schemes begin to interlock in interesting ways. To begin with, the radii of the apse walls carry around the hexagonal crossing to define the thicknesses of the arches bordering this central space. More provocatively, the choir stalls shown extending from the new nave into the crossing bay terminate at points 22.5 degrees off the old cathedral's centerline, suggesting that octagonal geometries had some relevance even in this hexagonal zone. And, indeed, the interplay between octagonal, hexagonal, and circular geometries works to establish the span of the new nave. The rays reaching from the crossing center out to the ends of the choir stalls intersect the circle inscribed within the inner wall lines of the hexagonal crossing at points that align perfectly with

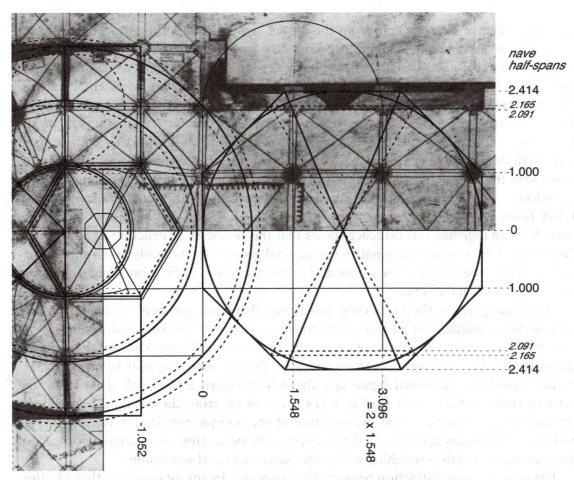

Figure 3.15 Siena, drawing S2, nave zone with geometrical overlay.

the axes of the new nave arcade. The span of the new nave bays, according to this construction, is .882 times as great at the diameter of the apse, when both are measured to their centerlines. Equivalently, one can say that the diameter of the apse is 1/.882 = 1.134 times the span of the nave bays. The lower half of Figure 3.14 expresses the dimensions of the chevet in these terms, to facilitate comparison with the nave structure of drawing S2, which is shown in Figure 3.15. The line separating the new nave structure from the crossing zone, which is labeled 0 in Figure 3.15, passes through the points where the solid circle describing the center of the chevet wall cuts the lines extending parallel to the new nave axis from the freestanding piers already located in the chevet composition.[21]

The interplay between hexagonal and octagonal geometries defines not only the span of the new nave bays, but also the relative proportions of all the walls and bays in the nave structure. The crucial generating figure in this geometry is a large octagon whose facet length equals the span of the nave bays. Such an octagon has a face-to-face diameter equal to 2.414 nave spans. When placed with its centerpoint on the centerline of the new nave, its outer faces line up with the outer margins of the nave walls as originally drawn; there is a clear distinction in S2 between the original wall, which is lightly shaded, and the black frame added around it. The hexagonal geometry begins to enter the picture when

[21] This line is thus offset by 1.052 nave half-spans from the corner piers of the crossing hexagon.

lines of 30-degree slope emerge from the center of the octagonal figure. They intersect the diagonal facets of the octagon at points 2.165 times further out from the building centerline than the nave arcades. These points lie in the window plane of the wall, which is described by a fine line, and by the kinks in the clearly described window embrasures.[22] The 30-degree rays intersect the circle inscribed within the octagon at points 2.091 times further out from the nave centerline than the arcades; these intersection points lie on the inner face of the nave walls. So, this simple construction of nested octagon, hexagon, and circle defines all the wall planes of the nave in S2.[23] This same construction also determines the bay lengths in the drawing. The inner wall plane just defined intersects the 22.5-degree ray of the octagon at points whose distance from the octagon's frame equals 1.548 times the half-span of the nave. Six identical bays of this format comprise the nave.[24] Taken together, this evidence shows that the geometrical structure of S2 involved the intersection between octagonal and hexagonal geometries, not only in the ambulatory and crossing zones where these forms declare themselves explicitly, but also in the more purely rectilinear nave zone.

This finding raises the tantalizing possibility that such geometrical structures also defined the proportions of S3 and the fragmentary fabric of Siena Cathedral's new nave, both of which at first appear similarly rectilinear. And, as Figure 3.16 and Figure 3.17 demonstrate, the proportions of these two nave designs indeed appear to have been set by the same basic octagonal figure already seen in Figure 3.15. In all these cases, the exterior surface of the outer wall is 2.414 times as far from the building centerline as the axes of the arcade piers, as the structure of the octagon requires. A variety of large and small differences between the three schemes, though, attest to an ongoing process of deliberation and option-weighing within the Siena cathedral workshop.

The most obvious distinction between the two groundplans, of course, is that S3 offers a simple faceted apse instead of the elaborated hemicycle and radiating chapels seen in S2. Such a large difference of layout clearly had programmatic implications, and the existence of these alternative plans surely reveals more about the interests and concerns of the project's patrons than it does about the working methods of the designers. Another fairly obvious point is that S3 is drawn at a larger scale than S2, measuring 93 by 67 centimeters, instead of just 80 by 57[25] centimeters. This strongly suggests that the two

[22] This line coincides closely with centerline of the piers defined in the construction of the ambulatory (2.170, where ratio 2.170/2.165 = 1.0028). Since the difference is so small as to be imperceptible, it would be impossible to determine which construction was used to determine the wall plane, if the analogous proportions did not also occur in the actual cathedral, which has no ambulatory. This strongly suggests that the 2.165 construction was the one used in the layout.

[23] Ascani suggests that the span of the nave was to have been 26 *braccia senese*, with the spans to the window plane, outer wall surface, buttress surface, and black framing box being 56, 60, 64, and 65 *braccia senese*, respectively. The ratio 60/26 gives a span to the outer walls of 2.307 times the nave span, measurably smaller than the geometrically defined 2.414 ratio proposed here, and palpably an imperfect fit with the drawing, as Ascani's fig. 14 shows; see *Il Trecento Disegnato*, pp. 88–9.

[24] Interestingly, if one constructs another large octagonal figure centered on the nave axis at the boundary between bays 4 and 5, one finds that its corners align with the eastern edges of the altar tables shown in niches in the nave walls, and that the rays of the octagon cut the inner wall plane at the end of the niche. These relationships suggest that the octagon construction was actually used by the creator of S2, not only to establish the bays closest to the crossing, but also to complete the full length of the nave.

[25] Ascani, *Il Trecento Disegnato*, p. 88.

were created under different circumstances, by different draftsmen working at different times, rather than by one designer developing two alternative schemes simultaneously.

Other more subtle factors distinguish S2 from S3. The crossing of S3, for example, lacks the perfect hexagonal symmetry seen in that of S2, since it is somewhat compressed along the axis of the new nave vessel. The ribs in the transitional bay between the crossing and the nave slope at angles of almost exactly 22.5 degrees, suggesting that an octagon may have been used in constructing this zone. The crossing itself appears to have been laid out with hexagonal symmetry in mind, since the crossing piers occupy points 60 degrees off the nave axis. Wrinkling in the parchment unfortunately makes it difficult to be absolutely precise about the geometry of the crossing and the apse in S3, but the construction shown in Figure 3.16 matches the drawing well. In this graphic, the crossing begins as a perfect hexagon, framed by the lines that describe the nave arcade axes. Circumscribing a circle about this hexagon, one finds framing lines 1.155 times further out from the nave centerline; the centers of the crossing piers fall at the points where these lines intersect the 60-degree lines radiating from the center of the crossing.[26] The apse, of course, has octagonal symmetry, and the ribs in the bays between the apse and the crossing slope at 22.5 degrees, like those in the transitional bay between the crossing and the new nave.[27] But the hexagonal and octagonal geometries do not really interact as explicitly as they do in the crossing and chevet of S2.

The nave geometries of the two drawings also differ subtly from one another. As the dotted lines in Figure 3.11 show, the nave in S3 is slightly but measurably longer than that of S2. And, as Figure 3.16 reveals, this difference again reflects the simpler geometrical structure of S3, in which the nave is a perfect double square. An octagon inscribed within each of these squares establishes the axes of the nave arcades, just as in S2, but there is no subsidiary structure of hexagonal symmetries to set the bay lengths and wall thicknesses in S3. Instead, the bay's length just comes from the division of each square module into equal thirds, so that each bay is $2 \times 2.414/3 = 1.609$ times as long as the half-span of the nave. The inner surface of the lateral walls, meanwhile, can be found by inscribing a circle within each square module, drawing line segments to connect the points where these circles cut the arcade axes, and then swinging arcs concentric with the large circles such that they just touch the line segments. This construction places the inner wall surfaces 2.197 nave spans apart from each other, instead of the 2.091 nave spans seen in S2.

The comparatively simple geometrical structure of S3 is just one of several factors that suggest that it was conceived before the more elaborated S2. It may be significant, for example, that only the latter drawing depicts the choir stalls and altars that would furnish the new building, features that would have demanded a designer's attention especially as the project moved towards realization. Importantly, too, S2 includes a

[26] Because of wrinkling, the pier centers in Fig. 3-16 are slightly displaced downward with respect to their proper locations, but the vertical span between them agrees well with the 1.155 nave-span distance shown in the graphic. And, while the span of the old cathedral's nave appears slightly too small for the construction shown there, this, too, results from wrinkling, as one can tell by noting that there really is a 60-degree angle between the visible compass prick at the center of the crossing and the pier centers facing the new nave; only the piers on the apse side are significantly displaced by the wrinkling.

[27] The lines connecting the crossing piers to the corners of the transitional bays may have been constructed either by using octagonally-derived 22.5 degree slopes, or by sighting from the pier centers to the corners of the original generating hexagon; the difference between these angles is effectively imperceptible.

Figure 3.16
Siena, drawing
S3, with
geometrical
overlay.

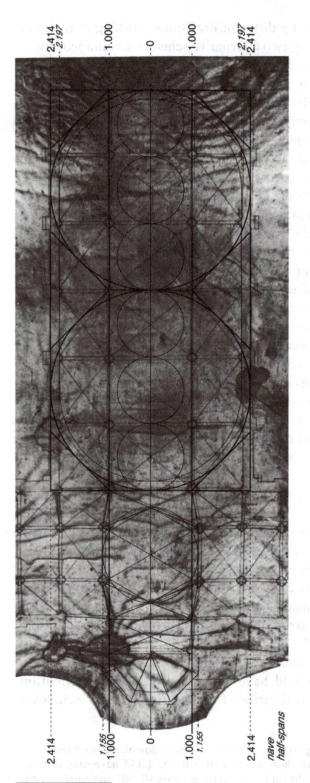

scale bar, which would have further enhanced the drawing's utility as a guide to construction. This bar, which is explicitly marked out in *braccia senese*, shows that the drawing had a scale of 1:156. The somewhat larger S3 includes no such scale bar, but Ascani observed that the width of the nave in that drawing was exactly one half of a Tuscan *braccio a terra*, a unit that he also identifies in the campanile design S1.[28] This is why he attributed S1 and S3 to Lando di Pietro, a designer who would have learned to work with this unit during his time in Florence, while he attributes S2 to Lando's follower Giovanni di Agostino, who directed the Sienese cathedral workshop after Lando's death.[29]

Comparison of the drawings with the extant fragments of the Duomo Nuovo confirms that S2 was indeed the more definitive design, as Ascani had suggested. The proportions of the built structure match those of S2 almost perfectly, as consideration of Figure 3.15 and Figure 3.17 reveals. The average length of the completed bays very closely approximates 1.548 half-spans of the nave, the ratio seen in S2, rather than the 1.609 ratio seen in S3. The only substantive difference between the masonry and S2 is that the present side walls are a bit slimmer than originally foreseen. More specifically, the distance between the inner wall surfaces approximates 2.165 times the nave span, which is larger than the 2.091 ratio seen in the equivalent plane of S2, but which matches the window plane in the drawing. It seems, therefore, that the complete octagon-plus-hexagon geometrical arma-

[28] Ascani uses a module-based analysis to argue that the scale of S2 was meant to be exactly 1:156, which accords well with the dimensions in the scale bar. He uses a similar analysis to argue that the scale of S3 was meant to be 1:144, but this case cannot be verified so directly, since S3 has no scale bar, and since the proportions of S3 differ markedly from those in the actual cathedral, as explained below. See *Il Trecento Disegnato*, pp. 89–91.

[29] Ascani, *Il Trecento Disegnato*, 93

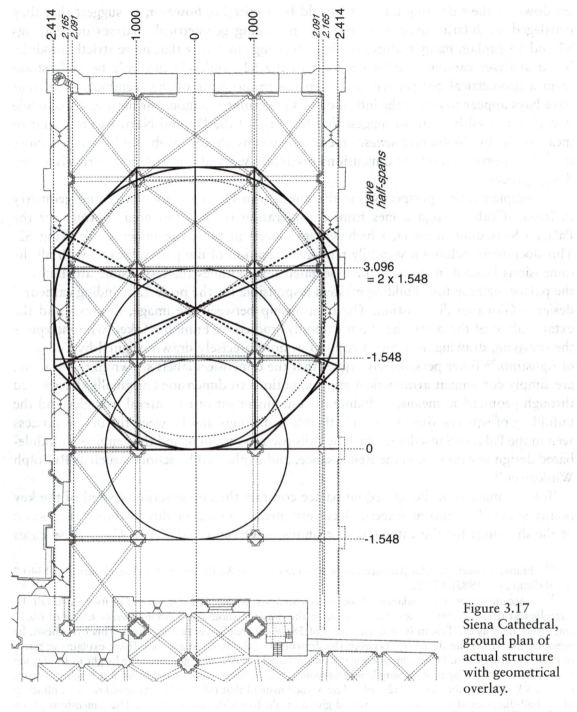

nave half-spans

2.414
2.165
2.091
1.000
0
1.000
2.091
2.165
2.414

3.096
= 2 x 1.548

-1.548

0

-1.548

Figure 3.17
Siena Cathedral,
ground plan of
actual structure
with geometrical
overlay.

ture from the drawing was retained in the actual construction, with the wall surface simply being pushed out from one line in the armature to the next.

In terms of absolute scale as well as proportion, the built fragments of the Duomo Nuovo conform closely to S2, with average bay length very closely approximating 12.02 meters, or 20 *braccia senese*, just as in the drawing's scale bar. The choice of this round number for bay length was surely not coincidental, which means that the designers in Giovanni di Agostino's circle thought at least partly in terms of modules when they

sat down at their drafting tables. It would be a mistake, however, to suggest that they privileged modularity over geometry. The preceding geometrical analyses of drawings S2 and S3 explain many features of these drawings in a way that more strictly module-based analyses cannot. The formal logic of the S2 hemicycle can only be understood from a geometrical perspective, and even the proportions of the seemingly rectilinear nave bays appear to reflect the influence of a governing octagonal armature. Thus, while Ascani may well be right to suggest that the bays of the Duomo Nuovo were meant to measure 20 by 26 *braccia senese*, these dimensions should probably be seen as close modular approximations to dimensions originally worked out in a geometrically based design process.

A complementary perspective on the interaction between modularity and geometry in Italian Gothic design comes from consideration of the illustrated contract for the Palazzo Sansedoni in Siena, which was produced in the same milieu as drawing S2. This document includes a sketchily rendered elevation of the palace façade, with all the dimensions labeled in *braccia*; the associated text outlines the less visible attributes of the palace, naming four building masters responsible for the project, including cathedral designer Giovanni di Agostino. The relationship between the image, the text, and the extant fabric of the palace has been carefully studied by Franklin Toker, who interprets the surviving drawing as a rough copy of a more precisely drawn original by Giovanni di Agostino.[30] Toker persuasively argues that the dimension labels shown in the drawing are simply convenient arithmetical approximations to dimensions originally determined through geometrical means, including the establishment of equilateral triangles and the unfolding of squares' diagonals.[31] He therefore distinguishes between the design process seen in the Palazzo Sansedoni, which he calls pseudo-modular, and the genuinely module-based design system seen in the Renaissance, and explicated by scholars such as Rudolph Wittkower.[32]

Toker's analysis of the Sansedoni palace contract thus underscores several of the key points about Trecento architectural culture already noted in this chapter's discussion of the drawings for the cathedral workshops of Orvieto and Siena. All of these cases

[30] Franklin Toker, "Gothic Architecture by Remote Control: An Illustrated Building Contract of 1340," *Art Bulletin* , 67 (1985): 67-95.

[31] Ascani accepts the fundamentals of Toker's analysis, while critiquing several of its details. On the metrological front, Ascani argues that the units in the drawing should be read as *braccia senese* of 60.11 cm, rather than as the Tuscan *braccia da panno* of 58.36 cm that Toker had assumed. This hypothesis, he suggests, would explain deviations between the drawing and the built palace that Toker explains in terms of changes of intention. On the proportional front, meanwhile, Ascani argues that the height of the façade was to have been set by a single simple ad *triangulum* relationship, which would give it a height-to-width ratio of $\sqrt{3}$, or approximately 1.732. Toker had argued instead that this height was based on the unfolding of the half-diagonal of a square, which would give a height-to-width ratio of 1.707. The dimensions of the façade in the drawing, which measures 70.1 cm high by 40.6 cm wide, give a ratio of 1.727, which agrees better with Ascani's scheme than with Toker's. On the other hand, Toker's construction agrees better with the numerical values cited in the contract: a baseline of 32.75 *braccia* and a height of 60 braccia gives a ratio of 1.710. Unfortunately, the imprecision of the drawing makes it difficult to resolve this debate definitively. It is important to emphasize, however, that Ascani and Toker are in substantial agreement both about many of the geometrical constructions used in the drawing, and about the conceptual priority of these geometrical constructions over the modular dimensions that approximate them. See Toker, "Gothic Architecture by Remote Control," esp. Fig. 16 on p. 83; Ascani, *Il Trecento Disegnato*, pp. 101-103 and Fig. 23; and Ascani, "Le dessin d'architecture médiéval en Italie," 271-3.

[32] Rudolph Wittkower, *Architectural Principles in the Age of Humanism* (London, 1949).

demonstrate that geometrical constructs based on squares, octagons, equilateral triangles and their derivatives were important for leading Italian designers in the first half of the fourteenth century. At the level of design logic, therefore, their work resembles that of their northern European contemporaries to a striking extent, the frequently remarked-upon contrasts between Italian and transalpine architectural cultures notwithstanding. From this perspective, the famous confrontation between northern and native designers at Milan around 1400 seems to mark not the first incursion of sophisticated Gothic design techniques into Italy, but rather an important early instance of assertive Italians challenging the legitimacy of those techniques. In the decades to follow, of course, Italian and northern architectural practices would diverge more dramatically. Italian builders began to embrace classical architectural theory, with its emphasis on simple modular ratios and the proportions of the human body. Down to 1500 and beyond, though, most northern builders remained fully committed to a geometrically based Gothic design system, whose most famous exponents in the late fourteenth century were members of the Parler family. Before returning to Italy to consider the Milan project and the emergent Renaissance challenge to the Gothic tradition, therefore, it makes sense to consider the drawings produced by the Parlers and their late Gothic successors in the northern world, with particular emphasis on the tower and façade drawings that consumed so much of their attention.

CHAPTER FOUR
Germanic Tower Drawings and the Elaboration of Tradition

Tower and façade projects occupy center stage in the history of Gothic architectural drawings, and in the history of Germanic late Gothic design in particular. The earliest surviving workshop drawings of the Gothic period, after all, include façade studies in the Reims Palimpsest, the Strasbourg and Cologne workshops, and the tower drawings associated more or less directly with the Freiburg spire project. In Italy, too, the oldest surviving drawings are façade elevations from Orvieto, with the Siena campanile and baptistery elevations following soon after. In the Holy Roman Empire after 1350, tower projects achieved an even greater relative prominence than they had previously. On these bases, it is not surprising that many of the most impressive surviving drawings are tower drawings from the Germanic late Gothic world. Ulm, Regensburg, Strasbourg, and Frankfurt, for example, all preserve spectacular tower drawings. And, many of the most magnificent specimens in Vienna's unrivaled Gothic drawing collections represent late Gothic towers, including those of the local Stephansdom. Because these drawings relate so closely to one another, they deserve to be considered as a set, even though they were produced over a span of more than a century and a half.

PRAGUE

All of the designers involved with the tower projects discussed in this chapter drew in significant respects on the legacy of Peter Parler, one of the most famous and influential artists of the Gothic era. Although the details of his life story remain murky, enough information survives to show that he had a remarkable career. Born into an architectural family, young Peter gained valuable design experience working under his father, Heinrich, at the church of the Holy Cross in Schwäbisch Gmünd. In 1356, when he was just 23 years old, he was summoned to Prague by Emperor Charles IV so that he could serve as the new imperial architect. By the time of his death in 1399, he had contributed significantly to the reshaping of Prague by erecting the Charles Bridge and transforming the cathedral. He also designed the church of Saint Bartholomew in Kolín, and he launched his sons Wenzel and Johann into distinguished architectural careers of their own. Peter Parler became so successful, it seems, because he managed to be both reliable and innovative. He would never have been entrusted with major imperial building projects if he had not had a solid background in conventional architectural practice. He would not have been singled out

at such a young age, though, if he had not displayed individual talents that set him apart from the other competent young designers in the Empire.[1]

Modern writings on Parler tend to emphasize the boldness and unconventionality of his work at Prague Cathedral, which contrasts strikingly with the more academic quality seen in the parts of the building designed by his predecessor Matthias of Arras, a Frenchman who had guided the project from its inception in 1344 until his death in 1352.[2] Prague Cathedral, as conceived by Matthias, would have closely resembled the southern French cathedral of Narbonne, with a regular belt of polygonal chapels wrapping around its east end.[3] Peter rejected this systematic vision, treating each individual component of the building as a thing in itself, and introducing mannered contrasts of architectural mode between these parts. Thus, for example, he placed great emphasis on the chapel of Saint Wenceslas, Bohemia's patron saint, treating it as a large cubic form that protrudes from the south side of the cathedral even while intruding into the space of its transept (Figure 4.1). The windows of the chapel are very small, and its interior walls appear encrusted with multi-colored stones. The massiveness of the chapel contrasts dramatically with the lightness and openness of the cathedral's superstructure, suggesting a distinction between two different eras of architectural and cultural history. Parler may well have come up with this theatrical manner in collaboration with his patron, Charles IV, a shrewd political propagandist who sought to underscore his connections to the Bohemian past by promoting the cult of Saint Wenceslas.[4] Political symbolism likely informed Peter's decision to construct an enormous tower adjacent to the cathedral's south transept and entry porch, which faced the emperor's palace; this unusual arrangement made the cathedral tower look like part of the palace when seen from the city below, underscoring the union of sacred and temporal authority that the complex embodied (Figure 4.2).[5] Inside the cathedral, meanwhile, Parler introduced complex new network vaults that suggest his familiarity with English prototypes, setting a precedent that would dramatically influence the direction of German late Gothic design.[6] Peter Parler owes his reputation as an innovator not only to his architectural works, but also to his career as a sculptor. The realism and individualism of the sculpted busts attributed to him is striking, marking an important stage in the emergence of portraiture. The fact that Parler sculpted a realistic

[1] The best comprehensive treatment of Parler's career is Marc Carel Schurr, *Die Baukunst Peter Parlers* (Ostfildern, 2003).

[2] Prague Cathedral has generated a literature too vast to be summarized here. For a full bibliography, see Schurr, *Die Baukunst Peter Parlers*. For a more accessible synopsis of research up to 2000, see Paul Crossley's summary in Frankl, *Gothic Architecture* (rev. edn), p. 347 n. 55; and Norbert Nussbaum, *German Gothic Church Architecture* (New Haven, 2000), pp. 241–2.

[3] Details of the wall moldings in the sacristy bay begun by Matthias suggest, however, that he may already have anticipated the installation of star vaults, which were later completed with innovative hanging keystones by Peter Parler. See Klara Benešovská, "Einige Randbemerkungen zum Anteil von Peter Parler am Prager Veitsdom," in Richard Strobel (ed.), *Parlerbauten. Architektur, Skulptur, Restaurierung* (Stuttgart, 2004), pp. 117–26.

[4] See, for instance, Eva Rosario, *Art and Propaganda: Charles IV of Bohemia, 1346-1378* (Rochester, 2000).

[5] Wolfgang Braunfels, *Urban Design in Western Europe: Regime and Architecture, 900–1900*, trans. Kenneth J. Northcott (Chicago, 1988), 283.

[6] Paul Crossley, "Peter Parler and England: A Problem Re-visited," in Strobel, *Parlerbauten*, pp. 155–80.

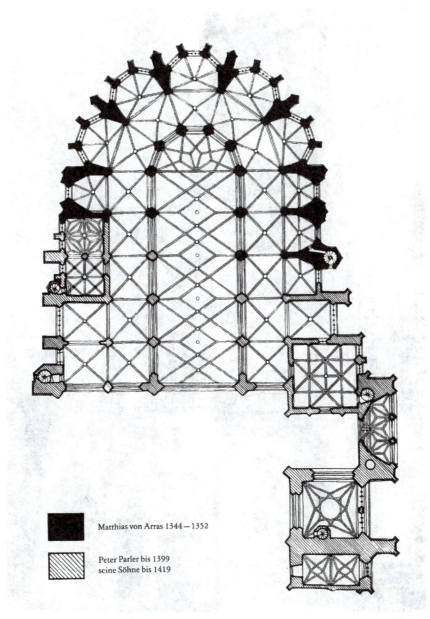

Matthias von Arras 1344—1352

Peter Parler bis 1399
seine Söhne bis 1419

Figure 4.1 Prague Cathedral, ground plan of medieval structure showing the constrast between the work of Matthias of Arras (in black) and the work of Peter Parler (hatched). The square plan of the cathedral's tower appears at the bottom right, joined by the thin structure of the portal to the equally-sized square plan of the Wenceslas Chapel.

portrait of himself, in particular, has often been taken to represent a new stage in the rise of the self-conscious artist.

It is worth asking, in this context, how innovative Peter Parler's design methods were. His willingness to embrace unconventionality, theatricality, and disjunction certainly deserve note. But, as the following case studies of his drawings for Prague Cathedral and its tower project will demonstrate, Parler continued to work in a traditional geometrically based manner that would have been familiar to Gothic builders working fifty to one hundred years earlier. The members of Cologne, Strasbourg, and Freiburg workshops, in

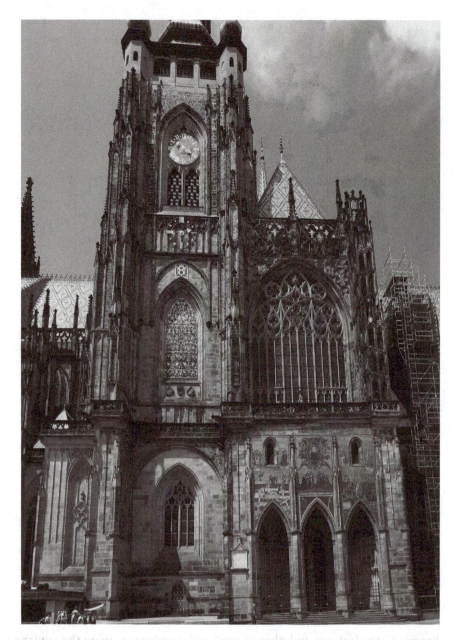

Figure 4.2 Prague Cathedral, view from the south. Visible from left to right are the cathedral's
tower and south transept with its portal.

particular, would have understood his approach perfectly. This makes good sense, since
Parler likely visited all three Rhenish centers before coming to Prague. Strasbourg and
Cologne have long been recognized as sources for Parler's formal vocabulary, and recent
research suggests his conversancy with Freiburg as well.[7] Knowledge of Freiburg might,
in fact, help to explain why Parler was recruited by Charles IV, since the construction of
a great tower for Prague Cathedral appears to have been one of the emperor's long-term
goals. The contrast between the blockiness of the Freiburg tower base and the skeletal

<hr>

[7] Schurr, *Die Baukunst Peter Parlers*, pp. 46–7, 122–3.

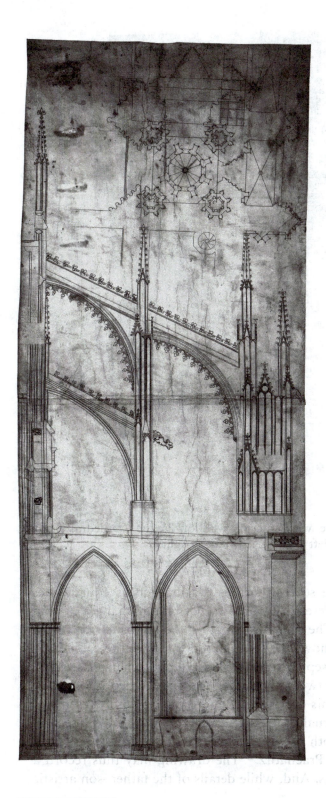

Figure 4.3 Drawing 16.821, showing the cross-section of the Prague Cathedral choir (below), and the ground plan of a tower (above).

quality of its spire may even have impressed young Parler enough to inform his own embrace of aesthetic disjunction.[8]

Three surviving design drawings from the Prague workshop offer valuable clues about Peter Parler's design methods, and about the evolution of the Prague Cathedral project. All three now belong to the Academy of Fine Arts in Vienna, and all three were probably brought to Vienna around 1400, when Peter Parler's son Wenzel left Prague to become head of the Viennese Stephansdom workshop. As Hans Böker has recently demonstrated in his magnificent catalog of the Viennese drawing collections, there is good reason to ascribe all three drawings to Peter Parler himself, although his sons may have contributed to the production of at least one of them, as explained below.[9] The first drawing, number 16.821, shows a half-section of the Prague choir and its flying buttress system, with a small groundplan of a spired tower occupying the top section of the tall parchment (Figure 4.3). The tower plan has never been conclusively identified, but it makes sense to interpret it in relation to Peter Parler's early planning for the Prague cathedral tower project. The second drawing, number 16.817v, shows the western interior wall of

<hr />

[8] If Parler visited Freiburg early in his career, he might have become acquainted with the designer of Freiburg Minster's choir; this master, in turn, was clearly intimately conversant with the design of the Freiburg spire, as Thomas Flum emphasized in *Der Spätgotische Chor des Freiburger Münsters* (Berlin, 2001), pp. 125–6.

[9] Böker, *Architektur der Gotik*, pp. 61–6, 74–8.

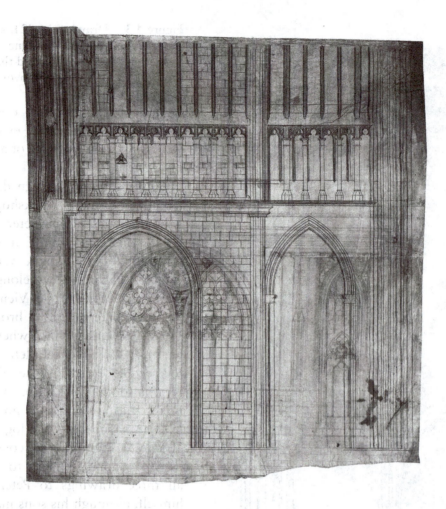

Figure 4.4 Drawing 16.817v, showing the west interior wall of Prague Cathedral's south
 transept, with the tower bay at left and the aisle bay at right.

the cathedral's south transept, including several curious details such as course lines
depicting an asymmetrically walled-up clerestory window, that hint at changes of plan
during the design process (Figure 4.4). The third drawing, on the opposite side of the
second and executed at the same scale, shows the south exterior face of the cathedral's
great tower, just to the west of the transept (Figure 4.5). Here, too, changes seem to
have been introduced, most obviously between the rather soberly detailed lower story
and the more complex superstructure. This upper story, interestingly, closely resembles
not only the equivalent section of the actual Prague tower, but also the middle section
of the Stephansdom tower in Vienna, both of which were built under the supervision
of Wenzel Parler and his assistant Peter Prachatitz.[10] The drawing may thus record a
collaboration between artistic generations. And, while details of the father–son artistic

10 Klára Benešovská critiques Böker's early dating for the whole drawing, noting that its upper reaches
can best be understood as dating after 1380, when a new wave of English influence reached the Prague
workshop. She suggests Peter, Wenzel, and Johann Parler, along with Peter Prachatitz, as possible contributors
to the drawing. See Benešovská, "The Legacy of the Last Phase of the Prague Cathedral Workshop: One
More Look at the 'Weicher Stil'," in Jiří Fajt and Andrea Langer (eds), *Kunst als Herrshaftsinstrument:*

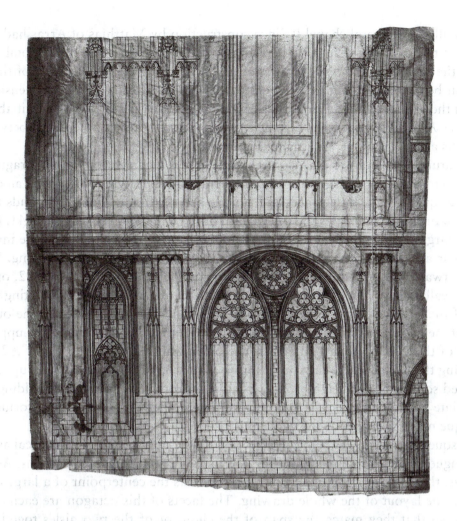

Figure 4.5 Drawing 16.817, showing the south face of Prague Cathedral's south tower, with the south transept portal at right.

dialog remain unclear, geometrical analysis of these drawings certainly can shed light on the working methods of the Parlers in Prague, establishing a baseline against which other Germanic late Gothic drawings can be fruitfully compared.

The section of the Prague choir shows a structure closely approximating what was actually built, but with markedly simpler tracery in the buttress uprights, and no indication of any complex vaults. This fact already begins to suggest a dating for the drawing sometime fairly early in Peter Parler's tenure in Prague. The intermediate pier of the buttressing system visually subdivides the drawing into two slender vertical slices, with the inner aisle at left, and the aisle-like space of the lateral chapels at right. This subdivision is geometrically precise, in the sense that the distance from the arcade pier axis to the intermediate pier axis equals the distance from the intermediate pier axis to the

Böhmen und das Heilige Römische Reich unter den Luxemburgern im Europäischen Kontext (Berlin and Munich, 2009), pp. 43–58, esp. 49–50.

interior wall of the lateral chapel.[11] Since construction by Matthias of Arras had already established the span of the inner aisle as half that of the choir vessel, the total interval between the arcade pier and the inner wall in the drawing equals the span of the choir, which can be called one unit for convenience. Moving into the vertical dimension, one finds that the upper-right interior corner of the chapel bay falls exactly one unit above the groundline. A perfect square thus fills the space of the two "aisles," measured between the arcade axis and the interior wall plane (Figure 4.6).

Quadrature and octature play crucial roles in the organization of the Prague choir scheme, even though no octagons appear explicitly in the drawing. Inscribing an octagon within the square of the aisle space, and a circle around that octagon, one finds that the top margin of the circle locates the top margin of the balustrade at height 1.041. Its right and left margins, respectively, locate the window plane of the chapel, and the inner face of the choir arcade wall, each .541 units from the central axis of the drawing. Moving further outward from the drawing centerline by another .041 to distance .582, one finds the outer wall plane, at right, and the margin of the parchment, at left.[12] Rotating the unit square of the aisle space by 45 degrees, one finds that its right tip locates the outboard margin of the main choir buttress .707 units out from the drawing center. The upper-right diagonal of this rotated square intersects the outer wall plane at a height of .624 units, establishing the height where the vaults spring at the top of the capitals. The upper tip of the rotated square falls at height 1.207, locating a prominent horizontal molding on the intermediate buttress axis. This is also the level where, in the middle of the triforium zone, a grotesque mask gazes out at the viewer.

Grotesques and gargoyles help call attention to key points in the geometrical armature of the Prague choir section, much as they had in the Freiburg tower elevations. As Figure 4.7 shows, the mask in the Prague triforium serves as the centerpoint of a large octagon governing the layout of the whole drawing. The facets of this octagon are each one unit in length, so that they match the span of the choir, or of the two aisles together. The top facet of the octagon thus falls at height 2.414, which corresponds in the drawing to the point where the upper flying buttresses intersect the gutteral wall. The top edge of the flying buttress slopes down to the point where the upper diagonal of the octagon intersects the inner wall plane of the aisle, at height 1.914. The adjacent corner of the octagon falls at height 1.707, right where a gargoyle springs from the buttress upright. A horizontal drawn at this height falls just above the seam joining the two parchments that comprise the drawing, and it intersects the left margin of the drawing precisely at the top of the main capitals. This octagonal framework thus appears to have determined the most important proportions of the drawing and its layout on the page. Still further evidence for the importance of the octagon comes from the way a single ray connects the mask at its

[11] This geometry marks a slight change from the format originally seen in the chapels built by Matthias of Arras, which are somewhat shallower.

[12] Erasures in the triforium zone of the drawing, to which Böker first called attention in *Architektur der Gotik*, p. 77, further attest to the importance of the octature construction just described. The triforium baseline, the adjacent drain, and several moldings at the top margin of the triforium were originally drawn 1.7 centimeters below their present position, before being erased and redrawn as they now appear. This interval corresponds closely to the interval between the octagon and its circumscribing circle, suggesting that Peter Parler or one of his drafting assistants mistakenly sighted to the top of the octagon instead of the top of the circle before discovering his mistake.

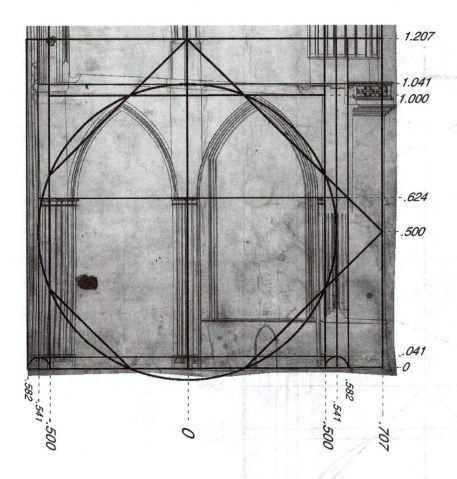

Figure 4.6
Drawing 16.821,
lower portion with
geometrical overlay.

center, the head of the gargoyle on the intermediate buttress pier, and the smaller gargoyle at height 1.707. In their appearance, and in their use as geometrical markers, these figures strongly recall those seen in Rahn Plan B and in the similarly Freiburgish 16.869. Since such figures are not seen in the drawings from Cologne and Strasbourg, this unusual detail contributes to the circumstantial case crediting Peter Parler with knowledge of the Freiburg milieu and its drafting practices.

Figure 4.8 shows how the remaining details of the Prague choir elevation can be determined within the half-octagonal armature advertised by the grotesques. At the bottom of the drawing, the height of the bases appears to have been determined by the octature-defined interval of .041 already seen as the half-width of the outer wall. Increasing this interval by a $\sqrt{2}$ factor, one finds the vertical .058 to the left of the drawing centerline that rises to define the left margin of the intermediate pier and the upright above it. The prominent horizontal in the chapel wall, at height .173, can be established by constructing a smaller octature figure in the aisle zone, scaled such that its diagonal facet aligns with that of the large master octagon. The bottom lip of the buttress balustrade aligns with the point at height .957 where the diagonal of the rotated square in the aisle zone intersects the vertical rising from the left side of the small door in the aisle wall, which is halfway between the drawing centerline and the inner chapel wall. At the top of the drawing, meanwhile, the tip of the intermediate buttress pinnacle falls at height 2.514, the level reached by a circle circumscribed about the master octagon.

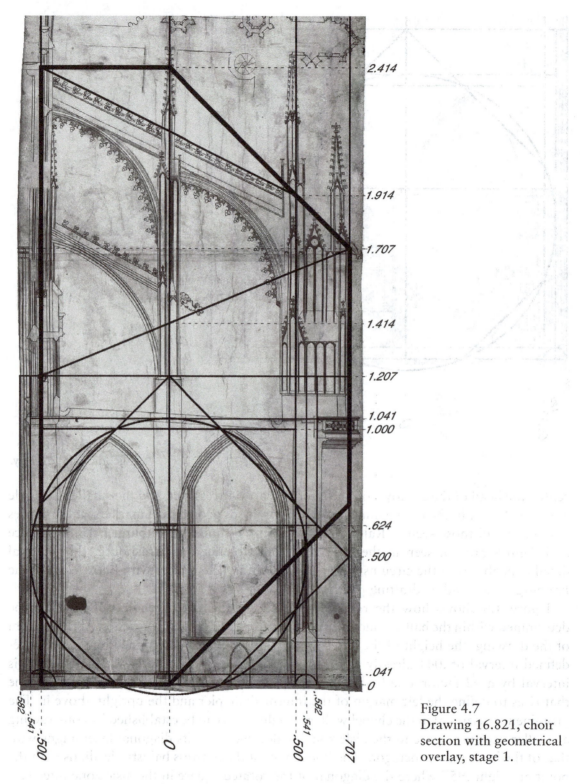

Figure 4.7
Drawing 16.821, choir section with geometrical overlay, stage 1.

One of the most important points in the Prague elevation lies halfway up the left margin of the octagon, at height 1.207. This point, just to the left of the mask in the triforium, serves as the center of curvature for the lower flying buttress, whose radius extends out to the leftmost vertical of the intermediate buttress pier. This arc sweeps up

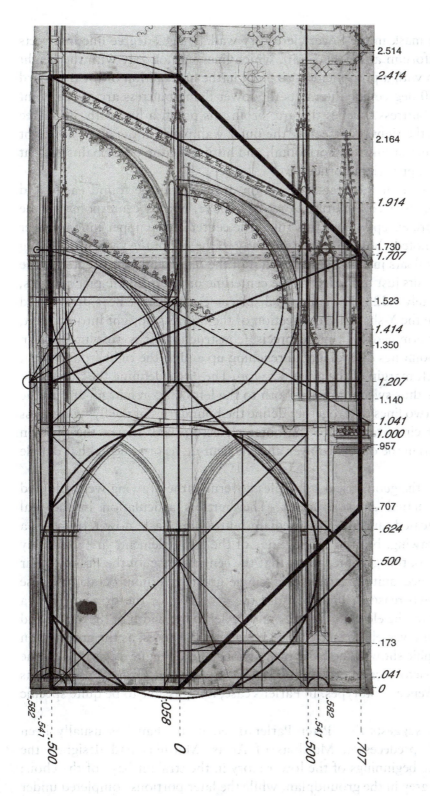

2.514
2.414
2.164
1.914
1.730
1.707
1.523
1.414
1.350
1.207
1.140
1.041
1.000
.957
.707
.624
.500
.173
.041
0

.582 .541 .500
.058
0
.582 .541 .500
.707

Figure 4.8
Drawing 16.821,
choir section with
geometrical overlay,
stage 2.

to height 1.730, where it locates the center of the upper inboard flying buttress, which is
constructed similarly. Within the lower arc, meanwhile, rays extending out at angles of 30,
45, and 60 degrees define several further lock points in the drawing. The 30-degree line
intersects the intermediate buttress pier just above the back of the gargoyle; the same level

marks the top edge of a mask in the lower clerestory wall. The 45-degree line intersects the outer wall of the triforium at height 1.350, which lines up not only with the height of the triforium but also with a prominent horizontal in the articulation of the outboard pier buttress. And the 60-degree line intersects the lower flying buttress arc at the point where the chord of the buttress touches the arc. From this point, a line with 30-degree slope aims down and to the right, intersecting the outer wall plane of the aisles at height 1.140, defining another major buttress horizontal, and hitting the top of the balustrade at height 1.041, right at its upper-right corner.

Most of the basic points in the Prague elevation drawing can be found easily and precisely using the octagon-based armature described above, but the centerpoints of the upper flying buttresses are exceptions to this rule. The center of the upper inboard flyer falls as height 1.730, as noted above, but it sits slightly to the left of the verticals defining the wall plane, so that it floats just above the capital of the main vault. The center of the outboard flyer, similarly, sits just to the left of the centerline of intermediate pier buttress, at a height of approximately 1.523. The leftward displacement may have been determined empirically, so as to take the Y-shaped cross-section of the buttress upright into account, or it may have been determined by a more precise construction. It is absolutely clear, though, that the centerpoint lies on a diagonal reaching up and to the right from a point at height 1.041 on the left margin of the great octagon. The circle defining the outermost arc of the flying buttress thus sweeps tangent both to the left octagon margin and to the horizontal at 1.041, the two lines that together define the boundaries of the flying buttress zone. A slightly smaller circle tangent to the outer clerestory wall marks the division between the tracery cusps in the outboard flyer and the fleur-de-lis ornaments that dangle beneath them.

Figure 4.9 shows that the geometrical principles governing the drawing were adopted quite faithfully in the actual choir structure. The buttress articulation in the real building is more complicated, and the intermediate buttress pinnacle now terminates a bit lower than in the drawing, but the proportions of the main elements are effectively identical. Importantly, too, this graphic shows that the central vessel of the Prague choir has proportions determined quite precisely by a single great governing octagon. These proportions occur for two reasons: first, because the geometry of the drawing uses a great half-octagon to relate the elevation of the main vessel to the width of the aisles; and second, because the central vessel is exactly twice as wide as the aisles, as the groundplan in the bottom of the graphic shows. The basic proportions of the Prague elevation scheme thus recall those of Orvieto façade drawing O2. Like Maitani in Orvieto, Parler was surely looking back to French prototypes. In Parler's case, it is possible to be quite specific about these influences.

Geometrical analysis suggests that Peter Parler owed more than has usually been imagined to his French predecessor, Matthias of Arras. Matthias had designed the radiating chapels and the beginnings of the lower story in the straight bays of the choir; these are shown in dark grey in the groundplan, while the later portions completed under Parler's guidance are shown in light grey. It was Matthias, therefore, who established the simple 2:1 relationship between the width of the main vessel and the aisles. And it was Matthias who began to define the elevation by establishing the height of the aisle and chapel vaults. But evidence from Prague cannot, by itself, say what Matthias intended

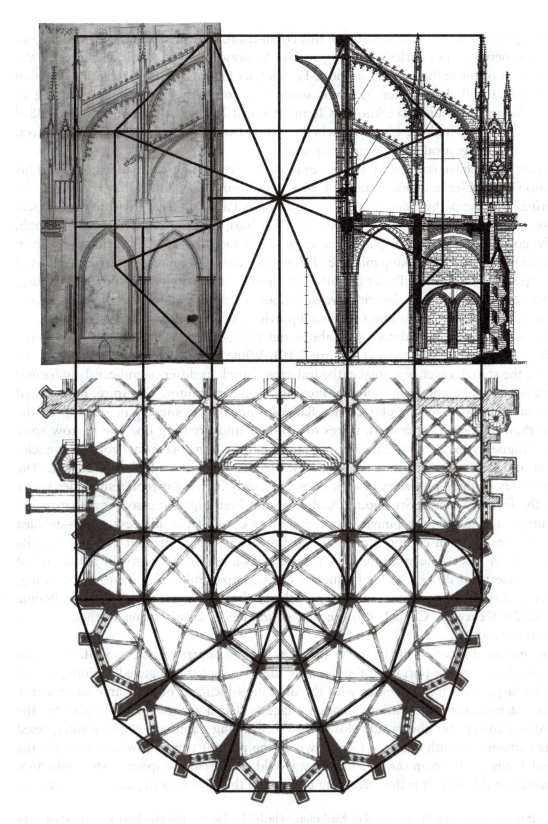

Figure 4.9 Comparison between proportions of drawing 16.821 (shown reversed at upper left), the actual section of Prague Cathedral (at upper right), and the cathedral's plan (below), all with geometrical overlay.

for the upper stories. It is significant, in this connection, that precisely the same octagon-based geometry seen in Parler's drawing and in the present Prague choir also governs the proportions of the cathedral at Clermont-Ferrand, as Figure 5.25 and related discussion in Chapter 5 will show. Since Matthias worked in southern France before coming to Prague, he surely would have known Clermont Cathedral, which was begun in 1248.[13] Matthias probably had the Clermont scheme in mind when he began the Prague project, for which he likely produced elevation drawings.

Parler would have studied Matthias's drawings when he first came to Prague, and his retention of the Clermont-like octagon-based proportioning scheme doubtless reflects the lingering influence of the older master's work. The way Parler used gargoyles as geometrical markers, meanwhile, suggests affinity with the Freiburg workshop. Interestingly, though, the Prague choir elevation displays neither the rigid modular stacking principle seen in Cologne Plan F, nor the striking mixture of triangular and octagonal geometries seen in the Freiburg spire. Thus, while Parler doubtless had some familiarity with Cologne, Freiburg, and Strasbourg, his Prague elevation drawing does not exhibit all the complexities seen in the great Rhenish tower drawings discussed previously.

The small tower plan drawn just above the Prague choir elevation presents many puzzles, especially in this context (Figure 4.10). While it seems obviously to depict the plan for the spired tower of a great cathedral-type church, it differs significantly in format from the towers planned for Cologne, Freiburg, and Strasbourg. The spire, represented by an octagon with rectangular corner flanges, appears far smaller in relation to the tower than the broad, openwork spires of Cologne and Freiburg do. The narrow spire format vaguely recalls that of Strasbourg Plan B, but the large octagonal corner pinnacles intrude on the main spire in a way that the slender pinnacles of Plan B do not. The octagonality of these pinnacles deserves note, not only because it represents a departure from the formats seen in Strasbourg, Cologne, and Freiburg, but also because it marks a return to the idea of the pinnacle as a miniature copy of the adjacent spire—an idea that had already been explored in the Laon Cathedral façade around 1200. It may be significant, in this connection, that Peter Parler was a major innovator in the design of microarchitectural shrines.[14] One frequently cited comparandum for the tower drawing, in fact, is a spire-shaped metal sacramental shrine that Parler created for use in Prague Cathedral's Wenceslas Chapel. But the mix of influences contributing to these designs remains unclear.

The intended function of the tower plan has proven controversial, as well. The scale and complexity of the portals in the drawing indicate that the depicted building would be quite large. This fact, together with the drawing's location on the same sheet as the Prague Cathedral choir elevation, strongly suggests that it records an early plan for the cathedral's tower. But the façade shown in the drawing cannot readily be interpreted as the cathedral's south transept façade, where the present tower now stands, since the lower-left edge of the plan shows a wall that would cut across the space of the south aisle if oriented in this way. It is thus tempting to imagine that the drawing actually represents

[13] It is interesting that the cathedral of Narbonne, which Matthias would also have known, appears to have slightly different proportions, with the choir vaults and walls rising slightly higher with respect to the span between the arcade pier centerlines.

[14] See Achim Timmermann, *Real Presence: Sacrament Houses and the Body of Christ, 1270–1600* (Turnhout, 2009), ch. 2.

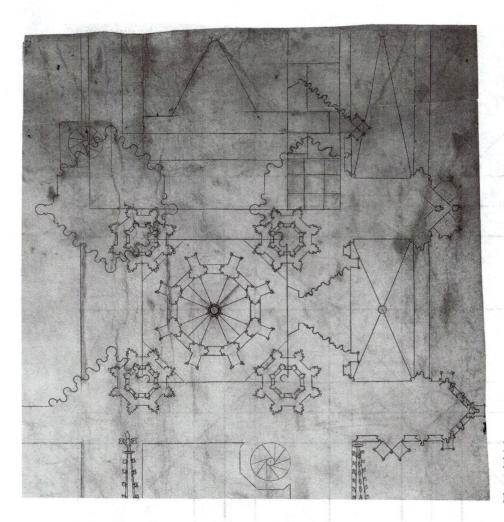

Figure 4.10
Drawing
16.821, tower
plan.

a scheme for the cathedral's west façade, conceived before the decision was taken to prioritize construction of the south transept façade instead.[15] This scenario would square well with the seemingly early dating of the choir elevation drawing below. The tower bay in the plan drawing, though, is wider compared to the adjacent vessel than the Prague Cathedral aisles are compared to the nave, which complicates this interpretation. There is, moreover, no obvious scale relationship between the tower plan and the choir section.

Fortunately, the internal logic of the plan's geometry proves more straightforward to decipher. The space between the corner pinnacles of the spire is smaller than the span between the buttress axes by a quadrature-derived $\sqrt{2}$ factor. Calling the distance from the tower center to the buttress axes one unit, therefore, one finds that the distance from the centerline to the corner pinnacles is .707 units, as Figure 4.11 shows. The outer walls stand as far beyond the buttress axes as the pinnacles do to the inside, i.e. 1.293 units

[15] Jaroslav Bureš made the west façade proposal in "Die Prager Domfassade," *Acta Historiae Artium*, 29 (1983): 3–50. More recently, Peter Kurmann made the fascinating suggestion that Prague Cathedral was meant to have only a very short nave, so that the transept towers would effectively function as west façade towers. See "Filiation ou parallèle? A propos des façades et des tours de Saint-Guy de Prague et de Saint-Ouen de Rouen," *Umění*, 49 (2001): 211–19. The tower plan drawing might have a place in some scheme of this kind, but the details of how the pieces of the west block would relate to one another remain hypothetical at best.

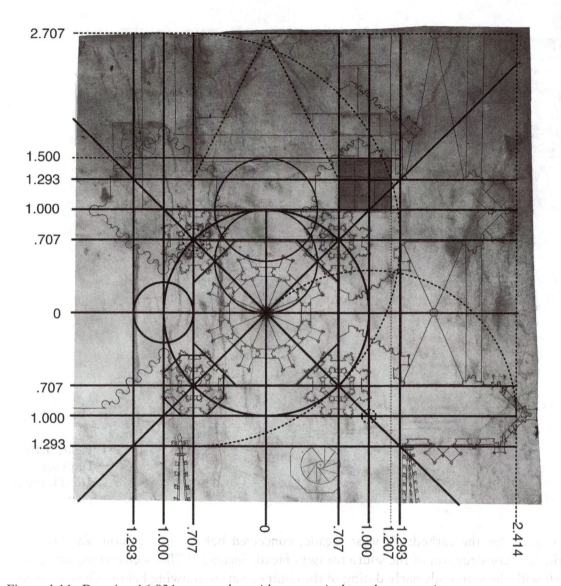

Figure 4.11 Drawing 16.821, tower plan with geometrical overlay, stage 1

away from the spire center. The face-to-face diameter of the corner pinnacles, measured across their outer flanges, is the same as the width of the walls, 2 × .293 = .586 units. A second system, based on modular repetition rather than quadrature, then enters the picture. A horizontal line 1.5 units above the spire center marks the top edge of a square roughly the size of the corner pinnacles above and to the right of the spire proper. This square, which can be called the guide square, appears shaded in the figure. It has its right edge .707 + .5 = 1.207 units right of the spire center.[16] A vertical line continues upward from this edge to the building centerline, and another matching vertical does the same 1.207 units to the left of the spire center.

Most of the larger dimensions in the plan unfold readily from this geometrical frame. Thus, for example, the building centerline falls at height 2.707, exactly two units above

[16] The guide square is subdivided into nine pieces, but they are not all equal squares. Instead, the partition between its first and second columns falls halfway between .707 and 1.000, that is, .854 units.

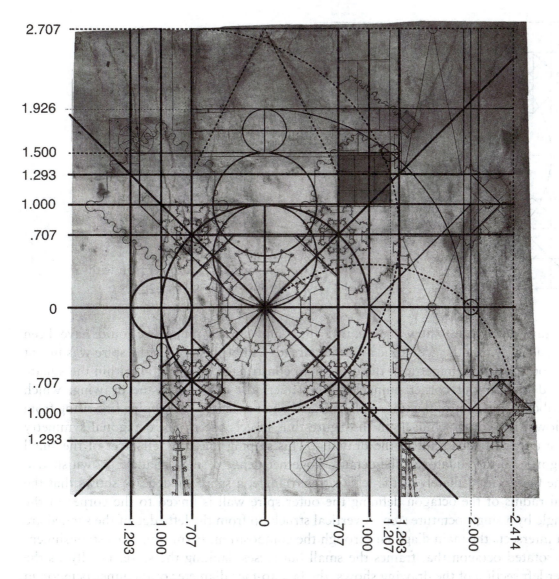

Figure 4.12 Drawing 16.821, tower plan with geometrical overlay, stage 2.

the centers of the corner pinnacles. The lines describing the diagonal ribs of the nave bay slope down from this centerline to points where the 1.293 horizontal intersects the frame of the verticals .707 out from the centerline. An arc centered on the intersection of the lower-right buttress axes and struck through the tower center will sweep out to a point 2.414 units to the right of the centerline, establishing the basic boundaries around which the tower buttresses would be constructed. Figure 4.12 adds details to this basic picture. An arc concentric with the tower and struck through the upper-right corner of the guide square reaches to height 1.926, establishing a prominent horizontal in the nave bay. The same arc sweeps right to locate the inner face of the porch-bounding arch, whose outer face can then be found by reflection about the vertical exactly two units to the right of the tower center. Small diagonals projecting forward from this line define the buttress between the porch bays, and a similar construction describes the forward keel of the lower buttress.

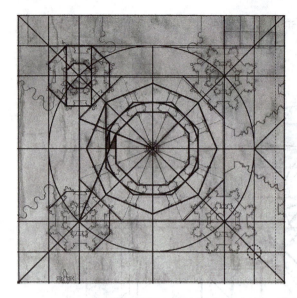

Figure 4.13
Drawing 16.821, tower plan with
geometrical overlay, stage 3.

Figure 4.13 shows how the central spire and corner pinnacles could have been constructed within the geometrical frames already established. Since the spire was meant to be octagonally symmetrical, the draftsman constructed an octagon within the square defined by the four corner pinnacles. The innermost octagon in the drawing, which describes the interior of the spire wall, is exactly half as large. The sloping line rising from the lower-left corner pinnacle in the figure thus bisects the ray of octagonal symmetry in the upper-left quadrant of the drawing. This sloping line, the left facet of the small octagon, and the equator of the octagon together define a small triangle shown shaded in the figure. Immediately to the left of this triangle, a small shaded arc shows that the facial radius of the octagon defining the outer spire wall is linked to the corner of the triangle by a single octature step. A vertical struck up from the left edge of the shaded arc then intersects the main diagonal through the composition, permitting the establishment of a rotated octagon that frames the small buttresses flanking the spire. Finally, as the upper-left section of the drawing shows, the face-to-face diameter of the inner octagon in the corner pinnacles equals the width of one facet in the larger octagon that frames each pinnacle.

Geometrical analysis of the tower plan offers a valuable gloss on the logic of its conception. While there is excellent reason to believe that Peter Parler had close familiarity with the architectural culture of the Rhineland, the Prague drawing appears looser and more improvisational than the great spire designs previously developed in that region, displaying neither the regular grid structure seen at Cologne nor the interlocking of octagonal and triangular geometries seen at Freiburg. And, while the narrowness of its spire impressionistically recalls the format seen in Strasbourg Plan B, the geometrical relationship between the spire and larger frame of the tower is less lucid than in that pioneering elevation drawing. Significantly, too, the Prague drawing is far simpler in its geometrical structure than the elaborate groundplans that Wenzel Parler and his successors would develop for the towers of Vienna's Stephansdom. The Prague drawing thus seems to represent an early and fairly primitive Parlerian foray into the design of great spired towers. Before moving on to consider the Vienna project, it makes sense to

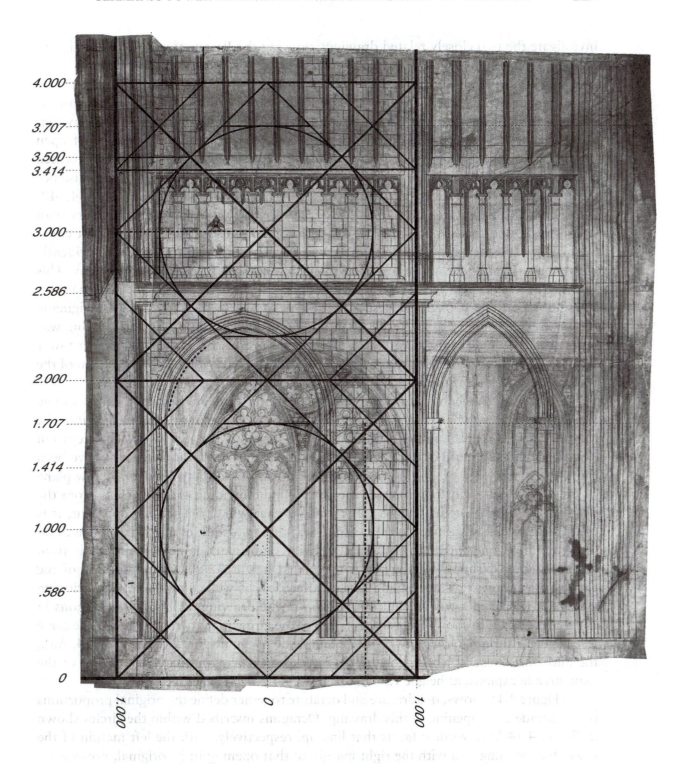

Figure 4.14 Drawing 16.817v, with geometrical overlay, stage 1.

investigate the two closely related drawings showing the Prague tower and the adjacent transept structure.

The second Prague drawing, showing the interior of the cathedral's south transept, provides valuable information showing that Peter Parler radically modified his plans as the project went forward. The most obvious hint of these modifications is the way that masonry lines have been drawn into the left bay, so as to reduce the number of open clerestory lancets from ten to four, with those four being offset from the bay center. The arcade arch below is also offset to the left. More subtly, Böker noted the existence of erased lines in the arch and wall; these are shown as dotted lines in Figure 4.14.[17] The left side of the arcade arch originally began its curve on a shallower trajectory than it does now, and there is a vertical to the right of the present arch opening that could align with the other end of such a shallow arch. The original arch opening evidently would have been wider and more open than the one now seen in this tower bay. This larger arch would also have been more symmetrical with respect to the bay margins. These observations strongly suggest that the bay shown in the drawing was originally meant to open onto a chapel, rather than a massive tower. The bay in the drawing was redrawn with reinforced structure, it seems, when the construction of the present tower was decided upon—a decision that may well have coincided with the abandonment of the towered façade scheme discussed in the previous paragraphs.

The original elements of the transept interior drawing align with a fairly simple geometrical armature based on the stacking of square and octagonal modules. Fortunately, a clearly described groundline in the tower bay makes it obvious where the elevation begins. Here, as in most Gothic designs, the fundamental dimension seems to have been the width of the largest bay shown, measured in this instance between the window plane of the wall at left, and the center of the shaft bundle dividing the tower bay from the aisle, in the middle of the drawing. For reasons that will soon become apparent, it is convenient to call this dimension two units. Stacking two squares of this facet length on the groundline, one finds that the center of the second square coincides with the bottom of the sculpted bishop's bust in the triforium, at height 3.000, while the base of the clerestory windows falls at height 3.500. Geometrical as well as modular proportioning systems also played a role in the construction of the drawing, as inscribed octagons in Figure 4.14 begin to show. The vertical facets of the large upper octagon occupy the same level as the triforium in the drawing, for example, between heights 2.586 and 3.414. And, the midpoint of the upper diagonal faces in the lower octagon marks the height of the main arcade capitals, at height 1.707.

As Figure 4.15 shows, quadrature and octature together define the original proportions of the arcade arch opening in this drawing. Octagons inscribed within the circles shown in Figure 4.14 have vertical facets that line up, respectively, with the left margin of the tower bay opening and with the right margin of that opening in its original, pre-erasure format. The original shape of the arch opening appears to have been a perfect semicircle, struck from the center of the bay at the level of the capitals. Semi-circular arches appear fairly rarely in Gothic design, but this curve matches perfectly with the erased traces of the original arch. And, just as tellingly, Peter Parler chose just such a large semicircular arch as the termination for the southern-facing window of the tower bay, shown in the

17 Vienna Academy drawing 16.817v. See Böker, *Architektur der Gotik*, pp. 65–6.

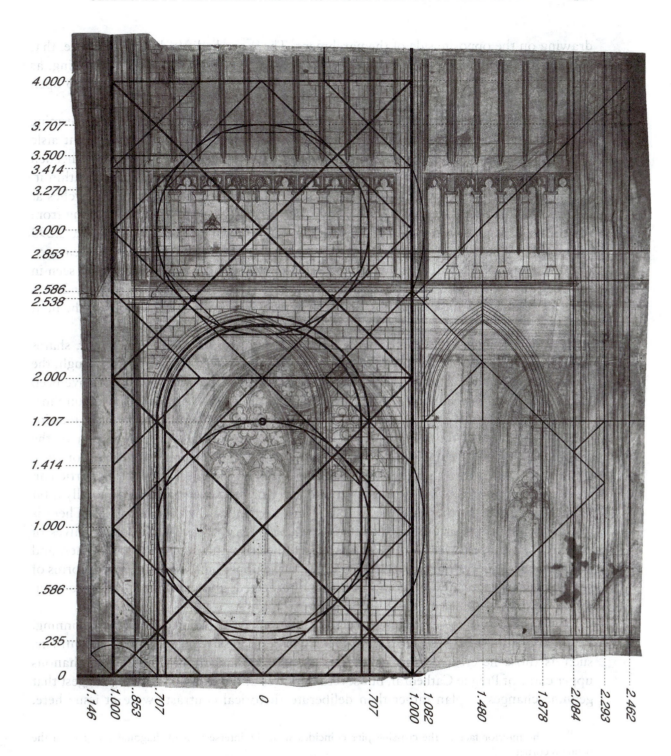

Figure 4.15 Drawing 16.817v, with geometrical overlay, stage 2.

drawing on the opposite side of the parchment. There can be little doubt, therefore, that this was the originally intended shape of the arcade opening in the interior drawing, as well. With such a large arcade opening, this bay would have been better suited to open into a large chapel than into a massive tower.

Simple extensions of the geometrical system already described suffice to determine both the detailing of the tower/chapel bay, and the overall layout of the adjacent aisle bay. In the chapel bay, for example, the width of the moldings on the large, round-headed arch opening equals the interval between the circle and the octagon inscribed within it. The analogous octagon in the second story sets the springline of the triforium arches at height 3.270. And, in the aisle bay, diagonals rising from the groundline and falling from the corner of second large octagon converge on the centerline of the crossing pier, 2.293 units to the right of the chapel centerline. The aisle bay is thus a double-square, measured up to the base of the triforium, which agrees with the proportioning of the aisle seen in the previously discussed choir section.[18] The scale of the choir section is roughly 2/3 as large as that of the transept interior, but both agree well with the proportions of the built structure.[19]

The final Prague workshop drawing, showing the exterior view of the tower, shares the scale of the interior view on its reverse, approximately 1:25.8. Curiously, though, the two drawings do not share the same groundline, so that dimensions could not have been transferred from one side to the other by tracing. As Figure 4.16 shows, the groundline, which is clearly visible a few centimeters above the bottom of the parchment in the interior view, disappears off the bottom of the exterior view, even in the deepest area of the irregularly shaped parchment. As Böker has noted, there are erasures on the exterior view, some of which attest to changes paralleling those seen on the interior view.[20] In particular, it seems that the large window in the ground story of the tower bay was originally a bit larger, descending further into the wall area now articulated with ashlar lines. There is also a striking difference of architectural style between the upper and lower halves of the drawing. In the lower half, the forms tend to be crisp and boxy in their outlines, and complex curves occur only in window tracery. In the upper half, by contrast, the forms of the buttresses, especially, are complex and multi-faceted, and curvilinear elements creep into the gablets articulating their surfaces.

It is hard to imagine that these formal distinctions were planned from the beginning. Peter Parler admittedly seems to have appreciated the expressive power of formal contrasts, such as those he created between the massive Wenceslas Chapel and the diaphanous upper choir of Prague Cathedral, but several features of the transept drawing suggest that genuine changes of plan rather than deliberate rhetorical contrasts were at issue here.

[18] The interior face of the crossing pier coincides with the intersection of diagonal rising from the octagon corner.

[19] Hecht, in "Zur Maßstablichkeit der mittelalterlichen Bauzeichnung," p. 267, gives the scale of elevation as 1:36.8, and gives scales of 1:25.8 and 1:25.5 for the exterior and interior, respectively. It seems clear, though, that the interior and exterior were meant to have the same scale. In the interior view, the center of the aisle opening falls 1.480 units to the right of the chapel center, since its left margin is established by an arc circumscribed around the first great octagon, and its right margin is set by the intersection of the horizontal at height 1.707 and the diagonal falling from the triforium base. The right margin of the crossing pier is set at 2.462 by the intersection of the diagonal rising from 2.538 and the horizontal at height 4.000.

[20] Böker, *Architektur der Gotik*, pp. 61–5. Böker sees this as evidence that 16.817 was an original design drawing created entirely by Peter Parler.

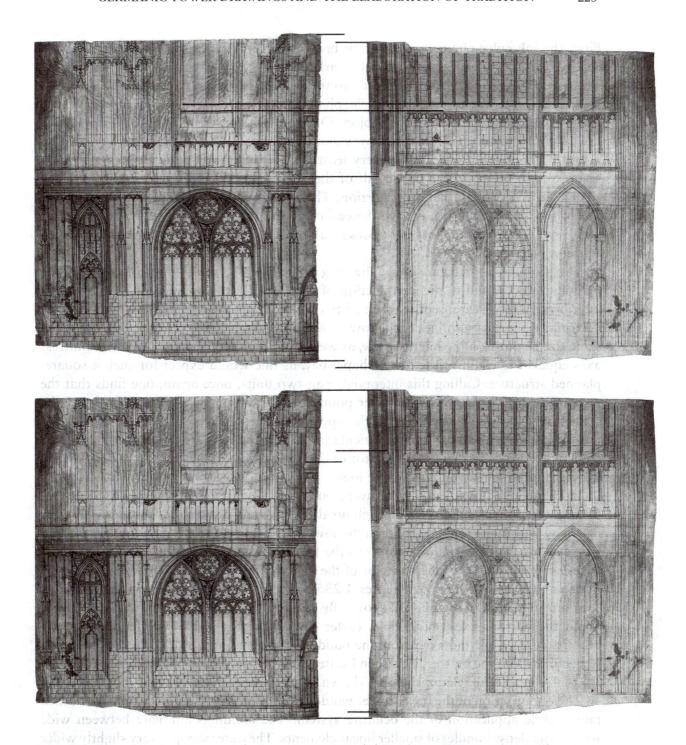

Figure 4.16 Comparison between drawings 16.817 (at left) and 16.817v (at right). In the upper views, the architectural elements such as the clerestory window base are aligned; in the lower views, the parchment corners are aligned.

First, the ink color changes subtly from brown to black above the blocky tower base. Second, two prominent figural corbels mark the transition in buttress cross-section, as slender buttress flanges below give way to the more plastic forms above. Similar corbels appear in the tower of the Viennese Stephansdom at precisely the level where Wenzel Parler took over leadership of the project. On these bases, it seems likely that the Prague drawing may have been completed by Wenzel Parler or his assistants after having been begun by his father, Peter. At the very least, a new set of artistic influences and ideas seem to have informed the upper half of the drawing, which may have been produced significantly later than the lower portion. The tower base in the drawing, after all, has much in common stylistically with the earliest work attributed to Peter Parler from the 1350s, while the second-story buttresses recall those of the cathedral's upper choir, which was completed only in the 1380s.[21]

The geometrical structure of the drawing attests both to substantial continuity in the planning process and to the introduction of new ideas in the upper zone. Just as in the interior view of the transept, a stack of two octagon-in-square modules seems to have determined the basic outlines of the tower elevation (Figure 4.17). These modules are the same size as those on the interior view, as well, since the span between the tower buttress axes equals the width of the tower/chapel bay, as one would expect for such a square-planned structure. Calling this interaxial span two units, once again, one finds that the prominent drip molding on the lower pinnacles falls at height 1.000, the backs of the transitional corbels at height 3.000, the upper tower window base at height 3.500, and the springers for the small arches articulating the upper buttress at height 4.000. Such alignments demonstrate that the creator of the upper zone clearly understood at least the basic modular scheme initiated in the lower zone.

In defining the thickness of his tower's buttresses, Peter Parler embraced an octature-based system that would echo throughout the rest of the drawing. When an octagon is inscribed within the rotated square in the tower base, and a circle is circumscribed about that octagon, its edges fall .765 units to the left and right of the tower centerline. These edges correspond to the inner margins of the main tower buttresses. Reflection about the buttress axes locates their outer faces 1.235 units out from the building centerline, as the bottom margin of Figure 4.17 shows. By constructing two successive octature figures about the buttress axes, meanwhile, Parler could have found the exterior faces of the buttress cores 1.171 units out from the building centerline, where $1.171 = 1/\cos^2(22.5°)$. Reflection about the buttress axes then locates the inner core margins .829 units out from the centerline. These relationships are shown in dotted lines in the top half of Figure 4.17.

The organization of the lower tower window and its framing moldings hint at another, more subtle application of the octature system. The moldings alternate between wide scoops and dense bundles of smaller linear elements. The outer scoop is very slightly wider than the inner one, demonstrating that this pattern was not produced by simple modular repetition. Instead, the structure of the molding sequence appears to have been determined by octature, as the lower portions of Figure 4.18 show. The octagons inscribed within the frame of the buttresses have radii of .765, 707, .653, .603, and .558, respectively. These distances correspond closely with the sequence of scoop and bundle moldings framing the window, although distortions in the parchment limit the precision possible in these

[21] See Benešovská, "The Legacy of the Last Phase of the Prague Cathedral Workshop," esp. pp. 49–50.

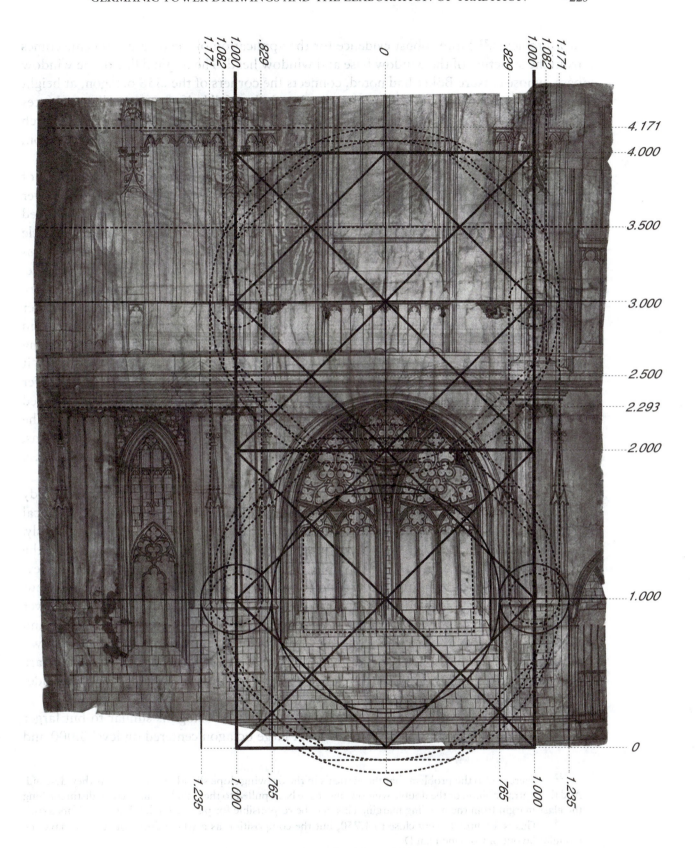

Figure 4.17 Drawing 16.817, with geometrical overlay, stage 1.

measurements.[22] More robust evidence for the application of the octature scheme comes from the structure of the window base and window head. The original line of the window base, whose erasure Böker had noted, connects the corners of the .558 octagon, at height .769. The springlines of the small lancets in the window fall halfway up the diagonal faces of the .603 octagon, at height 1.427. And, the springline for the great semicircular arch over the window coincides with the upper edge of the square framing the .603 octagon, at height 1.603.

The overall framing of the drawing's lower zone appears to involve a variety of quadrature-based relationships. It is clear, for example, that the horizontal molding over the tower window begins at height 2.414, coinciding with the top of a circle circumscribed about the original generating square of the tower base. The left edge of the same circle appears to coincide with the right margin of the narrow sacristy window in the buttress 1.414 units left of the tower centerline. The left margin of that window, meanwhile, appears to line up with the left-hand edge of the circle circumscribed about the square framing the buttresses. Since the edges of that square fall 1.235 units out from the tower centerline, the edge of the circle falls 1.746 units left of the centerline.[23] The left margin of the side-facing buttress in the drawing seems to have been established by striking a diagonal up from the left margin of the front-facing buttress adjacent to it until it meets the equator of the original generating square 2.235 units to the left of the tower centerline. And, it seems likely that the axis of the leftmost pinnacle was established by swinging an arc down from the point where the left window margin intersects the horizontal terminating the window zone.[24] Such a construction would, in general terms, echo the progressive unfolding of the aisle widths seen in the Strasbourg nave design, a precedent with which Peter Parler may well have been familiar.

In geometrical as well as formal terms, the upper zone of this drawing seems to embody variations on the themes introduced in the design of the lower half. The basic geometrical armature of stacked boxes functions continuously across both zones, as noted previously. This framework appears to have been established already in the interior view on the reverse of the drawing. Thus, for example, the backs of the corbels in the exterior view fall at the same height above the groundline as the bishop's bust on the interior view. The draftsman responsible for the upper zone clearly understood the logic of the lower zone perfectly—as one would expect if the two halves were drawn by Peter Parler and his sons, or Peter himself acting alone. But, the geometrical continuity between the two sections is not seamless. The only verticals that seem to carry through both sections are the buttress axes and the various buttress margins, including the left margin of the side-facing buttress, 1.746 units to the left of the tower centerline.

The upper zone organizes itself around a set of nested octagons similar to but larger than those seen in the lower tower window. A large octagon centered on level 3.000 and

[22] There is also the problem that the verticals in the drawing slope slightly to the right as they descend. And the central mullion of the double window may have been pulled to the right by a mistake in distinguishing the glass margin from the molding margin. This may be responsible for pulling the left buttress off its axis.

[23] This is admittedly very close to 1.750, but the composition as a whole does not seem to have the modular layout of Cologne Plan D.

[24] This horizontal falls at height 2.293, halfway up the lower diagonal facet of the octagon inscribed in the second stacked generating square. Here again, though, the relationships between the components are somewhat obscure, due to the slight slope of the "verticals" in this zone.

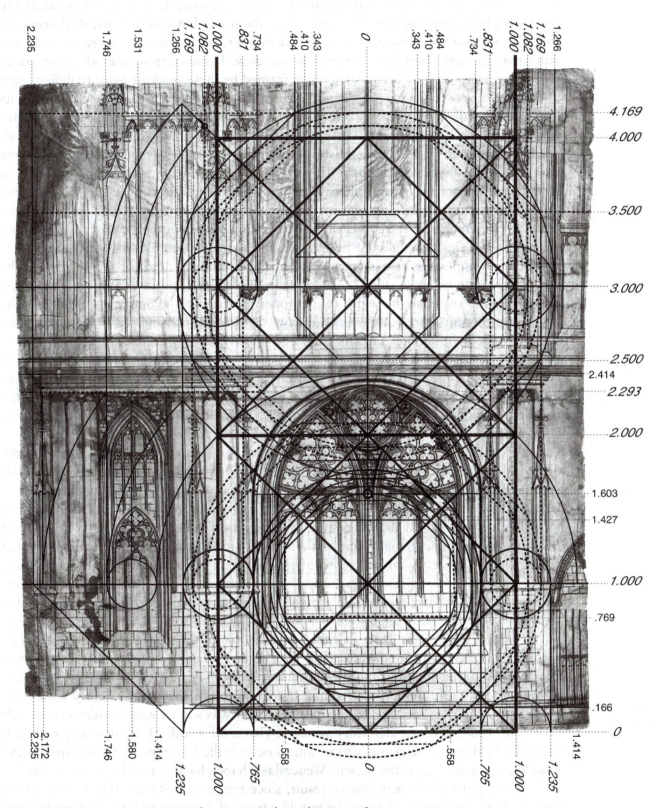

Figure 4.18 Drawing 16.817, with geometrical overlay, stage 2.

framed by the outside of the buttress core margins reaches up to level 4.171, locating the prominent horizontal molding that cuts across the tower buttresses. Verticals descending from the octagon's inboard corners frame the upper tower window, or more precisely, the outer margin of the moldings framing the window. These verticals are .484 units away from the tower centerline. A small octagon framed by these verticals helps to define some of the fine structure of the window base. Thus, for example, a horizontal connecting its upper outboard corners locates a molding diving two parts of the blank field beneath the window. The intersections of this small octagon's diagonal facets with the diagonals reaching out from its center establish the verticals framing the inner field of the tower window, .343 units from the tower centerline. And, as in the lower window, there is a subtle rhythm of big scoops alternating with linear moldings in this zone. The most prominent vertical separating two of the scoop moldings falls .410 units out from the centerline, aligning with the corner of the octagon inscribed within the original generating square. So it seems that the same design principles were indeed used in both zones.

The most important new geometrical element in the upper half of the drawing is the large circle, one octature step larger than the one framed by the lower buttress cores, which helps to establish the width of the upper buttresses. The outermost points on the equator of this circle are 1.266 units out from the tower centerline. Verticals rising along these lines define the outer faces of the richly faceted upper buttresses. Reflecting these lines about the buttress axis, one finds the equivalent inner margins .734 out from the centerline. Since this is closer to the center than the .829 distance inherited from the buttress cores of the lower façade, the draftsman responsible for the upper half of the drawing introduced prominent corbels to span the interval in between, providing bases for the new and more robust buttress structure above.

Taken together, the evidence from the drawings demonstrates that plans for the cathedral underwent many changes, even after the arrival of Peter Parler in 1356. Parler was one of the most precocious designers of the Gothic age, and he broke quickly with the work of his predecessor Matthias of Arras, but his own vision for the cathedral was not fixed and absolute, as the drawings show. The details of the buttress uprights in the choir drawing, for example, remain simpler than those of the actual building, suggesting that it was drawn fairly early in Parler's tenure in Prague. The small tower plan immediately above must have been drawn at around the same time; the large parchment was surely chosen to accommodate the elevation, but the plan was added in before the elevation was finished, since one of the finials was left off the elevation so as not to overlap the lines of the plan. It thus seems likely that the tower shown in the plan drawing represents an early draft of a contemplated west façade for Prague Cathedral, conceived at a time when construction of the present south tower had not yet been decided upon. The interior view of the cathedral's transept, in its original state, appears to date from roughly same early period. The bay now occupied by the massive tower was shown with a wide-open arcade arch and broad, ten-light clerestory window. Given the width of the bay in question, it seems likely that a large chapel was meant to occupy the lower story. This chapel would have been just as large as the present Wenceslas Chapel, located two bays to the east.

This is a particularly provocative result, since the most strikingly odd feature of the cathedral's current plan is the way the box-like form of the Wenceslas Chapel crashes into the space of the transept. Matthias of Arras appears to have foreseen no such dramatic

intrusions into the cathedral's regular bay system, and Peter Parler probably did not either, when he first took the job at Prague. Instead, he evidently planned a great chapel for the space now occupied by the tower. But Charles IV had strong programmatic reasons for wanting to establish the great chapel over the spot where the previous shrine of Saint Wenceslas had stood. It seems likely, therefore, that Peter Parler changed his plans, effectively sliding the great chapel two bays to the east, into its current position, and freeing up the bay to the west of the transept for the construction of a great tower. Such a scenario would effectively explain the revisions in the drawing of the transept interior.

Since the Wenceslas Chapel and adjacent south portal were already complete by 1367, along with a portal buttress that helps to support the tower, the modifications to the transept drawing were likely made already quite early in Peter Parler's tenure in Prague. It is tempting to imagine, in fact, that the architect and the emperor settled upon the cathedral's present unconventional layout during a series of "brainstorming" sessions in the late 1350s. If the cathedral's south tower was indeed foreseen by this point, rumors of the project might have reached Vienna in time to inspire the launching of the Stephansdom tower project in that city in 1359. In practice, however, construction of the Prague tower appears to have been deferred for several decades, becoming the main priority for the workshop only after the completion of the cathedral's upper choir in 1385.[25] The upper portion of the tower drawing was likely produced around this time, before Peter Parler's death in 1399 but late enough to reflect the richly sculptural style that he and his sons had developed in their designs for the choir superstructure. It was probably Wenzel who brought the drawing to Vienna, where he employed a very similar style in his additions to the Stephansdom's south tower around 1400.

The histories of the Prague and Vienna tower projects ultimately unfolded very differently, despite close links between the two workshops. Following the deaths of Johann and Wenzel Parler in 1404, their former assistant, Peter Prachatitz, capably led the work in both cities. By the second decade of the fifteenth century, though, the political situation in Prague began to deteriorate, since Charles IV's son Wenceslas proved unable to manage the confrontation between the Catholic church hierarchy and his reform-minded Bohemian subjects, led by Jan Hus. The execution of Hus at the Council of Constance in 1415 provoked a crisis, which broke into open warfare upon Wenceslas's death in 1419. In this context, further work on Prague cathedral became effectively impossible. The cathedral, confined within the imperial palace complex across the river from Prague's merchant quarter, was both topographically and ideologically isolated from the local

[25] The chronology of the tower construction is not entirely clear, although the start of work on the tower has often been associated with the placement of a commemorative plaque on its southeast corner in 1396. See Schurr, *Die Baukunst Peter Parlers*, p. 67; Klára Benešovská, "La haute tour de la cathédrale Saint-Guy dans ses rapports avec la façade sud," *Umění*, 49/3–4 (2001): 274; and Petr Chotěbor, "Der grosse Turm des Veitsdoms: Erkenntnisse, die bei den Instandsetzungsarbeiten im Jahr 2000 gewonnen wurden," *Umění*, 49/3–4 (2001): 265–6. For a revisionist early dating of the tower project, see Böker, *Architektur der Gotik*, p. 65. Bork, *Great Spires*, pp. 165–7, gives an argument for an early beginning of work on the tower based in part on Böker's valuable analysis, and in part on a misinterpretation of Chotěbor's discussion of the tower foundation. The discussion presented here corrects and supersedes that one. Benešovská's latest publication on the subject, "The Legacy of the Last Phase of the Prague Cathedral Workshop," opens by explicitly suggesting that work on the tower and transept zone was probably getting underway by 1385, when the upper choir was completed (p. 43). The crucial point, in any case, is that the tower was likely conceived early in Parler's tenure, even if construction began significantly later.

citizenry. The abandonment of the Prague south tower project should be seen, therefore, not simply as a side-effect of a chaotic social and political situation, but also as a metaphor for the central conflict of the Hussite Wars: the alienation of the Czech citizenry from the Holy Roman Empire and the Catholic church, two institutions whose partnership the cathedral tower had been designed to advertise. The triumphant completion of the Viennese Stephansdom's south spire in 1433, conversely, was made possible by a potent mixture of aristocratic initiative and broad popular support. By that time, Vienna had already inherited Prague's mantle as the most important center of Gothic design in the eastern reaches of the Empire.

VIENNA

Vienna occupies a special place in the history of Gothic architecture not only because of its prominence in the Middle Ages, but also because of its unique status as a repository for original Gothic drawings. The unrivaled collection in the Kupferstichkabinett of the city's Akademie der bildenden Künste includes 428 of them, which amounts to roughly 80 percent of the world's surviving examples, and the Wien Museum Karlsplatz preserves a far smaller but still impressive collection of 14 major drawings. The Viennese collections are also comparatively well known to historians of Gothic architecture, although the sheer number of drawings has tended to provoke amazement rather than close engagement with the material. Hans Koepf published virtually all of the Viennese drawings in a 1969 catalog with minimal text, which has been decisively superseded by Hans Böker's lavishly produced and far more detailed 2005 catalog.[26] Significantly, too, Böker used his work on the drawings as a springboard to writing a revisionist monograph on the history of the Stephansdom, providing one of the most detailed demonstrations of how drawing-based scholarship can inform the writing of architectural history.[27] Further insight into the character of the Vienna workshop can be gleaned from geometrical analysis. Neither Koepf nor Böker approach the Viennese drawings with geometry in mind, but Maria Velte briefly studied the geometry of the fifteenth-century Viennese tower plans in her 1951 essay on quadrature and triangulation in Gothic design.[28] As in so many studies of the Gothic geometry, though, Velte's proposals involve the somewhat arbitrary imposition of rigid quadrature schemes over the drawings. The next section of this chapter will demonstrate that the Viennese tower drawings were both more geometrically complex and more intellectually coherent than Velte had imagined.

The Stephansdom, the great hall church that dominates Vienna's city center, began as a large, twelfth-century parish church, and its central location helped to keep it closely associated with civic identity throughout its history (Figure 4.19). Wholesale modernization of the building began in the fourteenth century, following Vienna's establishment as the principal power base of the Habsburg dynasty. The pivotal figure in this transformation

[26] Koepf, *Die gotischen Planrisse der Wiener Sammlungen*; Böker, *Architektur der Gotik*, esp. pp. 16–51 for a history of the collections.

[27] Johann Josef Böker, *Der Wiener Stephansdom: Architektur als Sinnbild für das Haus Österreich* (Salzburg, 2007).

[28] Velte, *Die Anwendung der Quadratur und Triangulatur*, Taf. 1 and 2.

was Archduke Rudolph IV, an ambitious prince who dramatically enhanced the prestige of the Habsburg family both through clever political maneuvering and through artistic and cultural patronage. Rudolph's role model and rival was his father-in-law, Emperor Charles IV, who had launched the construction of Prague's Gothic cathedral in 1344. Among Rudolph's first acts as reigning duke of Austria was to preside at the cornerstone-laying of the Stephansdom's south tower in 1359. Rudolph's long-term goal was doubtless to promote Vienna to episcopal rank, following the example of Charles IV at Prague. Lacking the resources to begin building a French-style cathedral, however, and perhaps attuned to the political and financial power of Vienna's citizenry, Rudolph made their parish church into the vehicle of his architectural expression. The substantial completion of the Gothicized Stephansdom in the Middle Ages attests to the wisdom of this choice. In 1365, shortly before his premature death, Rudolph established the University of Vienna, once again copying Charles IV, who had founded a university in Prague in 1348.

Since Rudolph IV emulated Charles IV in so many respects, his decision to add a great southern tower to the Stephansdom may provide indirect evidence for early tower planning at Prague Cathedral. There was not, admittedly, a one-to-one correspondence between the parts of the two buildings. The Stephansdom was a hall church with three simple apses in echelon, after all, rather than a basilica with radiating chapels organized around an ambulatory. It seems far more than coincidental, however, that both buildings came to include massive south towers, an unusual arrangement seen in few other Gothic churches. In view of the active artistic and cultural dialog between Prague and Vienna in the mid-fourteenth century, the two tower projects must have informed each other to some extent, even in their early history. It is unclear, however, which began first. Since cultural influences tended to flow from Prague to Vienna in Rudolph's reign, it might seem likely, in the abstract, that the Stephansdom project was inspired by Peter Parler's early planning for the Prague transept tower. This scenario, though, would push all the previously discussed revisions to the Prague drawings into the three short years between Parler's arrival in Prague and the 1359 tower foundation ceremony in Vienna. It may be more reasonable to suggest that Rudolph IV actually stole the march on his father-in-law in this one instance, launching the Stephansdom tower initiative before the Prague tower project had even been decided upon. Parler's dramatic decision to insert a tower rather than a chapel into Prague Cathedral's transept zone might therefore be seen as a competitive response to the upstart Viennese project. The drawings associated with the Stephansdom south tower show, in any case, that ideas from Prague had already begun to inform the Viennese project decades before the arrival of Wenzel Parler.

Unfortunately, no drawings survive to record the earliest phases of tower planning undertaken during Rudolph's short but eventful reign. It remains unclear, in fact, whether Rudolph and his builders originally envisioned a symmetrical church with two matching transept towers, as the fifteenth-century Viennese chronicler Thomas Ebendorfer suggested.[29] In practice, construction activity centered on the Stephansdom's south tower, which rose slowly but steadily in the decades after 1359; work on its northern pendant began only a century later, after the south spire had already been completed. Because of this delay, the north tower remained incomplete at the close of the Gothic era, and

29 See Richard Perger, "Die Baumeister des Wiener Stephansdomes im Spätmittelalter," *Wiener Jahrbuch für Kunstgeschichte*, 23 (1970): 73. See also Böker, *Der Wiener Stephansdom*, pp. 97–100.

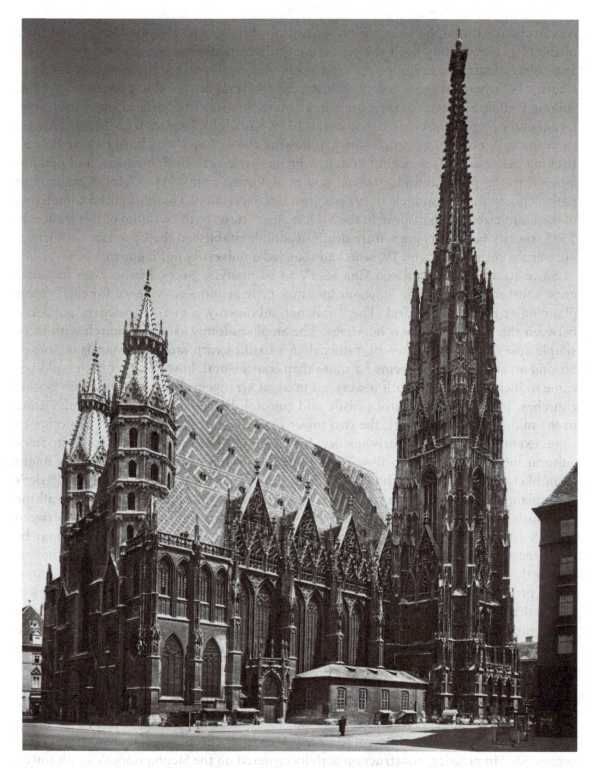

Figure 4.19 Vienna, Stephansdom, overall view from the southwest.

it was anticlimactically capped off by a small turret in the later sixteenth century. Thus, while Rudolph's planners could not have foreseen the present asymmetrical form of the Stephansdom in detail, their decision to concentrate on the construction of the church's southern tower had dramatic consequences for the building's subsequent history. Only a small portion of the south tower appears to date from Rudolph's reign, however. This section, first identified by Hans Böker, includes the base of the stair turret in the tower's northeast corner, and some of the lower interior walls in the adjacent chapel.[30] These walls are quite plain, and comparison with other Rudolphinian buildings suggests that the exterior of the tower may have been originally conceived as simple and boxy, as well.

A surviving plan drawing, which holds inventory number 16.819v in the Vienna Academy collection, documents what was probably the next phase of the Stephansdom tower planning process, even if it is a fifteenth-century copy of an earlier original, as Böker has suggested (Figure 4.20).[31] The drawing shows a complex structure whose lower stories correspond closely to those actually built, with diagonally planted pinnacles along the buttress margins, and an entry porch between the main buttresses. The vaulting of the porch is simpler than that of the present tower, suggesting that the drawing was conceived before the construction of the tower base. The forms in 16.819v, though, are more ornate than those typically seen in Rudolph's architecture, and since the chapel built between the eastern tower buttresses was consecrated only in 1396, the tower base shown in the drawing was probably conceived no earlier than 1375 or so. Since many years of work would have been necessary to raise the first story of the tower, which was complete when Wenzel Parler arrived in Vienna around 1400, the design of the tower base must have been established by around 1380. A date of conception in the 1370s also makes good sense for the upper stories shown in the drawing, which differ markedly from those built by Wenzel Parler and his successors. The corner pinnacles in the drawing, most obviously, have triangular rather than quadratic symmetry. With their bold salience, in fact, the pinnacles shown in the drawing closely resemble those of the spire at Freiburg im Breisgau. Ambitious spire designers had good reason to refer to the Freiburg spire, which was by far the largest and most impressive monument of its type in the mid-fourteenth century. Freiburg, moreover, was near the ancestral lands of the Habsburgs, and the city had come under Habsburg control in 1368.

The layout of the drawing provides valuable clues about the draftsman's priorities and working methods. Instead of showing the complete plan of the tower, he chose to depict only its western half. The parchment he used is therefore basically rectangular, although an irregular patch is missing from one corner. On the more perfectly squared portion of the parchment, he drew the full southwest quadrant of the tower in considerable detail. On the more fragmentary section, though, he indicated only a few bits of the northwest tower buttress. Emphasis, not surprisingly, seems to have been placed on the outboard portion of the tower, facing the city. In 16.819v, as in most Gothic drawings showing towers, the main buttress axes appear to have had conceptual and geometrical priority. In this particular case, the two perpendicular axes of the southwest tower buttresses cut the squared end of the parchment into four perfect quarters, as the heavy lines in Figure 4.21 show; this clearly demonstrates their fundamental importance for the geometry of

30 Böker, *Der Wiener Stephansdom*, pp. 98–102.
31 Böker, *Architektur der Gotik*, p. 69.

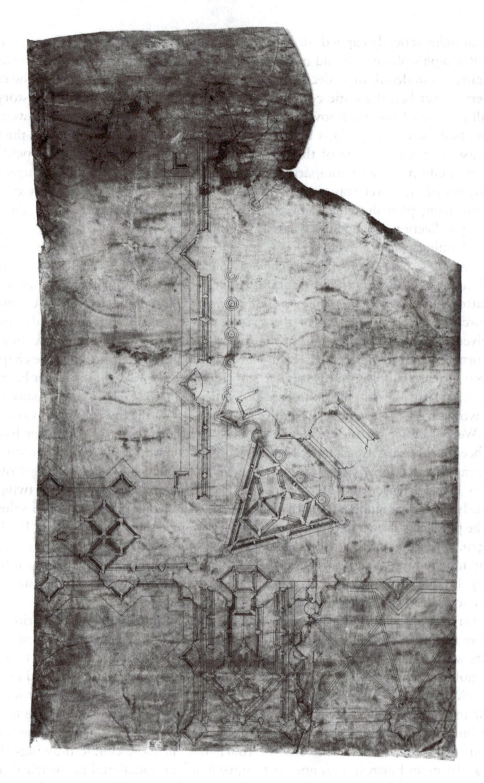

Figure 4.20 Drawing 16.819v, showing an early scheme for the ground plan of the Viennese Stephansdom.

the drawing.[32] It therefore makes sense to call the span between the tower centerline and the buttress axis one unit, so that each of the square sections in the drawing is one unit on a side. In the drawing, one unit equals 23.3 centimeters. Since the equivalent dimension in the real building is 600 centimeters, the scale of the drawing now approximates 23.3:600, or 1:25.8. This, interestingly, is exactly the scale of the Prague transept views 16.817 and 16.817v.[33]

A few straightforward geometrical operations suffice to determine most of the proportions in the main body of the tower. One finds the outboard faces of the main tower walls, for example, by simply circumscribing a circle around the quarter of the southwest tower zone, as shown in the right half of Figure 4.21. The outer wall margins, therefore, are 1.207 units out from the tower center. The size of the octagonal upper tower zone also emerges readily in this framework, through octature and quadrature. The outer wall surfaces of the octagon are located .924 units out from the tower center, so that the corners of the octagon fall on a circle framed by the main buttress axes. And the distance from the centerpoint to the inner wall surfaces is .653, since $.653 = .924/\sqrt{2}$. These proportions perfectly match those of the actual tower, in which one unit equals 600 centimeters. The size of the inner octagon in the drawing, significantly, gives the interior width of the tower hall at ground level, which is 784 centimeters, or 2×600 cm $\times .653$. This is a fascinating result, since it implies that the construction of the tower at ground level depended on early phases of planning for the tower superstructure, as recorded in 16.819v. Geometrical analysis of this drawing thus provides a valuable new perspective on the design of the tower base.

The detailing of the tower superstructure in 16.819v can be readily constructed around the basic octagonal form of the upper tower core, as the dotted lines in Figure 4.21 indicate. The window aperture in the diagonal face of the tower core is described, oddly, by a small circle inscribed within the wall thickness. The slender shafts framing the window, on its outboard side, mark the points where this circle is cut by the diagonal reaching between the centers of the main tower faces, each 1.207 units out from the center. The unusual circular shape of the window opening calls attention to itself, especially because the moldings framing the window are set on perpendicular axes that converge on its center, like the lines on a gunsight. The relevance of this construct becomes clear when these axes are extended outwards, since they intersect the square "space box" around the octagonal tower core at points that become the inner corners of the triangular corner pinnacle. The location of these two points suffices to locate the single outboard corner, since the pinnacle is a perfect equilateral triangle in plan. This differentiates it from the superficially similar triangular pinnacle flanges seen in the transitional stories at Freiburg, whose roughly 62-degree corner angle apparently resulted from a "cat's cradle" construction across the whole tower plan, as described in Chapter 2. The creator of

[32] This also demonstrates that the parchment was cut to fit the tower drawing, rather than to fit the drawing of vaulting on the reverse, which is not aligned with the axes of the parchment. This strongly suggests that the tower was drawn first. The late dating for the vault drawing, therefore, does not necessarily apply to the tower drawing. It is conceivable, on this basis, that 16.819v is an original design drawing from the fourteenth century, rather than a late copy.

[33] The original scale may been 1:25 or 1:24, with parchment shrinkage accounting for the difference, but the close agreement between the Vienna and Prague drawings suggests that differential shrinkage effects, at least, were quite small.

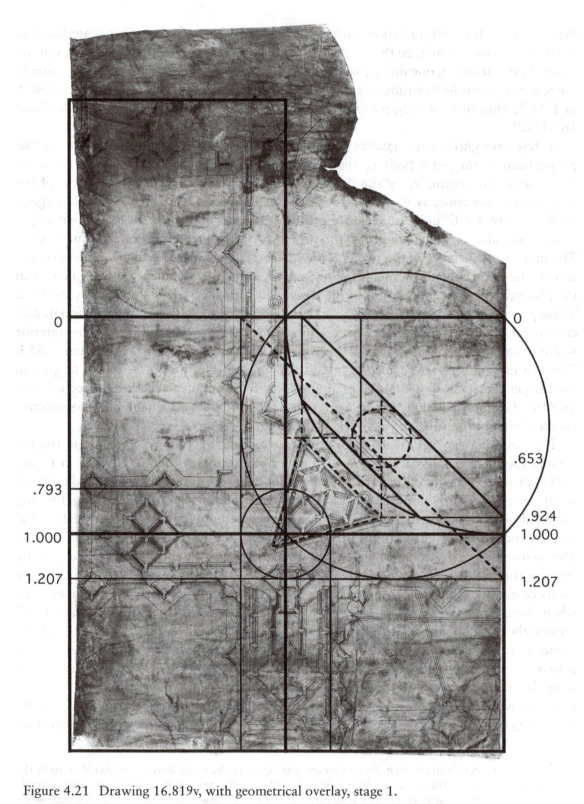

Figure 4.21 Drawing 16.819v, with geometrical overlay, stage 1.

16.819v could not use this construction method, of course, since the drawing shows only one quadrant of the tower plan. Here, therefore, a subtle formal distinction bears witness to a real difference of design methodology.

The proportions of the salient tower buttresses in 16.819v do not match those seen in the actual tower base, which is quite surprising, at first blush, given the close formal resemblance between the forms seen in the drawing and in the masonry. In the drawing, both of the southwestern tower buttresses are longer and broader on their front faces than they are in the building, measured against the main square of the tower base. And, they are not even truly rectangular in plan, since some of their borders are slightly skewed with respect to the main tower axes. This imprecision, in fact, explains the mismatch with the tower. The formal logic of the buttress design shown in the drawing involves a geometrical recipe that—when implemented properly—gives exactly the proportions of the actual buttresses. The outer margins of the buttresses at ground level should align with the outer walls of the tower base, 1.207 units out from the tower centerline, as the lower left of Figure 4.21 shows, while the inner ones should fall 1 - .207 = .793 units out. The width of the front face of the buttress should thus be 1.207 - .793 = 2 × .207 = .414 units. Since a unit in the actual tower equals 600 centimeters, this translates into a buttress width of 248 centimeters, which agrees perfectly with the masonry of the south tower. So, there can be little doubt that this geometrical recipe was used to guide the construction process. The creator of drawing 16.819v, though, made a series of mistakes that distort the buttress geometry.

The formal logic of the buttress design shown in the drawing makes it possible to understand both the intended proportions of the buttresses and how and where the draftsman went astray in his work. The thin but solid lines in Figure 4.22 show how the construction was probably supposed to go. First, a diagonal was struck through the center of the diagonal wall face in the tower octagon, intersecting the cardinal axes of the tower 1.115 units out from the centerline. A line struck to the left from this intersection point and parallel to the front face of the entry porch hits the outside margin of the main tower block at the point marked 0 in the figure. A diagonal struck down and to the right from that point passes tangent to the small pinnacle cluster at the edge of the tower body before intersecting the interior margin of the porch-flanking buttress at a point 1.529 units out from the tower center. This point should, in theory mark the middle of the buttress salience. An arc swung about this point reaches the outer margin of the buttress 1.851 units out from the tower center. This predicted buttress salience of 1.851 - 1.207= .644 units, which translates into .644 × 600 cm = .387 cm, precisely matches the dimensions of the actual tower.[34]

The dotted lines in Figure 4.22 show the cascade of errors that distort the buttresses seen in the drawing This cascade appears to have begun at point 1, where the draftsman

[34] It is also conceivable that the salience of the south tower buttresses was originally planned using a simple octagon-based relationship later seen in the north tower design, whereby the buttress salience would equal 2cos22.5° = 1.848 times the span between the buttress axes. 1.848 nearly equals 1.851, after all, to a tolerance of one tenth of one percent. But drawing 16.819v certainly was not laid out according to that simple and lucid plan, as the grievous errors in its buttress shapes show, so it seems reasonable to associate its production with the more additive approach described here, leaving the 1.848 recipe to be discussed below in the context of the Wenzel Parler's work on the south tower and the campaigns on the north tower in the mid-15th century.

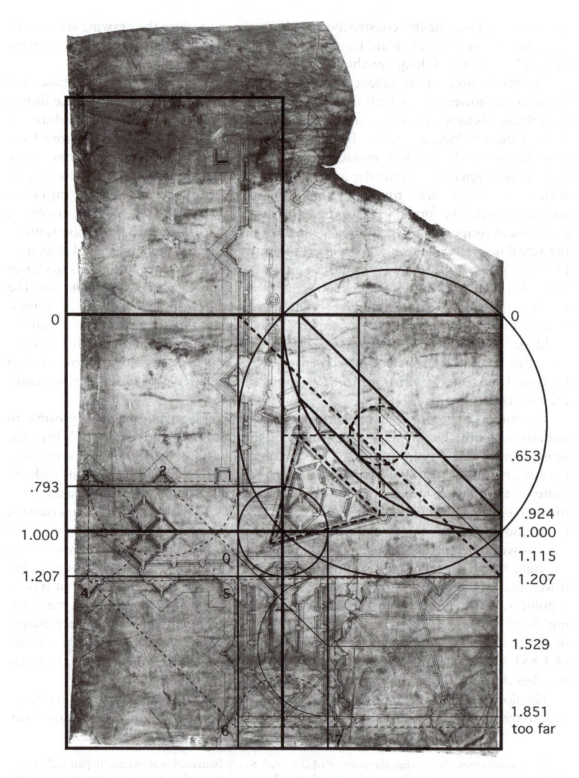

Figure 4.22 Drawing 16.819v, with geometrical overlay, stage 2. The numbers 1 through 6 suggest the likely order in which an original mistake propagated around the drawing in the course of its production, creating buttresses that are over-large compared to the tower core and buttress axes.

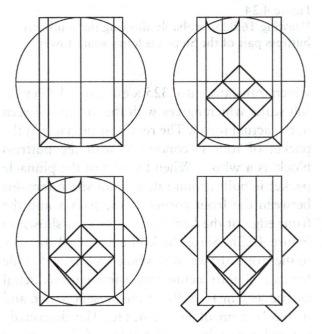

Figure 4.23
Hypothetical rectified layout sequence for the buttress scheme shown in drawing 16.819v; this sequence gives buttresses whose size and proportions closely match those of the actual Stephansdom tower.

drew the buttress margin just a bit too far out from its centerline; this error interval can be called ε. The diagonal reaching up and to the left from point 0 intersects the buttress margin at point 2, ε above and further to the left than it should be. This error ε gets doubled when an arc is swung from point 1 to point 3 about the center at point 2, locating the outer face of the buttress 2ε further to the left than intended. Since the opposite buttress corner at point 4 was located by symmetry about the buttress axis, the front buttress face is also 2 too wide. This was clearly an error, since the long buttress face to the right of point 4 was drawn along a subtly sloping line struck back to level 1.207. This line carries the chain of errors into the porch-flanking buttress, since symmetry about the diagonal axis of the tower pushes point 5 at the buttress intersection a bit too far down and to the left. A diagonal reaching down from point 4 thus intersects the outer face of the porch-flanking buttress at point 6, which is considerably further out from the tower centerline than the 1.851 level where it ought to be. And, finally, setting the front buttress width equal to the previously constructed one locates point 7, from which a vertical rises to complete the outline of this rather bloated buttress.

The detailed articulation of the buttresses in 16.819v can be readily understood despite these proportional distortions. Four principal elements fit within the boxy frame of the overall buttress plan: a bladed keel at the front of the buttress, a diagonally planted packet of four square pinnacles standing just inside the keel, a flange connecting this pinnacle packet to the main body of the tower, and a smaller pinnacle assembly marking that junction. These details deserve careful attention, in part because they helped to establish geometrical givens with which Wenzel Parler and his successors would have to contend. Parler introduced dramatic changes into the buttress design, as the next section of this chapter will explain, but he retained the basic keel format introduced in the 16.819v scheme. In 16.819v the format of this keel appears to have been established geometrically, like the rest of the articulation. As Figure 4.23a shows, the width of the keel can be found by striking diagonals inward from the buttress corners until they intersect the circle framed by the front and rear faces of the buttress. This gives a keel width of .325 units,

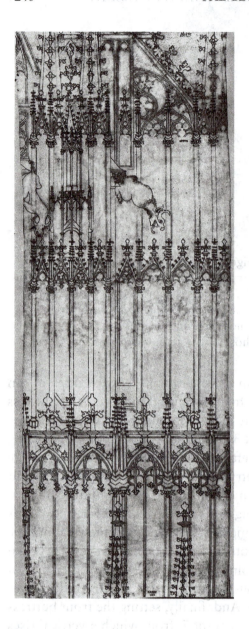

Figure 4.24
Drawing 16.825, probably showing the southeast buttress pair of the Stephansdom's south tower.

which translates into .325 × 600 cm = 195 cm at full scale, which agrees with the dimension seen in the actual tower. The rearmost pinnacle in the packet of four is concentric with the buttress block as a whole. When the rest of the pinnacle packet is built around it, a small space remains between the front corner of the packet and the front edge of the keel-framing box, as shown in Figure 4.23b. Since the keel extends all the way to the front surface of this box, its forward blade forms a slightly acute angle; this curious detail can be seen in 16.819v, in the present tower, and in the bottom of Figure 4.23c. The diagonally planted pinnacles on the sides of the buttress base have the same size as those in the upper pinnacle packet, as seen in Figure 4.23c, and in Figure 4.23d, which shows the overall outlines of the completed buttress. On the back side of the packet, significantly, a slender masonry flange projects from the rearmost pinnacle in the packet to meet the main body of the tower. The buttress articulation in 16.819v thus amounts to a more elaborate version of the buttress scheme seen at Freiburg, with the perpendicular buttress flanges meeting the boxy body of the lower tower just before the emergence of the octagonal upper tower and its flanking triangular pinnacles.

Further valuable evidence for how the scheme in 16.819v may have looked in three dimensions comes from a fragmentary elevation drawing showing a portion of the tower's southeast buttress. This drawing, number 16.825 in the Vienna Academy collection, has usually been dated late in the history of the Stephansdom workshop, because it includes complex articulation and curvilinear tracery elements that seem likely to postdate 1400 (Figure 4.24).[35] The overall format of the buttress it depicts, though, matches that of the Freiburg-like 16.819v, with narrow flanges joining the outer pinnacle packets to the body of the lower tower. The two drawings are also executed at nearly the same scale, so that several major elements in the elevation

[35] Böker associates 16.825 with the construction of the north tower, but Zykan's association of 16.825 with the south tower, and with 16.819v in particular, seems more convincing because of the depicted design's overall format. See Böker, *Der Wiener Stephansdom*, p. 111; Böker, *Architektur der Gotik*, pp. 86–8; and Marlene Zykan, "Zur Baugeschichte des Hochturms von St. Stephan," *Wiener Jahrbuch für Kunstgeschichte* 23 (1970): 56–9.

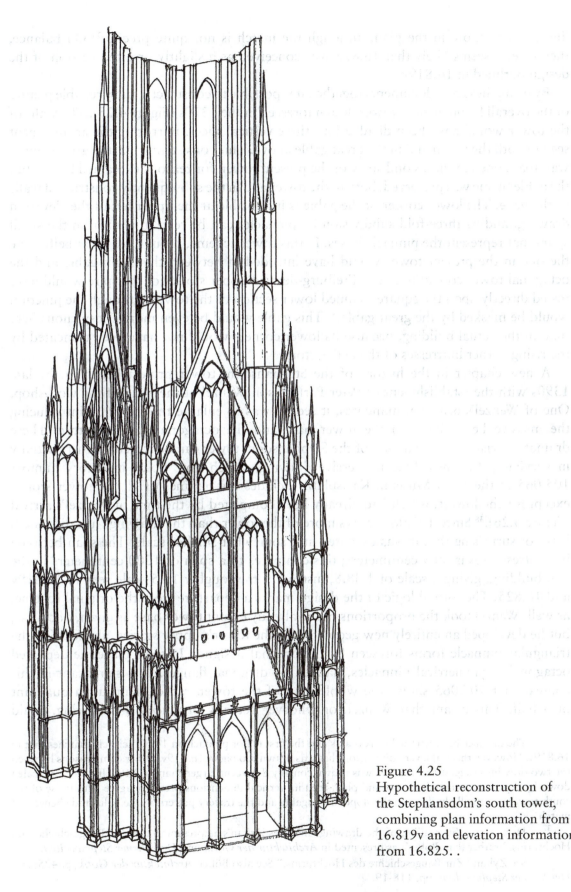

Figure 4.25
Hypothetical reconstruction of
the Stephansdom's south tower,
combining plan information from
16.819v and elevation information
from 16.825. .

line up with those in the plan, although the match is not quite precise.[36] On balance, therefore, it seems likely that 16.825 was conceived as a slightly updated version of the design outlined in 16.819v.

By using these two documents together, it is possible to construct a fairly reliable picture of the overall Stephansdom tower design foreseen in the 1370s (Figure 4.25). The walls of the tower would have been divided into three vertical slices, mirroring the arrangement seen in both the porch and in the great gable above. This consistent tripartite arrangement was abandoned in the second story of the present tower, for reasons explained below, but the gable theme was preserved, both in the tower and in the subsequently constructed walls of the nave. The lower corner of the gable is just visible at the upper left of the elevation drawing, and its three-fold subdivision by pinnacles can be read in plan from the small spurs that represent the pinnacle bases. In this tower scheme, though, no great belfry like the one in the present tower would have intruded in between this main gable and the octagonal tower core above. The Freiburg-derived upper stories of the spire would have rested directly upon the square-planned lower section of the tower, although the junction would be masked by the great gable.[37] This gable would be even more conspicuous here than in the actual building, because its lower corners would not have been truncated by the rising corner buttresses of the belfry story.

A new chapter in the history of the Stephansdom tower project began in the late 1390s with the establishment of Peter Parler's son Wenzel at the head of the workshop. One of Wenzel's principal mandates, it seems, was to enlarge the tower by introducing the massive belfry between the tower base and the octagonal superstructure. These dramatic revisions to the design of the Stephansdom tower can be traced at least partially in surviving drawings. One impressive drawing, which now holds inventory number 105.065 in the Wien Museum Karlsplatz, includes the outlines of all the tower stories except for the lowest, which had already been completed by the time of Wenzel's arrival (Figure 4.26).[38] Since 105.065 shows more of the tower than the drawings just discussed, it is not surprising that it was executed at a somewhat smaller scale. The span between its buttress axes is 30.9 centimeters; this compares to a span of 1200 centimeters in the real building, giving a scale of 1:38.8, instead of the roughly 1:25 scale seen in 16.819v and 16.825. The formal logic of the design marks a departure from the original scheme, as well. Wenzel took the proportions of the already extant tower base as given, of course, but he developed an entirely new geometry for the tower's upper stories, abandoning the triangular pinnacle forms foreseen by the original designer. In their place, he deployed octagonally symmetrical pinnacles, flanked by diagonal flanges. It is significant in this context that 105.065 shows the whole plan of the tower, rather than just a quadrant or a half. This meant that Wenzel, or whoever actually produced the drawing, could

[36] The distance between the buttress axis and the first major pinnacle in 16.825 closely matches that in 16.819v. However, this is the very dimension that was drawn too big in 16.819v. Other comparisons between the two drawings suggest that 16.825 was drawn roughly 8 percent larger than 16.819v. If 16.825 is scaled down by 8 percent to match the ground plan, then its vertical dimensions precisely agree with those of the south tower as actually built; even the slope of the gable and the tracery pattern in the balustrade beneath it match.

[37] Here again, this reading of the drawings matches Zykan's as presented in "Zur Baugeschichte des Hochturms," rather than Böker's as presented in *Architektur der Gotik* and *Der Wiener Stephansdom*.

[38] See Zykan "Zur Baugeschichte des Hochturms." See also Böker, *Architektur der Gotik*, p. 425; and *Der Wiener Stephansdom*, pp. 118-19.

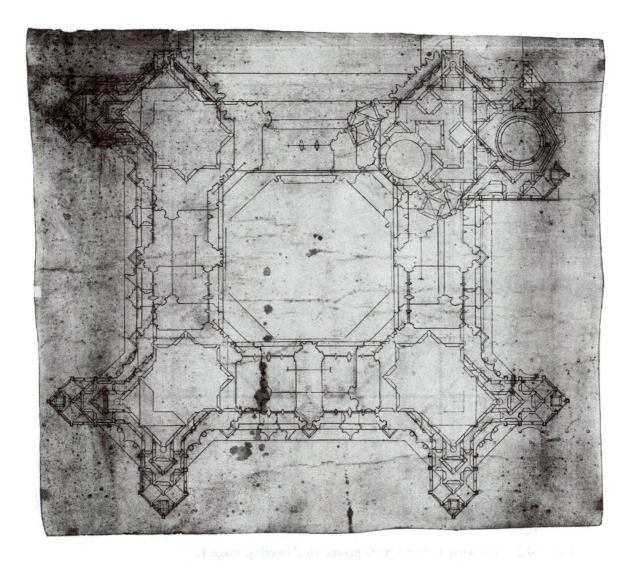

Figure 4.26 Drawing 105.065, showing a revised plan for the south tower of Vienna's Stephansdom.

generate its forms by drawing lines connecting points in adjacent quadrants, working inwards in a sort of "cat's cradle" pattern. This drafting method could not have been used in the less complete plan 16.819v for the tower base, but it does appear to have been used in the small Parlerian tower plan discussed previously in the context of the Prague Cathedral project. Both drawings also display octagonally symmetrical corner pinnacles, although the ones in the Stephansdom are star-shaped rather than simply octagonal. Such similarities make good sense in light of Wenzel's role in bringing artistic influences from Prague to Vienna. The Stephansdom tower plan, though, appears far more complex than the Prague drawing, especially since many distinct planes are shown within the thick tower walls.

Among the most striking elements in plan drawing 105.065 are the large diagonally planted buttress blocks that emerge from the corners of the tower core. Even a cursory examination of these blocks suggests that they must play a fundamental role in the geometry of the drawing, because of the way they interlock both with the star octagons

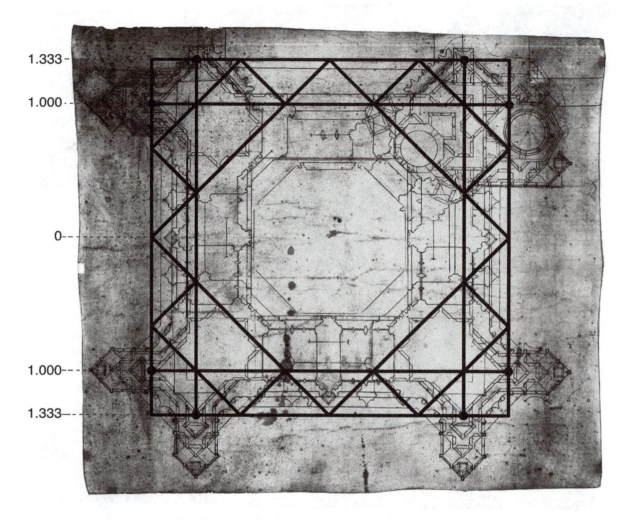

Figure 4.27 Drawing 105.065, with geometrical overlay, stage 1.

of the corner pinnacles, and with the salient blades of the buttress keels. Small circles also highlight the corners of these blocks. As Figure 4.27 shows, these corner points are 1.333 times as far away from the tower centerline as the buttress axes. The buttress axes, in other words, are 3/4 as far out as the block corners. This strongly suggests that the outer square framing the blocks was the first element to be constructed, with the buttress axes following immediately after the partition of the square's sides into fourths. Arithmetical and modular relationships thus figured prominently in the layout of the plan. Dynamic geometry, though, also contributed significantly to the shaping of the drawing. A rotated square inscribed within the outer frame, for example, locates the inboard facets of the corner pinnacles.

The proportions of the parchment offer further valuable clues about the layout of 105.065. Since the tower superstructure was to be octagonal, it is not surprising that large octagons were used to frame the drawing. As Figure 4.28 shows, the right margin of the parchment aligns closely with the right facet of a large octagon whose facial radius equals 2.000 times the distance from the centerline to the buttress axes. The left margin of

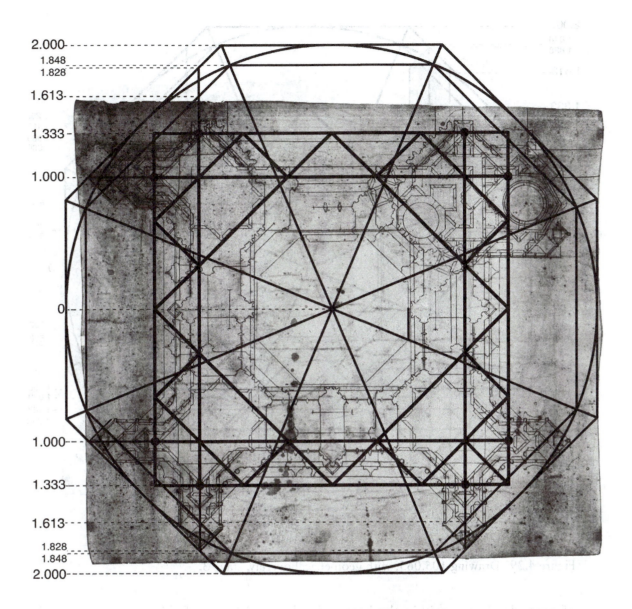

Figure 4.28 Drawing 105.065, with geometrical overlay, stage 2.

the parchment, meanwhile, coincides the left facet of a slightly smaller octagon inscribed within the first by octature. The facial radius of this inscribed octagon is 1.848, just a tiny bit less than the 1.851 distance previously explained as the distance to the front face of the tower buttresses in the ground story. This similarity allowed Wenzel to use the 1.848 distance as an approximate frame for the buttress superstructure in his plan drawing, and it would later influence the designers of the Stephansdom's north tower, as well. Just slightly further in, the buttress axes intersect the sides of the big exterior octagon 1.828 units out from the tower centerline. These points define the front corners of the buttress keels. Analogous points 1.613 units from the centerline mark the intersections between the buttress axes and the slightly smaller inscribed octagon, locating the front corners

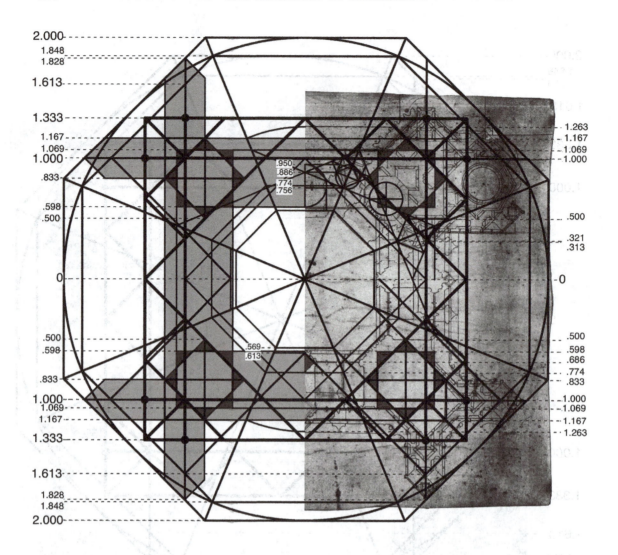

Figure 4.29 Drawing 105.065, with geometrical overlay, stage 3.

of pinnacle clusters within the keels. The diagonal facets of this octagon, meanwhile, show up explicitly in the drawing as the diagonal moldings where Wenzel Parler inserted corbels to carry the reinforcing flanges alongside the belfry buttresses.

Figure 4.29 shows how the fine structure of the drawing emerges from within the basic geometrical frame. As indicated previously, the star octagons describing the corner pinnacles are among the most important generators of the plan geometry. Their scale and location are fully determined by the way they interlock with the salient buttress keels. Their inner corners, centerpoints, and outer corners are thus .500 units, .833 units, and 1.167 units out from the centerline, respectively. The inner and outer facets of the octagons set within them, meanwhile, fall .598 and 1.069 units out. The main body of the tower wall, which is lightly shaded in Figure 4.29, thus occupies the space between .598 and 1.167 units from the centerline. In the center of the drawing, an octagon with facial radius of .569 units sits just inside the square space defined by these shaded walls. Its corners are found by the intersections between the rays of octagonal symmetry and the

diagonals slicing in towards the tower center from the corners of the diagonal buttress blocks established at the very beginning of the layout process; this relationship is shown in the lower-right facet of Figure 4.29. Slightly outside the central octagon, and in the shaded area of the wall, another set of lines fall .613 units out from the tower center. These can be found by striking diagonals along the sides of the buttress flanges from the previously established points on the keels 1.613 units from the centerlines. The outermost square shown in the groundplan, meanwhile, falls 1.263 units out, which is one octature step out from the 1.167 lines, as the small arcs at the top and bottom of the figure show.

Further details of the wall structure involve the "cat's cradle" connection of corner points within the octagonal frame of the tower core, as the upper-right quadrant of Figure 4.29 indicates. The outermost of these points lie on the 1.069 lines that align with the flat outer faces of the corner pinnacles. Lines connecting every second corner of this octagonal array cross the cardinal axes of the drawing .886 units out from the center. These lines cross the radial lines of octagonal symmetry .756 units out from the tower centerlines, at the inner corners of the rotated square pinnacle clusters at the corners of the tower core. Since the outer corners of the clusters are already fixed 1.069 units out from the centerline, the size and orientation of the rotated square framing the cluster can be unambiguously determined. The sloping side of this cluster intersects the line .886 units from the centerline, thus defining the side length of the innermost rotated square in the cluster. Lines struck outwards parallel to the rays of octagonal symmetry then describe the sides of the bladed flanges at the corners of the tower core. The midpoints of these sides are .950 units out from the centerline, right where a prominent line appears in the drawing. Another prominent line describing the single window of the belfry side falls .774 units out, which is halfway between the previously established .598 and .950 lines, as the small semicircle in this zone indicates. An octagon with this facial radius of .774 establishes the diagonals just intruding into the unshaded central zone of the overall composition, which describe the inner faces of the moldings on the piers of the tower interior. Another set of diagonals slightly closer to the tower center corresponds to the sides of the large rotated square framed by the buttress axes. As the right-hand margin of Figure 4.29 shows, the corners of the .774 octagon fall .321 units out from the centerline, aligned with a line through the wall thickness, while the corners of the .756 octagon fall .313 units from the centerline.

The most prominent window openings shown in the drawing are those of the double-window story, which have two layers of tracery: an outer set aligned with the outer face of the corner pinnacles, 1.069 units from the centerline, and another inner set .686 units out from the centerline, i.e. halfway between the .774 octagon and the inner pinnacle face .598 units out from the centerline; these relationships are shown in the bottom facet of Figure 4.29. The tunnel-like connection between the two layers of tracery is described by lines perpendicular to the wall plane, located .500 units out from the centerline, as shown

Figure 4.30
Drawing 105.066,
showing a revised
elevation for
the south tower
of Vienna's
Stephansdom.

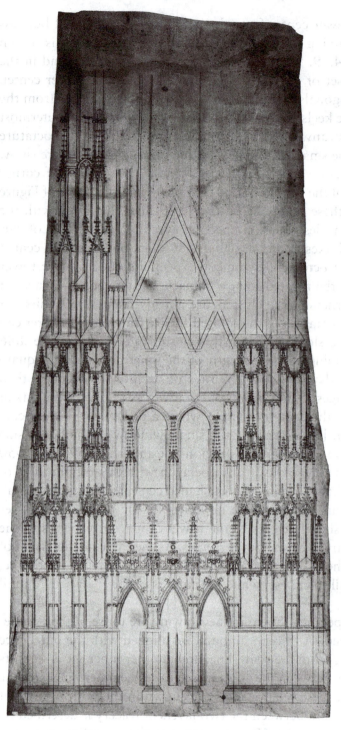

in the right-hand facet of the figure.

Altogether, therefore, plan drawing 105.065 shows that Wenzel Parler and his colleagues blended several different design strategies as they tackled their phase of the Stephansdom tower project. They appear to have begun by constructing a modular frame, with the buttress axes 3/4 of the way out to the corners of the diagonal buttress blocks. The overall layout the drawing on the page, though, is clearly octature-based, and it shows that they preferred to work with ideal self-consistent geometries even when adding onto pre-existing structures like the tower base. The dynamics of geometrical play could quickly generate complex relationships even within this simple and lucid framework, though, as the subsequent steps of the process demonstrate. In this particular drawing, the construction of the corner pinnacles played a crucial role in the overall design process, since some of the major wall elements align directly with the pinnacles, while others depend on the pinnacle geometry indirectly, through the construction of "cat's cradle" corner-to-corner relationships.

The geometrical and formal logic of Wenzel Parler's tower design scheme reveals itself further in an impressive elevation drawing, Wien Museum 105.066, executed at precisely the same scale as the plan

105.065 (Figure 4.30).[39] Unlike the plan drawing, which explicitly shows only the stories to be constructed by Wenzel and his team, the elevation shows all the stories from the groundline to the middle of the belfry story, where the drawing peters out incomplete. The precise form intended for the upper tower and spire thus remains unclear—and it may even have been unclear to Wenzel and his draftsmen. The form of the ground story, by contrast, was fully fixed, since it had been constructed already by Wenzel's predecessor, in accord with the previously discussed groundplan 16.819v. In between, the elevation drawing shows a tower story with two small windows, very similar to the one that Wenzel and his masons built in the years around 1400. As comparison with the plan makes clear, a reduction from the three windows likely foreseen in 16.819v was made necessary by Wenzel's introduction of the buttress-strengthening diagonal flanges designed to help carry the belfry story unforeseen in the earlier design.

Given the importance of the Stephansdom project, and the precision with which

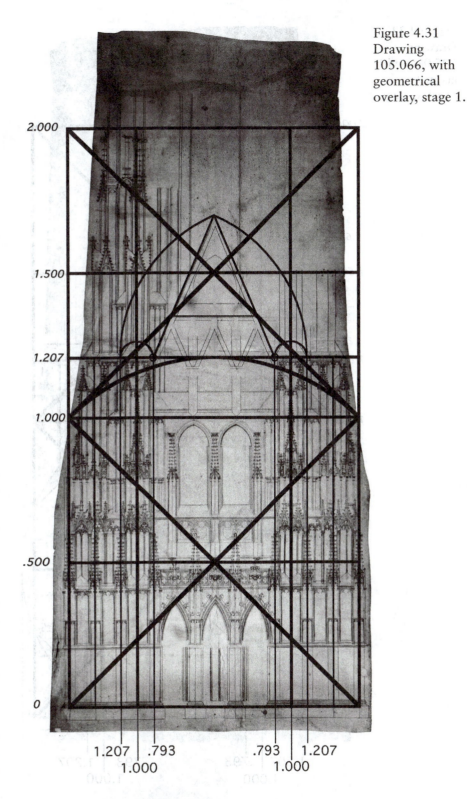

Figure 4.31
Drawing
105.066, with
geometrical
overlay, stage 1.

39 See Zykan "Zur Baugeschichte des Hochturms"; Böker, *Architektur der Gotik*, pp. 430-35; and Böker, *Der Wiener Stephansdom*, pp. 118-19. Böker attributes 105.066 to Peter Prachatitz, but attribution to Wenzel seems plausible in view of the stylistic distinction between the plasticity of the buttresses shown in the drawing and the flickering quality of the belfry built by Prachatitz. In the present chapter, both 105.065 and 105.066 are attributed to Wenzel, but in this context the points about their geometry and relative dating are more important than their attribution.

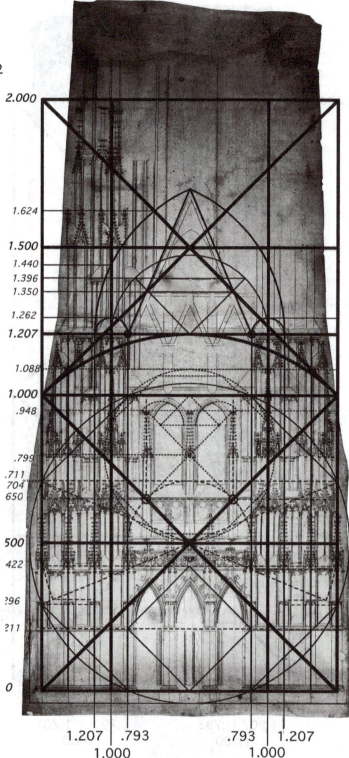

the drawings for it were executed, the essentially perfect correspondence between the elevation drawing and the completed lowest story of the south tower comes as no surprise. Wenzel and his team must have taken a careful survey of the built structure, using the already established pinnacle axes as important governing lines in the elevation. Then, starting from the extant structure, they developed an elevation scheme with a simple and lucid geometrical structure.

The drawing as a whole was laid out as a stack of two large squares, whose side length is given by the span between the outer buttress pinnacle axes in the tower base (Figure 4.31). This dimension can be defined as one *large unit*, italicized, to distinguish it from the smaller unit previously used in discussion of the groundplan. The baseline for the square construction, interestingly, was the upper edge of the dado, rather than the groundline. With this baseline, the lower of the two major squares terminates at the top edge of the tower story with the two small windows. The edges of the parchment pass exactly through the upper corners of this first great square. The middle of the second square, at height *1.500*, marks the level where several lines describing the main buttresses terminate on the right-hand half of the drawing, and where small gablets spring

on the left. The top edge of this second large square, at height *2.000*, marks the tips of the topmost pinnacles drawn onto the left buttress. So these basic square modules clearly played a crucial role in the layout of the drawing. Significantly, too, the seam between the upper and lower parchments in the drawing passes through the points where the diagonals of the upper square cross the main buttress axes of the tower.

Perhaps the most striking thing about the organization of Wenzel's elevation drawing, though, is the punctuation of the buttress articulation exactly *1.207 large units* above the baseline. This visually crucial disjunction, in other words, lines up with the upper point of a circle circumscribed around the first great square. The same basic circle-plus-square construction had also governed the proportions of drawing 16.819v, shown in Figure 4.21. The masonry of the tower base, therefore, incorporates the same 1.207 ratio in the horizontal dimension, since the span of the front buttress faces is 1.207 times larger than the distance between the main buttress axes. Wenzel Parler and his colleagues obviously had to pay careful attention to the proportions of the already extant tower base. So it comes as no great surprise that the horizontal proportions of drawing 105.066 match those of the built tower base quite precisely; the pinnacle axes in the drawing fall at the familiar distances of 1.207 and .793 small units out from the building centerline, after all, as Figure 4.31 shows. But the translation of the 1.207 ratio into the vertical dimension demonstrates that Wenzel Parler and his team were not just copying the proportions of the tower base that they had inherited from their predecessors. Instead, they appear to have understood the geometrical logic of the original design, to which they self-consciously referred even as they dramatically changed the overall format of the tower by thickening the buttresses and introducing the great belfry.

This relationship between Wenzel's elevation and the already established pinnacle axes of the tower base becomes even clearer in the upper portions of Figure 4.31. These pinnacle axes rise smoothly to the previously established height of *1.207 large units*, framing the main tower buttresses as they rise. Arcs centered on the inner buttress margins at this level and struck through the outer buttress margins opposite intersect on the tower centerline to locate the tip of the great gable screening the base of the belfry. The sloping sides of the gable coincide perfectly with the line drawn from this tip to the arc centers, which are highlighted in Figure 4.31 by small dots. Interestingly, moreover, these sloping lines intersect the diagonals of the upper large square at precisely the level where the three small sub-gablets terminate in an emphatic horizontal molding. So, the geometrical structure of the great gable high in the tower derives quite directly from the basic proportions established in the tower base.

The upper section of Figure 4.32 shows how permutations on this basic scheme give other details of the buttress structure in the gable zone. The large arcs that located the gable tip cross the diagonals of the second great square at a height of *1.624 large units*, locating the tips of the small gablets on the buttresses. These same arcs intersect the principal buttress axes at a height of *1.440*, locating the top edges of a prominent glacis molding on the buttress. The lower edge of the molding, at height *1.396*, marks the level where diagonals rising from the tower center at height *1.207* intersect a circle centered at that height and struck through the main buttress axes. The *1.350* gablet height was already established in the construction shown in Figure 4.31. And the height of the glacis

filling the space between height *1.207* and *1.262* simply equals the half-width of the main buttress, as the small semicircles at that level indicate.

The lower portions of Figure 4.32 are interesting because they show parts of the tower base designed by Wenzel's predecessor, in addition to the new stories built under Wenzel's supervision. As noted previously, the width of the tower measured across its outer pinnacle axes equals its height from baseline to the top of the double-window story, so that the whole composition can be inscribed in a square. An octagon inscribed within this great square appears to have played a role in the layout of 105.066, since a circle circumscribed about this octagon reaches down to define the groundline of the tower, while the circle's left and right edges coincide closely with the edges of the parchment at its equator. The tower dado thus descends below the baseline *0* of the overall geometrical scheme. The lower leftmost corner of the octagon, at height *.296*, appears to have established the level at which the tiny arches spring within each of the buttress-flanking pinnacles. The upper leftmost corner of the octagon falls at height *.704*, near the tips of some tiny sub-pinnacles on the buttresses. But an even better match with these pinnacle tips comes from a different construction. To explain this, a short digression is in order. The distance from the tower centerline to the inner buttress face, which was *.793* units, can be expressed as *.211 large units* in the elevation. The triple-arched face of the tower porch is a perfect square measuring twice this dimension on a side. It thus rises from height *0* to height *.422*, with the first prominent stringcourse in the tower base falling halfway up, at height *.211*. An arc of this radius with its center at the center of the first great generating square will sweep from height *.500* to height *.711*. This height matches the tiny pinnacle tips in the buttresses even better than the *.704* height of the large octagon's corner.

The same arc-based construction used to define the *.711* level helps to establish the geometry of the double-window story zone. The arc framed by the inner buttress faces crosses the diagonals of the first great square at height *.650*, locating the base of the sill under the twin windows. Two small circles at this level mark these intersection points. A square with those points as its lower two corners reaches up to height *.948*, the level where many small pinnacles terminate, both on the buttresses and on the wall flanking the windows. The sides of the square align with the axes of the small pinnacles flanking the windows. The midpoint of the square falls at level *.799*, which marks not only the boundary between shaft and spirelet in these pinnacles, but also the top edge of the wall moldings just visible at the extreme left margin of the drawing. The centers of curvature for the heads of the twin windows can be found by dropping diagonals from the top center of the first great square until they intersect the diagonals crossing the square centered at level *.799*. This same point at level *.799* can also serve as the center for an octagon framed by the principal buttress axes; a circle circumscribed around this octagon reaches up to height *1.088*, establishing a prominent horizontal near the base of the great gable. As this analysis demonstrates, Wenzel Parler and his colleagues used simple combinations of octature, quadrature, and square stacking to establish the proportions of elevation drawing 105.066, while taking as their point of departure the proportions that had been established in the tower base through the work of their predecessors.

The geometrical structure of the present tower closely matches that of drawing 105.066, as Figure 4.33 shows. The basic geometrical armature, in both cases, is a stack of two great squares, whose side length equals the span between the outer buttress faces,

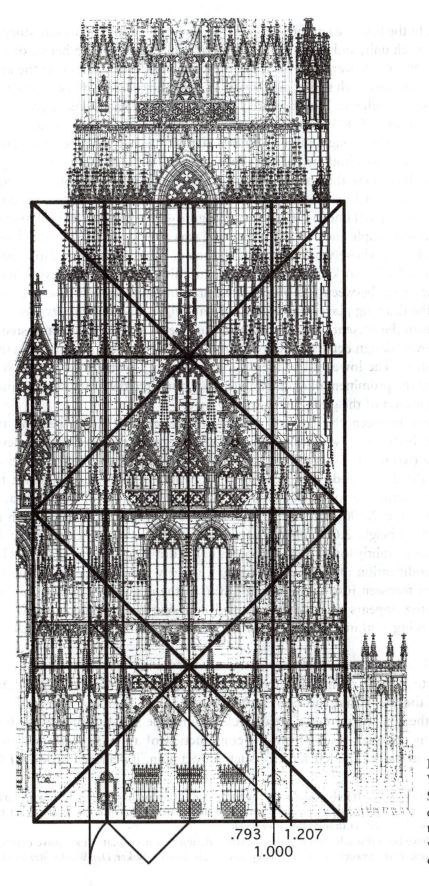

.793 | 1.207
1.000

Figure 4.33
Vienna,
Stephansdom,
elevation of south
tower lower stories
with geometrical
overlay.

or one *large unit*. In the tower, as in the drawing, the top of the double-window story falls at a height of one such unit, and a prominent series of gablets springs at a height of *1.500 large units*. In the present tower, moreover, another similar belt of gables and the arches of the main belfry window both spring at a height of *2.000 large units*, marking the top of the great double-square scheme. It is absolutely clear, therefore, that the basic geometrical armature introduced in 105.066 strongly governed the form of the present tower.

Within this basic frame, though, there are subtle distinctions between the present tower and the drawing, in terms of both proportion and articulation. In the actual masonry, the height of the tower base up to the bottom sill of the double-window story precisely equals the width of the front tower face, measured across the outer faces of the buttresses flanking the entry porch; the diagonal line in the bottom of Figure 4.33 expresses this relationship. It seems likely that this simple and elegant proportion was already planned by the designer of the 16.819v scheme, whose workmen built the tower porch, which is also a perfect square in elevation.[40] His work clearly informed the thinking of his successor Wenzel Parler, as the close match between 105.066 and the masonry of the tower base shows, but the geometry of the drawing places the window sill at height *.650 large units*, just a hair higher than it falls in the present masonry. Wenzel thus seems to have subtly adjusted and rationalized his tower design between the creation of 105.066 and the construction of the double-window story. The lower sill of the double windows also marks the level where Wenzel introduced the prominent diagonal flanges that reinforce the buttresses, preparing the way for the addition of the great belfry story above.

The divergences between the present tower and drawing 105.066 become more pronounced in the belfry zone, which occupies the second great square of the geometrical armature that the two designs share. This is hardly surprising, since Wenzel Parler died in 1404, leaving the design and construction of the belfry to his former assistant Peter Prachatitz. While continuing to respect the major punctuation lines of the composition at heights of *1.500* and *2.000 large units*, he shortened the belfry window, which now begins to terminate at height *2.000*, instead of continuing upwards as it does in 105.066. The great gable is also subtly lower than it appears in the drawing. This change goes hand in hand with a modification of the buttress format, namely the elimination of the boxy diagonal moldings foreseen just below height *1.396* in the drawing.[41] In general terms, therefore, Prachatitz appears to have streamlined and shortened elements of Wenzel's design while working within the same basic geometrical armature that Wenzel had established.

The details of Prachatitz's revised belfry design are shown in Figure 4.34. Interestingly, Prachatitz chose to place a prominent crease in the buttress articulation at a height of *1.221*, instead of the *1.207* that had been foreseen in drawing 105.066. The *1.207* level had arisen from the construction of a great circle around the square framing the belfry. The *1.221* level, by contrast, results from the construction of an octagon framed by the principal tower buttresses. The left facet of such an octagon, if centered at level *1.000*,

[40] The creator of 105.066 certainly understood the front face of the porch to be square, but the baseline of this square appears to differ slightly from that seen in the actual masonry, since the drawing starts the square at the top of the dado, rather than at the floor level.

[41] It may well have been this adjustment to the buttress design that necessitated expensive demolition and reconstruction work on the tower in 1407. These repairs are discussed in Böker, *Der Wiener Stephansdom*, p. 112.

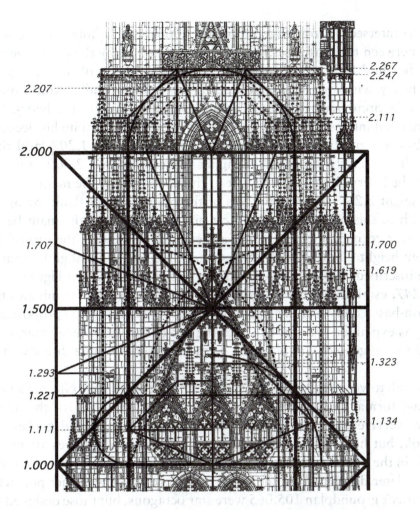

Figure 4.34 Vienna, Stephansdom, elevation of south tower belfry story with geometrical overlay.

reaches to height *1.111*, which marks the springing of the three arches in the lower section of the great gable. This horizontal falls halfway between the belfry baseline and the crease on the buttresses, as the small arc in the lower left of Figure 4.34 shows. On the right side of this illustration, meanwhile, a slightly larger octagon extends out to the outer face of the main forward-facing tower buttress, so that the upper corner of its right facet falls at height *1.134*. The top of this octagon reaches level *1.323*, establishing the height of a prominent horizontal in the tracery articulation of the great gable. The arc circumscribed about this octagon establishes a new point on the belfry baseline slightly beyond the outer faces of the lower buttresses; dotted lines struck through this point and through its mirror image at left rise to frame the upper margins of the belfry, coinciding perfectly with the outer pinnacle tips at height *2.267*. The tip of the great gable at height *1.619* can be found at the intersection of two dotted arcs tangent to the inner buttress faces, struck using centers at height *1.221* on the buttress axes. These arcs continue upwards to reach height *1.700*, locating the main level of the finial atop the gable.

Simple octagonal geometries play important roles in establishing the elevation of Prachatitz's belfry scheme. A large octagon inscribed within the great square would have corners at heights *1.293* and *1.707*, as the rays and labels in the left side of Figure 4.34 indicate. Level *1.293* marks the height of the pedestals on the outer buttress faces, where statues were likely intended to stand. Two more such rays reach up from the center

of the great square to intersect its top edge at height *2.000*, establishing the width of the main belfry face between the buttresses. A half-octagon framed by these intersection points reaches up to height *2.207*, locating the ring collar near the tip of the ogee gable crowning the main belfry window. This same height, not coincidentally, would mark the top edge of a circle circumscribed about the great square framing the belfry. So, Prachatitz clearly remained interested in these large-scale geometries, despite his decision to place the lower buttress punctuation at level *1.221* instead at the *1.207* level that Wenzel had foreseen. Two slightly larger half-octagons centered at level *2.000* suffice to determine the rest of the belfry elevation. The first of these, framed by the main buttress axes, reaches up to height *2.267*, locating the tips of the pinnacles that flank the upper belfry zone. The width of this octagon's upper facet gives the width of the main belfry window, while the lower corners of the octagon, at height *2.111*, locate the tips of the gablets springing from height *2.000*. Within this octagon, a circle and a slightly smaller octagon can then be inscribed; the latter figure, shown with dotted lines in Figure 4.34, reaches to height *2.247*, establishing the bottom lip of the molding that terminates the belfry. Similar octagon-based constructions had also helped to determine the proportions of drawing 105.066, as explained previously. Up to the top of the belfry level, therefore, Prachatitz continued to use geometrical planning methods inherited quite directly from Wenzel Parler.

Higher up in the south tower superstructure, Prachatitz appears to have effected a very subtle geometrical and formal shift. Since none of his original drawings for the upper tower and spire have survived, detailed analysis of his spire design would go beyond the scope of this book, but his revision of the corner pinnacle form deserves attention, because it helps to fill in the missing steps between the already discussed drawings for the south tower and those later developed for the north tower project. The corner pinnacles depicted in Wenzel Parler's groundplan 105.065 were star octagons, but those designed by Prachatitz rise from square bases partitioned into 3 × 3 grids like tic-tac-toe boards; this difference can be seen in the contrasting left and right halves of Figure 4.35. Prachatitz worked within the same basic frame that Wenzel had established, so that the edges of his pinnacles line up with the flat faces of the ones that Wenzel had planned. But he then subdivided each pinnacle face into three equal slices, adopting a modular approach to pinnacle design that differs from Wenzel's purely geometrical use of square rotation in this zone. This construction, in turn, appears to have established the size of the main octagonal tower core, whose outer faces line up with the subdivision lines 2/3 of the way across each pinnacle, as measured from the tower centerline. The present tower core is thus slightly larger than the one planned by Wenzel Parler using a geometrical "cat's cradle" construction, as the central shaded areas in Figure 4.35 show.

It would be misleading to identify Wenzel Parler and Peter Prachatitz exclusively with the geometrical and modular design modes. As noted previously, Wenzel Parler evidently used simple arithmetical ratios to establish the basic outlines of groundplan 105.065 before embarking on its geometrical elaboration. And Prachatitz, for his part, certainly used dynamic geometry to develop both the larger and smaller forms of his spire design. But the slight shift of emphasis in the pinnacle design is interesting as one small but telling example of how modularity and repetition increasingly came to inflect fifteenth-century

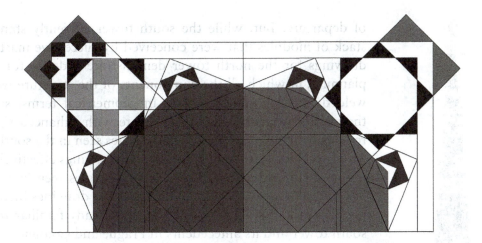

Figure 4.35 Comparison between proportions of actual Stephansdom spire base (at left) and those foreseen in drawing 105.065 (at right).

Gothic design. More specifically, the mix of geometrical and modular approaches used by Prachatitz in the south tower design established a precedent that strongly influenced the later leaders of the Vienna Stephansdom workshop.

The history of the Stephansdom workshop in the fifteenth century has proven difficult to elucidate, despite the wealth of visual and documentary evidence associated with the building. Certain crucial names, dates, and facts are well established. The magnificent south spire was successfully completed in 1433, thanks in part to support from the local citizenry (Figure 4.36). The spire clearly represented the power and wealth of the city, as well as the ambitions of the Habsburg dynasty that had launched its construction. Peter Prachatitz did not quite live to see his masterwork completed, since he died in 1429, but the visual and structural coherence of the spire suggest that his successor Hans von Prachatitz followed through on the project without introducing any major innovations. The next leader of the workshop, Hans Puchsbaum, began to construct the foundations of the north tower, starting in 1450. Until recently, therefore, the earliest surviving drawings for the north tower project have generally been attributed to Puchsbaum, as have many of the other stylistically similar drawings in the massive Viennese corpus. Puchsbaum, however, died already in 1455, and his career at the head of the Stephansdom workshop was much shorter than that of his successor Laurenz Spenning, who lived until 1477. In his recent publications, therefore, Hans Böker proposed a substantially new chronology for work at the Stephansdom, arguing that Spenning rather than Puchsbaum should be seen as the author of most of these drawings, including the early ones for the north tower. These would then date to the years around 1466, after the completion of the tower foundation pad but shortly before work began on the first above-ground story of the tower.[42] This redating has significant implications for interpretation of the Stephansdom in its political context, since Böker sees the Habsburg Emperor Frederick III as the driving force behind many of the additions to the building in the late fifteenth century.

The drawings for the north tower, regardless of their precise dating and attribution, attest to substantial continuity within the Stephansdom workshop. Scholars have long recognized that the designers of the north tower took the south tower as their point

[42] Böker, *Der Wiener Stephansdom*, pp. 255–84.

Figure 4.36.
Vienna,
Stephansdom,
full elevation
of south
tower.

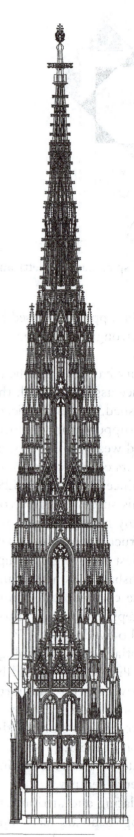

of departure. But, while the south tower currently stands as a stack of modules that were conceived by successive masters, the drawings for the north tower demonstrate a desire for unitary planning, in which all the components of the structure would be welded into a seamless whole. In geometrical terms, similarly, the north tower drawings recapitulate with enhanced rigor and regularity many of the motifs and themes seen in the south tower. More specifically, the north tower plan drawings effectively blend the modular and geometrical design strategies seen in the south tower and its pinnacles, while the elevation drawings incorporate the principle of stacking great squares already familiar from the south tower and its antecedents in Prague and Cologne.

Three closely related plan drawings and two complete elevation drawings executed at the same scale document the first phases of planning for the Stephansdom's north tower.[43] In all of these drawings, the distance between the buttress axes is roughly 42.3 centimeters; comparison with the corresponding 1244-centimeter span in the actual tower shows that their scale is 1:29.4. This closely approximates 1:30, of course, but the parchments would all have to have stretched equally, instead of shrinking, for that to have been the original scale. It is clear, in any case, that these drawings were executed at a scale different than the 1:25.8 seen in the early groundplan 16.819v or the 1:38.8 scale seen in the drawings here attributed to Wenzel Parler.

Here, as with most tower and pinnacle designs, it makes sense to begin geometrical analysis with the groundplans, since these determined the dimensions that would later be used to establish the elevations. The three early plan drawings for the Stephansdom north tower present almost exactly the same design, differing only in their treatment of a secondary spiral staircase turret. One drawing has no such stair, another shows the stair integrated into a corner buttress, and the third shows the stair in a turret of its own alongside the main body of the tower, in a format which closely matches that of the present tower. This drawing, which holds inventory number 16.872v in the Vienna Academy collection, was presumably the last of the three to be executed (Figure 4.37).[44]

Tower plan 16.872v, like its two near-twins, shows the complete outlines of all the north tower stories from ground level to the base of the spire. The plan nearly fills the roughly square parchment assemblage onto which it was drawn. The relationship between the parchment shape and the geometry of the drawing, in fact, is quite precise, as Figure 4.38 shows. The bottom and

[43] These are Vienna Academy drawing 16.872v, and Wien Museum drawings 105063 and 105064. See Böker, *Architektur der Gotik*, pp. 176–8, 420, and 421–5, respectively.

[44] Böker, *Der Wiener Stephansdom*, pp. 271–5.

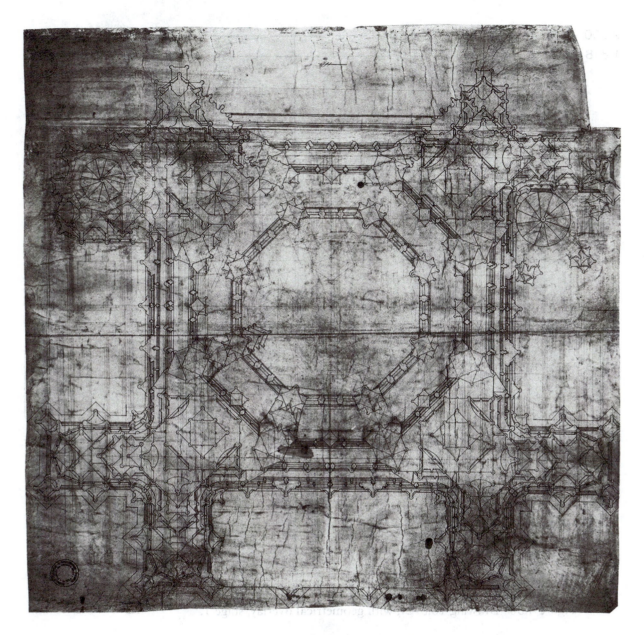

Figure 4.37 Drawing 16.872v, showing a ground plan for the north tower of Vienna's
 Stephansdom.

left margins of the sheet are exactly twice as far out from the tower center as the buttress
axes. The top margin of the sheet, and the bottom edges of the main tower buttresses, fall
1.848 units out from the tower center, a dimension that results directly from an octature
relationship; 1.848 = 2(cos22.5°). This is the same basic layout already seen in the south
tower groundplan 105.065, but the precision of these relationships is even more striking
here.

 In general, the Vienna north tower plans deserve recognition as some of the most
complex and geometrically intricate drawings to survive from the Gothic era. Particularly
noteworthy is the way in which they combine geometrical and modular design strategies,

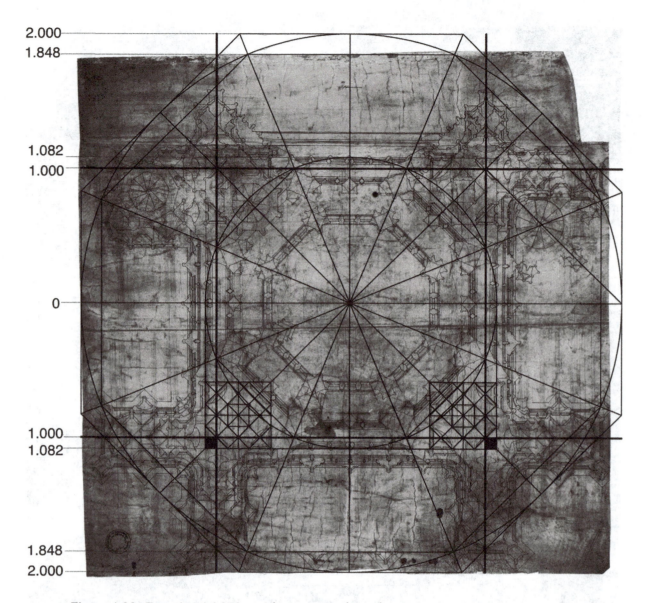

Figure 4.38 Drawing 16.872v, with geometrical overlay, stage 1.

building on the hybrid approach already seen in the work of Peter Prachatitz. In 16.872v
and its twins, one of the most important modules was generated by swinging a circle about
the octagon framed by the buttress axes. The radius of the circle will be 1/cos22.5° = 1.082,
so that the "extra" salience of the circle beyond the buttress axes is .082.[45] In Figure 4.38,
a small square module of this size is shown in black; the main corner pinnacles of the
tower are composed of 6 × 6 arrays of such modules. The pinnacles thus have the same
basic "tic-tac-toe" shape of the ones built by Prachatitz in the south tower, but their size

[45] The .0824 interval that results from octature is nearly identical to the .0833 interval that would
result from subdividing the span to the buttress axes into 12 equal slices; the difference amounts to just 1
percent of a small dimension. Since the pinnacles are 6 × 6 arrays, the subdivision into 12 slices would give
these pinnacles dimensions of exactly .500 units on a side, and buttress blocks with corners 1.333 units out
from the tower centerlines, like those seen in 105.065. In practice, though, the pinnacles are a tiny bit smaller,
suggesting that the octature-based construction was used instead.

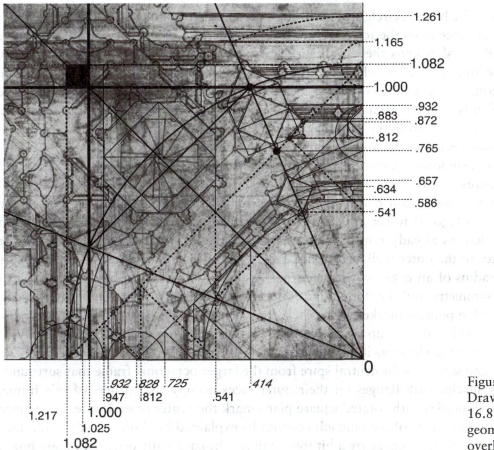

Figure 4.39 Drawing 16.872v, with geometrical overlay, stage 2.

here relates directly to the overall geometry of the tower plan, without the geometrical decoupling produced in the south tower by the successive masters and their changing visions.

Figure 4.39 zooms in on the upper-left corner of the drawing to show how the upper stages of the tower were constructed within the basic square frame defined by the corner pinnacles. The outer faces of the corner pinnacles, 1.082 units out from the centerline, locate the walls of the uppermost square tower story. The dotted diagonal lines in the figure show how this length can be progressively bisected to gives segments 1/2, 3/4, and 7/8 as big as the original; these dimensions work out to .541, .812, and .947 of the span to the buttress axes, as the labels along the bottom margin of the figure indicate. Verticals extended up from the .541 and .947 points on the baseline exactly frame the octagonal stairway turret, whose centerpoint lies on the diagonal reaching up from the tower's centerpoint. The wall thickness of the turret was determined by a simple square rotation within this frame.

As the right margin of Figure 4.39 indicates, the fine structure of the main spire walls was considerably more complicated. Despite the precision with which the drawing was executed, it is impossible to be absolutely certain about how this zone was conceived, since various alternative scenarios give nearly identical dimensions. It seems likely, though, that the starting point was the already established dimension of .541 units. An octagon with this length as its facial radius has its corners on the inside corners of the small pinnacles

framing the spire base. A circle struck through these corner points has radius .586, which equals the distance from the tower center to the inside face of the spire walls.[46] Another octature relationship joins these wall surfaces to an octagon of facial radius .634. The faces of the inner pinnacles, which diverge outwards from the inner corner points on the .541 octagon, intersect the .634 line to locate the side corners of the pinnacles. Since the pinnacle plan is a perfect rotated square, this information suffices to locate the pinnacle center, .657 units out from the tower center. The outer faces of the spire wall also lie .657 units from the center, as the arc sweeping from the pinnacle center to the wall indicates.

The cruciform lower elements of these innermost pinnacles were not just constructed about the cores by quadrature; they are a bit too large for this simple hypothesis to hold. Instead, their construction relates via a kind of cat's cradle to the larger frame of the surrounding octagonal tower core. One of the crucial dimensions in this construction is .812, which, as already noted above, marks the point 3/4 of the way out from the tower center to the outer wall at distance 1.082. Another key distance is .765, which is the facial radius of an octagon whose corner lies at the intersection between the ray of octagonal symmetry and the dotted line connecting the centers of the main tower faces; this intersection point is marked by a black dot in Figure 4.39. Raking lines struck back from points .812 and .765 up on the vertical axis of the figure define the back edges of the cruciform lower elements in the innermost pinnacles.

A small gap separates the central spire from the larger octagonal frame that surrounds it. Large pinnacles with flanges on their outer faces occupy the corners of this frame, while small pinnacles with rotated square plans mark the center of each face. Here, once again, the fine structure of the pinnacles cannot be explained by simple quadrature, since the rotated square inner cores are a bit too small for the cardinally oriented square boxes that frame their inner faces, toward the spire. The proportions of these small pinnacles actually derive from their place in the larger composition of the groundplan. Thus, for example, the distance from the tower center to the inner edges of the boxy frames seems to be the already familiar .812. The equivalent surface on the outer side of the pinnacles, which coincides with the outer surface of the large octagonal tower core, falls .932 units out from the center. One plausible construction generating this dimension is shown near the bottom margin of Figure 4.39, with the relevant dimensions noted in italics. The key surface in this construction is the diagonally oriented inner face of the spire wall. A diagonal line extending this segment intersects the horizontal axis of the diagram .828 units out from the tower center. This dimension can be subdivided into 1/2, 3/4, and 7/8 fractions with slender solid lines, just like the heavy dotted lines subdivided the larger 1.082 dimension previously. In this case, the 7/8 fraction gives a distance of .725 units. So, a circular arc centered at .828 and struck through .725 will swing out to .932, or 9/8 of the original .828 determined by the slender diagonal. This .932 distance from the

[46] Since the .541 and .947 subdivisions definitely appear to have been used in the construction of the stair turret, it seems likely that the .541 dimension and its .586 derivative were used to define the inner face of the spire wall, as well. This wall surface could also have been established, though, by connecting the inner faces of the large square corner pinnacles. Assuming the octature-based construction of the pinnacles, this would give an interval of 1-5x(.0824), or .588. If the more modular construction like that in 105065 was intended, the dimension would be 1-5x(.0833), or .583. Both of these are indistinguishable in a drawing of this scale from the .586 cited here. The rest of the construction would proceed as described in the main text.

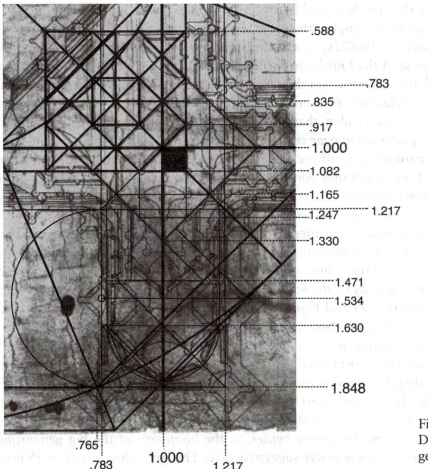

.588
.783
.835
.917
1.000
1.082
1.165
1.217
1.247
1.330
1.471
1.534
1.630
1.848

.765
.783 1.000 1.217

Figure 4.40
Drawing 16.872v, with
geometrical overlay,
stage 3.

spire center locates the outer wall surface of the octagonal tower core.[47] Transferring this dimension back up to the right-hand margin of Figure 4.39, it becomes clear that the center of the small mid-face pinnacle will fall .872 out from the center, halfway between the outer wall at .932 and the boxy inner face at .812.

The larger flange pinnacles at the corners of the octagonal spire core also have rather complex geometries, although their construction starts simply enough. Black dots in Figure 4.39 mark the corners of the already established octagons with facial radii 1.000 and .765. The centers of the large pinnacles lie exactly halfway in between these dots, on the corners of an octagon with facial radius .883. A smaller black dot just to the right of the octagon's rays of symmetry marks the point where the heavy dotted diagonal connecting the corners of the original 1.082 square crosses the octagon of facial radius .812. This point lies on the front edge of the square base of the large pinnacle, within which another rotated square is inscribed. The triangular half of another such rotated square protrudes from the outboard side of the pinnacle, describing the flange at the corner of the tower

[47] This dimension can also be generated by inscribing a circle within the square frame of each corner pinnacle; the distance from the inner face of that circle to the tower center will be .934, effectively indistinguishable from the .932 cited above.

core. It is interesting and significant that the outermost point on this flange falls slightly but measurably inside the box described by the large 1.082 square. Subtle distinctions of this kind abound in Gothic design, but they can be seen with particular clarity in carefully executed drawings such as 16.872v, where the small offsets between the structures of the tower core and those of the four large corner pinnacles hint at the interplay between multiple geometrical frameworks. Another interesting design principle seems to be at work in the small pinnacles that face inwards from the eight flanged corner pinnacles, forming bracket-like shapes in plan that project inwards as if to embrace the central spire assembly. These pinnacles appear complex at first glance, but all their salient faces are aligned with the cardinal axes of the tower, or with perfect diagonals, and all these faces intersect at least one previously constructed point. So, their plan can emerge quite naturally from the larger forms in the composition. That approach to design would be taken much further in the salient buttresses of 16.872v.

Before going on to consider the internal structure of the main tower buttresses, it is helpful to consider several of the remaining larger-scale relationships that define the outlines of the tower as a whole. Three of the tower sides are geometrically equivalent, but the one adjacent to the body of the Stephansdom differs from the others. In this side, shown at the top of Figure 4.38 and Figure 4.39, there is a prominent horizontal 1.165 units above the tower center; this horizontal, in other words, is two of the small .082 modules above the main buttress axis. An arc swung up from the point where this 1.165 horizontal intersects the ray of octagonal symmetry rises up to a point 1.261 away from the tower center, locating the final horizontal that described the arch separating the tower from the nave.[48] A slightly different construction defines the other three faces of the tower. As the lower-left corner of Figure 4.39 shows, the key element here is a semicircular arc centered 1.082 units out from the tower center, at the boundary of the big generating square that was used to define the tower superstructure. This arc, when struck so that its right margin lines up with the left margin of the octagonal staircase .947 units out from the tower center, sweeps around to locate the outer margin of the tower 1.217 units out from its center. This bordering line, when extended, also describes the margin of the main tower buttresses, whose internal structure can now be understood.

Figure 4.40 zooms in on the lower-right corner of drawing 16.872v to show the geometry of the main tower buttresses. The front face of the buttress, shown at the bottom of the figure, falls 1.848 units below the tower centerline, aligning with the front face of the huge framing octagon already established in Figure 4.38. The outer margin of the buttress falls 1.217 units out from the tower centerline, as just explained. Reflection about the main buttress axis establishes the left buttress margin .783 units out, slightly but measurably to the right of the huge octagon's corner .765 units out from the tower centerline. The smaller elements of the buttress articulation then develop within the resulting rectangular frame. Starting at the top of the graphic, the regular modular geometry of the large corner pinnacles intrudes into the frame of the buttresses. The corner of the diagonally planted block growing out from the pinnacle, for example, reaches down to a point on

[48] Here again, one must consider the possibility that the fundamental interval here was not an octature-determined .0824, but a modularly determined .0833, or 1/12. If so, then the dimension would be 1.167 and 1.263, as in 105.065. Because the size of the pinnacles in 16872v agrees better with the octature-based construction, that strategy has been privileged in the main text.

the buttress axis 1.330 units down from the tower centerline.[49] The diagonal reaching down and to the right of this corner point intersects the huge framing octagon 1.471 units down from the centerline. A horizontal struck to the left from this intersection point defines the front face of one major sub-block within the buttress, which is marked in the drawing by many adjacent mullion profiles. Another significant punctuation point falls 1.534 units down from the tower centerline, which is halfway out the buttress salience, as the arc on the left of Figure 4.40 indicates. A horizontal drawn across at this level locates the diagonally planted pinnacle that emerges from the buttress surface. More specifically, the salient corner of this pinnacle falls at the point where the 1.534 horizontal intersects the diagonal face of the large framing octagon. One face of the pinnacle thus aligns with that of the large octagon, while the other slices back toward the tower center. The other similar pinnacles flanking the main buttresses have the same size. The last crucial point in the buttress geometry falls 1.630 units out from the tower centerline, where the diagonals struck back from the front face of the buttress intersect the buttress axis. This point serves as the geometrical center for the octagonally symmetrical front end of the buttress superstructure, which provides a nearly circular profile very different than the bladed keel seen in the equivalent portion of the south tower buttresses. The slight setback of this rotated octagon from the rectangular frame of the lower buttress structure may well have been determined by the intersection between the buttress axis and the diagonal face of the huge governing octagon with which construction of the whole drawing began. Certainly the organization of the buttress attests to an interesting byplay between the larger form-giving elements, such as the huge octagon and the buttress axes, and smaller ones, such as the crossing pinnacle modules.

Overall, therefore, tower plan 16.872v deserves recognition as a complex and finely calibrated formal system, one in which Spenning and his colleagues paid close attention to even the most minute details of the design. The fact that the other two surviving north tower plans have exactly the same proportions and detailing, despite the changing treatment of the secondary stair turret, strongly suggests that the geometrical structure of the design was seen as fundamental. This makes good sense, in part because the choices encoded in the groundplan would exert a decisive influence on the shape of the tower that would then be extrapolated from it. This is not to say, of course, that the groundplan fully determined the elevation. Indeed, the two surviving fifteenth-century elevation schemes for the complete north tower differ markedly in their proportions, because they were "pulled out" of the groundplan in subtly different ways. It is clear, moreover, that in at least one instance the process of working out the elevation actually forced modification of plan drawing. All three of the surviving north tower plans show pinnacle arrangements closely based on the format of the south tower, with an inner corona of eight small pinnacles and an outer corona of eight larger pinnacles. But 16.872v also includes, on one of its western rays, a pinnacle sketched in between the two coronas, and a set of three overlapping pinnacles on the inside of the inner corona. These "extra" pinnacles correspond to those that cloak the spire tip in the elevation drawing 105.067, to be discussed below. This evidence tends to corroborate the late dating for 16.872v already proposed on the basis of its stair turret design, since this drawing appears to be the only one that was still being updated to take account of developments in the design of the elevation.

[49] This would be 1.333 instead of 1.330 if the modular approach seen in 105.065 had been used.

Figure 4.41
Drawing 105.067,
showing an elevation
for the north tower of
Vienna's Stephansdom.

Figure 4.42
Modern
redrawing of
105.067.

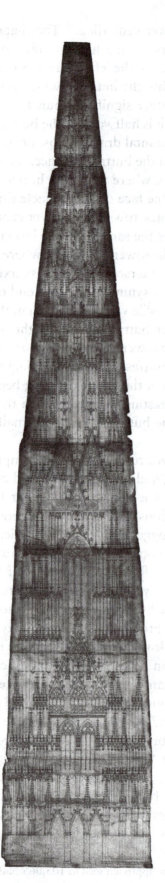

Drawing 105.067 in the Wien Museum Karlsplatz presents what is probably the earliest surviving elevation scheme for the Stephansdom's north tower (Figure 4.41 and Figure 4.42).[50] In terms of both proportion and articulation, it still has much in common with the south tower, not yet displaying some of the stretching and decorative elaboration seen in later drawings, and in the masonry of the north tower stump itself. It differs from the south tower, though, in having the two "extra" tiers of pinnacles near the base of the spire, which would have blended the tower and spire smoothly together; the south spire, by contrast, emerges from its tower only above a point of sharp punctuation where all the pinnacles end simultaneously. The essentially seamless articulation shown in the drawing would also have given the north tower a more unified appearance than its more additively conceived southern pendant. The overall logic of the composition, though, derives directly from the south tower.

In terms of geometrical structure, too, 105.067 incorporates many of the ideas already seen in the designs for the south tower. Here, once again, it makes sense to speak in terms of a large unit equal to the span between the buttress faces, which then gets stacked to determine the elevation. This can be seen, for example, in Figure 4.43, where the second belt of ogee gablets in the belfry story terminates at height 2.000, the top margin of the second such module in the stack. More subtly, all the tiny sub-pinnacles flanking the tower buttresses terminate at height .500, halfway up the first large unit. To understand the rest of the geometrical armature in this design, though, it is necessary to take into account not only the large unit, but also the buttress dimensions within this frame. In 105.067 and all the north tower designs, the large framing unit equals exactly 1.848 times the span between the buttress axes, thanks to the simple octagon-based relationship already illustrated in Figure 4.38. Or, to say it another way, the buttress axes are 1/1.848 = .541 as far apart as the outer buttress margins, so that the extent of each buttress beyond the axis equals (1 - .541)/2 = .229 large units. As the bottom portion of Figure 4.43 shows, .229 is also the height where the diagonals of the first great square cross the rising buttress axes, establishing the level of the first prominent horizontal molding in the buttress articulation. The analogous intersection points in the top half of this first square, at height 1 - .229 = .731, mark the top edge of the first parchment section in the drawing. And, in the second square, the same pattern starts to repeat itself, since a series of tiny sub-pinnacles terminates at height 1.229. With this basic buttress dimension established, it becomes possible to determine the many levels in the elevation that depend indirectly upon it.

Arcs as well as straight lines appear to have played an important role in determining the proportions of drawing 105.067. A large quarter-circle filling the entire first large square box and centered on its upper-left corner intersects the right margin of the forward-facing buttress at height .441, establishing the top margin of the triple portal. An equivalent large arc centered on the bottom right of the box intersects the box diagonal at height .707, a √2 relation that locates the tips of yet another belt of tiny pinnacles. The same arc passes through the buttress margins and central axes at heights .958 and .973 respectively. The .958 level marks the springing of the double windows in this story. Another large arc struck from the center of the first big box through its upper corners reaches height 1.207, in a relationship like that already seen in the south tower. This level is important in

50 Böker, *Der Wiener Stephansdom*, p. 257; Böker, *Architektur der Gotik*, pp. 435–6.

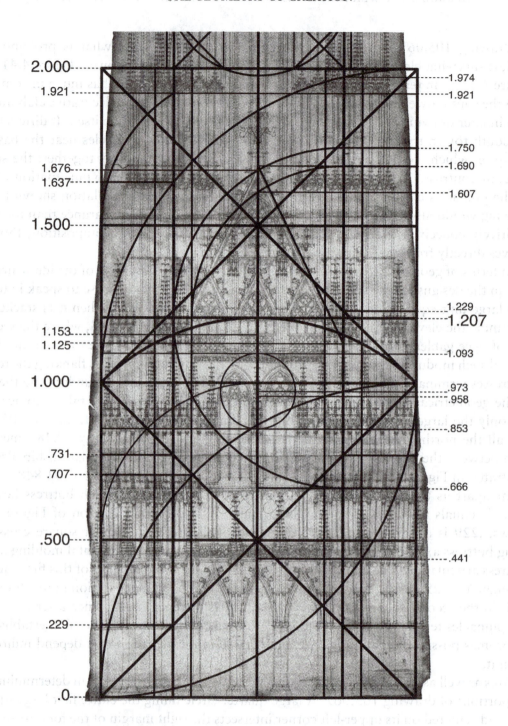

Figure 4.43 Drawing 105.067, bottom third with geometrical overlay.

105.067 because an arc centered at this level on one of the main buttress axes and struck through the other buttress axis will descend to level .666, locating the molding at the base of the double-window story. The same arc reaches upward to height 1.750, crossing the tower centerline at height 1.676. An arc concentric with this one but slightly smaller touches the right margin of the left buttress, rising to height 1.690, locating not only the top of a gable row, but also the tip of the great gable.

The geometry of the gable base, like that of the tip, depends indirectly on the construction of arcs. The most important of these arcs is the large one rising from the box corners to height 1.207. As it rises, it passes through the buttress margins at height 1.125, and through the buttress axes at height 1.153. The former level marks the geometrical base of the great gable, although the sloping sides of the gable become visible only higher up. The 1.125 intersection also establishes the level where a series of small capitals punctuate the buttress, preparing the way for the next set of large pinnacles, while the 1.153 intersection locates the top of the story-ending balustrade. Meanwhile, an arc inscribed in the top left quadrant of the first big box intersects the diagonal of that box at height .853, the level where a belt of small decorative gablets wrap around the tower. A small circle with its bottom-most point on this level and its center on the previously established level .973 reaches up to level 1.093, which is the top lip of the foliate molding terminating the double-window story.

Similar principles govern the rest of the articulation in the second box or great square. The same arc that established the top of the gablet row at height 1.690 passes through the tower centerline at height 1.607, defining the bottom of that row. The tops of the little arches in this row fall at height 1.637, where the great arc filling the second box intersects the buttress axis. The same arc intersects the other buttress axis at height 1.974, defining the top of the next gablet row. And, finally, an arc centered at height 1.500 sweeps up to cross the buttress axis at 1.921, defining the bottom margin of that gablet row.

Above the second great box, the geometry of the drawing shifts gears dramatically, and the large unit is abandoned (Figure 4.44). This makes good sense, because this large unit originally reflected the face-to-face span of the buttresses at ground level, a dimension with little relevance for the upper portions of the tapering spire structure. Since the parchment substrate of drawing 105.067 also tapers, there was simply no place on the parchment to construct another large square; it is significant that the right margin of the parchment passes exactly through the bottom-right corner of the second great square at level 1.000, suggesting that this baseline was used for its construction. The parchment at level 2.000 is too narrow to repeat this process, so the main buttress axes emerge as the primary form-generators in the next level of the tower. Interestingly, this geometrical shift has no formal parallel in the articulation of the belfry story, which rises smoothly across this transition.

An octature construction within the buttress axes establishes the geometry of the upper belfry zone. The center of this figure, at height 2.271, locates a prominent parchment seam running right through the middle of a gablet belt near the head of the belfry window. The top of the octagon establishes the base of the belfry-terminating molding at height 2.541, while the top of the circle circumscribed about the octagon locates the top margin of the molding at height 2.563. This geometry is very similar to that seen in the south tower, except that here a whole octagon is stacked on top of the second great square, instead of just half of one. In drawing 105.067, therefore, the tower base and belfry together would have been seen somewhat taller than in the south tower.

Above the belfry zone, a dramatic double gable screens the lowest stage of the octagonal tower core. This double gable fits precisely into a square inscribed between the buttress axes, which rises from height 2.563 to height 3.104. The slope of these pinnacles very closely approximates 72 degrees, which might at first suggest that they reflect some

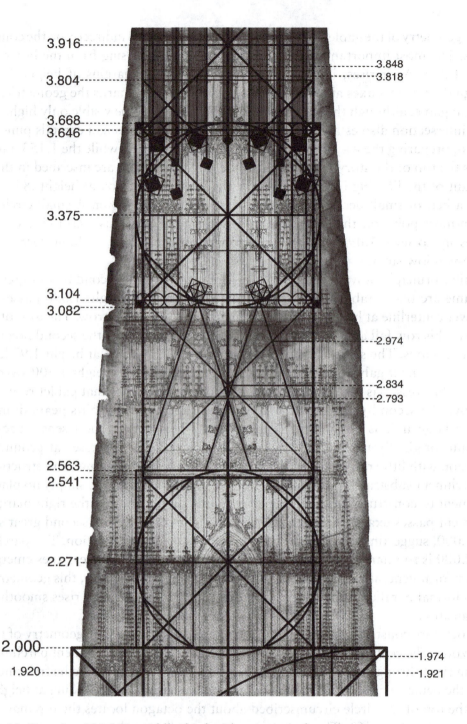

Figure 4.44 Drawing 105.067, middle third with geometrical overlay.

play on pentagonal symmetry, but they are a hair too sharp, and their proportions can be explained more naturally without recourse to pentagons. The gables work well aesthetically because their tips align with the rising vertical flanges on the corners of the tower core. The span between the tips, in other words, was determined by the geometry of the octagonal superstructure as already established in groundplan 16.872v. This span

gives the correct slope for the gables, which intersect at height 2.793 to locate a prominent horizontal bar in their openwork articulation. The gable slope also intersects the diagonal crossing this story at height 2.974, determining the level from which a belt of small arches spring.

Since all the horizontal dimensions in the upper reaches of 105.067 appear to have been determined by the geometry of the groundplan, it is convenient to superimpose some of the salient elements of that groundplan on the tower elevation. The square framed by the main buttress axes and balanced atop the tips of the double pinnacle, as it were, fills the space between levels 3.104 and 3.646, with its center at level 3.375. This square can be treated as an image of the tower's groundplan. The outer faces of the corner pinnacles in the plan extend slightly beyond the buttress axes in an octature relationship. The image of the tower cross-section with its pinnacles thus fills the space between levels 3.082 and 3.668. The small black squares in the corners of this large square echo those shown in Figure 4.38 of the groundplan. This small module equals one-sixth of the width of the major crossing pinnacles; this is indicated here by the row of three small circles with this radius, separated by vertical lines that slice the corner pinnacle into its constituent strips. In the upper half of the plan image, black squares filling the middle of these strips describe the cores of the corner pinnacles. Moving upwards into Figure 4.45, the shaded silhouettes above these squares show that these cores rise straight up to height 4.028, before tapering down to a tip at level 4.295. The same basic elevation pertains for the corner flanges flanking the octagonal tower core; only the flanges nearest the centerline are shown with shading in Figure 4.45, since the outer set overlaps in elevation with the corner pinnacles. In the plan image, however, these outer flanges are clearly visible as black squares rotated 22.5 degrees off the horizontal. Also visible are the small pinnacles halfway across each tower facet, which correspond in elevation to three very narrow pinnacles also terminating at level 4.295. And, finally, there are the pinnacles of the inner corona, flanking the spire base. These are shown in the figure as the four small black rotated squares, clustering close about the octagon center at level 3.375. Heavy vertical lines extend from their centers to describe the axes of these pinnacles, whose tapering tips fill the space between heights 4.606 and 4.872. These are the last of the elements shown carefully and systematically in the tower groundplans.

The vertical punctuation points in the upper reaches of 105.067 were determined by stacking a series of progressively smaller modules based on the groundplan (Figure 4.45). So, for example, the prominent belt of gablets articulating the tower octagon sits at level 3.375, the center of the square image of the groundplan. The next module, based on the same square without its octature-based extensions, reaches from height 3.646 to 4.187, where its upper-left corner meets the margin of the tapering parchment. An octagon inscribed within this square has one set of corners at level 4.028, which is where the primary corner pinnacles begin to taper, and another set at 3.804, where the smaller pinnacles clustered alongside these main ones begin their own taper. The center of the octagon, at height 3.916, marks the top edge of a traceried screen that runs around the tower core within the corona of pinnacles. Horizontals on this tracery screen and its flanking pinnacles fall at heights 3.848 and 3.818, which are determined by intersections between rising pinnacle axes and the diagonals of the generating square at this level.

Figure 4.45
Drawing
105.067, top
third with
geometrical
overlay.

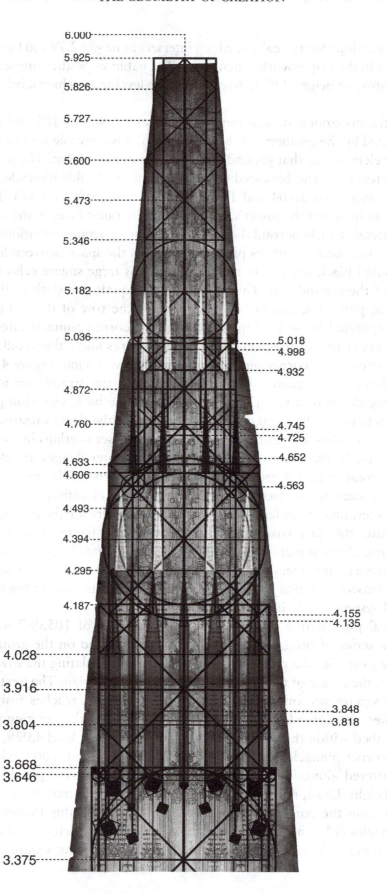

The slightly smaller module above reaches from heights 4.155 to 4.633, where its upper-left corner touches the margin of the parchment. It is framed by the verticals rising from the centerpoints of the main corner flanges in the plan image. Its bottom edge lines up with the points where these verticals intersect the diagonals of the larger module below. Its center, at height 4.394, coincides with a prominent tracery circle in the last slender gablet of the main tower face, which acts as a visual advertisement of the geometrical structure. An octagon inscribed within this square has lower corners at height 4.295, the level where the main pinnacles terminate. This is also the height where a second set of pinnacles, shown here in white, begins to taper.

These white pinnacles, significantly, are not shown at all on two of the three surviving groundplans for the north tower, and only one of them is sketched in on plan 16.872v, in between the main pinnacles and the spire base. As noted previously, therefore, this last-minute addition to 16.872v seems to have been motivated by the draftsman's realization that extra pinnacles would be needed to achieve the smoothly tapering overall tower silhouette that he sought in the elevation. The tips of these added pinnacles fall at height 4.563, where the diagonals of the square centered at 4.394 intersect the diagonal facets of the octagon inscribed within it. A circle circumscribed about this octagon reaches from height 4.135 to 4.652, and its left margin coincides with the left margin of the parchment. A somewhat smaller circle concentric with this one reaches down to height 4.187, the top of the previous module, and up to 4.606, where it establishes the baseline of yet another set of pinnacles.

This next pinnacle corona, shown with dark shading in Figure 4.45, corresponds to the innermost set of spire-flanking pinnacles carefully shown in the groundplans. Their tips fall at height 4.872, the level where diagonals rising from the corners of the previous module intersect the tower centerline. This same point serves as the center of two concentric octagons, the larger reaching from height 4.725 to 5.018 and the smaller reaching from 4.745 to 4.998. The width of the larger octagon equals the span between the inner corners of the dark pinnacles, as the verticals rising from the corresponding black squares in the groundplan image indicate. The width of the smaller octagon, meanwhile, is set by verticals that step in from the dark pinnacle axes by the same amount that those axes step in from those of the white pinnacles below; this relationship is demonstrated by the small circles at level 4.563 that reach between the white pinnacle axes, with the dark pinnacle axes at their center.

The importance of the octagon construction begins to become apparent above level 4.932, where a fourth and final pinnacle corona reaches up to level 5.182. The axes of the pinnacles align with the sides of the smaller octagon, and they begin to taper at the octagon's corners, at height 4.932. These pinnacles are shown in white because, like the second set positioned between levels 4.295 and 4.563, they do not appear in the systematically drawn portions of the groundplan, which the first and third sets do. The first and third sets, not coincidentally, correspond to the large and small pinnacle coronas already present in the south tower. As already noted in the discussion of the groundplan, therefore, it seems that Laurenz Spenning and the rest of the team responsible for the design of the north tower took the format of the south tower as their point of departure. Only during the development of the elevation scheme shown in 105.067, it seems, did they decide to add the extra second and fourth pinnacle sets, a few elements of which they then

sketched into groundplan 16.872v. Since 105.067 includes four pinnacle coronas instead of just two, it presents a more smoothly tapering profile than the south tower, where the relatively low termination of the pinnacle creates a decidedly notched silhouette.

Above the pinnacle-defining octagons, a final tapering piece of parchment shows the crocket-lined upper shaft of the spire. The width of this parchment at its base equals that of the third pinnacle corona. A square of this width concentric with the octagons reaches up to height 5.036. Diagonals drawn from this height but aligned with the outer octagon converge on the tower centerline at height 5.182, establishing not only the pinnacle tips in the fourth and final corona, but also the springline of a small collar of ogee arches that wraps the spire at this level. This is also the level at which the parchment begins to taper. A circle centered at this level and reaching down to the top facet of the larger octagon at height 5.018 reaches up to height 5.346. A square whose side length equals the span of the last pinnacle corona fills the space between heights 5.346 and 5.600; its upper corners coincide with the margin of the parchment. Diagonals from these corners intersect the tower centerline at height 5.727, which marks the base of the collar separating the spire from the finial above. A smaller square based on the middle facet of the first corona reaches up to height 5.925, and its corners once again align with the parchment margin, but the geometry of the finial zone remains unclear, especially since its tip was truncated. The proportions of the finial suggest, though, that it the complete tower and spire would originally have reached a height of around 6.000 large units. It is conceivable that this simple ratio was intended all along to give the height of the spire, but the visual relationship of the planned structure to its southern prototype surely played a more important role. As subsequent discussion of the north tower stump will demonstrate, the scale of the base would give an overall height for the 105.067 scheme very close to that of the extant south spire.

In sum, then, drawing 105.067 presents a geometrically and formally rigorous solution to the design of the Stephansdom's north tower. The basic geometry of the tower base involves a stack of two large squares, as in the south tower, but above that level the size of the relevant modules diminishes progressively, matching and determining the taper of the parchment in the spire zone. The size of these modules was clearly based upon the dimensions established in the groundplan drawings. Plan 16.872v, in particular, appears closely related to the elevation scheme in 105.067, since it alone among the groundplans includes extra pinnacles sketched in between the two more complete coronas that the designers had copied from the south tower. In 105.067, therefore, four complete coronas of pinnacles veil the spire, like successive cylinders in a collapsible telescope. This systematic formal solution effectively expresses the character of the progressively tapering geometrical armature underlying the drawing. Drawing 105.067 was probably the first elevation drawing prepared for the north tower project, but it was by no means the last. Several other large and impressive elevation drawings of the tower still survive in Vienna, at least one of them probably dating from after 1500.[51]

The only other complete medieval drawing of the tower elevation, though, is number 17.061 from the Vienna Academy collection, which has typically been seen as the first fifteenth-century revision of the scheme shown in 105.067 (Figure 4.46). These two

[51] These drawings include Wien Museum numbers 105.015 and 105.061. See Böker, *Architektur der Gotik*, p. 416.

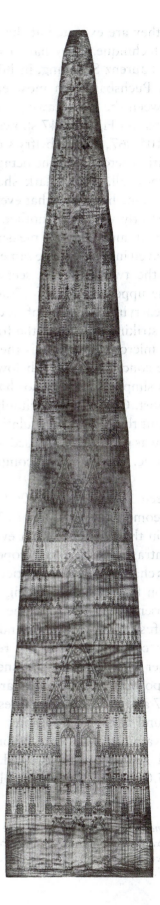

Figure 4.46
Drawing
17.061,
showing
a revised
elevation for
the north
tower of
Vienna's
Stephansdom.

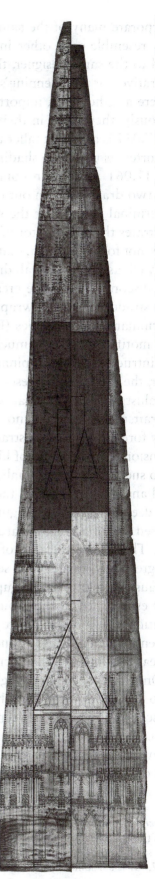

Figure 4.47
Comparison
of proportions
between
Viennese north
tower schemes
17.061 (at left)
and 105.067
(at right). The
more lightly
shaded zone
corresponds
to the belfry
story in each
case, while the
more darkly
shaded zone
corresponds to
the octagonal
tower story
beneath the
spire.

drawings incorporate many of the same formal features, they are executed at the same scale, and they resemble each other in terms of drafting technique. They have usually been attributed to the same designer, therefore—either to Laurenz Spenning, in Böker's revisionist narrative, or to Spenning's predecessor Hans Puchsbaum, in most earlier accounts.[52] There are, however, important differences between the two drawings. First, and most obviously, they differ in their relative proportions. As Figure 4.47 shows, the tower base in 17.061 is a tiny bit taller than it had been in 105.067, but the belfry story is significantly shorter, as the white shading indicates. Dramatic stretching of the octagonal tower core in 17.061 more than compensates for this shortfall, as the dark shading shows, but the two drawings turn out to have precisely the same height, so that even the crockets and terminal collar near the spire tip line up perfectly with one another. This clearly demonstrates that the creator of 17.061 was looking at, and probably measuring, 105.067. It does not follow, though, that the two were conceived in precisely the same way.

Formal as well as proportional differences between the two drawings seemingly attest to some discontinuity in the creative process. In the upper portion of 17.061, a prominent balustrade appears to wrap around the spire, carrying a corona of nodding ogee arches terminating in pinnacles (Figure 4.48). More striking even than the formal novelty of this motif, which owes much to contemporary microarchitecture, is the way the balustrade intrudes in front of pinnacles that should be concealing it. Just below this level, moreover, the diagonals representing the spire edges simply disappear, so that the spire tip and balustrade seem to float without proper support. One might charitably say here that the draftsman simply had not finished his work, but the detailed articulation of the erroneously fore-grounded balustrade suggests that he was genuinely confused about the three-dimensional implications of his linework in this zone. The rigorously composed 105.067 has no such errors or anomalies.

Geometrical analysis reveals that the distinctions between 17.061 and 105.067 were more than skin deep. As a glance at Figure 4.49 shows, the geometrical armature of 17.061 involved repeated use of a great square module, not only in the tower base, but even in the spire zone. This direct stacking of identical units contrasts with the telescope-like stacking of progressively smaller units seen in 105.067. This change in focus is particularly interesting because it involves a decoupling of the elevation from the diminishing story widths already established in the groundplan. Such a loosening of the dialog between plan and elevation could easily result in the kind of confusion about foreground and background seen in the balustrade zone of 17.061. So, the curious errors in this region may hint at a real discontinuity in the creative process, rather than just the carelessness of a draftsman. On the other hand, though, many of the proportioning systems apparently at play in 17.061 derive directly from those seen in 105.067 and the south tower designs, so any such discontinuity has to be seen against a background of robust tradition.

This evidence for continuity and change has to be examined with care before its relevance for interpretation of the creative process behind 17.061 can be assessed. The bottom section of the drawing closely resembles that in 105.067, but the horizontal levels

[52] Böker, *Architektur der Gotik*, pp. 375–6; and Böker, *Der Wiener Stephansdom*, p. 283. The detail views of 17.061 in these publications are beautiful and reliable, but the overall view of the drawing as printed exhibits dramatic stretching that is particularly evident in its upper reaches. This conveys the misleading impression that 17.061 is substantially taller and more slender than 105.067, which is not the case.

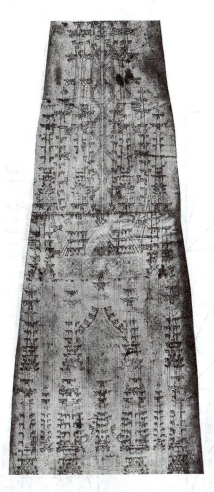

Figure 4.48 Drawing 17.061, detail showing the lower spire and problematic balustrade zone.

are adjusted very slightly (Figure 4.50). It seems that the arc-based construction used to determine the balustrade base at height .441 in 105.067 was used once again in 17.061. The same principle would go on to figure prominently throughout 17.061, becoming one of its main geometrical motifs. In the lower zone, for example, the same arc used to create the .441 crosses the right buttress at height .042, establishing the level of the sockel. The equivalent arc above the diagonal of the lower square intersects the buttress margins and tower centerline at heights of .637, 702, .866, and .958, locating a row of arc springers, the sill of the double window, and the top and bottom of a gablet belt, respectively.

The top of the first great square in 17.061 defines the springline of the heads in the double windows, a simple geometrical relationship that gives the tower base slightly taller proportions than those seen in 105.067. The balustrade above the windows moves up correspondingly; its lower and upper margins fall at heights 1.125 and 1.175, so that they line up with the points where the buttress margins intersect the large arc rising from the box corners to height 1.207. The level 1.125 serves as the geometrical baseline of the great gable, just as it had in 105.067, despite this upward displacement of the balustrade. The gable tip, though, falls higher up, at level 1.771, where the diagonals of the second great box cross the buttress axes. The tips of a row of tiny pinnacles fall at this same level, and the associated gablets spring at height 1.653.

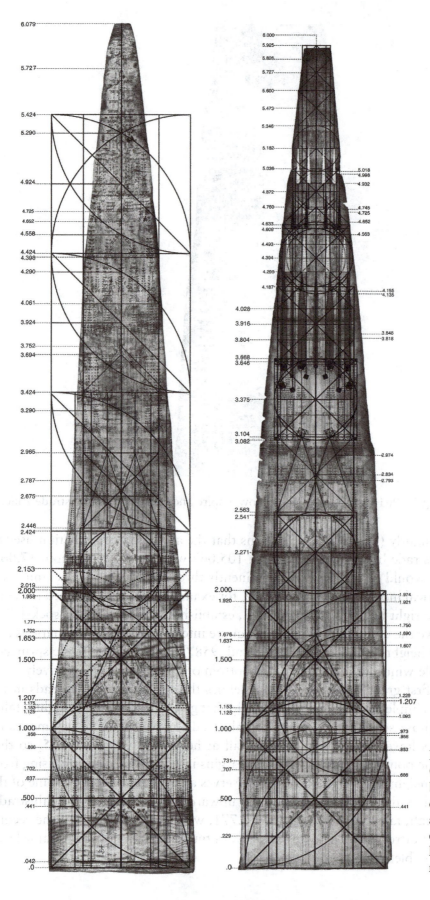

Figure 4.49
Comparison
between the
overall geometrical
armatures of
drawings 17.061 (at
left) and 105.067 (at
right).

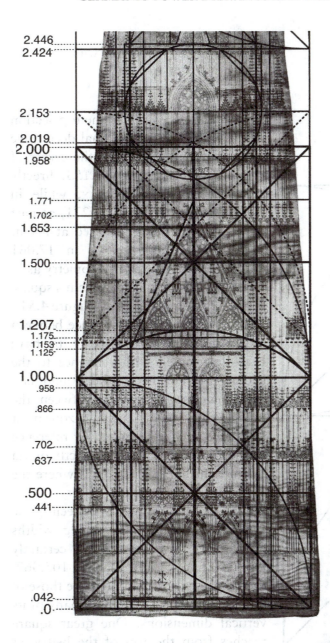

Figure 4.50
Drawing 17.061, lower half with
geometrical overlay.

The location of this springline offers a valuable clue about the organization of the
drawing as a whole. Height 1.653 marks the center of a great box with baseline at height
1.153, the level where main buttresses axes intersect the large balustrade-defining arc that
reaches up to 1.207. The top of this box falls at height 2.153, the springline of the final
gable belt and window in the belfry story. Thus, while drawing 105.067 had included
only two great squares, 17.061 extends this stacking principle above height 2.000, as this
finding already begins to show. As the dotted lines in Figure 4.50 indicate, arcs inscribed
within this first "extra" box cross at height 2.019, locating the tip of the finial atop
the great gable. Similar large box-filling arcs appear to have played a crucial role in
determining the geometry of 17.061, even in its narrow upper reaches.

The transition between the belfry and upper tower octagon proceeds in 17.061 very
much as it had in 105.067, but somewhat lower. In both drawings, a half-octagon framed

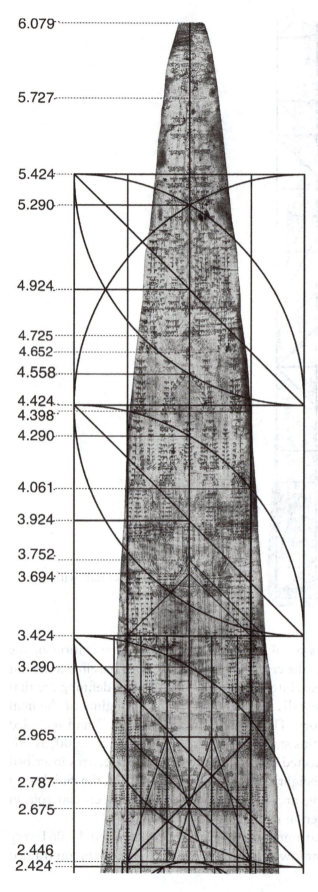

Figure 4.51
Drawing 17.061, upper half with geometrical overlay.

by the buttress axes fills the top section of the belfry, above the final decorative gable belt. But in 17.061 the center of that figure falls at height 2.153, directly atop the large added box, while in 105.067 it fell at height 2.271, as part of a complete octagon based at height 2.000. The double gable in 17.061 follows exactly the same geometry as in 105.067, being inscribed within a square frame by the buttress axes (Figure 4.51). In both drawings, the distance between the twin gable tips appears to have been determined with reference to the geometry established in the groundplan. The analogous distances between the pinnacle tips in the upper spire zone must also have been determined by reference to the groundplan, either directly or via the intermediary of 105.067, where the same dimensions occur.

The relationship between the elevation and the diminishing widths of the successive stories was certainly less direct in 17.061 than in 105.067, though, since great squares like those of the tower base determine so many of its vertical dimensions. One great square reaches from the top of the belfry, at level 2.424, to level 3.424, where the triply bundled corner pinnacles begin to taper. There is also a perceptible kink in the right-hand margin of the parchment at this level, further suggesting its importance for the layout of the drawing. Large arcs within this box also appear to have played a prominent role in the composition of this story. One large arc, under the diagonal of the box, intersects the buttress axis at height 2.787, where many small pinnacles

flanking the double gable terminate. The analogous arc over the diagonal intersects the tower centerline at level 3.290, establishing the height of the finial tips atop the double gable. The next large box reaches up to height 4.424, where the eight primary pinnacles flanking the tower core start to taper. Its midpoint at level 3.924 locates the top edge of a gablet belt, and the intersection of its upper arc with the tower centerline, at height 4.290, locates the collars around another major pinnacle set; intersections of this arc with the buttress axes at height 4.061 and 4.398 also coincided with break-points in the pinnacle articulation. The last large box in the stack reaches up to height 5.424. Nothing marks this level as special, but the two major arcs inscribed within the box cross the tower centerline at height 5.290, precisely establishing the level at which a small wreath of ogee arches begins to wrap around the spire. Immediately below this level, the tips of the last two pinnacle coronas actually fall on the arcs. These results may not seem surprising at first blush, since they represent a logical extension of the arc-based design system already seen in the tower bases of 17.061 and its likely prototype, 105.067. As Figure 4.49 and Figure 4.51 make clear, though, such arcs cannot have been drawn on 17.061 itself, since their geometrical centers lie far beyond the borders of the parchment. Instead, the relevant dimensions must have been drawn on a separate "master square" and then transferred onto the narrow upper section of 17.061. There is no evidence that any such system had to be used in the more self-contained 105.067, where all the necessary geometrical figures fit onto the parchment.

Further evidence for a methodological difference between the production of the two drawings comes, ironically, from the alignment between some of their upper elements, which implies that some of the geometrical armature of 17.061 may have been based directly on that of 105.067, instead of being worked out independently. As shown in Figure 4.47, the finial, collar, and crockets near the top of the spires all match quite precisely. Less visible but equally revealing is the relationship shown in Figure 4.49, where it becomes apparent that the problematic balustrade in 17.061 fills the space between levels 4.652 and 4.725, heights already familiar from 105.067 as the top of one pinnacle-defining circle and the bottom of a smaller pinnacle-defining octagon located just above. In the horizontal dimension, meanwhile, the excessive width of the pinnacles flanking the balustrade seems to have been based on a misinterpretation of those shown in 105.067; lines like those that had served as the outer margins of the pinnacles in the third corona of 105.067 serve as pinnacle centerlines in 17.061, so that the pinnacle width doubles. These over-large pinnacles have no analogs in the surviving groundplans for the north tower. This implies that these problematic elements, at least, were conceived by a draftsman thinking about the elevation in pictorial terms, rather than approaching it analytically as an extrapolation of the groundplan, as the creator of 105.067 evidently had.

Ultimately, therefore, geometrical analysis reinforces the traditional view that 105.067 was the first of the north tower elevations to be drawn, while providing a new perspective on how subsequent variations such as 17.061 could have been developed from it. These drawings of the Stephansdom tower obviously belong to the same workshop tradition, and both of the examples just discussed were likely produced under the guidance of the same workshop leader. But the contrasts between them complicate attempts to attribute both designs to a single hand. There must have been some discontinuity between the production of 105.067 and the conception of 17.061's geometrically illogical balustrade

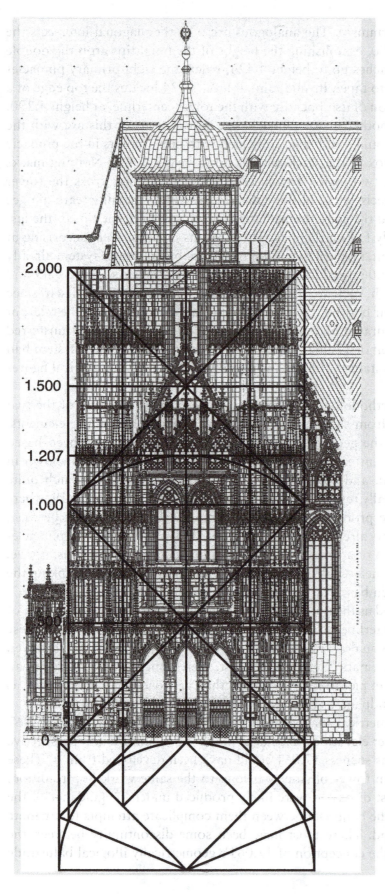

Figure 4.52
Vienna, Stephansdom,
north tower elevation with
geometrical overlay.

zone: for example, an apprentice could have tried to complete the drawing without fully understanding his master's intentions. The repeated use of great square modules in 17.061, moreover, shows that a revised approach to geometrical layout was already being used in the more coherent middle portions of the drawing.

The masonry of the Stephansdom's north tower stump incorporates many formal revisions not yet seen in the surviving elevation drawings, but its proportions also demonstrate that the geometrical principles at work in the drawings continued to inform the builders even as the tower project wound down in the sixteenth century. In the actual north tower, as in all the related drawings, the large unit defining the great squares is 1.848 times the span between the buttress axes, thanks to the simple octagon-based relationship illustrated once again at the bottom of Figure 4.52. In the actual tower, as in drawing 17.061, the heads of the double windows spring exactly at height 1.000, the top of the first box. The entry portal is a bit taller than in the drawings, though; the balustrade above it begins at height .500, instead of terminating at or below that level, as in 17.061 and 105.067, respectively. The balustrade over the double window, meanwhile, reaches up to height 1.207, the level familiar from the drawings as the top of an arc struck through the upper corners of the first box. The window head in the great gable springs at height 1.500, halfway up the second box. Finally, and most strikingly, the tower stump as a whole terminates at a height of 2.000, measured to the stair turret at the left of Figure 4.52, or the more complete wall section on the right. So, it seems that masters of the Stephansdom workshop continued to see the principle of square-stacking as important even when facing an unwelcome work stoppage, which was probably determined by the increasingly constrained financial circumstances of the project's civic and imperial patrons in the early sixteenth century.

The size of the great box unit in the north tower offers a final fascinating clue to the continuity of tradition in the Stephansdom workshop. In the north tower, this unit measures 22.65 meters, 38 centimeters larger than the equivalent unit in the south tower. A possible reason for this slight scale increase begins to emerge when the topography is taken into account. The ground on the north side of the Stephansdom lies about 38 centimeters lower than it does on the south. In both the north and south towers, though, the top edge of the first great box was meant to align with the leaf molding wrapping around the top margin of the nave wall. Since this molding falls at the same absolute level on both sides of the church, the box on the northern side had to be 38 centimeters larger to make up for the lower ground. This scaling factor obviously had to be worked out quite precisely before construction could begin, and even before the plan drawings like 16.872v could be created, since they include elements of the church adjacent to the tower, and not just the tower itself. So, the scaling factor would have been known to the draftsmen that created both 105.067 and 17.061, whose upper elements align with each other quite precisely. Since 105.067 is missing the tip of its terminal finial, there is good reason to take the height of the more complete 17.061 as the intended height of both drawings. Multiplying the height of 17.061, which is 6.079 units, by the 22.65 meter length of each unit, one arrives at an intended height of 137.69 meters for the north tower and spire. This almost perfectly matches the height of the south spire, which had been completed in 1433. On this basis it seems clear that the north tower was intended all along to equal the height of its southern prototype.

Ultimately, therefore, geometrical analysis of the Stephansdom tower drawings has yielded a valuable gloss not only on the history of the building, but also on the working methods of the designers in the workshop that created it. The unrivaled richness of the Viennese drawing collections has made it possible to trace the successive stages of the Stephansdom tower projects in detail, revealing both substantial methodological continuity and occasional surprising changes of direction. The first surviving design for the south tower, recorded in groundplan 16.819v, incorporates triangular corner pinnacles that recall those of Freiburg, but they appear to have been constructed with a different geometrical logic. This drawing also features buttresses identical in format to the present Vienna tower base, although a cascade of drafting errors distorted the proportions of the buttresses in the drawing. The face-to-face span of the actual south tower base equals the height of the Stephansdom's choir, indicating that even the creator of this early scheme was already thinking in terms of large square units like those that would be employed by the northern tower builders well into the sixteenth century. The next master of the Stephansdom tower project, Wenzel Parler, introduced many formal changes, especially new, octagonally symmetrical corner pinnacles and new buttresses designed to reinforce an added belfry story, but he clearly understood the geometrical logic of his predecessor's design. It is not surprising that the elevation drawing most closely associated with his tenure in Vienna, 105.066, was organized around a stack of two great-square units, since this organizational principle had also governed the tower he had worked on previously, that of Prague Cathedral, as geometrical analysis of the associated drawings has already shown. The upper portions of the south tower, designed by Wenzel's former apprentice Peter Prachatitz, incorporate many of the same design principles, but Prachatitz introduced a new corner pinnacle design based on a grid of squares instead of octagons, thereby setting a precedent that would inform the design of the north tower later in the fifteenth century.

The surviving designs for the north tower show that it was all conceived as a piece, to a far greater extent than the somewhat heterogeneous south tower. The early drawings for the north tower, in particular, are so closely related in style and scale that they have usually been seen as the work of a single master artist—either Hans Puchsbaum, in most older literature, or Laurenz Spenning, in Hans Böker's recent and largely convincing revisionist account. Geometrical analysis of the two complete elevation schemes, though, shows that only the first, 105.067, was based on direct and close engagement with the logic of the groundplan. The alternative scheme 17.061 appears to have been based on a simple stack of identical squares, rather than on progressively smaller units related to the width of each successive story. This helps to explain how its creator could have become confused about the three-dimensional implications of his work, resulting in the strangely incoherent detailing of the balustrade level near the spire tip. So, even if the two were created in the same workshop, and under the influence of the same dominant artistic personality, they seem to have been produced in rather different ways. Despite such surprising distinctions, the overall picture of the Stephansdom tower workshop is certainly one of substantial

formal and methodological continuity, from Rudolph Habsburg's inception of the south tower project in 1359 all the way down to the abandonment of the north tower project in the early sixteenth century.

ULM

During most of the period during which the towers of the Stephansdom were under construction in Vienna, an even larger tower was being built in Ulm (Figure 4.53). The Ulm tower occupies a special place in the history of Gothic architecture both because of its great size and because its history illustrates in particularly clear form many of the themes common to major late medieval spire-building projects: the value of civic patronage; the importance of architectural drawing as a tool of design and display; and the tension between this drawing-based design mode and the physical realities of large-scale construction. As preceding chapters have already noted, the successful construction of the openwork spire of Freiburg Minster, a parish church that directly served the local citizenry, contrasted with the abandonment of the spire projects at the cathedrals of Cologne and Prague, churches that represented episcopal interests often opposed to those of the locals. Even in Vienna, where the Habsburgs clearly played an important role in catalyzing construction at the Stephansdom, the support of the local citizenry proved crucial to completion of the magnificent spire at the Stephansdom, which was their main parish church. But the link between spire building and civic pride was even more obvious at Ulm, where mayor Lutz Krafft laid the foundation of a colossal new parish church in 1377, immediately after the destruction of the previous city church by the besieging armies of Emperor Charles IV. The new building was originally planned as a hall church, but its design was soon modified to create a taller and more pretentious basilican elevation, and the scale of the western tower was greatly increased.[53] These modifications have been widely and plausibly interpreted as architectural expressions of Ulm's greatness, since Ulm led the Swabian City League against aristocratic opposition in the decades around 1400 when the tower project was getting under way.

The evolution of the Ulm spire project can be traced in a series of drawings that deserve particularly careful consideration because several of them figure prominently in Konrad Hecht's influential but flawed discussion of medieval architectural proportion.[54] Hecht recognized that examination of original drawings could give more reliable evidence for the intentions of Gothic designers than even the most careful analysis of Gothic buildings, since their proportions are uncompromised by errors introduced in the construction process. So, having spent much of the first portion of his book systematically destroying the many rather fantastic geometrical schemes that had been proposed for the tower and spire in Freiburg-im-Breisgau, Hecht concluded his book with an analysis

[53] For these aspects of the building, see *600 Jahre Ulmer Münster: Festschrift*, eds Hans Eugen Specker and Reinhard Wortmann (Ulm and Stuttgart, 1977), esp. the articles by Hans Peter Koepf ("Lutz Krafft, der Münstergrunder"), and Reinhard Wortman ("Hallenplan und Basilikabau der Parlerzeit in Ulm"). For the spire project in particular, see Bork, *Great Spires*, pp. 219–40.

[54] The most comprehensive source on the Ulm drawings is still Karl Friedrich, "Die Risse zum Hauptturm des Ulmer Münsters," *Ulm und Oberschwaben*, 36 (1962): 19–38. Hecht discusses the Ulm drawings in *Maß und Zahl*, pp. 387–468, with particular attention to the elevation drawings.

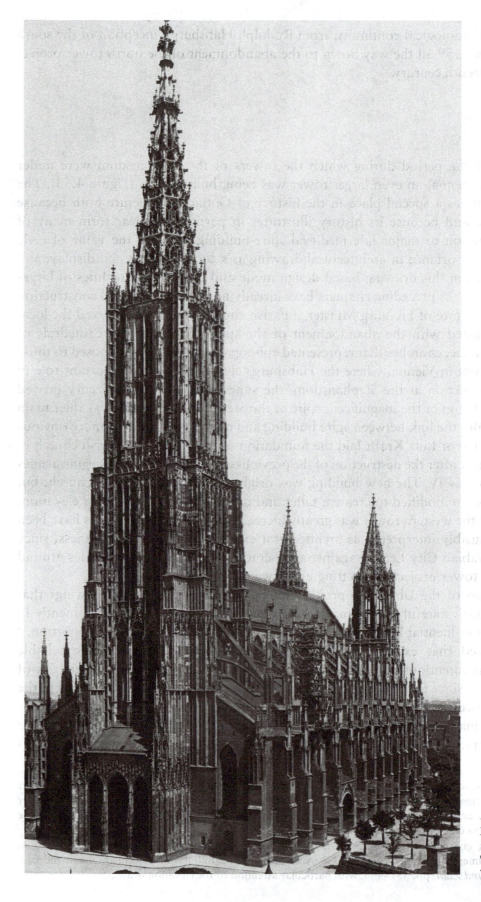

Figure 4.53
Ulm Minster,
overall view from
west.

of tower drawings from Ulm, where he thought he could make a rigorous case for his strictly module-based interpretation of Gothic design. As the present chapter will show, modularity did indeed play a role in the early planning for the Ulm tower, but a far smaller role than Hecht had imagined.

Hecht failed to appreciate the geometrical aspects of the Ulm tower design in part because he chose to consider only the spectacular elevation drawings associated with the project, paying no attention to the corresponding groundplans, several of which also survive. This was a major and surprising methodological error on his part, since it had long been recognized that Gothic designers based the proportions of their elevations on dimensions established in the groundplan, according to the principle of *Auszug*, or pulling out. This design principle is clearly illustrated in the famous late Gothic design booklets written by Matthäus Roriczer, Hans Schmuttermayr, and Lorenz Lechler, which Hecht knew well. The relevance of those booklets, which emphasize the geometrical construction of pinnacles, should have been especially obvious, since spires resemble overgrown pinnacles, as Velte had already observed.[55]

The direction of the Ulm tower project appears to have been set by Ulrich von Ensingen, one of the most committed and prolific spire designers of the Middle Ages. Little is known of Ulrich's early career or the precise reasons why he was chosen as master of the Ulm workshop, but his pyrotechnic style and bold vision were ideally suited to the character of the Ulm commission. Evidently a native of the Swabian town of Ensingen, young Ulrich seems to have gained an early familiarity with the architecture of Prague and Bohemia.[56] While still a young man he applied to be master of works at the gigantic cathedral of Milan, testimony both to his own feelings of self-worth and to the high salaries offered in Lombardy. Then, in 1392, he was called to Ulm for a five-year contract. Although the nave of the great parish church had scarcely been begun, Ulrich turned his attention to the design of the great western tower and its spire, the project from which all of his subsequent work evolved. Following a brief visit to Milan in 1394, he was appointed master for life in Ulm in 1397. Although he would soon move to Strasbourg, Ulrich von Ensingen and his descendants remained in control of the Ulm workshop for nearly a century.

Ulrich's vision of the Ulm tower and spire can be seen most easily in the great elevation drawing known as Ulm Plan A, which has a scale of roughly 1:36 (Figure 4.54).[57] This drawing, whose lower portion has been cut off, shows the Ulm tower terminating in a subtly concave openwork spire. The overall format of the spire derives from Freiburg, but the elaborate curvilinear detailing in the drawing attests to Ulrich's knowledge of up-to-date Parlerian design. The openwork stair turrets that flank the main core of the tower, similarly, recall the earlier stair turrets of Prague Cathedral's south transept, Freiburg Minster's west tower, and the lower portions of Strasbourg Cathedral's west façade. The relative proportions of the turret faces shown in Plan A indicate that these turrets were meant to have hexagonal plans, like the turrets that Ulrich and his successors later built at both Ulm and Strasbourg.

55 Velte, *Die Anwendung der Quadratur und Triangulatur*, pp. 24–8.
56 See Barbara Schock-Werner, "Ulrich d'Ensingen, maître d'oeuvre de la cathédrale de Strasbourg, de l'église paroissale d'Ulm, et de l'église Notre-Dame d'Esslingen," in Recht, *Bâtisseurs*, pp. 204–8.
57 See Friedrich, "Risse zum Hauptturm des Ulmer Münsters," pp. 20–26.

Figure 4.54
Ulm Plan A

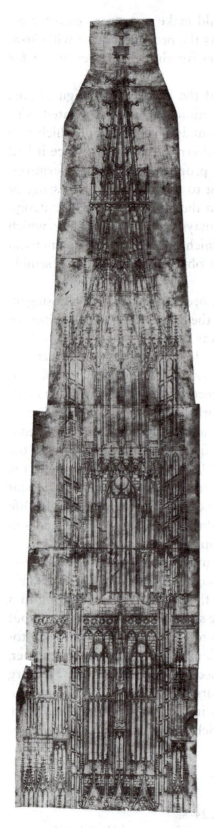

Two closely related groundplans for the Ulm tower, both executed at the same scale as Plan A, seem to record even earlier phases of Ulrich von Ensingen's design process (Figure 4.55).[58] This is particularly clear in the case of the first one, still preserved today in Ulm, which shows the corner turrets with four-fold rather than six-fold symmetry (Figure 4.55 top). In technical terms, it is interesting that Ulrich chose to explicitly show an armature of iron reinforcement rods in the left-hand portion of this drawing, suggesting that he may have been trying to reassure his patrons about the structural solidity of his planned tower. The second plan, which is now in London, differs from the first in that it shows mainly elements at or near ground level, without as much attention to the octagonal superstructure and its flanking turrets (Figure 4.55 bottom).[59] It also differs very subtly from the first design in its treatment of some detail elements such as molding profiles. In their conceptual and geometrical structure, though, the two drawings are effectively identical. In both cases, the main square body of the tower fills about two-thirds of the parchment, while the massive westward-facing tower buttresses frame an entry porch that occupies the remaining portion. These buttresses end in diagonally bladed keels that appear symmetrical at ground level. The upper portions of the buttresses, though, pinch subtly inwards, as the crowding of details toward the building centerline within those buttress outlines indicates. This pinching cannot be dismissed as an anomaly, since it recurs in all the Ulm drawings and in the masonry of the tower itself, and it cries out for a coherent geometrical explanation. In the Ulm drawing (Figure 4.55 top), another interesting detail appears in the westernmost facet of the tower core, adjacent to the porch, where the outlines of the clearly visible inner octagon stand slightly but decisively inboard of the horizontal line connecting the two western stair turrets. Since a series of wall moldings terminate at this horizontal, it, too, must have been important to Ulrich, and its offset from the tower octagon must be seen as meaningful.

Figure 4.56 shows how a surprisingly simple geometrical scheme produced all these details of the tower plan. Ulrich von Ensingen's first step was probably

58 See Friedrich, "Risse zum Hauptturm des Ulmer Münsters," pp. 30–31.
59 London, Victoria and Albert Museum, inv. no. 3549.

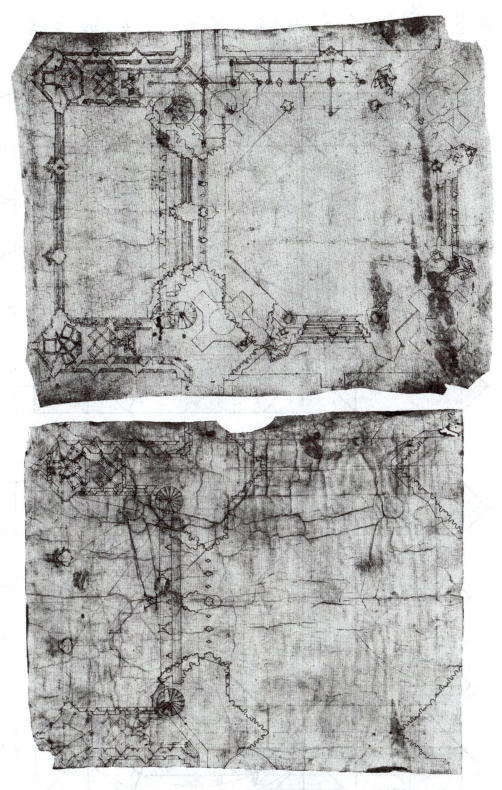

Figure 4.55 Ulm Minster, tower plans now in Ulm (above) and in London (below).

Figure 4.56
Ulm Minster,
basic
geometrical
armature of
tower plans.

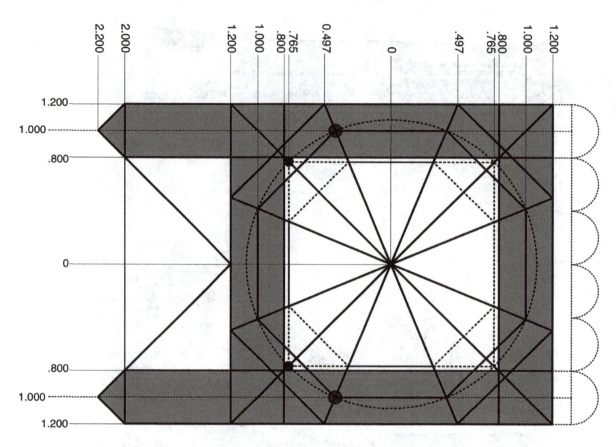

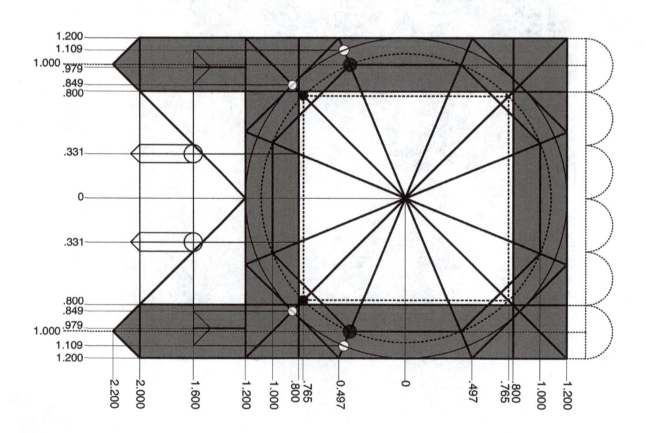

to establish the axes and thicknesses of his main tower buttresses. Hecht would have been pleased to observe that these proportions are governed by a simple modular relationship. The buttresses are exactly one-fourth as wide as the empty space between them. So, calling the distance from the building centerline to the buttress axis 1 unit, as usual, one finds that the distances to the inner and outer buttress faces are .800 units and 1.200 units, respectively. Equivalently, one can say that the salience of each buttress beyond its axis equals one-tenth of the span between the axes. This simple modular relationship, which is shown by the small dotted arcs at the right of the figure, echoes the recommendations for wall thickness published by Lorenz Lechler in the early sixteenth century. Within this modular armature, though, Ulrich von Ensingen soon constructed complex geometrical figures whose subtleties would go on to influence all later contributors to the tower project. Most obviously, he constructed a great octagon within the square framework of the tower base, establishing the basic symmetry pattern for the tower and spire superstructure. The large hashed circle in Figure 4.56a passes through the corner points of an octagon framed by the main buttress axes; two of these corner points are indicated by the larger shaded dots in the figure. The large hashed circle cuts the diagonals subdividing the tower; these intersection points are indicated by the smaller shaded dots closer to the porch. The centers of these dots mark the corners of the hashed square, which frames the hashed innermost octagon. This octagon thus sits slightly inboard from the shaded areas describing the buttresses, just like the corresponding octagon in the original drawing. This subtle offset, therefore, can only be understood by considering the interaction of modular and geometrical design strategies.

Figure 4.56b shows how a similar construction helps to explain another crucial subtlety of Ulrich von Ensingen's tower design, namely, the way the tower buttress axes pinch inward above ground level. The white dots in the figure label the points where a large circle inscribed within the overall tower footprint intersects the principal diagonals and the rays to the octagon corners. Lines projected forward from these intersection points define the inner and outer margins of the buttresses in the second tower story, which fall .849 and 1.109 units out from the tower centerline, respectively. And, as the heavy lines within the salient buttresses indicate, their centerlines are .979 units out from the centerline. In other words, they stand slightly inboard of the original dotted buttress axes, just as they should, accounting for the inward pinch of the upper buttress structure.

Figure 4.56b also shows how the geometry of the tower porch was generated. The length of the main buttresses can be found by simply striking diagonals from the front face of the main tower footprint; the buttresses thus start to taper exactly 2.000 units in front of the tower centerpoint, and their bladed front edges fall .200 units further forward. The front faces of the inwardly pinched upper buttress cores fall 1.600 units in front of the tower center, i.e. halfway in between the main body of the tower and the point where the buttresses start to taper at ground level. The two free-standing supports at the front edge of the porch, meanwhile, do not divide the entrance opening into equal thirds. Instead, the centerlines of these supports fall .331 units out from the building centerline, so that they line up with the points where the rays of octagonal symmetry cross the interior margin of the shaded buttress base. Their width can be derived from the intersection of the porch's generating diagonals with the lines connecting the upper

Figure 4.57
Ulm Minster,
tower
plans with
geometrical
overlay, stage
1.

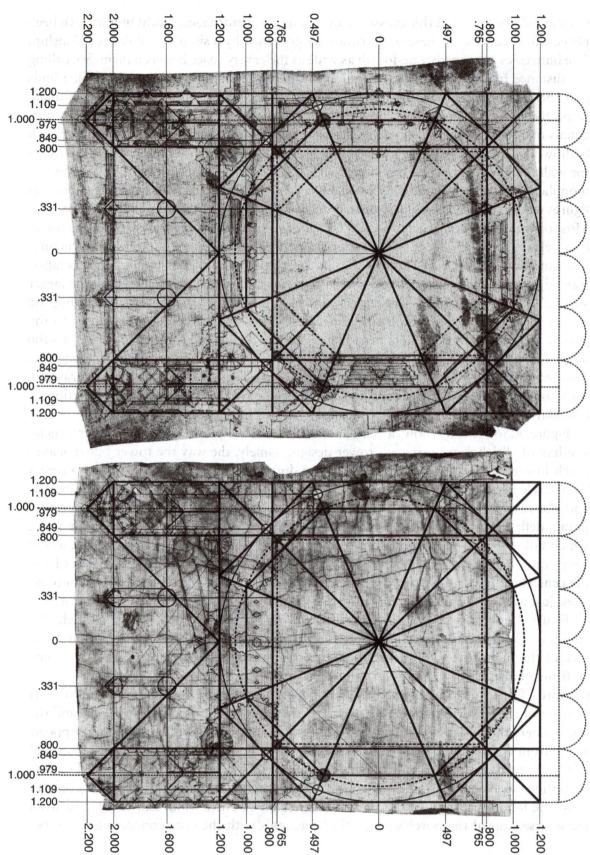

buttress cores, as the figure shows, but some other alternative construction may well have been used in this case.

The geometrical armature described in the preceding paragraphs perfectly matches both of the plans shown in Figure 4.55. In a number of cases, the proportions of one of these drawings help to explain details of the other one. As Figure 4.57 shows, for example, the box of dashed lines .765 units out from the tower center, which frames the inner octagon in the first Ulm plan, describes the boundaries of the tower hall in the London drawing. And, while no octagonal elements are explicitly shown in the second plan, it is striking that the inner faces of the great arches leading into the tower hall are .497 units out from the tower centerlines, so that they line up with the corners of a great octagon inscribed within the basic box of the tower footprint. The elevation of one of these great arches is lightly scribed into the top quadrant of the drawing; other visible construction lines describe the wall thickness, the wall centerlines, and the diagonals subdividing the tower. The presence of such lines in the groundplans for structures like the Ulm and Vienna towers deserves emphasis, because it helps to explain the comparative scarcity of construction lines in the associated elevations, which had led Hecht and other skeptics to doubt the relevance of geometrical planning methods in Gothic design.

There are several minute differences between these two plan drawings in terms of how they relate to the basic geometrical scheme described thus far. The parchment with the plan showing the tower octagon and its turrets, for example, just barely accommodates the whole geometrical frame, while the parchment of the second plan has been trimmed on its eastern face to the midline of the wall. And, while the arches defining the front of the porch in the Ulm drawing stand just slightly more than 2.000 units out from the tower center, they have been pulled back in the London drawing so that only the keeled fronts of the small free-standing piers protrude beyond this line.

Figure 4.58 adds details to this picture, with particular attention to the western tower wall and its main window, known as the Martinsfenster. In the Ulm drawing, the inner mullions, framing arch, and outer mullions of the Martinsfenster fall .957, 1.123, and 1.281 units west of the tower center, respectively. The .957 dimension also fixes the distance between the tower center and the iron reinforcement bars, and it recurs again at the east side of the tower, framing the east face of the octagonal tower core. Another crucial dimension visible in that zone is 1.148 units, the facial radius of an octagon whose diagonal facets cross the main diagonals of the tower to locate the centerpoints of the Greek-cross-shaped stair turrets. All of these dimensions can be generated by simple additions to the geometrical framework already established. So, as the nested circles in the left portion of Figure 4.58a indicate, 1.148 units is just 1.5 times the .765 interval defining the radius of the inner tower octagon. The .957 interval falls halfway in between 1.148 and .765, as the smaller circle shows. The construction of the 1.281 interval is rather different, involving the swinging of an arc from the tower center through the point where the main buttress axes cross the back edge of the western tower wall; 1.281 is the length of the hypotenuse of a triangle whose leg lengths are 1.000 and .800, respectively. And, finally, as the bottom portion of Figure 4.58 shows, the 1.123 dimension can be found by cutting the just-mentioned arc with a line segment slicing west from the point where the diagonal facet of the tower octagon cuts the back wall of the western buttress. Many of these dimensions are common to both of the plans under discussion. However,

Figure 4.58
Ulm Minster,
tower
plans with
geometrical
overlay,
stage 2.

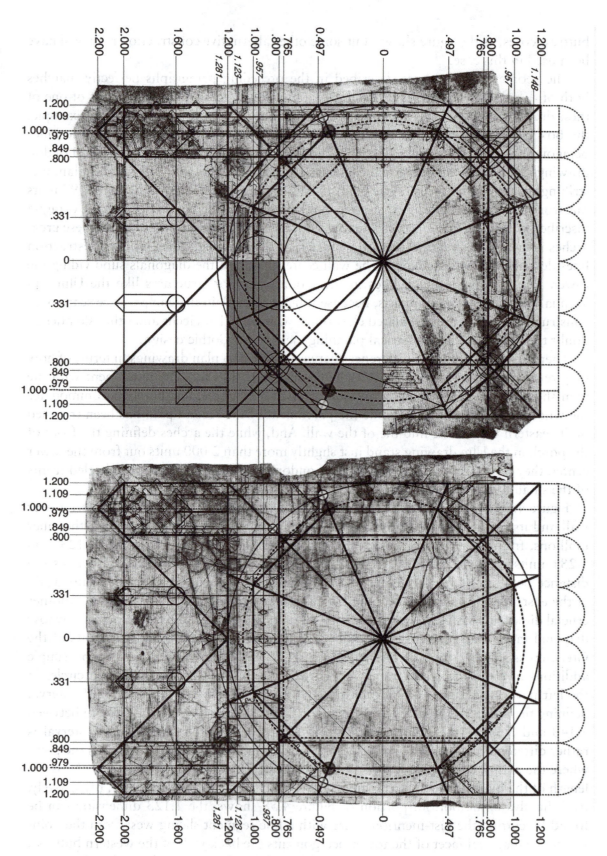

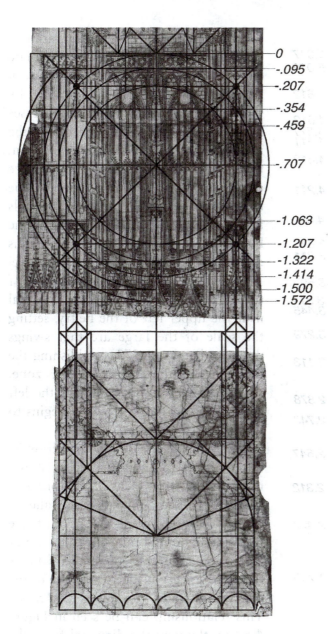

Figure 4.59
Ulm Plan A, lower portion, and corresponding ground plan, both with geometrical overlay.

the precise sequence of layers in the Martinsfenster differs slightly between the two. The inner mullion layer, which had been .957 units out from the tower center in the design above, is pulled back to a distance of just .937 in the groundplan below. This final dimension can be found by cutting the diagonal facet of the tower octagon by another east–west line segment starting where the rays of octagonal symmetry hit the front edge of the main tower footprint. Such minor adjustments notwithstanding, the overall geometrical structure of the two designs is effectively identical.

The use of a common scale for these plans and for Plan A strongly suggests that Ulrich von Ensingen established the key dimensions of the design in the groundplans before transferring them directly into his masterful elevation drawing. This, after all, is exactly what original medieval documents like Roriczer's booklet on pinnacle design would lead one to expect. Figure 4.59 shows this alignment. The italicized numbers rising beside Plan A count off distance as measured between the pinched upper buttress axes established in the plan, since this dimension evidently guided layout of the elevation, at least in the belfry zone and above. These new "pinched" units, therefore, are 1.958 = 2 × .979 times as large as the units used to describe the groundplans in the preceding figures.

Since the lowest portions of Plan A are missing, it makes sense to begin analysis with the belfry story, whose articulation provides valuable clues about its geometrical structure. The sharply defined upper edge of the belfry-crowning balustrade provides a convenient baseline for measurement, here called level 0. Another prominent horizontal is defined by the bridge of traceried arches .707 *units* below. The familiar quantity .707 arises here because the interval between these two horizontals equals the radius of a circle circumscribing a unit square framed by the buttress axes; the corners of this square are indicated by black dots in Figure 4.59. The level of the upper dots, at height -.207, also establishes the springline of the small arches screening the main belfry openings. The smallest of

Figure 4.60
Ulm Plan
A, upper
portion
with
geometrical
overlay.

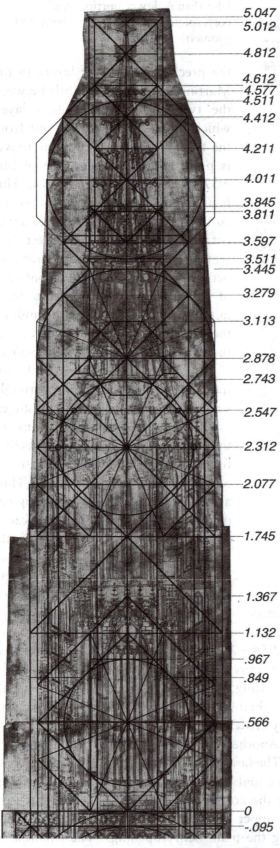

the three circles in the graphic is framed by the unit square. The intermediate circle, which fills the space between heights -.095 and -1.322, is framed by the outer margins of the main buttresses defined at ground level. Because of the relationships established in the plan, this is equivalent to saying that the size of the intermediate circle is set by the intersection between the big diagonals in the belfry and the inner face of the buttresses at that level. In an analogous construction, the horizontal at level -.095, which defines the bottom edge of the balustrade, intersects the big diagonal near the upper left of the belfry, setting the scale of the large arc that swings down to height -1.573, establishing the top edge of the Martinsfenster zone. Along the way, this arc defines the left edge of the parchment, which begins to taper inward at its equator.

The left-edge side of the drawing differs from the right, since it shows not only the front faces of the forward-facing buttresses, but also the salience of the lateral buttress. The distance from the building centerline to the outer face of that buttress equals the distance from the tracery bridge to the top of the belfry balustrade, here called .707 *units*. This relationship can be seen in Figure 4.59 by the way the diagonal from the belfry center ends precisely on the top left corner of the balustrade. Another important element in the construction of the lateral buttress is the horizontal line at height -1.063, where the pinched frontal buttress axes cross the medium-sized circle filling the space between heights -.095 and -1.322. This horizontal marks the transition between an area of unarticulated buttress surface and a more complex cladding of pinnacles and blind tracery. The intersection of this horizontal with the leftmost arc

establishes the vertical line to which the parchment edge tapers in the upper part of the belfry zone. The taper stops at a seam between two parchments pieces at height -.459, the level where the innermost circle intersects the inner faces of the buttresses. Here, as in many Gothic drawings, both the articulation patterns in the depicted architecture and the format of the parchment offer valuable evidence for the geometrical design methods used by the draftsman.

Since the two slender tower stories soaring above the belfry in Plan A were meant to have octagonal plans, it comes as no great surprise to find that stacked octagonal modules also play a major role in determining their elevation (Figure 4.60). The width of these octagonal modules is set by the distance between the outer edges of the front-facing tower buttresses, which is 1.132 times the distance between the pinched upper buttress axes. The top of the first module thus falls at height *1.132* in Figure 4.60, establishing the center of the oculus terminating the main lancet in the first octagonal story. The center of the first octagon, at level *.566*, locates not only a punctuation point in the slender buttress flanges flanking the tower, but also a horizontal seam between two of the parchment pieces comprising the drawing. Another punctuation point in the flanges comes at height *.849*, three-quarters of the way up the first octagonal module. The main lancet window in this first octagonal story begins to taper at height *.967*, aligned with the top of a circle inscribed within this module by quadrature. The row of small ogee arches dividing the two octagonal stories terminates at height *1.367*, aligned with the tip of a rotated square extrapolated from this module.

Up through the first octagonal story, at least, Ulrich von Ensingen and his assistants evidently continued to keep track of the verticals corresponding to the outer buttress faces at ground level. This may be seen most obviously in the fact that the parchment piece beginning at height *1.745* is just wide enough at its base to span these lines, even though its width is palpably narrower than that of the piece below, giving the overall drawing a notched silhouette at that level. The height *1.745* itself seems to have been determined by striking diagonals from the already established height *1.132*, using the full span between these verticals as a baseline.

In the next story of the tower core, these verticals peel away to reveal another octagonal composition identical in size to the one below. The center of this octagon thus falls at height *2.312*, marking the top edge of the tower core and its flanking stair turrets. The lower corners of the octagon's sides at height *2.077* establish the level from which the small terminal arches of the tower core spring. The corresponding upper corners at height *2.547* set the height of the small pinnacles disposed around the base of the spire. The sweeping sides of the concave spire also pass through the points on this level that are crossed by the diagonal sides of a rotated square inscribed within the octagonal module; these points are marked by small circles in Figure 4.60. Similar circles at level *2.312* mark the outermost points on the spire base, which align with verticals rising from the inner faces of the tower buttresses. The larger circle passing through these points rises to height *2.743*, locating a prominent horizontal in the openwork articulation of the spire. The octagon inscribed within this circle has outer faces that align with the vertical centerlines of the buttress turrets, which continue upward to govern the upper spire zone. The top face of the larger framing octagon, at height *2.878*, also helps to govern the taper of the spire, as the final set of small circles here indicates. A small octagon framed by these

points rises to height *3.113*, locating the bases of one set of pinnacles adorning the spire flanks. Verticals rising from the sides of this small octagon set the width of the pinnacle-bedecked "crow's nest" gallery in the story above.

The relationship between large and small octagons in this zone of the spire closely recalls that established in Strasbourg Plan B more than a century earlier (see Figure 2.18). In that drawing, however, all of the design elements were straight-sided and crystalline in appearance, conforming to the norms of the then-popular Rayonnant style. Ulrich von Ensingen's Plan A presents a very different appearance because of its incorporation of prominent curvilinear elements like the concave spire. As the present analysis demonstrates, though, Ulrich's design actually had a coherent geometrical structure of its own, even in the spire zone. His use of curvilinear forms, therefore, can better be understood as a clever way to avoid the sharp formal disjunction seen in designs like Strasbourg Plan B, rather than as a symptom of late Gothic capriciousness.

Stacked octagonal and square modules define the geometry of the upper spire zone in Plan A. Immediately above height *2.878* the parchment begins to taper, its curvature initially reflecting the profile of a circle inscribed within the octagonal module that rises to height *3.445*, where the crockets supporting the "crow's nest" begin to spring. The next such octagonal module rises to height *4.577*, with its center at height *4.011*. The taper of the parchment means that the external edges of this figure could not have been included in the drawing, but the shape of the taper offers valuable clues about its presence. It is no coincidence, for example, that the parchment tapers to meet the rising verticals of the turret centerlines precisely at height *4.011*. A circle centered at this level and framed by these verticals reaches down to the base of the "crow's nest" at height *3.511* and up to another parchment seam at height *4.511*. The top of the "crow's nest" balustrade falls at height *3.597*, the midpoint of the lower diagonal faces in the last large octagonal module. The corresponding points on the upper diagonal facets fall on the margin of the parchment at height *4.412*, a relationship that is particularly precise on the left edge. These diagonal faces can be extended to a convergence point at height *4.812* on the tower axis, a point that marks the base of the tiny balustrade near the tip of the spire. The last bits of parchment around the spire tip are small, but they are wide enough to accommodate the geometrical armature rising from the "crow's nest" below. There appear to have been two closely related geometrical frames in this zone: an outer one based directly on the size of the "crow's nest," which terminates at height *5.047*; and a slightly smaller one based on modules of size *.200* terminating at level *5.012*. These heights mark, respectively, the equator and the base of the crescent-moon figure on which a statue of the Madonna would likely have stood, if the design was foreseen along the lines of Ulrich von Ensingen's later and closely related scheme for the Strasbourg spire, which will be discussed later in this chapter.

Taken together, the evidence from Plan A and from the two early groundplans for the Ulm tower provides a great deal of valuable information about Ulrich von Ensingen's design methods. It seems clear that he began by creating his groundplans, before extrapolating the elevations upwards in accord with the principle of *Auszug* later described by Matthäus Roriczer. In composing his groundplans, Ulrich began by establishing simple

Figure 4.61 Ulm Plan C.

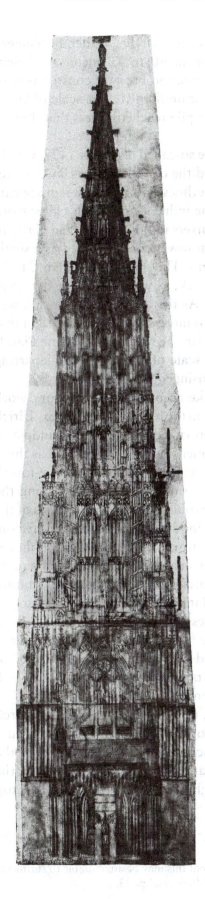

arithmetically defined grids, but upon these he soon superposed complex geometrically based systems, to produce subtle effects like the inward pinching of the buttress axes seen in both groundplans. The match of scales between these groundplans and the elevation known as Plan A, meanwhile, demonstrates how directly relevant dimensions could be pulled from the groundplane into the third dimension. The stacking of geometrical figures in Plan A is rather loose, recalling the improvisational character of Strasbourg Plan B more than the relentlessness of Cologne Plan F. Even more clearly than in the Cologne drawing, though, the trimming and suture structure of the parchment in Plan A attests to the importance that medieval designers placed on the geometrical armatures that guided their work. Like so many of his colleagues, moreover, Ulrich von Ensingen clearly used formal elements like tracery patterns and moldings to highlight crucial points in his work, although these relationships are not obvious to the casual observer. These aspects of Ulrich's design method deserve particularly careful study because his work exercised such a powerful influence on the architectural culture of the southwestern empire throughout the fifteenth century, especially in cities like Ulm, Strasbourg, Basel, and Esslingen where he and his descendants pursued the construction of elegant spires.

In Ulm itself, work on the great western tower proceeded only fairly slowly in the decades after Ulrich von Ensingen was called to Strasbourg in 1399. The masters who followed in Ulrich's footsteps—his son-in-law Hans Kuhn, Kuhn's son Kaspar, and then Ulrich's own son Matthäus and grandson Moritz—placed as much emphasis on the construction and furnishing of the church as they did on the tower project. Moritz, at least, developed a revised design for the tower, now known as Ulm Plan B, but it was little more than a revised and even down-sized version of his grandfather's Plan A, and it seems to have left the Ulm city council unimpressed. Despite a supposedly lifetime contract, Moritz was replaced in 1477 by his former assistant Matthäus Böblinger, who had previously worked alongside his father, Hans

Böblinger, to complete the west tower of Esslingen's Frauenkirche. Under Böblinger's leadership, the western tower rose rapidly, growing from 40 to 70 meters in height between 1477 and 1494, before problems with the foundation brought construction to a halt. As it turned out, this "temporary" halt would last until 1881. The scale of Ulm's projected spire was such that even this mighty 70-meter pile reached to less than half of the structure's intended height.

Böblinger's vision of the entire spire is known from the so-called Plan C of 1477, which, despite a few small discrepancies, substantially governed the completion of Ulm Minster in the nineteenth century (Figure 4.61).[60] In its general outlines Böblinger's design appears more concise than Ulrich's Plan A, possibly reflecting the influence of Ulrich's later work on the north tower of Strasbourg cathedral. The stair turrets in Böblinger's Plan C rise in one straight thrust, as at Strasbourg, while the octagonal tower core is treated as a single tall and elegant story, rather than two as in Ulrich's designs. The spire cone in Plan C lacks the dramatic concave profile characteristic of Ulrich's work, as well, giving the design as a whole a more straightforward and lucid appearance. As the following discussion will demonstrate, the geometrical structure of Plan C was also more straightforward than that of Ulrich's Plan A, having more affinity in this respect with the relentless Cologne Plan F. Interestingly, too, Böblinger executed his drawing at a scale of roughly 1:48, departing from the 1:36 scale evidently preferred by Ulrich von Ensingen.[61]

In developing Plan C, Böblinger obviously had to take account of the masonry work undertaken by his predecessors. Since the first campaigns on the tower were begun by Ulrich von Ensingen in substantial conformity with the two previously discussed groundplans, the buttresses in Plan C had to have the same relative dimensions at ground level as those in the earlier designs. And, indeed, the buttresses in Plan C are shown exactly one-fourth as wide as the space of the porch between them, as the small row of circles along the bottom margin of Figure 4.62 indicates. But, just as one would expect from analysis of the groundplans and Plan A, geometrical rather than strictly modular relationships contribute to establishing many of the other proportions in the tower elevation that Böblinger carefully recorded in Plan C. So, for example, the front face of the porch is not simply a square, but rather a slightly taller rectangular figure circumscribed around an octature figure framed by the buttress axes. In discussing these relationships, it is convenient to use notation in which the distance between these main buttress axes at ground level is defined as one unit. These are the units of measure used in the full sequence of numbers rising along the left side of Plan C in Figure 4.62. The italicized numbers along the right side of Plan C are expressed in terms of the same "pinched" units used to describe Plan A, which will prove useful in analyzing the geometry of the drawing's upper reaches.

Speaking in terms of the regular "unpinched" units, then the front face of the porch can be understood as a rectangle of height 1.082, or $1/\cos 22.5°$. This ratio arises because the porch circumscribes a circle, which in turn circumscribes an octagon framed by the buttress axes. The center of the circle falls at height .541, at the tip of the baldachin over the trumeau. The bottom and top faces of the octagon, at heights .041 and 1.041, define the top

[60] See Friedrich, "Risse zum Hauptturm des Ulmer Münsters," pp. 33–6; and Hecht, *Maß und Zahl*, pp. 466–8.

[61] The scale of the drawing is now closer to 1:50.5 than 1:48, but this may be attributable to shrinkage of the parchment. See Friedrich, "Risse zum Hauptturm des Ulmer Münsters," p. 33.

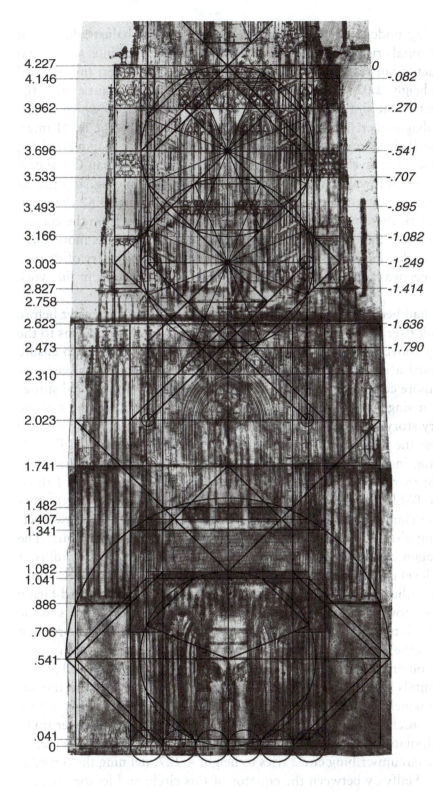

Figure 4.62
Ulm Plan C, lower portion with geometrical overlay.

of the sockel molding and the bottom of the porch's terminal molding sequence, respectively. The first gablets on the buttress keels begin to spring at height .706, where the ray from the octagon center to its lateral corner intersects the main buttress axis.

The format of the lateral buttress and the parchment also emerge readily from this scheme. The outer faces of the lateral buttress can be found by drawing diagonals from heights 0 and 1.082, starting from the inner face of the forward-facing buttress. The upper diagonal cuts the outer face of the frontal buttress at height .886, establishing the level where the plain articulation of the lateral buttress gives way to blind tracery. Similar diagonals struck from heights .041 and 1.041 on the outer face of the forward-facing buttress locate the outer margins of the parchment. A large arc struck through these points from the centerpoint of the porch cuts the outer faces and centerlines of the forward-facing buttresses at heights 1.341 and 1.407, respectively. The former height establishes the height of the shed roof over the porch, while the latter sets the baseline

for the balustrade running under the Martinsfenster. The top of the balustrade falls at height 1.482, where diagonals rising outward from the top of the porch intersect the inner faces of the front-facing buttresses. These diagonals eventually intersect the edges of the lateral buttresses at height 2.023, establishing the springline for the main arch in the Martinsfenster. This part of the drawing is on a second parchment sheet, which begins at height 1.741, where diagonals rising from the shed roof corners at height 1.341 intersect the tower centerline. This second sheet ends at height 2.623, as the diagonals rising from the outer buttress faces at level 2.023 indicate. As the buttresses of Plan C rise past the Martinsfenster, they pinch inward, just as they do in the actual building, and just as Ulrich von Ensingen had already foreseen in his tower designs. In Figure 4.62 the small circles at height 2.023 mark these points of transition. Diagonals rising from the centers of these small circles intersect the opposite buttress axes at height 3.003, as more small circles show. This level marks one of the crucial geometric centers in the belfry of Plan C, where Matthäus Böblinger was finally able to assert some independence from the work of his predecessors.

Since the Ulm tower had been constructed up to the level of the Martinsfenster before Matthäus Böblinger took over leadership of the project, his original contributions to the tower design begin only above that level. One of his main goals was certainly to ensure that the tower maintained a boldly soaring silhouette. But, as observed previously, he also sought to create a more concise tower format by replacing the two octagonal stories of Ulrich's design with a single one. To compensate for this decision, he stretched the proportions of his belfry story. As Figure 4.59 showed, the distance from the top of the belfry to the gablets over the Martinsfenster A had been *1.500* pinched units in Plan A. The equivalent dimension in Plan C is *1.790* pinched units, as the column of italicized numbers along the right margin of Figure 4.62 indicates. And, as comparison of those two illustrations shows, Böblinger achieved this stretching by replacing the strictly one-centered geometry of the Plan A belfry with a double-centered design featuring two octature figures overlapping along the tracery bridge at absolute height 3.493 units. The center of the lower octagon has already been established at height 3.003. The radius of the small circles at that level equals the interval between the octagon and its circumscribing circle. The diameter of the small circle corresponds to the width of the forward-facing buttress flange that rises above it to the top of the belfry. The outermost verticals in the drawing at this level, which terminate at the top of the belfry, are located by the rotated square extrapolated from the octagon centered at height 3.003. The sides of this rotated square pass through the outer margins of the buttress flanges at heights 2.827 and 3.166, respectively. The horizontals at these levels frame well-defined tracery panels on the lateral buttresses. Another panel of complex curvilinear tracery falls between height 3.533, the top of the circle circumscribing the lower octagon, and height 3.696, the upper tip of the rotated square extrapolated from that octagon. This level also serves as the center of the next octagon, whose circumscribing circle rises to height 4.227, defining the top edge of the belfry balustrade. Halfway between the equator of this circle and its top edge, at height 3.962, a final tracery panel begins. The terminal balustrade begins at height 4.146, so that its height equals the width of the buttress flanges that support it. Throughout the belfry zone of Plan C, therefore, even the rather capricious-looking tracery articulation of the buttresses actually expresses the geometrical structure of the drawing.

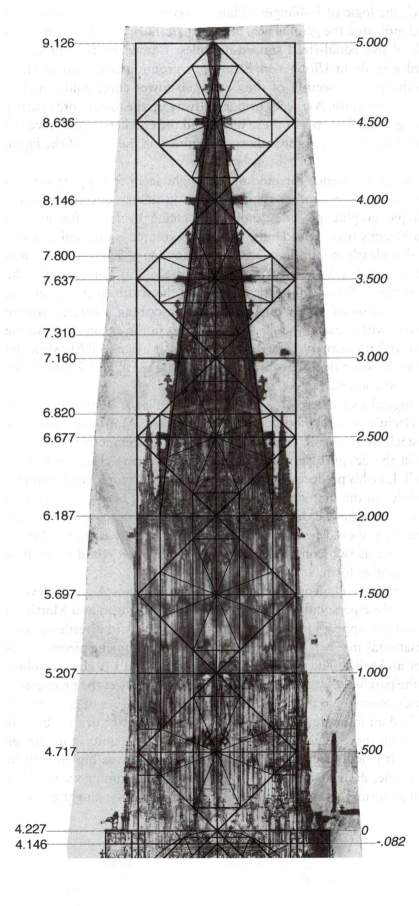

9.126 5.000

8.636 4.500

8.146 4.000

7.800 3.500
7.637

7.310 3.000
7.160

6.820 2.500
6.677

6.187 2.000

5.697 1.500

5.207 1.000

4.717 .500

4.227 0
4.146 -.082

Figure 4.63
Ulm Plan C, upper
portion with geometrical
overlay.

Above the belfry level, the logic of Böblinger's Plan C becomes very simple and even repetitive. As Figure 4.63 indicates, the geometrical armature of the drawing here involves little more than a stack of five equal-sized square modules, framed by the "pinched" buttress axes established already in Ulrich von Ensingen's groundplans. Two of these modules correspond to the vertical section of the octagonal tower core, while the last three correspond to the tapering spire. A tracery bridge halfway up the tower core visually expresses the border between the first two of these units, and the crockets of the spire fall at regular intervals of one half module, as the italicized numbers on the right of the figure indicate.

At first blush, this powerful evidence for modularity might seem to support Hecht's argument that modular constructions rather than dynamic geometry governed Gothic design. Indeed, this simple graphic provides more convincing evidence for module stacking in Plan C than Hecht's own considerably more convoluted numerical analysis does. But this graphic also clearly contradicts Hecht by showing that modularity was only part of the picture. Geometrical constructions mattered also. So, for example, the width of the spire base at height 6.187/*2.000* is smaller than the width of the governing modules by an irrational fraction of $\sqrt{2}$, as one can see by inscribing a rotated square and an octagon successively within each module. The pinnacles in the corona around the spire base terminate even with the corners of one such octagon, at height 6.820, while the successive tracery rings in the spire depart from heights 6.820, 7.310, and 7.800, all of which coincide with octagon corners.

On a broad methodological level, therefore, analysis of Ulm Plan C demonstrates the woeful inadequacy of Hecht's strictly module-based hypotheses. Matthäus Böblinger was certainly happy to stack similar design elements, just as his contemporary Matthäus Roriczer recommended in the design of pinnacles, but both designers clearly relied on dynamic geometry as well. Like his predecessor Ulrich von Ensingen, moreover, Böblinger seems to have used modules in the first steps of his design process, before going on to use dynamic geometry to elaborate the details. From this perspective, it becomes clear that modularity and geometry should be seen not as mutually exclusive approaches to the design process, but rather as two complementary approaches that could be used in fruitful dialog to generate Gothic form.

On a more local and specific level, geometrical analysis of Ulm Plans A and C reveals an interesting contrast of artistic personality between Ulrich von Ensingen and Matthäus Böblinger. Ulrich von Ensingen appears to have developed his Plan A in a restlessly and even recklessly improvisational manner, tacking on successive parchment pieces to his drawing as it grew taller and taller. The geometrical structures in Plan A change subtly from story to story, and the parchments grow smaller and smaller to reflect the progressive narrowing of the drawing's geometrical frame. Böblinger used a similar set of geometrical tools, and he obviously had an intimate understanding of Ulrich's tower design, but his approach to geometry was far more regimented, as the stacking of like units in the upper portion of Plan C reveals. It is telling that the parchment in Plan C was big enough to accommodate this boxy frame, showing none of the "shrink-to-fit" trimming seen in Plan A. In geometrical as well as formal terms, therefore, Böblinger evidently sought to bring

new rigor, clarity, and discipline to the Ulm tower design, while retaining the colossal scale, soaring profile, and rich detailing that had made Ulrich von Ensingen's design so compelling.

Consideration of Plan A, Plan C, and the history of the Ulm tower project also provides an interesting gloss on the relationship between drawing and construction in the Middle Ages. The emergence of drawing as a leading tool of design, especially in the middle of the thirteenth century, tended to decouple design from workshop practice. Since the Middle Ages lacked any analytical theory of structure, the only way to see if a new design would work was, essentially, trial and error. So long as design and construction were closely coupled, the results could be brilliant. But, as drawing grew in popularity, two complementary problems began to emerge. On the one hand, humble designers could repeat older designs virtually line for line, using rules of thumb gleaned from the experience of previous generations. For this reason, many scholars have seen late Gothic design as sterile and reactionary, at least in structural terms.[62] On the other hand, though, the rise of drawing permitted draftsmen to record visionary designs that their own practical experience had not fully prepared them to execute. So, when Ulrich von Ensingen drew up Plan A, he could not really predict how strong a foundation would be needed to support his foreseen 500-foot tower. And, unlike the builders of the Cologne workshop, who constructed a simply enormous foundation pad for their cathedral's comparably tall towered façade, Ulrich and his team underestimated the structural challenge that they faced. The foundations that they built proved to be too weak to support the tower, which began to crack in 1493. Matthäus Böblinger, who was then completing the belfry in accord with Plan C, was dismissed from his post, and a host of external consultants were called in to plan the consolidation of the tower base. This major setback, combined with the chaos of the Reformation and the religious warfare it spawned, put a stop to the Ulm tower project for more than 300 years. It was only in the nineteenth century, after the foundations had been strengthened, using industrial technology, that work on the tower could resume. The Ulm spire was finally completed in 1890, in substantial accord with Böblinger's Plan C, and it remains the tallest church spire in the world today. The history of the Ulm tower project thus reveals a great deal about both the limitations and the enduring power of Gothic architectural drawings.

REGENSBURG

In Regensburg, even more than in Ulm, the practice of architectural drawing got ahead of what the local workshop could achieve in the Middle Ages. In the decades around 1400, the Regensburg workshop produced two visionary schemes for the completion of the local cathedral's west façade, one featuring a richly decorated façade block with an elaborate rose window, and the other featuring a single, enormous openwork spire veiled by decorative flying buttresses. In terms of grandiosity, these projects rival or even exceed the contemporary work of Ulrich von Ensingen in Ulm or Wenzel Parler in Vienna. At some level, this high degree of ambition was appropriate, since Regensburg Cathedral

[62] See Robert Mark, "Structural Experimentation in Gothic Architecture," *American Scientist*, 66 (1978): 542–50.

Figure 4.64
Regensburg
Cathedral,
comparison
between
between façade
schemes: at top
right, medieval
portions of
actual façade;
at bottom right,
the actual south
tower; at bottom
center, the so-
called two-tower
scheme, modern
redrawing;
at left, the
single-tower
scheme, modern
redrawing.

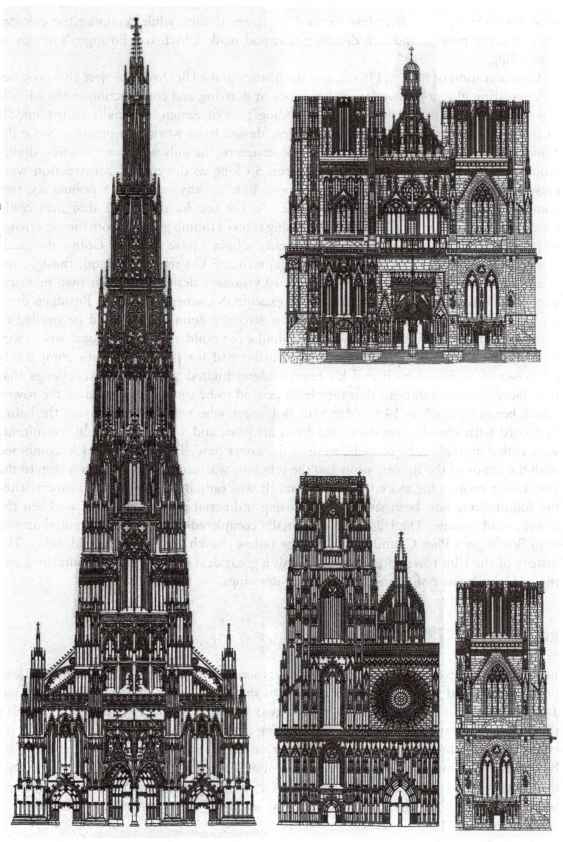

was no mere upgraded parish church. The city had been seat of a diocese since the eighth century, and the cathedral's reconstruction in the Gothic style, which began in the 1270s, reflected knowledge of the most up-to-date and sophisticated French Rayonnant designs. Indeed, Regensburg Cathedral has long been recognized as an enlarged version of Saint-Urbain in Troyes, despite the contrast between the cathedral's muscularity and the brittleness of its French prototype. In the late thirteenth century, therefore, Regensburg Cathedral was perhaps the most architecturally advanced church under construction east of the Rhineland. Construction proceeded relatively rapidly between 1280 and 1380. By 1325 the entire choir and most of the transept were completed, including a reinforced crossing meant to support a central tower.[63] No such tower was built in the Middle Ages, and attention turned to the construction of the nave, which took place between 1325 and 1341.[64] Then, between 1341 and 1380, the south tower of the west façade was built up to its full medieval height, just above the third story (Figure 4.64, bottom right).

In formal terms, this south tower follows the example set by the rest of the rather sober exterior. Ambitious Rayonnant precedents inform the design, as is evident in the Strasbourg-derived statue canopies of the buttresses, for example, but the overall effect at Regensburg is mural and surprisingly stark. In the lower story of the tower only two small lancets pierce the wall, while in the second story all the tracery forms are carved in shallow relief. Even the use of tracery harp-strings in the upper level does little to relieve the flatness of the façade, since the mullions are arranged in the plane of the wall. Perhaps the most novel feature of the façade, one that may even have influenced Peter Parler, was the use of an exterior balustrade to divide the first story from the second, forming a sort of lower sockel zone.[65] In general, however, the appearance of the south tower was both sedate and traditional.

By the time the third story of the south tower was completed in 1380, the tremendous progress of Gothic architecture in central Europe was making the Regensburg façade look outmoded. Levels of decorative richness formerly seen only at the Rhenish cathedrals of Strasbourg and Cologne had appeared not only in Peter Parler's upper choir of Prague, but also in the elaborate rose window of St. Lorenz in Nuremburg. Other Parler projects, including the Frauenkirche in Nuremberg and the colossal Ulm Minster also threatened to eclipse the cathedral of Regensburg, once the most sophisticated building in the region.

Evidently in response to these challenges, the Regensburg workshop produced a large drawing of an ambitious and sumptuously decorated two-tower façade—or, more properly, of all the sections of such a façade except the south tower (Figures 4.64, bottom center, and 4.65).[66] With its dense cladding of tracery panels and niches, this "two-tower" drawing resembles the masterful Strasbourg Plan B from a century earlier, but its

[63] See Manfred Schuller, "Bautechnik und Bauorganization," in Peter Morsbach (ed.), *Der Dom zu Regensburg: Ausgrabung, Restaurierung, Forschung,* (Munich and Zurich, 1989), p. 80.

[64] Achim Hubel, *The Cathedral of Regensburg*, trans. Genoveva Nitz (Munich, 1991), p. 7.

[65] See Jaroslav Bureš, "Der Regensburger Doppelturmplan: Untersuchungen zur Architektur der ersten Nachparlerzeit," *Zeitschrift für Kunstgeschichte*, 49 (1986): 1–38.

[66] Friedrich Fuchs claims that a spire was intended to crown the tower shown in the drawing; see "Zwei mittelalterliche Aufriß-Zeichnungen: Zur Westfassade des Regensburger Domes," in Morsbach (ed.), *Dom zu Regensburg*, p. 224. It seems equally plausible, however, that the drawing was meant as an updated version of Notre-Dame in Paris or other great façades that had been left square-topped, defining their own genre whatever the original builders' intention.

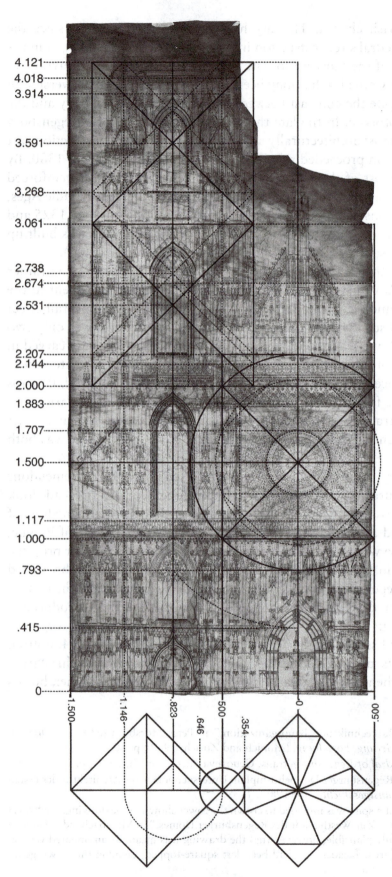

4.121
4.018
3.914

3.591

3.268

3.061

2.738
2.674

2.531

2.207
2.144

2.000

1.883

1.707

1.500

1.117
1.000

.793

.415

0

-1.500
-1.146
.823
.646
.354
0
-.500

Figure 4.65
Regensburg two-tower scheme
with geometrical overlay.

curvilinear tracery forms and ogee arches betray the up-to-date influence of the Parlers. A pointed turret above the rose window provides a counterpoint to the horizontality of the two prominent balustrades.[67] The rose itself, surrounded by a vortex of tracery, synthesizes influences from Strasbourg and St. Lorenz in Nuremberg. Cusped arches in the corner turrets of the tower evoke goldwork. Overall, the drawing creates an impression of exceptional richness and sophistication.

The relationship of this drawing to the actual progress of construction in Regensburg remains poorly understood. The drawing represents a more advanced and ambitious version of the two-tower façade program introduced in the cathedral's south tower. Many features of the south tower, such as the strong balustrades and tiny side-aisle portals, recur in the drawing in more elaborate form. Even certain details, such as the diagonal molding on the outboard lateral buttress and the differing treatments of the upper and lower balustrade, seem to have been borrowed from the south tower. These formal analogies, together with the absence of the south tower from the drawing, suggest that the design was developed as a scheme for the completion of the Regensburg façade, incorporating the extant south tower. On the other hand, the lavishness of the drawing contrasts dramatically with the sobriety of the south tower as built, giving it the flavor of an ideal project. Optimal realization of the scheme in the drawing would entail destroying the south tower and starting from scratch.

Underneath its dazzling tracery cladding, the geometry of the so-called two-tower drawing turns out to be surprisingly simple. The central buttress divides the drawing evenly, so that the width of the strip framing the nave matches the width of the strip framing the tower and its salient buttress; this relationship recalls that seen in the present Strasbourg façade block.[68] And, as the diagram in the bottom portion of Figure 4.65 shows, the rest of the horizontal proportions of the drawing can be easily determined by a simple combination of rotated squares. Calling the width of the nave bay one unit, so that the distance from the building centerline to the first buttress axis is .500, one starts by inscribing an octagon within a rotated square in the nave bay, thus finding a point .354 units left of the centerline. Reflecting this point around the nave buttress establishes a new axis .646 units left of the centerline, as the solid circle in the figure indicates. The central axis of the side aisle can then be found .823 from the centerline, halfway between .646 and 1.000. The axis of the outer forward-facing buttress, finally, can be established at distance 1.146 simply by reflecting the inner buttress at .500 about the aisle axis, as the dotted arc in the figure shows.

In elevation, too, the structure of the two-tower drawing is quite lucid. The height up to the base of the first balustrade is 1.000 above the baseline defined by the sockel, exactly equaling the nave width. The center of the rose window falls at height 1.500, and the bottom of the second major balustrade falls at height 2.000. Other relationships demonstrate, though, that geometry rather that just simple modularity governed the heights in the lower façade. As one might expect, given the prominence of the rose window and its elaborate frame, circular figures concentric with the rose play important

[67] One hundred years or so after the Regensburg drawing was made, an analogous turret was built at Toul. The west façade of Saint-Gudule in Brussels has a similar format.

[68] The actual masonry shown in the drawing sits just slightly inboard of the parchment margin, so the relationship is not actualized quite as it is at Strasbourg today, but the partition of the parchment clearly demonstrates that this proportioning principle was at work.

roles in the overall composition. So, for example, the actual rose window has a radius of .207, with its top lip rising to height 1.707, because it aligns with the vertical facets of a large octagon framed by the nave buttress axes. The radial tracery field around the rose fills a square box reaching from height 1.117 to height 1.883; these heights are determined by the intersection of the diagonals through the rose with the dotted circle circumscribed about the octagon just mentioned. Moving downward, a somewhat larger circle circumscribing the whole square frame of the rose zone descends to height .793, establishing the level from which a row of gablets spring. An even larger arc also centered on the rose swings down from this level on the aisle axis to set the height of the first major molding on the façade at height .415. And, moving back upward, it is worth noting that level 1.707 sets the springline for the window in the aisle bay, while level 1.883 marks the seam between two of the parchment pieces comprising the drawing.

The boxy appearance of the tower in the drawing reflects its underlying geometry—it appears to have been conceived as a stack of two perfect squares. The square size was set by the span between the aisle buttresses, increased on each side by the .207 interval by which the circle circumscribing the rose frame rises above level 2.000. Since the aisle axes were already established at distances 1.146 and .500 from the building centerline, the square size in question is $(1.146 / .500) + (2 \times .207) = .646 + .414 = 1.060$, or 1.061, to be more precise with the rounding. The first square thus rises between heights 2.000 and 3.061, while the second rises from 3.061 to 4.121. The fine structure within these two boxes is fairly straightforward, mostly involving offsets from the main boxes that are established by constructions around the rose window. So, for example, the circle circumscribing the rose frame cuts the right margin of the bottom box at height 2.144, establishing the top margin of the second façade balustrade. A diagonal reaching up and to the left from this intersection point hits the tower axis at height 2.674, where a horizontal suture joins together two more of the drawing's constituent parchment pieces. The top of the circle around the rose also establishes a fundamental horizontal at level 2.207, which lines up with the bottom of the tower window, and with many decorative elements in the façade cladding. Dotted diagonals reaching up from there reach level 3.268, defining a new box equal in size to the two main ones but displaced upwards by an offset of .207. The bottom lip of the upper tower window falls at this height 3.268. The midpoint of the second main box, at height 3.591, establishes the level from which the corner buttresses around the tower core begin to taper. The dotted diagonals rising from level 3.268 intersect each other at the top of the second tower window. Along the way, they cross the solid diagonals of the second main square to define the width of window, which is slightly narrower than those below. The solid diagonals cut the aisle buttress axes at height 3.914, setting the level to which the gable over the window tapers. The tower's terminal balustrade begins at height 4.018, halfway between 3.914 and the top of the second box at height 4.121. Given the conceptual rigor evident in the rest of the composition, it is somewhat surprising that the balustrade itself extends beyond the top of the box. Level 4.121 does, however, serve as the "equator" for the undulating tracery

that swirls about this level. The tower in this drawing was almost certainly meant to end with this terminal balustrade, rather than carrying additional tower stories or a spire.[69] The façade here appears to have been conceived as a richly articulated updating of the boxy façade format popularized by buildings like Notre-Dame in Paris.

The intimate geometrical relationship between this first Regensburg drawing and the actual structure of the cathedral's façade block deserves careful scrutiny, since it can shed some light both on the façade's conception and on the drawing's dating. The balustrades of the south tower provide convenient geometrical lock points that the creator of the drawing certainly must have borne in mind when developing his design. And, as Figure 4.66 shows, the proportions of the drawing correlate quite closely with those of the present façade when their balustrades are aligned. The thickness of the balustrades and the moldings beneath them also match reassuringly well in this scheme. It might at first appear problematic that the geometrical baseline of the drawing floats slightly above the floor level of the present church, but this is actually to be expected, since this baseline was defined by the top edge of the sockel in the drawing, rather than by the groundline as such. In the present Regensburg façade, moreover, the sockels are unusually tall, aligning well with the drawing baseline in the graphic. As the middle of Figure 4.66 shows, the equator of the rose window in the drawing coincides with the springline of the window heads in the present nave wall. This demonstrates that the geometry of the drawing continued to exercise an influence on the Regensburg workshop when the wall was built in the 1430s. More surprisingly, perhaps, the height where the tower construction was abandoned in the Middle Ages quite precisely matches the height where the diagonals of the large "X" in the first free tower story cross the tower's buttress axis. This suggests that the geometry of the drawing may have informed the decision about where and when to stop tower construction, just as in the case of the north tower of Vienna's Stephansdom. By itself, though, this evidence does not demonstrate that the drawing was produced prior to the stoppage of work on the tower around 1380. It may well be, instead, that the drawing has the same geometrical skeleton as an earlier drawing used to establish the design of the south tower. This, indeed, would make a great deal of sense, since the drawing seems intended to show how up-to-date ornament could be added to a façade scheme whose basic outlines had already been established.

Close analysis of the horizontal proportions in the surviving double-tower drawing complicate this picture somewhat, hinting both at substantial continuity within the Regensburg workshop, and at some subtle deviations within that basic framework. As the bottom edge of Figure 4.66 shows, the half-span of the nave in the drawing is measurably larger than the nominally equivalent dimension seen in the south side of the actual façade, when the balustrades in the two designs are aligned as described above. More specifically, the span in the drawing appears to be larger than that in the building by an octature factor. So, the dimension that had been called .500 units in Figure 4.65 can also be expressed as .541 *italicized units*, where .500 of these *units* equals the span from the building centerline to the buttress axis of the south tower. This means, for example, that

[69] The format of the second tower story admittedly involves the whittling away of the tower corners and the emergence of big corner pinnacles, somewhat as in the spired Cologne Plan F. But the proportions of the balustrade in the Regensburg drawing are not those of a regular octagon; the crease lines come too far out from the tower centerline. So, the plan at the top of the drawing should be imagined as a square with slightly truncated corners, rather than as a spire-supporting octagon.

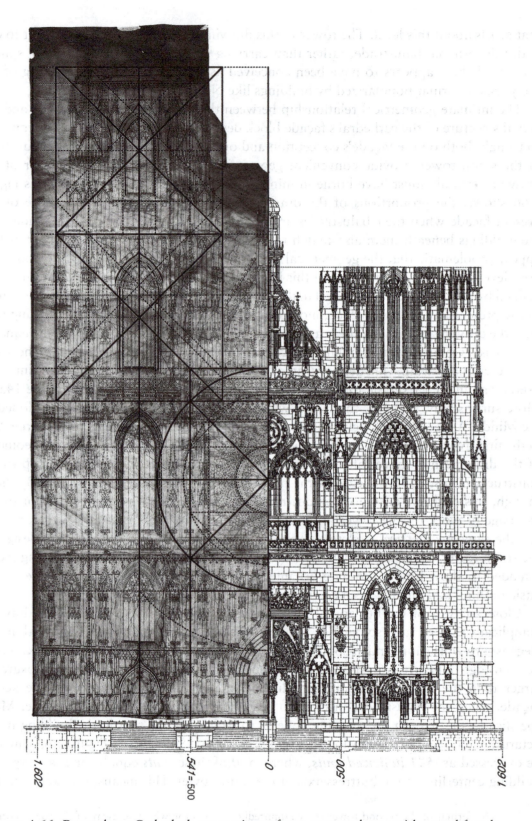

1.602 .541=.500 0 .500 1.602

Figure 4.66 Regensburg Cathedral, comparison of two-tower scheme with actual façade.

the rose-window zone in the drawing would have been too large to fit into the space of the nave. This may help to explain why the north side of the façade was built somewhat wider than its southern pendant, with an accompanying subtle displacement of the north arcade piers behind. Even here, though, the dimensions of the older southern structure were not forgotten. The northernmost surface of the façade block above the floor level falls *1.602 units* out from the building centerline, just like the southernmost surface of the massive podium that fills the space between the floor level and the ground level below. As the following paragraphs will explain, this dimension was actually established in the very earliest campaigns on the cathedral's thirteenth-century choir, and it figures prominently not only in the present façade and in the two-tower drawing, but also in the radically different alternative drawing featuring a single, enormous axial tower surmounted by an openwork spire (Figure 4.64 left).

Current scholarship tends to date the single-spire drawing to around 1400, slightly later than the first drawing. Such a dating makes good sense from the perspective of inter-city competition, since elaborate spire-carrying towers were under construction in this period in Ulm, Strasbourg, Prague, Vienna, and many smaller centers. In stylistic terms, the Regensburg design is noteworthy for the tiers of flying buttresses that veil its spire pyramid. Flying buttresses had originally emerged as functional structural elements in the cathedral architecture of twelfth-century France, but in the thirteenth and fourteenth centuries they increasingly appeared as decorative elements in manuscript illumination, stained glass, and goldwork, often attaining fantastically attenuated proportions. The rise of architectural drawing clearly facilitated this cross-media transfer, and it also permitted the creator of the Regensburg design to appropriate the transformed motif back into the planning for a full-scale building for one of the very first times.

The single-spire drawing for Regensburg seems fanciful and visionary not only because of its apparently intended scale, and because of its pioneering use of decorative micro-architectural motifs, but also because it appears to make no concession whatever to the structure of the actual Regensburg cathedral façade. To implement this scheme, the recently constructed south tower would have to have been torn down, an expensive and time-consuming undertaking. In impressionistic terms, at least, one gets the sense that the creator of the single-spire design wanted to leave behind the awkward realities of the situation in Regensburg, where the built fabric of the cathedral and the limited budgets of its patrons would inevitably impose constraints on architectural ambition. Geometrical analysis shows, though, that the creator of the drawing paid very close attention to the formal logic of the cathedral's thirteenth-century choir (Figure 4.67).

At Regensburg, as at Saint-Urbain at Troyes, the side aisles end in faceted apsidioles, which are displaced slightly to the west of the larger apse of the main vessel. All of the wall structures and buttresses in the apse and apsidioles express octagonal symmetry, and so do the ribs in the apsidioles. The designer of the choir geometry probably began by setting out a large octagon to describe the inner surfaces of the main apse walls. Niches cut into these walls define a second wall plane, whose depth can be found by circumscribing a circle about this octagon. This line describing this second wall plane can be extended west to establish the inboard walls of the apsidioles. The eastern edge of the apsidioles, meanwhile, coincides with the western edge of the octagon used to lay out the main apse interior. The octagons that describe the interior walls of the apsidioles are smaller

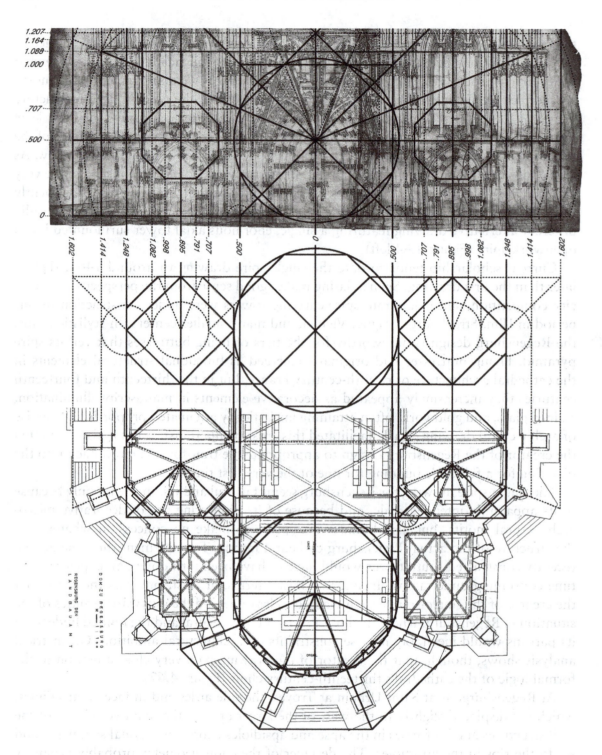

Figure 4.67 Regensburg Cathedral, comparison between the plan of the choir (at bottom) and
the base of the single-tower scheme (at top), illustrating their use of the same shared
proportioning figure (in the middle).

than the main apse octagon by a factor of √2; this can be seen explicitly in the graphic above the plan, where horizontals extending out from the midpoints of the diagonal apse facets frame the flat facets of the octagons aligned with the aisles. So, calling the facial diameter of the apse octagon *one unit*, one finds that the centerpoints and outer faces of the apsidioles fall *.895* and *1.248 units* out from the building centerline, respectively. The relationships described so far suffice to locate all of the main interior elements in the cathedral's east end. Significantly, too, lines extended east from the apsidiole centers can be used to frame a large half-octagon around the exterior of the church, which neatly surrounds the outlines of the massive podium around the apse buttresses. This shows that the podium, too, was treated as geometrically significant by the thirteenth-century choir designer.

The geometry of the podium and buttresses in the choir straight bays deserves particular note, since it will bear in some surprising ways on the geometry of the single-spire design. As Figure 4.67 indicates, the outer edge of the podium stands *1.602 units* out from the centerline; this dimension would go on to govern the width of the south façade podium, as noted previously. The distance from the apsidiole centerline to the outer edge of the sockel, in other words, is twice as great at the distance from the apsidiole center to the apsidiole wall: *1.602 - .895= 2 × (1.248 - .895)*. The podium supports buttresses that are pierced by walkways next to the main wall of the building. The outer margins of those walkways are *1.414 units* out from the building centerline, a perfect √2 times larger than the facial diameter of the choir-defining octagon.

All of these geometrical relationships are summarized in the graphic in the middle of Figure 4.67, which consists of octagons, rotated squares, and circles. Precisely analogous elements interlock in very similar combinations in the groundplans of the roughly contemporary Strasbourg and Cologne cathedral façades, as shown in Figure 2.35. Such parallels are to be expected, since the Regensburg choir designer was drawing on French Rayonnant sources in much the same way as his colleagues in those Rhenish centers. In both Strasbourg and Regensburg, more specifically, the influence of Saint-Urbain in Troyes was pronounced. The example of Cologne clearly demonstrates, meanwhile, that architectural visions declared around 1300 could remain in force throughout the late Middle Ages, and beyond. But Cologne can be seen as an extreme case, in which the actual forms of the Rayonnant vision in Plan F were substantially respected even in the late Gothic era. The formally radical Regensburg single-spire drawing certainly marks a more dramatic break with the past than anything produced by the Cologne workshop. In geometrical terms, though, it remains perfectly faithful to the proportioning scheme developed for the choir in the late thirteenth century, thereby attesting to a striking continuity of expertise within the Regensburg workshop.

All of the lines established in the Regensburg choir design map smoothly into the single-spire design. When the main buttress axes of the tower are aligned with the facets of the original choir-generating octagon, *.500 units* out from the building centerline, the side-aisle centers and the outer buttresses axes fall *.895* and *1.248 units* out, respectively, aligning with the centers and walls of the apsidioles. The interior margins of the passageways in the choir buttresses, *1.414 units* out, align with the outermost pinnacles in the spired façade scheme. In the area around these pinnacles, moreover, the parchment edges align quite closely with the outer surfaces of the buttress sockels in the choir, *1.602 units* out from the centerline. Finally, the margins of the side-aisle portals can be found

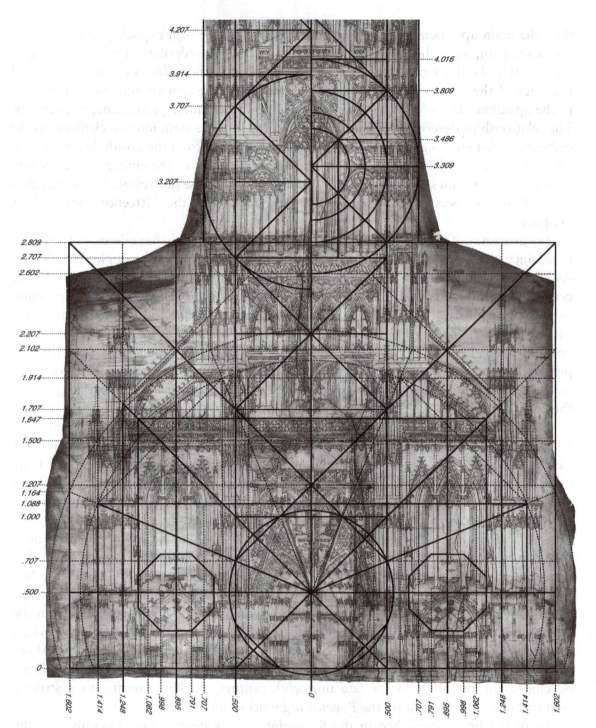

Figure 4.68 Regensburg single-tower drawing, lower half with geometrical overlay.

.707 and *1.082 units* out, while the margins of the doors themselves are .791 and .998
units out; these dimensions are set in Figure 4.67 by the dotted circles and octagons in the
proportioning figure between the choir plan and the drawing.

Moving from the horizontal dimension into the elevation, it quickly becomes clear
that the geometrical focal point of the lower façade in the single-spire design is the point

on the building centerline at height *.500*. This point is the center of a unit square framed by the buttress axes, and it also marks the launch-point for the twin gables that intrude in front of the main portal; these gables were meant to describe a salient triangular porch, a reduced version of which was later built into the actual Regensburg façade. A prominent molding across the façade at height *.500* emphasizes the importance of this level, separating the small side-aisle portals from the windows above. Even the shape of the parchment attests to the importance of the focal point at level *.500*. The lower-right margin of the parchment follows the arc of a large circle centered at this point and struck via octature through the corner of an octagon framed by the *1.602* verticals. Stepping in slightly, a similar octagon framed by the *1.414* verticals has corners at height *1.088*, a level where a prominent horizontal molding punctuates the outer buttresses, and those of the tower. Lower flanges on the buttresses fall at height *.707*, aligned with the corners of an octagon inscribed within the original unit square. The balustrade over the porch begins at height *1.207*, at the tip of a star extrapolated from this octagon.

Moving further upwards into the area shown only in Figure 4.68, the bottom of the major balustrade running across the entire façade falls at the simple modularly determined height of *1.500*. The top of this balustrade falls at height *1.647*, where the diagonals reaching up from the focal point intersect the verticals rising from the sides of octagons centered on the aisle portals; each facet of these octagons is equal to the width of the aisle door. The same diagonals from the focal point intersect the verticals *1.414* units out from the centerline at height *1.914*, thus locating the tips of the outermost pinnacles. And, finally these diagonals intersect the *1.602* verticals at height *2.102*, locating the top edge of a major horizontal molding in the tower bay. The bottom of that molding coincides with the top of the second-largest dotted circle surrounding the focal point, which is circumscribed about an octagon whose top facet falls at height *1.914*. Verticals descending from the corner of that octagon define the outboard surfaces of the front-facing tower buttresses.

A second and closely related geometrical system begins to emerge in the zone between the porch and the flying buttresses that flank the tower. The center of this system is the point on the building centerline at height *1.207*, near the top of the porch. Diagonals reaching outward and upward from this point intersect the outermost verticals at height *2.809*, marking both the bottom sill of the tower window and the level where the parchment kinks upward into the spire zone. These same diagonals cross the side-aisle axes at height *2.102*, along the top chord of the flying buttresses. The flyer chords themselves are also perfect diagonals, but heading in the other direction, so that they cross at right angles. In the tower bay itself, the diagonals can also be "bounced" off the main buttress axes to define a square-unit box filling the space between height *1.707* and *2.707*. The top edge of this square aligns with the top edge of the balustrade under the tower window. The diagonals crossing the square intersect the diagonals of the flying buttresses at height *2.602*, defining the bottom lip of the tower balustrade, and the outboard corners of the parchment's wide base piece.

The slender upper parchment section framing the spire rises vertically instead of tapering (Figures 4.68 and 4.69). The edges of the parchment are almost exactly *1.414* units apart from each other, though some wrinkling at the edges makes this less than perfectly precise. The zone around the first tower window can be described by two circles

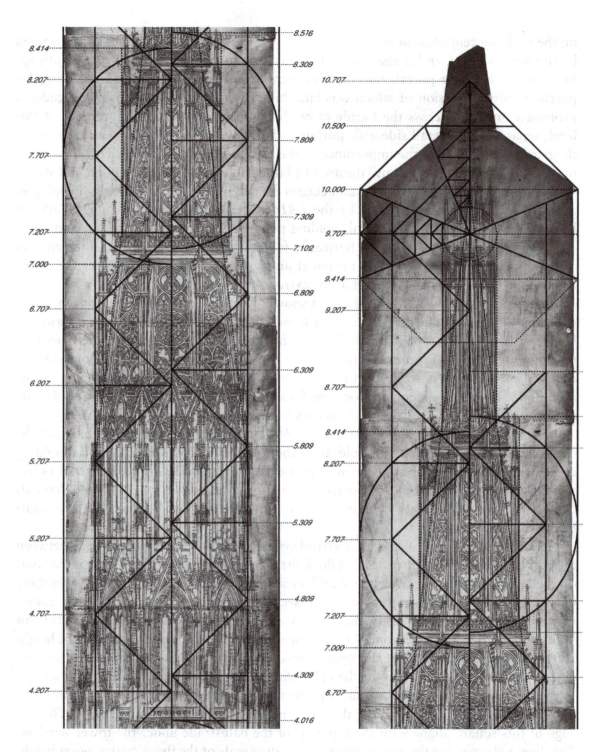

Figure 4.69 Regensburg single-tower drawing, upper half with geometrical overlay.

of diameter *1.414*, slightly displaced from each other. The one shown on the right of Figure 4.68 reaches from the balustrade baseline at height *2.602* up to height *4.016*, where it defines the top of another balustrade at the base of the first octagonal tower story. Inscribing three successively smaller circles within this one by quadrature, one finds that the innermost circle cuts the diagonal from its center at height *3.486*, where a prominent molding punctuates the tower buttress, while the center itself, at height *3.309*, establishes the top of a blind tracery figure flanking the window. Starting with this center, one can then count off a series of unit boxes all the way up to level *8.309*, which is the floor of the upper "crow's nest", as the numbers along the right margin of the left tower graphic in Figure 4.69 indicate. A circle circumscribed about this last box reaches down to level *7.102*, which is the floor of the lower "crow's nest", and up to level *8.516*, which marks both the top of the tracery cusping around the upper "crow's nest", and also another seam between parchment pieces.

The analogous sequence shown on the left parchment margins in Figures 4.68 and 4.69 seems to have played an even more important role in the layout of the drawing. The first box in this series fills the space between heights *2.707* and *3.707*, with a center at *3.207*. A circle circumscribed around this box reaches up to height *3.914*, the base of the balustrade in the first octagonal story. The base of the next box, at height *4.207*, establishes the base of a small tower window, while its top at height *5.207* plays the same role in the next free tower story. The midpoint at level *4.707* marks the springline of the window heads in the first free octagonal story. The box margin at level *6.207* establishes the top of the balustrade at the spire base, and the next margin, at level *7.207*, marks the top edge of the balustrade in the lower "crow's nest". The next box ends at level *8.207*, which is marked on the building centerline by the centerpoint of a small tracery roundel under the upper crow's next. A circle circumscribed about this box reaches down to level *7.000*, where it establishes the baseline of the series of moldings stepping out to support the lower "crow's nest", and up to level *8.414*, where it marks the top of the balustrade over the upper "crow's nest".

The final geometrical flourish in the spire design involves an octagonal construction centered at level *9.707*, at the end of the left box sequence. An octagon centered at this level and framed by the same uprights as the parchment strip has upper lateral corners at height *10.000*, precisely where the strip begins to taper. This is also the level to which all the sloping lines defining the spire pyramid converge. The width of the uppermost set of flying buttresses appears to have been determined by stepping in from the octagon in four quadrature steps. The tip of the spire falls at height *10.707*, which is the tip of the star extrapolated from the octagon, and the terminal finial begins at height *10.500*, right at the octagon's upper facet.

In sum, two surprising facts stand out about the geometry of the Regensburg single-spire drawing. First, the design has a more lucid and straightforward geometrical structure than one might imagine based on the complexity and convolution of its articulation. The lower façade geometry involves large octagons, circles, and diagonals, and the same

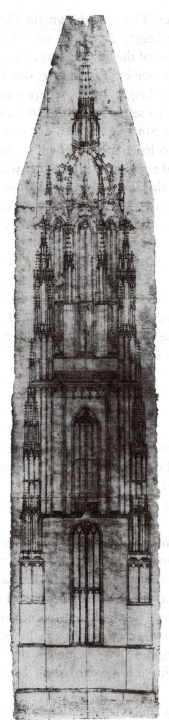

Figure 4.70
Frankfurt Plan
A, drawn by
Madern Gertener,
showing
elevation of
west tower
forFrankfurt's
Bartholomäus-
kirche.

ingredients are stacked repeatedly at smaller scale in the free stories of the spire. The second and even more striking fact about the drawing's geometry, though, is that all of its horizontal proportions derive directly from those of the cathedral's thirteenth-century choir, a fact that attests to a striking degree of intellectual continuity in the Regensburg workshop for well over a century.

Unfortunately, the members of the Regensburg Cathedral workshop never had the resources necessary to realize the grandiose visions proclaimed in the two great drawings from the decades around 1400. Ideas from both drawings were incorporated into the actual façade, but usually in simplified form (Figure 4.64 upper right). So, for example, a triangular porch was built onto the façade, but without the small upper chapel whose windows peek out from behind the porch gables in the single-spired drawing. In a particularly interesting translation from parchment into masonry, similar windows were built into the flat wall plane of the façade, without the forward salience that appears to have been intended in the drawing. Over the course of the late Middle Ages, the north tower of the Regensburg façade was built up to the height of the older south tower, but work was abandoned at that point. The current tower terminations and openwork spires were added in the nineteenth century. While attractive in their own right, they lack the individuality and grandiosity of the spire seen in the single-spire drawing, a document that surely ranks as one of the most dazzling products of the Gothic tower design tradition.

FRANKFURT

In 1415, a decade or two after the likely production of the Regensburg single-spire drawing, the innovative designer Madern Gertener developed a less ambitious but equally individualistic tower scheme for the Bartholomäuskirche in Frankfurt am Main. Gertener's design, as recorded in the elevation drawing known as Frankfurt Plan A, terminates not in a large spire, but rather in a small

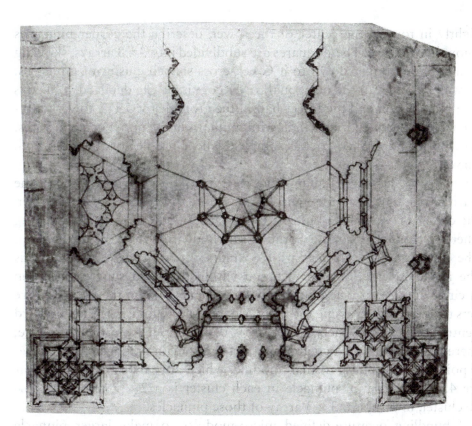

Figure 4.71
Frankfurt,
ground plan
for west tower
of Frankfurt's
Bartholomäus-
kirche.

dome topped with a pinnacle (Figure 4.70).[70] This form was probably meant to evoke the imperial crown, an appropriate reference since the church was the site for imperial elections. Gertener's tower design was unusual, also, in lacking a western portal. The main entrances to the church are on the side of the tower, leaving the western tower base surprisingly blank, boxy, and unarticulated. Only in the upper stories of the tower does this reductive mode give way to an airier and more exuberant vocabulary, with complex pinnacles and decorative flying buttresses rising alongside the octagonally symmetrical upper tower. To the left side of the domelet, a small linear scale counts off distance in terms of Frankfurt's local foot, a unit of approximately .296 meters.[71] The presence of this scale, however, does not prove that the drawing was conceived in modular terms. As the following analysis will demonstrate, Plan A was conceived in much the same geometrical fashion as the other towers discussed in this chapter.

The formal logic behind Gertener's tower design can be traced fairly easily thanks to the survival of an original groundplan, executed at precisely the same scale as his Plan A (Figure 4.71). The basic footprint of the tower is a square, amplified on its western edge by square buttress blocks, each one centered on a corner of the larger square. Rotated squares within these blocks show how the buttresses dissolve progressively into pinnacle clusters in their upper stories. A second set of squares, equal in size to the buttress blocks

[70] See Friedhelm Wilhelm Fischer, *Die spätgotische Kirchenbaukunst am Mittelrhein, 1410–1520* (Heidelberg, 1962), esp. pp. 42–50. See also Ernst-Dietrich Haberland, Hans-Otto Schembs, and Hans-Joachim Spies, *Madern Gerthener, "Der Stadt Frankfurd Werkmeister"* (Frankfurt-am-Main, 1992), esp. pp. 39–49.

[71] Müller, *Grundlagen gotischer Bautechnik*, pp. 295–6.

but displaced slightly in toward the center of the tower, describe the corner pinnacles flanking the octagonal tower core. These squares are subdivided into 3 × 3 arrays, showing that the lower square would taper down to a Greek-cross-shaped cluster of pinnacles. The window and wall structure of the octagonal tower core is clearly depicted, and so is alignment between the octagon and the tower hall in the ground story. The tower hall is shown as a square whose western corners align with mullions in the upper octagon walls, and whose eastern border is marked by the complex salient profiles of the great arch leading into the nave.

The overall geometry of this plan is quite lucid, as Figure 4.72 shows. If one calls the span of the tower hall one unit, then the main square of the tower base is two units on a side, so that the center of each outer buttress block falls 1.000 out from the building centerline. But there is more than simple arithmetical subdivision at stake in the plan. The centers of the corner buttress clusters are .765 units out from the centerline. This dimension can be found by inscribing an octagon within the main square, and then circumscribing a circle about that octagon; the pinnacle centers lie on the points where the circle intersects the diagonals crossing the main square. And, significantly, the inboard corners of the central pinnacles in each cluster are .707 units out from the centerline, on the points where the facets of the octagon intersect those main diagonals. These two octature-defined points thus establish a small module, which appears shaded in all four corners of Figure 4.72. The central pinnacle in each cluster is a 2 × 2 array of these modules, and the cluster, in turn, is a 3 × 3 array of those pinnacles.

This system of bundling octature-defined micro-modules to make larger pinnacle and buttress forms directly anticipates the system seen in the north tower plans for the Stephansdom in Vienna. The 3 × 3 pinnacle clusters in the Frankfurt design, moreover, closely resemble those that Peter Prachatitz was adding to the south tower of the Stephansdom in the very years when Gertener was developing his drawings. In this context, moreover, it is interesting that one of the only medieval towers to feature a domed termination similar to Gertener's was that of St. Maria am Gestade in Vienna, which was built in the 1420s, probably also under the direction of Peter Prachatitz.[72] Several drawings in the vast Viennese collections also show motifs drawn from Gertener's work. The connections between the Frankfurt and Vienna workshops, however, have yet to be thoroughly explored.

Figure 4.73 shows the geometrical system of the Frankfurt tower plan in more detail. The inner and outer faces of the pinnacle bundles fall .591 and .940 units out from the tower centerline, respectively. Since the cores of the outermost buttress blocks are the same size as the adjacent pinnacle clusters, their inner and outer faces fall .824 and 1.176 units out from the centerline. The rest of the geometrical structure depends on octagon-based constructions built up around the tower hall. So, for example, an octagon inscribed within the box of the tower hall has facial radius of .500, and its lateral facet corners fall .207 units off the centerline. The latter dimension is also the facial radius for the octagonal central pinnacle; the Frankfurt design thus has the same basic relationship between tower octagon and terminal spirelet that was seen a century and a half earlier in Strasbourg Plan B (see Figure 2.18). Moving outwards, dotted lines through the corners of the tower hall describe squares rotated 22.5 degrees, whose corners describe the bladed

72 Bork, *Great Spires*, p. 287.

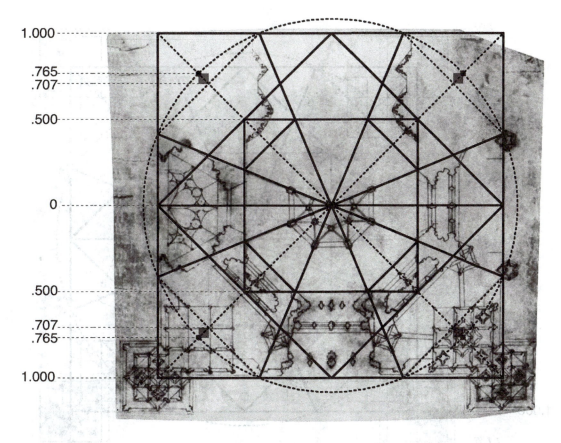

Figure 4.72 Frankfurt, ground plan for west tower with geometrical overlay, stage 1.

flanges at the corners of the octagonal tower core. For purposes of comparison with the elevation drawing, the most important fact about the construction is that it established the inner set of corner flanges .354 units out from the centerline. These points will extend into vertical crease lines in Plan A. Similarly, the points where the dotted lines intersect the rays of octagonal symmetry fall .250 units out from the centerline; these points define the width of the window openings in the upper tower. Finally, as the upper-left quadrant of Figure 4.73 shows, the construction of a small dotted circle between the corner flange and the solid lines of the original quadrature figure establishes a point .780 units out from the centerline. Horizontal lines extended from this point frame the inner faces of the dotted boxes surrounding the corner buttress blocks. Since the distance from .780 to the main buttress axes is 1.000 - .780 = .220, the outer faces of the dotted boxes fall 1.220 units out from the centerline. These dotted boxes describe the lower stories of the buttress blocks, below the point where they step in to become pinnacles. In the elevation drawing, therefore, verticals 1.220 units out from the tower centerline will provide the outermost framing lines of the overall composition.

The proportions of Gertener's plan A, of course, depend on the geometrical relationships he had established in the equally scaled groundplan drawing, as Figures 4.74 and 4.75 show. So, for example, the height of the tower sockel, .220 units, exactly equals the just-described salience of the lower buttress blocks. The horizontal salience of the tower sockel beyond the main axes is $\sqrt{2} \times .220$, as the solid arcs at the groundline of Figure 4.74 show.

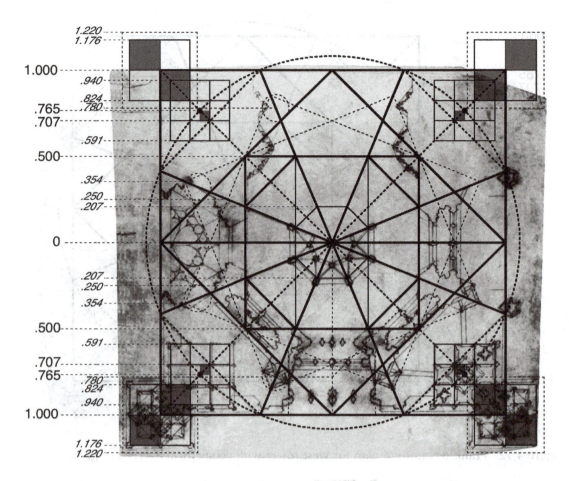

Figure 4.73 Frankfurt, ground plan for west tower with geometrical overlay, stage 2.

The next prominent horizontal molding above the sockel falls at height 1.000, and the base of the first tower window falls at height 1.082—the height of an arc circumscribed about an octagon of facial radius 1.000. The horizontal bridge of tracery across the window falls one unit further up, at height 2.082. The small solid circles drawn at this level re-establish the inner buttress block surfaces already seen in the plan; since the outer surfaces are 1.220 units out from the centerline, the inner faces are .780 units out. The solid verticals slightly closer in to the buttress axes, meanwhile, rise to frame the pinnacles atop the buttress blocks, whose outer and inner faces were already established in the plan at distances 1.176 and .824 from the tower centerline, respectively.

In general terms, the elevation of Plan A can be understood as a stack of nested octagons inscribed within the axes located by the tower plan. The first of these figures is centered, like the tracery bridge, at height 2.082. The outermost of its octagons, inscribed within the outlines of the outer buttress block, has corners at height 2.588, establishing the level where the buttress blocks step back to reveal pinnacles. A circle circumscribed about this large octagon reaches up to height 3.356, where the first main tower story ends in a prominent molding. The octagon in this set framed by the buttress axes fills the space between level 1.082, the bottom of the first tower window, and 3.082, where the window

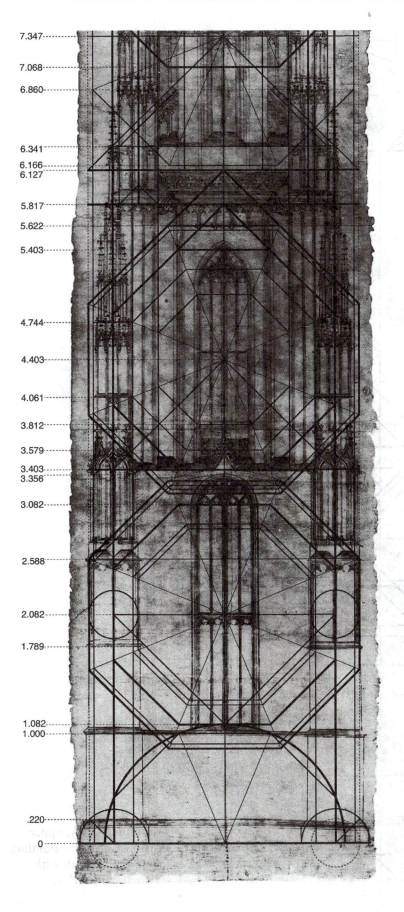

7.347
7.068
6.860
6.341
6.166
6.127
5.817
5.622
5.403
4.744
4.403
4.061
3.812
3.579
3.403
3.356
3.082
2.588
2.082
1.789
1.082
1.000
.220
0

Figure 4.74
Frankfurt Plan A, lower
portion with geometrical
overlay.

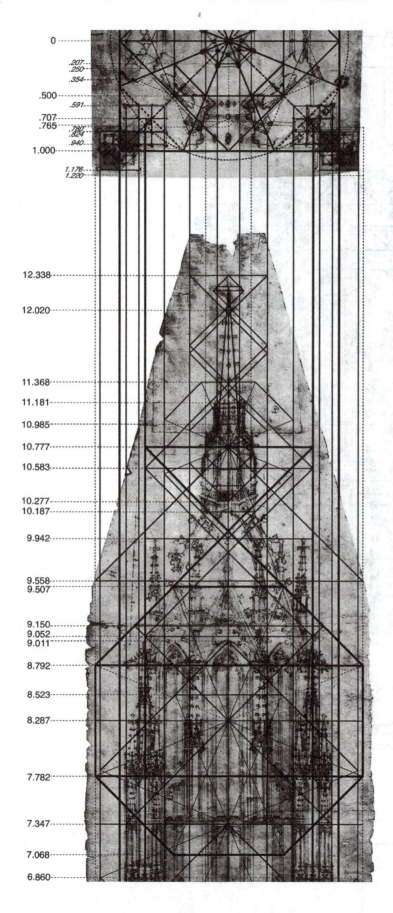

Figure 4.75
Frankfurt Plan A, upper
portion, and corresponding
ground plan, both with
geometrical overlay.

head begins. The smallest of the octagons at this level, framed by the inner faces of the buttress blocks, has inner facets that match the width of the window.[73]

The next set of nested octagons is centered at height 4.403, exactly one unit above the baseline of the second tower story. The largest of the octagons thus rises to height 5.622, which is marked by a row of inverted fleur-de-lis. The tip of the rotated square extrapolated from that octagon falls at height 6.127, establishing the top margin of the balustrade between the second and third tower stories. The octagon framed by the buttress axes, meanwhile, fills the space between heights 3.403 and 5.403, and the tip of the star extrapolated from it falls at height 5.817, the base of the molding that caps the second tower story. The next smaller octagon, framed by the pinnacles rising from the buttress blocks, has lateral corners at height 4.061 and 4.744, which mark major articulation points on those pinnacles. The bottom face of the octagon, at height 3.579, locates the tip of the small ogee arch that caps the window of the first tower story. Finally, there is a smaller octagon, this one framed by the verticals of the inner corner pinnacles faces, which were established in the plan .591 units from the centerline. The bottom facet of this octagon falls at height 3.812, marking the tips of the finials on the small ogee arches that wrap the buttress blocks.

The geometrical structure of the next tower level is a bit more convoluted, involving not one but two sets of overlapping octagonal figures. Fortunately, Gertener left behind enough formal clues to make this structure comprehensible. So, for instance, the prominent horizontal molding at height 7.347 advertises the center of the first octagon set; this point can be found by striking diagonals in from the bottom corners of the tower story, at height 6.127 and 1.220 units out from the centerline. These diagonals intersect the verticals of the buttress block axes at height 6.341, the bottom of the lip beneath the window openings in the tower core. Just below, Gertener made a clearly visible hash mark on the drawing at height 6.166, which coincides with the bottom facet of the octagon centered at 7.347 and framed by the solid verticals rising from the margins of the buttress blocks. The top of this octagon falls at height 8.523 and, more importantly, the tip of the star extrapolated from it falls at height 9.011, the top of the windows in the tower core.

The relationship of the first and second octagonal systems in the upper tower reflects a change of axis, as the composition tightens in toward the spire. The center of the first system, at height 7.347, was a full 1.220 units above the story base, expressing the full width to the outside of the buttress blocks. But the center of the second system falls at height 8.287, just .940 above the previous center; this interval is the width to the outside of the corner pinnacles. The diagonal lines sloping between levels 7.347 and 8.287 parallel the second set of decorative flying buttresses that join these corner pinnacles to the tower core. An analogous construction locates the first set of flyers between heights 6.341 and 6.860. In both cases, clearly, Gertener saw the relevant verticals as those framing the pinnacles at this level. In developing the second octagonal system, though, he used the full 1.220 width to the outer framing lines of the composition. The base of the second octagon thus falls at height 8.287 - 1.220 = 7.068, while its top facet falls at 8.287 + 1.220 = 9.507, the level that marks the top of the tracery fields in the gables at

[73] It is unclear whether the moldings on the buttress blocks were meant to be at height 1.789, where the diagonals cross the rays of octagonal symmetry, or whether they were meant to begin at level 1.794, halfway between 1.000 and 2.588.

the base of the dome. The lower lateral corners of this large octagon fall at height 7.782, where the tiny gablets in the corner pinnacles spring, and the upper lateral corners fall at height 8.792, the level where the main gables spring from horizontal moldings on the tower core. At this level, too, the main gargoyles protrude from the tower, each reaching far enough to place its face on the verticals rising from the outer margins of the corner pinnacles. Here, therefore, as in the Freiburg and Prague drawings, architectural sculpture calls attention to key geometrical fixed points in the design of the structure.

The large gargoyles on the tower core engage in a geometrical dialog with the small gargoyles on the spirelet atop the dome, thus helping to establish the overall format of the tower termination. The upper diagonal facets of the large octagon start at height 8.792, the level of the main gargoyles. These diagonals can be extended past the drawing centerline until they intersect the axes of the corner pinnacles at height 10.777, where the small gargoyles sit. Diagonals descending from this level intersect the outermost dotted verticals at height 9.558, which is precisely where the drawing's backing paper begins to taper inwards. This is also the level where the gable tips fall—as noted previously, their inner tracery fields terminate just below, at level 9.507. The diagonals descending from 10.777 also cross the verticals describing the inner faces of the buttress blocks at level 9.942, which is where the pinnacles around the dome base terminate.

The level advertised by the small gargoyles at height 10.777 also serves as the center of another set of nested octagons that controls the geometry of the spire tip. The largest of these octagons, framed by the inner margins of the corner pinnacles, has its top facet at height 11.368 and its bottom facet at height 10.187, where its corners mark the intersection of the spirelet base with the top of the dome. The next smaller octagon, framed by the verticals rising from the corner flanges of the tower core, fills the space between the balustrade atop the dome and the tips of tiny gablets at the base of the spirelet pyramid. A final octagon has the same size as the spirelet footprint shown in the plan drawing, as the dotted verticals connecting the two drawings in Figure 4.75 indicate. The top of this small octagon sets the baseline for the tiny gablets just mentioned, and its upper diagonal facets describe the small decorative buttresses linking the tiny gargoyles to the base of the spirelet pyramid. The width of this small octagon is twice that of the spire pyramid. The height of the final spirelet appears to have been set by the middle octagon, the one framed by the verticals rising from the corner flanges of the tower core, which continue on to set the width of the drawing's upper edge. If the upper diagonal facets of this octagon are extended and allowed to "bounce" off of those verticals, they return to the opposite vertical at height 12.338, exactly aligned with the top of the spirelet's terminal cross.[74]

In sum, then, it is clear that Madern Gertener established the proportions of Frankfurt Plan A by using systems of stacked octagons, most of whose dimensions he had already

[74] One final geometrical system, interlocked with the others, may have contributed to the framework of the upper zone of Plan A. Diagonals reaching up from the center of the large octagon at level 8.287 intersect its upper diagonal facets at height 9.150, a seam between two of the pieces of paper that comprise the drawing. Along the way, these diagonals cut the corner pinnacle axes at height 9.052. These diagonals can be "bounced" between those lines, which they hit again at height 10.583, before bouncing back into the narrower frame established by the corner flanges. The byplay between these diagonals and the ones emerging from the octagons centered on the gargoyles may have helped to set the fine structure of details like the cross base at height 12.020, but these details may also have been drawn less systematically.

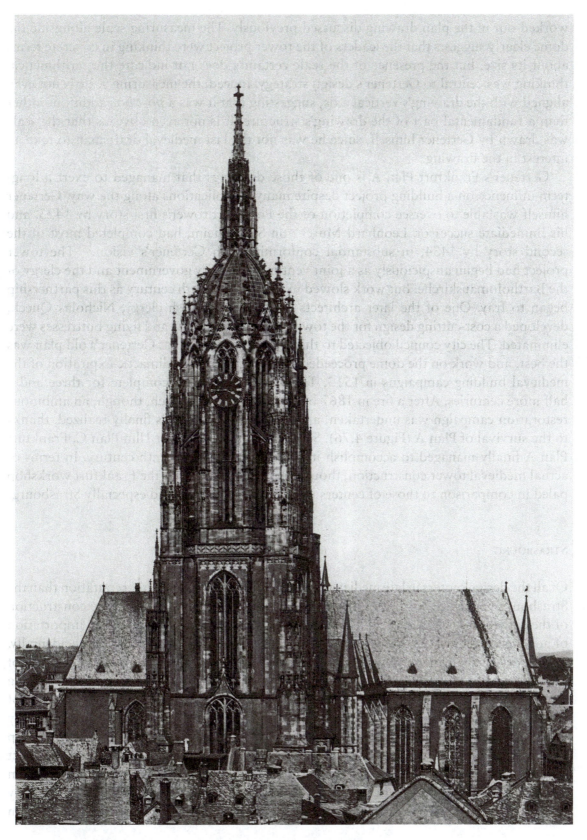

Figure 4.76 Frankfurt, overall view of Bartholomäuskirche from west.

worked out in the plan drawing discussed previously. The measuring scale alongside the dome clearly suggests that the leaders of the tower project were thinking in concrete terms about its size, but the presence of the scale certainly does not indicate that arithmetical thinking was central to Gertener's design strategy. Indeed, the measuring scale is not even aligned with the drawing's vertical axis, suggesting that it was a *post hoc* addition, rather than a fundamental part of the drawing's structure. It is not even obvious that the scale was drawn by Gertener himself, since he was not the last medieval draftsman to take an interest in the drawing.

Gertener's Frankfurt Plan A is one of those drawings that managed to exert a long-term influence on a building project despite many complications along the way. Gertener himself was able to oversee completion of the Frankfurt tower's first story by 1423, and his immediate successor, Leonhard Murer von Schopfheim, had completed most of the second story by 1434, in substantial conformity with Gertener's vision.[75] The tower project had begun auspiciously as a joint venture of the city government and the clergy of the Bartholomäuskirche, but work slowed in the later fifteenth century as this partnership began to fray. One of the later architects hired by the parish clergy, Nicholas Queck, developed a cost-cutting design for the tower in which the dome and flying buttresses were eliminated. The city council objected to this, however, saying that Gertener's old plan was the best, and work on the dome proceeded until the rather anticlimactic expiration of the medieval building campaigns in 1513. The tower remained incomplete for three and a half more centuries. After a fire in 1867 badly damaged the church, though, an ambitious restoration campaign was undertaken, and Gertener's vision was finally realized, thanks to the survival of Plan A (Figure 4.76). So, like Cologne Plan F or Ulm Plan C, Frankfurt Plan A finally managed to accomplish its mission in the nineteenth century. In terms of actual medieval tower construction, though, the achievements of the Frankfurt workshop paled in comparison to those of centers like Freiburg, Vienna, and especially Strasbourg.

STRASBOURG

Of all the design centers in late medieval Europe, none enjoyed a greater reputation than the Strasbourg Cathedral workshop. In the mid-thirteenth century, already, the construction of the cathedral's nave had established Strasbourg as a leading center for the importation of advanced architectural ideas from France into the German world. Not coincidentally, the history of the workshop was bound up from that early point with the emergence of drawing as a tool of architectural design; Strasbourg Plan A may be the oldest surviving workshop drawing of the Gothic period, and the amazing Strasbourg Plan B was one of the first documents to reveal the power of drawing to raise designers' ambition to formerly unprecedented levels. Throughout the rest of the Gothic era, the Strasbourg workshop continued to embrace innovation, even in the construction of the façade, a civic project that enjoyed a particularly high profile in both literal and symbolic terms. As noted in Chapter 2, the proportions of the formally innovative Strasbourg Plan B were already modified before the beginning of work in 1277, and more obvious divergences from

[75] A drawing attributed to Leonard and known as Frankfurt Plan B is basically similar to Plan A except for updated tracery details and gable forms. See Fischer, *Die spätgotische Kirchenbaukunst*, pp. 41–3.

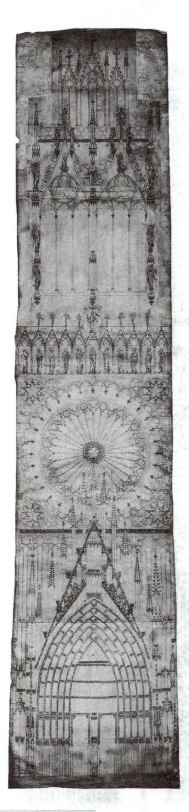

Figure 4.77
Strasbourg Cathedral, Drawing 5, showing central bay of façade with scheme for belfry.

the drawing began to appear in the second story of the façade, with the construction of the so-called harp-string tracery flanking the rose window. An even more radical transformation of the façade morphology appears to have been proposed shortly before 1365, when the next tower stories were completed. The towers themselves appear fairly conventional, but the decorative detailing on the southern face of the north tower terminates halfway up, suggesting the sudden embrace of a new scheme that would place a large belfry between the two towers, obscuring their inner faces and visually binding the façade into a single huge, cliff-like mass.

The earliest known representation of the Strasbourg belfry ranks as one of the most spectacular architectural drawings of the Middle Ages. With a height of just over 4 meters, it shows a vertical slice of the Strasbourg façade only as wide as the central nave vessel from ground level to the top of the belfry (Figure 4.77). Several distinct factors suggest that this drawing was produced by a new arrival in the Strasbourg workshop. First, of course, it marks such a dramatic change of direction that it can be attributed only with difficulty to the same Master Gerlach who had designed the adjacent tower stories. Second, the drawing differs from most others of the Gothic era in depicting not only architectural ornament, but also beautiful color renderings of statues in their niches, at least in the still-to-be-completed zone over the rose window.[76] These figures closely resemble those seen in Bohemian illumination around 1360, suggesting that artists and ideas were flowing into Strasbourg from the Prague of Charles IV and its environs in the years when the belfry scheme was first conceived. And, finally, the proportions of the drawing depart from those of the actual façade in ways that agree better with the approach an ambitious outsider might take than with the detailed expertise of a workshop insider.

[76] Strasbourg, Musée de l'Oeuvre Notre-Dame, inv. no. 5. It is unclear whether the artist of the figures is the same draftsman responsible for the architectural framework. See Recht, *Bâtisseurs*, pp. 393–7. See also Bruno Klein, "Der Fassadenplan 5 für das Straßburger Münster und der Beginn des fiktiven Architekturentwurfes," in Stefanie Lieb (ed.), *Form und Stil: Festschrift für Gunther Binding zum 65. Geburtstag* (Darmstadt, 2001), pp. 166–74.

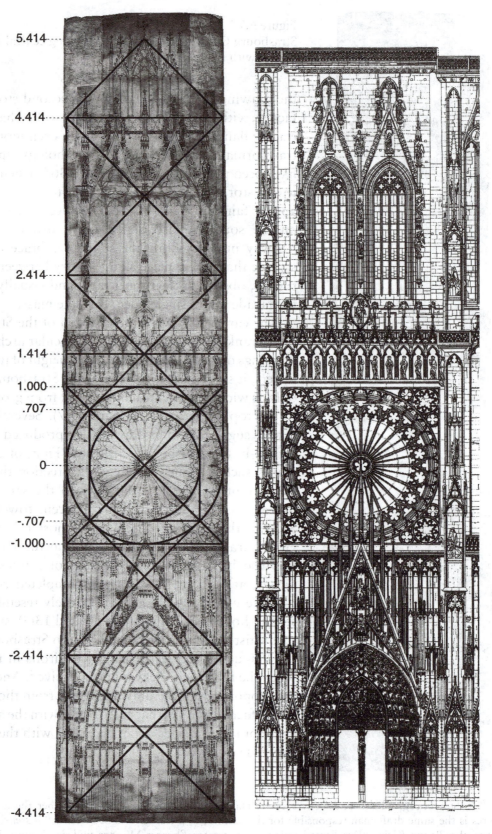

Figure 4.78 Strasbourg Cathedral, comparison between Drawing 5 with geometrical overlay (at left) and the corresponding bay of the actual cathedral façade.

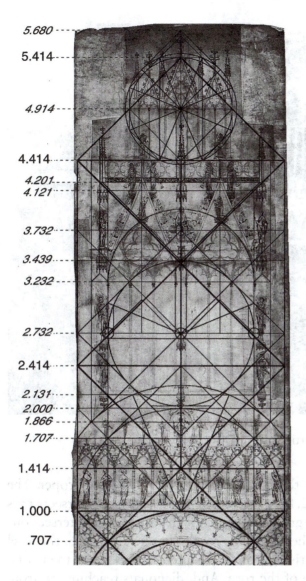

Figure 4.79
Strasbourg Cathedral, detail of Drawing 5 with geometrical overlay on belfry.

The layout of the belfry drawing was based quite directly on the size of the rose window frame, as Figure 4.78 shows. Calling the radius of the rose one unit, the groundline of the façade and the top edge of the belfry proper fall exactly 4.414 units below and above the rose center, respectively, a number that results from taking diagonal tangents to the rose and letting them "bounce" once off the framing axes of the drawing. This construction roughly matches the actual proportions of the façade, but the groundline falls a bit too low, so that the central portal appears taller than it should. The resultant stretching is particularly evident in the tympanum. More significantly, perhaps, the vertical axes framing the drawing play double duty as the centerlines of the narrow gabled panels flanking the portal, and as the margins of the rose window frame. In the real façade, though, these are two distinct axes. Since the margins of the rose coincide with the edges of the massive façade buttresses, which are even wider at ground level than in the rose story, and since the gabled panels have to stand entirely inboard of buttresses, the panel centers are subtly but decidedly closer together than the edges of the rose. The petals of the rose are shown smaller than they should be, since they fill a circle inscribed within the outer rose frame by quadrature. These minor but telling discrepancies reveal that the creator of the belfry drawing was more concerned with capturing an impressionistic view of the lower façade than with studying its formal and geometrical logic in detail. By itself, of course, this does not prove that he had to have come from outside the Strasbourg workshop, but it does chime well with that interpretation.[77]

Figure 4.79 shows the geometry of the belfry design in more detail. Simple quadrature constructions govern the design in and just above the rose. The gablets in the gallery of apostles thus begin to spring 1.414 units above the rose center, and they terminate at a height of 1.707, the level where an arc centered on the top of the rose cuts the verticals that frame its petals. A slightly larger arc with the same center reaches up to the base of

[77] Master Gerlach, by contrast, appears to have paid close attention to the geometrical logic of Plan B even when designing his tower stories, as noted in Chapter 2.

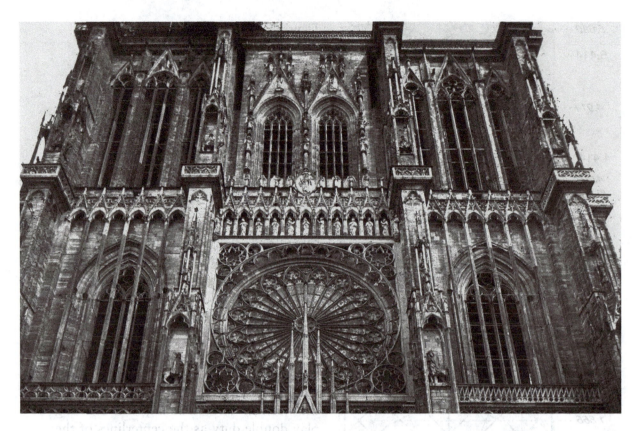

Figure 4.80 Strasbourg Cathedral, central portion of west façade block and belfry.

the central masonry strip diving the twin three-light openings in the belfry proper. The baseline of these openings falls at height 2.131, where this same large arc intersects rays rising from the top of the rose at 22.5 degrees off vertical. The analogous intersections between this arc and the diagonals from the top of the rose fall at height 1.866, the level of the trumpeting angels' heads. Verticals rising from these intersections frame the belfry, which is slightly narrower than the frame of the rose. And, diagonals reaching up from these intersections converge on the façade centerline at a height of 2.732, which marks the center of the belfry and the groundline for the three statue niches at this level. A circle centered at this point and framed by the outer margins of the belfry openings rises to height 3.439, where the next set of statue bases begin to taper. More significantly, the diagonals through the center of this circle cut it at height 3.232, which marks the springline for the arches in the belfry openings. Indeed, a circle of the same size centered at this new level precisely describes the extrados of the main arches before rising to pass between the eyes of the Christ statue who sits enthroned on the belfry's central axis. The statues of Mary and John flanking him kneel on consoles placed where the arc crosses the vertical centerlines of each major opening. These centerlines, in turn, can be found by an interesting octature-based construction. As the small circles at height 2.732 indicate, the width of the masonry strip dividing the openings equals the sum of the two gaps between the large circle at this level and the octagon inscribed within it, whose presence is shown in the graphic by two raking lines 22.5 degrees above the circle's equator. The establishment

of this strip determines the width of the two major openings, whose centerlines can then be found by simple bisection.

In the upper reaches of the drawing, the basic geometrical armature already seen in Figure 4.78 interlocks with smaller constructions based on octature and quadrature. The top margin of the balustrade terminating the main belfry story falls at height 4.414, as already noted, while the tip of the small shrine above the belfry proper falls a unit further up, at height 5.414. The diagonals of this basic armature cross the verticals flanking the belfry openings at height 4.121. The baseline of the foliage band under the balustrade falls at height 4.201, one quarter of the way between the 4.121 and 4.414. The small shrine, meanwhile, appears to have been organized around a small octagon centered at height 4.914, halfway between the top of the balustrade and the tip of its central gablet. The window heads in the two flanking bays of the shrine spring at this level, and the capitals in the central bay appear to have been adjusted downward very slightly in an *ad hoc* manner to accommodate the slightly bigger arch crowning this wider bay. The width of this central bay, including its flanking pinnacles, appears to have been set by the corners of the small octagon just mentioned. Diagonals tangent to the circle framing this octagon converge at height 5.680, locating the tip of finial terminating the central gablet, the highest architectural point shown in the drawing.

The geometry in this upper zone of the drawing is not distinctive enough to provide strong evidence about its authorship. Precedents for its combination of stacked square and octagonal elements can be found in Strasbourg, Prague, and throughout the Gothic world. Formal analogies between the drawing's painted figures and Bohemian illumination, on the one hand, and between the drawing's small shrine and the windows of Master Gerlach's flanking towers, on the other, suggest that a complex combination of local and international influences went into this first version of the belfry project. As noted previously, though, the rather impressionistic rendering of the lower façade may suggest the work of someone unfamiliar with the traditions of the Strasbourg workshop, and the decisive break from the traditional two-tower vision initially embraced by Gerlach certainly seems to suggest the impact of new ideas.

The design of the belfry was altered in several respects during the course of construction, which took place in the last quarter of the fourteenth century. During these campaigns, which were overseen by Michael Parler of Freiburg and his assistant Claus de Lohre, the small shrine seen in the drawing was eliminated, and the overall height of the belfry was raised to match the height of Gerlach's towers (Figures 4.78 right and 4.80). The overall effect, therefore, was to make the façade into a visually unified rectangular mass, eliminating the vestiges of the two-tower format that would have persisted in the slightly shorter drawing-based scheme. The belfry in its present form also has smaller window openings than those foreseen in the drawing, with more tightly spaced mullions. These changes, together with the prominence of the terminal balustrade, make the belfry appear more solid and robust than it would have in the earlier design. There is no good reason to believe, though, that the redesigned belfry was ever meant to carry a large tower or spire. It is significant in this context that large slots separate the top half of

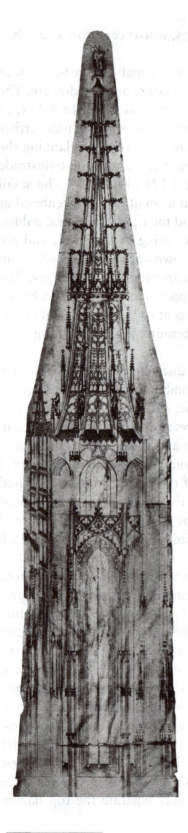

Figure 4.81
Bern plan for the Strasbourg north tower.

the belfry from the adjacent towers and their buttresses. For this reason the towers provided a far stronger base for future construction than the belfry could. It is thus unsurprising that the next campaigns on the Strasbourg façade involved additions to the north tower rather than to the belfry.

It was Ulrich von Ensingen who undertook construction of the north tower, having been lured from Ulm to Strasbourg in 1399. His work on the Ulm tower had obviously impressed the members of the Strasbourg fabric committee, and he naturally incorporated many ideas from his Ulm designs into his new scheme for the Strasbourg tower. In general terms, in fact, his Strasbourg tower design can be understood as a reinterpretation of the design ideas he had proclaimed in Ulm Plan A (see Figure 4.54). In both designs, slender openwork spiral staircases flank a tower core made of two octagonally planned stories. An enormous elevation drawing now preserved in Bern, moreover, shows an elevation of the Strasbourg façade complete with a decidedly concave openwork spire like the one in Ulm Plan A (Figure 4.81).[78] It remains unclear whether this plan should be attributed to Ulrich himself, or to his son Matthäus Ensinger, who likely brought it to Bern when he was hired there in 1420. In either case, though, it certainly records design ideas from Ulrich's circle, underscoring the continuity between his designs for Ulm and his vision of the Strasbourg tower. Ulrich's design for the Strasbourg tower, though, appears considerably more streamlined than his Ulm design. The overall proportions of the tower core are more slender, and the stair turrets rise alongside the core in one continuous surge, instead of stepping inwards as they do in Ulm Plan A. In these respects, in fact, the Strasbourg tower seems to represent an intermediate stage of development between Ulrich's Plan A and Matthäus Böblinger's Ulm Plan C. Analysis of the Bern drawing later in this chapter will demonstrate that this relationship holds in geometrical terms, as well.

[78] Bernisches Historisches Museum, inv. no. 1962. See Barbara Schock-Werner, *Das Straßburger Münster im 15. Jahrhundert: Stilistische Entwicklung und Hüttenorganisation eines Bürger-Doms* (Cologne, 1983), pp. 145, 292–7; and Recht, *Bâtisseurs*, pp. 402–3.

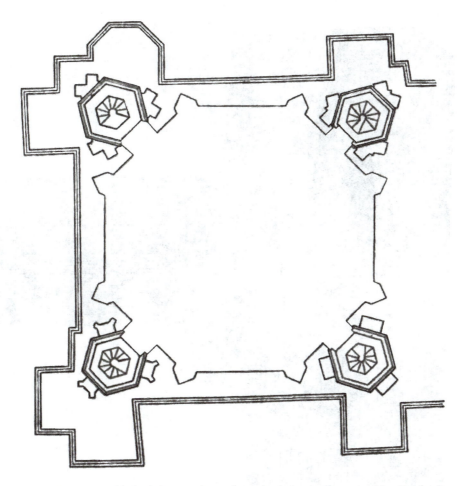

Figure 4.82 Strasbourg Cathedral, basic plan of north tower and upper façade block.

The most essential difference between Ulrich's Ulm and Strasbourg tower projects, of course, was that he began the latter by building on a pre-existing façade platform, instead of starting at ground level. This fact, by itself, helps to explain why the Strasbourg tower had to be narrower than the Ulm one. And, it also helps to explain why Ulrich adopted a very different approach to the design of the tower groundplan than he had at Ulm. In the Ulm drawings, the crucial geometrical givens were the spacing between the principal buttress axes at ground level, and the spacing between the "pinched" buttress axes that pertained higher up. In Strasbourg, though, Ulrich built no such buttresses. Instead, he simply built an octagonal tower core flanked by four hexagonal corner turrets. Figure 4.82 shows the plan of these components and the adjacent areas of the Strasbourg tower platform. As this illustration makes clear, the geometry of the platform is slightly irregular, since each corner has its own unique buttress format. The northern corners of the façade block, which are shown at left in the figure, are each abutted by two buttresses at right angles to each other, while the two southern corners of Ulrich's tower fall partway across the façade block, where only a single buttress abuts each face. In addition to this obvious difference, the eastern buttresses shown at the top of the figure are each flanked by rectilinear flanges, giving those buttresses stepped outlines in plan. And, finally, a large stairway turret adjoins the northeast corner of the façade block; its outline gives

Figure 4.83
Strasbourg
Cathedral,
Drawing 11,
showing plan
of the north
tower.

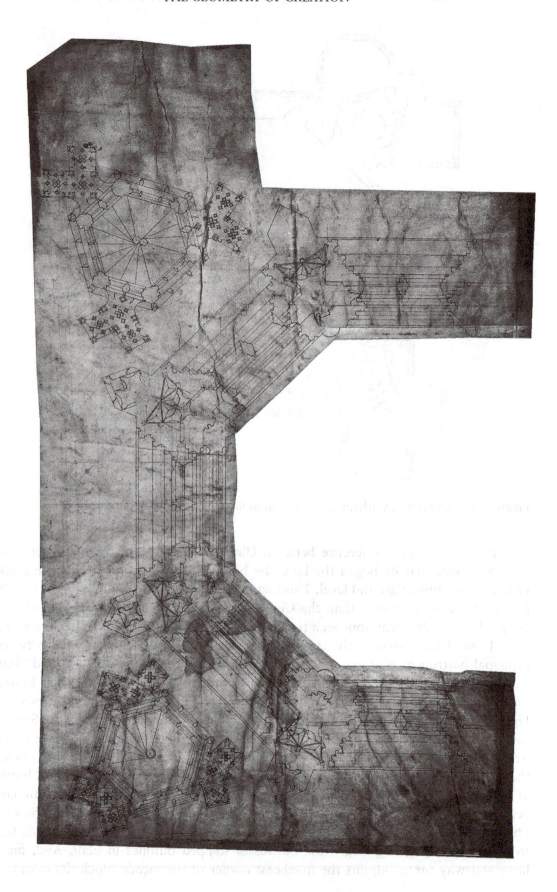

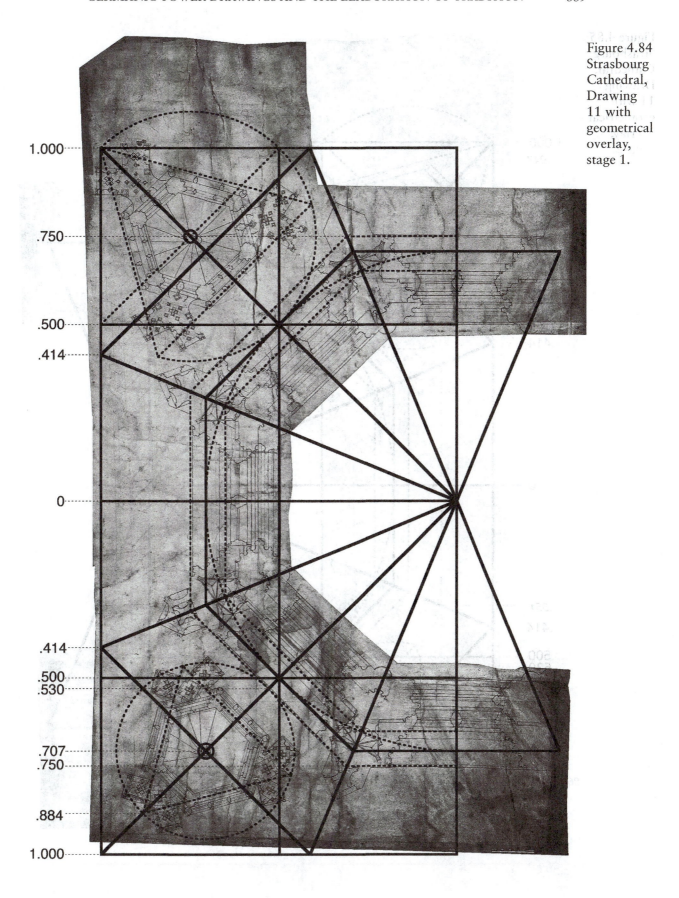

Figure 4.84
Strasbourg
Cathedral,
Drawing
11 with
geometrical
overlay,
stage 1.

Figure 4.85
Strasbourg
Cathedral,
Drawing
11 with
geometrical
overlay,
stage 2.

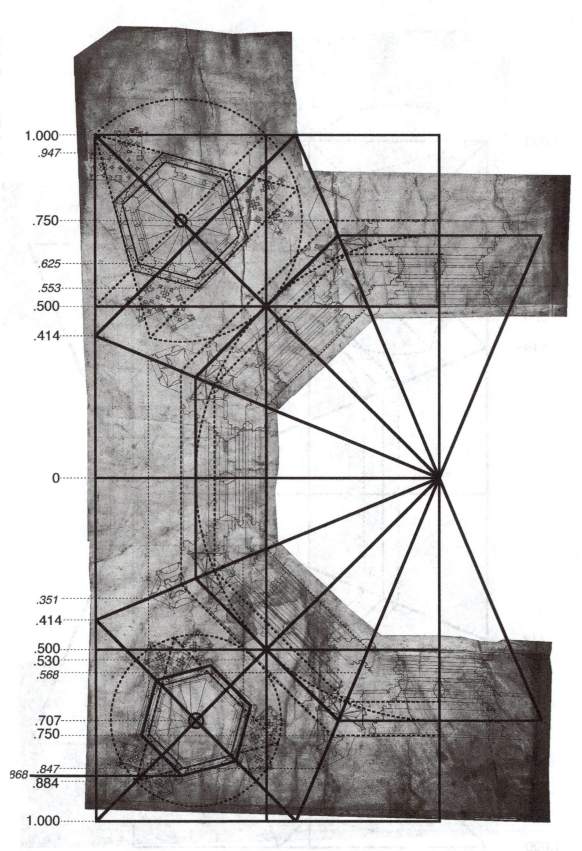

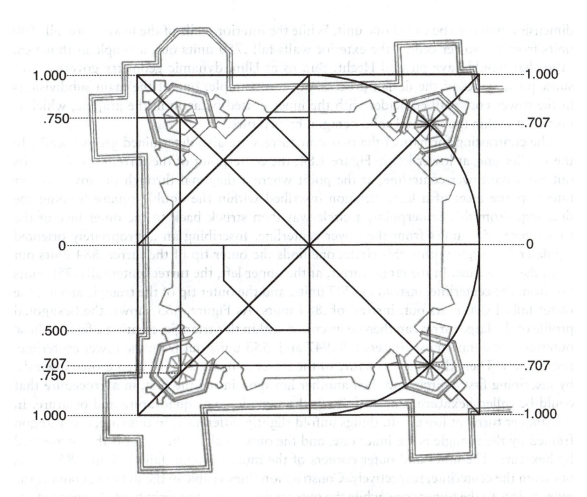

Figure 4.86 Strasbourg Cathedral, basic plan of north tower and upper façade block, with geometrical overlay.

the upper-left corner of the diagram its faceted profile. In designing the Strasbourg north tower, Ulrich von Ensingen took these irregularities into account, while simultaneously developing an elegant geometrical frame for the new work.

Ulrich von Ensingen's approach to the layout of the Strasbourg tower can be understood through analysis of an original plan drawing still preserved in Strasbourg (Figure 4.83).[79] The drawing shows five-eighths of the octagonal tower core, and two of the turrets, one of which is larger than the other. The shape of the drawing at first appears somewhat irregular, because the center has been cut out, and because the parchment extends at the upper-left corner to accommodate the construction of the larger turret. As Figure 4.84 shows, though, the basic geometrical armature of the drawing was a double square, where the side length of each square matches the free diameter between the interior walls of the tower octagon. Since there are no buttress axes to consider in the drawing, this crucial

[79] Strasbourg, Musée de l'Oeuvre Notre-Dame, inv. no. 11. See Schock-Werner, *Das Straßburger Münster*, pp. 287–90, and Recht, *Bâtisseurs*, p. 400. For an interesting but overly rigid geometrical analysis of the drawing (mis-identified as inv. no. 14), see Velte, *Die Anwendung der Quadratur und Triangulatur*, pp. 45–7 and Taf. VI.

dimension will here be called one unit. While the interior walls of the tower core fall .500 units from the tower center, the exterior walls fall .750 units out, a simple arithmetical ratio that would have pleased Hecht. But, as at Ulm, dynamic geometry governs most subsequent stages of the design process. So, for example, one of the main subdivisions in the tower core wall coincides with the inner dotted octagon in the graphic, which is inscribed within the original solid octagon by octature.

The contrasting formats of the two stair turrets are also determined geometrically. In the smaller one, at lower left in Figure 4.84, the centerpoint of the turret falls .707 units out from the tower centerline, at the point where a diagonal through the tower center intersects the facet of a large octagon inscribed within the double square framing the drawing. From this centerpoint, a circle was then struck back to the outer face of the tower core, .530 units from the tower centerline. Inscribing an appropriately oriented equilateral triangle within this circle, one finds the outer tip of the turret .884 units out from the centerline. In the larger turret, at the upper left, the turret center falls .750 units out from the centerline, instead of .707 units, and the outer tip of the triangle around the turret falls 1.000 units out, instead of .884 units. As Figure 4.85 shows, the hexagonal profile of the large turret can then be inscribed within this triangle, creating a figure whose outermost and innermost corners fall .947 and .553 units out from the tower centerline, respectively. Then, the inner structure of the turret appears to have been grown inwards, by inscribing first a circle and then another hexagon inside the first, in a procedure that could be called hexature, since it follows the same logic as quadrature and octature. In the smaller turret at lower left, things unfold slightly differently. In this case, the hexagon framed by the triangle is the inner one, and the outer wall of the turret is then generated by hexature. The inner and outer corners of the inner hexagon fall .568 and .847 units out from the centerline, respectively. Construction lines visible in the drawing connect the inner points to the tower core, while the outer points locate the eight bladed flanges of the tower core. The outermost corner of the outer hexagon, meanwhile, falls .868 units out from the centerline. This dimension is highlighted with a bold line in the figure, because it corresponds to a crucial framing line that Ulrich von Ensingen would use in developing the tower elevation. Before going on to consider the tower elevation, though, it is worth exploring how this ideal geometry corresponds to the plan of the actual tower.

As Figure 4.86 shows, the two different turret sizes foreseen in the drawing really were built into the masonry of the Strasbourg tower. The large size with the .750 unit centerline was used for the northeast turret, while the small size with the .707 centerline was used for the two southern turrets. The northwest turret centerline appears to fall about halfway between these values, for reasons that are not entirely clear. Barbara Schock-Werner argues that this turret was the first to be built, since it lacks decorative refinements seen in the other three.[80] But Ulrich von Ensingen obviously had to have its geometrical structure well worked out before its construction began. Consideration of the layout in Ulrich's plan drawing offers further tantalizing evidence for a change of plans. The large turret in the drawing certainly must be intended to represent the northeast turret in the building, not only because its relative size and articulation so closely match the real northeast turret, but also because that corner of the façade block is the most appropriate place to build such an elaborated structure; as Figure 4.82 showed, this was the corner of the

[80] Schock-Werner, *Das Straßburger Münster*, pp. 136–9.

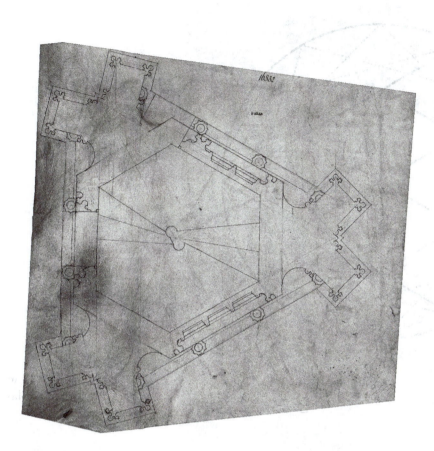

Figure 4.87
Drawing 16.832,
showing a turret
from Strasbourg
Cathedral.

façade block that already incorporated two large buttresses and a large staircase turret rising from below. If the large turret occupies the northeast corner in Ulrich's plan, then the other turret in the drawing should logically be the northwest turret, so long as one assumes the normal viewpoint from above. But, as Schock-Werner notes, the articulation of the smaller turret in the drawing more closely matches that of the southeast turret, as if the drawing were a mirror image of the actual tower plan. It is hard to know exactly what to make of this evidence, but it is tempting to imagine that the northwest tower was intended originally to have the .707 geometry seen in the drawing. Some kind of change in plan or constructional error appears to have intervened between the start of work on this first turret and the start of work on the tower core, thereby muddying the geometrical waters. Then, the three more stylistically advanced turrets could be built in perfect alignment with the tower core: the large turret in the northeast corner with the .750 geometry, and the two on the south side with the .707 geometry.

The protean creativity characteristic of the Strasbourg workshop comes through clearly in the design of the turrets. The fact that all four have different articulation suggests either that Ulrich von Ensingen wanted to show off his own capacity for formal invention, or that he allowed members of his entourage to develop variations on the basic design themes that he had established. The large northeast turret was clearly meant to be the "deluxe" one of the set, incorporating a double spiral stair so that ascending and descending climbers could pass each other without meeting. This turret also differs

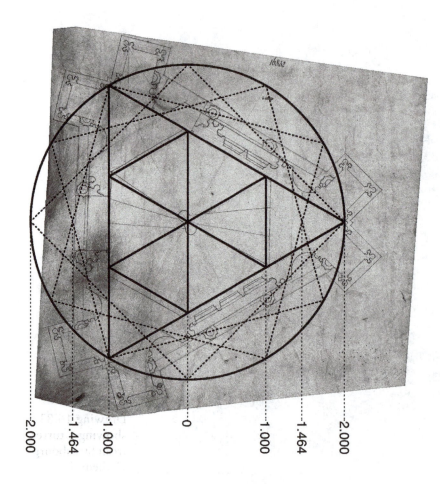

Figure 4.88
Drawing 16.832 with
geometrical overlay,
stage 1.

from the others in that its openwork faces have three openings per bay rather than just two. And, consequently, its plan differs very subtly from a regular hexagon—the three openwork sides are slightly longer than the three sides hidden by pinnacles. A carefully drawn plan of this turret survives today in the Vienna Academy collection, where its presence provides evidence of the active commerce of architectural ideas between the eastern and western portions of the Empire in the late Gothic era (Figure 4.87).[81] The design of this turret is fairly complex, showing that the sophistication of the Strasbourg workshop tradition embraced the microcosm as well as the macrocosm.

As Figure 4.88 shows, the geometry of the northeast turret involved twelve-fold as well as six-fold symmetry. The fundamental generating figure for the design appears to have been a large equilateral triangle, within which a set of nine smaller equilateral triangles can be packed; it will be convenient to call the altitude of each small triangle one unit. In this terminology, the radius of the circle circumscribed around the large triangle is two units. Inscribing three rotated squares within that circle so that their corners subdivide the circle into twelve equal arcs, one finds that the sides of adjacent squares intersect 1.464 units out from the turret center. This distance establishes the location of the turret's outer wall plane, as the left side of Figure 4.88 shows.

In Figure 4.89 a hexagon drawn in solid lines describes these wall planes. A small black dot marks the center of the upper-right facet of this hexagon. Sloping lines radiating

[81] Inv. no. 16832. See Böker, *Architektur der Gotik*, pp. 105–6; Recht, *Bâtisseurs*, pp. 405–6.

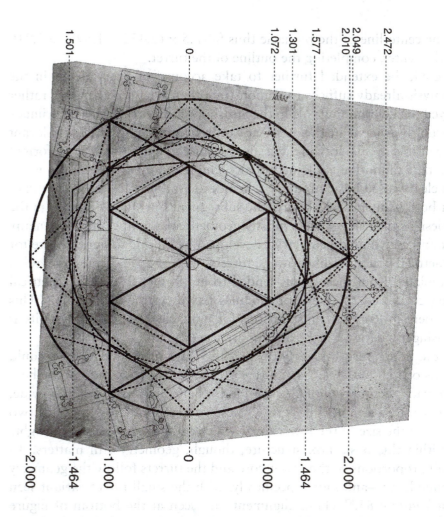

Figure 4.89
Drawing 16.832 with
geometrical overlay,
stage 2..

downwards link this point to the two points described by tiny circles where the adjacent faces of this hexagon intersect the far side of the original large triangle. The right-hand one of those lines intersects the top edge of the large triangle 1.072 units to the right of the tower center, establishing the narrow vertical turret facet shown in dotted lines; the other two dotted facets are the same distance from the center, giving the turret as a whole its subtle alternation between longer and shorter sides. A circle struck through the outer intersection points, meanwhile, has a radius of 1.501 units, as indicated at upper left in the figure. This circle intersects the 30-degree ray rising to the right of the tower center at a distance 1.301 units right of that center. Diagonal lines through those intersection points then converge 2.049 units directly to the right of the center, describing a tiny right-angled keel that is clearly indicated in the drawing. This keel forms the geometrical hinge from which the two small diagonally planted pinnacles fold out from the corner of the turret. The scale of these pinnacles is set by the intersection of two of the large rotated squares 1.577 units to the right of the turret center. A horizontal line struck to the right from this intersection point meets the diagonal rising from the keel 2.472 units to the

right of the center. The centerline of the pinnacle thus falls $.5 \times (2.472 + 1.577) = 2.010$ units to the right of the center, completing the outline of the turret.

This description could be extended further to take account of every detail in the drawing, but this analysis already suffices to demonstrate that dynamic geometry rather than modularity played the determining role in the Strasbourg turret design. The primacy of geometry is particularly evident in this case, not only because many of the relevant construction lines are visible in this drawing, but also because its quasi-hexagonal format results in dimensions that cannot be explained in any simple modular system. So, while Ulrich von Ensingen clearly used basic modular schemes to establish the overall outlines of his tower plans at both Ulm and Strasbourg, the subsequent operations that fill in the details and give the designs their flavor were mostly geometrical. Significantly, too, many of the most complex and convoluted geometries developed by Gothic designers were for groundplans of symmetrical structures like towers, turrets, spire-shaped shrines, or vaults. The elevations extrapolated from these plans tended to be simpler in their geometrical structure, often being conceived as stacks of modules based on the groundplan. This pattern, so clearly evident in Roriczer's instructions for pinnacle design, manifests itself also in Ulrich von Ensingen's design for the Strasbourg tower.

The elevation of the Strasbourg tower, both in reality and in the Bern Plan, could hardly be simpler in its overall outlines. As Figure 4.90 shows, the tower, up to the base of the spire, is just a stack of square modules two and a half times as tall as it is wide. The lower spire and the area around the "crow's nest" correspond to a stack of two smaller squares, each half the size of the lower ones, which fill the space between heights 2.750 and 3.750. Within this basic box structure, though, geometry still matters. To begin with, the overall proportions of the tower core and the turrets follow the geometry established in the groundplan—and more specifically, with the small-turret variant seen in the bottom left of Figure 4.85.[82] These alignments are seen at the bottom of Figure 4.90. So, for example, the outer corner of the turret, which had appeared as the heavy line .868 units out from the tower centerline in Figure 4.85, here rises to become the new outermost vertical in Figure 4.90, defining the scale of the new unit boxes in the elevation. The lines that had been labeled .847 in Figure 4.85, similarly, rise to define the edges of the bladed flanges flanking the tower core in Figure 4.90.[83] The precision with which the geometry of the Bern drawing matches that of the plan drawing is particularly evident at the top of the right-hand stair turret, which is rendered just as a simple skeleton of four vertical lines. As the dotted lines rising from that zone indicated, these verticals align precisely with the corners of the hexagonal turret shown in the plan drawing, whose outlines are indicated above. All of the relative proportions in the Strasbourg tower plan,

[82] This consistent use of the small-turret variant makes good sense from a practical point of view, since it permits the drawing to be constructed symmetrically. This may well be the reason why the draftsman responsible for the Bern drawing chose to represent the south side of the Strasbourg tower, which has two equal-sized turrets, even though the lower portion of the drawing shows the Strasbourg façade block from the west. Schock-Werner, paying careful attention to the articulation of the turrets, had already noticed that the south side of the tower was represented with the west side of the façade. Above and beyond considerations of symmetry, it may have simply been more convenient to represent the south side of the tower, since this is the side visible from the top of the tower platform. See Schock-Werner, *Das Straßburger Münster*, p. 292.

[83] The .847 construction clearly lines up better with the corner flanges in the ground plan than the .868 does, but the .868 hexagon matches the construction lines better. The distinction would be very subtle, and could have been overlooked by the creators of the Bern plan.

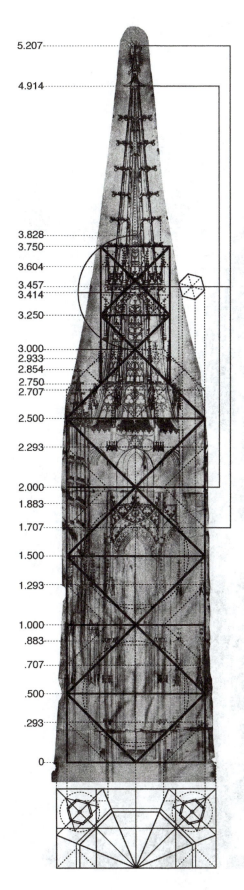

Figure 4.90
The Bern plan for the Strasbourg north tower, with geometrical overlay..

in fact, match those in the Bern elevation, even though the scale of the plan drawing is considerably larger. This again demonstrates that Ulrich von Ensingen and his followers paid careful attention to these plan–elevation relationships, just as one would expect. Once these basic relationships were established, though, the creators of the elevation could proceed to develop new relationships in the vertical plane.

In the Bern drawing, octature and quadrature clearly played a role in establishing articulation points in the tower elevation. An octagon inscribed in the first main square, for example, has a corner at height .293, locating the bottom consoles on which statues would stand on the finished tower. The analogous point in the second square, at height 1.293, locates the bases for a set of pinnacles flanking the left turret, while the same point in the third square locates the top of the short windows in the second tower story at height 2.293. Further below, when one inscribes an octagon within the first main rotated square, and a circle about that octagon, one finds that the top of the circle reaches a height of .883, establishing the height of a horizontal molding on the flanges of the tower core. The analogous construction in the second main square locates the top edge of the first tower story at height 1.883, just above the prominent interlaced ogee arch that divides the two stories. The springline for this arch falls at height 1.500. There is a suture between two parchment pieces just below height 2.000, and the prominent shaded collar around the base of the spire ends at height 2.500. These results underscore the importance of the overall square-based armature in the drawing.

The lower portion of the spire in the Bern drawing is remarkable for the lucidity of its geometrical structure, and for the way that the seemingly capricious curvilinear tracery patterns in the openwork actually reflect that structure. As observed previously, the main geometrical ingredient

Figure 4.91
Strasbourg
Cathedral,
overall view
of the current
tower and spire.

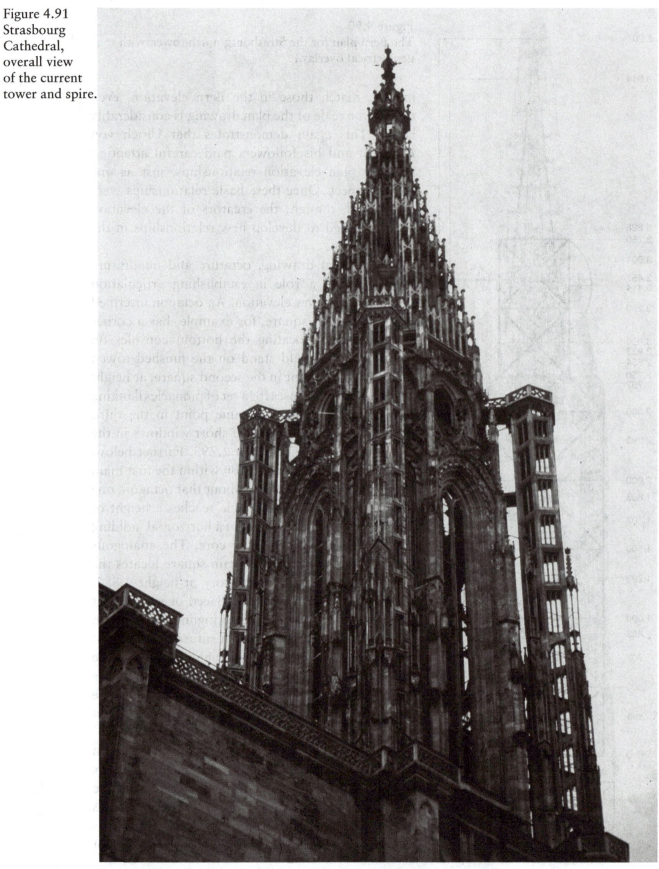

in this zone is a stack of two small boxes that reaches from height 2.750 to 3.750. The walls of the first box align with the first set of spire-mounted pinnacles, and the bottom of the box corresponds to a prominent horizontal molding at height 2.750. The traceried panels immediately below begin to curve inward at height 2.707, even with the corner of a large octagon centered at height 2.500. The small pinnacles at the spire base, four of which are visible in the drawing, also terminate at height 2.707. The tip of the spirelet over the left stair turret falls at height 2.854, halfway up the diagonal face of the large octagon just mentioned. A semicircle inscribed within that octagon intersects with the sides of the small box stack at height 2.933, a level picked out in the drawing both by the presence of a series of concave quatrefoils in the spire tracery, and by the fact that another set of spire-framing pinnacles begins to taper there. A similar pinnacle-tapering takes place at height 3.250, between the two small boxes, and the final pinnacles terminate at height 3.750, the top of the second box. Height 3.250 also marks the center of curvature for another set of tracery panels in the spire wall. In view of these relationships, it seems likely that most if not all of the tracery elements in the spire articulation were deliberately positioned with respect to the drawing's geometrical armature. But, while many of the geometrical aspects of the spire base zone are fairly straightforward, exploring the geometry of every tracery element would be an exercise in diminishing returns, especially since some of the details of the design become rather subtle.

Even some of the large elements in the spire zone, in fact, appear to have been determined by somewhat convoluted means. So, for example, the last tracery panel under the "crow's nest" and the substructure of the "crow's nest" itself fall at levels 3.414 and 3.457. These heights appear to have been set by drawing verticals from the top facet of the large octagon at height 3.000, as dotted lines in Figure 4.90 indicate. Dotted diagonals can then be drawn from the points where the dotted verticals intersect the solid horizontal line at height 3.250, and the solid diagonals immediately below. These dotted diagonals then converge at height 3.457 and 3.414, respectively. The interval between 3.000 and 3.414 then appears to have been doubled, since height 3.828 marks the boundary between a small trefoil in the central spire panel and the narrow, petal-shaped opening that surmounts it.

The construction of the spire tip also seems to have proceeded by this process of interval-doubling, but this time using the "crow's nest" floor at height 3.457 as a geometrical center. So, for example, the interval between this floor and the major box division at height 2.000 can be reflected up to locate a prominent collar wrapping the spire shaft at height 4.914. In exactly the same fashion, the interval down to the octagon corner at height 1.707 can be reflected up to locate the top of the Madonna statue's head

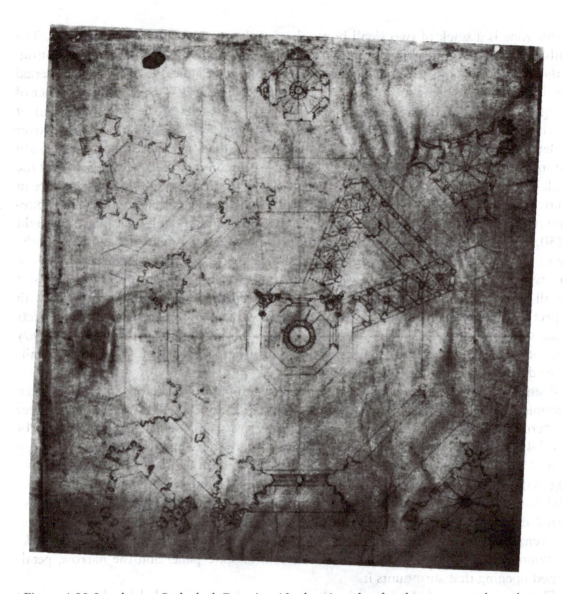

Figure 4.92 Strasbourg Cathedral, Drawing 12, showing plan for the unexecuted south tower.

at height 5.207. So, while the procedure to locate the "crow's nest" floor may have been convoluted, the subsequent use of that geometrical pivot point was very straightforward and economical.

Altogether, therefore, the Bern drawing seems to embody not just a formal streamlining of ideas introduced in Ulm Plan A, but a geometrical and conceptual streamlining, as well. The uniform stacking of boxy elements in the Bern drawing contrasts with the more irregular construction of Plan A, while simultaneously anticipating the logic of Böblinger's even more rigorous Ulm Plan C. Since this clear geometrical structure matches that of the tower stories actually built under the supervision of Ulrich von Ensingen before his death in 1419, this clarification of forms should probably be seen as characteristic of Ulrich's own late work, rather than as evidence for attribution of the Bern drawing to his son Matthäus Ensinger.

In the two decades following Ulrich's death, his successor Johannes Hultz crowned the Strasbourg tower with a structure very different than the one that the Ensingers had

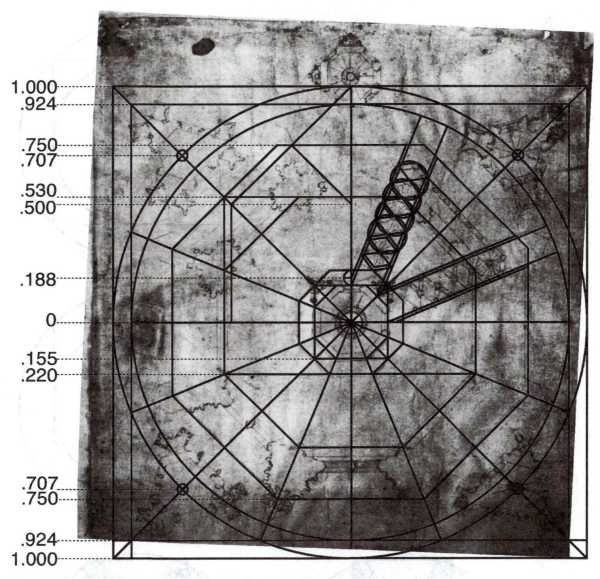

Figure 4.93 Strasbourg Cathedral, Drawing 12 with geometrical overlay.

foreseen. Instead of a concave openwork spire ornamented with pinnacles and crockets, Hultz designed a strictly pyramidal spire covered with openwork staircase canopies, creating a three-dimensional lattice of dizzying and unprecedented complexity (Figure 4.91). The completion of the spire in 1439 gave the Strasbourg façade a total height of 466 feet, overtopping the south spire of Vienna's Stephansdom, which had been completed six years earlier. The Strasbourg spire was the tallest masonry structure built in the Gothic era, and, with the collapse of several timber spires that were reportedly even taller, it stands today as the tallest surviving work of the Middle Ages.[84] The triumphant completion of the spire helps to explain why the assembled master masons of the Germanic world chose in 1459 to establish Strasbourg as the head masonic lodge of the Empire.

The geometrical logic of Hultz's spire design cannot be traced as fully in original design drawings as some of the other major Gothic spire projects analyzed in the preceding

[84] On the heights of other contemplated and destroyed spires, see Bork, *Great Spires*.

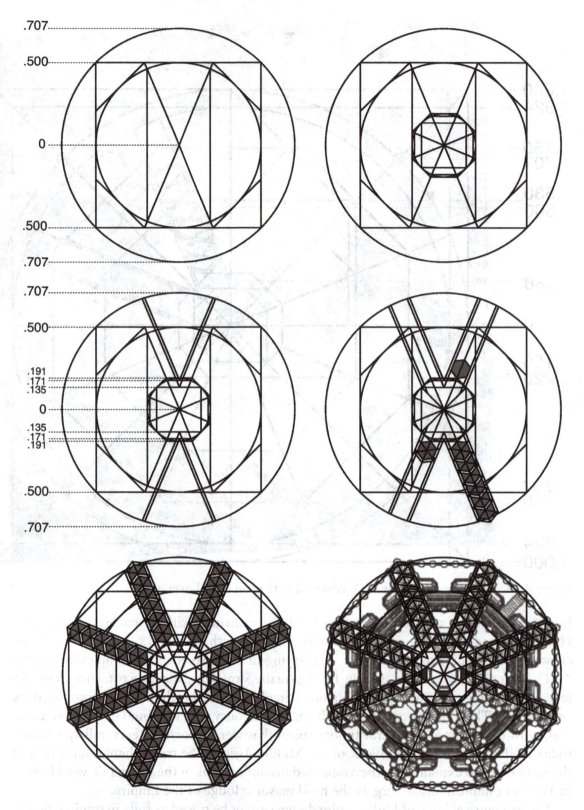

Figure 4.94 Strasbourg Cathedral, hypothetical sequence of steps to establish the geometry of the north tower plan.

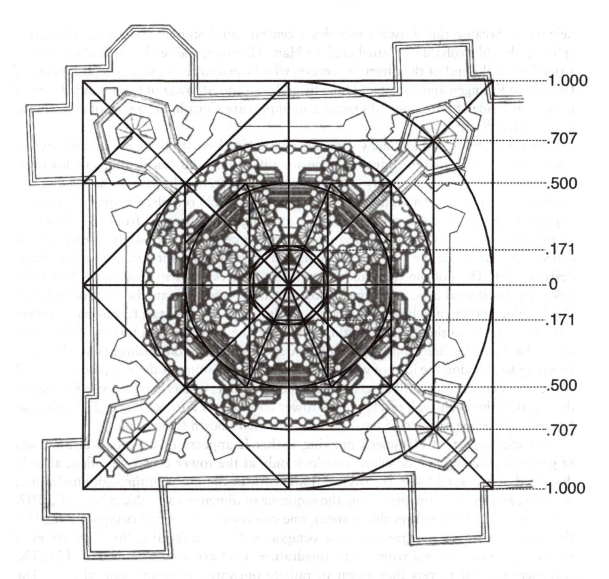

Figure 4.95 Strasbourg Cathedral, complete plan of north spire and upper façade block, with geometrical overlay.

chapters. The few relevant drawings that do survive have generally been seen as late copies of variable quality.[85] Even these, however, can provide valuable clues about the way the logic of the Strasbourg spire format was understood by Hultz's followers. Perhaps the most readily comprehensible of these drawings is a comparatively simple plan that shows only two of the foreseen eight sequences of stair turrets (Figure 4.92). This, by itself, already reveals something important, since it suggests that these sequences were developed one at a time, rather than emerging through a dialogic process of interlocking with all of their

85 Both Recht, in *Bâtisseurs*, pp. 404–5, and Schock-Werner, in *Das Straßburger Münster*, pp. 370–76, dismiss as late copies several drawings that show the north tower: one plan of the spire in the possession of Ulm's Evangelische Gesamtkirchengemeinde; an elevation of the spire in the same collection; and a plan of the spire in London's Victoria and Albert Museum (inv. no. 3550). Velte, however, provided a geometrical analysis of the first of these schemes, which she conflated with the London drawing and which she saw as an original by Hultz. See *Die Anwendung der Quadratur und Triangulatur*, pp. 42–5 and Taf. IV.

neighbors. Because this drawing includes a central spiral staircase unseen in the actual spire, it should probably be attributed to Hans Hammer, the leader of the Strasbourg workshop at the end of the fifteenth century, who hoped to rival the accomplishments of Ulrich von Ensingen and Johannes Hultz by adding a spired tower of this modified format to the south side of the cathedral's façade; an impressive elevation drawing of this scheme also survives.[86]

The proportions of Hammer's drawing reveal his close study of the already extant north tower, while also introducing some simplifications and clarifications of his own. The drawing nearly fills a roughly square parchment sheet, but the axes of the drawing are slightly rotated from the margins of the sheet. As Figure 4.93 reveals, this rotation actually expresses the geometrical structure of the drawing. The distance from the drawing's vertical axis to the right-hand margin of the parchment at its top-right corner can be called one unit, while the equivalent distance at the bottom-right corner is an octature-derived .924. The bottom-right and bottom-left corners are also 1.000 and .924 units below the horizontal axis, respectively. Together these offsets create the rotation between the drawing and the parchment. In Hammer's drawing, all four stair turrets have centers .707 units out from the tower centerlines, just like the two southern turrets of the north tower. So, Hammer here appears to have understood Ulrich von Ensingen's work, while choosing to abandon the idea of varying turret sizes. In Hammer's drawing the outer wall of the tower core stands .750 units out from the centerline, just as in Ulrich von Ensingen's design. But, the inner wall of Hammer's tower core stands .707 × .750 = .530 units out from the centerline, instead of the .500 seen in Ulrich's north tower plan.

A crucial aspect of Hammer's drawing is that it appears to have two distinct sets of geometrical components, which interlock only at the tower center. The first, already described above, establishes the overall framework of the drawing through quadrature, octature, and subdivision, producing the sequence of dimensions 1.000, .924, .750, .707, .530. Continuing inwards in this manner, one can construct a small octagon framed by the facets of the .530 octagon; this new octagon will have a facial radius .220. An even smaller octagon inscribed within it by quadrature will have a facial radius of .155. The sequences of stair turrets then begin to radiate outwards from this central core. The stair turrets are shown as perfect hexagons, framed by rays extending outward from the inner core to the perimeter of the drawing. As Figure 4.93 shows, the innermost lines determining the size of the hexagons extend out from the facet midpoints on the .155 octagon. The thickness of the walls framing the stair turret sequences also matters to the composition, since extensions of these walls wrap in serpentine fashion back and forth between the hexagonal stair facets, thus determining the spacing between them. In Hammer's drawing the outer margins of these walls appear to converge to points .188 units out from the tower center, that is, halfway between the .155 and .220 octagons. With this wall thickness, the computer-drawn turret sequences in the figure quite precisely match those in the drawing.

86 The plan drawing discussed here is Strasbourg, Musée de l'Oeuvre Notre-Dame, inv. no. 12; see Schock-Werner, *Das Straßburger Münster*, pp. 182–4, 314–22. The corresponding elevation drawing holds inv. no. 7 in the same collection; see ibid., pp. 323–42. Velte mis-identified the plan drawing as inv. no. 16, analyzing it geometrically in *Die Anwendung der Quadratur und Triangulatur*, pp. 38–42 and Taf. III.

Many of the ideas seen in Hammer's drawing can also be traced in Hultz's design for the north spire, which is not surprising, given Hammer's obvious dependence upon that prototype. Indeed, the preceding analysis of Hammer's drawing makes it possible to construct a plausible step-by-step sequence for how Hultz could have designed the north spire, as Figure 4.94 shows. A crucial geometrical given for Hultz would have been the span from the center to the inner wall of the tower core, which is here called .500 units, using the same scale used to describe Ulrich von Ensingen's plan in Figures 4.83, 4.84 and 4.85. Taking this octagon as a starting point, Hultz evidently inscribed a circle within it, and then connected the resultant octature-determined points on the circle, as the vertical lines in Figure 4.94a show. Then he could have constructed a smaller octature figure within those framing lines, as in Figure 4.94b. As the numbers alongside Figure 4.94c indicate, the outer octagon would have facial radius .191 units, and the octagon and square inscribed within it would have facial radii of .171 and .135, respectively. These dimensions differ slightly from the .220, .188, and .155 seen in Hammer's drawing because of the different starting diameters and because of the use of octature rather than averaging to establish the penultimate figure, but the basic logic of the design is similar. And, the unfolding of the stair turret sequences out from this core proceeds just as in Hammer's drawing, as Figure 4.94c and 4.94d show. First, lines are constructed parallel to the rays to the corner of the octagon, departing in this case from points .135 and .171 units out from the tower center. Next, a shaded hexagon can be inscribed between the inner set of lines, with its inner corner touching the corner of the .191 octagon. Then, the thickness of the wall between the inner and outer sets of lines can be wrapped around the front of the shaded octagon, as in the lower-left quadrant of Figure 4.94d. Finally, this substructure can be copied six times in succession, pushing out towards the perimeter of the tower, as in the lower-right quadrant of the same graphic. When it is reflected around to produce a full plan with eight-fold symmetry, Figure 4.94e results. And, as Figures 4.94f and 4.95 show, this geometry perfectly matches that of Hultz's spire.

This analysis of the Strasbourg spire, and of the drawings associated with the great tower projects of the German world more generally, shows that even the most highly complicated works of the medieval architectural imagination can be understood in terms of a geometrically based design process, in which a fairly limited number of simple geometrical operations were combined to produce final forms of great complexity. Modular proportioning systems were often employed, especially in the initial phases of groundplan layout, but most of the subsequent steps in the design process appear to have involved quadrature, octature, corner-to-corner connection, and compass-based play. In the vertical dimension, the structures developed in the groundplan were often stacked, just as one might expect by analogy to the pinnacle design process described by Roriczer. But, again, the fine details of most of the tower elevations cannot all be explained in terms of modular stacking. More typically, the horizontal divisions in these great towers were set by the intersection of large-scale diagonals with many of the subsidiary vertical lines projected up from the groundplan. So, the sense that the elevations are generated by a process of *Auszug* or "pulling out" is very strong in these tower designs. Significantly, too, these tower designs attest to a striking degree of methodological continuity over the course of the whole Gothic era. Approaches to quadrature and stacking already seen in the Laon tower plans sketched by Villard de Honnecourt in the thirteenth century were

still being used not only in the workshops of Strasbourg, Cologne, and Freiburg around 1300, as described in Chapter 2, but also in the workshops of Prague, Vienna, Ulm, Regensburg, Frankfurt, and Strasbourg in the late fourteenth and fifteenth centuries.

Since the great tower and façade plans of the German world are the most spectacular architectural drawings of the Gothic era, they are well worth attention in their own right, but their study also has broader importance for the interpretation of Gothic design, in at least three major senses. First, of course, analysis of these drawings can shed light on the histories of the particular building projects with which they were associated, helping to make clear when and how the forms now seen in masonry were conceived. Second, the richness and coherence of the corpus of Germanic tower drawings makes this group an ideal sample set for the testing of geometrical hypotheses. Tower design was obviously a complex task, but it was also a crisply defined one, strongly constrained by notions of axial symmetry and the need for successive stories to align properly. Comparison of many different drawings reveals both the variations introduced by individual designers and the consistency of major geometrical themes, among them the fundamental importance of tower buttress axes. This means, in turn, that the Germanic tower drawings can act as geometrical Rosetta Stones, providing valuable evidence for design practices that may have been used in other regions and in other contexts. As the following chapter will demonstrate, there appears to have been strong methodological continuity not only in German Gothic tower design, but also in Gothic architectural culture as a whole.

CHAPTER FIVE
Wider Horizons

To put the previously examined German tower and façade drawings into context, this chapter will offer a broader but more scattered sampling of late Gothic drawings. To provide a typological complement to the discussion of full-scale towers, it will examine designs for two elaborate microarchitectural tabernacles and two building groundplans, all from the German world. To provide some geographical balance, it will consider two façade drawings from France and one from Belgium. Geometrical analyses of these drawings will reveal that the design principles illustrated at length in the previous chapters were by no means the exclusive province of German tower designers, but that they were widely understood and applied in building projects throughout the northern Gothic world.

TWO GERMANIC TABERNACLES

Spirelike microarchitectural tabernacles, like full-scale spires, were popular subjects for German late Gothic draftsmen. The formal and conceptual dialog between full-scale and miniature spires can be traced all the way to the origins of the Gothic style in the twelfth century. The first church spire worthy of the name, the south spire of Chartres Cathedral, already incorporated miniature spires at its base, and pinnacles would become ubiquitous elements of architectural articulation by the early thirteenth century. The rise of architectural drawing in this period also facilitated the translation of such architectural motifs into miniature forms in other media like goldwork, stained glass, and manuscript illumination, as already noted previously in the discussion of the Regensburg single-spired design. Another important impetus to the development of elaborate microarchitectural shrines came from the Church, whose promulgation of the feast of Corpus Christi after 1264 precipitated the development of microarchitectural tabernacles to house the blessed sacramental wafer. These sacrament houses already began to have spire-like forms by the late fourteenth century, but the real flourishing of the genre came in the fifteenth century.[1] The design of elaborate miniature shrines became a privileged site for the display of architectural imagination and virtuosity, and a case can even be made that the construction of such shrines became something of a surrogate for the construction of full-scale towers and spires.[2] Microarchitectural tabernacles were of course far less expensive than full-scale spires, and they were also far less constrained by gravity, since they were generally lightweight structures reinforced by attachment to the adjacent church walls. Since this

[1] Achim Timmermann has argued persuasively that this architectural celebration of the Eucharist may have been intended as a rejoinder to the Hussites. See *Real Presence*, esp. ch. 3.

[2] François Bucher, "Micro-Architecture as the 'Idea' of Gothic Theory and Style," *Gesta*, 15/1–2 (1976): 71–91.

meant that their creators could let their imaginations run wild, it is no wonder that tabernacle design became one of the most fertile areas of late Gothic architectural culture. And since tabernacle designs were often quite complex, it is fortunate that some surviving drawings in this genre include both plans and elevations; geometrical investigation of such drawings can shed more light on the logic of the design than investigation of plan and elevation fragments in isolation.

One particularly thorough drawing, which holds inventory number 16.828 in the Vienna Academy collection, includes not only a complete elevation, but also three plans (Figure 5.1).[3] The primary one shows the tabernacle's elaborate superstructure, and two smaller ones show the stories immediately below: the square plan of the corpus, the wafer-enshrining heart of the monument, appears in the lower-left drawing; and the octagonally symmetrical plan for the frieze of pointed arches that hangs down from the corpus appears at the lower right. The tabernacle superstructure exhibits four-fold symmetry, with four main buttress uprights flanking a central pinnacle of square plan; in the middle of the structure, however, an octagonally symmetrical corona of smaller pinnacles mediates between these elements. In these respects, the tabernacle in the drawing resembles the far more elaborate sacrament house of Ulm Minster, the largest such monument ever erected (Figure 5.2). And, while the circumstances of the drawing's production are not known, it does include a prominent mason's mark, also seen on a drawing from Darmstadt and dated to 1462.[4] All of this evidence suggests that drawing 16.828 was produced in the western reaches of the Empire in the third quarter of the fifteenth century.

In examining the geometry of 16.828, it makes sense to begin with analysis of its superstructure plan. Perhaps the most striking thing about this plan is the acute angle of the four main keels that extend to the outer buttress uprights. These measure around 70.5 degrees, an unusual angle that does not arise automatically by dividing a circle into any integer number of slices. This angle can, however, be produced by the simple construction shown in Figure 5.3a.[5] The horizontal baseline in that figure represents the width from corner to corner of the tabernacle, which will be called one unit. From the center of that baseline, diagonals can be struck until they meet arcs rising from the ends of the baseline. Drawing a horizontal line across the top of this composition, and then connecting the midpoint of that horizontal to the outer corners of the lower baseline, one finds that the resultant angles are 35.26 degrees, exactly matching the half-width of the keels. Verticals drawn down from the points where these sloping lines intersect the original diagonals then begin to frame the center of the composition. In particular, as Figure 5.3b shows, these vertical lines can be used to frame an octagon, which can in turn be circumscribed by a circle. Verticals rising from the equator of this circle intersect the original diagonals in points marked in the figure by heavy black dots; these dots represent pinnacles that sit at the junction between adjacent keels. The centerpoints of these pinnacles will rise to

3 Böker, *Architektur der Gotik*, pp. 97–101.

4 Achim Timmermann, "Vier kleinarchitekturrisse der Spätgotik," *Das Münster*, 55 (2002): 117–26.

5 This construction is equivalent to the one reproduced by Ueberwasser as fig. IId in "Der Freiburger Münsturm im 'rechten Maß'," 31. Ueberwasser relates this figure back to simple quadrature constructions shown by Villard de Honnecourt, but he also finds it in the so-called Basel Goldsmiths' drawings, which he discusses in "Spätgotische Baugeometrie: Untersuchungen an den Basler Goldschmiedrissen," in *Jahreberichte der Öffentlichen Kunstsammlung Basel*, 1928–30, pp. 79–122. The relevant figures are conveniently reproduced in Müller, *Grundlagen gotischer Bautechnik*, p. 113; and in Recht, *Bâtisseurs*, p. 454.

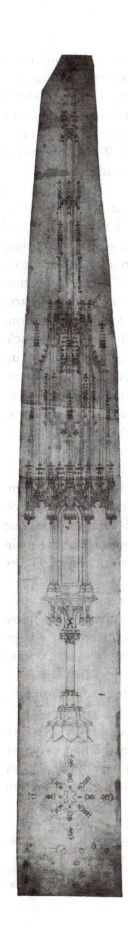

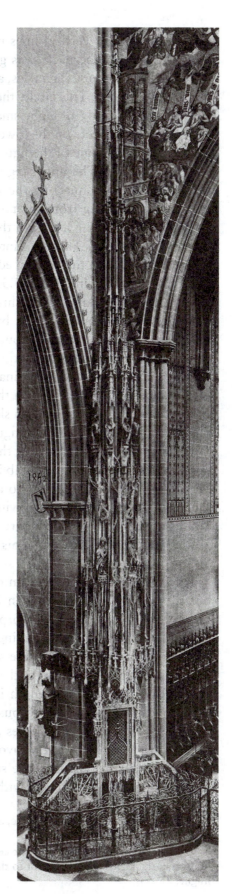

Figure 5.2
The
sacramental
tabernacle of
Ulm Minster.

Figure 5.2
The
sacramental
tabernacle of
Ulm Minster.

Figure 5.1
Drawing 16.828,
showing the plan
and elevation of
a sacramental
tabernacle
with four-fold
symmetry.

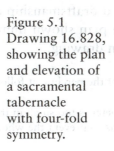

become important vertical lines in the elevation. Figure 5.3c shows how the innermost structure of the tabernacle was generated first by stepping out one more octature step from the lines to these pinnacles, and then by inscribing successive rotated squares within the resultant circle. This circle, the outer one shown in Figures 5.3c and 5.3d, also serves to locate the corona of eight small pinnacles around the tabernacle core; five of these appear as shaded dots on the lower half of the circle in Figure 5.3d. The Z-shape of heavy lines in the same zone of the figure, meanwhile, shows how more dimensions in the core were determined. The upper leg of the Z slices to the right, from the interior corner of the star octagon connecting the pinnacles in the corona. This horizontal intersects the diagonal descending from the tabernacle center to the lower right. The diagonal leg of the Z descends to the left from this intersection point, until it hits the vertical centerline of the composition. This final intersection point sets the size of a square whose bottom edge coincides with the bottom edge of the Z. The larger importance of this construction becomes apparent in Figure 5.3e, where an octagon is inscribed within this square. Diagonals extrapolated from this octagon bounce off the equator of the composition, forming a large double-square box that encompasses the lower half of the tabernacle core. Verticals rising from the outer edges of this box intersect the diagonals reaching up from the center of the composition, and then arcs sweep down to its equator, creating an overall shape just like the original one in Figure5.3a, but slightly larger. In Figure 5.3f, sloping lines struck down from the black dot on the top center of the figure parallel the sides of the original keel, with a slope of 35.26 degrees. These lines, which lie just outside the boundaries of the original figure, can be reflected about the original lines to create a third, inner, set of keel lines. At the center of the tabernacle, meanwhile, small circles can be hung on the previously established framework, completing the layout of the design. When this figure is reflected, to achieve the tabernacle's complete, four-fold symmetry, the result is Figure 5.3g. Removing all the construction lines from this composition, one arrives at the more legible Figure 5.3h, which perfectly matches the outlines of the main groundplan in the drawing. This alignment can be seen in the lower portion of Figure 5.4.[6]

The two plans at the bottom of drawing 16.828 are far simpler than the one above, but they relate to each other in interesting ways. The one at right, showing the frieze of hanging arches under the corpus, has perfect octagonal symmetry. Inscribing a large octagon within the circle framing its outer points, and then inscribing a square within that octagon, one finds that the sides of the square line up with the sides of the square corpus plan at left. The size of the cruciform support at the heart of the corpus, similarly, corresponds to the facet length in the outermost octagon at right. The overall size of the corner elements in the corpus appears to have been set by the relationship between these two squares, as the circles at the corners of the figure indicate; the fine structure of the corner mullions likely involved free-hand draftsmanship as well as many smaller circular constructions. Like the superstructure plan shown immediately above, both of these smaller plans align well with the elevation drawing.[7]

[6] In the right side of this graphic, a discoloration of the parchment follows the curve of the outer arc through the shrine corner.

[7] For some reason, however, the central shaft diameter is too small in the plan. It is possible that the draftsman thickened it when he got to the elevation, so as to prevent the whole structure from looking too fragile.

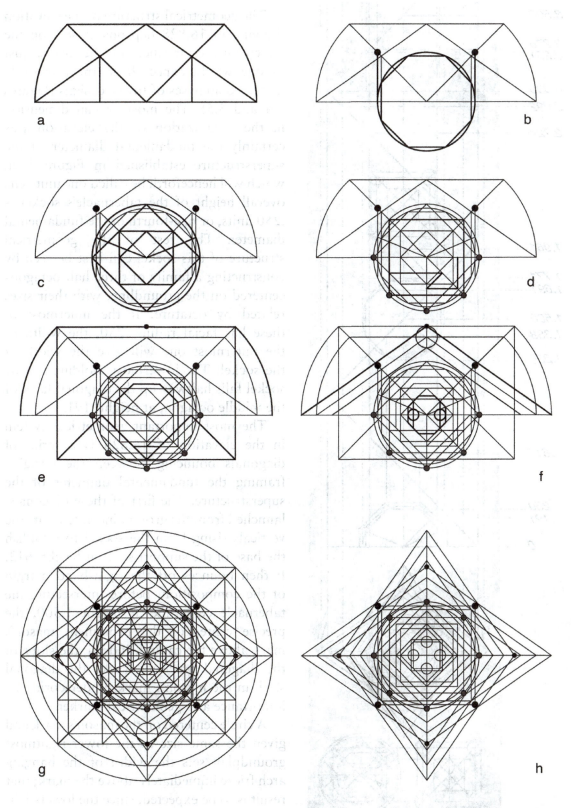

Figure 5.3 Hypothetical sequence of steps in the establishment of the superstructure plan for the tabernacle depicted in drawing 16.828.

Figure 5.4
Drawing
16.828, lower
portion with
geometrical
overlay.

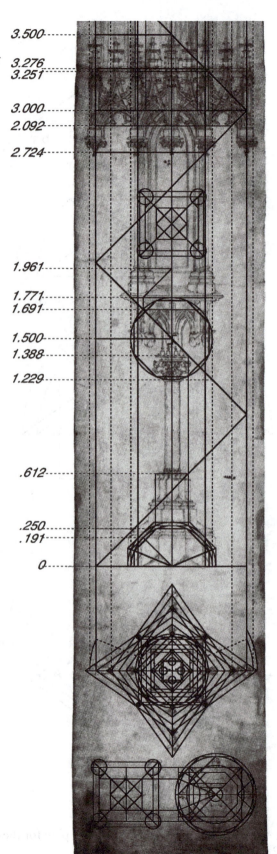

The geometrical structure of the elevation drawing in 16.828 depends closely on the dimensions established in the plans, just as one would expect from the previously discussed analyses of tower designs (Figures 5.4 and 5.5). The most crucial dimension in the organization of the elevation was certainly the fundamental diameter of the superstructure established in Figure 5.3a, which will henceforth be called one unit. The overall height of the tabernacle's sockel is .250 units, or one-fourth of the fundamental diameter. The rest of the geometrical structure of this sockel can best be seen by constructing a family of three half-octagons centered on the groundline, with their sizes related by octature. If the innermost of these has facial radius .250, the width of the outermost one will give the width of the sockel. The lowermost molding on the sockel falls halfway up the diagonal facet of the middle octagon, at height .191.

The most important geometrical system in the elevation of 16.828 is a series of diagonals bouncing between the uprights framing the fundamental diameter of the superstructure. The first of these diagonals, launched from the groundline at left, hits the verticals rising from the sockel to establish the base of the support shaft at height .612. It then bounces off the right-hand margin of the composition, before intersecting the tabernacle centerline at height 1.500, the precise center of the prominent mason's mark above the capital. Indeed, the slope of the diagonal precisely tracks the diagonal slash in the mason's mark, underscoring its importance as a geometrical marker.

A circle centered on the mason's mark and given the same size as the lower rightmost groundplan sets the width of the hanging arch frieze immediately above the mark; that result is to be expected, since the lower-right plan depicts this level. But this construction also works in the vertical dimension. The

circle's base locates the top of the column at height 1.229, and its top locates the base of the corpus at height 1.771. The lower corner of the octagon inscribed within the circle establishes the top of the column capital at height 1.388. The circle intersects the main diagonal at height 1.691, at the top of the small hanging arches. A small diagonal struck from the corpus baseline just above this intersection point meets the tabernacle centerline at height 1.961, locating the base of the central panel in the corpus. The width of this panel precisely matches that specified in the plan at lower left, as the overlaid schematic in this zone of the elevation indicates.

The importance of the main diagonal system becomes particularly clear in the zone where the wreath of arches establishes the full width of the superstructure above the corpus. The principal diagonal hits the right margin of the composition at height 3.000, the top of the wreath arches. Along the way, at height 2.724 it intersects the vertical rising from the interior corners of the superstructure. This point and the others adjacent to it on the main vertical axes locate the dangling bosses under the wreath; five of the eight bosses are visible in the front view shown in the elevation. The intersection of the main diagonal with the dotted secondary vertical sets the springline of the wreath arches above their imposts at height 2.092. The outermost dotted verticals, meanwhile, frame the outer edges of the pinnacles in the wreath.

Above the level of the wreath, the principal diagonal continues to bounce, but it does so against a slightly different set of vertical lines, since the octagonal geometry of the inner shrine core begins to matter at this point. This geometry is reproduced explicitly between levels 5.500 and 5.743, where small dots indicate the location of pinnacles; thin verticals descend from these dots to level 3.000. The principal diagonal crosses the outermost of these pinnacle lines at height 3.251, establishing the height of the arches in the wreath. Just a bit higher, at height 3.276, the diagonal crosses the main vertical rising from the corner pinnacles below; this level marks a suture between two parchment pieces in the drawing. The small pinnacles of the wreath zone terminate at height 3.500, where the diagonal crosses the centerline. Slender buttress uprights rise from the wreath, with prominent punctuation points at height 3.724, where the diagonal crosses main uprights on the left side. The pinnacles on the uprights begin at height 4.000. The principal diagonal then crosses, in rapid succession, the dotted vertical rising from the shrine base, the solid centerline of the main bosses, and the axis of the inner pinnacle in the upper shrine core, at heights 4.229, 4.276, and 4.328, respectively. These levels correspond to the base, midline, and tip of the finials on those pinnacles.

As the outer uprights terminate, the geometrical structure of the innermost and uppermost pinnacle begins to become relevant. The quadrature-based plan of this zone was already established in the bottom-left plan in the drawing, and its core is reproduced in the elevation centered at height 6.000; from there, four closely spaced vertical lines descend to level 4.000. The main diagonal crosses these lines at heights 4.571 and 4.621, the base and midline of the large pinnacle bases on the remaining major uprights. The diagonal then crosses previously established verticals at heights 4.672 and 4.724, defining the top of those pinnacle bases and the intersection of the flyers from the uprights to the core, respectively. The pinnacles begin to taper at height 4.902, where the diagonal cuts the outer dotted vertical, and they terminate at height 5.229, where the diagonal passes back across the inner dotted vertical after bouncing at height 5.000. The smaller pinnacles

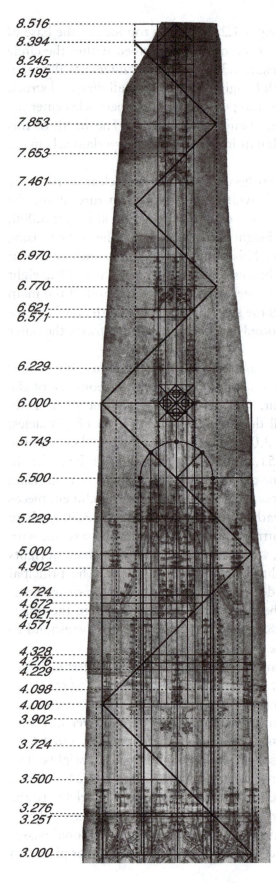

Figure 5.5
Drawing 16.828, upper portion with geometrical overlay.

of the inner core, meanwhile, terminated at height 5.500. The upper pinnacle cluster, with its square plan, rises above this corona. A prominent horizontal molding punctuates this upper cluster at height 6.000.

The geometrical structure of the drawing changes markedly above height 6.000, where the tapering parchment becomes too narrow to include the main framing verticals that govern the composition in its lower reaches. So, the principal diagonal now begins to bounce between the two more closely spaced dotted verticals that rise from the shrine base. The first intersection of the diagonal with these verticals falls at level 6.229, where small sub-pinnacles on the square-planned central pinnacle begin to taper. The diagonal hits the dotted line on the other side of the drawing at height 6.770, where another set of sub-pinnacles begin to taper, at the top edge of a small set of ogee arches. The base of the ogee arches and a molding immediately beneath them fall at height 6.621 and 6.571, where the main diagonal cuts the slender solid verticals of the central pinnacle. An analogous intersection above the next "bounce" of the diagonal locates the tips of the sub-pinnacles at height 6.970. Very similar intersections at heights 7.461, 7.653, and 7.853, respectively describe the final sub-pinnacles and ogee arches in the zone where the central sub-pinnacle starts to taper. And, at the top of the drawing, intersections at levels 8.195, 8.245, and 8.394 define the structure of the collar and floral finial that occupy the pinnacle tip. Another half-square within the solid verticals of the pinnacle core then frames the last bits of the finial, bringing the total height of the elevation to 8.516 units. The parchment is sharply cut off at this level, and its upper right-hand corner coincides precisely with the dotted vertical used to frame

the bouncing principal diagonal above height 6.000. Here, once again, the trimming of the parchment evidently reflects attention to the geometrical structure of the drawing.

In both formal and conceptual terms, therefore, tabernacle drawing 16.828 closely resembles the tower drawings analyzed in previous chapters. In all these cases, the generation of the groundplan clearly preceded the development of the elevation, since the heights in the elevation can be established only by using verticals extrapolated from the groundplan. The tabernacle of course lacks the principal buttresses typical of full-scale towers, and this makes it more difficult to study the geometry of its plan, but once the plan has been understood, analysis of the elevation proceeds just as with designs for full-scale structures. The shift to progressively narrower axes was seen not only in 16.828, but also in many tower and spire drawings. The shape and placement of the mason's-mark shield in 16.828, moreover, offers valuable evidence for the use of "bouncing diagonal" constructions similar to those evidently used in tower design. With its mix of straightforward plan and elevation views, finally, 16.828 belongs firmly within the main population of Gothic architectural drawings, in which the objective display of geometric information mattered more than subjective appeals to the perspective of the viewer.

By the late fifteenth century, though, some Gothic draftsmen were beginning to introduce perspectival visual cues into their drawings, and tabernacle designers were among them. One of the most interesting of these quasi-perspectival tabernacle drawings, which bears inventory number 16.838 in the Vienna Academy collection, shows a snowflake-like hexagonally symmetrical groundplan surmounted by a partial elevation of the corpus shrine and superstructure presented as if seen in a raking angle from below (Figure 5.6).[8] The side facets of the hexagonal corpus thus slope down to the sides of the drawing, while the central facet is presented frontally. Since almost all tabernacles of this type had elaborate bases supporting the corpus, the omission of the base in the drawing may reflect the draftsman's realization that this element would typically be seen from above, while the corpus and superstructure were seen from below. No comparable rationale explains the truncation of the drawing's upper portion, which is probably just the result of the drawing's dismemberment at some point in its long history. Some idea of the structure's planned appearance can be gained by considering the hexagonally symmetrical sacrament house of St. Elizabeth in the Silesian city of Wrocław erected between 1453 and 1456 by Jodokus Tauchen, and the slightly later one of Saint Nicholas in the Bohemian town of Znoimo, for which the Viennese drawing may be an early study.[9] All of these designs should be understood as emanating from the architectural culture of the Viennese Stephansdom workshop, which was dominated by Hans Puchsbaum and Laurenz Spenning in the middle decades of the fifteenth century. The dramatic perspective cues seen in 16.838, though, are not seen in any of the drawings for the Stephansdom's north tower, so the tabernacle drawing should probably be seen as a slightly later and more experimental offshoot of this workshop tradition.

The geometrical construction of tabernacle 16.838, like that of all such structures, surely began with the groundplan, where no perspectival cues complicate the picture. Figure 5.7 shows a sequence of successive steps that generate all the details of this plan. First, the overall snowflake shape of the plan is established by inscribing two triangles

8 Böker, *Architektur der Gotik*, pp. 122–3.
9 Timmermann, *Real Presence*, ch. 3.

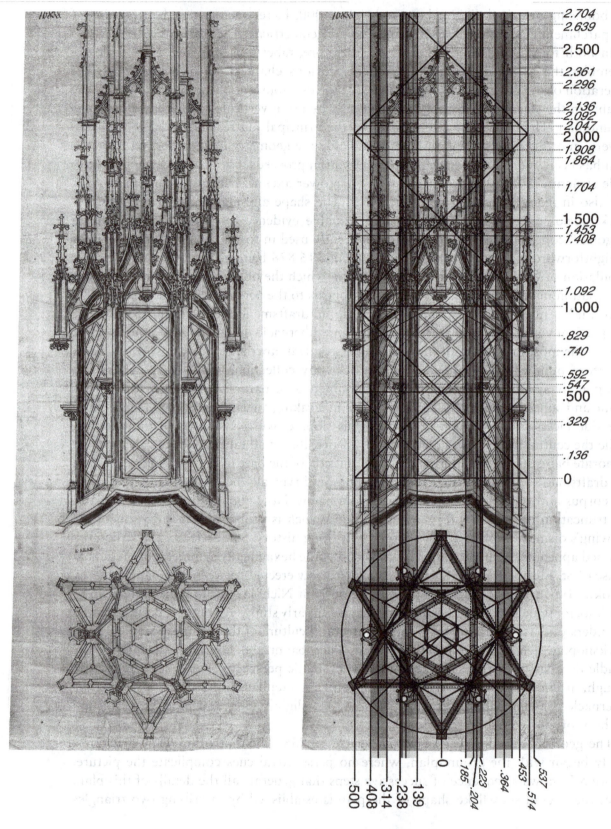

Figure 5.6 Drawing 16.838, showing the plan and elevation of a sacramental tabernacle with hexagonal symmetry. At right, the same drawing with geometrical overlay..

within the framing circle of the composition; these lines are shown solid in Figure 5.7a. The next important item to be set was the thickness of the main buttresses, which are shown as small squares on the perimeter of the framing circle. Shaded dots on their front faces begin to project this crucial dimension into the interior of the composition. Two sets of dotted triangles flank the original solid triangles; the inner dotted lines converge to the front face of the shaded dots, while the outer lines are tangent to the outer surface of the dots. The area between these dotted lines, which appears shaded in the upper portion of Figure 5.7b, describes the basic buttress frame of the tabernacle.

Three subsidiary constructions can then be easily established on this frame. First, as the left side of Figure 5.7b shows, a large hexagon can be established by drawing a vertical through the area where the shaded parts of the buttress frame cross each other; these points are picked out in the graphic with small open circles. The lines in this hexagon will go on to describe ribs in the small triangular vaults that cover each satellite canopy in the tabernacle. Meanwhile, the right-hand side of Figure 5.7b shows the generation of the smaller shaded hexagon that describes the middle stories of the tabernacle core. The inner surfaces of the hexagon can be found very simply by inscribing a snowflake within the hexagon defined by the original buttress centerlines. The outer surfaces are then found by giving the figure the same thickness as the original shaded buttresses; the open circles in the lower-right quadrant of Figure 5.7b show this relationship. Figure 5.7c shows a fully symmetrical view of the plan with these elements in place, along with the third construction: a small central snowflake inscribed between the inner surfaces of the shaded hexagon. The hexagonal central core of the tabernacle is larger than the hexagonal core of this inner snowflake by a "hexature" relationship, a fact that may be more clearly seen in the larger Figure 5.7d at upper right.

With this basic armature established, it becomes possible to develop the geometries of the remaining details in the groundplan. At the equator of the large outer snowflake, for example, small hexagons represent two of the canopies flanking the main shrine. The centers of these hexagons are located by first striking diagonals out to the original framing circle of the composition, and then drawing verticals from those intersection points up to the figure's equator. The outer facets of the hexagons can then be located by drawing verticals to connect the inboard corners of the outer snowflake frame; the whole canopy is then enlarged by a single hexature expansion. Squares inscribed in the inboard halves of these canopies describe the outer buttress uprights rising alongside the shrine core. The sloping solid lines connecting the inboard faces of these uprights to the shaded hexagon of the core represent the flying buttresses leaping between these inner and outer shells, while the small squares at the intersection points represent the inner uprights. Figure 5.7e shows the full groundplan of the tabernacle, with the canopies now present at all six corners, and with all the construction lines removed to give a figure that matches the plan in the drawing.

The lower right of Figure 5.6 shows that this match to the original drawing is quite precise, and it adds the quantitative labels that are helpful in describing the extrusion of the plan into the elevation. Here, the four most important dimensions for interpreting the elevation are the distances to the interior and exterior faces of the buttress clusters that are shown shaded in the figure; there appear to be two clusters on each side of the composition. Calling the side length of one of the original generating triangles one unit,

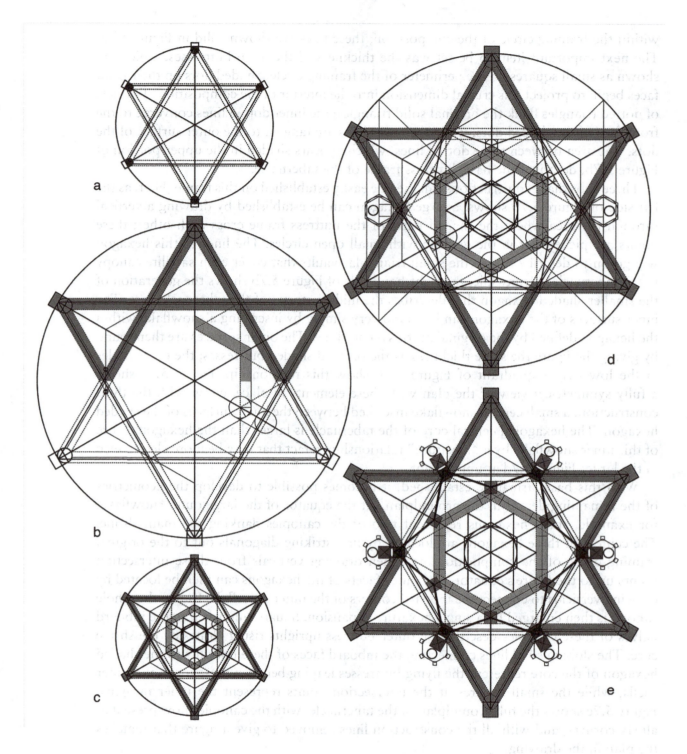

Figure 5.7 Hypothetical sequence of steps in the establishment of the plan for the tabernacle depicted in drawing 16.838.

the distances from the centerline to the interior and exterior edges of the first cluster are .139 and .238 units respectively, while the analogous distances for the outer clusters are .314 and .408 units. It is important to realize, though, that the inner cluster really represents elements in two different planes. The first set of uprights, in the foreground, rises directly over the hexagonal canopies joined to the large generating snowflake frame. These uprights fill the space between .139 and .223 from the centerline, with a salient corner toward the viewer .185 from the centerline. The second set of uprights, in the background, rises alongside the hexagonal inner core, so that only a small edge peeks out behind the first set, filling the space between .233 and .238. Since these intervals are so close to one another, it would be difficult to properly interpret the spatial implications of the elevation if the groundplan were not visible immediately below. More readily interpretable are the corners of the snowflake pattern, where the outboard faces of small pinnacles fill the space between .514 and .537 from the centerline.

With this information about the tabernacle's groundplan established, it becomes surprisingly easy to analyze its elevation, since the quasi-perspectival cues in the drawing do not intrude on its basic geometrical organization, which involves the same kind of module stacking and diagonal bouncing seen in more conventionally orthogonal tower and tabernacle designs. Indeed, the elevation of 16.838 is basically just a stack of square modules where all the horizontal divisions are determined by intersecting one set of main diagonals with the many verticals rising from the groundplan. The geometrical baseline of the composition, here labeled height 0, is the base of the corpus, as seen on its front face. The quasi-perspectivally slanting lateral faces were described simply by striking lines down with 30-degree slope; the scooped curvilinear base beneath the corpus appears to have been drawn freehand. The grille on the front face of the corpus rises from height 0 to 1.000, and the foliate corbels that flank it fall at height .500; the outboard corbels are at height .329, thanks once again to the 30-degree slope down the outer corpus facets. The tips of the outboard pinnacles fall at height 1.500, as does the top of the shaft of the analogous pinnacle on the center axis, closest to the viewer. The base of this pinnacle falls at height 1.092, where the diagonals of the second square cut the outer margins of the shaded buttress uprights. The analogous intersection at height 2.092 sets the level from which the outer tier of flying buttresses springs inward. The inner tier of flying buttresses converges to a point at height 2.500 on the central axis, which is marked by a horizontal molding. These two tiers of buttresses in the drawing actually represent just one set of flyers in the structure; they are represented at different heights only because of the quasi-perspectival lifting of the centerline with respect to the sides. Similar diagonal "slippage" would no doubt have been evident in the now-lost upper portion of the drawing.

Analysis of tabernacle drawing 16.838 shows, then, that its draftsman created his quasi-perspectival effects by introducing slight permutations into the traditional Gothic system of *Auszug*, or geometrical extrapolation from the groundplan into the elevation. This approach has virtually nothing in common with the Italian approach to linear perspective, and it cannot even be seen as corresponding precisely to the more impressionistic perspectival realism achieved by northern painters like Jan van Eyck and his successors. Both of those pictorial approaches change the relative scales of objects to indicate their distances to the viewer, but the geometry of 16.838 does not do this. Significantly, though, the draftsman in 16.838 really was adjusting his geometrical

system, rather than simply drawing perspectival details onto a completely orthogonal geometrical framework. In this respect 16.838 can be compared to a modern isometric drawing, which blends information from the plan and elevation while keeping relative scales constant. But the tabernacle drawing differs from modern isometries, since the adjustments to its geometry were not fully systematic. Small wonder, then, that this quasi-isometric approach to projection remained relatively rare and experimental even at the end of the Gothic era, being confined mostly to small drawings of microarchitectural details. Drawing 16.838 is actually one of the larger and more impressive works in this genre. Even in the late fifteenth century, when there was a clear and growing interest in the representation of the third dimension, the real work of Gothic design remained most closely associated with the development of two-dimensional schemata, especially groundplans.

BUILDING GROUNDPLANS

Given the fundamental importance of groundplans in the Gothic design process, it might at first appear surprising that groundplans of complete buildings and their larger subsections do not figure more prominently in the corpus of surviving Gothic drawings. Several principal factors help to explain this. First, there is the simple fact that wholesale reconstruction of great public buildings was undertaken only quite rarely, while additions were made to them rather frequently. In statistical terms, therefore, it is not surprising that few Gothic drawings represent complete buildings. This distribution is further skewed by the fact that so many of the surviving Gothic drawings come from the late Gothic world of the Holy Roman Empire, where additions to existing churches were typical, rather than from thirteenth-century France, where Gothic rebuildings were often more globally planned. Since groundplans were not easily legible to patrons and to the public, they were rarely produced as lavish presentation drawings in the way that elevations of towers, façades, and tabernacles often were. This relatively low status doubtless contributed to their low survival rate.

Despite these problematic circumstances, groundplans survive in sufficient numbers to demonstrate their use by and importance for Gothic builders. The portfolio of Villard de Honnecourt includes many groundplan drawings, especially of east ends and ambulatories, like the plan of Cambrai Cathedral briefly considered in Chapter 1. Villard's sketches cannot plausibly be seen as real workshop drawings, but their very existence provides indirect evidence for the use of such drawings among thirteenth-century French builders. Further such evidence comes from the survival of fourteenth-century copies of the choir plans of Notre-Dame in Paris and the cathedral of Orleans.[10] The plans for the Duomo Nuovo of Siena provide strong evidence for the use of geometrically based groundplan design in fourteenth-century Italy, as noted in Chapter 3. Groundplans of a rather different sort also survive for the Cathedral of Milan, as a following chapter will explain, and for the very late Spanish cathedrals of Salamanca, Seville, and Segovia. But, as with other categories of Gothic drawing, the German world preserves the greatest number of

[10] See Otto Kletzl, "Ein Werkriss des Frauenhauses in Strassburg," *Marburger Jahrbuch für Kunstwissenschaft*, 11–12 (1938–39): 103–58.

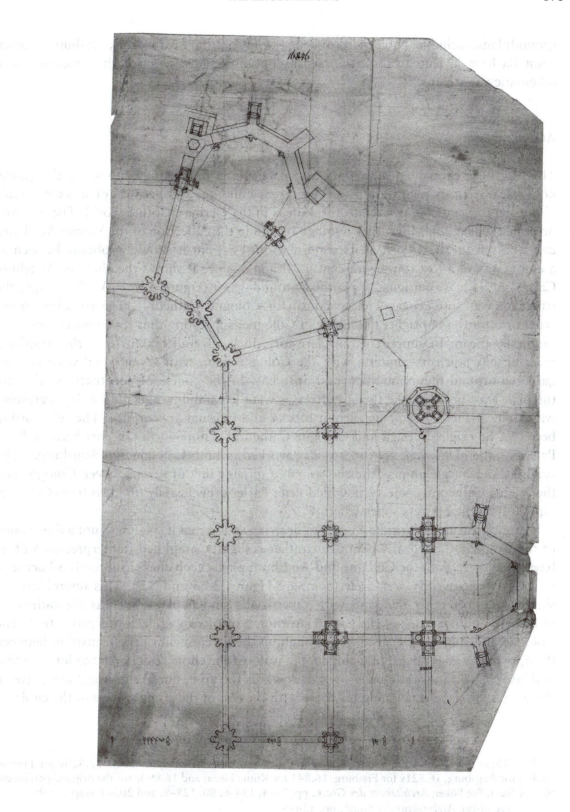

Figure 5.8 Drawing 16.846, showing the ground plan of Augsburg Cathedral as originally planned.

groundplans, including choir plans of Prague and Augsburg cathedrals, Freiburg Minster, Saint Barbara in Kutna Hora, the parish church of Steyr, along with numerous more schematic vault plans.[11]

AUGSBURG

The Augsburg choir plan stands out as a particularly interesting example of this genre, both because of its relationship to the present building, and because of what it reveals about the transmission of architectural ideas in the German Gothic world. The drawing on paper, which holds inventory number 16.846 in the collection of the Vienna Academy, dates only from the 1490s, as its watermark attests, but it should probably be seen as a close copy of a lost fourteenth-century original, since it shows the choir of Augsburg Cathedral as it was originally planned around 1350 (Figure 5.8).[12] At that stage, the structure was foreseen as a close cousin of Cologne Cathedral. The drawing shows cruciform buttress uprights like those in Cologne, suggesting that flying buttresses were originally meant to support a tall clerestory. In its overall layout, too, the Augsburg drawing has much in common with the Cologne plan, with seven equal-sized chapels gathered around the ambulatory and apse bay. In the course of construction, though, the plan was modified, the flying buttresses were left unbuilt, and only a tiny clerestory was built, giving the choir its current blocky and unusual appearance. The relationship between the original design and Cologne Cathedral is noteworthy in part because Peter Parler's father, Heinrich, appears to have worked in both Cologne and Augsburg.[13] The original Augsburg plan may thus be seen as a missing link of sorts between Cologne and the Prague Cathedral projects, in which Peter Parler drew heavily on ideas from Cologne, especially in the buttress superstructure.

Geometrical analysis of the Augsburg drawing shows that its plan was not a direct copy of the Cologne Cathedral scheme, but rather a slightly simplified reinterpretation of its basic themes. In both the Cologne and Augsburg plans, each chapel subtends 30 degrees, or exactly one-twelfth of a circle (compare Figures 2.26 and 5.9). This resemblance is significant, since other buildings with superficially similar plans, such as the cathedrals of Amiens and Beauvais, or the Cistercian church of Altenberg, lack this geometry.[14] The Cologne and Augsburg plans differ, though, in their treatment of the transition between the apse and straight bays. In Cologne, the walls of the choir vessel opening into the first and last chapels are subtly bent inwards towards the apse, but in the Augsburg drawing these bays are unbent, aligning precisely with the rest of the straight bays in the choir.

[11] These plans, all in the Vienna Academy collection, have inventory numbers 16.820v for Prague, 16.846 for Augsburg, 16.821v for Freiburg, 16.841 for Kutna Hora, and 16.890v for the original parchment plan of Steyr. See Böker, *Architektur der Gotik*, pp. 73–4, 134–6, 80, 128–9, and 203–5, respectively.

[12] See Böker, *Architektur der Gotik*, pp. 134–6.

[13] Böker, *Architektur der Gotik*, pp. 134–6. See also Marc Carel Schurr, "Heinrich und Peter Parler am Heiligkreuzmünster in Schwäbisch Gmünd," in *Parlerbauten: Architektur, Skulptur, Restaurierung* (Stuttgart, 2004), pp. 29–37; and idem, "Die Erneuerung des Augsburger Domes im 14. Jahrhundert und die Parler," in Martin Kaufhold (ed.), *Der Augsburger Dom im Mittelalter* (Augsburg, 2006), pp. 49–59.

[14] Lepsky and Nussbaum, *Gotische Konstruktion und Baupraxis*, pp. 42–58.

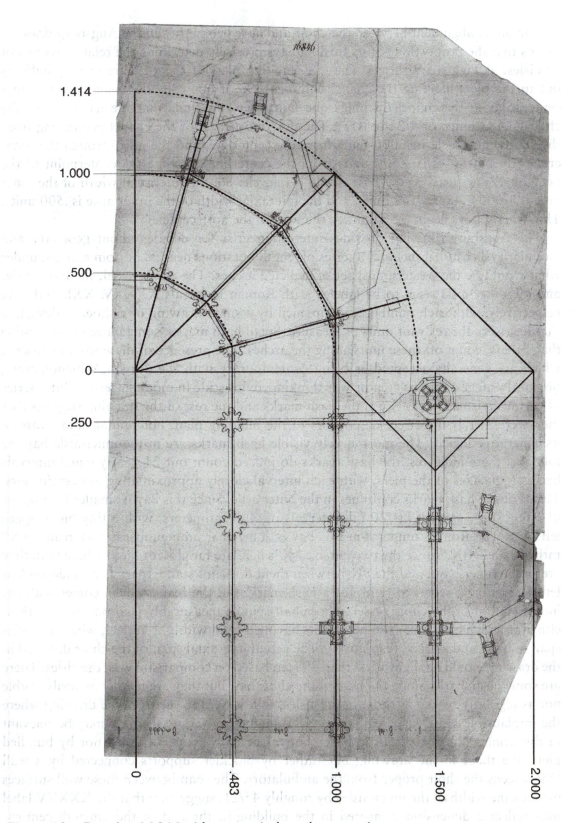

Figure 5.9 Drawing 16.846 with geometrical overlay, stage 1.

The direct alignment between the choir and apse geometries in the Augsburg drawing means that the proportions of its turning bays precisely determine the relative widths of its aisles, as Figure 5.9 shows. The free-standing piers of the apse are exactly halfway out to the piers flanking the chapel entrances. So, if one calls the span from the apse centerpoint to the chapel openings one unit, then one finds that the half-span of the choir is .483 units, or 1/2 × cos15°. The outermost facet of the chapel protruding from the south choir aisle is 2.000 units from the centerline, and the axis through the outer cruciform buttresses is 1.500 units from the centerline, just like the centerpoint of the octagonal stair turret at the base of the hemicycle. So, the interaxial width of the inner aisle is 1.000 – .483 = .517 units, and the interaxial width of the outer aisle is .500 units. The straight bays begin .250 units to the west of the apse center.

The Augsburg drawing provides interesting grist for debates about geometry and modularity, because it includes a series of length notations near its bottom margin, under what would be the westernmost set of depicted arches. The choir vessel, the inner aisle, and the outer aisle seem to be labeled with Roman numerals XXXXV, XXI, and XIX respectively, with each number accompanied by a small drawing of a shoe, to designate that feet were the relevant units of measure. Small hash marks, some more clearly visible than others, count off these units along the arches. The presence of these length markers, which are generally accepted as being contemporary with the drawing's manufacture, obviously suggest that its creator was thinking about scale in modular terms. But a series of curious mismatches between the hash marks and the rest of the drawing suggests that they were merely imperfect descriptors of the building plan, not fundamental parts of its generative logic.[15] The most clearly visible hash marks are in the inner-aisle bay. As the label there indicates, the hash marks do indeed count out 21 nearly equal intervals between the axes of the piers, with each interval closely approximating .41 centimeters. This series of hash marks continues in the outer aisle. Since this bay is smaller by a factor of .500/.517 = .965, it fits 20 full intervals of .41 centimeters, with a tiny bit of space left over. The Roman numeral in this bay is somewhat ambiguous; it may read "XX" rather than "XIX," since the two cursive "X"s here are far closer together here than they are in the other bays, and the "I" between them does not stand apart as an independent letter; it actually seems to reinforce a hash mark. But the real problem comes with the interpretation of the choir vessel, whose half-span is measurably less than the width of either aisle, which is inconsistent with its having a total width of 45 feet, when the aisles span only 21 and 20 feet, respectively. The actual interaxial span of the choir depicted in the drawing would be slightly less than 39 feet, based on comparison with the aisles. There are some hash marks along the base of the choir bay, but they are neither as easily visible nor as regularly spaced as those in the aisles, so it is hard to see from the drawing where the implausible but clearly legible XXXXV might have come from. It may be relevant in this connection that the Augsburg choir as actually built is framed not by bundled piers like those in the drawing, but rather by blockier supports connected by a wall that screens the choir proper from the ambulatory. The span between these wall surfaces exceeds the width of the inner aisles by roughly 45/21, suggesting that the XXXXV label may reflect a dimension measured in the building at the end of the fifteenth century,

[15] Böker takes these numbers at face value in *Architektur der Gotik*, pp. 134–6, without commenting on the mismatch to the proportions of the depicted structure.

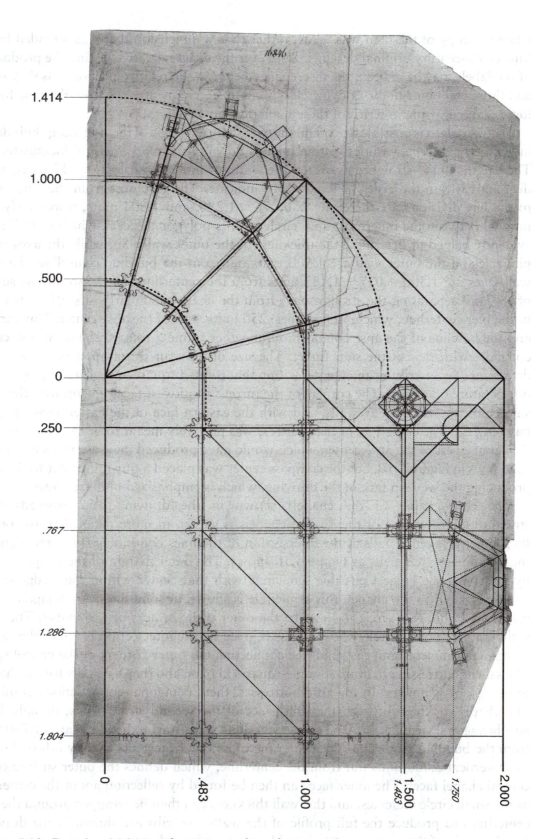

Figure 5.10 Drawing 16.846 with geometrical overlay, stage 2.

when the copy of the plan was made, rather than a dimension that was intended by the fourteenth-century original designer. Whatever the exact narrative behind the production of the labels may have been, the discrepancy between the relative proportions they imply and those embodied in the drawing clearly complicates any attempt to explain the formal logic of the drawing in terms of these numerical notations.

Fortunately, it is possible to explain the overall formal logic of the Augsburg choir design in geometrical terms without getting bogged down in these arithmetical inconsistencies. The lengths of the straight bays equal the width of the inner aisles, or .517 units, as the diagonals within the aisles in Figure 5.10 indicate. The distances from the apse center to the bay divisions are therefore .250, .767, 1.286, and 1.804 units, respectively. The interval between the innermost apse circle and its polygonal facets, which is .017 units, evidently helped to determine the thickness of the outer walls. So, while the axes of the pinnacles on the outer wall are 1.500 units out from the building centerline, the inner wall faces are 1.500 - .017 = 1.483 units from the centerline. The westernmost surface of the wall separating the straight bays from the chapels, similarly, sits .017 units west of the pier centerline, which, in turn, lies .250 units west of the apse center. This surface, and the baseline of the apse composition, together frame a rotated square whose center coincides with that of the stair turret. The size of the stair turret appears to have been determined by inscribing an octagon within that rotated square and then stepping out via one octature operation. The corners of the turret's southwest facet line up with the outer surface of the straight-bay walls, and with the eastern face of the easternmost straight-bay buttress. The centerline of that buttress was probably meant to be the pier centerline .250 units west of the apse center, which would have produced the western face shown in solid lines in Figure 5.10, but the compass center was placed a tiny bit further to the west, producing the western face in the drawing, which is emphasized in dotted lines.

The construction of the chapels shown in the drawing also proceeds fairly straightforwardly. One of the apsidal chapels is shown in more detail than the others. Its geometrical center falls at the intersection of the lines continuing the entry arches of the two adjacent chapels, as Figure 5.10 shows. The outer margin of the chapel was set by inscribing the biggest possible semicircle with that center within the wedge-shaped space allocated to the chapel; this semicircle is shown in solid lines. An octagon can be inscribed within that circle to describe the outer wall surfaces of the chapel. The inner walls frame a dotted circle whose radius is given by the intersection between the rays of octagonal symmetry and the solid line connecting the outer corners of the chapel space. The salient buttresses are simple double-squares in plan, and they naturally follow the rays of octagonal symmetry. In the apse buttresses, then, octagonal constructions dominate. The chapel sticking out from the south face of the second straight bay, though, has a half-hexagonal termination. The centerlines of its walls start to bend inwards 1.750 units from the building centerline. The centerline of its outer facet sits slightly inboard of the main vertical 2.000 units out from the centerline, which defines the outer surface of the central chapel facet. The inner face can then be found by reflection about the centerline, as the small circle indicates, and this wall thickness can then be wrapped around the wall centerlines to produce the full profile of the walls. No ribs are shown in the drawing, but the angle of the westernmost chapel buttress, at least, lines up with the angle created by the dotted X inscribed within the outboard half of the chapel's first bay. If the center

of this X was taken as the boss of a unified chapel vault, this arrangement would have provided some visual integration between the components of the chapel.

STEYR

Comparison between the Augsburg drawing and the plans for the parish church of Steyr helps to document the strong continuity of design method between two very different phases of Germanic Gothic architecture. The Augsburg drawing, as noted previously, appears to record a mid-fourteenth-century scheme in which the cathedral would closely resemble Cologne Cathedral and its French antecedents, with radiating apsidal chapels, a basilican elevation, and simple quadripartite vaults. The parish church of Steyr, by contrast, was planned roughly a century later, and it features three apses in echelon, a hall church elevation, and complex net vaults (Figure 5.12). The overall outlines of the design were surely determined by Hans Puchsbaum, who initiated construction of the church in 1443 before going on to take over leadership of the Stephansdom workshop in Vienna. Puchsbaum, however, likely foresaw simpler vaults than those seen in the choir today. The planning for the vaults is recorded in three drawings in the Vienna Academy, which Hans Böker has persuasively dated to the 1460s, attributing them to Puchsbaum's successor Laurenz Spenning. Drawing 16.890v, which was executed on parchment, was probably Spenning's original vault design drawing, on which attention will focus here (Figure 5.11). The nearly identical 17.052 and the more fragmentary 17.029 were copies drawn on paper. The scale match between all three versions provides reassuring evidence for the dimensional stability of Gothic drawings. Further refinements were introduced between the production of these drawings and the construction of the church's vaults, where new patterns are seen in the aisle bays.[16]

One thing that the Augsburg and Steyr plans have in common with each other, and with many of the other surviving groundplans from the Germanic world, is that they show structures with no visible transept. This is noteworthy because it means that their proportions cannot have been folded out from the central crossing square in accord with the procedure that Stephen Murray, Linda Neagley, and Michael Davis have discerned in the groundplans of French buildings such as Amiens Cathedral, Saint-Urbain in Troyes, and the churches of Saint-Ouen and Saint-Maclou in Rouen.[17] In the case of the Augsburg plan, at least, the relative proportions of the choir and its aisles appear to have unfolded instead from the geometry of the east end, and a similar procedure seems to have governed the Steyr plan, as well, as the following discussion will demonstrate.

The crucial geometrical seed for the development of the Steyr design appears to have been the octagonal geometry of the main apse, which relates intimately to the structure of the choir aisles. As Figure 5.13 shows, the outer walls of the apse stand 1.082 times as far apart as the axes of the choir aisles, forming a perfect octature relationship. These outside surfaces can then be projected westward to define the outer surfaces of the arcade walls. The inner surfaces are found by reflection about the arcade centerlines. So, calling the half-span of the main vessel one unit, the distance from the building centerline to the

[16] Böker, *Architektur der Gotik*, pp. 203–5, 340, 367, and 25.

[17] Murray, *Notre-Dame, Cathedral of Amiens*; and Davis and Neagley, "Mechanics and Meaning."

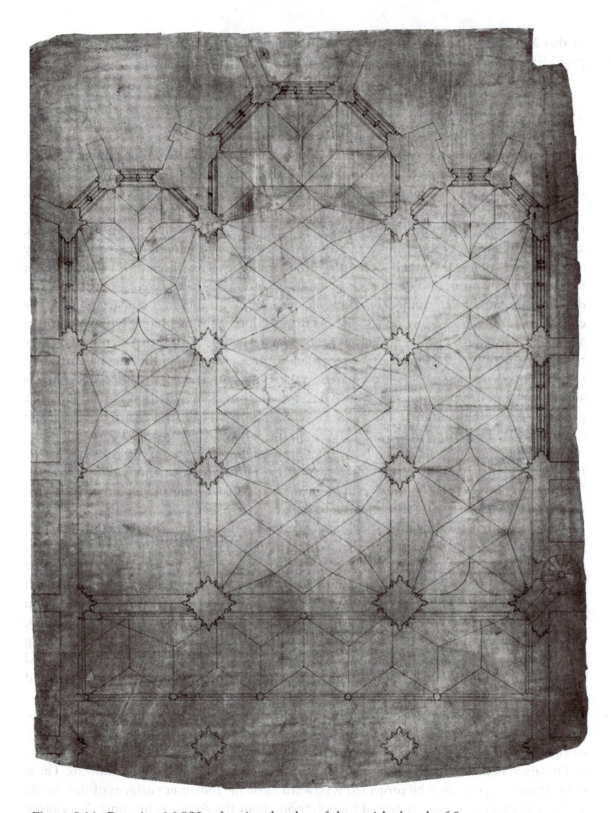

Figure 5.11 Drawing 16.890v, showing the plan of the parish church of Steyr.

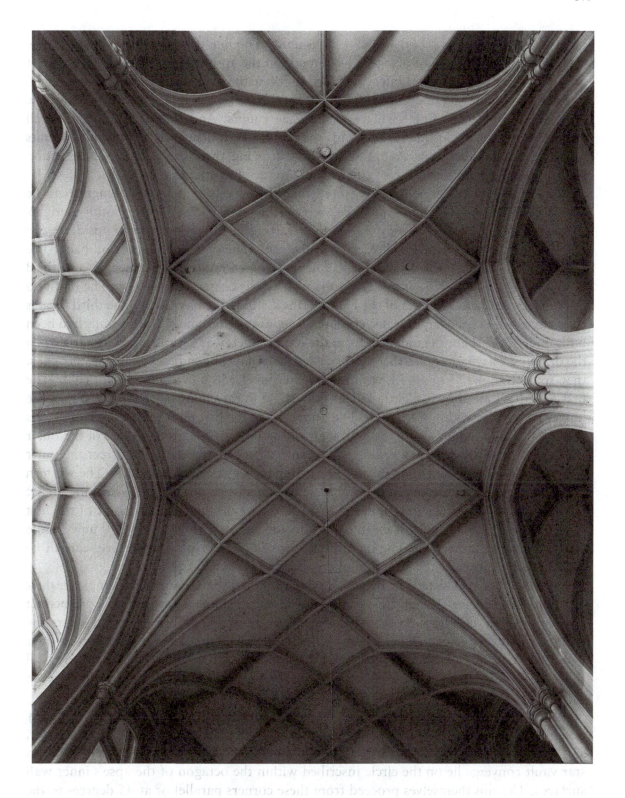

Figure 5.12 Steyr, parish church, vault.

inner arcade surface is 1.000 - .082 = .918 units. The line describing this inner arcade surface intersects the ray of octagonal symmetry in the apse composition .380 units west of the octagon's center. If this interval is used to frame the diagonal facets of the octagonal apsidioles flanking the main apse, then the distance from the building centerline to the inner faces of the apsidioles will be set to 2.380 units. And, folding the arcade wall thickness around the apsidiole, one finds that its outer wall surface will fall 2.544 units from the building centerline. As in the Augsburg drawing, therefore, a simple construction based on the geometry of the east end sets all the vessel widths.

The Steyr plan resembles the Augsburg plan in the way that the bay lengths can be determined by counting equal intervals westward from the apse. As the south or right-hand side of Figure 5.14 shows, a diagonal starting in the corner of the apsidiole can be bounced from the inside wall surface to the centerline of the apsidiole and back. The point of departure is .380 units west of the apse center, and the first, second, and third bounces are 1.678, 2.975, and 4.273 units west of the center, respectively. The first two bounces locate the centerlines of the narrow ribs dividing the bays, while the third locates the eastern edge of the larger transverse arches separating the choir, whose walls had been built under Puchsbaum's guidance, from the nave, which was yet to be constructed when the drawing was made. Since these transverse arches have the same thickness as the walls, they span from 4.273 to 4.438, with their centerline 4.356 units right of the center. The first nave bays are shown slightly longer than those in the choir; more precisely, they are longer by half the width of the wall. The centerline of the first nave piers falls 5.818 units west of the apse center, where the diagonals of the bay intersect the midline of the outer walls, instead of being 5.736 west of the center, where the diagonals intersect the inner wall surface, as they would be if the choir geometry were repeated exactly. The western boundary of the choir screen in the first nave bay, finally, can be found by striking an arc from the midpoint of the free-standing reinforced pier through the midpoint of the first nave aisle bay, and swinging it up to hit the arcade axis, which it does 5.390 units to the west of the apse centerline. The main divisions of the Steyr plan, therefore, can all be found fairly easily once the structure of the east end is established.

The wall and pier details evidently designed by Puchsbaum are quite simple in their geometrical structure. The buttresses of the apse and apsidioles, for example, are perfect double squares, like those on the radiating chapel in the Augsburg drawing, where the side length of each square equals the wall thickness. The piers are more complex in their details, of course, but each of them fits into a rotated square √2 greater than the wall thickness. The reinforced piers separating the choir from the nave are half again larger in side length.

Among the most prominent forms in the Steyr drawing are the vault patterns evidently designed by Puchsbaum's successor Spenning. The geometry of the main apse vault, surprisingly, is among the simplest in the building. The corners to which the ribs of its star vault converge lie on the circle inscribed within the octagon of the apse's inner wall surfaces. The ribs themselves proceed from these corners parallel or at 45 degrees to the building axes, rather than proceeding directly to the apse center.[18] In the straight bays of the main vessel, one set of lines forms an X subdividing each half-bay, while a second

[18] Such a simple radial rib pattern seems initially to have been planned, since traces of erased lines from the north corners of the apse to center are visible in the drawing.

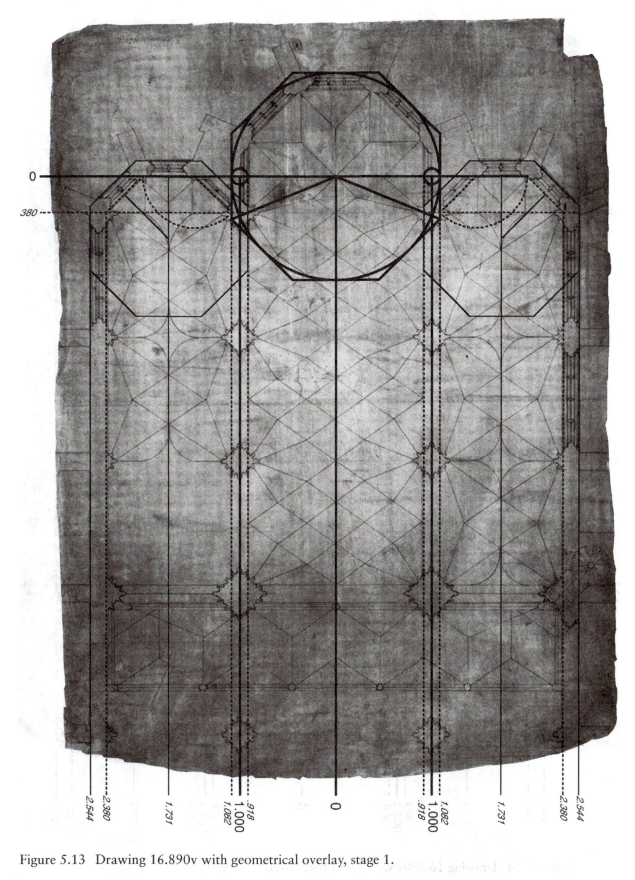

Figure 5.13 Drawing 16.890v with geometrical overlay, stage 1.

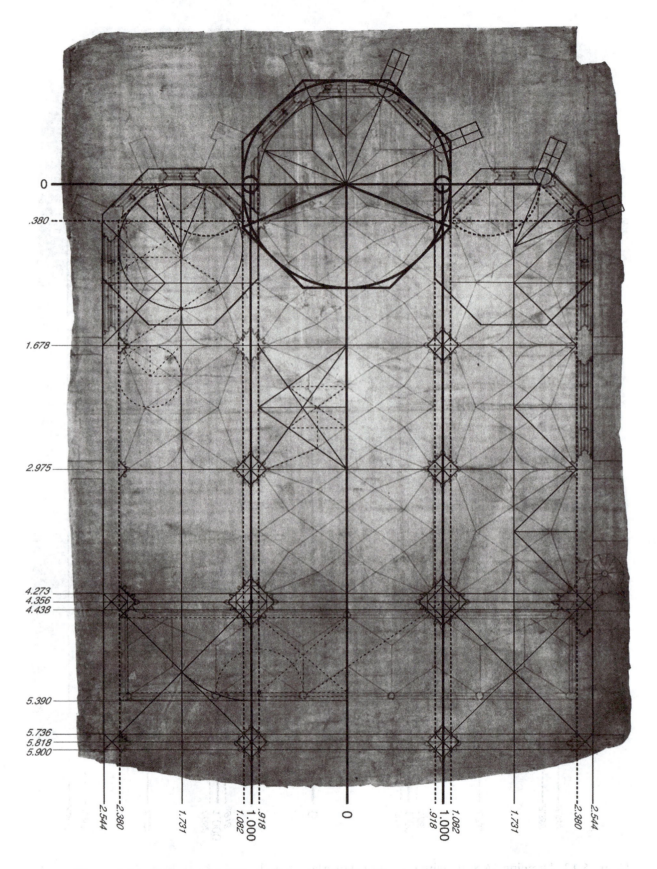

Figure 5.14 Drawing 16.890v with geometrical overlay, stage 2.

set forms a triangle with its base on the building's axis of symmetry. These two figures intersect to divide each bay into equal thirds, measured along that axis. And, as the dotted lines show, a smaller and narrower X within the middle third of each bay completes the geometrical armature to which all the ribs are aligned. Here, as in most Gothic buildings, the ribs converge to precise points on the piers, rather than to their centers.

The vaults of the side aisles, which include curved ribs, are perhaps the most complicated in the drawing, especially in their eastern terminations. The first step in the construction of the apsidiole vaults must have been to inscribe a circle within the octagon of their inner wall surfaces. As in the main apse, the ribs of the apsidiole proceed out from this circle at multiples of 45 degrees. This circle also intersects the aisle centerline in a point marked with a small dot in Figure 5.14. A dotted line departing from the shaft bundle at the first regular bay division, .678 units west of the main apse center, passes through that point and onwards to the midline of the bay. Reflection of this figure within each bay suffices to locate most of the straight ribs and their intersection points in the aisle vault. But the curving ribs follow a slightly different structure. The easternmost curved ribs in the apsidiole vaults must have been constructed by locating their end points, connecting the end points with a line like the dotted one shown in Figure 5.14, and then constructing a perpendicular to that line. The intersection of that perpendicular with the spatial envelope defined by the front edges of the wall shafts became the centerpoint from which the arch was struck. The other curved ribs, which align with the piers, can be constructed more simply, since their centers are the centers of each quarter-bay of vaulting, as the complete dotted circle in the figure indicates.

This analysis of the Steyr groundplan offers a case study in how late Gothic vault patterns could be conceived, but a great deal more work remains to be done in this area. Vault drawings generally lack the scale and finish of the great presentation drawings emphasized in this book, but in terms of sheer numbers they are among the most prevalent surviving documents of the late Gothic era. In the collections of the Vienna Academy, there are some fairly impressive and well-finished vault drawings, like those for Steyr, or for the nave of the Stephansdom, but many others are humbler works, showing only vault patterns, with no attention to wall articulation or other such concrete architectural details. Some of these may have been produced essentially as student exercises, as Hans Böker has suggested in his catalog of the Viennese drawings. And, while some of these plans cannot be securely identified with any known building project, Böker provides many valuable new identifications in his catalog, thereby bringing into clearer focus the networks of professional and artistic exchange in the Germanic late Gothic world.[19] The full implications of all this work, however, remain to be worked out in the literature on Gothic design practice.

The Viennese vault drawings, and other vault plans that survive in a variety of sketchbooks from the fifteenth century and later, are also valuable sources of information about how Gothic designers generated complex three-dimensional vaults using only fairly straightforward two-dimensional drawings. This fascinating topic has been most closely studied by Werner Müller, who argues that vault heights were determined by projecting

[19] Böker, *Architektur der Gotik*.

elements of the plan up into a single large principal arc.[20] Müller believes that this procedure, which is well attested in architectural training manuals from the late sixteenth and early seventeenth centuries, was already well established by the fifteenth century, and he has generated many elegant computer models to demonstrate how this procedure can generate three-dimensional vault surfaces based on surviving plan drawings. The range of applicability of this technical practice remains unclear, though, since at least some late Gothic vaults appear to have been constructed with multiple radii of rib curvature.[21] Even just in terms of two-dimensional plan analysis, many questions remain about the relationship between geometrical schemes like those described here in the Augsburg and Steyr drawings, on the one hand, and the module-based approximations and rules of thumb described in late medieval design booklets like Lorenz Lechler's *Unterweisungen*, on the other.

Despite lingering uncertainties like these, there can be no doubt that the study of original drawings has already contributed greatly to the study of Gothic design practices in the German-speaking world. And, as the first portion of this chapter has demonstrated, Germanic draftsmen used many of the same design strategies when they were developing building plans and tabernacle schemes that they did in their particularly impressive tower and façade drawings. At this point, therefore, it makes sense to move outwards from the German world, with its wealth of late Gothic drawings, into the French and Belgian world, from which several of these valuable documents survive, so as to get a more comprehensive overview of northern Gothic design practice.

THE CLOISTERS DRAWING

One of the few Gothic drawings to survive from late Gothic France is an elegant partial elevation of a church porch, which is now kept at the Cloisters, in New York (Figure 5.15). Because of its restrained but confident use of Flamboyant forms, the Cloisters drawing has been dated to the latter half of the fifteenth century by both Robert Branner and Linda Neagley, whose analyses of the drawing were published in 1976 and 2002, respectively.[22] Branner's discussion was largely descriptive, calling attention to the many rule lines and compass pricks evident in the drawing, and noting the draftsman's use of perspective depth cues on elements such as the sockels of the porch piers. Neagley went further than Branner, arguing that the drawing was produced in Normandy, and suggesting that the draftsman took an innovative approach to the treatment of architectural space by developing the front and rear wall planes of the depicted porch with two separate geometrical systems. The association with Normandy makes a great deal of sense on formal grounds, but further geometrical analysis reveals that the elements in both wall planes can be understood in terms of a single unified system, one that would have been comprehensible to designers throughout Gothic Europe.

[20] Müller, *Grundlagen gotischer Bautechnik*, esp. pp. 151–83; idem, "Le dessin technique à l'époque gothique," 237–54.

[21] See Wendland, "Cell Vaults."

[22] Cloisters, accession number 68.49. See Robert Branner, "A Fifteenth-Century Architectural Drawing at the Cloisters," *Metropolitan Museum Journal*, 11 (1976): 133–6; Neagley, "A Late Gothic Architectural Drawing," 90–91.

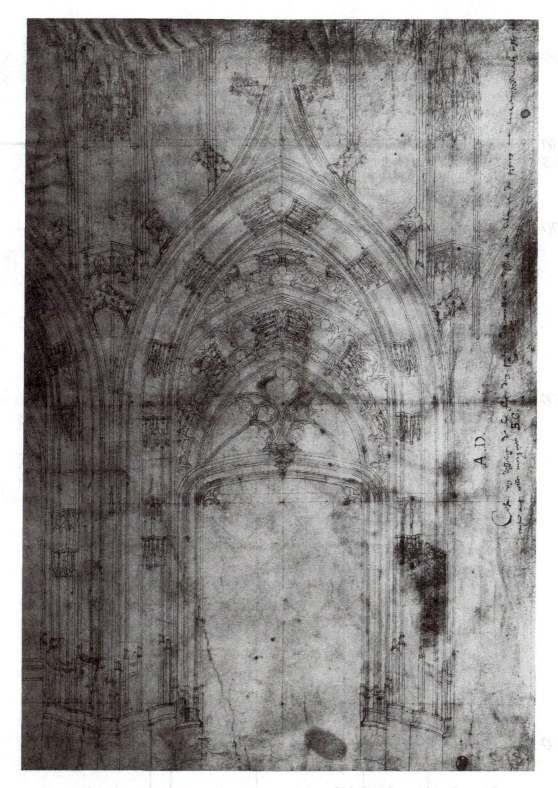

Figure 5.15 The Cloisters drawing, showing an unidentified church porch and portal.

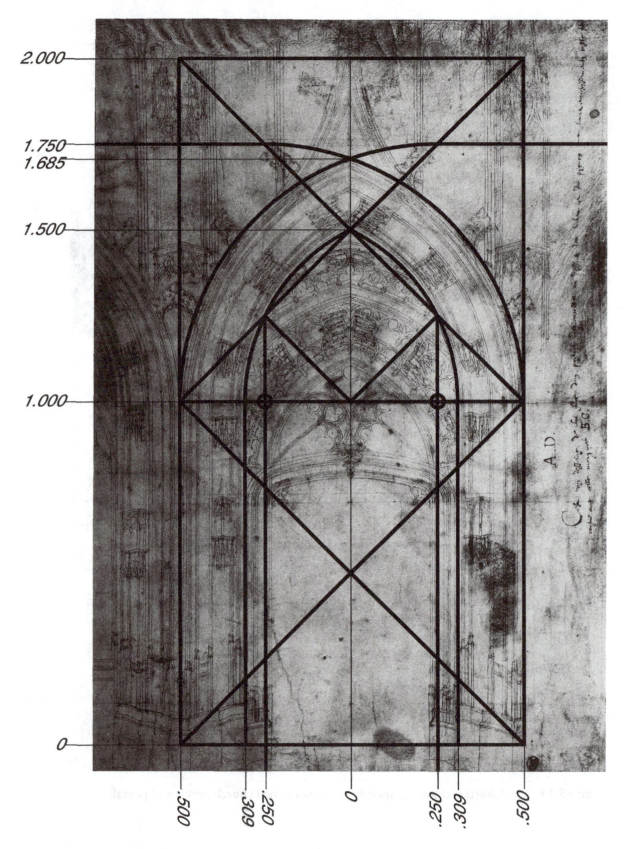

Figure 5.16 The Cloisters drawing, with geometrical overlay, stage 1.

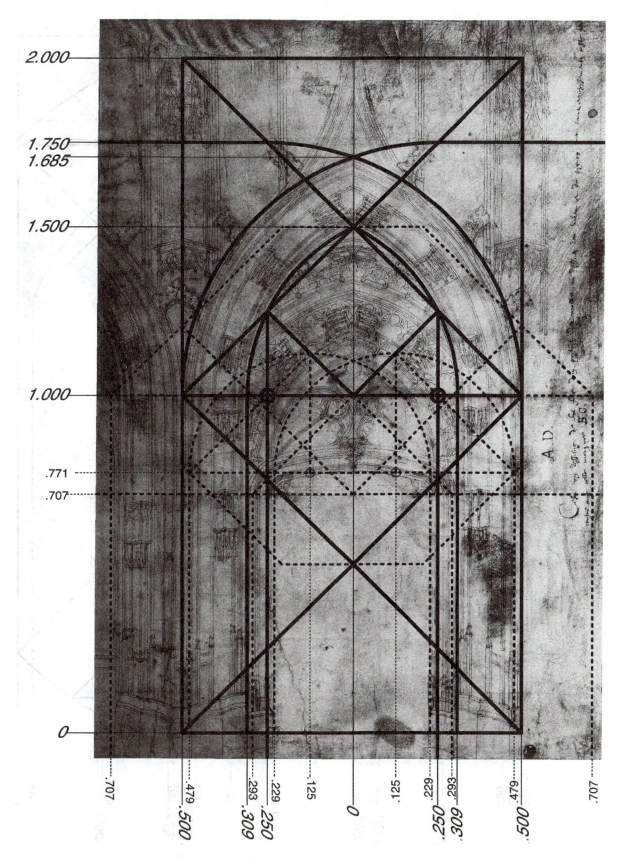

Figure 5.17 The Cloisters drawing, with geometrical overlay, stage 2.

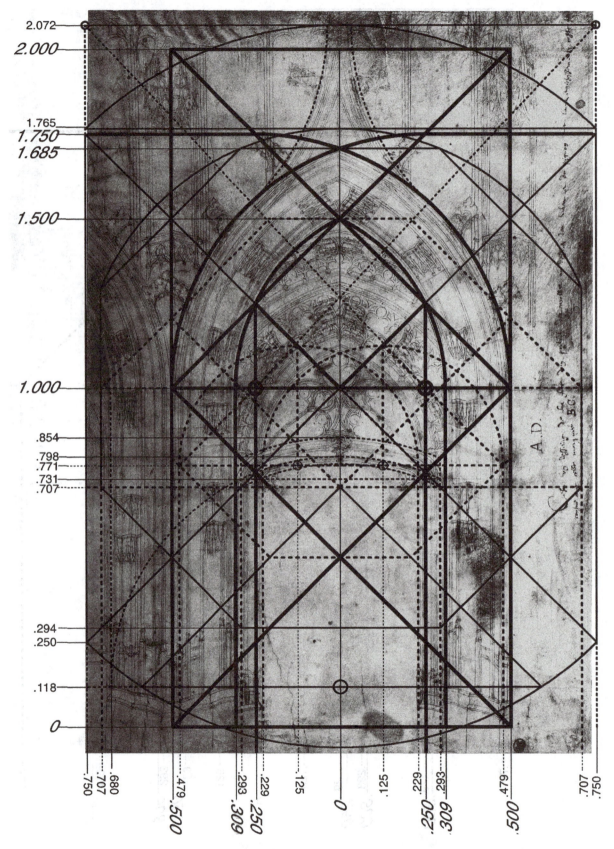

Figure 5.18 The Cloisters drawing, with geometrical overlay, stage 3.

The Cloisters drawing has a simple geometrical structure based on a double square, as Figure 5.16 indicates. The size of the squares is set, as usual, by the distance between the main buttress axes of the composition, which can be called one unit. The horizontal joint between the two squares, at height 1.000, marks the springline of the arches on the front surface of the porch. The centers of curvature for these arches are located one-quarter of the way across the portal span, at distances .250 units from the vertical centerline of the drawing. The intrados of the arches intersect at height 1.500, at the middle point of the top square. The arcs sweeping down from this intersection meet the equator of the drawing .309 units out from the centerline. The solid verticals dropped from these points describe the inboard edges of the piers in the front plane of the porch. The extrados of the arches, meanwhile, intersect at height 1.685, before rising up to reach height 1.750, the level at which small brackets introduce canopies capping the empty statue niches on the buttress axes. Level 2.000 marks the springline for the small semicircular arches that decorate the upper part of the front porch face.

Within this basic double-square frame, constructions based on the octagon begin to define more of the basic outlines of the porch design, as the dotted lines in Figure 5.17 show. Inscribing an octagon within the frame defined by the buttress axes, and extending diagonals down from the upper corners of its vertical faces, one finds an intersection point on the drawing centerline at height .707, where a prominent horizontal construction line marks the level from which the basket-handle arch of the inner portal springs. Diagonals reaching down from the drawing center reach this level .293 out from the centerline, establishing dotted verticals that will help to frame this portal in the rear wall plane. And, diagonals reaching down from the centers of the main front arches intersect the lower diagonal facets at height .771, establishing the level from which the pointed arches over the portal spring in the rear wall plane. The centers of these arches are .125 units out from the drawing centerline, exactly halfway as far out as the corresponding centers of the front arches. Semicircular arcs struck from these centers through the just-mentioned intersection points at height .771 begin .479 units out from the drawing centerline, before sweeping around to end .229 units out from the centerline on the other side of the drawing. These arcs precisely describe the boundaries of the tympanum over the portal. Verticals descending from the inner arc ends frame the opening of the portal, aligning precisely with the innermost verticals of the portal sockel at level 0. The verticals descending from the outer arc ends, meanwhile, locate creases between the scoops of the outer sockel, .479 units out from the centerline.

In the Cloisters drawing, as in so many other Gothic drawings, the trimming of the parchment offers valuable clues about the working methods of the designer, and about the relationship between modular and geometrical thinking in particular. As Figure 5.18 shows, the vertical edges of the Cloisters drawing are almost exactly .750 units out from the centerline, which underscores the importance of simple modular relations based on subdivision of the basic interaxial distance into halves, quarters, and eighths. But the subsequent constructions established within this framework were clearly conceived in terms of dynamic geometry, rather than modularity. In the upper half of the drawing, for example, there is a prominent horizontal construction line at height 1.765. This level can be established by circumscribing a circle about the large octagon whose vertical facets are .707 units out from the centerline. A large arc struck from the drawing center with

endpoints at height 1.765 on the drawing margins will rise to height 2.072. Points at this level and .750 units out from the drawing centerline serve as the centers from which the top sections of the main ogee arches were struck, as the dotted arcs indicate.

In the lower half of the drawing, meanwhile, the structure of the portal attests to a similar geometrical play within a modular frame. Diagonals struck down from the drawing center intersect the drawing margins at height .250, and .750 units out from the centerline. A large arc struck from the drawing center through these intersection points sweeps nearly to the bottom of the drawing. Along the way, it is intersected by diagonals dropped from the point at height .707 on the drawing centerline. These intersection points fall at height .118, which is marked by a prominent construction line and a clearly visible compass prick point on the drawing centerline. This compass prick serves as the geometrical center from which the basket-handle arch of the inner portal was struck. The innermost arc of the basket-handle was struck through the points at height .707 and .293 units out from the centerline. This arch rises to a height of .776, just a hair over the previously located horizontal at height .771. The second major arch in the basket-handle was struck through the points where the main diagonals of the first generating square cross the verticals .309 units out from the centerline. This arch rises to height .798, and its constituent arc can be swept further to define the left side of the main pier .680 units to left of the centerline. The outer arch of the basket-handle, finally, was struck through the points where the diagonals of the generating square cross the verticals .293 units out from the centerline; this arch thus rises to height .854. The arches of the rear wall plane, in other words, are tightly integrated into the geometrical system that defines the rest of the drawing, including even the borders of the parchment.

As this analysis shows, the Cloisters drawing emerged from a design practice that would have been familiar to draftsmen throughout Gothic Europe. The articulation of the drawing certainly marks it as a product of fifteenth-century France, but its geometrical structure would have made good sense to its creator's German contemporaries, and probably to his thirteenth-century ancestors as well. The octature-based geometries seen in the Cloisters drawing, after all, are anticipated not only in Strasbourg Plan B, but also in the Reims Palimpsest. The quasi-perspectival details seen in the sockel of the Cloisters drawing, moreover, impressionistically recall the more emphatic depth cues seen in Villard de Honnecourt's Laon tower elevation, although a more apt comparison might be with the roughly contemporary Ulm Plan C, where Matthäus Böblinger introduced subtle depth cues in the spire zone without compromising its rigorous geometrical structure. Consideration of the Cloisters drawing in its broader context thus demonstrates substantial methodological continuity in Gothic architectural culture.

CLERMONT-FERRAND

Even stronger evidence for the continuity of Gothic design practice across wide ranges of time and territory comes from analysis of a magnificent Flamboyant façade drawing produced for the cathedral of Clermont-Ferrand (Figures 5.19 and 5.20).[23] Probably produced around 1500 by the local Clermont architect Pierre Montoloys, as Michael

23 Clermont-Ferrand, Archives Départmentales du Puy-de-Dôme, series 3G, armoire 18, sac B, côte 29.

Davis has argued, this drawing appears progressive in its articulation, especially in its use of flowing tracery.[24] Flamelike patterns cover the entire expanse of the upper façade, including the central window space of the upper nave, which in traditional French façade design would have been occupied by a rose window. The tracery fields in the tower bays, moreover, are asymmetrical. This innovative feature gives the façade a strongly dynamic character, as if the flames of tracery were striving upwards and towards the building centerline. Other aspects of the design, however, hint at a strong geometrical order governing the whole drawing. The overall organization of the depicted façade, with its three great portals separated by crisply defined principal buttresses, recalls "classic" thirteenth-century prototypes. The plan appended to the bottom of the drawing, meanwhile, clearly shows the crystalline geometry of each of these pinnacle-encrusted buttresses. The 45-degree angle at which the main portal embrasures recede in the plan, furthermore, subtly suggests the presence of an underlying octagonal armature. As it turns out, octagons govern the geometry of the whole drawing, both in plan and in elevation. In elevation, especially, these octagons link the drawing very closely with the structure of the cathedral's thirteenth-century choir, which may have already influenced the fourteenth-century work of Matthias of Arras and Peter Parler at Prague. Underneath its flowing tracery articulation, therefore, the Clermont drawing has a surprisingly rigorous and traditional geometrical structure.

The groundplan and elevation in the Clermont drawing occupy two separate parchment sheets, which are slightly misaligned with respect to each other, but the intended relationship between the two can be readily reconstructed nevertheless. The most conspicuous geometrical lock points in the groundplan are the centers of the two pinnacles fronting the buttresses that flank the main portal. If these points are taken as the corners of an octagon framed by the buttress axes, then the center of the octagon falls at the level labeled 0 in Figure 5.21. A prominent horizontal construction line runs across the elevation at this level, which clearly indicates its importance. Calling the distance between the buttress axes one unit, one finds that the pinnacle centers are .207 units below this starting line. The diagonal facets of the octagon stand just in front of the main portal's sloping embrasures. Striking a horizontal to the right from the midpoint of the octagon's right-hand diagonal facet until it hits the right-hand buttress of the main portal, and then drawing a diagonal up and to the right until it hits the starting line, one finds the centerline of the side portal trumeau .854 units to the right of the building centerline. Reflection about this axis locates the right-hand margin of the side portal 1.207 units from the building centerline. The width of the aisles is thus exactly .707 as great as the width of the nave, a simple $\sqrt{2}$ relationship that arises naturally from this octagon-based geometry.

Another octagon-based construction, shown in dotted lines in Figure 5.21, begins to define the depth of the façade block. A second half-octagon, inscribed like the first between the axes flanking the main portal, reaches a level 1.000 units below the starting line. The midpoints of its upper diagonal faces are .647 units below the starting line. Striking a horizontal at this level through the rays of the octagon's symmetry, and then

[24] Michael Davis, "'Troys Portaulx et Deux Grosses Tours': The Flamboyant Façade Project for the Cathedral of Clermont," *Gesta*, 22/1 (1983): 67–83.

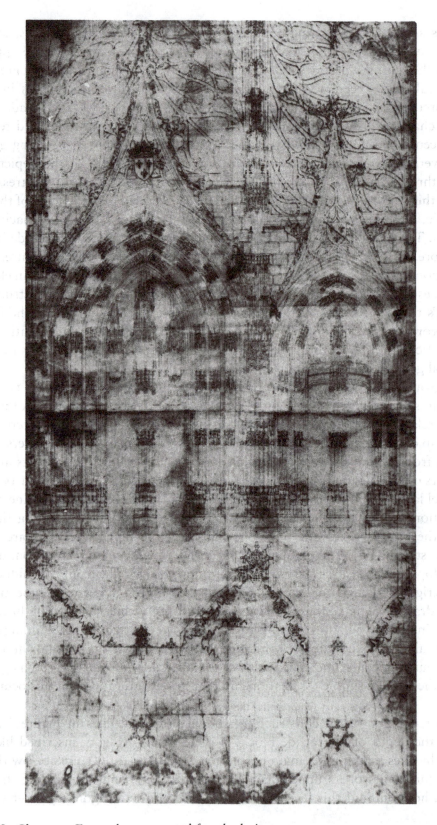

Figure 5.19　Clermont-Ferrand, unexecuted façade design.

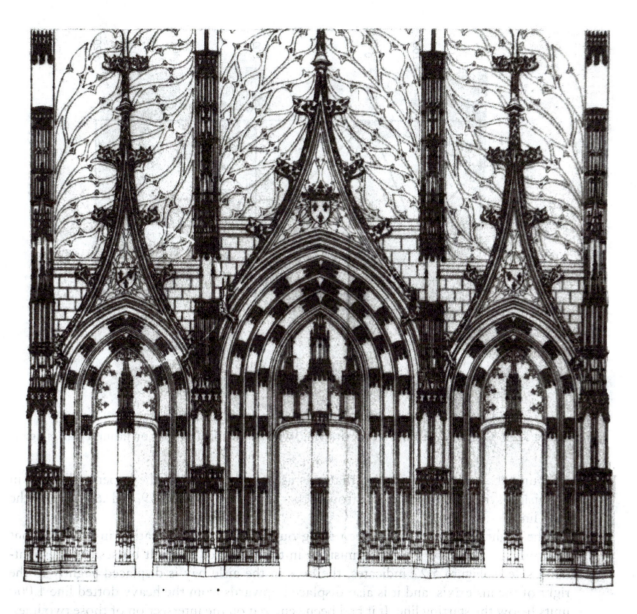

Figure 5.20 Clermont-Ferrand, unexecuted façade design, modern redrawing.

striking an arc through these intersection points in an octature figure, one finds the level
.617 units below the starting line that describes the plane of the façade's main doors.

Building further on this structure, it is possible to generate further details in the
groundplan, as the fine but solid lines in Figure 5.22 show. Starting from the points
where the just-described horizontal cuts the dotted rays of octagonal symmetry, one can
project forward diagonals that define the centerlines of the main portal embrasures. The
interval between these diagonals and the heavier lines of the original half-octagon sets the
scale of the rotated squares that describe the main pinnacles between the portals, which
are centered .207 units below the starting line. The interval between the .647 and .617
horizontals, meanwhile, sets the scale of the two smaller rotated squares that describe the
trumeau of the main portal. The point where these two squares meet establishes a level

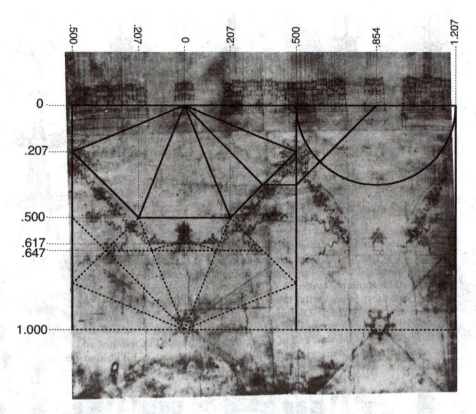

Figure 5.21 Clermont-Ferrand façade drawing, with geometrical overlay on ground plan, stage 1.

.588 units below the starting line that was used as the center of the upper wall plane in the aisles; symmetrical moldings around that line reach levels .559 and .617 below the start line.

The slight misalignment between the groundplan and the elevation in the Clermont drawing may relate to a seeming mistake in the layout of its vault bosses. As the right-hand side of Figure 5.22 indicates, the boss in the aisle bay is displaced slightly to the right of the aisle axis, and it is also displaced upwards from the heavy dotted line 1.000 units below the starting line. If it had been centered on the intersection of those two lines, then the ribs of the aisle vault would have proceeded at perfect diagonals to meet the borders of the aisle bay .647 units below the starting line. But, as the light dotted lines in the illustration show, the actual placement of the aisle boss can be found if the left dotted diagonal is dropped from the .617 horizontal instead. The intersection between these mismatched diagonals falls .986 units below the starting line, at the level where one finds the centers of the bosses in both bays. And, connecting the aisle boss to the middle of the aisle portal, one finds a slight slope matching that of the right-hand parchment margin, which continues smoothly into the upper parchment piece. This slope, then, may help to explain the slight skew between the geometries of the groundplan and the elevation in the drawing.

To understand the geometrical structure of the elevation in the Clermont plan, it makes sense to begin with the same octagon-based figures already seen in the groundplan. In Figure 5.23 these are shown as before, but this time perfectly aligned with the axes

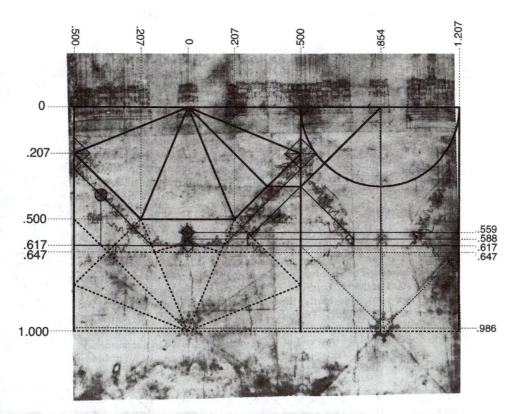

Figure 5.22 Clermont-Ferrand façade drawing, with geometrical overlay on ground plan, stage 2.

of the elevation. As noted previously, a prominent horizontal construction line runs through the center of the octagon in the main portal; it falls .104 above the groundline of the elevation. Or, to phrase it another way, the groundline falls halfway between this construction line and the lower corners of the octagon's lateral facets. The corresponding line above the octagon's equator, at height .207, marks the top of the complex sockel zone and base of the tall faceted shafts below the empty statue niches of the portals. Those shafts terminate at height .451, the level where the diagonal used to establish the aisle width in the groundplan intersects the right-hand margin of the drawing. The canopies over those niches, similarly, terminate at height .707, the level where a diagonal struck from the base of the nave-framing buttress hits the right margin. The height to this major horizontal division, which marks the boundary between the doorways and the tympana above, thus equals the width of the aisles. Twice as far up, at height 1.414, the solid portion of the aisle wall ends in a prominent horizontal molding, above which the flamelike tracery begins to flow.

The geometry of the nave bay in the Clermont drawing unfolds quite directly from the stacking of octagonal figures frame by the buttress axes. The original octagon centered at height .104 governs not only the heights of the sockel zone, but also the width of the doors and trumeau: the doorway zone is framed by the verticals connecting the octagon's inner corners, and the verticals framing the trumeau rise from the points where the octagon's rays of symmetry intersect the groundline. When the upper diagonal facets of the original octagon are extended, they intersect at height .811, which is the level at which

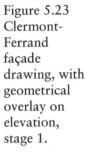

Figure 5.23
Clermont-
Ferrand
façade
drawing, with
geometrical
overlay on
elevation,
stage 1.

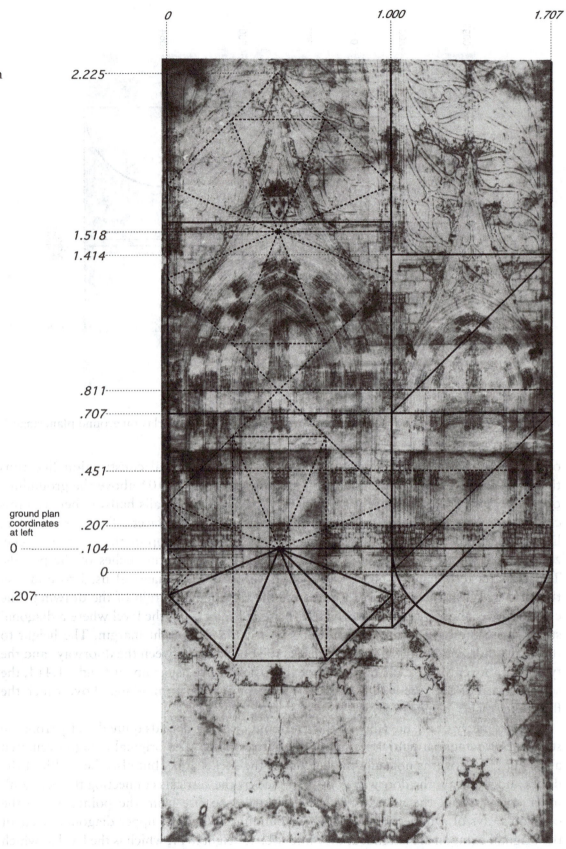

the tympanum in the main portal begins to taper, as the archivolts begin to curve inward. A whole set of statue canopies also begins at this level. This horizontal can be used as a plane of reflection, establishing a second buttress-framed octagon with its center at height 1.518. This level marks the bottom of the molding terminating the solid wall at the base of the elaborately traceried central window. The extensions of the octagon's upper diagonal facets converge at height 2.225, which marks the tip of the great gable over the portal or, more precisely, the point where the leafy moldings along the side of the gable merge to form its terminal finial.

The Clermont drawing has obviously been truncated along its top edge, leaving the window tracery and finial incomplete, but the overall proportions of the depicted façade appear to have been set by a great octagon whose base facet coincides with the base of the nave bay. Several independent arguments favor this idea, which is depicted in Figure 5.24. First, this geometrical structure explains several features of the drawing that the steps described so far have not. So, for example, the center of the great octagon falls at height 1.207, precisely at the tip of the central portal tympanum. The top lip of the wall behind the main portal falls at height 1.664, the level where the ray to the octagon's right upper corner intersects the vertical centerline of the aisle bay. Second, the patterns of tracery in the drawing seem to flow smoothly around this geometrical armature. In the aisle bay, the curves and countercurves in the tracery wind around the octagon's diagonal facet, and in both the nave and the aisle bay, the tracery lines start to flatten towards the top of the parchment, suggesting that the top of the windows should come near the top of the octagon, at height 2.414. Finally and most importantly, though, these octagonally determined proportions match those of the cathedral's thirteenth-century choir, as Figure 5.25 shows.

The identification of Clermont Cathedral's own choir as the source for the octagon-based geometries in the façade drawing provides crucial evidence both for the continuity of Gothic design practice, and for the usefulness of drawing-based research in identifying Gothic design strategies. The Cathedral of Clermont was begun in 1248, and it would surely have been known to Matthias of Arras, who worked in southern France before moving east to begin work on Prague Cathedral in 1344. In this context, the fact that the cathedrals of Prague and Clermont both have central vessels with the same octagonally determined 1:2.414 proportions strongly suggests that ideas from Clermont and its milieu helped to determine the Prague elevation. More specifically, it suggests that Matthias of Arras generated an octagon-based elevation scheme for Prague that his successor Peter Parler continued to respect in its overall outlines. As Chapter 4 explained, Peter Parler's use of gargoyles and grotesques as geometrical sign-posts in his elevation drawing of the Prague choir makes its octagon-based structure clear and undeniable, helping to reveal a surprisingly simple design scheme that had gone unremarked in the many studies of Prague Cathedral. So, too, the perfect 1:$\sqrt{2}$ relation between the nave and aisle widths in the Clermont façade drawing provides strong evidence for use of octagon-based geometries in the Clermont workshop around 1500, thus suggesting the fruitful idea that such structures should also be sought in the earlier portions of the cathedral. It is worth noting that the two elevations are not absolutely identical, despite their use of the same proportioning figure. In Clermont, the relative proportions of the aisles are taller than at Prague; at Clermont, the equator of the octagon lines up with the top of the aisles instead

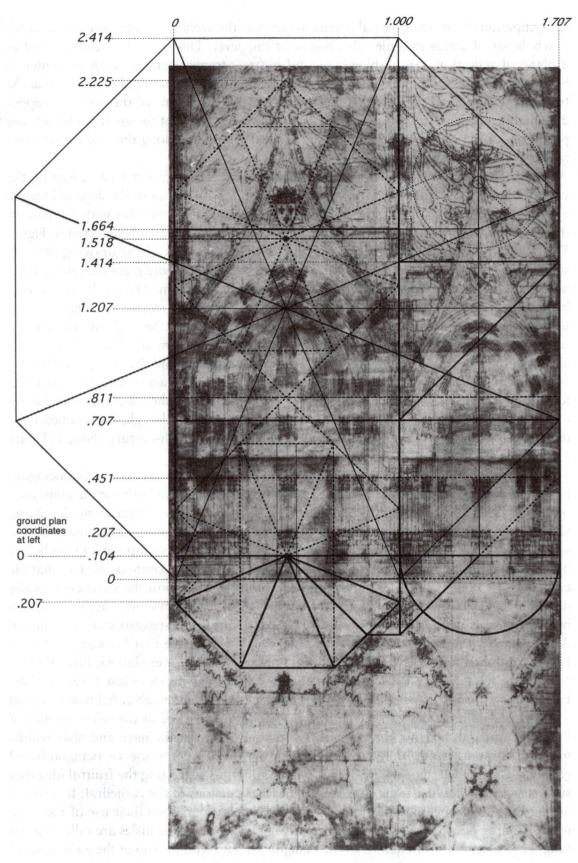

Figure 5.24
Clermont-
Ferrand
façade
drawing,
with
geometrical
overlay on
elevation,
stage 2.

ground plan
coordinates
at left

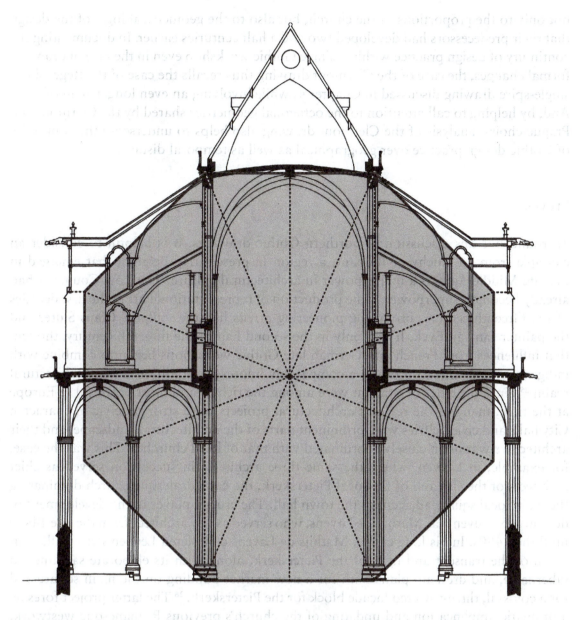

Figure 5.25 Clermont-Ferrand, section of cathedral choir with octagon overlay.

of the middle of the triforium, but the basic scheme is very similar (compare Figures 4.7, 4.9 and 5.25). The setbacks on the Clermont buttresses even line up with the corners of the octagon. Here, as at Prague, the close match between this simple figure and the proportions of the cathedral had previously gone unremarked.

The presence of octagonal geometries in the Clermont choir helps to explain why Pierre Montoloys and his colleagues working around 1500 chose to adopt a simple octagon-based framework for their façade design. At first glance, the format of the façade appears to mark a real departure from the format of the rest of the cathedral, since the large side portals of the façade would not align smoothly with the double aisles of the nave and choir. But the geometrical correspondences between the older portions of the cathedral the new façade design show that the members of the Clermont workshop remained attuned

not only to the proportions of the church, but also to the geometrical logic of the design that their predecessors had developed two and a half centuries earlier. In documenting the continuity of design practice within a single Gothic workshop even in the face of dramatic formal changes, the case of the Clermont drawing thus recalls the case of the Regensburg single-spire drawing discussed in Chapter 4, while involving an even longer span of time. And, by helping to call attention to the octagonal geometries shared by the Clermont and Prague choirs, analysis of the Clermont drawing also helps to underscore the continuity of Gothic design practice over geographical as well as temporal distances.

LEUVEN

To round out this discussion of northern Gothic drawings, it is helpful to consider an example from the duchy of Brabant, a region in present-day Belgium that emerged in the late Middle Ages as a major power in architectural culture. The Low Countries had already become a superpower in the production of representational art in the first decades of the fifteenth century, producing pioneering artists like the sculptor Claus Sluter and the painter Jan van Eyck. It was only in the second half of the fifteenth century, though, that influences from French and German late Gothic workshops began to combine with indigenous traditions to produce a comparably impressive tradition in the architectural realm.[25] Since the cities of Brabant were among the richest and most powerful in Europe at the time, many of the region's architectural projects were strongly civic in character. City halls and civic belfries were prominent parts of the architectural landscape, and their architecture was often closely coordinated with that of local churches. This was the case, for example, in Leuven, where the same three architects in succession served as chief architects of the city and of the local Pieterskerk, the cathedralesque church dominating the main local square adjacent to the town hall. The crucial player in the development of downtown Leuven was Mathijs de Layens, who served as city architect from the late 1440s until the 1480s. In his long career, Mathijs de Layens completed Leuven's city hall, built much of the transept and nave of the Pieterskerk, along with its elaborate sacramental tabernacle, and drew up plans both for a new market building on the main square and for a colossal, three-towered façade block for the Pieterskerk.[26] The latter project foresaw a dramatic amplification and updating of the church's previous Romanesque westwork, whose triple-towered format de Layens had already adopted for the lateral façades of the city hall. His design for the new façade was publicly exhibited in 1481, two years before he died, and it still survives in fragmentary condition today. Far better preserved, though, is the revised elevation drawing prepared in 1506 by his successor Joost Metsijs, reportedly a clock-maker by training, who began construction of the new façade block in the opening years of the sixteenth century (Figures 5.26 and 5.27).[27]

[25] Christopher Wilson notes this curiously delayed dynamic in *The Gothic Cathedral: The Architecture of the Great Church, 1130–1530* (London, 1990), p. 237.

[26] See Edward van Even, *Louvain dans le passé et dans le present* (Leuven, 1895); also Marjan Buyle, Thomas Coomans, Jan Esther et Luc Francis Genicot, *L' architecture gothique en Belgique* (Brussels, 1997).

[27] Collection M, Leuven, inv. no. LP/927.

Figure 5.26
Leuven façade
drawing.

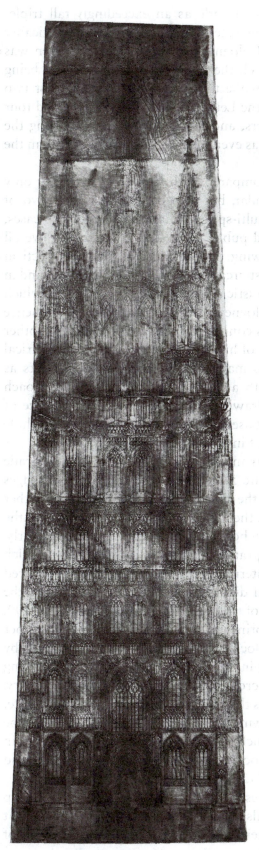

Figure 5.27
Leuven façade
scheme, modern
redrawing.

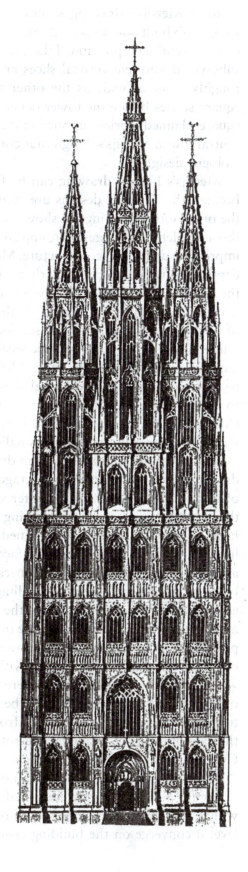

Joost Metsijs's drawing shows the Pieterskerk façade as an exceedingly tall triple-spired slab built out of stacked stories whose boxiness tends to conflict with the verticality of the overall composition. Like the façade of Cologne Cathedral, that of Leuven was subdivided into five vertical slices at ground level, the one for the central vessel being roughly twice as wide as the other four. But, while the Cologne façade has just two square stories before the tower octagons begin, the Leuven façade was to have had four square-planned stories supporting the side towers, and five such stories supporting the central tower. Metsijs's design thus comes across as even more strongly repetitive than the Cologne design.

Metsijs's Leuven drawing can be fruitfully compared with Cologne Plan F not only because the depicted designs are somewhat similar, but also because these are two of the only Gothic drawings to show a complete multi-spired church façade. In both cases, this completeness suggests an appeal to a broad public interested in getting an overall impression of the foreseen structure. Metsijs's drawing, though, includes subtle perspectival depth cues, which are particularly evident in the staircase at the base of the façade, and in the angled facets of its triple towers. This illusionistic approach to representation, which was not seen in the more strictly orthogonal Cologne drawing, may reflect the influence of Netherlandish painting; it is significant in this connection that Joost Metsijs's brother Quentin was among the most successful painters of his day. As the following geometrical analysis will demonstrate, Joost Metsijs had to make some awkward adjustments as he tried to combine perspectival illusionism with a more traditional Gothic approach to design. And, probably because the Leuven drawing was only about half the size of Cologne Plan F, its geometry was simpler, being based on large units that span the whole width of the façade, rather than smaller units that involve only one tower.

The lower section of the Leuven drawing is organized, much like the Clermont façade drawing, around a single large octagon. As Figure 5.28 shows, though, the outer edges of this octagon align with the outer surfaces of the side-facing façade buttresses, rather than with the axes of the front-facing buttresses, the approach seen in virtually all of the façade and tower drawings examined so far. The bottom edge of the octagon, similarly, lines up with the top edge of the façade sockel, rather than with its groundline, which appears geometrically ambiguous because it is interrupted by the perspectivally rendered bases of the salient buttresses. Calling the facial diameter of the octagon one unit, the equator of the octagon establishes the springline of the main nave window at height .500, and its top facet marks the top edge of the third principal story at height 1.000. The other principal subdivisions within the lower façade block can be fairly quickly established by octature. Inscribing a large circle within the original master octagon, and then drawing verticals to connect the points where this circle crosses the rays of octagonal symmetry, one finds small intervals which can be doubled, as the small circles in the graphic indicate, to establish verticals .424 units out from the drawing's centerline. These verticals describe the axes of the front-facing façade buttresses, which generally have conceptual priority in Gothic drawings. These verticals cut the rays of octagonal symmetry at heights .324 and .676, locating the tops of the first and second window stories, respectively.

Figure 5.29 shows how the smaller structures of the Leuven lower façade develop within this basic octagonal armature. Diagonals departing from the buttress axes at level 0 converge on the building centerline at height .424, establishing the top edge of

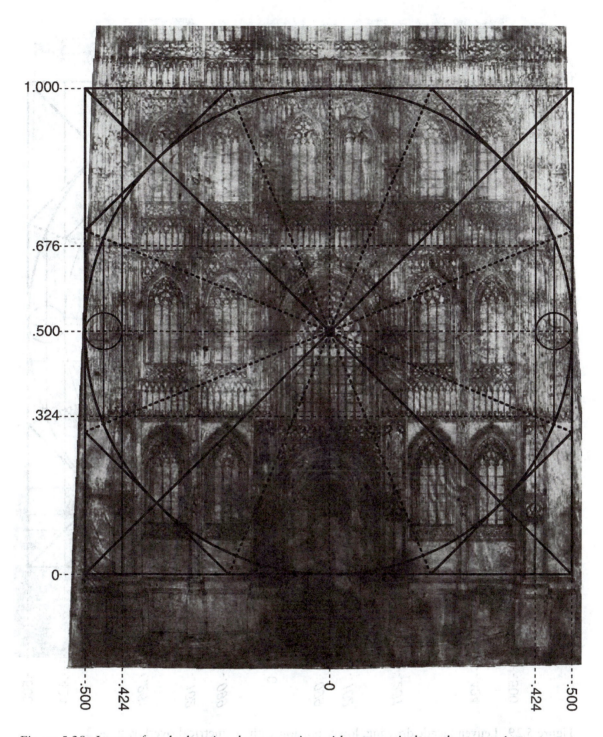

Figure 5.28 Leuven façade drawing, lower portion with geometrical overlay, stage 1.

the façade's first triforium-like sub-story. These diagonals intersect the diagonal faces of an octagon framed by those buttress axes at height .162, and .261 units out from the centerline. Height .162 marks the center of the arch over the main portal. The circle framed by the outer buttress axes descends down to level .076, defining the baseline of the traceried belt below the first main windows. This same circle intersects the rays of

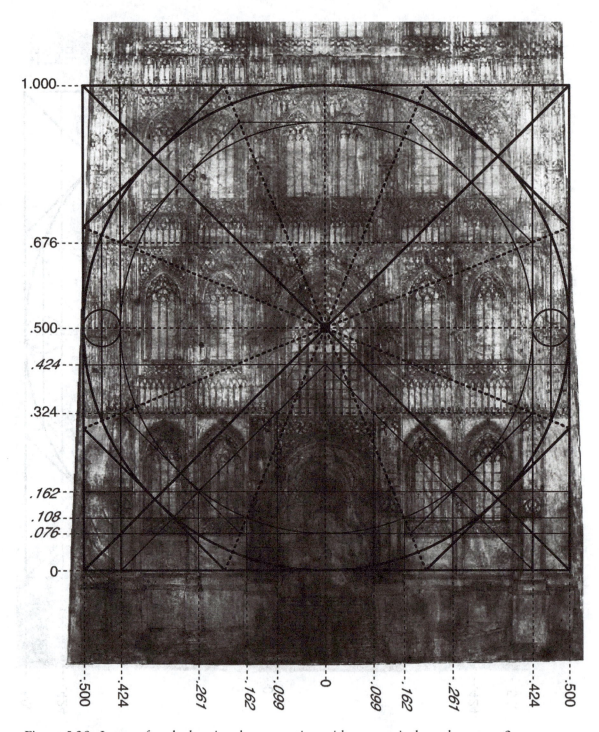

Figure 5.29 Leuven façade drawing, lower portion with geometrical overlay, stage 2.

octagonal symmetry at height .108, and .162 units out from the centerline. The height of these intersections defines the top lip of the just-mentioned tracery belt, while their lateral position defines the outer surface of the front-facing buttresses flanking the main portal. The inner surfaces of these buttresses are .099 units out from the centerline, striking

downward from the points where the diagonals from the outer buttresses intersect the previously established horizontal at height .324.

The proportions of the façade block shown in Metsijs's drawing map fairly well onto the actual façade block, which stands today as an incomplete fragment, whose construction had to be abandoned in the late sixteenth century, due to the inadequacy of its foundations. Figure 5.30 shows the relative scaling that was probably intended, with the conceptually privileged outer buttress surfaces set equal to each other. With this scaling, the outer surfaces of the forward-facing outer buttresses also align .449 units out from the centerline, which is a noteworthy result, since the buttresses in the drawing are perspectively splayed outwards. Further evidence for the correctness of this scaling comes from the way the buttress faces .162 and .261 units out from the centerline in the drawing align perfectly with the edge of the inner aisle bay in the groundplan of the present façade block. The inner face of the outer buttress in the drawing can be found .386 units out from the centerline, where the circle framed by the buttress axes cuts the horizontal at height .324. This dotted vertical carries smoothly down into the plan, describing the inside face of the outer buttress and the wall arch behind it. The main windows of the façade are thus flanked by buttress faces .162 and .386 units out from the building centerline, respectively. The midline between these buttress faces falls .274 units out, between the twin dotted circles shown in Figure 5.30. This line describes the small buttress flange between the main windows in the drawing, and it also lines up perfectly with the center of the small, free-standing pier at the bottom of the groundplan.

A variety of irregularities in the groundplan, which create misalignments between the groundplan and the elevation drawing, strongly suggest that the plan for the Leuven façade block was modified in the course of construction. This is most obvious in the plan of the buttresses flanking the main portal, where the asymmetrically scooped-out form of the buttress occupies only a fraction of the rectilinear socket prepared to support it. Tellingly, too, the intermediate buttresses in the façade are asymmetrical, so that their exterior axes are shifted outboard with respect to their inner axes. The inner axes and all the wall arches in the façade block line up with structures depicted in the drawing, but the exterior buttresses are subtly displaced by comparison. It seems that the drawing and the interior articulation of the façade block reflect one phase of planning, while the exterior reflects updates introduced during construction.

The reception of Metsijs's drawing in the Leuven façade workshop may have become complex, but the intrinsic geometrical structure of the drawing was fairly simple, at least in its overall outlines, with the dimensions established at ground level mapping smoothly into its upper reaches (Figure 5.31). As in many drawings of tapering towers and tabernacles, though, the outermost components of the geometrical frame govern only the lower stories, so that the slightly smaller components remain to govern the superstructure. In the case of the Leuven drawing, the large square of facial radius 1.000 that spans the outer buttress faces at ground level is the only one of its kind. The module that gets stacked up to define the rest of the drawing is the slightly smaller square framed by the buttress axes. The first of these squares fills the space between heights 1.000 and 1.848, ending precisely where one of the parchment sheets in the drawing ends. The second rises to height 2.696, and the third rises to height 3.543, establishing the top margin of the drawing. The most important verticals that rise within this frame are those .274 units out

Figure 5.30
Leuven
façade
drawing,
lower
portion with
geometrical
overlay and
alignment
with plan of
actual façade
block.

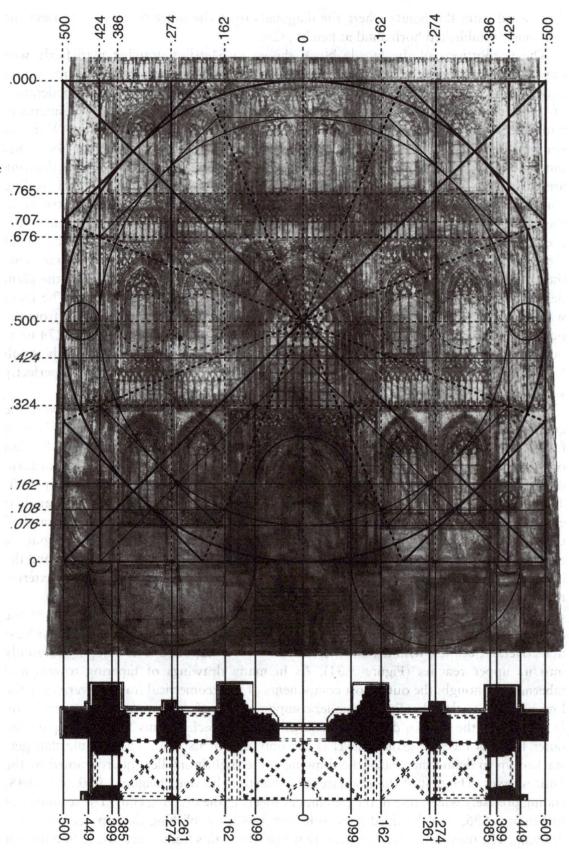

from the centerline, which define the centerlines of the side towers. When one inscribes an octagon within the first of these squares, one finds that its lower diagonal faces intersect these tower centerlines at height 1.101, defining the top edge of the traceried balustrade over the third tower story. The octagon's rays of symmetry intersect the tower centerlines at height 1.311, defining the top of the windows in the fourth tower story, and at height 1.537, where a small tracery bridge subdivides the window in the first octagonal tower story. The diagonal of the square cuts the inscribed octagon's upper diagonal facet at height 1.724, establishing the top edge of the traceried balustrade on the last blocky story of the middle tower. The geometrical structure of the second square is less than perfectly clear, in part because of quasi-perspectival distortions to be discussed further below, but the simple framework of squares and octagons clearly governs the drawing even in its uppermost section, as consideration of the spire tips reveals. Each of the three openwork spires terminates in a large and delicate-looking cross, which would presumably have been made of metal in the actual monument. The centers of the two lateral crosses fall precisely at height 3.119, aligned with the center of the last square, and the large collars that separate them from the spires below fall at height 3.006, which marks the corner of an octagon concentric with the square and framed by the spire centerlines. The cross atop the central spire ends at height 3.543, aligned with the top of the drawing's geometrical frame.

In producing the Leuven drawing, Joost Metsijs seems to have run into some difficulties attempting to reconcile traditional Gothic geometries with illusionistic quasi-perspectival depth cues. Unlike the creators of the Cloisters drawing or the tabernacle drawing 16.838, he was not simply adjusting heights to suggest a viewpoint from above or below. In addition, he was adjusting widths, splaying the buttresses in the drawing outwards as if seen by a viewer on the building axis, and letting them step slightly inward as they rose, to suggest their stepping back from the viewer at each setback. In the vicinity of height 1.500, therefore, the midpoints of the towers shown in the drawing are pushed in slightly toward the drawing centerline, instead of following the verticals of the tower centerlines (Figure 5.32). By around height 2.000, though, the towers have begun to step back outwards, and this process is complete by roughly height 2.500, so that the lateral spires align perfectly with their geometrically determined centerlines, as the overall view in Figure 5.31 shows. One gets the sense that Metsijs was trying to improve upon Gothic conventions of representation by introducing quasi-perspectival illusionism, only to realize halfway through his project that his so-called "improvement" would actually force him to abandon the Gothic system altogether, a step that he was not willing to take.

The presence of quasi-perspectival cues in many late Gothic drawings may attest to a growing interest in illusionism, and it is conceivable that frustration with the limits of strictly orthogonal representation may have played a role in the destabilization of Gothic architectural culture in the years around and after 1500. Several arguments suggest, though, that this must have been at most a fairly minor factor, at least as far as Gothic designers themselves were concerned. Firstly, the existence of quasi-perspectival modes of representation did not by itself pose a threat to Gothic design practice. The portfolio of Villard de Honnecourt, after all, had included drawings with perspectival depth cues alongside more strictly orthogonal architectural drawings, and Gothic design practice continued to thrive for nearly three centuries after the portfolio's production.

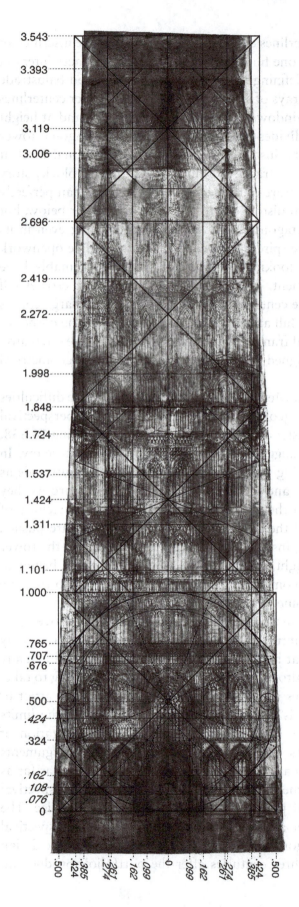

Figure 5.31
Leuven façade drawing with geometrical
overlay.

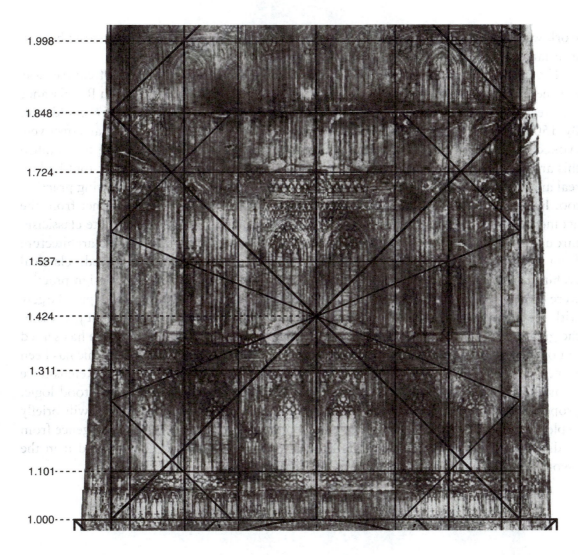

Figure 5.32 Leuven façade drawing, middle portion with geometrical overlay, showing inward
displacement of tower articulation.

Geometrically strict plans and elevations, moreover, remained the norm in Gothic
draftsmanship down to 1500 and beyond, more than a century after the introduction of
highly realistic representational art by pioneers such as Peter Parler, Claus Sluter, and Jan
van Eyck, who are often discussed within the framework of a "Northern Renaissance."[28]
It is true that surviving Brabantine architectural drawings like the Leuven façade design
tend to incorporate more prominent perspectival cues than contemporary drawings from
the German world, and this distinction may have something to do with the prestige
of realistic representational art in the region, but draftsmen like Metsijs continued to

[28] One interesting exception to this rule is a drawing executed around 1480 and attributable to Juan
Guas, which shows the interior of the Toledan church of San Juan de Los Reyes in a dramatically staged
pseudo-perspectival view. See Sergio Sanabria, "A Late Gothic Drawing of San Juan de los Reyes in Toledo
at the Prado Museum in Madrid," *Journal of the Society of Architectural Historians*, 51 (1992): 161–73. In
Spain, though, orthogonal ground plans and building sections remained the norm for Gothic drawings well
into the sixteenth century, as in the drawings for the new cathedral of Salamanca. See, for example, Fernando
Chueca Goitia, *La Catedral Nueva de Salamanca. Historia documental de su construcción* (Salamanca, 1951).

work with high geometrical precision, and their colleagues obviously understood how to translate their intentions into masonry.[29]

The crucial factor in the destabilization of the Gothic design system, of course, was not the growing interest in realism, but rather the challenge posed by Italian Renaissance architecture, which appealed to patrons in ways that Gothic architecture could not. By 1500 Italian designers had begun to work in a formal vocabulary that effectively evoked the authority of classical Antiquity, and Italian authors had begun to establish this architecture within a sophisticated rhetorical and theoretical framework that had no real analog in the workshop traditions of the Gothic world. In terms of drawing practice, too, Italian draftsmen had begun by 1500 to work in a mode largely distinct from the geometrical mode typical of Gothic design. The dramatic spread of Italianate classicism throughout Europe in the sixteenth century thus tended to displace Gothic architecture from its long-held position of authority. In the centuries that followed, classical architecture became established as normative and the nuances of Gothic design practice were largely forgotten. The preceding chapters of this book have been occupied largely with the recovery of these nuances, tracing the dynamics of the Gothic design process to the greatest possible extent on its own terms. However, since the Renaissance has served not only as a foil to Gothic tradition but also as a filter through which the Gothic has been seen, this discussion would be incomplete without some consideration of the Renaissance ideas that have so strongly shaped how subsequent generations have understood logic, proportion, and harmony in architecture. The following chapter, therefore, will briefly explore the emergence of Renaissance design practice in Italy, tracing its emergence from medieval tradition and examining its appeal to the patrons who championed it in the pivotal decades around 1500.

[29] Brabantine draftsmen were able to achieve a surprising degree of geometrical rigor even when incorporating fairly prominent perspectival depth cues into their drawings. This can be seen not only in Metsijs's Leuven drawing, but also in the so-called Chalon plan for the great tower of Saint Rombout's church in Mechelen, which was probably produced by a member of the Keldermans family in the early sixteenth century. The buttresses in the drawing are shown dramatically splayed but the proportions of the elements in the drawing nevertheless match those in the actual tower quite closely. The alternative design, known as the Hollar plan, conversely, shows a tower whose main elements appear dramatically stretched, even though its buttresses are presented frontally. This plan was first published as an engraving by Wenceslas Hollar in 1649, and its relationship to the original plan drawings for the Mechelen project remains less than clear, although it has usually been seen as a fairly faithful recording of a design from the early sixteenth century. Neither version of the Mechelen design has the same geometrical clarity as the strictly orthogonal elevation drawings produced in the German world, but comparison between the two versions shows that the correlation between degrees of orthogonality and degrees of proportional accuracy was by no means strict. The crucial modern study of the Mechelen tower is Linda van Langendonck's 1984 dissertation for the Catholic University of Leuven, "De St. Romboutstoren te Mechelen." See also J.H. van Mosselveld et al. (eds), *Keldermans: Een architektonish netwerk in der Nederlanden* (The Hague, 1987).

CHAPTER SIX
The Italian Challenge to the Gothic Design System

The displacement of Gothic design by Renaissance classicism was one of the most dramatic pivots in the history of western architecture, involving revolutionary changes not only in the appearance and structure of buildings, but also in the way that they were conceived. The dynamics of this transition were of course extremely complex, and any reasonably complete account of the phenomenon would have to deal at length with the broader cultural context of architectural production. Even a fairly specialized book like this one, moreover, must acknowledge that the distinction between Gothic and Renaissance architectural cultures was anything but sharp. Category labels like "Gothic" and "Renaissance" are inevitably somewhat imprecise and artificial, and there has never been universal scholarly consensus about their definitions.[1] Even within the architectural spheres recognized as canonically Gothic or Renaissance, there was a great deal of variety, which complicates attempts to define essential characteristics of each mode. And, in the sixteenth century especially, many designers created hybrid structures that are effectively impossible to pigeonhole into one category or the other, since they drew on both architectural traditions. Despite these very real ambiguities and complications, though, the terms "Gothic" and "Renaissance" remain useful as labels for the two major architectural modes that existed side by side from roughly 1400 to 1600.

In Renaissance architectural culture, drawing and geometry played very different roles than they did in the Gothic culture. As the preceding chapters have shown, Gothic designers created their drawings through the use of dynamic geometry, with each simple step building on the last to produce final forms of great sophistication. Repeating modules were sometimes used to establish the basic armatures in Gothic drawings, but virtually all of the subsequent steps in the design process appear to have involved the use of the compass and rule to unfold richer and more complicated forms from the basic armature. This process generated dimensions whose mutual relationships were often irrational in the mathematical sense, meaning that they cannot be distilled into simple arithmetical ratios. For this reason, it was important that Gothic drawings were very precisely drawn. For this reason, too, Paul Frankl evocatively described Gothic as an architectural style based on partiality and subdivision.[2] He saw the architecture of Antiquity and the Renaissance, by contrast, as fundamentally additive in conception, involving the combination of theoretically indivisible elements like spheres, cubes, or classical columns. This approach to design could be effectively captured in sketches

[1] For a concise and still surprisingly relevant overview of the difficulties of categorizing late Gothic, see Jan Białostocki, "Late Gothic: Disagreements about the Concept," *Journal of the British Archaeological Association*, 29 (1966): 76–105.

[2] Frankl, *Gothic Architecture*, pp. 10–14.

executed far more roughly than Gothic drawings, since the details did not relate to the whole through the same kind of intricate geometrical cascade. This is not to say, of course, that Renaissance designers were uninterested in precision. But their interest in precision was largely bound up with the description of pre-existing forms, rather than the development of new ones. Realistic depictions of the human body, dimensioned sketches of ancient monuments, and perspectival renderings of buildings in three-dimensional space all attest to the Renaissance interest in accurate description, but the draftsman in all of these cases operates as an observer of an external reality, rather than as a creator with direct access to the logic of his creation.

It was in Italy, of course, that the Renaissance challenge to the Gothic design system first emerged. Continuity with the Roman and early Christian past played a strong role in Italian architectural culture throughout the Middle Ages, making Italy less receptive than the rest of Europe to Gothic architectural innovations. As the analyses of drawings from Orvieto and Siena demonstrated in Chapter 3, though, at least a few of the leading cathedral designers in the Italian peninsula were fully conversant with geometrically based Gothic design practices by the early fourteenth century. The famous and well-documented quarrel between northern and local builders at the cathedral of Milan around 1400, therefore, should not be understood as resulting from the first major incursion of northern Gothic ideas south of the Alps.[3] Instead, it marks just one phase in the ongoing confrontation between Gothic and Italian design practices, a phase in which Italian builders were still widely perceived as less theoretically sophisticated than the expert northern consultants whose advice they so vociferously resisted. Already at Milan, though, the Italians were beginning to seek theoretical justifications for their positions in the writings of Aristotle, and in the Vitruvian notion that the height of a capital should relate to that of its column as the height of a human head does to the whole body.[4] Just a few decades later Brunelleschi would introduce his pioneering, classically inspired designs in Florence, and by the middle of the fifteenth century, Alberti had given Renaissance architecture new theoretical and rhetorical standing with the publication of *De Re Aedificatoria*. From that point forward, Renaissance architecture would have more appeal for educated patrons than Gothic architecture would, despite the stupendous achievements of Gothic builders and the refinement of their design practices.

THE DESIGN DEBATES AT MILAN CATHEDRAL

Before going on to consider the confrontation between Gothic traditions and the architectural culture of the mature Italian Renaissance, it is worth considering the situation at Milan at somewhat greater length, especially since this episode has been the subject of

[3] The idea of Milan marking the first significant incursion of northern geometrical design into Italy is presented in Ascani's discussion of the Milan drawings, in *Il Trecento Disegnato*, pp. 114–25.

[4] Appeals to the authority of Aristotle, of course, were typical of medieval scholasticism, whose relationship to the professional culture of Gothic designers has been examined by commentators including Erwin Panofsky, in *Gothic Architecture and Scholasticism* (Latrobe, 1951), and Paul Binski, in "Working by Words alone." But, while references to Aristotle can hardly be taken to signify a preoccupation with Antiquity, the appeal by Milanese builders to authorities from outside Gothic architectural culture certainly did represent a challenge to that design tradition.

classic articles by Frankl, Panofsky, and Ackerman that continue to shape perceptions of Gothic design practice even today. The basic outlines of the Milan project are therefore familiar to many students of Gothic architecture. The cathedral was begun in 1386 with the backing of Duke Giangalazzeo Visconti, on a huge scale but within an otherwise traditional Lombard framework.[5] As Ackerman points out, Lombard design practice up to this point had been brick-based and rather provincial, with only minimal connection to the architectural culture of the northern Gothic world.[6] In this respect, the situation in Milan differed appreciably from those in Orvieto and Siena decades earlier. By 1389, though, the Milanese began to realize that the cathedral project involved challenges that they were not prepared to meet alone, and they hired Nicholas Bonaventure, the first of a series of northern European consultants.

The state of planning in the Milan workshop in 1390 was recorded in a series of drawings by Antonio di Vicenzo, an architect from Bologna who would go on to work at the comparably enormous Bolognese church of San Petronio. Figure 6.1, for example, shows a plan of the cathedral with its vertical section superposed in the nave. These drawings differ in several important respects from the Gothic drawings discussed in previous chapters. First, of course, they were not design drawings. Instead of generating the design from within, Antonio was documenting it after the fact, much as later Italian architects would document the appearance of ancient classical monuments. Second, Antonio achieved a useful level of precision not by drawing carefully with compass and rule, in the Gothic manner, but rather by adding text labels with dimensional information to an otherwise rather imprecise drawing. In this case, standardized modules were not merely convenient descriptive tools, as they would be for later Renaissance investigators of ancient monuments, since the Milan design recorded by Antonio di Vicenzo appears to have been modular in its very conception, with vessel widths based on simple units of 16 Milanese *braccia*, and vertical dimensions based on units of 10 *braccia* each (Figure 6.2a).[7] This proportioning scheme displays none of the interlocking geometrical relationships that give mature Gothic design its characteristic flavor. In the context of late-fourteenth-century Milan, this should probably be understood as reflecting lingering attachment to a provincial Romanesque mode rather than a precocious embrace of Renaissance planning methods, but the distinction between the two cannot be drawn with perfect sharpness. The rather un-Gothic quality of Antonio's drawings deserves particular note because Konrad Hecht cited both these drawings and the closely related work on San Petronio in Bologna as evidence for the predominance of modular thinking in Gothic design.[8] The

[5] The cathedral was not just a Visconti initiative; the city government was also intimately involved with the project. See Evelyn S. Welch, *Art and Authority in Renaissance Milan* (New Haven, 1996).

[6] Ackerman, "'Ars Sine Scientia'," 85–8.

[7] This, at least, appears to have been the fundamental architectural concept at this stage, as explained by Ackerman, in "'Ars Sine Scientia'," p. 89. Ackerman notes explicitly that the drawing was a sketch not executed to scale. Peter Kidson, however, is inclined to take the proportions of the drawing more seriously. He also notes that Antonio di Vicenzo's recording of the design was less than straightforward, since he used two different units in his labels: *piedi* to describe the plan, and *braccia* to describe the elevation. From a densely argued analysis of the relationship between these labels and the measured size of the cathedral, he works backwards to determine the size of the *braccia* used by the masons. See "Three Footnotes to the Milan Debates," in *Arte d'Occidente, Temi e metodi. Studi in onore di Angiola Maria Romanini* (Rome, 1999), esp. pp. 273–8.

[8] Hecht, *Maß und Zahl*, pp. 130–71.

fact that these particular examples lack complex geometrical structure, though, hardly constitutes an argument against the widespread use of geometrical planning methods in the rest of Europe, where Gothic design practice was much more securely established than in Lombardy and Bologna.

The next phase of the Milan Cathedral project involved the introduction of a more stereotypically Gothic scheme based on the equilateral triangle. This idea appears to have been introduced by Annas of Firimburg, one of the first German consultants to become involved in the project. Frankl, in his 1945 article on "The Secret of Medieval Masons," suggested that medieval builders favored the use of equilateral triangles because they were perfect Platonic forms.[9] This may very well have been part of their appeal, but the fact that they could be so easily and rigorously drawn was surely relevant as well. And, while Frankl's other writings display great sensitivity to the distinction between Gothic "partiality" and classical "additivity," his emphasis on the Platonic perfection of the equilateral triangle misleadingly suggests that Gothic designers were concerned principally with absolute proportions, despite a wealth of evidence that they were more concerned with the relationships generated by their geometrically dynamic design processes. It is true that some Gothic buildings really did have sections closely based on the equilateral triangle, as in the case of Strasbourg Cathedral discussed in Chapter 2. But Gothic designers clearly felt free to adopt more complex proportioning schemes, and they not infrequently altered the proportions of their buildings during construction. In this respect, at least, the continuing modifications of the elevation at Milan were typical of Gothic practice, rather than symptomatic of a drastic breakdown of the Gothic system, as Ackerman's widely cited 1949 article, "Ars Sine Scientia Nihil Est," had suggested. It is telling, moreover, that the real fetishization of the equilateral triangle in connection with Milan Cathedral came only in the sixteenth century, with the appearance of Cesariano's 1521 edition of Vitruvius, and the closely related *Vitrivius Deutsch* by Rivius.[10] These publications depict Milan Cathedral in outwardly Gothic form, but they belong intellectually to the Renaissance, and their forcing of the cathedral's section into a strictly equilateral frame reflects a preoccupation with fixed Platonic form that probably would have appeared quite odd to most Gothic designers.

In 1391, already, the mathematician Gabriel Stornaloco proposed a small but significant deviation away from the geometrically pure equilateral triangle scheme, whose meaning was first clarified for modern scholars in a short 1945 article by Erwin Panofsky that accompanied Frankl's essay on the "Secret of Medieval Masons."[11] As Panofsky demonstrated, Stornaloco was able to work out a clever modular approximation to the geometrically determined height of an equilateral triangle, which is an irrational number if the baseline is an integer. In the particular case of the Milan elevation, a strictly geometrical construction based on the building's width of 96 *braccia* would produce a height of roughly 83.13 *braccia*. After Stornaloco's consultation confirmed that the proper value would be slightly less than 84 *braccia*, the builders decided to give the building a height of 84 *braccia*, which could be conveniently divided into six strips, each 14 *braccia* high (Figure 6.2b). There was nothing inherently new about using

9 Frankl, "The Secret of Medieval Masons."

10 Müller, *Grundlagen gotischer Bautechnik*, pp. 42–3.

11 Erwin Panofsky, "An Explanation of Stornaloco's Formula," *Art Bulletin*, 27 (1945): 61–4.

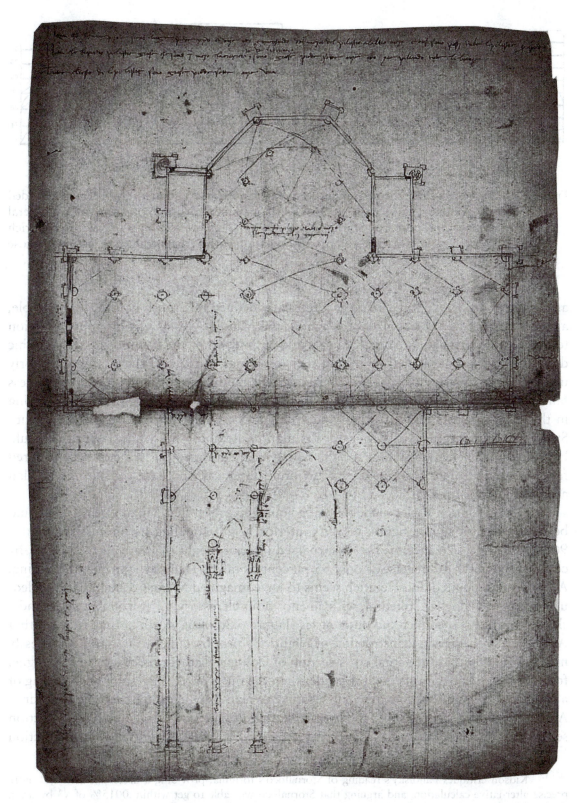

Figure 6.1 Ground plan and elevation of design for Milan Cathedral, as recorded by Antonio di Vicenzo in 1390.

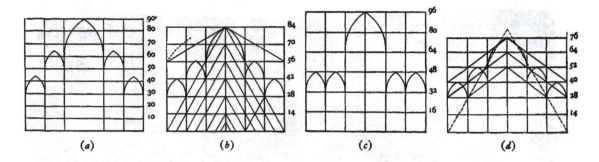

Figure 6.2 Proportioning schemes for successive Milan Cathedral designs: (a) scheme recorded
by Antonio di Vicenzo in 1390; (b) arithmetical approximation to equilateral
triangle, proposed by Stornaloco in 1391; (c) square section proposed by Heinrich
Parler in 1392; (d) final compromise solution with Pythagorean triangles above those
proposed by Stornaloco.

arithmetical ratios to approximate geometrically defined relationships; 7/5, for example,
appears to have been recognized throughout the Middle Ages as a good approximation
to the √2 ratio of a square's diagonal to its sides. And, while the methods used by Gothic
designers to translate dimensions from their drawings to their worksites remain poorly
understood, it appears likely that they used *ad hoc* modular approximations to other less
familiar geometrically determined relationships that arose in the design process. Nothing
in the record of traditional Gothic design practice, though, offers a close parallel with
Stornaloco's intellectually rigorous approximation method.[12] So, while Stornaloco could
be called an outside consultant for the Milan Cathedral project, his expertise differed
fundamentally from that of the northern Gothic designers who were consulting at Milan
around the same time.

In 1392, Heinrich Parler made the audacious suggestion that Milan Cathedral should
be built within a square figure, with its interior height equaling its impressive span of
96 *braccia*, or 54.24 meters. The unsurpassed interior height of Beauvais Cathedral, by
contrast, is "just" 46 meters, or only 85 percent as tall as Heinrich's proposed building.
As Ackerman pointed out, Heinrich seems to have imagined Milan Cathedral as a scaled-
up version of Cologne Cathedral, with an enormous clerestory, a triforium passage, and a
shared height for the inner and outer aisles (Figure 6.2c). It is worth noting, though, that
Ackerman's schematic reconstruction of Heinrich's proposed elevation has a relentlessly
modular quality that the actual cross-section of Cologne Cathedral does not. At Cologne,
for example, the inner aisle is subtly wider than the outer aisle, suggesting the working of
a geometrical design scheme like that seen in the plan drawing for Augsburg Cathedral.
Another building surely known to Heinrich Parler, Prague Cathedral, had a choir section
set by a governing octagon, as Chapter 4 showed. So, while Ackerman's reconstruction

[12] Kidson critiques Panofsky's reading of Stornaloco's formula, providing a more coherent and more
precise alternative calculation, and arguing that Stornaloco was able to get within .0015% of √3 by using
the known approximation 265/153. See "Three Footnotes on the Milan Debates," esp. pp. 271–3. Kidson's
argument, however, does not change the basic narrative explained by Panofsky, Frankl, and Ackerman—
namely, that the leaders of the Milan workshop chose on pragmatic grounds to round the height of their
building to 84 braccia, even though they knew, based on Stornaloco's work, that the real value was somewhat
smaller.

of Heinrich's scheme is evocative and helpful in suggesting its verticality, it should not be taken as representative of the geometrical structure in northern Gothic cathedrals. The rather unsubtle regularity of its groundplan, after all, was determined by the purely Lombard work on the cathedral's foundations. The discrepancy between Heinrich's vision and the habits of his Milanese employers soon proved too great to bridge, and he was dismissed from the project in May 1392.

In the wake of Parler's dismissal, a new and much lower elevation scheme was developed by the members of the Milan workshop, one that involved two distinct sets of triangles (Figure 6.2d). The nearly equilateral geometries proposed by Stornaloco would set the elevation up to a height of 28 *braccia*, at which point a new geometry based on the proportions of the Pythagorean 3-4-5 triangle would take over. The total height of the section would thus be $28 + 4 \times (3/4) \times 16 = 76$ *braccia*, lower than any of the previous proposals. As Ackerman observed, the coexistence of multiple design options all conceived "*ad triangulum*" in one sense or another complicates interpretation of the written sources from the Milan project. More largely, these linguistic challenges serve as useful reminders that simple terms like "*ad triangulum*" or "*ad quadratum*" fail to capture the complexity and diversity of Gothic design practice.[13] The most persistent of the northern Gothic consultants in Milan, the Frenchman Jean Mignot, objected to many aspects of the project, and he tried without success to advocate for a return to the 84-*braccia* height of Stornaloco's scheme. Ultimately, though, it was the geometrically hybrid 76-*braccia* scheme that governed the construction of the cathedral over the rest of its long history.

Ackerman understood Mignot's critiques of the Milan project mostly as evidence for a northern commitment to fixed and consistent geometrical frameworks, but this reading deserves at least a bit of qualification. At no point does Mignot appear to have explicitly argued against the mixing of two kinds of triangles in the section, and his own proposal for the restoration of the 84-*braccia* height involved stretching the vaults rather than creating a fully coherent geometrical system, though this might have been his preferred strategy under other circumstances.[14] Even in thirteenth-century France, the *locus classicus* of Gothic architectural order, changes to building sections had often been introduced during construction.[15] And, as the previous chapters have demonstrated, many Gothic drawings involved geometrical "gearshifts," as, for example, when tower elevations were made of stacks of progressively smaller boxes. So, there was nothing inherently heretical, from a northern Gothic point of view, in making geometrical transitions of this sort, although Ackerman evidently saw these mid-course adjustments to the elevation as the most shocking affronts to his twentieth-century vision of a rational design process.

In its broad outlines, Ackerman's famous article on Milan holds up remarkably well more than half a century after its composition, but his emphasis on rigid geometrical order leads him to subtly conflate two aspects of northern Gothic design that are best

[13] Even when closely related buildings were based on the same proportioning figure, their final forms could differ subtly, as the previously remarked contrasts between the octagon-based geometries of Clermont-Ferrand and Prague cathedrals demonstrate.

[14] Ackerman memorably called this format "a Pythagorean sandwich on equilateral bread," but this description applies at least as well to the hybrid scheme that he was seeking to modify. See "'Ars Sine Scientia'," 104.

[15] As at the cathedrals of Beauvais, Metz, and Auxerre, to cite just a few prominent examples.

understood as distinct but complementary. On the one hand, there was the draftsman's geometrically based process of form-generation, with which this book has been largely concerned. On the other hand, there was the builder's empirical process of learning by doing, based on the observation of cracking and bending patterns in real buildings. This latter approach was not scientific in the sense of being based on well-formulated theories, but it was highly effective in its limited sphere, allowing Gothic builders to achieve levels of structural efficiency that were unmatched until the modern era. Progress in this direction was particularly rapid in the century between 1150 and 1250, which was marked by widespread experimentation with new forms and design solutions. By the time work began on Milan Cathedral more than a century later, the lessons learned through experience had been codified into rules of thumb useful to northern Gothic builders.[16] Mignot, for example, argued that a wall buttress should have a depth roughly three times its thickness. Such empirically derived proportioning rules differed qualitatively from the more abstract geometrical relationships that arose naturally in the drawing-based design process.

Ackerman blurred this distinction by writing, first, that Gothic design was "based on the adoption of certain *a priori* formulae to which the entire structural and aesthetic character of a building must conform," and then going on to say that "The geometrical projects for the design of the section of Milan Cathedral immediately come to mind as the most striking example of the use of such formulae."[17] By "*a priori* formulae," then, Ackerman seems to be talking about figures like the square and the equilateral triangle. And, he strongly implies that Gothic builders saw conformity with these pre-determined figures as important guarantors of structural stability. But when Mignot berated the Milanese for their lack of geometrical "scientia," he concentrated on issues like buttress thickness rather than on the adherence to a single uniform elevation scheme. It seems, therefore, that Mignot's critique was based principally on his experience with the structural performance of actual northern buildings, more than on abstract concerns about Platonic geometrical perfection. One of the most important points about the empirically derived rules, in fact, is that they placed constraints on the draftsman's visual imagination. At any given point in the drawing process, several different avenues of geometrical development might lie open to the draftsman, and the rules of thumb would help to determine which of those avenues would result in a structurally plausible building. It was the fruitful dialogic interaction between these two complementary modes of thinking, in fact, that gave Gothic design its characteristic formal order.

In the latter part of his Milan article, Ackerman drew the distinction between Gothic and Renaissance principles of order with real sensitivity, but with slightly confusing terminology. In many respects his analysis parallels Paul Frankl's eloquent contrast between Gothic "partiality" and classical "additivity." Ackerman described Gothic proportioning schemes as abstract and relational, noting that a Gothic building element "has no autonomous existence, but gains its form only by virtue of its logical association with the whole." He then describes classical architecture as "organic," by which he means that each element can stand on its own as an independent whole, with its own intrinsic

[16] Mark, "Structural Experimentation in Gothic Architecture."

[17] Ackerman, "'Ars Sine Scientia'," 105.

set of proportions.[18] His basic point is, of course, accurate and important, but the term "organic" often connotes the potential for growth and change. Many authors, therefore, have used the word "organic" to describe Gothic buildings, which often appear to have grown over time like living organisms.

In an important sense, Gothic and Renaissance design embody two antithetical approaches to the passage to time. The Gothic style is what Frankl called a "style of becoming," in which the building's final form can be understood as the physical trace of a geometrical growth process unfolding over time.[19] By contrast, Renaissance canons of proportion, and classical norms of architectural design more generally, use modules to specify in an essentially timeless way how a building must be.[20] These two distinct approaches to design practice exemplify ordering strategies known respectively as process description and state description, to adopt the language introduced in the 1960s by Herbert Simon, a pioneer in the study of complex systems theory.[21] Process descriptions explain methods for generating components in a complex system, while state descriptions describe the components themselves. Process descriptions allow for open-ended growth and elaboration, while state descriptions are inherently closed and finite. Each of these approaches has its advantages. As Simon pointed out, process descriptions are generally required to describe truly complex systems like human bodies, which grow in response to rules encoded in DNA. State descriptions, by contrast, suffice to describe only fairly simple systems. Because of their simplicity and reliability, though, state descriptions like those in classical design can be communicated much more easily to non-expert audiences than the complex and essentially open-ended procedural rules of Gothic design.

The problem of communication between different professional cultures comes through clearly in the confrontation between the partisans of "*scientia*" and "*ars*" in the Milan accounts. The northern consultants clearly saw themselves as cerebral design experts, informed by their knowledge of geometrical design practices and empirically tested rules of thumb. Their approach cannot be called scientific in the modern sense, and it might even be a stretch to call it theoretical, but it certainly was based on a very highly refined design method readily comprehensible only to other similarly trained experts. The Milanese builders, by contrast, aimed both lower and higher in their approach to ideas. Lower, because they identified themselves largely as champions of "*ars*" or quality craftsmanship, rejecting the complex geometrical methods of the northern experts. Higher, because they attempted to justify their decisions with appeals to Aristotle, to the Bible, and to quasi-Vitruvian theories of architectural proportion, like the idea that a capital should be taller than a base because a human head is taller than a human foot. As Ackerman clearly demonstrated, they grossly misunderstood the passages they cited from Aristotle, and they had no real appreciation for the norms of classical design, but their attempt to wrap

18 Ackerman, "'Ars Sine Scientia'," 105.

19 Frankl, in *The Gothic*, pp. 619 and 774, notes the derivation of this concept from his teacher Heinrich Wölfflin.

20 Dagobert Frey drew a similar-sounding distinction in *Gotik und Renaissance als Grundlagen der modernen Weltanschauung* (Augsburg, 1929), but he was more concerned with the perception of the pictorial arts than with form-generation in architecture. For a brief but interesting discussion of this principle of temporal scanning in the observation of Gothic and Renaissance drawings, see Sanabria, "A Late Gothic Drawing of San Juan de los Reyes," 166–8.

21 Herbert A. Simon, "The Architecture of Complexity," *Proceedings of the American Philosophical Society*, no. 106 (1962): 467–82.

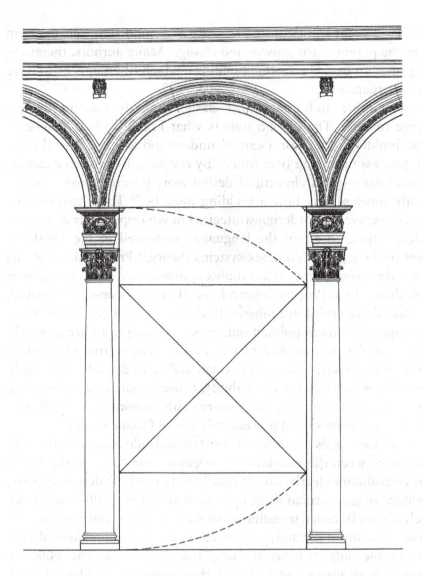

Figure 6.3
San Lorenzo, Florence,
proportions of arcade,
drawn by Matthew A.
Cohen.

their craft in the language of high-brow ideas nevertheless opened up an important new front in the war of ideas that they were waging against the northern consultants, whose exasperation is palpable in the documents. The tenacious Mignot, evidently frustrated by working in this surreal rhetorical environment, sought and received the support of Duke Giangalazzeo Visconti when he asked that an independent panel of experts be brought in to evaluate the work. Even this temporary success did not avail Mignot in the long run, though, since the local builders continued to dominate the debate, eventually securing his dismissal in 1402.

THE EMERGENCE OF CLASSICAL ARCHITECTURE IN THE ITALIAN RENAISSANCE

As the fifteenth century wore on, the rise of Renaissance architecture created an alternative to northern Gothic design that was visually and intellectually compelling in ways that princes and other educated non-specialists could appreciate, accomplishing in

reality what the Milanese builders around 1400 could only dream of. In a book like this one, dedicated to the study of Gothic design, it should suffice to mention only few key points in this immensely complex process. Brunelleschi's pioneering work on Florentine buildings like the Ospedale degli Innocenti and the church of San Lorenzo is widely considered to mark the birth of Renaissance architecture. In both a political and a visual sense, this classicizing architecture can be read as a rejoinder to the predominantly Gothic architecture of Visconti Milan, an important rival to still-Republican Florence. This is not to say, of course, that Brunelleschi's career marked a sharp break from the medieval past. Local Romanesque buildings like the baptistery of San Giovanni and the church of San Miniato al Monte were crucial precedents for his work. And, as Matthew Cohen has recently argued, the proportions of San Lorenzo may well have been largely established before Brunelleschi's intervention. Cohen showed, moreover, that the proportions of San Lorenzo's arcade involve both geometrical and modular constructions, which implies a certain overlap between the design strategies stereotypically identified with medieval and Renaissance design, respectively. One particularly interesting detail in his analysis is that the crucial spatial intervals at San Lorenzo appear to have been measured between the edges of column plinths, rather than between the column centerlines (Figure 6.3).[22] This really does mark a decisive departure from the Gothic system, which was essentially linear in conception. In Gothic design, pier centerlines and buttress axes are geometrically fundamental, as the previous chapters have shown, with wall and pier thicknesses typically being generated only later in the design process. In classical design, by contrast, the width of a pier or column was a fundamental quantity, establishing a module size from which most other dimensions in the building, including the column height, would be derived. The canonical relationships between column width and column height were established in Antiquity, and they were hardly unknown in the Middle Ages, but Romanesque and especially Gothic builders had progressively evolved away from these rigid proportioning rules, developing their own more flexible approach to architectural form-generation.[23]

One of the central paradoxes of the Renaissance is that it was at once progressive and reactionary, developing new ways to explore the world even as it looked backwards to the achievements of Antiquity. Different fields, of course, manifested this tension in different ways. In the realm of visual culture, it is probably fair to say that the progressive and exploratory aspects of the Renaissance manifested themselves most fully in the representational arts, where the growing taste for realism and analytical rigor fostered the development of scientific perspective, which was perfected by Brunelleschi and publicized by Alberti. The reactionary aspects of the Renaissance, conversely, manifested themselves most fully in the architectural sphere, ultimately forcing the abandonment of many fruitful medieval innovations, including the pointed arch, the flying buttress, and

[22] This illustration appears as fig. 9 in Matthew Cohen, "How much Brunelleschi? A Late Medieval Proportional System in the Basilica of San Lorenzo in Florence," *Journal of the Society of Architectural Historians*, 67/1 (2008): 18–57. The image is based on original measurements of the basilica recorded by Cohen from scaffolding; these measurements are available for the reader's inspection in Appendix 2 of the above-noted article.

[23] For perspectives on the use of quasi-classical columns in Gothic architecture, see, for example, Marvin Trachtenberg, "Desedimenting Time: Gothic Column/Paradigm Shifter," in *RES: Anthropology and Aesthetics*, 40 (2001): 5–28; and Peter Draper, "Canterbury Cathedral: Classical Columns in the Trinity Chapel?" *Architectural History*, 44 (2001): 172–8.

the whole Gothic system of geometrically based proportioning. The supposedly "correct" forms, after all, had already been invented in Antiquity.[24]

These profound formal and intellectual shifts decisively changed the role of architectural drawing. In Gothic design practice, the drafting table was the main locus of creativity. By drawing very precisely with compass and rule, the designer could generate formal relationships on parchment more subtle than anything he had explicitly planned beforehand. These relationships could then be judged against the empirically derived rules of thumb governing prudent building practice. In Gothic architectural culture, therefore, the thinking was primarily visual and structural, and drawings generally stood on their own, independent of elucidating texts. In Renaissance architectural culture, conversely, the thinking was primarily verbal and theoretical, and drawings often gained their power from their association with texts. And, while Gothic drawings were the traces of a largely open-ended creative process, Renaissance drawings often served to illustrate ideas that had already been established, whether in nature, in Antiquity, or in a theoretical text.

The history of Renaissance architecture was closely bound up with the history of architectural treatises, in which texts had conceptual priority over illustrations.[25] The text of Vitruvius's *De Architectura* had survived the Middle Ages, and it began to enjoy wider fame in the early fifteenth century thanks to the efforts of the Florentine Humanist Poggio Bracciolini, despite the fact that its original illustrations had been lost in Antiquity. Its most direct Renaissance successor, Alberti's *De Re Aedificatoria*, also initially appeared without illustrations, and its discussion of proportion emphasized the importance of simple arithmetical ratios that recall musical consonances, an idea that appeals to the intellect more than to the eye. Filarete's *Trattato di architettura*, which is often considered to be the first illustrated treatise of the Italian Renaissance, includes a geometrically rigid star-shaped plan for the ideal city of Sforzinda, but most of the other illustrations are sketchy and pseudo-perspectival. In no case does Filarete appear to have used dynamic geometry to discover new formal relationships in the Gothic manner, which is hardly surprising, given his own stated antipathy to Gothic design. Francesco di Giorgio adopted a similarly descriptive pictorial approach in his wide-ranging *Trattato di architettura, ingegneria e arte militare*. Many of his illustrations of machines are rendered in perspective, while his architectural drawings are mostly schematic plans and elevations showing proportional relationships between architectural elements and the human body. The basic analogy between the body and the classical column had already been established in Antiquity, as Vitruvius's text attests, and some dim echo of this idea may have informed the Milanese builders who defended the cathedral's large capitals around 1400, but Francesco di Giorgio took the concept much further, using comparisons with human features to set not only the proportions of columns and capitals, but also those of whole churches and even whole cities. Here the images really do help to make the text comprehensible, but they again

[24] For a classic statement of the ways that realism and classicism entered Renaissance visual culture most strongly through painting and architecture, respectively, see Erwin Panofsky, *Renaissance and Renascences in Western Art* (New York, 1972), esp. 165–7.

[25] Alina Payne, *The Architectural Treatise in the Italian Renaissance: Architectural Invention, Ornament, and Literary Culture* (Cambridge, 1999).

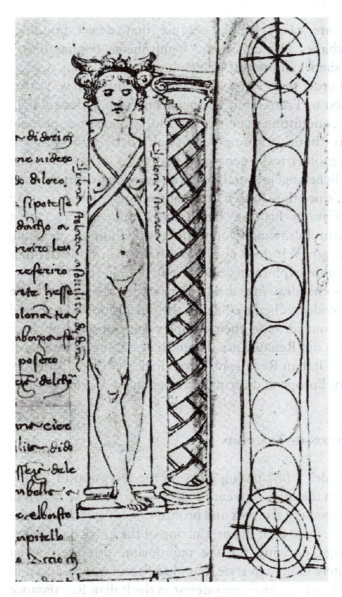

serve more as illustrations of ideas than as laboratories for the careful working out of formal relationships in the Gothic manner.[26]

Renaissance architects could afford to draw in a looser and less geometrically precise manner than their Gothic contemporaries in large part because they were engaged in description rather than in the generation of qualitatively new forms. When Francesco di Giorgio shows the figure of a young woman within the outline of an Ionic column, for example, the idea comes through clearly, despite the sketchiness of the rendering (Figure 6.4). And, when he shows the proportions of the column by stacking a series of circles within it, the ratio of height to width is obvious, despite the loose draftsmanship. In a very real sense, therefore, the use of modules could allow draftsmen to convey their ideas with precision, even when their drawing style was not precise. This principle can also be seen in the annotated field sketches that Giuliano da Sangallo prepared in his study of ancient monuments like the Colosseum (Figure 6.5). Standardized module-based systems of measure can be powerful tools for describing the state of a system from the outside, even when the

Figure 6.4 Francesco di Giorgio, proportions of columns based on the human figure (at left) and the repetition of regular modules (at right).

procedural logic that governed its initial development remains unclear. Precision in measurement can thus serve as a surrogate for real understanding, for which it can prepare the way. Imprecise drawing, conversely, can usefully convey ideas when the basic forms in question are well understood. Leonardo da Vinci's famous sketches of

[26] One area in which Renaissance draftsmen surely did use drawing to work out geometrical ideas, however, was in the design of fortifications, where the lines that mattered were the lines of fire permitted by the shape of the bastions and the surrounding topography. Francesco di Giorgio, for example, was a pioneer in the design of polygonal bastions, inaugurating a tradition of the so-called "trace Italienne" or star fort, which would play a significant role in warfare for the next several centuries. The design process for such forts can be likened to the Gothic church design process discussed in this book, but only in the very general sense that geometrical unfolding was involved in both cases.

centralized churches, for example, are easily legible because they depict buildings composed of simple and familiar shapes like cubes and hemispheres (Figure 6.6).[27] Leonardo certainly combined those shapes in interesting ways, and some of his designs have a geometrically cascading visual order that relates large and small forms in ways that recall the Gothic "partiality" identified by Frankl, but he appears to have understood all those relationships in his head before committing them to paper. So, while his perspectival sketches certainly seem to record his "brain-storming" design alternatives, he was not really using the drawings in the same geometrically generative way that Gothic draftsmen used their plans and elevations.[28] Michelangelo's architectural drawings contrast even more strongly with Gothic drawings, since they have a quasi-human muscularity instead of a quasi-crystalline formal order. Cammy Brothers has recently argued, in fact, that Michelangelo revolutionized architectural drawing by importing techniques of sketching from the figural and representational arts.[29] It does not follow from this, however, that his drawing process was necessarily more exploratory and inventive than that of Gothic draftsmen. The greater precision of Gothic drawings does not mean that they were sterile presentations of previously worked out ideas. On the contrary, their precision was required so that Gothic designers could work out ideas in their complex and formally abstract mode, which made far less appeal than did Renaissance design to agreed-upon standards of proportion. The sketchiness of most Italian Renaissance drawings, therefore, probably would have been shocking to northern European draftsmen trained in the Gothic mode.

Hermann Vischer and the Hybridization of Tradition

The career of Hermann Vischer provides a fascinating gloss on the reception of Italian architecture by a northern draftsman in the early sixteenth century. Hermann was born in 1486 as the eldest son of the noted Nuremberg sculptor and bronze-caster Peter Vischer the Elder, who would be charged two years later with the production of the grave monument for Saint Sebaldus. The oldest design drawing for the monument, produced when Hermann was a baby, remains resolutely Gothic in style, but modifications introduced in the project's long history attest to the Vischers' growing interest in the Italian Renaissance mode. The monument was finally completed in 1519 as a hybrid structure with a largely Gothic spatial framework and loosely classicizing detailing. In the meantime, Hermann had grown to manhood and undertaken a trip to northern Italy, where between 1515 and 1516 he produced a series of fascinating drawings that depict classical building in the hard-edged and geometrically precise manner characteristic of Gothic tradition.[30] His subjects

[27] See James Ackerman, "Leonardo da Vinci's Church Designs," in *Origins, Imitation, Conventions*, pp. 58–93.

[28] On the relationship between perspective and orthographic modes of representation in Italian Renaissance architectural design, with particular emphasis on the under-estimated importance of perspectival drawings, see Ann C. Huppert, "Envisioning New St. Peter's: Perspectival Drawings and the Process of Design," *Journal of the Society of Architectural Historians*, 68 (2009): 158–77.

[29] Cammy Brothers, *Michelangelo, Drawing, and the Invention of Architecture* (New Haven, 2008).

[30] Astrid Lang, "Die frühneuzeitliche Architekturzeichnung als Medium intra- und interkultureller Kommunikation: Entwurfs- und Repräsentationskonventionen nördlich der Alpen und ihre Bedeutung für den Kulturtransfer um 1500 am Beispiel der Architekturzeichnungen von Hermann Vischer dem Jüngeren"

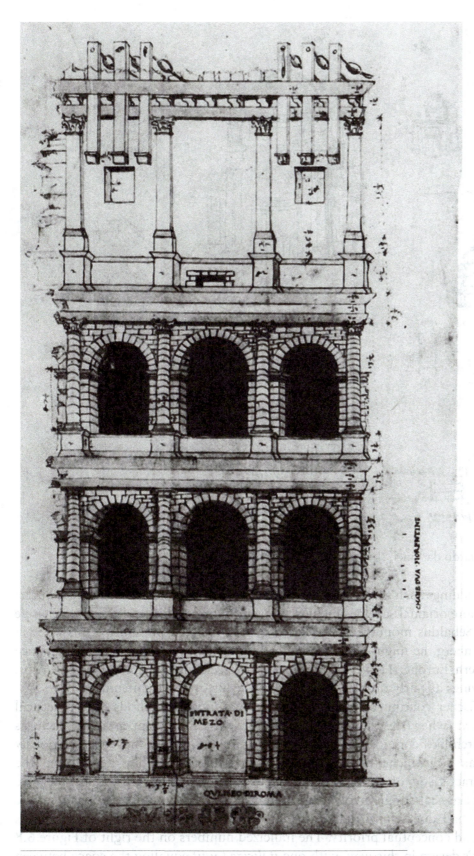

Figure 6.5 Giuliano da Sangallo, sketch of the Colosseum annotated with dimensions.

(PhD. diss., University of Cologne, 2009). See also Derick Dreher, "The drawings of Peter Vischer the Younger and the Vischer Workshop of Renaissance Nuremberg" (PhD. diss., Yale University, 2002).

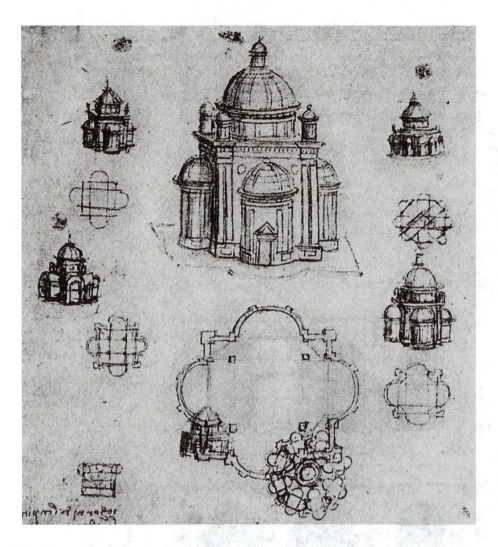

Figure 6.6 Leonardo da Vinci, sketches of centralized churches.

include actual buildings such as the Pantheon and Alberti's San Andrea in Mantua, but he also produced more original schemes including several thoroughly classicizing alternative designs for the Sebaldus monument. If Hermann had lived to popularize this style in his native Nuremberg, he might have dramatically affected the progress of Renaissance design in northern Europe. However, he died in an accident while crossing the Alps, leaving his drawings as fairly obscure footnotes to the history of architecture.

Hermann Vischer continued to use the traditional Gothic methods of geometrical construction even when describing structures of classicizing appearance, such as the triumphal-arch-like composition shown in Figure 6.7, which has been variously interpreted as an altar niche or a funerary monument. But, while he rejected the sketchiness characteristic of most Italian Renaissance drawings, he seems to have understood that classical design involved a different approach to modularity than Gothic design generally had done. In virtually all Gothic drawings, pier axes and centerlines appear to have had conceptual priority. The italicized numbers on the right of Figure 6.8 measure Vischer's design in this way, with one *italicized unit* equaling the space between

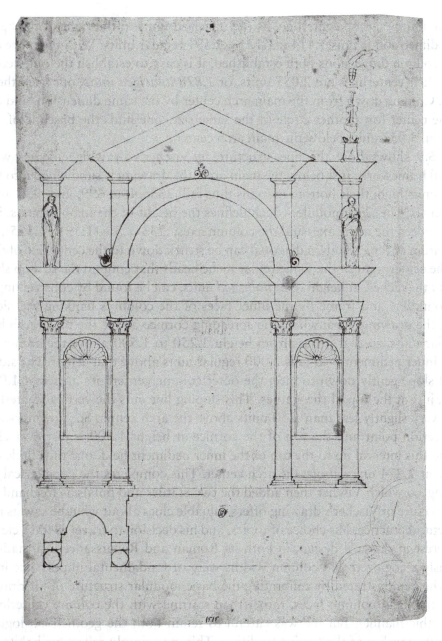

Figure 6.7 Hermann Vischer, drawing of pedimented wall monument.

the drawing centerline and the inner column axis. In Hermann's design, though, the really crucial dimension appears to have been the radius of the arch at the center of the drawing, from which the rest of the composition grows. In the left-hand half of Figure 6.8, therefore, this radius is taken as one unit. The width of the columns is exactly one-fourth as large, or .250 units. This dimension also equals the height of the entablature directly over the arch. Vischer's drawing thus incorporates a simple modular structure based on measurements to column faces, a system with close analogies to the one Cohen discerned at San Lorenzo in Florence. But, as at San Lorenzo, pier axes and geometrical constructions also matter in Vischer's drawing. The centerline of the niche flanking the main arch is √2 greater than the

span to the inner column centerline, as the italicized units in the right of the figure make clear; this dimension is thus 1.414 × 1.125 = 1.591 regular units. With the niche centerline and inner column dimensions both established, it is easy to establish the outer columns by reflection; their centerlines are 2.057 units, or *1.828 italicized units*, out from the drawing centerline. Coming down from the main arch center by the same dimension, and using that level as the center for another circle of the same size, one finds the baseline of the whole composition, 3.057 units below the main arch center.

Figure 6.9 shows how the fine structure of Vischer's drawing emerges within this geometrical framework. Just below the main arch, the drawing is subdivided into four slices each .233 units high; their bottom margins thus fall .233, .466, 699, and .932 units below the arch center. The .233 module, which defines the height of the main capitals, is half the distance between the niche axes and the column axes; .233 = .5 × (1.591 - 1.125). From the bottom margin of the capitals, a diagonal can be struck down to the centerline of the niches, locating the centerpoint of the semicircular niche heads that contain the scallop shell motif. The base of the niches, at height *.606 italicized* units, can be found by constructing a square on the groundline and frame by the inner faces of the columns flanking the niche. Near the top of the drawing, meanwhile, the spreading cornice above the main arch has height .250 regular units, so that it rises from height 1.250 to 1.500 above the arch center. The top of the inner pediment field falls 2.000 regular units above that center. The sides of that inner field slope gently down to meet the outer column centerlines at height 1.000 above the center, just at the top of the statues. This sloping line cuts the vertical centerline of the niche bay very slightly less than .250 units above the arch center. So, the interval between this intersection point and the top of the cornice at height 1.500 is just over .250 units. Translating this interval up to the top of the inner pediment field, one thus finds the top of the pediment 2.274 units above the arch center. This completes the geometrical layout of the drawing, to which Vischer then added the two statues and finials as freehand sketches.

The structure of Vischer's drawing offers valuable clues about what he saw as important in architectural practice. His choice of topics, and his decision to travel to Italy, clearly attest to his interest in classical design, in both its Roman and Renaissance incarnations. And, he obviously recognized that column widths were of fundamental importance in classical design, as he demonstrated by calibrating the basic modular structure of his drawing with respect to the inner column faces, rather than starting with the column centerlines in the normal Gothic manner. But, he was careful to retain both the geometrical logic and the precise draftsmanship of the Gothic tradition. This may simply reflect his habits and early training, or it may reflect an active distrust of the sketchier Italianate drawing mode, either on his part or on the part of the northern audience that he hoped to address.

How Renaissance Design Won the Communication War

In the half-century bracketing 1500, the power relationship between the Gothic and Renaissance design traditions changed dramatically, as ideas first formulated in Italy began to influence northerners like Hermann Vischer. Prior to 1475 or so, only a few northern artists such as Jean Fouquet appear to have paid careful attention to Italian Renaissance architecture, and northern patrons generally remained content with Gothic building

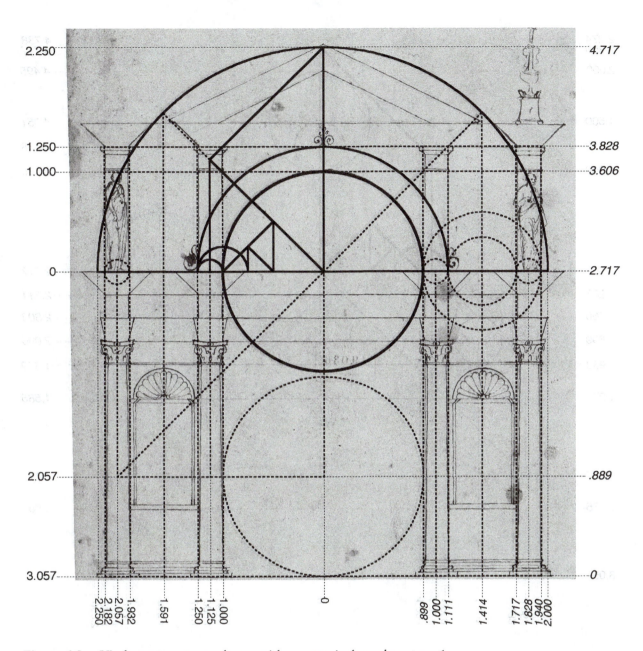

Figure 6.8 Vischer monument scheme with geometrical overlay, stage 1.

projects. But classical design had two enormous advantages that made it appealing to the well-educated princes and aristocrats who increasingly dominated European architectural production at the turn of the sixteenth century: first, it effectively evoked the political power of Roman civilization; second, it fit together neatly with the humanist intellectual culture that was spreading throughout Europe at the time. In both cases, there were some ironies that complicate the still-influential association of the Renaissance with enlightenment and progress.

In the political sphere, for example, Florentine artists may have begun using classical forms to evoke their Roman republican heritage, in opposition to the aristocratic threat from Visconti Milan, but Medici patronage in the middle decades of the fifteenth century

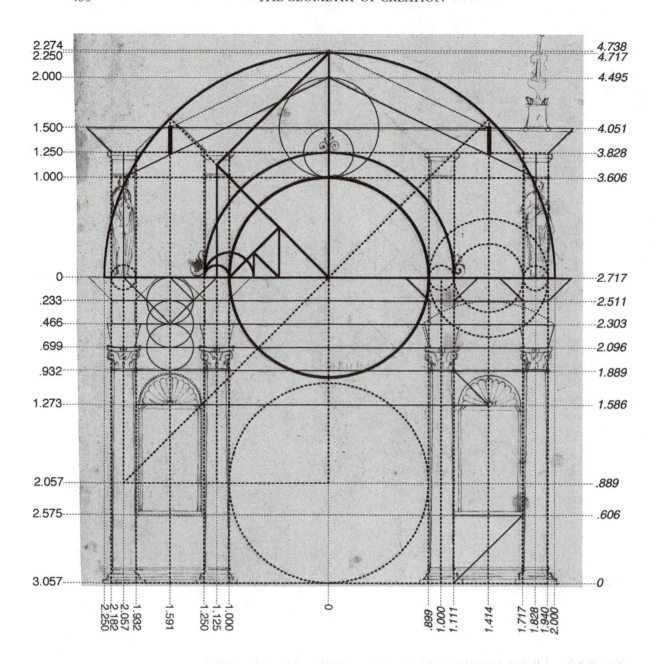

Figure 6.9 Vischer monument scheme with geometrical overlay, stage 2.

shifted the flavor of Florentine classicism into an aristocratic register. Power-hungry rulers and the members of their courts saw the propagandistic advantages of this quasi-imperial mode, which could not be faulted for its pagan associations, since it had also been embraced by the papacy. Matthias Corvinus of Hungary was the first transalpine ruler to chart this path in the late fifteenth century, and the kings of France began to follow suit, especially after their invasion of Italy in 1494.[31] In England, Spain, and Germany, too, kings and courtiers were the leading patrons of classicizing art and architecture, which

[31] Jan Białostocki, *Art of the Renaissance in Eastern Europe* (Ithaca, 1976); Henri Zerner, *Renaissance Art in France: The Invention of Classicism* (New York, 2004).

they imposed from above in a period when Gothic design was enjoying an extraordinary creative flourishing of its own.

Gothic architectural culture was enormously sophisticated on its own terms, but it was poorly prepared to respond to the Italian Renaissance challenge because its sophistication could not be readily expressed in verbal terms that humanist princes and other well-educated laymen could understand. In a very real and important sense, the logic of Gothic design was "unspeakable." It could be communicated from master to apprentice, of course, as the continuity of Gothic architectural practice over four centuries demonstrates, but this teaching evidently involved visual thinking and learning by doing, not verbal communication with non-experts outside the workshop culture. Even in the years around 1400, when Gothic architecture enjoyed tremendous prestige, Jean Mignot and the other northern consultants at Milan had obvious difficulties in convincing the local builders and patrons of the legitimacy of their arguments. The Milanese held their own partly through the strength of numbers, but also through their willingness to invoke impressive-sounding authorities like Aristotle. As Ackerman made clear, these invocations were nonsensical and frighteningly uninformed, but they evidently struck the Milanese as useful debating points. And, as Peter Kidson has observed, Gothic designers like Mignot were hardly paragons of analytical thinking; the geometrical strategies behind their amazing buildings are well worthy of study, as the preceding chapters have shown, but they are intellectually vacuous compared to mathematical explorations of the classical and Renaissance worlds.[32]

Over the course of the fifteenth century, the rhetorical case for classical architecture improved even more rapidly than the architecture itself. The elegant Ciceronian Latin of Alberti's *De Re Aedificatoria*, in particular, made a persuasive case for Renaissance architecture, complementing the re-popularization of Vitruvius's *De Architectura*. Like its ancient model, Alberti's text framed architecture in broad terms that thoughtful non-specialists could respect and appreciate. The northern Gothic tradition never produced such a comprehensive and eloquent text. The few architectural texts surviving from late Gothic Germany are pitifully short, awkward, and narrowly formulaic in comparison, combining the worst qualities of cookbooks and math textbooks. Some of them, like the so-called Vienna Meisterbuch, were composed already around 1400, but Paul Crossley has argued that Matthäus Roriczer published his *Büchlein* in 1486 as a direct rejoinder to the appearance of new editions of both *De Architectura* and *De Re Aedificatoria* in the previous year. This is plausible, since Roriczer dedicated his booklet to his patron, Wilhelm von Reichenau, the bishop of Eichstätt, an educated humanist who would have been familiar with these works. Crossley has also explained the emergence of explicitly vegetal architecture, like that seen in the remarkable chapel vaults from Ingolstadt, as part of a self-conscious German reaction to classical architectural theory.[33] By carving ribs as branches, he suggests, German builders could invoke both the Vitruvian idea that architecture began with the construction of wooden huts, and the reports by Tacitus

[32] Kidson argues that by the time of Matthäus Roriczer and Piero della Francesca, a gulf of mathematical sophistication had emerged between the Gothic and Renaissance worlds, and that recognition of this gulf helps to explain why the Gothic tradition "collapsed at the onset of the Renaissance with scarcely a word in its own defense." See "Three Footnotes on the Milan Debates," p. 273.

[33] Crossley, "The Return to the Forest." For complementary glosses on the branchwork style, see Kavaler, "Architectural Wit"; and Ethan Matt Kavaler, "Nature and the Chapel Vaults at Ingolstadt: Structuralist and Other Perspectives," *Art Bulletin*, 87 (2005): 230–48.

that Germans of his day worshiped in forest groves, thereby giving their work a patina of theoretical respectability that it would have lacked otherwise. These arguments are somewhat speculative in their specifics, but there can be no doubt that Gothic designers in the decades around 1500 were operating in a new environment, where they were forced to respond defensively to the challenge posed by Italianate classicism.

Ultimately, of course, Gothic architectural culture proved unable to defend itself against its increasingly assertive Renaissance rival, but it is worth noting that its defeat took place more in the realm of rhetoric and theory than in the realm of architectural practice itself. The demise of Gothic design cannot be blamed on a lack of creative energy or technical expertise. Gothic design continued to flourish well into the sixteenth century, and Gothic builders continued to produce structures that were at least as well engineered and functional as the classical alternatives. To the extent that patrons came to prefer classicism, it was largely because of its intellectual, political, and theoretical associations. In architectural history, as in the modern commercial marketplace, success or failure can turn on the quality of the advertising as much as on the quality of the product. And, of course, successful communication depends on a degree of empathy and mutual understanding. It is surely significant, in this connection, that the humanist princes who helped to spread classical architecture throughout Europe had far more in common with Alberti than they did with Gothic designers. They could appreciate a finely turned classical phrase, or the beauty of Pythagorean musical theory, but they had no particular expertise with the workshop traditions of Gothic geometry or building practice. They were, in an important sense, dilettantes. Gothic builders, conversely, came to be seen as lacking because they could not communicate like humanist intellectuals, or participate fully in the culture of Renaissance court life. So, while the Renaissance has usually been celebrated for elevating the social status of artists and architects, there was an important sense in which the establishment of architecture as a liberal art actually undercut the autonomy and dignity of a Gothic architectural culture that had been characterized by a high degree of professionalism.

Gothic designers truly lost the communication war when illustrated versions of classical architectural treatises began to be published in the sixteenth century. Verbally and rhetorically outmatched at least since the mid-fifteenth century, they suddenly faced a new challenge in the visual sphere where their ideas were actually developed. The dynamically unfolding geometrical processes of Gothic form-generation cannot be easily captured in simple and concise illustrations; this book, therefore, has had to rely on multiple illustrations for each drawing under discussion, augmented by lengthy texts narrating the likely drawing sequence. The ideals of classical design, by contrast, can be more readily conveyed in printed books, since the formal logic of classicism is essentially static and atemporal, involving what Simon called state description rather than process description. It is interesting in this connection that one of the first well-illustrated printed treatises, Cesariano's 1521 edition of Vitruvius, shows Milan Cathedral with an idealized equilateral triangular cross-section whose rigid perfection conveys neither the chaotic history of the Milan workshop nor the more flexible geometrical cascade structure typical of northern Gothic design (Figure 6.10). In its own subtle way, therefore, even this superficially Gothic-looking illustration helped to obscure the dynamics of the Gothic design process. More obviously harmful to the popularity of Gothic architecture, of course, was the

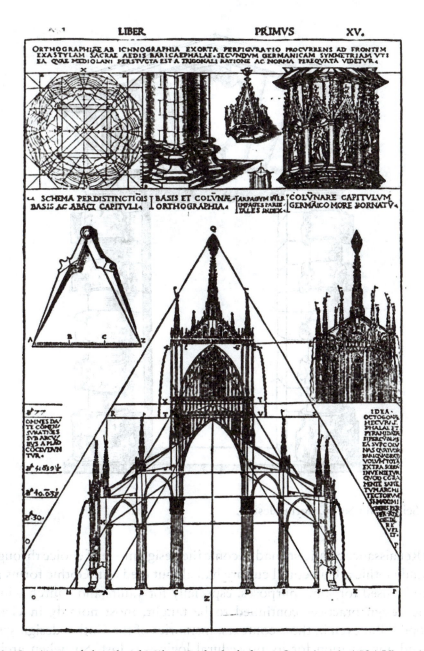

Figure 6.10 Section and details of Milan Cathedral, from Cesariano's 1521 Vitruvius.

printing of illustrated treatises explicitly championing classical design. The publication of Serlio's *Libri* starting in 1537, for example, played a dramatic role in spreading the taste for Renaissance architecture throughout Europe, with his imaginative mannerist designs having particular impact at the French court of Francis I (Figure 6.11). Vignola's *Regole delli cinque ordini d'architettura* appeared in 1562, and Palladio's *I Quattro Libri dell'Architettura* followed in 1570. All of these works proclaimed the virtues of classical design and its module-based systems of proportion, and their cumulative impact was immense.

Figure 6.11 Sebastiano Serlio, portal design.

By 1600 Renaissance classicism had become the design mode of choice throughout most of Europe, and Gothic architectural culture had all but died out. Gothic forms admittedly continued to be used for some purposes, especially for vaults and church windows, and some Gothic design practices continued to be taught, most notably in Germany and central Europe.[34] But even in these contexts, memories of the Gothic design system faded over time, and appreciation for its procedural logic was lost. So, when architects and scholars began to contemplate Gothic architecture more sympathetically in the nineteenth century, they effectively had to build up a new understanding of medieval design from scratch. Not surprisingly, therefore, many of the geometrical schemes proposed to explain Gothic architecture, starting in the Romantic era, were highly fanciful, although it is important to note that the architects involved in the completion and maintenance of great medieval buildings like Cologne Cathedral or the Stephansdom in Vienna developed an understanding of Gothic form that few subsequent scholars have matched. The flood of unconvincing geometrical studies of Gothic architecture continued well into the twentieth century, and Konrad Hecht was right to criticize much of this work as imprecise and

34 Hermann Hipp, *Studien zur "Nachgotik" des 16. und 17. Jahrhunderts in Deutschland, Böhmen, Österreich und der Schweiz* (Tübingen. 1979).

sloppy. His own purely module-based discussion of Gothic architecture, however, boils down to little more than quantified description, which fails utterly to explain the forms of the buildings in question. A variety of recent studies have suggested that there was much more to Gothic geometry than Hecht believed, but his work has continued to exercise an unfortunate chilling effect on the field, preventing the full appreciation of the sophisticated design system that was so decisively rejected in the Renaissance.

CONCLUSION
Gothic Drawings as Traces of the Creative Process

The main goal of this book has been to advance the scholarly conversation about Gothic design techniques by bringing to bear detailed evidence about the geometry of Gothic architectural drawings. Drawings are ideal subjects for geometrical study because they include compass prick points, construction lines, and other telltale traces of the creative process, and because their proportions are those intended by the designers, uncompromised by the sorts of errors that creep into full-scale buildings in the course of construction. As the preceding chapters have demonstrated, the study of drawings can offer a remarkably intimate perspective on the Gothic creative process over two different timescales: over the hours of the draftsman's labor, and over the centuries of the Gothic era.

The case studies in this book have demonstrated that Gothic draftsmen adopted a dynamic approach to design, combining simple geometrical operations in unfolding sequences to produce final forms of great complexity. It is worth emphasizing, especially in light of the rather romanticized view often taken of medieval geometry, that their approach was highly practical. The most frequently encountered governing figures in Gothic drawings were squares, equilateral triangles, and octagons, all of which can be easily constructed with compass and rule. The unending variety with which such figures could be combined, though, shows that simple terms like "*ad quadratum*" and "*ad triangulum*" provide a grossly insufficient vocabulary for the description of Gothic design options. The dialog between all these polygons and their circumscribing circles plays such an important role in Gothic design, meanwhile, that terms like "octature" and "hexature" deserve to be recognized alongside the more well-established term "quadrature."

There can be absolutely no doubt that Gothic draftsmen used this geometrical approach to design, because their drawings and buildings proclaim it in many different ways. Tracery patterns, for example, were obviously conceived geometrically. And, while Gothic draftsmen were generally careful not to mar their great presentation drawings with conspicuous prick marks and construction lines, enough such marks survive, especially in ground plans, to demonstrate their widespread use. As the preceding case studies have shown, moreover, coherent geometrical armatures precisely match the main inked lines in dozens of the most important drawings of the Gothic era. In many instances, seemingly capricious decorative details in the drawings actually call attention to key points in these armatures. Gargoyles, grotesques, and tracery elements were all used as signposts or *aide-mémoires* that would help to make the drawings geometrically legible to the designers and their colleagues. In many cases, too, the trimming and suturing patterns in the parchments align

with geometrical armatures governing the drawings. The convergence of all this evidence should convince even the most committed skeptics that geometrical design methods played a central role in Gothic architectural culture.

While the focus of this book has been on geometry, it is important to acknowledge that geometrical and modular approaches to design were not mutually exclusive in any absolute sense. In some instances, Gothic designers evidently began with simple modular relationships, as Ulrich von Ensingen did in constructing the ground plan of the Ulm tower, before he went on to construct an elaborate geometrical scheme within this modular frame. In other instances, Gothic builders used arithmetical approximations to geometrically derived proportions, as when Lechler recommended the use of 7/5 to stand in for $\sqrt{2}$. The translation of designs from the drawing to the worksite would have been facilitated by the use of module-based scaling systems, and there is abundant evidence for the use of consistent foot units in many Gothic worksites. Unfortunately, though, the proliferation of measuring units in Gothic Europe complicates comparison between different building projects. In many cases where design drawings survive, moreover, changes of relative proportion were often introduced during construction, which makes it impossible to unambiguously specify the intended scale of the drawing. The relationship between the geometrical design strategies described in this book and the modular strategies also current in the Gothic era remains to be fully clarified; this should be a fruitful area for further research.

The evidence presented in this book demonstrates striking continuity of design practice over the whole of the Gothic era. The survival of Villard de Honnecourt's portfolio demonstrates that architectural drawings were already in use in the early thirteenth century, even if Villard himself was a layman rather than a designer. Given the poor survival rate of Gothic drawings, and the manifest complexity of Gothic architecture even in its early stages, it is conceivable that such design drawings were being used already in the mid-twelfth century. Villard's overall building plans, especially the schematic one of a Cistercian church built up of squares, clearly illustrate the linear quality of Gothic design, in which pier center points and buttress axes had conceptual priority. This treatment of the building as a linear skeleton would continue to characterize Gothic well into the sixteenth century. Villard's drawings of the Laon Cathedral tower, meanwhile, show that both square rotation and square stacking were used to set tower proportions in the years around 1200, as they still would be around 1500. The geometrical structure of the second Reims Palimpsest design, similarly, shows that octature was already in use as a proportioning scheme by around 1250. Plan A for Strasbourg Cathedral, like the building's section, incorporates geometries based on the equilateral triangle, but the subtle mismatch between these two schemes illustrates the danger of relying exclusively on reductive terms like "*ad triangulum*." Geometrical analysis of Strasbourg Plan B suggests that the entirety of this great drawing was conceived by one designer who took the octagonal plan of the spires as his point of departure, but the discontinuity in the drawing's production hints that he may have had a late-breaking realization about the three-dimensional implications of his design. This scenario, if true, would illustrate both the power and the perils of drawing as a tool of Gothic architectural design.

The geometrical study of design drawings offers a valuable perspective not only on the overall continuity of Gothic design practice, but also on the micro-histories of many particularly noteworthy workshops, and on the relationships between these micro-histories.

The competitive dialog between Strasbourg, Cologne, and Freiburg, for example, can only be appreciated through consideration of the associated drawings and their geometrical logic. The analyses of those workshops presented in this book thus provide a newly detailed origin story for the openwork spire, one of the most spectacular monument types of the Gothic era. Geometrical consideration of the Orvieto and Siena drawings, similarly, sheds new light on the history of those workshops, showing that their links to northern Gothic practice were closer than has previously been imagined. The case studies of Prague, Vienna, Ulm, Frankfurt, and Regensburg all attest, in their own ways, to striking continuity within particular Gothic workshops. The visionary and seemingly impractical single-spire plan for Regensburg Cathedral, for example, has a geometrical structure directly based on the cathedral's thirteenth-century choir. The octagonal section geometry of the Prague choir, meanwhile, was probably established by Peter Parler's predecessor Matthias of Arras based on his knowledge of Clermont-Ferrand cathedral, where the octagonal geometry of the thirteenth-century choir went on to influence the Flamboyant façade design produced around 1500.

This dramatic methodological continuity across wide geographical and temporal horizons clearly demonstrates that Gothic designers could communicate with each other, but the collapse of the Gothic system in the face of competition from Renaissance Italy suggests that they had real trouble in communicating with non-specialists. The famously acrimonious debates at Milan around 1400 already show that northern Gothic designers had difficulties getting their arguments across to people outside their professional culture. At that point, the Milanese had only laughable theoretical justifications for their opposing points of view, but the popularization of Vitruvius's *De Architectura* and the emergence of Alberti's *De Re Aedificatoria* catapulted Renaissance builders into a position of rhetorical and theoretical superiority. This mattered particularly because these qualities could be readily appreciated by the educated aristocratic patrons whose taste increasingly determined the direction of architectural culture in the years around and after 1500. The static formal rules of classical architecture, finally, could be translated into simple illustrations far more readily than the dynamic procedural rules of Gothic design, which meant that Gothic designers had no effective rejoinder to the illustrated treatises of Serlio, Vignola, and Palladio.

In the centuries since the Renaissance, Gothic design has been alternately reviled and praised, but it has rarely been studied with the close attention that it merits. Because Gothic buildings appear so fantastic and superhuman, with their restless and quasi-crystalline formal order, even admirers of the style have had difficulty understanding the procedures by which medieval designers with simple tools came up with their audacious schemes. And because Gothic design involves highly precise geometrical relationships, it demands to be studied with great care. The analysis of original design drawings offers one powerful method for achieving this precision, as the preceding chapters have shown. But the results presented here represent just the tip of the iceberg, in terms of what can usefully be done with geometrical analysis of Gothic design. Many drawings remain to be explored in this way, and building surveys are becoming increasingly precise and increasingly rapid, thanks to technological advances, opening exciting new possibilities for geometrical study of full-scale structures. In the near future, therefore, the geometry of Gothic architectural creativity may at last receive the attention that it so richly deserves.

Bibliography

Ackerman, James S., "'Ars Sine Scientia Nihil Est': Gothic Theory of Architecture at the Cathedral of Milan," *Art Bulletin*, 31 (1949): 84–111.

_____, review of Maria Velte, *Die Anwendung der Quadratur und Triangulatur bei der grund- und aufrißgestaltung der gotischen Kirchen* (Basel, 1951), *Art Bulletin*, 35 (1953): 155–7.

_____, "Villard de Honnecourt's Drawings of Reims Cathedral: A Study in Architectural Representation," *Artibus et Historiae*, 35 (1997): 41–9.

_____, *Origins, Imitation, Conventions: Representation in the Visual Arts* (Cambridge: Cambridge University Press, 2002), esp. "Leonardo da Vinci's Church Designs," pp. 67–93; and "The Origins of Architectural Drawing in the Middle Ages and Renaissance," pp. 28–65.

Ad Quadratum: The Practical Application of Geometry in Medieval Architecture, ed. Nancy Wu (Aldershot: Ashgate, 2002).

Die Architekturlehrer der TU Braunschweig, 1884–1995, eds Roland Böttcher, Kristiana Hartmann and Monika Lemke-Kokkelink (Braunschweig: Stadtarchiv und Stadtbibliotek, 1995).

Ascani, Valerio, "Le dessin d'architecture médiéval en Italie," in Roland Recht (ed.), *Les Batisseurs des cathédrales gothiques* (Strasbourg: Editions les Musées de la Ville de Strasbourg, 1989), pp. 255–77.

_____, *Il Trecento Disegnato: Le basi progettuali dell'architettura gotica in Italia* (Rome: Viella, 1997).

Barnes, Carl F., *The Portfolio of Villard de Honnecourt: A New Critical Edition and Color Facsimile* (Farnham: Ashgate, 2009).

Les Batisseurs des cathédrales gothiques, ed. Roland Recht (Strasbourg: Editions les Musées de la Ville de Strasbourg, 1989).

Benešovská, Klára, "La haute tour de la cathédrale Saint-Guy dans ses rapports avec la façade sud," *Umění*, 49/3–4 (2001): 271–89.

_____, "Einige Randbemerkungen zum Anteil von Peter Parler am Prager Veitsdom," in Richard Strobel (ed.), *Parlerbauten. Architektur, Skulptur, Restaurierung: Internationales Parler-Symposium Schwäbisch Gmund, 17–19 Juli 2001* (Stuttgart: Theiss, 2004), pp. 117–26.

_____, "The Legacy of the Last Phase of the Prague Cathedral Workshop: One More Look at the 'Weicher Stil'," in Jiří Fajt and Andrea Langer (eds), *Kunst als Herrschaftsinstrument: Böhmen und das Heilige Römische Reich unter den Luxemburgern im Europäischen Kontext* (Munich: Deutscher Kunstverlag, 2009), pp. 43–58.

Białostocki, Jan, "Late Gothic: Disagreements about the Concept," *Journal of the British Archaeological Association*, 29 (1966): 76–105.

_____, *Art of the Renaissance in Eastern Europe: Hungary, Bohemia, Prague* (Ithaca: Cornell University Press, 1976).

Binski, Paul, "'Working by Words alone': The Architect, Scholasticism and Rhetoric in Thirteenth-century France," in Mary J. Carruthers (ed.), *Rhetoric beyond Words: Delight and Persuasion in the Arts of the Middle Ages* (Cambridge: Cambridge University Press, 2010), pp. 14–51.

Böker, Johann Josef, *Architektur der Gotik: Bestandskatalog der weltgrossten Sammlung an gotischen Baurissen (Legat Franz Jäger) im Kupferstichkabinett der bildenden kunst Wien/ Gothic Architecture: Catalogue of the world-largest collection of Gothic architectural drawings (Bequest Franz Jäger) in the collection of prints and drawings of the Academy of Fine Arts, Vienna* (Salzburg: A. Pustet, 2005).

_____, *Der Wiener Stephansdom: Architektur als Sinnbild für das Haus Österreich* (Salzburg: A. Pustet, 2007).

Bonelli, Renato, *Il Duomo di Orvieto e l'architettura italiana de duecento Trecento*, 3rd edn, rev. (Rome: Officina Edizioni, 1972).

Bony, Jean, *The English Decorated Style: Gothic Style Transformed, 1250–1350* (Ithaca: Cornell University Press, 1979).

Bork, Robert, *Great Spires: Skyscrapers of the New Jerusalem* (Cologne: Abt. Architekturgeschichte, 2003).

_____, "Into Thin Air: France, Germany, and the Invention of the Openwork Spire," *Art Bulletin*, 85 (March 2003): 25–53.

_____, "Plan B and the Geometry of Façade Design at Strasbourg Cathedral, 1250–1350," *Journal of the Society of Architectural Historians*, 64 (December 2005): 442–73.

_____, "The Geometrical Structure of Strasbourg Plan A: A Hypothetical Step-by-step Reconstruction," *AVISTA Forum*, 16/1 (Fall 2006): 14–22.

_____, "Stacking and 'Octature' in the Geometry of Cologne Plan F," in Alexandra Gajewski and Zoë Opačić (eds), *The Year 1300 and the Creation of a New European Architecture* (Turnhout: Brepols, 2008), pp. 93–110.

Bouwen door de eeuwen heen in Vlaanderen; Inventaris van het cultuurbezit in Vlaanderen, Architectuur: 1. Provincie Brabant, Arrondissement Leuven (Liège: Mardaga, 1971).

Branner, Robert, "Drawings from a Thirteenth-Century Architect's Shop: The Reims Palimpsest," *Journal of the Society of Architectural Historians*, 17 (1958): 9–21.

_____, "Villard de Honnecourt, Reims and the Origin of Gothic Architectural Drawing," *Gazette des Beaux-Arts*, 6th ser., 61 (March 1963): 129–46.

_____, "A Fifteenth-Century Architectural Drawing at the Cloisters," *Metropolitan Museum Journal*, 11 (1976): 133–6.

Braunfels, Wolfgang, *Urban Design in Western Europe: Regime and Architecture, 900–1900*, trans. Kenneth J. Northcott (Chicago: University of Chicago Press, 1988).

Brothers, Cammy, *Michelangelo, Drawing, and the Invention of Architecture* (New Haven: Yale University Press, 2008).

Bucher, François, "Design in Gothic Architecture: A Preliminary Assessment," *The Journal of the Society of Architectural Historians*, 27 (1968): 49–71.

_____, "Medieval Architectural Design Methods, 800–1560," *Gesta*, 11 (1972): 37–51.

_____, "Micro-Architecture as the 'Idea' of Gothic Theory and Style," *Gesta*, 15/1–2 (1976): 71–91.

_____, *Architector: The Lodge Books and Sketchbooks of Medieval Architects* (New York: Abaris Books, 1979).

Bureš, Jaroslav, "Die Prager Domfassade," *Acta Historiae Artium*, 29 (1983): 3–50.

_____, "Der Regensburger Doppelturmplan: Untersuchungen zur Architektur der ersten Nachparlerzeit," *Zeitschrift für Kunstgeschichte*, 49 (1986): 1–38.

Buyle, Marjan, Thomas Coomans, Jan Esther, and Luc Francis Genicot, *L'architecture gothique en Belgique* (Brussels: Editions Racine, 1997).

Champris, Thierry de, *Cathédrales, le verbe géométrique* (Paris: G. Tredaniel, and Brussels: Savoir pour être, 1994).

Chotěbor, Petr, "Der grosse Turm des Veitsdoms: Erkenntnisse, die bei den Instandsetzungsarbeiten im Jahr 2000 gewonnen wurden," *Umění*, 49/3–4 (2001): 262–70.

Chueca Goitia, Fernando, *La Catedral Nueva de Salamanca: historia documental de su construcción* (Salamanca: Universidad de Salamanca, 1951).

Clark, William W., "Reims Cathedral in the Portfolio of Villard de Honnecourt," in Marie-Thérèse Zenner (ed.), *Villard's Legacy: Studies in Medieval Technology, Science and Art in Memory of Jean Gimpel* (Aldershot: Ashgate, 2004).

Coenen, Ulrich, *Die spätgotischen Werkmeisterbücher in Deutschland: Untersuchung und Edition der Lehrschriften für Entwurf und Ausführung von Sakralbauten* (Munich: Scaneg, 1990).

Cohen, Matthew A., "How much Brunelleschi? A Late Medieval Proportional System in the Basilica of San Lorenzo in Florence," *Journal of the Society of Architectural Historians*, 67/1 (2008): 18–57.

Crossley, Paul, "The Return to the Forest: Natural Architecture and the German Past in the Age of Dürer," in Thomas W. Gaehtgens (ed.), *Künstlicher Austausch: Akten des XXVII. Internationalen Kongresses für Kunstgeschichte, Berlin 15.–20. July 1992* (Berlin: Akademie-Verlag, 1993): 71–80.

_____, "Peter Parler and England: A Problem Re-visited," in Richard Strobel (ed.), *Parlerbauten. Architektur, Skulptur, Restaurierung: Internationales Parler-Symposium Schwäbisch Gmund, 17–19 Juli 2001* (Stuttgart: Theiss, 2004), pp. 155–80.

Davis, Michael T., "The Choir of the Cathedral of Clermont-Ferrand: The Beginning of Construction and the Work of Jean Deschamps," *Journal of the Society of Architectural Historians*, 40/3 (1981): 181–202.

_____, "'Troys Portaulx et Deux Grosses Tours': The Flamboyant Façade Project for the Cathedral of Clermont," *Gesta*, 22/1 (1983): 67–83.

_____, "On the Drawing Board: Plans of the Clermont Terrace," in Nancy Wu (ed.), *Ad Quadratum: The Practical Application of Geometry in Medieval Architecture* (Aldershot: Ashgate, 2002), pp. 183–204.

Davis, Michael T., and Linda Elaine Neagley, "Mechanics and Meaning: Plan Design at Saint-Urbain, Troyes and Saint-Ouen, Rouen," *Gesta*, 39 (2000): 173–84.

Dehio, Georg, *Untersuchungen über das gleichseitige Dreieck als Norm gotischer Bauproportionen* (Stuttgart: J. G. Cotta, 1894).

_____, "Zur Frage der Triangulation in der mittelalterlichen Kunst," *Repertorium für Kunstwissenschaft*, 18 (1895).

_____, *Das Strassburger Münster*, 2nd edn (Munich: R. Piper & Co., Verlag, 1941).

Dehio, Georg, and Gustav von Bezold, *Die kirchliche Baukunst des Abendlandes* (4 vols, Stuttgart: J. G. Cotta, 1901).

Drach, Karl Alhard von, *Das Hütten-Geheimnis von gerechten Steinmetzen-Grund in seiner Entwicklung und Beudeutung für die kirchliche Baukunst des Deutschen Architekturs* (Marburg: N. G. Elwert, 1897).

Draper, Peter, "Canterbury Cathedral: Classical Columns in the Trinity Chapel?" *Architectural History*, 44 (2001): 172–8.

Dreher, Derick, "The Drawings of Peter Vischer the Younger and the Vischer Workshop of Renaissance Nuremberg" (Ph.D. diss., Yale University, 2002).

Even, Edward van, *Louvain dans le passé et dans le present* (Leuven: Auguste Fonteyn, 1895).

Fergusson, Peter, "Notes on Two Cistercian Engraved Designs," *Speculum*, 54 (1979): 1–17.

_____, "Prior Wibert's Fountain Houses," in Evelyn Staudiger Lane, Elizabeth Carson Pastan, and Ellen M. Shortell (eds), *The Four Modes of Seeing: Approaches to Medieval Imagery in Honor of Madeleine Harrison Caviness* (Farnham: Ashgate, 2009), pp. 83–98.

Fernie, Eric, "The Proportions of the Saint Gall Plan," *Art Bulletin*, 60 (1978): 583–9.

_____, "A Beginner's Guide to the Study of Architectural Proportions and Systems of Length," in Eric Fernie and Paul Crossley (eds), *Medieval Architecture and its Intellectual Context: Studies in Honour of Peter Kidson* (London: The Hambleton Press, 1990), pp. 229–38.

Fischer, Friedhelm Wilhelm, *Die spätgotische Kirchenbaukunst am Mittelrhein, 1410–1520* (Heidelberg: Carl Winter Universitätsverlag, 1962).

Flum, Thomas, *Der spätgotische Chor des Freiburger Münsters: Baugeschichte und Baugestalt* (Berlin: Deutscher Verlag für Kunstgeschichte, 2001).

Frankl, Paul, "The Secret of the Medieval Masons," *Art Bulletin*, 27 (1945): 46–60.

_____, *The Gothic: Sources and Literary Interpretations through Eight Centuries* (Princeton: Princeton University Press, 1960).

_____, *Gothic Architecture* (Princeton: Princeton University Press, 1962).

_____, *Principles of Architectural History: The Four Phases of Architectural Style, 1420–1900*, trans. James O'Gorman (Cambridge, Mass.: MIT Press, 1968). Originally published in 1914 as *Die Entwicklungsphasen der neueren Baukunst*.

_____, *Gothic Architecture*, rev. edn by Paul Crossley (New Haven: Yale University Press, 2000).

Freigang, Christian, "Bildlichkeit und Gattungstranszendenz in der Architektur um 1300," in Norbert Nussbaum and Sabine Lepsky (eds), *1259: Altenberg und die Baukultur im 13. Jahrhundert*, Veröffentlichung des Altenberger Dom-Vereins, 10 (Regensburg: Schnell & Steiner, 2010), pp. 377–96.

Frey, Dagobert, *Gotik und Renaissance als Grundlagen der modernen Weltanschauung* (Augsburg: Filser, 1929).

Friedrich, Karl, "Die Risse zum Hauptturm des Ulmer Münsters," *Ulm und Oberschwaben*, 36 (1962): 19–38.

Frisch, Teresa, *Gothic Art 1140–c. 1450: Sources and Documents* (Toronto: University of Toronto Press in association with the Medieval Academy of America, 1987).

Fuchs, Friedrich, "Zwei mittelalterliche Aufriß-Zeichnungen: Zur Westfassade des Regensburger Domes," in Peter Morsbach (ed.), *Der Dom zu Regensburg: Ausgrabung, Restaurierung, Forschung* (Munich and Zurich: Schnell & Steiner, 1989), pp. 224–30.

Gallet, Yves, "La nef de la cathédrale de Strasbourg, sa date et sa place dans l'architecture gothique rayonnante," *Bulletin de la cathédrale de Strasbourg*, 25 (2002): 49–82.

Goethe on Art, ed. John Gage (Berkeley: University of California Press, 1980).

Günther, Hubertus, *Das Studium der Antiken Architektur in den Zeichnungen der Hochrenaissance* (Tübingen: E. Wasmuth, 1988).

Haas, Walter, and Dethard von Winterfeld, *Der Dom S. Maria Assunta—Architektur*, vol. 3 of *Die Kirchen von Siena*, eds Peter A. Riedl and Max Seidel (Munich: Deutscher Kunstverlag, 2006).

Haase, Julius, "Der Dom zu Köln am Rhein in seinen Haupt-Maßverhältnisse auf Grund der Siebenzahl und der Proportion des goldenen Schnitts," *Zeitschrift für Geschichte der Architektur*, 5 (1911/1912).

Haberland, Ernst-Dietrich, Hans-Otto Schembs, and Hans-Joachim Spies, *Madern Gerthener, "Der Stadt Frankenfurd Werkmeister": Baumeister und Bildhauer der Spätgotik* (Frankfurt-am-Main: J. Knecht, 1992).

Hahnloser, Hans R., *Villard de Honnecourt: Kritische Gesamtausgabe des Bauhüttenbuches ms. fr. 19093 der Pariser Nationalbibliothek* (Graz: Akademische Druck und Verlagsonstalt, 1972).

Harrison, Stuart, and Paul Barker, "Byland Abbey, North Yorkshire: The West Front and Rose Window Reconstructed," *Journal of the British Archaeological Association*, 3rd ser., 140 (1987): 134–51.

Harvey, John, *The Gothic World, 1100–1600, A Survey of Architecture and Art* (London: B. T. Batsford, 1950).

Hearn, M.F., "Villard de Honnecourt's Perception of Gothic Architecture," in Eric Fernie and Paul Crossley (eds), *Medieval Architecture and its Intellectual Context: Studies in Honour of Peter Kidson* (London: The Hambleton Press, 1990): 127–36.

Hecht, Konrad, "Der St. Galler Klosterplan: Schema oder Bauplan?" *Abhandlung der Braunschweigischen Wissentschaftlichen Gesellschaft*, 17 (1965): 165–206.

_____, "Zur Maßstäblichkeit der mittelalterlichen Bauzeichnung," *Bonner Jahrbuch*, 166 (1966): 253–68.

_____, "Zur Geometries des St. Galler Klosterplanes," *Abhandlung der Braunschweigischen Wissentschaftlichen Gesellschaft* 29 (1978): 57–96.

_____, *Maß und Zahl in der gotischen Baukunst* (Hildesheim: G. Olms, 1979).

_____, *Der St. Galler Klosterplan* (Sigmaringen: Thorbecke, 1983).

Heckner, Ulrike, and Hans-Dieter Heckes, "Die gotischen Ritzzeichnungen in der Chorhalle des Aachener Doms," in Ulrike Heckner and Gisbert Knopp (eds), *Die gotische Chorhalle des Aachener Doms und ihre Austattung* (Petersberg: M. Imhof, 2002), pp. 339–61.

Heideloff, Carl Alexander, *Die Bauhütte des Mittelalters: eine kurzgefaßte geschichtliche Darstellung mit Urkunden und anderen Beilagen . . .* (Nuremberg: Stein, 1844).

Hertkens, Joseph, *Die mittelalterlichen sakraments-häuschen: eine kunsthistorische studie* (Frankfurt-am-Main: P. Kreuer, 1908).

Hipp, Hermann, *Studien zur "Nachgotik" des 16. und 17. Jahrhunderts in Deutschland, Böhmen, Österreich und der Schweiz* (3 vols, Hannover: Ewald Böttger, 1979).

Hiscock, Nigel, *The Wise Master Builder: Platonic Geometry in Plans of Medieval Abbeys and Cathedrals* (Aldershot: Ashgate, 2000).

Hoffstadt, Friedrich, *Gotisches ABC-Buch, das ist: Grundregeln des gothischen Styls für Künstler und Werkleute* (Frankfurt-am-Main: S. Schmerber, 1840).

Holzer, Stefan, review of *Das Lehrwerk des Matthäus Roriczer*, by Wolfgang Strohmayer, in *Kunstform* 7 (2006), Nr.03, www.arthistoricum.net/index.php?id=276&ausgabe=2006_03& review_id=10507.

Horn, Walter, "The Dimensional Inconsistencies of the Plan of St. Gall," *Art Bulletin*, 38 (1966): 285–308.

Horn, Walter, and Ernest Born, *The Plan of Saint Gall: A Study of the Architecture and Economy of and Life in a Paradigmatic Carolingian Monastery* (3 vols, Berkeley: University of California Press, 1979).

Hubel, Achim, *The Cathedral of Regensburg*, trans. Genoveva Nitz (Munich: Schnell & Steiner, 1991).

Huppert, Ann C., "Envisioning New St. Peter's: Perspectival Drawings and the Process of Design," *Journal of the Society of Architectural Historians*, 68 (2009): 158–77.

Jacobsen, Werner, *Der Klosterplan von St. Gallen und die karolingische Architektur: Entwicklung und Wandel von Form und Bedeutung im fränkischen Kirchenbau zwischen 751 und 840* (Berlin: Deutscher Verlag für Kunstwissenschaft, 1992).

Kavaler, Ethan Matt, "Nature and the Chapel Vaults at Ingolstadt: Structuralist and Other Perspectives," *Art Bulletin*, 87 (2005): 230–48.

_____, "Architectural Wit," in Matthew M. Reeve (ed.), *Reading Gothic Architecture* (Turnhout: Brepols, 2007), pp. 130–50.

Keldermans: Een architektonisch netwerk in de Nederlanden, eds J.H. van Mosselveld, and H. Janse (The Hague: Staatsuitgeverij; Bergen op Zoom: Gemeentemuseum Markiezenhof, 1987).

Kidson, Peter, "Panofsky, Suger and St Denis," *Journal of the Warburg and Courtauld Institutes*, 50 (1987): 1–17.

_____, "A Metrological Investigation," *Journal of the Warburg and Courtauld Institutes*, 53 (1990): 71–97.

_____, "The Historical Circumstance and the Principles of the Design," in Thomas Cocke and Peter Kidson (eds), *Salisbury Cathedral: Perspectives on the Architectural History* (London 1993), pp. 31–97.

_____, "Three Footnotes to the Milan Debates," in *Arte d'Occidente, Temi e metodi: Studi in onore di Angiola Maria Romanini* (Rome: Sintesi Informazione, 1999), pp. 269–78.

Klein, Bruno, "Der Fassadenplan 5 für das Straßburger Münster und der Beginn des fiktiven Architekturentwurfes," in Stefanie Lieb (ed.), *Form und Stil: Festschrift für Gunther Binding zum 65. Geburtstag* (Darmstadt: Wissenschaftliche Buchgesellschaft, 2001), pp. 166–74.

Kletzl, Otto, review of *Das Proportionenwesen in der Geschichte der gotischen Baukunst und die Frage der Triangulation*, by Walter Thomae, in *Zeitschrift für Kunstgeschichte*, 4 (1935): 56–63.

_____, "Zwei Plan-Bearbeitungen des Freiburger Münsterturms," *Oberrheinische Kunst*, 7 (1936): 14–35.

_____, "Werkrißtypen deutscher Bauhüttenkunst," *Sitzungsberichte der Kunstgeschichtliche Gesellschaft Berlin* (1937–38): 20–22.

_____, "Ein Werkriß des Frauenhauses in Straßburg," *Marburger Jahrbuch für Kunstwissenschaft*, 11–12 (1938–39): 103–58.

_____, *Plan-Fragmente aus der deutschen Dombauhütte von Prag in Stuttgart und Ulm* (Stuttgart: Felix Krais Verlag, 1939).

_____, "Die Kreßberger Fragmente: Zwei Werkrisse deutscher Hüttengotik," *Marburger Jahrbuch für Kunstwissenschaft*, 13 (1944): 129–70.

Klotz, Heinz, "Deutsche und Italienische Baukunst im Trecento," *Mitteilungen des Kunsthistorischen Inhstituts in Florenz*, 12 (1966): 171–206.

Koepf, Hans, *Die Gotischen Planrisse der Wiener Sammlungen* (Vienna: H. Böhlaus, 1969).

Kurmann, Peter, *La Façade de la cathédrale de Reims* (2 vols, Paris: Edition du Centre nationale de la récherche scientifique; Lausanne: Payot, 1987).

_____, "Filiation ou parallele? A propos des façades et des tours de Saint-Guy de Prague et de Saint-Ouen de Rouen," *Umění*, 49 (2001), 211–19.

_____, "Architecture, vitrail, et orfèvrerie: à propos des premiers dessins d'édifices gothiques," in Robert Tollet (ed.), *Représentations architecturales dans les vitraux* (Liège: Région Wallone, Commission Royale des Monuments, Sites et Fouilles, 2002), pp. 33–41.

_____, *Die Kathedrale St. Nikolaus in Freiburg: Brennspiegel der europäischen Gotik* (Lausanne: Bibliothèque des Arts, and Freiburg [Schweiz]: Stiftung für die Erhaltung der Kathedrale St. Nikolaus, 2007).

Labuda, Adam, "Das Kunstgeschichtliche Institut an der Reichsuniversität Posen und die 'nationalsozialistische Aufbauarbeit' im Gau Wartheland, 1939–1945," in Jutta Held and Martin Papenbrock (eds), *Kunstgeschichte an den Universitäten im Nationalsozialismus* (Göttingen: V & R Unipress, 2003), pp. 143–60.

Lang, Astrid, "Die frühneuzeitliche Architekturzeichnung als Medium intra- und interkultureller Kommunikation: Entwurfs- und Repräsentationskonventionen nördlich der Alpen und ihre Bedeutung für den Kulturtransfer um 1500 am Beispiel der Architekturzeichnungen von Hermann Vischer dem Jüngeren" (Ph.D. diss., University of Cologne, 2009).

Langendonck, Linda van, "De St. Romboutstoren te Mechelen" (Ph.D. diss., Catholic University of Leuven, 1984).

Lepsky, Sabine, and Norbert Nussbaum, *Gotische Konstruktion und Baupraxis an der Zisterzienserkirche Altenberg: Bd. 1, Die Choranlage* (Bergisch Gladbach: Altenberger Dom-Verein, 2005).

Liess, Reinhard, "Der Riß B der Straßburger Münsterfassade: eine baugeschictliche Revision," in *Orient und Okzident in Spiegel der Kunst: Festschrift Heinrich Gerhard Franz zum 70 Geburtstag* (Graz: Akademische Druck- und Verlagsanstalt, 1986), pp. 171–202.

_____, "Die Rahnsche Riß A des Freiburger Münsterturms und seine Straßburger Herkunft," *Zeitschrift des Deutschen Vereins für Kunstwissenschaft*, 45 (1991): 7–66.

Lund, Fredrik Macody, *Ad Quadratum: A Study of the Geometrical Bases of Classic and Medieval Religious Architecture* (London: B. T. Batsford, 1921).

Lützeler, Heinrich, *Der Turm des Freiburger Münsters* (Freiburg: Herder, 1955).

Mandelbrot, Benoit, *Fractals: Form, Chance, and Dimension* (San Francisco: W. H. Freeman, 1977).

Marina, Areli, "Order and Ideal Geometry in Parma's Piazza del Duomo," *Journal of the Society of Architectural Historians*, 65 (2006): 520–49.

Mark, Robert, "Structural Experimentation in Gothic Architecture," *American Scientist*, 66 (1978): 542–50.

Medieval Architecture and its Intellectual Context: Studies in Honour of Peter Kidson, eds Eric Fernie and Paul Crossley (London: The Hambleton Press, 1990).

Mojon, Luc, *Der Münsterbaumeister Matthäus Ensinger: Studien zu seinem Werk* (Bern: Benteli, 1967).

Müller, Werner, "Le dessin technique à l'époque gothique," in Roland Recht (ed.), *Les Batisseurs des cathédrales gothiques* (Strasbourg: Editions les Musées de la Ville de Strasbourg, 1989), pp. 237–54.

_____, *Grundlagen gotischer Bautechnik: ars sine scientia nihil* (Munich: Deutscher Kunstverlag, 1990).

Murray, Stephen, "The Gothic Façade Drawings in the 'Reims Palimpsest'," *Gesta*, 17/2 (1978): 51–6.

_____, "The Choir of the Church of St.-Pierre, Cathedral of Beauvais: A Study of Gothic Architectural Planning and Constructional Chronology in Its Historical Context," *Art Bulletin*, 62 (1980): 533–51.

_____, *Notre-Dame, Cathedral of Amiens* (Cambridge: Cambridge University Press, 1996).

Murray, Stephen, and James Addiss, "Plan and Space at Amiens Cathedral: With a New Plan Drawn by James Addiss," *Journal of the Society of Architectural Historians*, 49 (1990): 44–66.

Naredi-Rainer, Paul von, *Architektur und Harmonie: Zahl, Maß und Proportion in der abendländischen Baukunst* (Cologne: DuMont, 1995).

Neagley, Linda E., "Elegant Simplicity: The Late Gothic Plan Design of St-Maclou in Rouen," *Art Bulletin*, 74 (1992): 423–40.

_____, "A Late Gothic Architectural Drawing at The Cloisters," in Elizabeth Sears and Thelma K. Thomas (eds), *Reading Medieval Images: The Art Historian and the Object* (Ann Arbor: University of Michigan Press, 2002), pp. 90–99.

New Approaches to Medieval Architecture, eds Robert Bork, William W. Clark, and Abby McGehee (Farnham: Ashgate, 2011).

Noack, Werner, "Der Freiburger Münsterturm," *Oberrheinische Heimat*, 28 (1941): 226–47.

Nussbaum, Norbert, *German Gothic Church Architecture* (New Haven: Yale University Press, 2000).

_____, "Der Chorplan der Zisterzienserkirche Altenberg. Überlegungen zur Entwurfs- und Baupraxis im 13. Jahrhundert," *Wallraf-Richartz-Jahrbuch*, 64 (2003): 7–52.

Panofsky, Erwin, "An Explanation of Stornaloco's Formula," *Art Bulletin*, 27 (1945): 61–4.

_____, *Gothic Architecture and Scholasticism* (Latrobe, Penn.: Archabbey Press, 1951).

_____, *Renaissance and Renascences in Western Art* (New York: Harper and Row, 1972).

Parker, Geoffrey, *The Military Revolution, 1500–1800: Military Innovation and the Rise of the West* (Cambridge: Cambridge University Press, 1996).

Pause, Peter, *Gotische Architekturzeichnungen in Deutschland* (Bonn: University, Phil. Fak., 1973).

Payne, Alina, *The Architectural Treatise in the Italian Renaissance: Architectural Invention, Ornament, and Literary Culture* (Cambridge: Cambridge University Press, 1999).

Perger, Richard, "Die Baumeister des Wiener Stephansdomes im Spätmittelalter," *Wiener Jahrbuch für Kunstgeschichte*, 23 (1970): 66–107.

Podlaha, Antonin, and Kamil Hilbert, *Metropolitní Chrám sv. Vita* (Prague: Czech Academy, 1906).

Rahn, Johann Rudolf, *Geschichte der bildenden Künste in der Schweiz, von des ältesten Zeiten bis zum Schlusse des Mittelalters* (Zurich: H. Staub, 1876).

Ranquet, Henri du, *La Cathédrale de Clermont-Ferrand* (Paris: H. Laurens, 1928).

Recht, Roland, *L'Alsace gothique de 1300 à 1365: Etude d'architecture religieuse* (Colmar: Editions Alsatia, 1974).

_____, *Le Dessin d'architecture: origine et fonctions* (Paris: A. Buro, 1995).

Reiners, Heribert, *Das malerische alte Freiburg-Schweiz* (Augsburg: Dr Benno Filser, 1930).

Riccetti, Lucio, *Opera, piazza, cantiere: quattro saggi sul Duomo di Orvieto* (Foligno: Edicit, 2007).

Roriczer, Matthäus, *Das Büchlein von der Fialen Gerechtigkeit: Faksimile der Originalausgabe, Regensburg 1486; und Die Geometria Deutsch, Faksimile der Originalausgabe, Regensburg um 1487/88*, ed. Ferdinand Geldner (Wiesbaden: Pressler, 1965).

Rosario, Eva, *Art and Propaganda: Charles IV of Bohemia, 1346-1378* (Rochester: Boydell & Brewer, 2000).

Rosenau, Helen, *Der Kölner Dom: Seine Baugeschichte und historische Stellung* (Cologne: Kölner Geschichtsverein, 1931).

Sanabria, Sergio, "A Late Gothic Drawing of San Juan de los Reyes in Toledo at the Prado Museum in Madrid," *Journal of the Society of Architectural Historians*, 51 (1992): 161–73.

Sankovitch, Annemarie, "The Myth of the Myth of the Medieval," *RES, Anthropology and Aesthetics*, 40 (2001): 29–50.

Schock-Werner, Barbara, *Das Straßburger Münster im 15. Jahrhundert: Stilistische Entwicklung und Hüttenorganisation eines Bürger-Doms* (Cologne: Abt. Architektur des Kunsthistorichen Instituts, 1983).

_____, "Ulrich d'Ensingen, maître d'oeuvre de la cathédrale de Strasbourg, de l'église paroissale d'Ulm, et de l'église Notre-Dame d'Esslingen," in Roland Recht (ed.), *Les Batisseurs des cathédrales gothiques* (Strasbourg: Editions les Musées de la Ville de Strasbourg, 1989), pp. 204–208.

Schöller, Wolfgang, "Le Dessin d'architecture à l'époque gothique," in Roland Recht (ed.), *Les Batisseurs des cathédrales gothiques* (Strasbourg: Editions les Musées de la Ville de Strasbourg, 1989), pp. 226–35.

Schuller, Manfred, "Bautechnik und Bauorganization," in Peter Morsbach (ed.), *Der Dom zu Regensburg: Ausgrabung, Restaurierung, Forschung* (Munich and Zurich: Schnell & Steiner, 1989), pp. 168–223.

Schurr, Marc Carel, *Die Baukunst Peter Parlers: der Prager Veitsdom, das Heiligkreuzmünster in Schwäbish Gmünd und die Bartholomäuskirche zu Kolin im Spannungsfeld von Kunst und Geschichte* (Ostfildern: Thorbecke, 2003).

_____, "Heinrich und Peter Parler am Heiligkreuzmünster in Schwäbisch Gmünd," in Richard Strobel (ed.), *Parlerbauten: Architektur, Skulptur, Restaurierung: Internationales Parler-Symposium Schwäbisch Gmund, 17–19 Juli 2001* (Stuttgart: Theiss, 2004), pp. 29–37.

_____, "Die Erneuerung des Augsburger Domes im 14. Jahrhundert und die Parler," in Martin Kaufhold (ed.), *Der Augsburger Dom im Mittelalter* (Augsburg: Wissner, 2006), pp. 49–59.

600 Jahre Ulmer Münster: Festschrift, eds Hans Eugen Specker and Reinhard Wortmann (Ulm: Stadtarchiv; and Stuttgart: Kohlhammer, 1977).

Shelby, Lon, *Gothic Design Techniques: The Fifteenth-Century Design Booklets of Mathes Roriczer and Hans Schmuttermayer* (Carbondale: Southern Illinois Press, 1977).

Siebenhüner, Herbert, *Deutsche Künstler am Mailänder Dom* (Munich: F. Bruckmann, 1944).

Simon, Herbert A., "The Architecture of Complexity," *Proceedings of the American Philosophical Society*, no. 106 (1962): 467–82.

Stanford, Charlotte A., "Building Civic Pride: Strasbourg Cathedral from 1300 to 1349" (Ph.D. diss., Pennsylvania State University, 2003).

Steinmann, Marc, *Die Westfassade des Kölner Domes: Der mittelalterliche Fassadenplan F* (Cologne: Verlag Kölner Dom, 2003).

Strohmayer, Wolfgang, *Das Lehrwerk des Matthäus Roriczer* (Hürtgenwald: Guido Pressler Verlag, 2004).

_____, *Matthäus Roriczer—Baukunst Lehrbuch* (Hürtgenwald: Guido Pressler Verlag, 2009).

Tardieu, Ambroise, *Histoire de la ville de Clermont-Ferrand* (2 vols, Moulins: Desrosiers, 1870–71).

Thomae, Walter, *Das Proportionswesen in der Geschichte der gotischen Baukunst und die Frage der Triangulation* (Heidelberg: Carl Winters Universitätsverlag, 1933).

Tietze, Hans, *Geschichte und Beschreibung des St. Stephansdomes in Wien*, Österreichische Kunsttopographie, v. 23 (Vienna: Filser, 1931).

Timmermann, Achim, "Vier kleinarchitekturrisse der Spätgotik," *Das Münster*, 55 (2002): 117–26.

_____, *Real Presence: Sacrament Houses and the Body of Christ, 1270–1600* (Turnhout: Brepols, 2009).

Toker, Franklin, "Gothic Architecture by Remote Control: An Illustrated Building Contract of 1340," *Art Bulletin*, 67 (1985): 67–95.

Trachtenberg, Marvin, "Gothic/Italian Gothic: Toward a Redefinition," *Journal of the Society of Architectural Historians*, 51 (1992): 261–87.

_____, *Dominion of the Eye: Urbanism, Art, and Power in Early Modern Florence* (Cambridge and New York: Cambridge University Press, 1997).

_____, "Desedimenting Time: Gothic Column/Paradigm Shifter," *RES: Anthropology and Aesthetics*, 40 (2001): 5–28.

Ueberwasser, Walter, "Spätgotische Bau-Geometrie: Untersuchungen an den 'Basler Goldschmiedrissen,'" *Jahresberichte der Öffentlichen Kunstsammlung Basel*, 1928–30, pp. 79–122.

_____, "Nach Rechtem Maß: Aussagen über den Begriff des Maßes in der Kunst des XIII.–XVI. Jahrhunderts," *Jahrbuch des preußischen Kunstsammlungen*, 6 (1935): 250–72.

_____, "Der Freiburger Münsterturm im 'rechten Maß,'" *Oberrheinische Kunst*, 8 (1939): 25–32.

Van Liefferinge, Stefaan, "Art, Architecture, and Science: Considerations on the Plan of the Chevet of Saint-Denis," in Robert Bork, William Clark, and Abby McGehee (eds), *New Approaches to Medieval Architecture* (Farnham: Ashgate, forthcoming).

Vellguth, Friedrich, *Der Turm des Freiburger Münsters: Versuch einer Darstellung seiner Formzusammenhänge* (Tübingen: Wasmuth, 1983).

Velte, Maria, *Die Anwendung der Quadratur und Triangulatur bei der Grund- und Aufrißgestaltung der gotischen Kirchen* (Basel: Verlag Birkhauser, 1951).

Villard's Legacy: Studies in Medieval Technology, Science and Art in Memory of Jean Gimpel, ed. Marie-Thérèse Zenner (Aldershot: Ashgate, 2004).

Viollet-le-Duc, E.-E., *Dictionnaire raisonné de l'architecture française* (10 vols, Paris: Bance, 1858–68), s.v "Clocher" and "Proportion."

Vitruvius Pollio, *De architectura libri dece*, trans. Cesare Cesariano, with commentary by Cesariano, Benedetto Giovio, and Bono Mauro (Como, 1521).

_____, *The Ten Books on Architecture*, trans. Morris Hicky Morgan (1914; New York: Dover, 1960).

Wangart, Adolf, *Das Münster in Freiburg im Breisgau im rechten Mass* (Freiburg-im-Breisgau: Karl Schillinger, 1972).

Welch, Evelyn S., *Art and Authority in Renaissance Milan* (New Haven: Yale University Press, 1996).

Wendland, David, "Cell Vaults: Research on Construction and Design Principles of a Unique Late-Mediaeval Vault Typology," in Karl Eugen Kurrer, Werner Lorenz, and Volker Wetzk (eds), *Proceedings of the Third International Congress on Construction History*, Brandenburg

University of Technology, Cottbus, 20–24 May 2009 (3 vols, Berlin: Neunplus1, 2009), pp. 1501–8.

Weyres, Willy, "Das System des Kölner Chorgrundrisses," *Kölner Domblatt*, 16–17 (1959): 97–104.

White, John, "I Disegni per la facciata del Duomo di Orvieto," in Guido Barlozzetti (ed.), *Il Duomo di Orvieto e le grandi cattedrali del Duecento: atti del convegno internazionale di Studi, Orvieto, 12–14 Novembre 1990* (Turin: Nuova ERI, 1995), pp. 68–98.

Wiener, Jürgen, *Lorenzo Maitani und der Dom von Orvieto, eine Beschreibung* (Petersberg: M. Imhof, 2009).

Wilson, Christopher, *The Gothic Cathedral: The Architecture of the Great Church, 1130–1530* (London: Thames and Hudson, 1990).

Wittkower, Rudolph, *Architectural Principles in the Age of Humanism* (London: Warburg Institute, University of London, 1949).

Witzel, Karl, Untersuchungen über gotische Proportiongesetze (Berlin: Ernst, 1914).

Wolff, Arnold, "Chronologie der ersten Bauzeit des Kölner Domes 1248–1277," *Kölner Domblatt*, 28–29 (1968): 9–229.

_____, "Der Kölner Dombau in der Spätgotik," in *Beiträge zur rheinischen Kunstgeschichte und Denkmalpflege 2 (Albert Verbeek zum 65. Geburtstag)* (Düsseldorf: Schwann Verlag, 1974), pp. 137–50.

Wortmann, Reinhard, "Noch einmal Straßburg-West," *Architectura*, 27 (1997): 129–72.

Zerner, Henri, *Renaissance Art in France: The Invention of Classicism* (Paris: Flammarion, 2003).

Zykan, Marlene, "Zur Baugeschichte des Hochturms von St. Stephan," *Wiener Jahrbuch für Kunstgeschichte*, 23 (1970): 28–65.

Index